An American Century of Photography

An American Century of Photography

FROM DRY-PLATE TO DIGITAL

The Hallmark Photographic Collection

KEITH F. DAVIS

Foreword by Donald J. Hall

Hallmark Cards, Inc.

in association with

Harry N. Abrams, Inc.

FRONTISPIECE: Plate 1 Horace D. Ashton, *Underwood & Underwood Photographer Making Views from Metropolitan Tower*, 1911, 4¼ x 3½"

This publication is one of a series from the Hallmark Photographic Collection celebrating the history and art of photography. Previous titles include *Todd Webb: Photographs of New York and Paris, 1945-1960* (1986), *Harry Callahan: New Color, Photographs 1978-1987* (1988), *George N. Barnard: Photographer of Sherman's Campaign* (1990), *Clarence John Laughlin: Visionary Photographer* (1990), and *The Passionate Observer: Photographs by Carl Van Vechten* (1993).

Editor: Brian Wallis

Designer: Malcolm Grear Designers, Providence, Rhode Island

Production: Rich Vaughn

Tritone Separations: Thomas Palmer, Newport, Rhode Island

Color Separations: Elite Color Group, Providence, Rhode Island

Printer: Meridian Printing, East Greenwich, Rhode Island

Library of Congress Cataloging-in-Publication Data

Hallmark Photographic Collection.

An American century of photography: from dry-plate to digital/The Hallmark Photographic Collection: Keith F. Davis: Foreword by Donald J. Hall.
p. cm.
"Exhibition accompanying this volume will be shown at a number of major museums in 1994–96, including the Nelson-Atkins Museum of Art, Kansas City, Missouri"—Pref.
Includes bibliographical references and index.
ISBN 0-8109-1964-8 (Abrams cloth)/ISBN 0-87529-701-3 (pbk.)
1. Photography—United States—History—19th century—Exhibitions.
2. Photography—United States—History—20th century—Exhibitions.
3. Hallmark Photographic Collection—Exhibitions. I. Davis, Keith F., 1952–.
II. Nelson Atkins Museum of Art. III. Title.
TR23.H35 1995
779'.0973'074—DC20 94-23263

All the prints illustrated in this volume are in the Hallmark Photographic Collection. Unless otherwise noted in caption data, all are vintage gelatin silver prints.

Aside from those works in the public domain, nearly all the images reproduced in this volume are copyrighted by their makers, or by the respective families, estates, foundations, or representatives of the artists. Every effort was made to contact all such parties to obtain official permission to reproduce, and we are very grateful for the kind cooperation extended by the artists included in this book, or by their families, estates, foundations, or representatives. In some cases, their permission to reproduce was conditioned upon publication of a credit line or notice of copyright. These are as follows: plate 24 Copyright Amon Carter Museum, Fort Worth, Texas. Karl Struss Collection; fig. 10 Photography Collections, University of Maryland Baltimore County; fig. 11, plates 28, 48, 49 Reprinted with permission of Joanna T. Steichen; plate 29 Copyright ©1981, Aperture Foundation Inc., Paul Strand Archive; plate 32 Courtesy of the Georgia O'Keeffe Foundation; plate 34 Courtesy of the Estate of Marjorie Content; plate 35 Copyright ©1976, Aperture Foundation Inc., Paul Strand Archive; plates 38, 39 Courtesy G. Ray Hawkins Gallery; plate 42 Courtesy Amon Carter Museum, Fort Worth, Texas. Laura Gilpin Collection; plates 51, 57, 58, 59, fig. 33 ©1981 Center for Creative Photography, Arizona Board of Regents; plate 56, fig. 34 Photographs by Ansel Adams copyright ©1994 by the Trustees of the Ansel Adams Publishing Rights Trust. All Rights Reserved; plate 61 Courtesy Alma Lavenson Associates; plate 62 ©1978, 1994 The Imogen Cunningham Trust; plate 63 ©1993 The Estate of Brett Weston; plates 64, 65, figs. 35, 36 Courtesy of Hattula Moholy-Nagy; plates 66, 67 ©1995 Artist's Rights Society (ARS), New York/ADAGP/Man Ray Trust, Paris; plate 68 Copyright Galleria Martini & Ronchetti, Genova, Italy; plate 69 Courtesy the Lisette Model Foundation, Inc.; plate 70, fig. 100 ©Estate of André Kertész; plate 71 Copyright Ilse Bing, Courtesy Houk Friedman Gallery, New York; plate 73 Courtesy Houk Friedman Gallery, New York; plate 76 Copyright ©1941, 1980, 1994 Lloyd & Douglas Morgan. Reprinted by Permission of Marketing Enterprises International, Inc.; plate 79, fig. 44 Estate of George Platt Lynes; plates 80, 81 Copyright 1981 The Historic New Orleans Collection; plate 84 Courtesy of The E. O. Hoppé Trust, c/o Curatorial Assistance, Inc., Pasadena, California, U.S.A.; plates 86, 96 Margaret Bourke-White ©Time Warner; plate 87 Copyright ©The Harold E. Edgerton 1992 Trust, Courtesy of Palm Press, Inc.; plate 89, fig. 55 Courtesy Commerce Graphics, Ltd., Inc.; plate 91, figs. 58, 59 Copyright Family of Dorothea Lange, Courtesy Houk Friedman Gallery, New York; fig. 30 ©1980, Mortensen Estate Collection; fig. 37 Courtesy Joan Munkacsi; figs. 50, 51 ©New York Daily News, L.P., used with permission; fig. 54 Courtesy The Brooklyn Museum; fig. 61 Estate of Carl Van Vechten, Joseph Solomon, Executor; plate 98 ©Smith Family Trust 1994; plate 99 Lotte Jacobi Archives, Dimond Library, U.N.H., Durham, N.H.; plate 110 Reproduction Courtesy the Minor White Archive, Princeton University, Copyright ©1989 by The Trustees of Princeton University. All rights reserved; plate 111 Reproduction Courtesy the Minor White Archive, Princeton University. Copyright ©1982 by the Trustees of Princeton University. All rights reserved; plate 112 Andreas Feininger, Life Magazine ©Time Warner; plates 114, 115 Copyright ©International Center of Photography; plate 118 ©1993 Center for Creative Photography, Arizona Board of Regents; plate 120 Copyright ©1950, Aperture Foundation Inc., Paul Strand Archive; plate 121 Copyright ©1955, Aperture Foundation Inc., Paul Strand Archive; plate 122 W. Eugene Smith, Life Magazine ©Time Warner; plate 123 Courtesy The Heirs of W. Eugene Smith; plate 124 ©Walker Evans Archive. The Metropolitan Museum of Art; plate 125, fig. 66 Copyright Estate of Arthur Siegel, Courtesy Houk Friedman Gallery, New York; plates 130, 141 ©William Klein; plates 132, 133 ©Roy DeCarava; plate 138 Photograph by Richard Avedon copyright 1955; plate 139 Courtesy Vogue. Copyright ©1950 (renewed 1978) by the Condé Nast Publications Inc.; plate 142 ©1974 Arnold Newman; plate 143 Courtesy Vogue. Copyright ©1967 by the Condé Nast Publications Inc.; plates 145, 158 Copyright Kenneth Josephson; plate 146, fig. 86 ©Elisabeth Sinsabaugh ©Katherine Sinsabaugh, 1994; plates 149, 155 Courtesy Eileen Adele Hale; plate 150 Courtesy Christopher Meatyard; fig. 63 AP/Wide World Photos; fig. 64 William Vandivert, Life Magazine ©Time Warner; fig. 67 Courtesy Amon Carter Museum, Fort Worth, Texas; fig. 72 Reproduction Courtesy The Minor White Archive, Princeton University. Copyright ©1982 by The Trustees of Princeton University. All rights reserved; fig. 76 Courtesy Sandra Weiner; fig. 79 Courtesy Miriam Grossman Cohen; fig. 83 Courtesy Francis McLaughlin-Gill; fig. 93 ©Richard Misrach; fig. 105 Copyright McDermott & McGough. Courtesy Robert Miller Gallery; plate 153 Courtesy Black Star; plate 154 ©Larry Burrows Collection. First published 1971; plate 156 Photograph by Richard Avedon copyright 1972; plate 163 ©1994 The Andy Warhol Foundation for the Visual Arts, Inc.; plate 164 Courtesy Estate of Gordon Matta-Clark; plate 167 Courtesy Brooke Alexander Editions; plate 169 Copyright Jan Groover. Courtesy Robert Miller Gallery, New York; plates 170, 171 Copyright William Eggleston. Courtesy Robert Miller Gallery, New York; plate 179 ©Lynn Davis; plate 184 Courtesy Metro Pictures; plate 187 Copyright ©1983 The Estate of Robert Mapplethorpe; plate 191 Copyright Adam Fuss. Courtesy Robert Miller Gallery, New York; plate 200 Copyright Wendy Ewald, Courtesy of James Danziger Gallery; plate 203 Copyright Sally Mann, Courtesy Houk Friedman Gallery, New York.

TABLE OF CONTENTS

Foreword

The fine arts have played an important role in the environment at Hallmark Cards for many years. In large measure, this environment stems from the special nature of our business and our people. Our creative staff includes hundreds of talented men and women drawn from the leading art schools in the nation. Their work, both during and after business hours, reflects the highest standards of excellence and innovation. Our fine art programs represent one way, of several, to both encourage and give larger symbolic expression to this ongoing creative enterprise.

My father, Joyce C. Hall, began our active collecting of contemporary art in 1949 with the establishment of the Hallmark International Art Awards program. In the course of these five projects, which ran through 1960, important paintings by American and European artists were acquired and toured to leading museums across the country. This program formed the basis for the Hallmark Fine Art Collection, which now includes well over 1000 paintings, prints, and ceramics, as well as major sculptures by artists such as Alexander Calder, Louise Nevelson, Kenneth Snelson, and Deborah Butterfield. In 1986 the Hall Family Foundation acquired an important collection of 58 Henry Moore sculptures, maquettes, and working models. This purchase was followed by acquisitions of selected masterworks of modern sculpture by Constantin Brancusi, Alberto Giacometti, Isamu Noguchi, Max Ernst, Claes Oldenburg, Joel Shapiro, and others. While our corporate collections are maintained within our headquarters building, these Foundation acquisitions are on long-term loan to the Nelson-Atkins Museum of Art.

The Hallmark Photographic Collection has grown from, and flourished within, this tradition of support for the visual arts. Developed with the assistance of David Strout, this collection was begun in 1964 with the acquisition of 141 prints by Harry Callahan. These were mounted in a one-man exhibition at the newly-opened Hallmark Gallery store at 720 Fifth Avenue in New York. The centerpiece of this store was a fine space for changing exhibitions in which a number of significant shows were presented over the following decade. The Callahan exhibit, which was on view from August 18 to October 10, 1964, included 141 black and white prints and 60 color slides shown by continuous projection. Notable exhibitions in later years included "Carl Sandburg: A Tribute" (1968) with photographs by Edward Steichen, "Young Photographers: Students of Harry Callahan at the Rhode Island School of Design" (1969), "Henri Cartier-Bresson's France" (1971), and "André Kertész: Themes and Variations" (1973). During these years significant prints by a number of other photographers—Edward Weston, Imogen Cunningham, László Moholy-Nagy, and others—were quietly added to our collection as opportunities arose.

In 1973 the Hallmark Gallery's exhibition function was discontinued and the collection relocated to our corporate headquarters in Kansas City. A few years later a period of steady growth and wide public visibility was initiated. In the fifteen years from 1979 to 1994, for example, the collection grew from 650 photographs to about 2,600. In this era some 50 different exhibitions were assembled and circulated to over 200 individual bookings in leading art museums and university galleries across the U.S., and in Canada, Australia, New Zealand, England, Wales, Switzerland, and France. To accompany the most important of these exhibits, we have also published eight catalogues and books that, we trust, have made worthwhile contributions to the literature of this field.

In addition to its function as a source of in-house creative inspiration, this resource has a two-fold public intention. We are interested in adding a unique cultural asset to our community, the greater Kansas City area, where Hallmark was founded in 1910. Most of our exhibitions have been presented at the Nelson-Atkins Museum of Art and the collection has served for years as a study resource for regional col-

leges and universities. Given our status as an international firm, we also have attempted to make judicious public use of the collection across the country and abroad. Our traveling exhibitions have been seen by hundreds of thousands of viewers, while we hope that our publications will remain interesting and useful for years to come.

These activities stem from a basic belief in the importance of the arts to our quality of life and our cultural well-being. Art—in any medium—is about the communication of ideas and emotions, the inevitability of change, and the power of the imagination. It represents a synthesis of tradition and innovation—and a respect for both—in order to express fundamental truths about our time and place. As we near the end of the twentieth century, it is also important to remember that art is about freedom and the natural diversity of ideas in a complex and dynamic world. Works of art provide new perspectives on familiar things by encouraging us to see through the eyes of others. We thus consider the support of fine art as a natural part of good corporate citizenship, and a way to encourage society at large to recognize and value its creative heritage.

It is a pleasure to survey the highlights of the first thirty years of the Hallmark Photographic Collection in this book and the accompanying exhibition. When this holding was begun in 1964 we were aware of no similar corporate collection anywhere in the world. Indeed, at that time the medium was taken seriously by only a handful of major institutions, such as the Museum of Modern Art in New York. That situation has changed dramatically in the past three decades. Photography is now widely recognized as one of the modern era's most important and vital forms of artistic expression. Most of the world's major museums have photographic programs of some kind, and interest in the medium by private collectors, scholars, and general audiences has increased at a remarkable rate. It is thus with some pride that we look back on our thirty-year commitment to the art of photography, and to its phenomenal growth in this period. We have enjoyed playing some small role in photography's recent history, and expect to continue to do so in the future. We sincerely hope that these efforts have a positive and lasting impact on as broad an audience as possible.

DONALD J. HALL
Chairman of the Board
Hallmark Cards, Inc.

Preface and Acknowledgments

Photography is like an enchanted garden where one is continually meeting the unexpected and wonderful.

> CATHERINE WEED BARNES, "The Real and The Ideal," 1891

The position of pictorial photography from the philosophical standpoint is intensely interesting. One might say it has entered the art-world as radium the physical world; there is something decidedly uncanny about it, and we really don't know where we stand.

> ROLAND ROOD, "Has The Painters' Judgment of Photography Any Value?" 1905

Photographs may be made to lie but they never make mistakes. We change our memories as we change our minds, but photographs do not. Our mental photographs continue to develop in the dark. They are retouched by unknown fingers while they are stored away and when we bring them again into the light of consciousness they have been altered though we suspect it not. But a photograph tells the same story until it is destroyed.

> EDWIN E. SLOSSON, "The Influence of Photography on Modern Life," 1923

The refinement of our historical sense chiefly means that we keep it properly complicated.

> LIONEL TRILLING, "The Sense of the Past," 1950

This volume surveys selected facets of American photography from the late 1880s to the present. This span, slightly more than a century, encompasses two-thirds of the entire history of the medium. It also demarks photography's modern age, an epoch inaugurated by several technical and cultural developments: the replacement of the cumbersome wet-collodion process with the dry-plate and roll-film technologies, the introduction of the hand-camera, the rise of amateur photography, and the perfection of the halftone method of reproducing photographs on the printed page. These changes greatly increased the presence of photography in American life, and provided the basis for the evolution of the medium over the next one hundred years. Despite remarkable technological developments in this era, the medium's basic principles—beginning with its reliance on light-sensitive compounds of silver—remained substantially unchanged.

Now, however, in the mid-1990s, we are in the midst of another great technological shift. The digital image, a creation of computer technology, is rapidly becoming part of our photographic vocabulary. New electronic processes allow images to be stored and manipulated with unprecedented freedom, replacing many of today's applications of silver-based photography. It seems inevitable that soon the synthetic nature of these new methods will dissolve the seemingly "natural" correspondence between visible reality and the lens-formed image. Since pictures produced by digital processes can be constructed and transformed at will, they differ radically from the camera's characteristically objective record of optical fact.[1] Thus, despite their futuristic implications, digitally engineered images are essentially prephotographic in nature: broadly expressive, but without the "truth function" we normally associate with the camera. While it is still too early to assess the impact of this new technology, it will undoubtedly change the way we use and think about photographs.

This volume combines two rather different projects. It is, first and foremost, a survey of some of the most significant works in the Hallmark Photographic Collection. Since its founding in 1964, this collection has grown to include about 2,600 prints by nearly 400 photographers. The collection's emphasis has been on selected facets of American work from the late nineteenth century to the present. No attempt has been made to be encyclopedic, and many artists, themes, and processes are not presently represented in the collection. However, within a basic art-historical framework, works have been collected in both depth and breadth. Unusually large holdings by Harry Callahan (295), André Kertész (238), Todd Webb (161), Clarence John Laughlin (127), Dorothea Lange (83), and Carl Van Vechten (76) constitute a significant proportion of the collection. Other artists are represented by smaller portfolios or, in a few cases, by a single work. While the Hallmark Photographic Collection remains strongest in self-expressive, "straight" photography, a conscious effort has been made to represent other technical, social, and artistic points of view. Thus, manipulated as well as "purist" images are included, as well as works produced for both artistic and utilitarian ends. In establishing the parameters of the collection, "American photography" has been defined rather broadly, so as to include work done by U.S. citizens abroad and by foreign artists in the U.S.; special attention also has been paid to Europeans who moved to the U.S. in the 1930s.[2]

In addition to surveying the highlights of the Hallmark Photographic Collection, this study attempts to outline aspects of the cultural and artistic context from which these works are derived. The text is intended to serve as an introduction to the history of modern American photography based, in large part, on the discipline's own literature. While additional points of view could have been gained by close readings in various other fields (art, literature, or the social sciences, for example), it seemed most practical to concentrate on photographic journals themselves, from the mid-1880s to the present, and the best of recent photographic scholarship. This approach stems from a belief in the critical importance of photographic publications, and a sense that they remain relatively unknown territory to many in the field. At the same time, however, research for this volume has made it abundantly clear that much valuable and insightful scholarship has been produced in recent years. A fraction of this fine secondary work is reflected in the notes and bibliography at the end of this volume.

Any attempt to summarize such a vast subject raises a host of intellectual and methodological dilemmas, beginning with the nature of historical inquiry itself. The history of photography is not a singular or easily defined entity. Although based on a discrete set of technical processes, the medium has been put to an extraordinarily wide range of uses since its introduction in 1839. Thus, while photography's means are easily traced, its effects are almost infinitely varied. One might just as logically propose a history of the printed word that embraces all its uses, from the most

rarified to the most trivial. Similarly, one might wonder what is inherently "American" about American photography. While any closely reasoned answer lies far beyond the scope of this book, a few tentative responses are suggested. Some of the most characteristic themes in American cultural life include the tensions between nature and technology, pragmatism and idealism, science and faith, high and popular culture, political unity and diversity, and individuality and community. These and similar themes lie at the heart of American cultural expression.

This survey of American photography emphasizes those figures who have used the medium in a deliberately self-expressive manner, and, secondarily, those whose works have influenced the way society has thought of itself. These two groups—artists and skilled commercial or journalistic professionals—are not mutually exclusive, though their motivations may differ. While representing only a small fraction of the medium's overall history, these applications nonetheless reveal much about photography's importance in both shaping and conveying ideas about the modern world. The text itself has been divided into four chapters, each focusing on a span of roughly a quarter-century. While partly a product of narrative convenience, these divisions nonetheless reflect some of the major cultural eras in American life.

If the past is all that has happened before today, history represents our effort to make sense of that vast and largely unknowable sequence of events. Inevitably, every historical narrative represents selected facets of the past as seen from a particular personal and cultural point of view. As historian Van Wyck Brooks observed in 1918, "The past is an inexhaustible storehouse of apt attitudes and adaptable ideals; it opens itself at the touch of desire; it yields up, now this treasure, now that, to anyone who comes to it armed with a capacity for personal choices."[3] The ability of the past to tell many stories, both familiar and unexpected, means that our understanding of it can never be complete or conclusive. However, our versions of the past may be made more subtle and useful by increasing our familiarity with certain primary sources and by embracing multiple, rather than singular, points of view. Like any other form of human narrative, written history requires a coherent structure—a beginning, middle, and end—to make "sense." While our narratives aim for lucidity, the real past is usually characterized by its raggedness and contradictions. Actual experience seems most often to be a fog of contingencies, conflict, and muddled motives, punctuated only occasionally by flashes of heroism, insight, or a sense of overarching design. It is exceedingly difficult for history to recapture this sense of the past as *lived experience* without itself becoming incomprehensible. Nonetheless, if we intend our narratives to be true to any degree to the past they purport to describe, this complexity and contingency must somehow be acknowledged.

This need for greater complexity is particularly critical in art history, and in the histories of photography derived from the art-historical model. Modern art history is based largely on biological or scientific notions of progress. In the biologi-

cal model, innovative works of art function as mutations from a normative pool of genetic possibilities. While many of these mutations are useless failures, a select few (Picasso, Duchamp, or Pollock, for example) are understood to allow the species as a whole (art) to flourish in changing conditions. The scientific model suggests a parallel between artist and scientist, with both using logic and intuition to solve problems and to build on past discoveries. However, both analogies are flawed by teleological thinking—the tendency to read the past strictly in relation to the values of the present. It would be more useful to replace these simplified notions of progress with a basic recognition of the constancy of change, particularly in the realm of ideas and aesthetics. Our modes of thinking and seeing in the 1990s are not the same as they were in the 1890s, and, similarly, will not precisely correspond to those of the 2090s. However, these very real differences in kind cannot be taken uncritically as differences in quality; we do not necessarily possess *better* ways of seeing or thinking than those who came before us. Each culture is a unique puzzle of success, failure, contention, and contradiction. As one historian has observed, "The past is a foreign country whose features are shaped by today's predilections, its strangeness domesticated by our own preservation of its vestiges."[4] Rather than routinely domesticating this strangeness by interpreting the past in light of our own ever-shifting values and interests, a greater challenge lies in striving to approach it on its own terms. This involves, in part, taking the ideas and values of the past seriously, if not uncritically.

A highly ordered narrative of master artists, lines of influence, and discrete creative movements effectively pares the living body of the past down to a rather skeletal kind of history. While certainly "true" in many important respects, this history is incomplete. Artistic invention is usually an intricately collective activity—flavored, always, by individual ideas and achievement—with talents of varying magnitude contributing to the process. By streamlining the complexity of this dynamic, we alter the meaning of the results: the originality of the most progressive artists may be relatively magnified, while partial or qualified success is ignored. New artistic ideas grow from, and are an integral part of, a gradually evolving climate of thought. Innovative ideas are an inevitable combination of new and old, and, no matter how dominant they become, these new ideas never fully replace competing approaches. New styles and viewpoints are absorbed gradually by artists and the public, and, in the process, are modified in myriad ways. Rather than wiping the slate clean, innovative ideas take their place within a rich intellectual mosaic of past and present. Inevitably, formerly new ideas become part of the status quo that subsequent approaches attempt to overthrow. This process suggests that the real dynamic of modern art history lies in the constant tension between the forces of innovation, fragmentation, and challenge, and those of preservation, synthesis, and confirmation. While the avant-garde claims allegiance only to the former set of attributes, the latter is also a fundamental part of our art history.

A broader view of the history of photography begins by supplementing the acclaim given the most notable figures with a new respect for a spectrum of "minor masters." Such figures are most often characterized by short careers, intermittent success, a lack of public ambition, or a less than monumental creative imagination. They are, in short, recognizably human, and thus integral to the fabric of history. Just as the highest peaks of a mountain range are part of an entire landscape of lesser peaks, foothills, and valleys, the pinnacles of achievement in this medium—Stieglitz, Weston, and Evans—are best understood in the context of their time and in the company of their associates. By reintegrating our most famous artists back into the complexities of their eras, we may rediscover their work as, at once, both stranger in intention and more comprehensible in achievement than we had realized. And an acknowledgment of the relative merits of lesser figures makes the multiplicity of history—its profusion of worthy narratives—more obvious. There is much pleasure to be taken in qualified or eccentric successes. The literary critic F.W. Dupee once described an interesting but obscure writer as "a wonder, a precious anomaly, at once great and small, easy to forget but delightful to remember."[5] Photographic history is replete with such delightful figures who deserve some measure of remembrance.

Ultimately, then, this volume accepts the essential validity of the existing canon of photographic history while striving to suggest a few of the ways in which it might be made richer and more varied. Only by keeping our historical sense "properly complicated" can we hope to evoke the texture of lived experience, and the meaning of photographs both to their own time and to ours. The resulting history may not precisely reflect all our present biases and interests, but it will tell us a great deal that we need to know.

This book, and the accompanying exhibition, could not have been accomplished without the talents and assistance of many people. First and foremost, we salute the achievements of the photographers included in this volume, and gratefully acknowledge the cooperation of the artists, estates, and representatives who granted permission for works to be reproduced.

Over the past few years, research has been conducted in a number of major museum collections, including those of the Metropolitan Museum of Art, the Museum of Modern Art, the Museum of the City of New York, the George Eastman House, the Art Institute of Chicago, the J. Paul Getty Museum, the Los Angeles County Museum of Art, the Center for Creative Photography, the Princeton University Art Museum, and the Royal Photographic Society. Also critical to this study were the resources of the Library of Congress, the New York Public Library, the Beinecke Library at Yale University, the Kansas City Public Library, the University of Kansas Libraries, the Linda Hall Library, and the library of the Nelson-Atkins Museum of Art. Thanks are

gratefully extended to the staffs of all these institutions for their invaluable assistance.

In several years of work on this project, information and assistance were provided by a great number of individuals, including Pierre Apraxine, Dr. Abraham Aronow, Carla Ash, Gordon Baldwin, Eleanor Barefoot, Tom Beck, Bonni Benrubi, James Borcoman, Janet Borden, Frish Brandt, Nan Brewer, Doris Bry, Peter C. Bunnell, Patrick Clancy, Stephen Cohen, Sheryl Conkelton, Evelyne Z. Daitz, James Danziger, Keith de Lellis, Douglas Drake, Catherine Edelman, Susan Ehrens, James Enyeart, Kathleen A. Erwin, Terry Etherton, Gloria Feinstein, Birgit Filzmaier, Kaspar M. Fleischmann, Megan Fox, Jeffrey Fraenkel, John Froats, Lance Fung, Beth Gates-Warren, Debra Gifford, Howard Greenberg, Sarah Greenough, Ursula Gropper, Tom Halsted, Maria Morris Hambourg, Vicki Harris, Paul Hertzmann, Susan Herzig, Tom Hinson, Jeff Hirsch, Barbara Hitchcock, Rick Hock, Edwynn Houk, Charles Isaacs, Estelle Jussim, Daile Kaplan, Elisabeth Kirsch, Norbert Kleber, Michael Klein, Hans P. Kraus, Jr., Marilyn Laufer, John Lawrence, Mack Lee, Janet Lehr, Harry H. Lunn, Jr., Peter MacGill, Ezra Mack, Robert Mann, Alix Mellis, Laurence Miller, Anthony Montoya, Myra Morgan, Wendy Olsoff, Lori Pauli, Terence Pitts, Eugene and Dorothy Prakapas, John Pultz, Jill Quasha, Howard Read, Leland Rice, Pam Roberts, Naomi Rosenblum, Jeff Rosenheim, Amy Rule, Mary Sabbatino, Martha A. Sandweiss, Julie Saul, Michael Shapiro, Andrew Smith, Robert Sobieszek, Thomas Southall, Chris Steele, Ann Thomas, Muna Tseng, Mike Weaver, Rick Wester, Margaret W. Weston, Stephen White, and David Wooters. For his consistent support, encouragement, and undying enthusiasm for all things photographic, special thanks are extended to George Rinhart. Sincere gratitude is also extended to Charles Swedlund, David Gilmore, Thomas Barrow, Van Deren Coke, John Szarkowski, Robert J. Doherty, David Strout, Sally Hopkins, and the late Beaumont Newhall for their encouragement and assistance over the years. It also seems appropriate to pay homage to the memory of Robert Taft, whose pioneering book *Photography and the American Scene* (1938) set an exceedingly high standard for the study of this fascinating subject.

The exhibition accompanying this volume will be shown at a number of major museums in 1994-96, including the Nelson-Atkins Museum of Art, Kansas City, Missouri; the Mead Art Museum, Amherst, Massachusetts; the International Center of Photography, New York City; the Auckland City Art Gallery, Auckland, New Zealand; the National Gallery of Victoria, Melbourne, Australia; the Art Gallery of New South Wales, Sydney, Australia; and the Museum of Photographic Arts, San Diego, California. We are grateful to all these institutions for their interest in this exhibition and for their care in presenting it to their viewers.

This book has been made possible by the devoted work of many talented colleagues. Brian Wallis provided invaluable service as editor, and also helped with the research on chapter four. The physical quality of this book is due to the careful design of Malcolm Grear Designers, the fine separation work of Thomas Palmer and Richard Benson, and the skilled pressmen at Meridian Printing. For her efforts in coordinating the distribution of this volume, sincere thanks go to Margaret L. Kaplan at Harry N. Abrams, Inc. At Hallmark, Jaye Wholey, Mike Pastor, Ken Jacobs, and Rich Vaughn once again provided invaluable help with both professionalism and good humor. I am particularly grateful to Pat Fundom and Nicki Corbett for their tireless assistance in all aspects of this book and the accompanying exhibition. For research assistance, deep thanks are extended to Megan Ramirez and Kevin Moore. I am also very grateful to Martha A. Sandweiss, Donald Hoffman, and Dr. Frances Connelly for their helpful comments on early drafts of sections of this text.

This book directly reflects the larger cultural interests of Hallmark Cards, Inc. My fifteen years with Hallmark have been both a pleasure and a privilege thanks to the support and guidance of William A. Hall, Irvine O. Hockaday, and Donald J. Hall.

KEITH F. DAVIS
Fine Art Programs Director

Kansas City, Mo. and
Henley-on-Thames, Oxon.
September 1994

2 **Eadweard Muybridge**, *High Jump*, 1885, collotype print, 5⅞ x 18¼″

CHAPTER I A Reluctant Modernism
1890-1915

American culture underwent dramatic transformations in the quarter-century from 1890 to 1915. In these years, the United States evolved from a rural, agrarian nation into one that was largely urban and industrial. The frontier—the greatest symbol of the expansive potential of American life—was declared officially closed in the census of 1890. Twenty-five years later, statistics revealed that the majority of Americans lived in cities and towns. The nation's population increased by about 50 percent in this period, and the vast waves of immigrants who arrived from Europe and Asia made American society increasingly heterogeneous. This population growth also produced a steady westward spread of "civilization," and a continued displacement of resident Native American populations.

The American economy grew at a remarkable rate in this era, despite the severe depression of 1893-97 and a milder downturn in 1907-08. Led by the success of such gigantic trusts as J. P. Morgan's U.S. Steel Corporation, industrial production expanded at an unprecedented rate. Since the business climate of these years encouraged an almost unbridled laissez-faire capitalism, many new industries flourished. But at the same time, many others were driven into insolvency by the unforgiving dynamics of the marketplace. This vigorous economic system created unprecedented wealth (and inequality), and became a powerful force for change. American culture gradually shifted from an ethic of scarcity and production to one of abundance and consumption. New modes of manufacture created a variety of goods cheaper and faster than ever before. Mass-production technologies changed the very nature of work, replacing experienced artisans with unskilled workers performing repetitive tasks. Although the factory wage-labor system created new jobs, it brought new insecurities as well, as wage cuts and layoffs became increasingly common. Such conditions often drove disgruntled workers or the unemployed to stage militant demonstrations for reform,

frightening many middle-class Americans with the specter of anarchism.

This economic turmoil was accompanied by dramatic changes in the nature of daily life. The family was transformed by new attitudes toward work, education, relations between the sexes, leisure time, and children. The American home was changed by a variety of technological improvements, including the widespread use of electricity, running water, and central heat. New transportation systems allowed families to live at greater distances from their jobs, prompting the growth of suburbs. This was a highly visual age in which pictures were produced on a rapidly expanding scale by the camera and printing press. The telephone, phonograph, automobile, airplane, and wireless all contributed to a radically new world in which, it seemed, time and space themselves had been conquered.

This transition from the nineteenth century to the twentieth represented a movement from a Victorian to a modern sensibility. The Victorian mind had been guided by a confident positivism, a faith in social progress, and a belief in the ultimate harmony of religion and science. The modern world eroded many of these certainties. Darwin, Marx, Nietzsche, Freud, and Einstein each contributed to a new constellation of ideas on the fundamental nature of the mind, society, and reality itself. The cumulative effect of these theories was to fracture and complicate formerly "simple" or "natural" explanations for things, making the world harder to understand. A variety of modern disciplines—particularly, science, philosophy, literature, and art—became increasingly specialized, employing ever more technical or abstract languages.

The roots of artistic modernism lay in these technological, social, and intellectual transformations of the last quarter of the nineteenth century. However, as historian George Cotkin has noted, this was a period of "reluctant modernism," in which many individuals struggled to reconcile

new ideas and technologies with the firmly entrenched values of an earlier era.[1] The result was often an uneasy balance of rationalism and intuition. The "progressive" age of the railroad, the telephone, and the automobile also produced an antimodernist fascination for hypnotism, telepathy, mysticism, and the occult. This curiously mixed cultural mind-set combined a sense of technological bravado with nostalgic yearnings for the simplicities of a real or imagined past. The persistent antimodernism of this period reflected a deep desire to recover emotional and spiritual values in the midst of an increasingly mechanistic and materialistic culture. The struggle to come to grips with the new possibilities and dislocations of modern life often found its best expression—whether direct or oblique—in the most technologically advanced art of the period: photography.

A New Age

American photographers celebrated the fiftieth anniversary of their medium in 1889 with both pride and melancholy. In one of the best analyses of photography's dramatic progress since the time of Daguerre, J. Wells Champney, a respected artist and enthusiastic amateur photographer, wrote,

> Can our readers picture to themselves the comic situation of a victim of the daguerreotypist of 1839, screwed to the back of a chair, his face dusted over with a fine white powder, his eyes tightly closed, obliged to sit a full half-hour in the sunlight?...
>
> Contrast this with the possibilities of to-day, when in the darkest of dark caves or cellars, or on the blackest of nights, the tyro photographer, armed with his little camera, and pistol loaded with magnesium cartridge, can obtain a picture full of vigour and marvellous in detail. This chasm has been bridged over in the fifty years since Daguerre gave before the French Academy of Sciences the secret of his wonderful process. The journey down the photographic history of those fifty years is full of wonderful struggles of mind over matter...until to-day hundreds of thousands contribute to our knowledge and happiness in the practice of photography whilst gaining their daily bread.[2]

It was indeed astonishing to contemplate photography's achievements in 1889. There were over sixty photographic journals and 161 photographic societies in existence across the globe. Photography had made important contributions to archaeology, astronomy, and medicine, while Eadweard Muybridge's celebrated studies of human and animal locomotion—made with exposures as rapid as 1/2000 second—had revealed amazing and hitherto invisible aspects of everyday life. So rapid was the pace of technical advancement, Champney observed, that in the few years since the completion of Muybridge's work, the recording of "rifle bullets and cannon-balls in flight has become an every-day matter."[3] Champney also looked to the future of color photography with certainty, convinced that such processes would soon become practical. He observed that the use of photography in publishing was increasing steadily with the

gradual perfection of the halftone method of printing illustrations, and that businesses were routinely using photographs to advertise and promote a great variety of goods. Police were making photographic "mugshots" of criminals, the military was employing the camera to miniaturize maps and documents for secret transport, and artists were mailing photographs of their paintings to distant clients. Most remarkably, Champney observed, the perfection of the handcamera had enabled the average American to take up photography.

Despite this impressive inventory of advances and applications, however, Champney was compelled to end his article on a bittersweet note:

> One cannot close even so incomplete a review as this of the first half-century of photography without a reference to the position it holds with regard to art. Though it would require a long essay to deal with the subject as it merits treatment, it is important to make certain confessions of blighted hopes, and at the same time to look with tempered enthusiasm into the future. As an aid to science, as a recorder, as a duplicator, photography has helped advance civilization. Of itself it has failed to occupy the place it may yet hold as a means for expressing original thought of a fine order. With its recognized qualities, and in the hands of a thoroughly trained worker perfectly familiar with the laws of chemistry and optics, and with artistic feeling and training, it may be placed on a plane where its beauties will force from all acknowledgment that it has powers which rank it as one of the finest of the graphic arts.[4]

Perceptively, Champney had pinpointed photography's central dilemma: the tension between utility and art. Against a backdrop of continued technical progress and expanding commercial applications, several generations of photographers had worked hard to prove that the camera was capable of "expressing original thought of a fine order." This artistic quest was understood to transcend the mundane demands of commerce or the amateur's casual snapshots. Photography certainly lent itself to a vast number of uses, all justly celebrated by the profession, but many photographers understood that real social prestige demanded a medium capable of producing art.

A Half-Century of Change

Photography had indeed made dramatic advances in its first half-century. In the daguerreotype era of the 1840s and early 1850s, when the business of photography was almost exclusively portraiture, practitioners were required to master only a single (if difficult, and potentially dangerous) process. The first great technical change occurred in the mid-1850s, when the daguerreotype gave way to the glass-plate negative and paper-print processes. The development of the wetcollodion negative and the albumen print spawned a number of new processes and formats, including the ambrotype, the tintype, the stereograph, and the carte-de-visite. Once professionals of the wet-plate era had mastered these various new mediums, they were rewarded by an expanded set of com-

mercial opportunities. For the first time, there was a popular market for mass-produced photographs of celebrities and scenic views. There were also numerous specialized applications for photography in commerce, science, and technology.

Between about 1855 and 1880, photographic technology achieved a new, if somewhat uneasy, equilibrium. The laborious wet-collodion process, which required that the glass-plate negatives be hand-coated, exposed, and processed within minutes, proved remarkably flexible for a wide variety of tasks. Brilliant work was produced by this technique: the portraits of Mathew Brady; the Civil War images of Alexander Gardner and George N. Barnard; and the western landscapes of Timothy O'Sullivan, William Henry Jackson, and Carleton Watkins. Although minimally inconvenient in studio work, the wet-plate process required photographers in the field to carry a portable darktent with all their solutions and processing trays. While professionals accepted this labor with little complaint, researchers (often amateur photographers) sought an easier dry-plate technique.

By 1879, the dry plate had become a practical reality, and photography was once again thrown into a period of disconcerting change. In this year at least three Americans—John Carbutt in Philadelphia, Albert Levy in New York, and George Eastman in Rochester—made and sold dry-plate negatives. At first, these plates were inconsistent and of interest only to amateurs. However, the advantage of the dry process soon became clear: the new plates were up to eight times more sensitive than wet-collodion negatives, allowing photographers to make pictures that would otherwise have been impossible.[5] In the early 1880s, for example, Joshua Smith of Chicago made a clear image from the back of a train moving at forty miles per hour.[6] In 1883, George W. Rockwood made "instantaneous" exposures with a large 14x17-inch camera from the deck of a pitching tugboat in New York harbor.[7] This new technology was so fast that, for the first time, lenses had to be equipped with shutters as standard equipment in order to facilitate exposures of a fraction of a second.

Professional photographers soon overcame their reservations about the new plates, and by 1883 the dry process was well on its way to dominance in the nation's portrait studios. The dry plate was far cleaner and—ultimately—more consistent than the collodion method. Most importantly for professionals, the increased speed meant that fewer portraits would be spoiled by the motion of the sitter. Squirming children, particularly in the fading light of late afternoon, had posed a notoriously difficult subject for portraitists. It was thus a hearty endorsement for a professional such as Rockwood to note that dry plates were "a wonderful thing for babies at 5 o'clock in the afternoon."[8]

Stopping Time

The increased sensitivity of the dry plate aided a specialized branch of photography initiated in the collodion era. In the 1870s and 1880s, Etienne-Jules Marey, Eadweard J. Muybridge, and Ottomar Anschtz (working, respectively, in France, America, and Prussia) all used high-speed photography to analyze human and animal motion.[9] Marey had begun work in this field as early as 1859, using a variety of nonphotographic devices. His 1873 book, *La machine animale* (published in English a year later as *Animal Mechanism*), had a considerable impact on Muybridge, an English-born landscape photographer residing in San Francisco.

Muybridge had begun his studies of motion under the sponsorship of former California governor Leland Stanford. By 1872 he had achieved partial success by photographing a running horse so that (with significant retouching of the negative) the position of its legs could be discerned. Significantly better results were achieved at Stanford's Palo Alto trotting track in 1878-79, and Muybridge's "instantaneous" photographs of walking and running horses received international attention.[10] After publishing these images in the book *The Attitudes of the Horse in Motion* (1881), Muybridge embarked on a lecture tour of France and England. In Paris he met Marey, who introduced him to the possibilities of the dry-plate process.

Upon his return to the United States, Muybridge launched an even more ambitious photographic study of motion under the patronage of the University of Pennsylvania in Philadelphia. From the spring of 1884 to early 1886, he produced over 20,000 plates of human and animal subjects. In an outdoor studio on the university grounds, he photographed people, clothed and nude, engaged in an exhaustive—and occasionally bewildering—variety of athletic and domestic activities. Simple movements such as walking, running, and climbing stairs were recorded, as were more complex activities such as making a bed, bending to pick up a handkerchief, throwing a baseball, and pole vaulting. Muybridge also took his apparatus to the Gentleman's Driving Park to record running horses, and to the Philadelphia Zoological Garden to document more exotic animal specimens. The results of this labor were published in 1887 in an enormous folio of 781 collotype plates titled *Animal Locomotion*. Only thirty-seven complete copies of this expensive work were produced, but many other prints were sold at a dollar each in smaller groups.

Muybridge's working method involved at least two batteries of twelve cameras each. One battery produced a series of lateral views of his subject, while the other made foreshortened views from the front. He also frequently used a third twelve-camera battery to record foreshortened views from the rear. The speed of each exposure was approximately 1/2000 second. As demonstrated in *High Jump* (plate 2), this technique records twelve sequential instants from two vantage points, thus breaking the continuous flow of real time into twenty-four facets. Temporal change is transformed into spatial display, creating a visual "map" that is at once eminently logical and curiously unreal. By multiplying space and fragmenting time, Muybridge prompted viewers of his day to consider the latent strangeness of the most ordinary

actions. As the *New York Times* noted, Muybridge's images of human and animal subjects "walking, galloping, flying, working at various trades and occupations, playing, fighting, dancing, batting, wrestling, fencing, boxing, [and] crawling [reinforced] with scientific certainty the old saying that, 'having eyes, ye see not.'"[11] Indeed, these pictures generated much discussion on the nature of vision and representation—the difference between "normal" and "instantaneous" impressions, for example, and the correspondence between scientific and artistic "truths."

Photographs such as *High Jump* suggest Muybridge's ideal of a neutral, analytical vision capable of revealing previously unseen facts. This image also has a graphic elegance that he undoubtedly found pleasing. Muybridge considered himself an artist first and foremost. Thus, while he sought both truth and beauty in his pictures, he felt free to manipulate his process for the sake of narrative or aesthetic effect.[12] For example, he fabricated certain sequences in *Animal Locomotion* by splicing together units from different photographic sessions, or by posing models in simulations of movement. These eccentricities speak to the complexity of all photographic "documents"—even those produced under what appear to be rigorously controlled conditions—and the perhaps inevitable blurring of analytical and expressive impulses.

The aesthetic possibilities of high-speed photography fascinated several other Americans of the 1880s. One of the most remarkable and little known is the amateur photographer Francis Blake. Born in Needham, Massachusetts, and later a resident of nearby Auburndale, Blake was a noted inventor and physicist. His high school work in mathematics was so distinguished that he was given an appointment with the U.S. Coast Survey in 1866 at the age of sixteen. In his twelve years with the Survey, Blake performed a variety of duties related to surveying, astronomy, and electrical science, both in the U.S. and overseas. Upon retiring from this position in 1878, Blake perfected a telephone transmitting device. The "Blake Transmitter" was purchased by the fledgling Bell Telephone Company for a generous share of the firm's stock. Blake continued his electrical research as a director of the company and received twenty patents between 1878 and 1890. He was a member of many scientific and historical organizations, and in his later years showed a particular interest in the fine arts.[13]

In 1889 or 1890, Blake made experimental photographs with a high-speed focal-plane shutter of his own design.[14] With this device, he recorded champion tennis players in mid-stroke, a boy riding a bicycle, and a locomotive traveling forty-eight miles an hour.[15] *Pigeons in Flight* (fig. 1, plate 3), the best-known of Blake's stop-action images, combine a still-startling rapidity of vision with an even more remarkable sense of pictorial structure. Against a carefully structured backdrop of simple architectural forms (framed both horizontally and vertically), Blake depicted elegantly arrayed clusters of birds frozen in flight. From the most unpredictable subjects, Blake created images of delightful spontaneity and

Fig. 1 Francis Blake, *Pigeons in Flight*, ca. 1889–90, 6⅛ x 8″

unexpected pictorial unity, snatching from the dynamic flux of activity before him magically resolved moments in which form and content are united in pictorial harmony.

Blake's pictures were exhibited frequently in the most prestigious exhibitions of the early 1890s and received many awards. By the middle of the decade, however, images such as these had fallen out of favor with judges, as interest shifted from such apparently simple mechanical feats to more idealized and picturesque subjects. Far more than mere technical exercises, however, Blake's seemingly naive stop-action images combine bold pictorial vitality with a delightful sense of whimsy. Gifted with a profoundly original mind, Blake used the camera to explore both the hidden folds of the fabric of time, and the graphic possibilities of picture making itself. A perfect synthesis of analysis and intuition, his work represents a remarkable photographic vision that owed little to the influence of other media.

George Eastman and the "Camera Epidemic"

By freeing practitioners from the need to coat and process each negative on the spot, the dry plate removed much of the labor—and the craft—from photography. As a result, the medium was suddenly opened to a legion of nonprofessionals, giving rise to the modern amateur photographer. The E. & H. T. Anthony firm immediately recognized the sales potential of this new market, and in 1881 offered simple 5x8-inch and 4x5-inch camera outfits under the heading "Cameras for the Millions."[16] Almost overnight, many other simple portable cameras flooded the market, and the formerly esoteric medium became a pastime for thousands of Americans. In an 1883 article titled "Taking Photographs for Fun—The Increasing Army of Amateur Photographers," the *New York Times* noted that

a few years ago one would not have found a dozen of these young men who take pictures for fun. African explorers and Western travelers have always taken an apparatus of some kind but it is only recently that pictures have been taken by private persons simply for the pleasure of it. Now the sup-

plying of amateur outfits has become one of the most important departments in the big photographic materials supply stores in the City.

The *Times* also reported that it was now common to see "nicely dressed young fellows loaded down with cameras and tripods at the trains and steam-boats" on their way to the country to photograph "a bit of romantic landscape, river, or mountain side." With the availability of special lightweight camera outfits, women were taking up the pastime, too. Many of these amateurs delighted in making "instantaneous" pictures of friends running or jumping by using shutter speeds of about 1/20 second.[17]

The craze for photography continued unabated, and a year later, the *Times* published a humorous editorial titled "The Camera Epidemic."

> The appearance of the cholera in Europe has to some extent diverted public attention from the spread of the camera in this country. Sporadic cases of camera of the true *lamina sicca* type have occurred in various parts of the United States at intervals during the last six or eight years, but it is only within three years that the disease has assumed an epidemic form, and only within the last year that it has become a national scourge. Unlike the cholera, the camera seems to prefer the country to the city, and its worst ravages occur in Summer resorts. In certain regions, such as the Adirondacks and the Thousand Islands, it has spread with frightful rapidity. Two years ago a case—in fact a very bad case—of camera occurred at Blue Mountain Lake, in the Adirondack region, but measures were promptly taken to isolate the patient, and the matter was carefully hushed up by the hotel keepers. Last Summer twelve cases of camera occurred within a circuit of forty miles of Blue Mountain Lake, and this Summer the disease has spread to nearly every Summer resort in Northern New York, and is raging with frightful violence. At Newport, Long Branch, and other seaside resorts the epidemic has broken out, and defies all restraint, and from all parts of the country reports are coming in to the National Board of Health which show that *camera lamina sicca* is devastating the entire region east of the Mississippi, and will almost certainly spread westward as far as the Pacific coast.

While it was noted that the afflicted "usually become wildly insane," the cause of the camera epidemic remained uncertain. The editorial concluded:

> There is no use shutting our eyes to the truth. If the *camera lamina sicca* increases next season as it has increased this it is estimated that fully 80 per cent of our entire population above the age of 10 years of age will be attacked by it.... Our only chance of safety lies in the destruction of every existing lens and the disinfection, by exposure to strong sunlight, of every dry plate.[18]

Amateur interest in photography did indeed spread quickly. In 1885, the San Francisco *Daily Chronicle* observed that,

> when the mania for photography takes hold of a man it is said to exceed in strength the passion for French cooking. The camera is as constant a companion as tobacco to a smoker. One young lawyer who has the disease very bad is having a camera constructed to look like a couple of law volumes....[19]

In 1887, the noted amateur Alexander Black wrote an amusing article for *Century Magazine* describing "that gentle madness...of one who has succumbed to the curious contagion of the camera."[20] In 1890, another admitted sufferer began a lengthy article on amateur photography with humorous, if almost credible, hyperbole:

> According to the last census, the population of these United States approximated 50,000,000 souls. Of these, 49,000,000 are amateur photographers, and the other 1,000,000 are hesitating whether or not to toy with the art of Daguerre.[21]

Photography's explosive growth in popularity during the 1880s was the result of a conjunction of social and technical factors. The rapid expansion of the middle class created an enormous pool of consumers with the money, the leisure time, and the artistic inclination to devote to photography as a hobby. For them, photography represented a thoroughly up-to-date pastime, perfectly in keeping with the progressive spirit of the age. The camera gave every man or woman the means to document their lives and surroundings, as well as the ability to express their finer aesthetic inclinations. Photography was also seen as a healthful pastime, best practiced—like the concurrent fad of bicycling—in sunlight and fresh air.

On the technical side, the pivotal figure in this period was George Eastman of Rochester, New York.[22] Eastman became interested in photography in 1877, when he was a 23-year-old bank clerk. Like other amateurs of the period, he bought a simple view camera and learned the wet-collodion process. Frustrated by the difficulties of the technique, Eastman began experimenting with various dry-plate formulas published in the photographic periodicals of the day. By the summer of 1879, he was making plates on a small scale and selling them to friends. Eastman began commercial production of dry plates in September 1880, and soon his plates were being distributed nationally by the noted E. & H. T. Anthony firm. By 1883, when he constructed a new factory in Rochester, Eastman's company was well on its way to leadership in the photographic industry.

His dominance was not easily won, however. By 1884, dry plates were being manufactured by various firms and stiff price competition was driving profits downward. Eastman responded astutely by exploring new markets for photographic products and services.[23] He recognized that if the dry-plate glass negative could prompt a "camera epidemic," still simpler techniques would allow even greater numbers of people to take up the camera. His goal to develop a roll-film process was realized imperfectly in 1884. However, in July 1888, he introduced the first successful film camera: the Kodak. In its leather case, the Kodak measured only 6½ inches long by 3½ inches wide by 3¾ inches high. While typical tripod-camera outfits could require forty pounds of equipment or more, the Kodak weighed less than two pounds. This radically simple camera sold for $25, complete with a roll of film that produced 100 circular images about 2⅝ inches in diameter. When the roll was fully exposed, the

camera was mailed back to Eastman's firm with $10. Technicians processed the film, made prints of all 100 images, and installed a new roll. The reloaded camera, negatives, and prints were then mailed back to the customer.

The press hailed the Kodak as the most remarkable achievement in the history of the medium.[24] Eastman, taking nothing for granted, promoted his new camera with an aggressive advertising campaign. The memorable slogan "You Press the Button—We Do The Rest" assured the general public that now, for the first time, photographs could be made by simply pointing the camera and pressing the "button."[25] By 1890, seven models of the Kodak were in production, offering a variety of features and formats ranging from the 2⅝" circular image of the original No. 1 to the rectangular 5x7-inch format of the No. 5. Hand cameras by other makers, with names such as "The Montauk," "The Ultimate," "The Hawkeye," "The Ferret," and "The P.D.Q." ("Photography Done Quickly"), were also available at prices ranging from $15 to $50.[26] By the end of the decade, an estimated 1,500,000 hand cameras were in use throughout the country.[27] This number only increased with the introduction of the Brownie camera, which sold for a mere dollar, in the spring of 1900.[28]

Most professionals took a dim view of this growing army of amateur photographers, complaining that hobbyists were "killing the business." Many amateurs routinely gave prints away, or made pocket money by accepting occasional assignments for pay. Undoubtedly this had some impact on the profits of undistinguished professionals. But enlightened professional photographers recognized that the "competition" provided by the amateur was in fact beneficial to all. In 1885, S. D. Wardlaw, president of the Rochester Society of Photographers, addressed this subject in a talk titled "A Word in Defence of the Amateur." Wardlaw argued that only the mediocre professional feared the activity of the Kodaker. Those who worked in photography for a livelihood could only gain by the public's interest in the medium, he said, since "there is no better way to instruct the public, in regard to our art, than to have them try it themselves." Wardlaw suggested that his profession had much to learn from the dedicated amateur, who came "well equipped with apparatus, armed with brains, talent, ability, a desire to achieve and with a love for the work in which they are engaged." He admonished his fellows to bring to their work "the same love and ambition to excel" that characterized the serious amateur. Still, Wardlaw's idealistic words could not change the widespread feeling that the amateur represented "a sharp thorn in the professional's side."[29]

Eastman's innovations forever changed the role of the professional and the nature of the medium. The rapid proliferation of cameras meant that professionals were no longer required to take the most basic pictures (e.g., simple portraits, baby pictures, records of new houses). Instead, the professional's role was now shaped by a growing number of applications that lay beyond the means of the casual hobbyist. On the other hand, the sheer number of amateurs

created new possibilities for profit. The selling of photographic supplies changed from a wholesale to a retail activity, for example, and photo-finishing grew into a separate industry. In short, "the change from professional to amateur predominance not only transformed the photographic industry from one characterized by decentralized, handicraft modes of production in 1879 to one characterized by centralized, mechanized modes of production in 1899," but also, and most importantly, it marked the emergence of a true mass market for photographic materials and services.[30] For Americans born after 1880, the camera would be an integral part of daily life.

Jacob A. Riis and the Social Landscape

The technical advances of the 1880s greatly expanded the range of subjects open to photographic depiction. This revolution was at once temporal, spatial, and social. The high-speed work of Muybridge and Blake dissected time for scientific and aesthetic purposes. The new ease of the photographic process allowed travelers and explorers to take cameras almost anywhere and to make images under the most adverse conditions. The sheer number of amateur cameras now allowed the most intimate and casual events of domestic life to be recorded. At the same time, photographers were able to record social realities previously invisible to mainstream culture.

The most important early exponent of photography for the purpose of social reform was Jacob A. Riis. Born in Denmark, Riis immigrated to the United States in 1870. After working at a variety of jobs, in 1877 he became a police reporter for the New York *Tribune* and, later, for the *Evening Sun*. At the time, the New York City police headquarters was located on Mulberry Street, in the heart of a Lower East Side slum. In this neighborhood, Riis became intimately familiar with crime and misery. Overcrowded, filthy, and riddled with vice, the slum represented a kind of perverse mirror image of the American Dream.[31] Impoverished families lived in cramped, unsanitary fire-trap tenements, while homeless adults and children survived on the street or in crude public shelters. Riis responded to the disease, unemployment, and vice he saw with passionate outrage. He argued that crime and poverty could not be attributed simply to the moral failure or genetic limitations of individuals.[32] The environment of the slum itself, he felt, suppressed positive impulses and promoted the most destructive tendencies. Riis sought to change these conditions by educating the public and, ultimately, shaming it into action. In publicizing these social ills, he became a leader in the growing social-reform movement. Through his friendship with researchers in the city's health department, Riis "came to understand, better than most reformers of his era, the fundamental logic which saw crime, ignorance, vice, and poverty as effects rather than causes."[33] Riis longed to convey the full tragedy of what he saw during his nighttime tours of the slum with city sanitation inspectors. Words could only convey a frac-

tion of the pathos and horror that he witnessed: as he noted in his autobiography, "I wrote, but it seemed to make no impression."

In the spring of 1887, Riis found the solution to his dilemma in a newspaper article on the development of flash powder. Excited by the notion that "the darkest corner might be photographed" by "flashlight," Riis eagerly shared this information with Dr. John T. Nagle of the Health Department's Bureau of Vital Statistics. A serious amateur photographer as well as a health worker, Nagle immediately understood the implications. He recruited two other amateurs, Dr. Henry G. Piffard and Richard Hoe Lawrence, both members of the Society of Amateur Photographers of New York, for technical assistance. Within two weeks this team had made its first nocturnal photographic excursion through the slums. Not surprisingly, the party's unannounced late-night visits provoked considerable anxiety among their subjects. As Riis noted in his autobiography,

> It is not too much to say that our party carried terror wherever it went. The flashlight of those days was contained in cartridges fired from a revolver. The spectacle of half a dozen strange men invading a house in the midnight hour armed with big pistols which they shot off recklessly was hardly reassuring, however sugary our speech, and it was not to be wondered at if the tenants bolted through windows and down fire-escapes wherever we went.[34]

An article published in the New York *Sun* in early 1888 described the surreal spectacle the group presented to its bleary-eyed subjects.

> With their way illuminated by spasmodic flashes, as bright and sharp and brief as those of the lightning itself, a mysterious party has lately been startling the town o' nights. Somnolent policemen on the street, denizens of the dives in their dens, tramps and bummers in their so-called lodgings, and all the people of the wild and wonderful variety of New York night life have in their turn marvelled at and been frightened by the phenomenon. What they saw was three or four figures in the gloom, a ghostly tripod, some weird and uncanny movements, the blinding flash, and then they heard the patter of retreating footsteps, and the mysterious visitors were gone...[35]

Not surprisingly, Riis's amateur cameramen soon tired of these late-night expeditions and their unsavory subject matter. In January 1888, Riis decided to learn photography himself, and after the usual beginner's mistakes he reached an acceptable level of technical competence. (Flash powder remained a particular problem: Riis noted that he "twice set fire to the house with the apparatus, and once to myself."[36]) Riis was never seduced by photography itself. As he later recalled, he took up the camera strictly out of necessity: "I had to use it, and beyond that I never went." By the technical standards of his time, Riis's modest appraisal that he was "no good at all as a photographer" was at least partly correct.[37] In fact, of course, Riis became as "good" as his objectives required. He sought to convey convincingly the visual reality of the city's underbelly, and for this his technique was perfect.

Fig. 2 Jacob A. Riis, *Home of an Italian Ragpicker, Jersey Street*, ca. 1888-89 (print by Alexander Alland ca. 1946), 10 x 13"

Riis's "style" is simply and bluntly factual. The harsh glare of the flash powder aggressively opens the dark spaces of the slums, revealing worn or soiled surfaces with pitiless clarity. His *Home of an Italian Ragpicker, Jersey Street*, ca. 1888-89 (fig. 2), for instance, is a veritable catalog of stains, dents, and detritus. Yet, despite its atmosphere of shabbiness and almost claustrophobic sadness, this image reveals a surprising tenderness and pride. The young immigrant mother poses for the camera warily, but forthrightly, holding her carefully wrapped child firmly in her arms. And, amid the jumble of tubs, barrels, and mattresses lies a recently used dustpan, a small detail testifying to the social value placed on cleanliness, even here in a dungeonlike hovel.[38]

Riis's lack of artistic training was altogether to his benefit. He never idealized his subjects or choreographed them into particularly pleasing "compositions."[39] He never wanted his pictures to be *pleasing*; he wanted them to be *effective*. While the power of Riis's work stemmed precisely from its authenticity, he fully understood how to use the inherently realist vision of the camera to its most powerful and persuasive effect. Riis's human subjects were usually portrayed so that they and their surroundings received equal emphasis. He was close enough to depict his subjects as individuals rather than as "types," yet he was removed enough to capture a vivid sense of the space they inhabited. As a result, these portraits powerfully convey Riis's belief in the fundamental relationship between character and surroundings. Jumbled, claustrophobic spaces and hopelessly constricted lives become intertwined aspects of a single problem.

Beginning in early 1888, Riis used lantern slides of his photographs in lectures to church and civic groups. He reached a larger audience when his essay "How the Other Half Lives" was published in the Christmas 1889 issue of *Scribner's*, complete with eighteen line drawings after his photographs. This article was expanded into his famous book *How the Other Half Lives: Studies Among the Tenements of New York* in 1890. This volume, illustrated with eighteen line drawings and seventeen halftone reproduc-

tions of Riis's photographs, represented one of the earliest successful uses of the halftone in an American book.[40] More importantly, the book received widespread acclaim from influential reformers such as Theodore Roosevelt, then New York City's Police Commissioner.

Riis's muckraking images were vastly different than anything done previously by either amateurs or professionals. His subject was too unsavory to attract the gentleman-amateur and too unprofitable to interest the professional. In fact, his pictures could only have stemmed from a passionate devotion to a cause larger than profit or personal expression. Riis sought to transform the moral life of his culture. To this end, he found the camera immensely useful in bringing middle- and upper-class audiences face to face with the pathos and tragedy of slum life. Blessed with an utter lack of "artistic" ambition, Riis felt no desire to idealize, generalize, or sentimentalize his subjects. His style was thus perfectly suited to his needs. By using the abrasive grit of fact to shock and prod his viewers to action, Riis created a powerful model for subsequent generations of reformers.[41]

Although Riis remains the best known of the early documentarians, he was not alone. A surprising number of photographers turned their cameras on subjects of sociological interest in the 1890s. In Chicago, Sigmund Krausz made rather stiff "character studies" of the city's working poor in his studio, while Alice Austen produced more naturalistic images of similar subjects on the streets of New York City.[42] In Hartford, Connecticut, minister John James McCook produced a remarkable study of tramp life.[43] These and other early documentary projects merit further attention.

Photography in the Age of Mechanical Reproduction

Original photographic prints played only a marginal role in the dissemination of Riis's ideas. At the time, the images were generally viewed as projected lantern slides accompanying his lectures or, in printed form, as hand-drawn engravings or process halftones. The engraving process required photographs to be translated by an artist into line drawings before being reproduced in magazines or newspapers. While this method preserved the basic elements of each photograph, the camera's unique specificity of detail was almost entirely lost. The halftone, by comparison, was produced directly from the original print and eliminated the interpretive hand of the artist-engraver.

The relative clarity and low cost of the halftone made it an ideal method of translating original photographs into print. However, the ultimate success of this process depended on the resolution of complex technical issues. The first printed halftone was published in the March 4, 1880, issue of the *New York Daily Graphic*, but this by no means marked a practical application of the process. Indeed, this first published halftone, *A Scene of Shantytown, New York*, did not even accompany a news story—it was merely used to illustrate one of "Fourteen Variations of the Graphic Process."[44] Attempts to use the halftone process in books

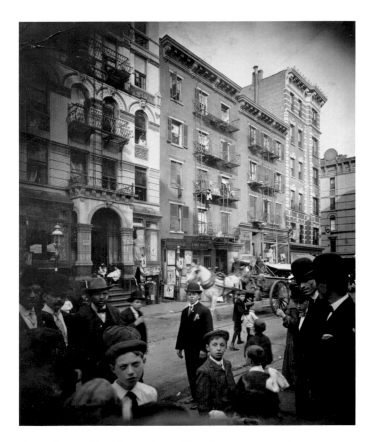

Fig. 3 Horace D. Ashton, *Low Class Apartments or Tenements, New York City*, 1905, 4⅜ x 3⅝″

and newspapers were hampered by persistent difficulties throughout the 1880s and early 1890s.[45] Only after an improved method for making ruled screens was patented in 1893 did the use of the process substantially increase. By the turn of the century, halftones filled magazines and newspapers across the country.[46] The photogravure process, a significantly more beautiful (and correspondingly more difficult and expensive) method of translating photographs into ink-on-paper form, was one of several other reproductive methods in use at this time. The widespread application of these various print technologies, and the ultimate domination of the halftone, utterly transformed the impact photography had on American society. Henceforth, photographs would be central to journalism, publishing, and advertising, and, indeed, to culture itself.

Realizing the great public interest in photographic illustrations, newspapers and journals began expanding their pictorial content.[47] *Collier's Weekly* shifted to an illustrated format in 1895, for example, and popular journals such as *Harper's Weekly, Illustrated American, The World's Work*, and *Cosmopolitan* all made extensive use of photographic reproductions in the following years. To satisfy their enormous need for source material, publishers began to hire staff photographers—creating the first generation of modern photojournalists. Independent picture agencies were also established to supply the rapidly growing demand for pictures. George Grantham Bain started the first of these agencies, the Bain News Service, in 1895. Underwood & Underwood, the large manufacturer of stereographs, entered

Fig. 4 Frances Benjamin Johnston, *Washington, D.C., Classroom,* 1899, cyanotype, 6⅞ x 9⅜"

Fig. 5 James H. Hare, *Crash of Orville Wright's Airplane, Ft. Meyer, Virginia,* 1908, 3½ x 6⅜"

the photo agency business in 1901, followed slightly later by International News Photos and similar organizations. This business appears to have enjoyed nearly exponential growth in its first decades; by 1920, for example, one essayist reported that nearly one hundred such enterprises were in operation in New York City alone.[48]

Turn-of-the-century illustrated journals published all manner of sensational, newsworthy, and educational photographs. Subjects of perennial interest included celebrities, sporting events, wars, political rallies, parades, expositions, and engineering feats.[49] There was always a ready market for pictures of disasters: explosions, fires, floods, sinking ships, wrecked trains, and airplane crashes. Such catastrophes proved highly profitable for the lucky or fleet-footed cameraman. In the immediate aftermath of the great San Francisco earthquake and fire, for example, the city was filled with "swarms of photographers" who earned considerable sums for images of the ruins.[50]

As a profession, news photography had an air of adventure. As one typically celebratory article of the period observed, "success in the exciting role of press photographer" was almost certain "if one has plenty of nerve, understands his tools, has the ability to turn out rapid work, [and] craves excitement and even a little danger."[51] Leading news photographers had to be patient, resourceful, adaptable, and clever enough to "scoop" their competition in the race for timely images. They traveled to all corners of the globe, climbed to the tops of skyscrapers, descended to the depths of coal mines, and came into contact with a broad spectrum of humanity. Horace Ashton, a now little-known employee of the Underwood & Underwood firm, typified this generation of news photographers. His varied subjects included the first public flights by the Wright Brothers and such social documentary topics as immigrants arriving at Ellis Island and the woeful conditions of New York City slums (fig. 3). Ashton's dizzying view of a news photographer high above New York (probably a self-portrait) sums up the era's romantic notion of the cameraman as an adventurer and daredevil, and a uniquely privileged observer of the

vast panorama of modern life (plate 1). Among the more celebrated men and women attracted to this work were A. Radclyffe Dugmore, Jessie Tarbox Beals, Frances Benjamin Johnston, and Jimmy Hare.[52]

Johnston was one of the most versatile photographers of her day. She began as a professional in 1889, and quickly established a reputation for her superb journalistic, architectural, and portrait work. Her subjects were enormously varied, encompassing iron mines, women's factory labor, Mammoth Cave, and the 1893 World's Columbian Exposition in Chicago. In addition to working on commissions, she also regularly sent work to Bain's news service. In 1899, Johnston spent six weeks photographing the schools of Washington, D.C, producing a total of 700 views.[53] A social issue of vital importance at the time, education was widely regarded as the key to establishing moral and political virtue. Thus, Johnston's carefully posed views seek to portray classrooms as models of order and probity (fig. 4). These photographs were exhibited at the 1900 Paris Exposition and resulted in commissions to document two African-American schools, Hampton Institute and Tuskegee Institute, as well as the Carlisle Indian School in Pennsylvania.[54] Johnston was also an eloquent supporter of women photographers, and at the Paris Exposition she presented a lecture on "The Work of American Women in Photography." She later organized an exhibition of work by twenty-nine U.S. women that was presented in Paris, Moscow, and St. Petersburg.[55]

Jimmy Hare was one of the most colorful of these pioneering photojournalists. Born in England, Hare came to New York in 1889 to work for the E. & H. T. Anthony firm. In 1895, he became the staff news photographer for the *Illustrated American,* recording everything from regattas to train wrecks. He traveled to Cuba in 1898 to cover the Spanish-American War for *Collier's Weekly.* He subsequently recorded cross-country speaking tours by Presidents McKinley and Roosevelt, religious sites in Jerusalem, the Russo-Japanese War of 1904, the San Francisco earthquake of 1906, the 1908 political conventions, and the inaugurations of 1909 and 1913. He was particularly celebrated for his photographs of early aviation, and he recorded many early public flights by the Wright Brothers. On September 17, 1908, he recorded the first airplane fatality (fig. 5), when a crash injured Orville Wright and killed his passenger,

Lieutenant Selfridge. In the years between 1911 and 1918, Hare photographed the Mexican Revolution, the First Balkan War, and the First World War. After retirement in 1922, he became a popular figure on the lecture circuit and the subject of an admiring biography.[56]

At the same time that photographs were seen in ever-increasing quantity on the printed page, mechanization allowed the production of original photographic prints in equally unprecedented numbers. For example, the stereograph, which had been first introduced in the late 1850s, gained new popularity in the 1890s and remained highly popular until after the First World War. These paired images, which produced a sense of spatial depth when seen in a stereoscope viewer, were produced by numerous firms. In 1901, the largest of these companies, Underwood & Underwood, was manufacturing a remarkable total of 25,000 stereographs and nearly 1,000 stereoscopes each day. These stereographs were assembled into thematic sets which ranged from less than a dozen to more than one hundred cards. These were marketed to the public through a sophisticated sales network.[57] Through such images, Americans enjoyed an exhilarating range of vicarious experiences—scenes of newsworthy, pictorial, or exotic interest from around the globe.

The vast majority of mass-market images—stereographs and news photographs alike—were created and viewed as "objective" documents. The format and informational nature of the stereograph combined to suppress evidence of individual vision, and the actual makers of these pictures are largely unknown. News photographs of the period were deliberately impersonal in style, reflecting the desire of publishers to represent events quickly and simply to a mass audience.[58] This apparently neutral approach suggested that the meaning of contemporary events was relatively simple and universally understandable. The artless naturalism of the great bulk of this work gave viewers a general understanding of—and a sense of access to—the world at large. While straightforward in style, however, the dramatic impact of these early news photographs was heightened through the use of captions, lively sequences, and dynamic page layouts.[59]

"The Peculiar Charm of Old Times"

While commercial and journalistic photographers produced endless records of the nation's technological progress, others focused on symbols of its preindustrial past. Influenced in part by P. H. Emerson's photographs of rural life in England's East Anglia district, many Americans traveled far and wide to record farmers and fisherfolk. Some of the most celebrated early pictures of Alfred Stieglitz and Gertrude Käsebier, for example, depicted French and German peasants. America's own past, seen through a haze of nostalgia, was the subject of innumerable photographs by Robert Redfield, Frances and Mary Allen, Rudolf Eickemeyer, Jr., and many others. Eickemeyer's gentle 1893 pastoral view of grazing sheep (fig. 6) is characteristic of his era's seemingly endless interest in

Fig. 6 Rudolf Eickemeyer, Jr., *Grazing Sheep*, 1893, platinum-palladium print, 5¾ x 8"

Arcadian subjects. Such views were standard artistic fare (the number of similar images in *Camera Notes* is remarkable, for example) while appealing to a broad popular audience. Eickemeyer's books *Down South* (1900) and *The Old Farm* (1901), both extensively illustrated with halftones of his photographs, sold briskly.[60] The most successful producer of decorative photographs, Wallace Nutting, reportedly sold nearly ten million hand-colored platinum prints of nostalgic views of colonial interiors and bucolic landscapes between 1900 and 1936.[61]

One of the most active, if least remembered, of these romantic documentarians was Clifton Johnson. After growing up on a farm in Hadley, Massachusetts, Johnson worked as an illustrator and later owned a successful bookstore in nearby Springfield.[62] Ironically, he came to appreciate the expressive power of photographs while studying painting. During his time at the Art Students League in New York, Johnson was one of several artists hired to redraw Jacob Riis's photographs for reproduction as line drawings in *How the Other Half Lives*.[63] Johnson subsequently embarked on a prolific thirty-year career as a writer, photographer, and folklorist.[64] His primary interest lay in rural ways of life threatened by the onslaught of modernity. While the thrust of Riis's work had been reform in the name of future good, Johnson's subject was the simplicity and beauty of a warmly remembered past. As Johnson noted,

> About "old times" there always hovers a peculiar charm. A dreamland atmosphere overhangs them. The present, as we battle along through it, seems full of hard, dry facts; but, looking back, experience takes on a rosy hue. The sharp edges are gone. Even the trials and difficulties which assailed us have for the most part lost their power to pain or try us, and take on a story-book interest in this mellow land of memories.[65]

Johnson chronicled the simple virtues of rural New England life in loving detail while lamenting its steady disappearance. By the mid-1890s, the farm population of New England had been in decline for forty years. Abandoned farmhouses were a common sight, the result of rising property taxes as well as the allure of the West and the city.[66]

Johnson's first book combining text and photographs, a study of Yankee farm life titled *The New England Country* (1893), was an immediate popular success. Numerous volumes followed, including *The Country School in New England* (1893), *The Farmer's Boy* (1894), and a series of "Highways and Byways" guides to various regions of the United States.

A typical example of Johnson's poetic documentary style, *Kitchen, Chesterfield, Massachusetts*, ca. 1895 (plate 4), was reproduced in his 1896 volume *A Book of Country Clouds and Sunshine*.[67] Johnson's love for his subjects made him particularly attentive to the expressive power of details.[68] In this case, he conveys the simplicity and quiet continuities of farm life in an image of both narrative and formal richness. An old-fashioned kitchen stove becomes the literal and symbolic source of the heat and sustenance central to daily life on the farm.[69] Through the relaxed informality of this image, Johnson creates a feeling of great intimacy, as if he were recording his own house. While Riis depicted a shockingly alien world in the cause of reform, Johnson worked as a preservationist in a realm he understood and treasured.

In San Francisco, Arnold Genthe was creating his own record of a soon-to-vanish facet of American life. In his native Germany, Genthe had been raised in an affluent and scholarly environment. He earned a doctorate in classical philology before emigrating to the United States in 1895. Desiring to send souvenirs of America to his relatives in Germany, Genthe took up photography to record the exotic sights of San Francisco's Chinatown. Although he used a hand camera, Genthe was remarkably deliberate, sometimes waiting for hours on street corners or in courtyards "for some picturesque group or character to appear."[70] The resulting synthesis of documentary and artistic concerns is exemplified in images such as *Street of the Gamblers* (plate 5), which unites a spontaneous and intuitive vision with a sophisticated sense of pictorial construction. Genthe's attention to costume, the ebb and flow of movement, and the subtle variety of gesture and pose all foreshadow his subsequent interest in dance. Genthe had little in common with his subjects, of course, and a certain emotional distance is evident in his pictures. He photographed as a sympathetic outsider, eager to preserve artistic vignettes of this dynamic and picturesque subject.[71]

After the destruction of Chinatown in the earthquake and fire of 1906, Genthe's images took on a particular poignancy and special historic significance.[72] In 1908, he published his photographs in *Pictures of Old Chinatown* (the revised 1913 edition was titled *Old Chinatown*). In an afterward to the revised edition, Genthe sadly acknowledged that his beloved subject was gone forever. In its place had arisen "a new city, cleaner, better, [and] brighter," but far less interesting. Genthe longed for "the old mellowness of dimly-lit alleys, [and] the mystery of shadowy figures shuffling along silently." The Chinatown of 1913 lacked much of its former allure. The residents had become acculturated. Genthe observed pointedly that the "general ambition to be 'American' in manners [is a] force more destructive than fire."[73] His book remains a melancholy tribute to an "exotic" culture's displacement by the rising tide of modernity.

The Vanishing North American Indian

The largest "vanishing" culture in American life was that of the Native American Indian. By the early 1890s, Native Americans were no longer perceived as an obstacle to white settlement of the West. Instead, they had come to symbolize a cultural alternative to the destructive and dispiriting effects of modernity. Artistic photographers such as Joseph T. Keiley and Gertrude Käsebier used Indian subjects for some of their most ambitious works. Numerous other photographers of the era, including Frederick Monsen, Charles F. Lummis, Adam Clark Vroman, Frank A. Rinehart, Edward S. Curtis, and Karl Moon produced significant bodies of documentary images of Indians.[74]

Adam Clark Vroman was one of the most remarkable of these photographers. A man of varied interests and refined tastes, Vroman was a successful merchant, a collector of rare books and Southwest Indian artifacts, an amateur archaeologist and historian, and a superb photographer. Vroman's interest in the camera blossomed after he opened a book, stationery, and photographic supply shop in Pasadena, California, in 1894.[75] Between 1895 and 1904, he made his best-known photographs of the Hopi and Navajo tribes in eight trips to Arizona and New Mexico. His preservationist interests also led him to document the old Spanish missions of California.

Vroman's first trip to the Southwest, in 1895, was motivated by his desire to see the Hopi Snake Dance. He was accompanied by a small group of friends that included two dedicated collectors of Indian artifacts and a professional photographer. After travel by train and wagon across an austere landscape (fig. 7), the party arrived at the base of the mesa to find "some forty white people camped, all to see the dance." Vroman noted that he "was not a little surprised to learn there were artists of note [as well as] authors, sculptors, newspaper correspondents from a half dozen papers, and some dozen or more ladies."[76] Vroman and his comrades clambered up a steep trail to the top of the mesa and settled into their guest quarters. In *Interior of "Our Home on the Mesa,"* Vroman recorded one of his traveling companions with a group of villagers who had stopped by to get acquainted (fig. 8). The next day Vroman and his friends were mesmerized by the otherworldly power of the snake dance. Though this was an exceedingly difficult subject to photograph, Vroman's images capture a richly contextual sense of the experience (plate 6). In the subdued light of dusk, the dancers blur into specters as they circle one of the rattlesnakes employed in the ceremony. All around them, village dwellers and visitors watch in rapt fascination.

Vroman took an objective and deeply respectful approach to this subject. His images document both the

Fig. 7 **Adam Clark Vroman**, *The Mesa (from East, showing the pass)*, 1895, 6 x 8"

Fig. 8 **Adam Clark Vroman**, *Interior of "Our Home on the Mesa,"* 1895, 6 x 8"

dance and the mixed audience in attendance. This unbiased interest in both the integrity of Native American practices, and their reality in 1895 as a "spectacle" for outsiders, was unusual. Vroman avoided the patronizing or romantic approach of many later photographers by recording the present as the present. His work is also distinguished by a consistent sense of his own presence as witness or participant. This self-reflexive stance is seen most cleverly in *The Mesa (from East, showing the pass)*, which includes very prominently the shadows of the photographer and his camera (fig. 7).

Not unexpectedly, photographic interpretation of Native Americans generally varied according to the intended uses of the images. Pictures made for scientific and ethnographic purposes or as essentially personal documents (such as Vroman's) tended to be relatively straightforward in style and content. However, pictures produced for popular sale were often highly romanticized, catering to white stereotypes of the past grandeur and exotic "otherness" of Indian life. These images tended to ignore (or actively suppress) evidence of the present in favor of a staged romantic past.

By the turn of the century, most signs of traditional Indian life had been obscured by acculturation. The 1898 Trans-Mississippi and International Exposition in Omaha, Nebraska, for example, was an attempt to celebrate and preserve Native American customs.[77] An important Indian Congress consisting of some 545 delegates from twenty-three western tribes was held in conjunction with this exposition. However, while conceived as an educational and historical gathering, the Omaha congress became in actuality a popular and profitable "wild west show." Indians were paid to stage dances and sham battles for the amusement of tourists. These performances, and the photographs of them produced for general sale, only encouraged romantic stereotypes, and the more complex realities of present-day Indian life went largely unrecorded. The official photographer of the 1898 Trans-Mississippi Exposition was Frank A. Rinehart. He and his assistant, Adolph F. Muhr (who later worked as Edward S.

Curtis's printer), made portraits of this congress's most notable participants, and platinum prints were produced for public sale. Shot-in-the-Eye (plate 7), a member of the Ogalalla Sioux tribe, was famous for having gained his wound and new name at the Custer massacre.[78] Like most of the Rinehart/Muhr portraits, this one is sympathetic and distinguished, clearly attempting to depict the sitter as an individual. Nonetheless, the nostalgic trappings and studio settings of these portraits remove their subjects from the difficult political realities of the time.

The photographer now most closely associated with this romanticizing tendency is Edward S. Curtis. Curtis became interested in recording Native Americans in the late 1890s while working as a portrait photographer in Seattle. By 1904 he was seeking sponsorship for an extremely ambitious photographic survey of Native American tribes. He secured generous underwriting from financier J. P. Morgan and spent much of the next quarter-century struggling to complete his mammoth work *The North American Indian* (1907-30). This publication contained twenty text volumes illustrated with more than 1,500 small photogravures, and twenty additional portfolio volumes with over 700 large-format gravures. A total of 291 copies of this work were ultimately compiled.[79]

Curtis deliberately merged scientific and artistic intentions to create a hybrid of documentary and Pictorialist styles.[80] In a sincere, if paradoxical, quest for authenticity, Curtis paid Native Americans to stage battles and ceremonies for his camera. Distressed at the evidence of acculturation, he frequently had his subjects change from their everyday dress of cowboy hats and blue jeans into "traditional" costumes (some of which he apparently carried with him as props). Curtis also felt free to manipulate the content of his scenes for aesthetic effect, and to retouch his negatives to remove evidence of the modern world. All such manipulations were made in an earnest effort to record a way of life that was, in large measure, gone. In striving to recreate a proud and "authentic" past from the (relatively) mundane evidence of the present, Curtis inevitably created a pictorial world of half-

remembered fact and romantic projection. In fact, he was once told by an Indian interpreter, "You are trying to get what does not exist."[81] Curtis received only lukewarm support from professional ethnographers.[82]

Curtis's talent for self-promotion also made some uneasy. He hired publicists and fundraisers to promote his work and was himself a tireless lecturer. By March 1905, when he presented a print exhibition and stereopticon showing at the Waldorf-Astoria Hotel in New York, it was reported that his performances "always command an enthusiastic reception" from the public.[83] Two years later, critic Sadakichi Hartmann reported that Curtis's "huge advertising campaign" had made him "just now the most talked-of person in photographic circles." This promotional barrage prompted Hartmann to comment,

> some noise has to be made, in order to avoid too great a loss of the invested money. But it is not particularly dignified. One would prefer to see less glamor and lime-light flare connected with a serious scientific publication, as this pretends to be.[84]

To support the expensive work of producing his volumes of text and photogravures, Curtis sold great numbers of his pictures in the form of platinum prints and "orotones." These were usually marketed in decorative frames, ready to hang, and proved popular as upscale wedding presents. Curtis's orotone process involved printing a photograph on a glass plate and sealing the back of the image with a viscous mixture of powdered gold pigment and banana oil. These images conveyed a moody iridescence and were described in Curtis's promotional literature as being as "full of life and sparkle as an opal." The most popular of these orotones, such as *Wishnam Fisherman* (fig. 9), were sold in considerable quantity at $15 for each 11x14-inch framed image.[85]

Curtis began work on *The North American Indian* at a time of great popular interest in the subject.[86] Southwest tribes had become popular tourist attractions and images of Native Americans were widely available. It is revealing, for example, that in 1904 a New York publisher attempted to discourage Curtis from publishing his Indian photographs by saying, "The market's full of 'em. Couldn't give 'em away."[87] In fact, this popular demand lasted until at least the early 1920s, when Americans' romantic fascination for Native Americans began to wane, at least temporarily. Ultimately, the importance of Curtis's pictures lies precisely in their uneasy union of two key aspects of modernity: the quest for "objective" data about the world and a deep nostalgia for a simpler, more heroic time.

Photographic Art

After the technical and social transformations of the 1880s, a deep rift developed between those who earned their living through photography and those who practiced it as an avocation. Wet-plate photography had been the nearly exclusive domain of the professional, but amateurs dominated the era of the dry plate. For thousands of enthusiastic hobbyists, photography was no longer an arcane science requiring lengthy training by experts or an array of technical and manual skills. Now that the actual making of photography was quite easy, serious amateurs began to define the nature of their activity in opposition to that of the professional. In photography, as in sports of the period, amateurs were felt to possess pure and elevating motivations, while those of the professional were seen as simply mercenary. Amateurs labored out of love rather than necessity and, at least in theory, placed no price on their achievements. From this perspective, the amateur had the potential to achieve a much higher and more personal form of expression than the technically minded professional could ever hope to reach. By thus turning their energy to the creation of art, the most ambitious amateur photographers began a lengthy journey through difficult and contested terrain.

For all its symbolic status, fine art had, in the 1890s, only recently gained a firm place in American culture. Indeed, the social respectability of art had developed very slowly. In colonial America, "the enjoyment, production and consumption of art was tinged with guilt" because it was associated with the superfluous wealth, rigid social structures, and "decadent" tendencies of the Old World.[88] Art suggested *artifice*, and was considered a distraction from the essential labor of building a new society. Well into the nineteenth

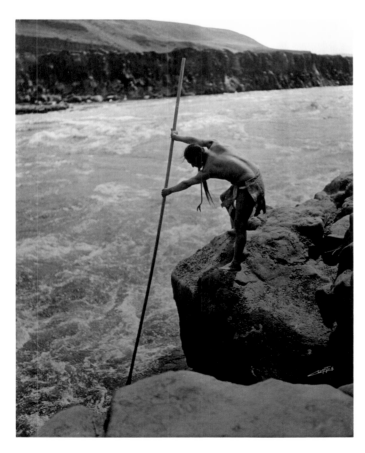

Fig. 9 **Edward S. Curtis**, *Wishnam Fisherman*, 1909, orotone, 13⅝ x 10⅝"

century, painting remained "a precarious and humiliating occupation."[89] Works of art were admired for their technique more than their originality, and artists were regarded as craftsmen rather than creators.

The fortunes of painters and sculptors only began to rise in about the 1830s with the growing belief that art had a valid cultural function: to codify and promote the great themes of nationalistic and religious life. These purposes were exemplified in the great landscape paintings of the pre-Civil War era. In the works of Thomas Cole and Frederick Edwin Church, for example, topographic description, historical allusions, political allegory, and religious symbols were melded into complex narratives.[90] Antebellum genre painters such as William Sidney Mount and George Caleb Bingham were similarly important in creating a collective self-portrait of American life. Works of art were praised when they taught moral lessons and provided an elevating and purifying force for a flawed but—it was hoped—continually improving society. Art was valued in direct proportion to its ability to promote civic and spiritual virtue, or to convey images of democratic harmony, social progress, and religious piety.

The spiritual undercurrents of this new American culture reflected the idealism of Transcendentalist thought. In the writings of Emerson and Thoreau, especially, sight is closely associated with insight. They suggest that a clear perception of one's surroundings will lead to a profound understanding of both the visible and the invisible.[91] The intense and focused viewer is thus a *seer*. The most memorable expression of this mystical state of hyperperception is contained in Emerson's essay "Nature."

> Standing on the bare ground—my head bathed by the blithe air and uplifted into infinite space—all mean egotism vanishes. I become a transparent eyeball; I am nothing; I see all; the currents of the Universal Being circulate through me; I am part or parcel of God.[92]

While it was rarely expressed in such sublime imagery, many critics of Emerson's time felt that the ultimate goal of art was to elevate man to a comparable state of holy ecstasy and virtue. Even as American art became increasingly secular after the Civil War, these mystical ideals remained. Often, however, the specifically religious impulses of a previous generation were reduced to generic musings on universal forces and spirituality.

Establishing a truly national art was a central issue for American artists throughout the nineteenth century.[93] Although Transcendentalist literature found a visual parallel in Luminism and Hudson River School painting, European artists and art theory exerted an overwhelming influence. American artists were burdened by a sense of inferiority. The grand scale of European history, and the monumental achievements of its writers, musicians, painters, and poets, all combined to give the Old World artist a stature unknown in the New World. This feeling of inadequacy only increased after the Civil War. The American art exhibit at the 1867 Exposition Universelle in Paris was widely regarded as provincial in both style and subject. Even the most admired American paintings were judged to be the result of mechanical description more than poetic interpretation. In comparison with works by the leading French painters, for example, an American critic noted that Church's monumental *Niagara Falls* displayed "a cold hard atmosphere and metallic flow of water" and was, ultimately, nothing more than "a literal transcript of the scene."[94]

This European privileging of a subjective intervention of the artist's hand and personality over a more straightforward mimetic representation strongly influenced the course of American art and photography in the following decades. American painting, in particular, shifted toward a more cosmopolitan and international style. Subjects of specifically American interest declined in popularity, replaced by Barbizon-style landscapes and genre scenes of French or Italian peasants. European art was increasingly valued by American collectors, and the most ambitious American artists felt it necessary to study in Dusseldorf, Munich, or Paris. "I would rather go to Europe than go to Heaven," said William Merritt Chase, and a great number of his countrymen agreed.[95]

France exerted the greatest artistic influence on Americans in the last third of the nineteenth century. A steady stream of American artists studied in the leading Parisian schools and studios, resulting in an international style that tended to blur national or regional distinctions. As Henry James observed in 1887,

> It sounds like a paradox, but it is a very simple truth, that when to-day we look for 'American art' we find it mainly in Paris, and when we find it out of Paris, we at least find a great deal of Paris in it.[96]

The results of this influence were evident at the 1889 Exposition Universelle in Paris.[97] The American painting display received excellent reviews, and it was generally agreed that the nation's art had finally come of age. Fully three-fourths of the Americans exhibiting had studied in France and their paintings blended seamlessly in style and subject with those of the leading Europeans. Using the same set of technical approaches, artists of all nationalities produced portraits, landscapes, marine studies, city views, still lifes, nudes, and historical, religious, and allegorical images. The most popular category, genre studies, focused on colorful foreign scenes and the timeless labor of rural European peasants. American contributions to this category included images of French shepherds, fishermen, and farmers, as well as views of Egypt and India. The recurrent depictions of premodern cultures attest to the fundamental unease of an era in the throes of transition to an urban and industrial world.

Photographic Aesthetics

The new champions of the art of photography in the 1890s drew liberally from the example of American painting. Many of the arguments for the social value of artistic photography were taken directly from earlier debates among painters.

Idealistic appeals to "truth," "beauty," and the "elevation of popular taste" were often set against an underlying set of more mundane professional, economic, and social concerns. What was disguised by frequent allusion to art's spiritual value was the fact that it constituted a tangible emblem of cultural status, as well as a symbolic model of order for a diverse and often unruly society.

"Art" had become an issue of concern for American photographers in the daguerreotype era of the early 1850s. As the number of practitioners grew, the business of photography became increasingly competitive. Semi-skilled operators turned out portraits at less than half the going rate, and more established studio owners fought to maintain price levels that would assure them a comfortable living. The arguments of these leading studio photographers combined aesthetics, economics, morality, and appeals to cultural pride. These arguments stressed perfection of technique, the elevation of public taste, the rewarding of refined abilities gained through study and experience, and the threat of "degeneracy" posed by poor materials and workmanship.[98] These themes were used repeatedly in subsequent appeals for a "true art" of the camera.

American photographic journals of the 1850s regularly published articles on artistic principles, noted painters, and important painting exhibitions. Many of the era's most refined sentiments on the artistic potential of photography were summarized in George N. Barnard's 1853 essay "Taste." Barnard argued that photography could only hope to be elevated "above the merely chemical" through the efforts of men with a rare combination of "virtues and gifts" and a tireless capacity for study and application. True art could not be achieved by following "the Juggernaut of vitiated public taste," Barnard claimed, but only by observing the timeless laws and uplifting power of history's greatest works. Without an understanding of these universal artistic principles and the sensitivity to express them, the photographer was a "mere copyist," a "mechanical slave." Art, according to Barnard, represented the union of "the True with the Harmonious and the Beautiful" in a work that resonated with "the soul of intellect." He concluded with this vision of the future of the photographic art:

Such is the spirit I would hope to see diffused among our artists…I would see science wedded to Art, with Truth and Beauty as their Handmaids and our profession soaring above the merely mechanical position which it now holds, aspir[ing] to a place among the higher branches of employment and the Daguerrean ranked as he deserves among the noble, intellectual and humanizing employments of the age.[99]

Barnard's essay underscores the basic aesthetic concepts that would prevail in photography a half-century later: the need to transcend the camera's purely optical nature, the guiding importance of painterly traditions, and the almost mystical significance of art.

Artist-amateurs of the late nineteenth century worked within an intellectual climate in which individual morality, natural beauty, and religious faith were understood to be united in art. The relationship between art and faith was expressed with particular clarity in an editorial in the first issue of the *American Amateur Photographer* in July 1889.

It has become a popular belief that all the difficulties have been removed, and that any one can take pictures. Photography has been degraded to the level of a mere sport, and many take it up, as they do lawn tennis, merely for an amusement, without a thought of the grand and elevating possibilities it opens up to them. The making of pictures is fast becoming merely an episode in a day's pleasure, not the earnest and untiring search for the beautiful. We submit that our art has a higher side than is apparent to him who uses only a detective or other small box, which, whatever their value, are far from representing all that is best and highest in photography. Indeed were this all, amateur photography would soon die of its own too-muchness.

It is not saying too much to affirm that there is a moral element in the practice of the art picturesque, which should be felt and followed by every worker with the camera; the morality which springs from the purpose, single and earnest, to interpret to unseeing eyes some portion, at least, of the charm and beauty with which God has filled this home of his making…

Such an earnest purpose as this lifts photography above the level of a mere pastime: it makes it an inspiration; an interpreter of the thoughts of God. He who has this purpose …will become a diligent and thoughtful seeker after the beautiful in nature, and, so far as lies in his power, an interpreter of it. He will learn to distinguish between grace and awkwardness; between the picturesque and the trivial; and this knowledge will give him a keener appreciation of nature's beauties and an added enjoyment in life. His highest aim will be to interpret aright the grace and charm of field and forest, lane and hedge-row, brook-side and sea-shore. Technical manipulation will be to him only a means to an end, and that end the interpretation of beauty.[100]

Ultimately, it was this "earnest purpose" that elevated the artist above the maker of mere documents. This creative urge, characterized by the writer Enoch Root as the "informing spirit of intellect and feeling," provided the spark capable of transforming worldly beauty into otherworldly insight. As Root noted,

Nature abounds in beautiful compositions of some form or another in every locality. An old dilapidated building, with its picturesque surroundings; a group of cattle in a brook; a winding path among overhanging trees; the buttressed ledge of rocks, with sunlit, trailing vines over dark recesses reflected in some limpid pool; the rock-bound streamlet; the gnarled, fantastic tree trunk—pictures everywhere.

A love and study of such scenes of beauty is one of the purest joys of existence—a power to translate such, a never ending source of delight. Such study is in harmony with our highest well being. It leads man away from mere animal sense, which clogs and falls, into a clearer atmosphere, where the intellect is quickened, the mind cultured, and the soul brought into nearer relationship with the Supreme Creator of all beauty and goodness.[101]

Such lofty sentiments constitute the intellectual framework for the artistic ambitions of the era. It is important to note, however, that these ideas remained at a high level of abstraction and were rarely used to explain individual pictures.

By the mid-1880s, it was widely accepted that "artistic" photographs combined fine technique, a worthy subject, and a knowledge of the traditional principles of art. The goal in such pictures was a kind of idyllic naturalism: the depiction of a world of harmony, grace, and balance unmarred by discord or ugliness. An artistic photograph was an expressive whole with a clear relationship between dominant and subordinate motifs, and narrative cues that stimulated associations and memories in the mind of each viewer.

The most astute critics of the period perceived a clear division between the realist and idealist realms of artistic creation. In an insightful article published in 1886 in the *Philadelphia Photographer*, Charlotte Adams stated that American photography and art were derived from a national faith in "hard, positive facts." Responding to an opinion from England on the incapacity of photography to be considered art, Adams observed that English theories stemmed from a "pseudo-idealism" that had no place in American life.

> We Americans are forming a distinct school of photography as well as of art.... Our American art...is grounded, root and branch, in realism and this love for hard, positive facts, so natural to the American temperament...Now photography, whether regarded as an art or as a mechanical process, owes its existence, in the higher sense, to the place accorded to realism in modern life; in other words, the insistence upon positive truths. It is essentially a modern thing...
>
> There will always be two factions in the artistic camp. The idealists and the realists are always at war. But, in this country, the realists now have the best of it, and the majority wins. Creative art, in its highest conventional sense, that is, in the sense of working through pure imagination and fancy, does not belong among us. Reproductive art, in the sense of depicting human life and nature as they exist, is the foundation of the modern American art-idea. Photography is simply a form of reproductive art. Realism and reproduction are one—with the difference of the informing spirit of intellect and feeling, which in some subtle, indefinable way raises the artistic above the mechanical.[102]

While the great majority of photographers, amateur and professional alike, would have heartily agreed with this view, it came under increasing fire from the "idealist" camp in the following decade. By 1889, regular criticism of the "realist" position was appearing in the American photographic press. At first, the most radical ideas came from England. In criticizing the universal acceptance of overall sharpness, one critic advanced the decidedly unconventional opinion that "finer pictures are sometimes got with the worse rather than the better photography."[103] Similarly, the respected English photographer P. H. Emerson argued that science and art were utterly different in both method and goal. In Emerson's view, science required precise facts and appealed to the intellect. Art, on the other hand, appealed to the emotions and benefited from a radical elimination of unnecessary information.[104] In addition to careful choice of subject, lighting, and point of view, Emerson argued for a careful use of selective focus to emphasize the primary motif and to suppress peripheral or background detail. The work and writings of

fellow Englishmen George Davison and H. P. Robinson were also important in advancing this view.

The Rise of the Camera Club

Professional photographers of the late nineteenth century were well served by journals such as *Anthony's Photographic Bulletin, The Photographic Times, The Philadelphia Photographer,* and *Wilson's Photographic Magazine.* Publications aimed at a more uniformly amateur audience began appearing in 1889 with the introduction of *American Amateur Photographer* (Brunswick, Maine) and *Photo Beacon* (Chicago). Of the more than thirty journals published in the next decade, the most important was Alfred Stieglitz's lavish *Camera Notes* (1897-1903), the organ of the Camera Club of New York. Other notable publications of this period include *Photo-Era* (Boston), *Photo-Miniature* (New York), *Camera Craft* (San Francisco), and *Photo Mirror* (St. Louis).[105] These journals were supported in large part by the advertising of manufacturers, reflecting the vast expansion of the business of popular photography.

These publications encouraged a sense of collective identity among amateur photographers. Changes in American society after the Civil War resulted in a broad movement toward the formation of clubs and societies of all kinds. This trend toward social and professional associations coincided precisely with the technical changes that give rise to modern amateur photography.[106] In 1880, fewer than ten clubs or societies dedicated to photography could be found in the United States, and all of these were constituted largely of professional photographers or men of science. By the end of 1889, however, about seventy photographic organizations were in existence with memberships overwhelmingly composed of amateurs.[107] A quarter of these clubs were headquartered in the New York metropolitan area. Others of note were located in Albany, Baltimore, Boston, Buffalo, Cleveland, Columbus, Chicago, Cincinnati, Hartford, Honolulu, Indianapolis, Louisville, Minneapolis, New Orleans, Portland (Oregon), Philadelphia, Pittsburgh, Rochester, San Francisco, Selma, St. Louis, Syracuse, Washington, D.C., and Worcester.[108]

The Photographic Society of Philadelphia, founded in 1862, was one of the most important of these early associations.[109] Some of the most distinguished figures in American photography were members in the society's first quarter-century, including Coleman Sellers, Frederick Gutekunst, John Carbutt, John C. Browne, John G. Bullock, William H. Rau, and Robert S. Redfield. In 1864, the society established its own publication, *The Philadelphia Photographer*, under the editorship of Edward L. Wilson. (This influential journal continued until 1888, when the title was changed to *Wilson's Photographic Magazine*.) The Photographic Society of Philadelphia remained one of the most respected organizations of its kind into the first decade of the twentieth century.

In New York City, the most significant early association was the Society of Amateur Photographers of New York. In

1885, a year after its founding, this organization gave rise to the American Lantern Slide Interchange by showing slides borrowed from the Cincinnati Camera Club. The New York society was also a co-sponsor of the important series of "Joint Exhibitions" held from 1887 to 1894 in collaboration with the Photographic Society of Philadelphia and the Boston Camera Club. In the first decade of its existence, the Society of Amateur Photographers counted among its members such noted figures as Catherine Weed Barnes, J. Wells Champney, Emilie V. Clarkson, William B. Post, and Alfred Stieglitz.[110] By 1895, the society had 260 members, making it one of the largest clubs of its kind in the world.[111]

The membership of American photographic clubs was typically drawn from the ranks of the upper and upper-middle classes. Within this economic strata, however, members came from a great variety of occupations. The Cincinnati Camera Club, for example, included "mechanics and millionaires, university professors and retired merchants, artists and architects, engineers and chemists, journalists and publishers, manufacturers and stock dealers, bankers and underwriters, lawyers and doctors." This club was unusual in actually barring professional photographers; most other organizations happily welcomed the relatively few professionals who cared to join.[112] With relatively few exceptions, women constituted an important part of club membership. In 1889, ten of the Cincinnati club's 150 members and nearly one-third of the Chicago Camera Club's 100 members were women. For a variety of reasons, however, including the demands of family and household, few of these pioneering women seem to have produced high-caliber work over an extended period.[113] On the other hand, by this time, women had become a significant presence in the professional ranks. In the 1890 census, for example, some 2,201 women listed their occupation as "photographer."[114]

The most important woman in the formative years of American amateur photography was Catherine Weed Barnes. A resident of Albany, New York, Barnes took up the camera in 1886. A few instructions from a local professional, combined with her considerable intelligence and determination, allowed Barnes to reach a high level of accomplishment within just a few years. Galvanized by the refusal of her local camera club to accept women, Barnes joined the more progressive Society of Amateur Photographers of New York in 1888, and, a year later, she emerged as the strongest voice in America for the cause of women's photography. In lectures and essays, Barnes argued powerfully for equal treatment and opportunities for women. She called for the abolishment of separate "ladies'" awards in competitions, stating bluntly that these were "not a complimentary distinction, although intended as such." "Good work is good work," she continued, "whether it be by man or woman...If the work of men and women is admitted to the same exhibition it should be on equal terms. Don't admit a woman's pictures because they are made by a woman but because they are well made."[115] Barnes concluded her essay "Why Ladies Should be Admitted to Membership in Photographic Societies" by

calling on all photographic institutions simply "to give us a fair field and no favor," and by predicting that "the day is coming, and will soon be here, when only one question will be asked as to any photographic work—'Is it well done?'"[116] She was equally forthright in her defense of photography's inherent artistic potential: "Photography does not need to beg admission to the temple of art or be admitted to it on a painter's ticket. She is entitled to her own doorway, for a photographer is not a painter any more than an organist is a violinist."[117]

A woman of extraordinary energy, Barnes was respected as a photographer, essayist, lecturer, and editor. While her portraits and picturesque views of historical sites were frequently praised, her most ambitious photographs involved elaborately staged tableaux illustrating passages from famous poems. Her photographic series after Alfred Tennyson's "Enoch Arden" and "Lancelot and Elaine" were widely exhibited.[118] Barnes was a popular speaker and appeared before many of the leading photographic groups in the New York region. In 1893, she delivered an important paper on "Amateur Photography" to the World's Congress of Photographers, held in Chicago in conjunction with the World's Columbian Exposition. Many of her lectures were published as essays in the American Amateur Photographer and other leading journals of the period.[119] Barnes became an editor of the American Amateur Photographer in 1890, and contributed a regular column under the title "Women's Work," as well as many other articles on the art of photography. This aspect of her career ended abruptly in 1893 when Barnes married H. Snowden Ward, the editor of the English monthly, Practical Photographer. After moving to London, she assisted her husband in establishing a new photographic publication, The Photogram, while continuing her own pictorial and literary work. Though she remained a dynamic force in English amateur photography, the departure of Catherine Weed Barnes was a significant loss to the American photographic community.[120]

Camera clubs provided a variety of benefits for their members. Each of the better clubs maintained a library of photographic publications, darkrooms for processing negatives and prints, and a meeting room for lectures and lantern slide showings. The Chicago Camera Club, established in May 1889, was a typically progressive association. In addition to the usual features, this club had a fully equipped portrait studio and a permanent display of framed works by photographers of international renown. An attendant was on duty each weekday from 9:00 a.m. until 6:00 p.m., and members were given keys to let themselves in after hours or on weekends. For these privileges, the club's 100 members each paid an initiation fee of $10 and annual dues of $12.[121]

Club meetings, usually held once or twice a month, had both social and educational components. The most informal gatherings, like the 1889 "Smoking Concert" of the Brooklyn Society of Amateur Photographers, offered such varied amusements as "music by members of the society, character performances, illustrations of mesmerism, and

sleight-of-hand tricks."[122] The main monthly meetings usually featured a technical demonstration of some new tool or process, or a lecture by a figure of at least regional renown. In 1889, for example, the members of the Cincinnati Camera Club heard talks by photographers as diverse as Eadweard Muybridge and the Mesoamerican archaeologist Augustus Le Plongeon.[123] It was also common for painters, art historians, or designers to lecture on art or to critique the members' work.

Another important part of club meetings was the projection of lantern slides, a popular form of education and entertainment in this era.[124] The 3 1/4 x 4-inch black-and-white glass positives cast bright and crisply detailed images on the screen, and were frequently accompanied by narration or music.[125] In the days before motion pictures and television, it is not surprising that these programs drew large crowds. Presentations typically featured the work of a single club photographer, a theme explored by all club members (often a celebration of their city or region), or a survey of work by members of other clubs. The American Lantern-Slide Interchange, begun in 1885, created a network for the circulation of slide sets around the country. Regional organizations, such as the New England Lantern Slide Exchange, were also established, and clubs regularly exchanged sets on an individual basis. For example, a set of seventy slides titled "Illustrated Boston," representing work by that city's camera club, was a huge hit with the members of the Pacific Coast Amateur Photographic Association in San Francisco. The set was shown twice at the association and once again in a public hall. The audience for this latter presentation "was very enthusiastic, but unfortunately only about seven hundred could be accommodated, and a larger number had to be turned away from the door."[126]

A highlight of every camera club's calendar was the annual photographic outing. Most of these involved excursions to picturesque rural areas and ranged in length from one to ten days. In such bucolic surroundings, far from the noise and haste of the city, amateurs could hike, photograph, or linger over a picnic lunch. These trips were so important that clubs such as the Photographic Society of Philadelphia had excursions committees to research and plan them.[127] In 1887, the Reverend W. H. Burbank, one of the founding editors of the *American Amateur Photographer*, described the pleasures of a typical outing. Travel by train and foot brought Burbank and a botanist friend to a small lake in the Hudson River valley, a scene "abound[ing] in picturesque bits."

> One of these was taken, a wide stretch of open water, rippled by a passing breeze; on the right a picturesque grouping of rocks and trees; in the near foreground a tangled growth of low bushes clearly outlined against the water, and a bit of the road, with the opposite hills in the distance...
> Another effective bit was a woodland vista with the leaf-strewn road running diagonally through the picture, lined on either side with trees whose branches met in graceful confusion overhead. In this bit the author did good service

by posing, gun in hand, in the middle distance, where his dark figure lengthened out the perspective.

Later in the afternoon, Burbank found another site rich in the kind of "picturesque and homely" scenes he treasured.

> There was the hemlock walk where the road ran steeply down between two lines of giant hemlocks with the sunlight streaming through the branches and flecking the tree trunks with spots of light; there was the charming little vignette, showing a glimpse of the river framed in by arching trees...and there was a lonely pine towering high in air, which with the huge rock at its foot, and the river and distant hills beyond, made a charming study which well repaid the day's toil, and made the photographer happy.[128]

Photographic Exhibitions

Camera clubs also took a leading role in sponsoring photographic exhibitions. Although photographs had been presented to the public regularly prior to the 1880s, few of these displays focused solely on aesthetic merit. At professional photography conferences, for example, original prints were displayed as advertisements of either their maker's skills or the products employed. Large public expositions, which often included photography as an example of civilization's progressive impulses, invariably emphasized technical achievements and also presented the medium's aesthetic side poorly. Many photographs were displayed at the 1876 Philadelphia Centennial Exhibition and the 1885 New Orleans Exposition, for example, but in both cases the result was a confused jumble of pictures and hardware. Some prints were shown in special photographic departments alongside promotional displays by manufacturers. However, the great majority of photographs were dispersed in scores of state or thematic displays. At New Orleans, for example, careful viewers could find William Henry Jackson's photographs in the Colorado section and the work of Carleton Watkins in the California display. Similarly, the numerous display halls of the World's Columbian Exposition, held in Chicago in 1893, were full of photographs made for a wide variety of scientific, documentary, promotional, and artistic purposes.[129] The structure and intention of these expositions strongly emphasized subject matter over interpretive expression, and the few memorable examples of the photographic art were vastly outnumbered by banal topographic and documentary records.

The first American photographic exhibitions designed to demonstrate the medium's expressive and artistic qualities were assembled in 1884. In that year, both the Providence Camera Club and the Boston Society of Amateur Photographers mounted the first of several annual exhibitions. The organization of the Boston show, in particular, established a pattern followed by other clubs. Selected by a jury composed of an artist, designer, and architect, the show included over 600 works by amateurs from all over the country. The favorable reception of the Boston Camera Club's first exhibition prompted other organizations to follow suit. In 1885, the first annual exhibition of the Society of Amateur Photog-

raphers of New York was deemed so successful that it was pronounced "the dawn of a new era in American photography."[130] The Pacific Coast Amateur Photographic Association in San Francisco also held its first exhibition that year. In 1886, the Photographic Society of Philadelphia collaborated with the Pennsylvania Academy of Fine Arts to present a huge exhibition of 1,871 prints by the most noted photographers in the United States and England. The Camera Club of Hartford also organized its first annual exhibition in 1886, a show that included work by members of the Providence Camera Club and the San Francisco Amateur Society.[131]

In 1887, the nation's three leading photographic societies pooled their resources to begin the most important series of photographic exhibitions yet conceived. The Joint Exhibitions of the Photographic Society of Philadelphia, the Boston Camera Club, and the Society of Amateur Photographers of New York were held each year from 1887 to 1894 (except 1890). In addition to the photographs of club members, the Joint Exhibitions featured work from across the country and overseas. These shows received great public attention and were enormously successful in defining and promoting the art of photography.

The leading photographers of the day entered all or most of the seven Joint Exhibitions. The Philadelphians Robert S. Redfield, John G. Bullock, Clarence B. Moore, and George B. Wood won many awards, while their clubmates Alfred Clements, Edmund Stirling, John C. Browne, Charles R. Pancoast, William Rau, and Dr. Charles L. Mitchell also received consistently good reviews. Women photographers such as Catherine Weed Barnes, Emma J. Farnsworth, Frances Benjamin Johnston, Elizabeth A. Slade, and Emma J. Fitz received positive notices in one or more of the exhibits. Among the many other exhibitors receiving special mention in the photographic press were Francis Blake, William B. Post, James L. Breese, Edwin Hale Lincoln, William Henry Jackson, William A. Fraser, and Rudolf Eickemeyer, Jr. The work of Alfred Stieglitz was first found worthy of special notice in 1889, while he was residing in Berlin. The English photographers Frank M. Sutcliffe, P. H. Emerson, H. P. Robinson, and George Davison repeatedly provided the highlights of the international sections of these shows.

The sixth Joint Exhibition, held in Philadelphia in 1893, was widely regarded as the best of the series. The Philadelphia club's organizing committee, chaired by Robert Redfield, assembled a show that Stieglitz, as a young photography critic, pronounced "without doubt, the finest exhibition of photographs ever held in the United States."[132] Some 1,800 prints by 200 entrants were hung, representing work from the United States, Great Britain, Germany, Switzerland, Japan, Australia, and India. The most discussed work in the exhibition was George Davison's photograph *The Onion Field*, which was unusual both for its large size and extreme softness of focus.[133]

From this high point, however, the following year's exhibit, under the direction of the New York Society, was a distinct disappointment. Many previous award winners declined to enter due to doubts over the competence of the judges. These concerns turned out to be justified. The final exhibition was decidedly uneven and the jury was rumored to have spent only four hours reviewing some 700 pictures.[134] As a whole, the exhibition seemed proof of the New York club's status as "the 'conservative' of the leading societies, in other words, the least progressive."[135] On this note of discord, the important Joint Exhibitions came to an end.

These shows represented an evolutionary step, rather than a revolutionary leap, in thinking about photography. By and large, the Joint Exhibitions retained the conventional subject classifications of earlier shows. For example, the 1885 exhibition of the Boston Society of Amateur Photographers had featured a total of twenty-five categories, including "Landscape," "Cloud Effect," "Snow Effects," "Surf," "Sail," "Animals," "Flowers," "Trees," "Microscopic," "Machinery," three portrait categories ("Full Figure," "Head," and "Group"), two architecture categories ("Exteriors" and "Interiors"), and for all-around skill, "Entire Collection."[136] The variety of work accepted for the Joint Exhibitions reflected this all-encompassing approach. Among the more than 1,300 prints hung in the 1891 display were examples of nearly all the above categories as well as such novelties as a flash image of a night-blooming cereus, archaeological studies of Yucatan ruins, and instantaneous snapshots of athletic events. The anecdotal nature of the many genre studies in the show is indicated by such titles as *Smithy, Carting Hay, Stalking a Trout—Sunlight Through the Mist, Watching Grandma Smoke, Feeding the Chickens*, and *A Letter from My Boy*.[137] The inclusion of photographic apparatus and the careful documentation of the developers used for each work reflected the continued emphasis on technical concerns.

By the early 1890s, the most progressive artist-photographers had come to regard these eclectic shows as outdated.[138] They argued that exhibitions should dispense with categories and prizes in order to focus solely on artistic achievement. The first major international exhibition organized on these lines was held in Vienna in 1891. Rigorously juried by a team of respected artists, the Vienna exhibition included some 600 prints by 176 photographers from around the world. From a total of 350 works, submitted by forty Americans, only twenty-five photographs by ten individuals were selected. Included in this elite group were John E. Dumont, George B. Wood, Alfred Stieglitz, James L. Breese, and John G. Bullock.[139] In London, in 1892, this spirit of artistic purism stimulated the formation of the Linked Ring, a group of advanced photographers who resigned from the conservative Royal Photographic Society in order to devote themselves to a higher level of artistic expression. The Linked Ring included Britain's leading artist-photographers, such as Henry Peach Robinson, George Davison, Alfred Maskell, and A. Horsley Hinton, but it also extended membership invitations to a select number of leading interna-

tional photographers. The first three Americans so honored were Stieglitz, Eickemeyer, and the precocious young Boston aesthete F. Holland Day. The Linked Ring also began organizing its own annual international Salon in 1893 to compete with the Royal Photographic Society's yearly exhibition. The Linked Ring's exhibition, based on the simple principle of "no medals and rigid selection," was intended to effect the "death of the old style of show where mechanical, scientific and industrial exhibits are all jumbled up together with very little distinction."[140]

Following the lead of these groups in Vienna and London, major international photographic exhibitions were begun in Hamburg (1893), Paris (1894), and Brussels (1895). In some cities, such as Milan and Antwerp, photographic sections were added to annual art exhibitions. The Munich Secession was one of the most important of these fin-de-siècle exhibitions. The first Munich Secession of 1892 presented avant-garde paintings as inherently separate from—and superior to—the stale traditionalism of the old Dusseldorf school. The 1898 Secession demonstrated its adherence to progressive ideas by including artistic photographs alongside paintings, sculpture, and prints. Avant-garde photographers throughout the world viewed this acceptance as a triumph.

"A Photographic Epoch"

After the collapse of the Joint Exhibitions, the most advanced American amateurs pushed for a salon organized on the model of the Vienna exhibition, with no medals and only the most rigorous admission standards. One of the most persuasive voices in this cause was that of Alfred Stieglitz. A native New Yorker, Stieglitz had studied photography in Germany with the noted Professor Hermann Wilhelm Vogel. He began exhibiting his work and writing on photography in 1887. Upon his return to New York in 1890, Stieglitz quickly became a leader in American amateur photography. Respected for the technical and artistic quality of his pictures, Stieglitz was also admired for his organizational, critical, and editorial skills. By 1896, when his club, the Society of Amateur Photographers of New York, merged with the New York Camera Club to form the Camera Club of New York, Stieglitz was perhaps the most widely respected figure in American amateur photography. This stature, and his earlier tenure as an editor of the *American Amateur Photographer* (from 1893 to 1896), resulted in Stieglitz's appointment as editor of the Camera Club's new journal, *Camera Notes*. This lavish quarterly, published under Stieglitz's direction from 1897 to 1902, was the most beautiful and serious American photographic journal yet seen.[141] It combined club news, book and exhibition reviews, articles of technical and philosophical interest, and reproductions of noteworthy photographs (in both gravure and halftone). The journal's stated goal was "to keep our members in touch with everything connected with the progress and elevation of photography."[142]

Under Stieglitz, *Camera Notes* represented an odd but stimulating amalgam of approaches. The Symbolist tone of the journal was set in the introductory essay of the first issue, in which Stieglitz stated that "in the case of the photogravures the utmost care will be exercised to publish nothing but what is the development of an organic idea, the evolution of an inward principle; a picture rather than a photograph, though photography must be the method of graphic representation."[143] This mystical and highly subjective view was underscored in subsequent essays by Joseph T. Keiley, William Murray, Dallet Fuguet, F. Holland Day, and others. With varying degrees of clarity and success, these writings emphasized Baudelaire's notions of "correspondences," Bergson's ideas on the ultimate unity of movement, time, and consciousness, and a general belief in the overriding importance of individual genius.[144] Amid such abstract thoughts were articles on lenses and developers, and a few pieces—such as an article on photographing animals in the wild—that were virtually indistinguishable from the fare of more mainstream photographic journals. Despite this unevenness, *Camera Notes* signaled the beginning of a new era.

The year following the debut of *Camera Notes* was one of considerable activity in American photography. The first show of 1898, the Eastman Photographic Exhibition at the National Academy of Design, was innovative in several respects. Described as "the largest and most interesting photographic exhibition ever held in America, as well as the biggest and most successful piece of photographic advertising so far attempted in this country," this show was part of a campaign to promote the Eastman company's hand cameras.[145] The promise of $3,000 in prize money prompted the submission of more than 25,000 prints from all over the world. From this total, an exhibition of 3,000 photographs, ranging from work by rank amateurs to such esteemed figures as Robinson and Stieglitz, was created for display in London and New York. Eight months later, the Academy of Design hosted a significant 500-print exhibition organized by the American Institute. The first Pittsburgh Salon, also held in this year, was most notable for the inclusion of work by a newcomer, Clarence H. White of Newark, Ohio.

Despite the prominence of these shows, the most important exhibition of 1898 was the first Philadelphia Photographic Salon. Organized under the joint management of the Pennsylvania Academy of Fine Arts and the Photographic Society of Philadelphia, the exhibit was directed by a committee of the most able Society members: George Vaux, Jr., Robert S. Redfield, and John G. Bullock. These men were of a single mind in planning the exhibition, and their intention was expressed clearly in the exhibition catalogue:

> The purpose of this Salon is to show only such pictures produced by photography as may give distinct evidence of individual artistic feeling and execution.
>
> For the first time in this country is presented a photographic exhibition confined exclusively to such pictures, rigidly selected by a jury, whose certificate of acceptance is the only award. A far greater general interest centres in a picture displaying artistic feeling and sentiment than in one

which simply reproduces faithfully places or things in themselves interesting. In one the picture itself pleases—this is art, and can be produced by photography. In the other we think only of the object reproduced, admiring perhaps the technical excellence displayed—this is "only a photograph."[146]

This strictly artistic focus was reinforced by the committee's choice of jurors: photographers Redfield and Stieglitz, painters William Merritt Chase and Robert M. Vonnoh, and illustrator Alice Barber Stephens. From the more than 1,200 works submitted, this panel selected 259 images by 100 photographers. While international in scope, the show was largely an American affair. Seventy-six of the 100 exhibitors came from the United States and, of the seven other nations represented, only England (sixteen) and Scotland (three) contributed more than a single artist. Eight of the exhibitors were professionals, the most notable being J. C. Strauss of St. Louis, Frances B. Johnston of Washington, D.C., and Philadelphians Elias Goldensky and William H. Rau. Seventeen of the 100 exhibitors were women.

The show was a smashing success. Critics from the photographic and general press alike called it "an unqualified success," a "revelation," "remarkable," and of such significance that it "mark[ed] a photographic epoch."[147] Public interest was so great that the exhibit stayed open a week longer than originally scheduled, running from October 24 to November 19, 1898. The work on view provided a broad survey of the creative photography of the fin-de-siècle era. The highest praise went to the ten prints displayed by Gertrude Käsebier, a newcomer to the exhibition world. Keiley exclaimed in *Camera Notes* that, "of the revelations of the Photographic Salon, her exhibition of portraits was the greatest. Nothing approached it; such work had not even been dreamed of as possible."[148] Chase, one of America's most celebrated painters, went further, describing Käsebier's work as equal to "anything that Van Dyck has ever done."[149] Clarence H. White also received great acclaim, as did more familiar figures such as Stieglitz, Keiley, Bullock, Mathilde Weil, and Eva L. Watson.

The most controversial work in the 1898 salon, *The Seven Last Words of Christ*, was submitted by F. Holland Day. A wealthy aesthete and eccentric bohemian, Day had operated a luxurious private press in Boston before turning his full attention to photography. After witnessing the Passion Play at Oberammergau in 1890, he became enthralled with religious subject matter and studied the treatment of sacred themes by the artists of his time. The seven tightly cropped views that comprise *The Seven Words of Christ* are actually self-portraits of Day—bearded, emaciated, and wearing a crown of thorns—reenacting the final agonizing minutes of the Crucifixion. The most ambitious of Day's entries in the 1898 show, *The Seven Last Words of Christ* drew both praise and criticism, and stimulated a heated debate on the nature of photographic art.

Despite this controversy, Day's provocative work was fully consistent with artistic tastes of the time. After the inclusion of Edouard Manet's *Dead Christ with Thorns* in the Paris Salon of 1864, painters in both Europe and America had taken a new interest in Biblical subjects.[150] In fact, such themes accounted for nearly half of the historical and literary works submitted to the Paris salons by late-nineteenth-century American painters.[151] By the mid-1890s, a few American photographers had also taken up such sacred themes. The first of these seems to have been H. W. Minns of New London, Ohio, who gained "a great deal of notoriety" for his 1894 photographs of a friend posed as Christ.[152] But even if such themes were in some ways standard artistic fare at this time, controversy arose when the results seemed too realistic. For example, Thomas Eakins's 1880 painting *The Crucifixion* was shocking to viewers precisely because it conveyed "as an actual event" the physical pain of Christ's death on the cross.[153] Works such as this prompted one critic in 1901 to comment on the "singular phenomenon of men who are at one and the same time mystics and realists; men who attempt the daring experiment of endeavoring to express the supernatural by the natural."[154]

The camera's inherent realism guaranteed that the photographic interpretation of historical or ideal subjects would always be open to criticism.[155] While painters had the capability to orchestrate—or simply invent—a past of perfect narrative and aesthetic closure, photographers could only record actual people in present time. Thus, photographs of "historical" subjects inevitably presented self-consciously theatrical recreations of familiar motifs rather than the illusion of an unmediated past. Depicting the Crucifixion, the most hallowed of all Christian subjects, only magnified the problem. It was reported, for example, that the citizens of Mr. Minns's community were "inexpressibly shocked that any human being, especially one of their neighbors, should have posed for so sacred a subject." Minns's model, a free-thinking ("somewhat eccentric") young school teacher, responded to this criticism by noting the "admiration and pleasure" accorded such subjects in the work of the great masters. "What," he asked defiantly, if somewhat naively, "is the difference between posing for a photograph and posing for a painting?"[156]

It was in this context that Day's interest in sacred subjects had come to culmination in July 1898.[157] On a hot summer afternoon, Day staged his personal Calvary on a hillside outside his hometown. Day himself was Christ and his friends played the roles of soldiers and saints. He went to great lengths to achieve historical accuracy: the design of the costumes was carefully researched, and the cross and wooden nails were made by a Syrian carpenter. In addition, Day had let his hair grow and had starved himself for months in order to most fully convey both the appearance and the pain of Christ. After staging and photographing many figure groupings outdoors, Day retired to the studio to produce *The Seven Last Words*. For these close-up self-portraits, Day had rolled his head agonizingly from side to side in order to evoke the sublime sacrifice of the Passion. The seven images chosen for the final work were sequenced and mounted

together in an elaborate architectural frame. He also considered each image a finished work and presented them singly (plate 10). Day printed these as intimately scaled contact prints but experimented with the mood of the pictures by processing some with a hand-applied glycerine developer. This technique produced unevenly vignetted images, creating a more subjective and poetic effect than conventional processing.[158]

The controversy over Day's work was entirely expected. Sadakichi Hartmann, one of Day's most enthusiastic supporters, described this work as "full of delicacy, refinement, and subtlety, an art of deep thought and charm, [and] full of dreamy fascination."[159] But a less partisan critic probably captured the feeling of most viewers when he said, "One hardly knows whether to admire the versatile ingenuity of Mr. F. H. Day or [to] condemn his utter want of good taste."[160] Another critic simply dismissed Day's religious tableaux with the pronouncement that "surely claptrap and misapprehension of the province and mission of art can go no further!"[161]

Undeniably—even outrageously—affected, *The Seven Last Words* was a powerful work, meant to provoke controversy. The theme was old, but Day brought to it a new, almost visionary intensity. From a critical perspective, this was the most ambitious artistic photography of the era, a conscious attempt to prove that the medium was supple enough to do justice to the most awesome of all subjects. Moreover, by casting himself as the Savior, Day immodestly suggested his own view of the role he might play in the hoped-for genesis of creative photography in America. By depicting himself as both artist and Christ, Day evoked the romantic faith that culture could be redeemed through the sublime power of art.

One of the other most discussed works in the 1898 Philadelphia Salon was William A. Fraser's *A Wet Night, Columbus Circle* (plate 11). Praised by critics and general viewers alike, this was the largest and most powerful of Fraser's three nocturnal views in the exhibition.[162] While many amateurs had experimented with night photography in the 1880s, the earliest artistically considered bodies of night images were made by Paul Martin in London in 1895, and, soon after, by Stieglitz in New York.[163] The timing of this work was, in part, a response to the beauty of electric lights, a relatively recent innovation that had transformed the look of the urban night. Fraser began his own night work in January 1896, after reading Martin's articles on the subject in the *London Amateur Photographer*.[164] In the years 1897 to 1899, Fraser received considerable acclaim for his pictures, which were exhibited widely, from London to Calcutta, in the form of lantern slides or (less commonly) as prints.[165]

While Fraser freely acknowledged the influence of Martin's work, and modestly disavowed any "claim to originality," his pictures were distinct from those of Martin or Stieglitz.[166] Fraser had begun by using Martin's technique of exposing the plate "a minute or two in the last departing daylight" and completing the exposure after full darkness

had fallen. This method assured that detail would be recorded in the darkest areas of the scene. However, it tended to produce a sense of artificiality, and Fraser soon rejected this trick in favor of true nighttime exposures. A careful craftsman, Fraser found that exposure times of two-and-a-half to ten minutes sufficed, even when the only source of illumination was the full moon. During these exposures, he was careful to cover his lens whenever a lighted vehicle passed before him, and to hold the camera still in windy weather. Fraser's preference for the effects of snow or rain brought him out in the most unpleasant conditions and made him the object of "all sorts of chaff and uncomplimentary remarks" from friends and strangers alike.[167]

For the 1898 Philadelphia Salon, Fraser printed three of these images as bromide enlargements, and *Wet Night, Columbus Circle* was the most acclaimed of this group. *Wet Night* was a technical tour de force: unusually large in scale, beautifully atmospheric, and luminously detailed from shadows to highlights. In its rendition of moisture-laden air and wet, reflective streets, Fraser's photograph functioned as a visual poem of natural Impressionism. Unlike Martin's work, which was criticized for its "somewhat hard and unatmospheric" crispness, Fraser's image was both purely photographic and delicately imprecise, leaving much to the imagination of viewers.[168] The majestic scale of this enlargement evoked an almost visceral feeling of time and place, engaging viewers much more powerfully than the smaller prints of either Martin or Stieglitz. The broad appeal of Fraser's image stemmed from its unprecedented synthesis of a purely modern technique and subject with a poetic mood of dreamy subjectivity.

From this promising start, the Philadelphia Salon proceeded in subsequent years to mixed reviews, controversy, and, finally, collapse. The 1899 Salon, juried by photographers Gertrude Käsebier, Frances Benjamin Johnston, F. Holland Day, Clarence H. White, and Henry Troth, was generally hailed as a success. However, some grumbling arose over the decision to supplement the juried show with a group of unjuried works by the judges and other noted photographers. This perception of unfair treatment was not unfounded, since, at 168 prints, the invitational section was nearly as large as the juried group of 182 works. The 1900 Salon, judged by Stieglitz, Käsebier, White, Frank Eugene, and Eva Lawrence Watson, reduced the size of both the juried (118) and unjuried (86) sections to achieve a higher overall level of quality.

Not surprisingly, protests arose over the growing elitism of these exhibitions. Photographers whose tastes were more traditional—or simply more inclusive—than those of the organizers and jurors criticized the Salons' moody aestheticism. *Wilson's Photographic Magazine* reported that "the everlasting gray, and brown, and black" works gave the 1899 Salon a "sombre and depressing" tone. The protest against the predominance of "low-toned and dim impressionistic work" grew more forceful with the 1900 exhibition.[169] As the critic for *Photo-Era* noted,

over all there hung like a pall an air of gloom, of despondency, almost of decadence. There was a dreary monotony about the tier on tier of weak, fuzzy, washed-out looking photographs which listlessly stared at me from gloomy frames as only a weak, fuzzy, washed-out looking photograph can stare.[170]

In his dual position as president of the Philadelphia Photographic Society and the Salon's guiding force, Redfield was pressured to broaden the scope of the exhibition. Conservative members of the society complained that the annual show represented an increasingly myopic perspective on the real achievements of modern photography. It was also clear that longtime society members were tired of regular rejection from their own salon. Charles L. Mitchell, a doctor and photochemist, led the campaign against the salon in personal letters to Redfield and diatribes in the photographic press. Mitchell concluded a scathing review of the 1900 Salon with these words:

> One cannot but feel strongly, in considering the class and the number of photographs exhibited, how narrow and limited is the field here represented. There is no architecture, but little landscape, very little *genre* work, no examples of the progress of photography in scientific application, no illustrative or decorative schemes, and mainly a collection of portrait studies—most of them bad. When photography is advancing by leaps and bounds as it is to-day, when its applications in medicine, in science, in newspaper and periodical illustration, in color work, etc., etc., is being daily extended and made more universal, it seems short sighted to confine an exhibition of photographs to the products of the disciples of one narrow, limited, and rather egotistical school. A more broad and catholic view should be taken of the matter. Let our friends of the "stained glass attitude" school of photography show their efforts, if they want to; they will at least serve to turn a merry jest and lend variety to the exhibition. But extend its scope, let all other methods of photographic expression be also given a showing, and let the walls of the Pennsylvania Academy of Fine Arts be lined with the latest and most interesting developments of photography in all its phases. It is time that there should be more variety in photographic exhibitions, and there is no organization better qualified, on account of its age, its experience, its conservative character, and its recognized high standard of work, to inaugurate such a movement than the Photographic Society of Philadelphia. But at the present time, there is getting to be too much "Bunthorne and the Lily" business about photographic salons. There is too much sentiment, too many "twenty love sick maidens" hanging on the accents of a few photographic Oscar Wildes and imitating their productions. There are too many "impressions" and too few clearly conceived, thoroughly expressed realities; too few real pictures, and too much "trash."[171]

The issue came to a head a few months later when Redfield declined to run for reelection as president. This opened the way for Mitchell, who lobbied hard among society members for his own candidate. To the surprise of nearly everyone, Mitchell's faction won. In retaliation, the society's 1901 Salon was boycotted by Stieglitz's circle and most leading international photographers. Stieglitz and Käsebier resigned their honorary memberships in the society, and Bullock and Redfield removed themselves from its board

of directors. The Philadelphia Photographic Salon ended with the failure of the 1902 exhibition.[172]

This backlash against the photographic aesthetes was not limited to Philadelphia. At precisely this time, Stieglitz found himself under mounting pressure from the Camera Club of New York to make *Camera Notes* more relevant to the interests of all its members. Stieglitz refused to compromise and resigned as editor in the summer of 1902. In an effort to create an American version of the exclusive Linked Ring, he then organized a loose association of carefully chosen photographers under the name "Photo-Secession." Stieglitz also began planning a new and independent publication, *Camera Work*, to continue the increasingly heated battle for the high art of photography.

The "Old" and "New" Schools of Photography

The ruptures that divided American photography in 1902 had been building for several years. The tensions between the science and art of photography, and the medium's various roles as profession, amusement, and artistic calling, had long been apparent. Many turn-of-the-century observers, including such conservatives as Dr. Mitchell, felt that the importance of photography stemmed mainly from the breadth of its applications in modern life. For him, the value of the process lay in its social utility as well as its expressive potential. Art photographers, however, felt compelled to separate their activity from this broad spectrum of uses, and to view it as intrinsically superior to that of both the professional and the ordinary Kodaker. Precisely because the camera was common to all these applications, "artists" denigrated the "merely photographic" in favor of more idealized expressions.

As adventurous photographers on both sides of the Atlantic began manipulating the medium to more subjective and expressive ends, a schism developed between the "old" and "new" schools of photography. Champions of the new impressionistic style dismissed the old devotion to technical precision and overall sharpness as hopelessly unartistic, "a method of looking at nature that is false and vicious, except for scientific purposes."

> Now it is no longer the photograph full of detail, sharp in outline, technically perfect, that pleases. What is aimed at is breadth of effect, the subordination of detail to the point where the picture represents the landscape as the artistic eye would see it, the preservation of atmosphere, and the avoidance of everything that is hard, unsympathetic, or destructive of the unity of the subject.[173]

The goal of these photographers was a union of the powers of both lens and mind to create images resonant with poetic suggestion. At the heart of this new attitude was the powerful idea that Emile Zola had so succinctly expressed in his famous aphorism, "Art is nature seen through a temperament." The subjectivity of the artist became all-important, and photographs were understood to be art only to the degree that they revealed "the impress of the mind."[174] As

Frank Sutcliffe wrote, "A photograph gives us the naked truth, which has to be clothed by the imagination."[175]

This shift in the photographic aesthetic of the 1890s is demonstrated in the work of the era's leading photographers. William H. Rau's mammoth-plate views illustrate most clearly the "old school" approach to landscape photography. A respected professional and longtime member of the Photographic Society of Philadelphia, Rau was a photographer of great experience and sophistication. He was one of the few professionals to play a leading role in an important amateur society, an activity that underscores his interest in aesthetic issues. After at least five years experience in large-format railroad photography, Rau was appointed the official photographer of the Lehigh Valley Railroad in 1895.[176] In this capacity he surveyed the length of the line, from New York City through Pennsylvania to upstate New York. He traveled this route in a lavishly equipped passenger car, complete with a darkroom, parlor, and a roof-mounted camera platform.

Working with an usually large 18x22-inch camera, Rau produced an extensive series of images that combined familiar conventions of nineteenth-century landscape art with a boldly modern sensibility (plate 8). Rau's noticeably elevated vantage point imbues his photographs with a sense of detached mastery and confidence that suggests his era's positivistic faith in both technology and Manifest Destiny.[177] The result is a provocative blend of picturesque nostalgia and technical sophistication, of bucolic tranquility and the irresistible dynamism of progress—a contrast that had long symbolized something essential in American culture. As early as 1820, for example, Washington Irving's "The Legend of Sleepy Hollow" celebrated "this peaceful spot" by observing that

> it is in such little retired…valleys…that population, manners, and customs, remain fixed; while the great torrent of migration and improvement, which is making such incessant change in other parts of this restless country, sweeps by them unobserved. They are little nooks of still water which border a rapid stream.[178]

Rau's view contains a dual focus on both "the great torrent" of cultural change and (quite literally) the "little nooks of still water" symbolic of an earlier and simpler era. His monumental pictures reveal quiet details along the railroad with far greater precision than actual observation from a moving train would have allowed. As Rau himself stated, his goal was "choice picture finds showing that which the regular traveler flying by on a fast express cannot see"[179] While this attitude suggests a nostalgia for the slower pace of an earlier era, Rau's vision was firmly progressive. His evocation of the machine in the Edenic "garden" of the American landscape is ultimately one of optimism and rationality which celebrates the triumph of modern ingenuity over the barriers of time and space.[180]

Rau succeeded in his attempt to make "views of surpassing beauty" that also satisfied the promotional interests of his sponsor. Lehigh Valley officials were certainly very pleased, since they framed over 200 of his photographs for placement in terminals and other public buildings along their route.[181] Rau's reaction to a display of railroad pictures at the 1876 Centennial describes the impact of his own images: "The photographs conveyed and revealed much better than guidebooks or conversation possibly could, the territory of wealth and beauty" that was opened up for human use by the "iron bands" of the railroad.[182]

Rau's pictures were distinguished from the great majority of the works shown in the photographic salons by their size and crystalline clarity. His vision rested on a massive accumulation, rather than a suppression, of information. The most avant-garde critics of the period would have considered these pictures old-fashioned, painfully precise, and woefully lacking in idealizing sentiment. In fact, the strength of this work stems from Rau's use of the vocabulary of the picturesque to record in bold scale a resolutely modern subject: the impact of technology on the landscape. To late-twentieth-century eyes, his photographs elegantly convey a fundamental tension between idealized notions of the picturesque and the real transformations wrought by industrial culture.[183]

The aesthetic of Robert Redfield, a close friend and associate of Rau's, was more characteristic of the gentleman-amateur of the period. Unlike Rau's large albumen prints, Redfield's modestly scaled views were most often printed in delicate tones of platinum (plate 9). Redfield's work represented one of the most refined expressions of the American naturalistic aesthetic of the late 1880s and early 1890s. His nostalgic and pastoral views of village life in New England and Pennsylvania evoked an agrarian past far removed from the complications of modern life. Redfield allowed his viewers imaginative entry into his pictures by presenting scenes rich in narrative appeal. For example, *Near Lake Waramaug* depicts a young man coming to meet a friend for a picnic. By choosing to represent this moment of the familiar courtship-leisure theme, Redfield allowed each of his viewers to recreate an idealized version of a perfect Sunday afternoon outing. The picnic was an important motif in nineteenth-century art, suggesting both a longing for intimacy with nature and the domesticated landscape as a source of therapeutic renewal.[184] Redfield was highly regarded for gently bucolic works such as this, and won numerous awards in the U.S. and abroad.[185]

John G. Bullock, a close associate of both Rau and Redfield, began working in photography in the early 1880s. He assisted Redfield in organizing the important exhibitions directed by the Photographic Society of Philadelphia from 1886 to 1900, and his work was similar to his friend's in both subject and style. However, *Study of a Birch Tree* (fig. 10), which probably dates from the late 1890s, suggests the influence of "new school" thinking on Bullock's inherently conservative aesthetic. More restricted in viewpoint than his earlier pictures, this image utilizes a shallow and "impressionistic" focus to transform the background into a visual screen of gently modulated tones. The result is a relatively abstract, two-dimensional rendering of a single, oddly shaped tree.

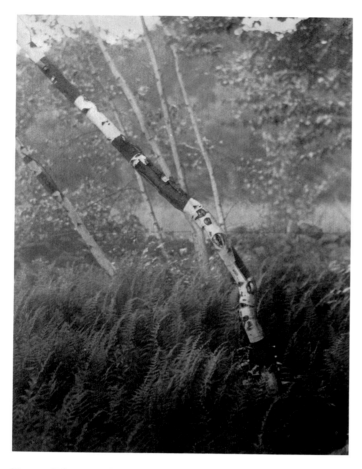

Fig. 10 **John G. Bullock**, *Study of a Birch Tree*, ca. 1895, platinum print, 7⅞ x 5⅞"

Fig. 11 Edward Steichen, *Moonlight: The Pond*, 1904, gravure, 6⅜ x 8"

Selective focus in landscape work was probably used more astutely by William B. Post than by any other American photographer of the era. Post, a respected member of the Camera Club of New York, began exhibiting his photographs in about 1893. While he worked with a variety of subjects, he was most highly praised for his images of water lilies and snow scenes.[186] Of the latter, *Intervale, Winter* (plate 13) was his acknowledged masterpiece. In this image, Post used an exquisitely delicate tonal scale to sketch the outlines of pictorial space. Characteristically, he focused his camera on seemingly minor foreground elements while carefully controlling the degree of softness throughout the rest of the picture. The result is surprisingly complex, as the viewer's attention is drawn almost equally to the small but crisply rendered weeds in the lower left, and to the expansive, subtly modulated landscape beyond. Sadakichi Hartmann quite properly praised Post's "elegance and grace," his frequently "astonishing" simplicity, and his unparalleled ability to render the "delicacy and luminosity of daylight."[187]

The "new school" approach to landscapes is seen clearly in two works by Ema Spencer (plate 12) and Edward Steichen (fig. 11). Both prints utilize the lowest register of the tonal scale to create a mood of dreamy mystery. The specific details of these scenes are so suppressed that both photographs function more as impressions than descriptions. While Spencer's image retains elements of an earlier form of picturesque naturalism, Steichen presents a moody tone

poem on the mysteries of nature and life. As Charles Caffin noted in an essay on Steichen's work,

> The lover of nature can never be satisfied with a mere record of the physical facts; to him there is, as it were, a soul within them, and he looks in pictures for its interpretation. It would not be far wrong to say that landscape art is the real religious art of the present age.[188]

In portraiture, the style of the "old school" was exemplified in the work of Benjamin J. Falk.[189] One of the most respected and influential professional portraitists of his day, Falk operated a luxurious studio on the fifteenth floor of New York's Waldorf-Astoria Hotel.[190] His portraits were widely praised as the epitome of the straightforward approach, "unmarked by peculiarity in handling," producing a result "which is plainly a photograph, not an imitation or simulation of something else."[191] Despite his disinterest in theory—he was quoted as stating, "all I try for is a good, satisfactory likeness, a pleasing effect, well posed and well lighted"—Falk's style was both sophisticated and deliberate.[192] His portrait of Thomas Edison (plate 14), one of the most famous symbols of American ingenuity and success, blends a sense of relaxed intimacy with a larger-than-life heroicism.[193] Edison's pose is elegantly casual, his bearing both modest and dignified. The clarity and subtlety of the inventor's mind is suggested by the somber richness of the image itself, a quality enhanced by the velvety tones of the platinum paper Falk chose for this image.

By contrast, Käsebier's portrait of Auguste Rodin (plate 15) exemplified the subjectivity of "new school" portraiture.[194] This image, printed on tissue in gum bichromate, paradoxically combines both gravity and ephemerality. Rodin's substantial form fills the frame and yet is largely dematerialized by Käsebier's soft-focus, high-key rendering and the rippled, translucent surface of the tissue support. Rather than "objectively" recording the details of his appearance, Käsebier sought instead to evoke Rodin's presence as a vibrant creative force. The introspective nature of this work

is emphasized by the sculptor's turned head and downcast eyes. Käsebier felt that "the full-face is the attitude a man shows to the world. He purposely keeps it inscrutable, and by long habit prevents it from revealing his true character."[195] She thus sought a pose that suggested poetic self-absorption rather than the polite, practiced artifice of one's "public" face.

The Roots of Pictorialism

It is appropriate that these examples of "old" and "new" portraiture depict an inventor and an artist. The turn-of-the-century photographic avant-garde derived its ideas from a complex set of cultural and philosophical sources. Central to their ideology was an antimodernist reaction against the mechanistic and materialistic nature of contemporary life. These critics felt the scientific, industrial, and bureaucratic modern age as "overcivilized," unreal, and devoid of sustaining values. A pervasive sense of "spiritual homelessness" stimulated in these late Victorians a profound yearning for a more intense and "real" emotional life.[196] They sought new states of psychic harmony by reawakening a "primal authenticity of thought, feeling, and action," and by rediscovering timeless mysteries.[197] Central to this quest was an emphasis on artistic creation over the more analytic achievements of the inventor or engineer.

The modern roots of this fundamentally mystical aesthetic can be found in the writings of Charles Baudelaire, who celebrated a state of hyperperception in which the things of the world became resonant with larger meanings and unexpected correspondences. In Baudelaire's poetic realm, the world was a magical "forest of symbols" in which "perfumes, sounds, and colours answer each to each" in an ecstatic union of sensation and thought.[198] This Symbolist aesthetic was further developed in the work of writers such as Stéphane Mallarmé, Paul Valéry, and Maurice Maeterlinck, and painters such as Paul Gauguin, Gustave Moreau, and Odilon Redon. Common to all this work was a blurring of contours and contrasts, and an emphasis on poetic indeterminacy. As Mallarmé wrote, "It is not *description* which can unveil the efficacy and beauty of monuments, seas, or the human face...but rather evocation, *allusion, suggestion*."[199] By the early 1890s, these ideas had spread from an initially small group of radical writers and artists to a much broader international audience.[200]

Symbolist art reflected a deep desire for imaginative escape from the structures of the everyday world. Nature was depicted as a realm of luminous mystery and Edenic comfort. In highly idealized form, the simplicity of the child and the "primitive" were celebrated for their innocent sincerity, psychic wholeness, and capacity for wonder. Oriental and medieval cultures also held a great allure for Symbolist poets and artists. "Pale innocence, fierce conviction, physical and emotional vitality, playfulness and spontaneity, an ability to cultivate fantastic or dreamlike states of awareness, an intense otherworldly aestheticism: those were medieval traits

Fig. 12 **Edwin Hale Lincoln**, *Stone Clover*, 1906, platinum print, 9⅜ x 7⅜"

perceived by late Victorians and embodied in a variety of dramatis personae," including peasants, saints, seers, and mystics.[201] In its most subjective and mystical form, Symbolist-inspired photography appealed to relatively esoteric tastes. More conservative photographers viewed these works as affected and mannered, while general audiences undoubtedly found them rather strange and bohemian.

Antimodernist ideas also shaped the Arts and Crafts movement of the same period. The Arts and Crafts movement grew out of the ideas of John Ruskin and William Morris in England, and stressed the dignity of work, the beauty of fine materials, and the spiritual importance of the simple life and of preindustrial technologies. This movement shared many of Symbolism's least mystical tenets and expressed them in relatively populist form. Both a philosophy and a crusade, the Arts and Crafts movement sought to reinstate the importance of art in everyday life, to humanize industry, and to bring modern man closer to nature.[202] The champions of this approach sought to unite beauty and utility in the design and manufacture of furniture, books, textiles, glass, and other objects. The exquisite limited-edition books produced by F. Holland Day's publishing house exemplified the high ideals and aestheticism of this approach.[203]

This reverence for the beautifully crafted object is reflected in the care taken by Pictorialist photographers in making and reproducing their prints. The leading artist-photographers of the day used a variety of relatively

Fig. 13 Bertha E. Jaques, *Goldenrod, Gone to Seed*, ca. 1906-08, cyanotype, 14½ x 5"

uncommon processes to emphasize the physical presence of each print. In his 1899 retrospective at the Camera Club of New York, Stieglitz included prints made by five processes: platinum, photogravure, carbon, gum-bichromate, and platinum-toned gelatin silver. While Stieglitz gradually returned to simpler printing processes, other photographers of his circle explored a wide range of technical approaches to printmaking. At a time when automatic printing machines could produce up to 245 cabinet photographs each minute, such labor-intensive approaches emphasized the importance of the artist's mind and hand.[204]

Fig. 14 Wilson Alwyn Bentley, *Snow Flake*, 1923-24, 3" diameter

Similar effort went into the reproductions in the most elite photographic journals of the period. Over the course of its existence, for example, Stieglitz's *Camera Work* utilized "straight photogravure,...mezzotint photogravure, duogravures, one-colour halftone, duplex halftones, four-colour halftones, and collotypes" for its illustrations.[205] Just when the halftone had become established as the cheapest and most practical mode of photographic reproduction, art photographers deliberately turned to the most difficult and beautiful processes. Photogravure was used extensively by Stieglitz for the featured illustrations of *Camera Notes* (1897-1902) and *Camera Work* (1903-1917). This process was also used by Stieglitz and others of his circle to make original exhibition prints. This application of gravure—as a means of both artistic expression and reproduction—gave the tipped-in plates of *Camera Notes* and *Camera Work* the status of multiple originals. As Estelle Jussim has noted, the process offered "snob appeal to the *cognoscenti*."

> Photogravures did not in the least resemble the popular silver chloride prints; gravures rather recalled the richness of mezzo-tints, the jet-black inks of lithography, the delicacy and fine lines of etching, the decorative capabilities of aquatint.[206]

Indeed, the production of photogravures was a slow and highly skilled process, with far more similarity to the making of etchings than halftones.[207] In the handcrafted elegance of their printing and design, *Camera Notes* and *Camera Work* exemplified the ideals of the Arts and Crafts movement.

The Arts and Crafts philosophy rested on a belief in the ultimate unity of art and life. For the artistic photographer, it was not enough to visit museums periodically to study great pictures. Instead, as J. Craig Annan advocated, "We must endeavor to surround ourselves in the rooms in which we chiefly live with the most beautiful objects which we can procure, and, what is equally important, we must exclude everything from our immediate surroundings which is antagonistic to beauty."[208] An artist's creativity thus was understood (literally) to begin at home, with aesthetic consideration given to the choice and arrangement of the contents of each room. The photography of interiors, which was

particularly popular in the 1890s, was thus important as a demonstration of the aesthetic judgment of both camera operator and home owner.

In addition to recording the lives of rural people and pre-modern cultures, Arts and Crafts photographers devoted considerable attention to nature itself. In the first years of the century, for example, Rudolf Eickemeyer and Sadakichi Hartmann collaborated on photo-illustrated nature essays with titles such as "A Winter Ramble," "The Camera in the Country Lane," and "A Reverie at the Sea-Shore." Hartmann also wrote the introduction for Eickemeyer's 1903 volume *Winter*.[209] Similar photographically illustrated texts of the period include *A Journey to Nature* (1902), a series of essays accompanied by bucolic images by the Philadelphia photographer Henry Troth.[210]

Edwin Hale Lincoln focused lovingly on the details of nature and became celebrated as a dedicated recorder of flowers.[211] He was best known for his photographic survey, *Wild Flowers of New England*, self-published in 1910-14 as a series of 400 platinum prints.[212] These flawless images, which combine a botanist's descriptive precision with an artist's feeling for composition (fig. 12), suggest an aesthetic midway between the Victorian naturalism of John Ruskin and the modernist purism of Edward Weston. In this same period, the Chicago printmaker Bertha E. Jaques, an active member of the Wild Flower Preservation Society, created over 1,000 cyanotype photograms of botanical specimens (fig. 13). While often made as studies for her etchings, Jaques's photograms were also exhibited as finished works at the Art Institute of Chicago and elsewhere. These shadow-images function as relatively "objective" documents while anticipating the expressive use of the photogram by avant-garde photographers of the 1920s.

But perhaps the most dedicated of these photographer-naturalists was Wilson Alwyn Bentley, the "Snowflake Man" of Jericho, Vermont. A farmer by trade, Bentley devoted his free time in the winter to making photomicrographs of snowflakes (fig. 14); in the remainder of the year he studied raindrops, frost, and dew. Bentley's fascination with "the fairy-like creations of crystaldom" began in 1885 and continued until his death forty-six years later.[213] Bentley's work became widely known through his public lectures, the sale of lantern slides of his best subjects, and, beginning in 1898, his many articles in the popular and photographic press.[214] In all this work, Bentley celebrated the infinite variety and strange beauty of snowflakes as a reminder of nature's inexhaustible wonder.

The Pictorialist, Symbolist, and Arts and Crafts aesthetics were all influenced by *japonisme*, a turn-of-the-century rage for all things Japanese that inspired in the leading photographers an appreciation for restraint, asymmetrical compositions, and pictorial flatness. American artists admired the sense of perfect placement embodied in the exquisite simplicity of the Japanese garden (first seen in this country at the 1876 Philadelphia Centennial), and the fact that the Japanese made no distinction between artist and

artisan.[215] Japanese art was the subject of numerous articles in the photographic press, lantern-slide lectures at camera clubs, and even an occasional exhibition in photography galleries.[216]

One of the most influential proponents of this aesthetic was Arthur Wesley Dow, curator of Japanese art at the Boston Museum of Fine Arts and an important teacher and writer. Dow did much to inculcate the Japanese style into the American artistic mainstream, particularly through his book *Composition*, which went through twenty editions after its first publication in 1899. *Composition* promoted the Japanese idea of *notan*, meaning the graceful orchestration of shapes and tones within the confines of the frame, the harmonious interplay of masses and voids, shadows and highlights. Dow emphasized the flatness and inherent abstraction of all pictures, prompting the many photographers who studied his volume to think of their work as a fundamentally graphic—rather than illusionistic—art. He wrote, "The *Notan* of a pattern or a picture is the arrangement of dark and light masses [which] conveys to the eye an impression of beauty entirely independent of meaning."[217] While this emphasis on shape and structure was not in itself new, Dow's book popularized an inherently modern approach to picture-making.[218] This formal interest was first united with, and then gradually displaced, the narrative associations and sentiments valued by an earlier generation of artistic photographers. These ideas provided a basic vocabulary for a generation of Pictorialist photographers while pointing the way to the fully nonobjective photographs of the late 1910s and 1920s.

The Generation of 1902

By the first years of the new century, it was clear that the struggle for the recognition of photography as art had achieved some real success. By this time, for example, the collecting of artistic photographs had begun, if only tentatively. Alfred Stieglitz was, in addition to being an artist and editor, one of the most important of these pioneering collectors of photography. Between 1894 and 1910, he acquired some 650 works by the leading Pictorialists of the era (most of which were later given to the Metropolitan Museum of Art).[219] William B. Post was another discerning collector; it was reported in late 1898 that Post had "determined to procure only the very best, willingly paying a liberal price for such work."[220] By all accounts, however, the most important early collection of Pictorialist photography belonged to George Timmins, a businessman and enthusiastic amateur photographer in Syracuse, New York. By mid-1896, Timmins had amassed a collection of some 278 photographs by seventy-seven noted photographers from twelve countries. An exhibition of this collection at a Syracuse art gallery in May 1896 was well received by the public.[221] Still, it was many years before photographic collecting grew beyond the activities of a small circle of wealthy amateur photographers.[222]

Photographic criticism had also reached a kind of adolescent vitality, with more ambition than insight.[223] The bulk of this writing was produced by photographers themselves. *Camera Notes*, for example, featured articles by Joseph T. Keiley, Dallet Fuguet, William M. Murray, F. Holland Day, Eva Watson-Schütze, and other practitioners with literary inclinations. Amateur photographers such as Alexander Black and J. Wells Champney also contributed essays to a variety of popular journals.[224] By 1898, the widespread interest in photography prompted several professional critics—including Charles H. Caffin, Sadakichi Hartmann, and Roland Rood—to enter the field. Caffin wrote on art and photography for a variety of publications, including the New York *Evening Post*, the New York *Sun*, *Cosmopolitan*, *Century Magazine*, and *Harper's Weekly*. His pioneering book *Photography as a Fine Art* (1901) consisted of seven essays originally published in *Everybody's Magazine* and *Camera Notes*.[225] After considerable experience as an art critic, Hartmann turned to photography in 1898 with a series of articles in the *Photographic Times*. He contributed frequently to such other journals as *Wilson's Photographic Magazine*, *The Camera*, *Photo-Era*, and Stieglitz's *Camera Notes* and *Camera Work*.[226] Rood's work was included in *Camera Work*, *American Amateur Photographer*, and other publications of the day.[227]

Despite these positive signs, it was clear that by 1902 American art photography had arrived at a critical juncture. The collapse of the Philadelphia Salon was indicative of larger conflicts over the direction that photography should be pursuing. At the vortex of these debates, as usual, was Alfred Stieglitz. Through his various activities as a photographer, editor, exhibition juror, collector, and friend of the leading international photographers, Stieglitz had established himself as the central figure in American photography. This role was not achieved without challenges, however. At the end of the 1890s, for example, F. Holland Day emerged as a rival to Stieglitz. In 1895-96, Day became the most dynamic new talent in American photography and the third American to be invited to join the exclusive Linked Ring. Stieglitz featured Day's work in the second issue of *Camera Notes* in 1897, and the Boston aesthete became a regular contributor to the journal of both images and essays. By 1899, Day was actively promoting the establishment of an American association to be modeled on the Linked Ring. Despite Day's invitations, however, Stieglitz declined to join this effort.

After retiring from his publishing business in 1899, Day devoted even greater effort to the cause of artistic photography. He traveled to London in 1900 and began organizing "The New School of American Photography," an exhibition that conspicuously excluded such established figures as Stieglitz and Eickemeyer. After failing to gain sponsorship from the Linked Ring (due largely to Stieglitz's opposition), Day's show opened under the aegis of the Royal Photographic Society. The 375 prints on display included more than 100 of his own, as well as considerably smaller portfolios by White, Käsebier, Steichen, Watson, and others.

An abridged version of the exhibition opened in Paris in early 1901. Despite the success of this exhibition, Day's role as a leader in the international art photography world grew no further due to his own personality and to Stieglitz's quiet opposition. In part, Day's ultimate failure as a political force is reflected in his success as an artist. His *Youth with Staff Shielding Eyes*, 1906 (plate 20), is a masterpiece of languid sensuality and Arcadian mysticism. However, its complete removal from the everyday world suggests Day's own inability to deal with friction and disagreement.

Stieglitz made his debut as an exhibition organizer in early 1901, selecting American work for the photographic section of the Glasgow International Art Exhibition. The satisfaction he took in assembling this show stood in marked contrast to the bad feeling surrounding that year's Philadelphia Salon, which was boycotted by Stieglitz's circle. But the main effect of these events was to hasten Stieglitz's shift from collective activities to complete autonomy. In the first months of 1902, as his relationship with the Camera Club of New York became increasingly strained, Stieglitz formed the idea of a new organization of photographic artists, which he called the "Photo-Secession." He first used this phrase in the title of the exhibition, "American Pictorial Photography Arranged by the 'Photo-Secession,'" which opened in New York on March 5, 1902. Three months later, Stieglitz resigned as editor of *Camera Notes* and began planning *Camera Work*, a new publication that would represent his vision alone. The first issue of this lavish quarterly (dated January 1903) appeared at the end of 1902, just as his Photo-Secession took quasi-official form. The group's first "council" included most of the leading Pictorialists: Eugene, Fuguet, Käsebier, Keiley, Steichen, Stieglitz, and John Francis Strauss of New York City; Bullock, Redfield, and Edmund Stirling of Philadelphia; William B. Dyer and Eva Watson-Schütze of Chicago; and Clarence H. White of Newark, Ohio. Three years later, with Steichen's assistance, Stieglitz opened his own exhibition space, The Little Galleries of the Photo-Secession, at 291 Fifth Avenue.

By 1905, therefore, Stieglitz had established himself as an autonomous impresario of creative photography. Through the vehicles of *Camera Work*, the Photo-Secession, and "291" (as the gallery came to be called), he was free to present and promote the work of his choice. In addition, he organized numerous exhibitions of Photo-Secession work for institutions in the U.S. and abroad. These included important shows in Denver (1903), San Francisco (1903), Bradford, England (1904), Dresden (1904), Paris (1904), Pittsburgh (1904), Vienna (1904), Washington (1904), Philadelphia (1906), New York (1908), and—the culmination of this series—the celebrated "International Exhibition of Pictorial Photography" at the Albright Art Gallery in Buffalo in 1910.

The Stieglitz Circle

The photographers Stieglitz exhibited and published in these years included both the familiar and the little-known. A core

group of artists was included in nearly all of his group exhibitions and reproduced often in *Camera Work*. The first six issues of *Camera Work* were devoted, respectively, to the work of Käsebier, Steichen, White, Frederick H. Evans, Robert Demachy, and Alvin Langdon Coburn. All would reappear in Stieglitz's journal with some regularity. Between 1903 and 1913, for example, Steichen's work was reproduced a total of sixty-eight times in eleven issues and a special supplement. Stieglitz also included pictures by such longtime acquaintances as William B. Post; leading Europeans such as Heinrich Kuhn, Hans Watzek, and C. Puyo; and such now-forgotten figures as Ward Muir, Prescott Adamson, and A. Radclyffe Dugmore.

Käsebier was one of the most widely admired of Stieglitz's original Photo-Secession circle. She had begun studying painting in 1889, at the age of 37, and turned seriously to photography four years later. After opening a professional portrait studio in New York in 1897, she became celebrated for her use of lighting and compositional motifs drawn from the Old Masters.[228] Her artistic breakthrough occurred at the 1898 Philadelphia Salon, where her work was praised as the best on view. In 1899, she served as a juror for the second salon, and sold a print of *The Manger* for $100, then the highest price ever paid for an artistic photograph.[229] By the time Stieglitz featured her in the first issue of *Camera Work*, Käsebier was regarded as one of the world's finest artistic photographers.

Käsebier's work embraced both an idealized domestic realm of tranquility and tradition, and a larger sphere of worldly, intellectual achievement. Reflecting the values of the day, the former was pictured almost exclusively as the province of women and children, while the latter was the domain of men. Her 1899 image of preparations for her daughter's wedding (fig. 15) presents a graceful vision of the intimacies and continuities of family life. Her portrait of Rodin (plate 15), on the other hand, depicts a man lost in thought, far removed from the mundane realities of existence. Käsebier evokes the romantic ideology of her time by depicting Rodin, then the world's most famous living artist, as an elemental creative force whose stolid presence seems to resonate with spiritual and intellectual power. Her Rodin possesses an almost hypnotic inward intensity, and seems able to infuse aesthetic life into inert matter through the mere touch of his hand. This image exemplifies Käsebier's lofty ambition to make "not maps of faces, but pictures of real men and women as they know themselves, to make likenesses that are biographies, to bring out in each photograph the essential personality that is variously called temperament, soul, humanity."[230] This photograph also reveals the essential elements of Käsebier's style: simplified masses of tone, a sense of dignity and presence created by a static pose and frame-filling composition, and an overall flatness of treatment.

Edward Steichen's artistic ambitions were at least as high as Käsebier's. Only twenty years old when he first received attention at the 1899 Philadelphia Salon, Steichen rapidly

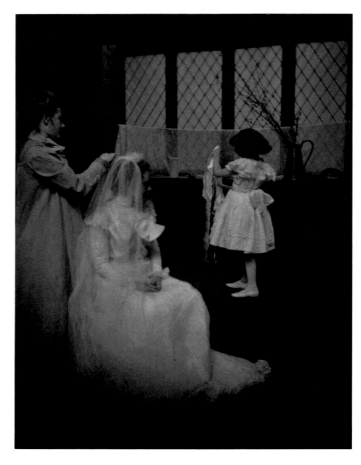

Fig. 15 Gertrude Käsebier, *The Wedding*, 1899, platinum print, 8 x 6"

emerged as a photographer of international stature.[231] In early 1900, he left his hometown of Milwaukee, stopped in New York to see Stieglitz (who bought three prints at five dollars apiece), and then sailed for a two-year stay in Paris. At home, Steichen was the star of the 1900 Philadelphia Salon, and the object of extravagant praise in the following years. In his review of the 1900 Salon, Keiley exclaimed,

> The three landscapes by Eduard J. Steichen stand alone in the Salon and in the entire range of American photographic landscape work. A single glance tells the observer that they are pictures by an artist of no mean ability, and that they are entirely distinct from all other photographic landscape work. They are full of poetic originality, and display an understanding of the artistic richness of the forest—the wonderful luxuriousness of its twilight shadows—the caressing softness and silvery qualities of the grays of its mistbreath—the flowing beauty of its trunk lines—the weird enchantment of the fading light through the countless vistas of the fragrant, sombre woods.[232]

Keiley's poetic reading of Steichen's photographs perfectly evoked their Symbolist ambitions. These earliest images, as well as his masterful *Moonlight: The Pond*, 1904 (fig. 11), created a moody realm of natural mystery and perceptual indeterminacy. The power of these images was enhanced by Steichen's technical brilliance. His exhibition prints of this era, created by complex combinations of platinum and gum bichromate, utilized a majestic scale and unprecedented depth of tone for powerful aesthetic effect.[233]

Steichen was the most notable exhibitor in Day's "New School of American Photography" show in London and Paris. In 1902, his photographs were the first to be admitted to the Paris Salon, the prestigious annual review of painting and sculpture. This acceptance by the art establishment created a sensation and was greeted by the photographic press with hyperbolic enthusiasm. The editor of *Wilson's Photographic Magazine* called the decision "epoch-making," declaring that it represented "the highest honor given to photography since Arago announced the invention of the daguerreotype in Paris in 1839."[234] Two years later, Hartmann described Steichen's reputation succinctly and pointedly: "He stands in a class by himself."[235]

In addition to showing widely in the most prestigious photographic exhibitions, Steichen maintained a successful career as a portraitist in New York and Paris. He also enjoyed a close and influential friendship with Stieglitz. Steichen designed the elegant cover of *Camera Work*, and encouraged Stieglitz to open his first gallery by offering the use of his former apartment at 291 Fifth Avenue. From Paris, Steichen also made Stieglitz aware of the work of Rodin, Cézanne, Matisse, and other important modern artists. Stieglitz subsequently introduced these artists to American audiences in exhibitions at 291.

Clarence H. White, the featured artist in the third issue of *Camera Work*, began photographing in the early 1890s while working in a wholesale grocery firm in Newark, Ohio. He came to national attention in the 1898 Philadelphia Salon and soon began a friendship with Stieglitz, Day, Käsebier, and others. He, too, quickly received international recognition. In 1899, White was given one-man exhibitions at the Camera Club of New York and the Boston Camera Club, included in the London Photographic Salon, and chosen as a juror for the second Philadelphia Salon. In 1900, he was featured in Day's "New School of American Photography" exhibition and elected to membership in the Linked Ring. Two years later, he won the grand prize in an exhibition organized by Stieglitz in Turin, Italy, and became a founding member of the Photo-Secession. White moved to New York in 1906, and assisted Stieglitz in the operation of his newly opened gallery. A year later, White began his influential teaching career with a position at Columbia University.

Despite its gently domestic subject matter, White's work became surprisingly controversial and was either praised or despised by critics. His supporters admired his masterful compositions, subtle tonalities, and refined mood. Most impressive was White's original sense of *notan*, and sympathetic critics urged amateurs to "study White carefully for what he can teach you about the proper adjustment of subjects to the spaces they occupy."[236] However, even White's supporters commented on his predilection for "a certain weird fancifulness of subject," and his detractors found his work offensively strange.[237] The editor of the *American Amateur Photographer* called his pictures "eccentric," while conservative members of the Camera Club of New York pronounced his 1899 exhibition "an outrage and an imposi-

tion."[238] A leading photographic editor fulminated against White himself, calling him "a lover of what is positively ugly" with "a degenerate taste in art."[239]

In truth, White created a remarkably original body of work from the simplest subjects. His most notable pictures, made before he left Ohio in 1906, depict members of his family in and around their house. White applied his unique understanding of pictorial structure, derived largely from his appreciation for Whistler and Japanese prints, to transform commonplace domestic activities into visual poetry. A work such as *The Orchard*, 1902 (plate 17), perfectly evokes the Pictorialist ideal of the world as an enchanted garden far removed from the complications of modern life. In this memorable photograph, nature and culture are united in a graceful ballet of sunlight and nurture. Similarly, White's *Self-Portrait*, ca. 1905 (plate 18), is at once descriptive and ethereal. His sensitive and thoughtful face seems suspended in a realm of elegant imprecision.

This dreamy radiance also characterizes the work of George Seeley. In 1902, Seeley met F. Holland Day and was inspired to take up photography. Seeley's national debut came in the First American Salon in December 1904, a New York exhibition boycotted by the Stieglitz circle. He was unanimously hailed as the star of the show, with "a power of expression which places him in the foremost ranks of American photographers."[240] Stieglitz promptly invited Seeley to join the Photo-Secession and featured his work in three subsequent issues of *Camera Work*. Seeley's photographs were included in leading international exhibitions through the early 1910s, and he continued to show with decreasing frequency for another two decades.

The idealized nature of Seeley's work reflected, in large measure, the serenity of his life. He resided quietly with his parents and sister in the small western Massachusetts village of Stockbridge. He worked as an art teacher in the public schools and served as a local reporter for the *Springfield Republican*. A member of the Congregational Church, Seeley was also an avid ornithologist and gardener. His most frequent model was his sister and lifelong companion, Laura, and the great majority of his pictures were made close to home. As George Dimock has observed, Seeley's

emotional life centered upon his parents and siblings. His photographs are transpositions of the intimate, familiar, and local into the realm of aestheticism—a realm accorded paramount importance within an idealist, romantic philosophy formulated in opposition to a positivist, nineteenth-century American pragmatism.... Seeley metamorphosizes his siblings into visionary damozels who enact some half-dreamt, half-forgotten saga wherein beauty, suffering, noble deeds, sensuous delight, and a past golden era are all vaguely intertwined. The image combines a free-floating pathos with an exquisite arrangement of formal shapes and delicate tones. Narrative, symbol, and dramatic event are strongly implied but never specified. The photograph's real content becomes the cultivation of a rarified and indeterminate plane wherein a Keatsian synthesis of beauty and truth holds sway.[241]

Fig. 16 Baron Adolf de Meyer, *Rita de Acosta Lydig*, 1913, platinum print, 9¼ x 7½″

These qualities are abundantly clear in *Autumn*, 1905 (plate 21), one of Seeley's most powerful allegorical images. This photograph, later chosen by Stieglitz for reproduction in *Camera Work*, creates a timeless, self-contained realm of languid aestheticism. This feeling of otherworldly ambiguity derives from such clever details as the placement of cattail shadows on an otherwise undefined background plane. These shadows make us question whether the "real" cattails in the image are actual plants in front of the figure, designs in the fabric of her gown, or themselves shadows. The answer, like the meaning of the image itself, remains uncertain. In the words of one critic of the day, Seeley's pictures "are rather representations of moods than statements of facts, and are hard to name as well as hard to describe."[242]

In addition to such notable members as Käsebier, Steichen, White, Seeley, and Coburn, Stieglitz's Photo-Secession grew to include a significant number of other American and European photographers. For example, Baron Adolf de Meyer's work was featured in two issues of *Camera Work* and in numerous exhibitions assembled by Stieglitz. De Meyer had begun exhibiting internationally in 1894 while living in Dresden. His reputation grew in subsequent years as he moved between Germany, England, and the United States. While he worked in several genres, de Meyer was best known for his elegant portraits (fig. 16).

Members of the Photo-Secession were drawn from across the United States and worked in a variety of styles. Thomas O'Conor Sloane, a resident of Orange, New Jersey, achieved national prominence in 1900 when he was included in the Philadelphia and Chicago Salons, and in a members' show at the Camera Club of New York. His gum bichromate prints were celebrated for their refined simplicity and richness of tone (plate 19). Denver resident Harry C. Rubincam became a member of the Photo-Secession in 1903. He was active in the Denver and Colorado Camera Clubs and wrote articles on photography for *Outdoor Life*, *Camera Work*, *The Photographer*, and other journals. He is now best known for a remarkable series of pictures made at a circus in about 1905 (plate 23).[243] These images combine the spontaneous vision of the snapshot with a more abstract interest in the geometric forms of the rink, tent, and support poles. This image is unusual in Pictorialist work for its artistic depiction of a public scene rather than a domestic or allegorical subject.

Anne W. Brigman, a long-time resident of Oakland, California, was one of the most romantic of Secession photographers. She joined the Photo-Secession in 1903 and, like Rubincam, exhibited internationally throughout the decade. In 1907, influenced by the work of Frank Eugene, she began using a pencil and graver on her negatives to create painterly effects in her prints.[244] Brigman's best-known work of this era (plate 22) creates a mood of poetic pantheism through the depiction of melodramatically posed figures in austere natural settings.[245] As a critic of the time noted,

> As you look at [Brigman's pictures] all sense of separation between the human being and nature is gone, and both seem part of all that is beautiful in elemental conditions. In all of Mrs. Brigman's symbolic studies, you feel the one dominant thought—that to her there is one great underlying spiritual inspiration, just one for both nature and man.[246]

In its final years, the Photo-Secession continued to attract such young talents as Karl Struss. Struss's serious interest in photography began in 1908, when he undertook studies with Clarence White. Two years later, Struss was represented by twelve prints in Stieglitz's important International Exhibition of Pictorial Photography at the Albright Art Gallery in Buffalo. In 1912, Struss joined the Photo-Secession and was featured in *Camera Work*. While typically modest in scale and gently muted in focus, Struss's pictures of this period are most notable for their compositional sophistication.[247] Later in life, Struss offered that "the fundamental thing in photography" was "space-filling."[248] This concern for the precise arrangement of the subject within its frame is seen clearly in Struss's exquisite *Brooklyn Bridge from Ferry Slip, Evening* (plate 24). He was fascinated by the structural complexity of this site: the rectilinear foreground architecture, the semicircular element of the ferry slip, and the bridge itself, soaring into the distance high overhead. He photographed this site repeatedly at various times of day and from several vantage points. This image brilliantly evokes the tension between two overlapping artistic ideas: the romantic moodiness of classic pictorialism, and an angular set of geometric relationships that is prototypically modern.

New York from its Pinnacles

This exploration of the city as a source of abstract form is seen most dramatically in Alvin Langdon Coburn's brilliant work of 1912. One of photography's great prodigies, Coburn first received critical attention in 1900 when his distant cousin, F. Holland Day, included nine of his prints in the "New School of American Pictorial Photography" exhibition. During the next ten years (which he divided between the United States and England), Coburn received widespread recognition and praise. In 1907, for example, the famed playwright and social critic George Bernard Shaw pronounced his young friend—Coburn was then only 25 years old—the world's finest photographer. Stieglitz was also an admirer, and included Coburn's earlier pictures in *Camera Work* and in exhibitions at 291.

Coburn's mature vision represented a unique synthesis of painterly, photographic, and literary influences.[249] Of great importance was his understanding of the principles of Japanese art, gained from his studies with Arthur Wesley Dow and through close examination of woodblock prints at the Boston Museum of Fine Arts. Coburn attended Dow's classes in the summers of 1902 and 1903, and thoroughly absorbed the lessons of Dow's important book *Composition*. These visual influences were augmented by Coburn's deep interest in Symbolist thought, English literature, and religious mysticism. Coburn's ambitious series of portraits of the most notable artists and writers of his day further enlarged his intellectual sphere: before recording such sitters as Henry James, George Bernard Shaw, William Butler Yeats, H. G. Wells, and Henri Matisse, Coburn immersed himself in their works. In 1910-12, Coburn came to understand post-impressionist art through the exhibitions at 291 and the influence of the painter and teacher Max Weber.[250]

For Coburn, the vitality of these new artistic ideas was best expressed in the image of the modern city. His book *New York* (1910) included heroic, soft-focus renditions of the city's bridges, streets, and skyscrapers. In 1911, he wrote that "photography born of this age of steel seems to have naturally adapted itself to the necessarily unusual requirements of an art that must live in skyscrapers…"[251] By 1912, Coburn's vision of New York had grown uniquely complex and challenging. While he had earlier taken such tall structures as the Singer Building and Metropolitan Tower as his subjects, Coburn now used them as vantage points for a radically new pictorial vision. Turning his camera steeply downward, Coburn produced a series of boldly vertiginous views that are at once objective and abstract. *The House of a Thousand Windows* (plate 25) is one of the most powerful of these photographs. This image plays the flatness of simple geometric forms—the rectangular and triangular shapes of the foreground building and tenement block, for example—against the spatial recession of the urban grid. The result is a curious tension between description and invention, and an almost eerie sense of pictorial vitality. (Note, for example, the subtle illusion that the sidewalk on the far right runs parallel to the vertical edge of the foreground skyscraper, rather than perpendicular to it.) While amateurs and commercial photographers had earlier used high vantage points, Coburn was the first to explore the artistic possibilities of such perspectives. In 1913, at the Goupil Galleries in London, he exhibited enlarged platinum prints of these profoundly original images under the collective title "New York from its Pinnacles." While their impact on American photographers seems to have been relatively slight, these remarkable pictures strongly prefigured the avant-garde concerns of a decade or more later.

Opponents of the Photo-Secession

The establishment of the Photo-Secession in 1903 represented an important shift in American photography from public to private concerns. This movement is clearly revealed in the evolution of Stieglitz's own writings. In an 1892 essay titled "A Plea for Art Photography in America," Stieglitz addressed himself to his amateur "colleagues" and wrote of "our work" as a communal enterprise.[252] Seven years later, in a *Scribner's Magazine* article on "Pictorial Photography," he observed that "there are but three classes of photographers—the ignorant, the purely technical, and the artistic." He now perceived photographic artists ("the most advanced and gifted men of their times") as intrinsically different from the general rule of photographic mediocrity.[253] However, he continued to address himself to the public at large and to devote his efforts to the transformation of American amateur photography as a whole into an artistic discipline.[254]

In reality, Stieglitz's fight for the recognition of photography as a fine art can only be understood as part of a broad movement in the last half of the nineteenth century toward the "sacralization of culture."[255] As historian Lawrence W. Levine has demonstrated, this era witnessed a shift "from popular culture to polite culture, from entertainment to erudition, from the property of 'Everyman' to the possession of a more elite circle."[256] This was the age of etiquette manuals, private libraries, and art museums. In all the arts, this growing elitism involved a radical process of purification and discrimination. Shakespearean plays were separated from theatrical programs that included magicians, dancers, and comics, for example, while museums gradually divided original paintings and sculpture from mummies and mastodon bones and, later, from photographic reproductions and plaster casts. The concept of culture took on strongly hierarchical connotations, reflecting Matthew Arnold's definition of it as "the best that has been thought and known in the world,…the study and pursuit of perfection."[257] As connoisseurship took effect, the entertaining heterogeneity of popular culture was distilled to the refinement of high culture, and clear distinctions were drawn between elite and common tastes.

The movement to "purify" photographic exhibitions by separating artistic images from those made for scientific, documentary, or technical reasons was an integral part of

this larger movement toward establishing cultural hierarchies. The problem was particularly acute with photography since the medium itself was widely viewed as mimetic rather than creative. Thus, to argue that a fine photograph was kin to an original sculpture rather than a soulless plaster cast (merely a *copy* of something real), art photographers had to establish a difference in kind between their work and the medium's many other reproductive and utilitarian applications.

The controversy over the 1901 Philadelphia Salon represented the triumph of the photographic "highbrows" over the "middlebrows" and the final demise of the ideal of a truly collective and democratic art. With this rupture, Stieglitz organized a tight band of like-minded photographers to prove the "real" expressive potential of their medium. In his first and most extreme Photo-Secessionist manifesto of 1903, Stieglitz evoked a bitter struggle by the enlightened few against the ignorant many. In this document, he noted that throughout human history "progress has been accomplished only by reason of the fanatical enthusiasm of the revolutionist, whose extreme teaching has saved the mass from utter inertia." For Stieglitz, the attitude of the Photo-Secession was "one of rebellion against the insincere attitude of the unbeliever, of the Philistine, and largely of exhibition authorities." He concluded by stating that "the Secessionist lays no claim to infallibility, nor does he pin his faith to any creed, but he demands the right to work out his own photographic salvation."[258]

In many respects, these hyperbolic pronouncements masked a set of rather mundane issues. As Ulrich Keller has suggested, the fight for photography's status as a fine art was, in part, a struggle for social and academic prestige.[259] Since no real market existed for the sale of art photographs, this struggle held no economic dimension. Instead, it represented an attempt by a largely privileged group to achieve enhanced cultural status. Since this status was derived from exceptional abilities rather than mere competence, sharp distinctions were drawn between "advanced" work and the status quo. The result was a series of public squabbles and turf wars that polarized the art photography world into pro- and anti-Stieglitz camps.[260] These began with a controversy over plans for the photographic exhibition at the 1904 St. Louis World's Fair.[261] Stieglitz refused to support reasonable efforts by St. Louis photographer J. C. Strauss to secure appropriate exhibition space at the fair. Instead, Stieglitz imperiously criticized Strauss's credentials to speak for "photography," implying, of course, that he alone held that right. A flurry of criticism followed in the photographic press.

This controversy gave added importance to the first organized challenge to the Photo-Secession. In December 1903, a group headed by Curtis Bell, president of the Metropolitan Camera Club of New York, formed a national organization called the Salon Club of America.[262] In mid-1904, this group announced its sponsorship of a major exhibition, the First American Salon, to be held in December

of that year. Stieglitz released a condescending statement to the press saying, "The proposed exhibition will be of such a type or character that neither I nor the Photo-Secession can have any connection with it."[263] He then worked privately to dissuade the leading American and European photographers from participating. The photographic journals were full of bitter commentary on the issue, with sentiment overwhelmingly on Bell's side.

Even former supporters such as Sadakichi Hartmann were amazed by Stieglitz's arrogance and manipulations in this instance. Hartmann was moved to write an unsigned essay on Stieglitz and his group in the *Photo Beacon* under the title "Little Tin Gods on Wheels." In this scathing piece, Hartmann fulminated against "their unbearable dictatorial attitude" and "incredible narrow-mindedness."

> The self-conceit of the Little Tin Gods on Wheels has become abnormal, preposterous, has grown into the very heavens. It could not even be caricatured, as no page could be large enough to convey the dimensions of their swelled heads. They think they are giants, towering high above the rest of humanity...[but] these little tin gods represent nothing but one little phase in the pictorial photography of America.

Most tellingly, Hartmann addressed by name some of the less privileged members of the Photo-Secession:

> Have you not sat at the portals of the toyshop long enough? Do you still fail to comprehend that you will never be admitted as their equals, that your work will never be considered as exalted as theirs?...Do you not see that even John G. Bullock, W. B. Dyer, Eva Watson-Schütze, R. S. Redfield and Edmund Stirling, who belong to the very council of the little T.G.O.W., are not *tony* enough to be expounded in the pages of the gray magazine?

Noting that "there is no room for the patriarchal system in America's art, nor for autocrats, high priests, inquisitors, or wholesale conscriptions, condemning people without a hearing," Hartmann called on the photographic community to

> wheel away the little tin gods to the place where they belong, and with them all their self-conceit, their ridiculous pose, their long hair, big ties and clerical collars, their sham aestheticism, their dismal tonalities, their red tape, and, above all, their contemptible un-American policy.[264]

It was in this charged atmosphere that the First American Salon took place. Some 9,100 works were submitted and a jury headed by artist Kenyon Cox selected 350 for display.[265] The most prolific exhibitors were Bell, Eickemeyer, Seeley, Jeanne E. Bennett, and Osborne I. Yellott. Among the numerous other participants were Day, Frank Roy Fraprie, Wilbur H. Porterfield, and John Chislett (plate 16). Seeley, universally regarded as the discovery of the exhibition, had been encouraged to enter by his friend Chislett, a noted Indianapolis Pictorialist and a close associate of Bell.[266] The exhibit was a popular success. While its democratic breadth of work resulted in mixed critical reviews, it was a respectable and representative showing of American Pictorial photography. The 1905 Salon received less enthusiastic reviews,

Fig. 17 **Dwight A. Davis**, *A Pool in the Woods*, ca. 1915, gum-platinum print, 12½ x 10¼"

partly due to the absence of Seeley, but introduced the work of such new regional talents as Dwight A. Davis of Worcester, Massachusetts (fig. 17).[267]

While Chislett and Davis both operated well within the "conservative" aesthetic of Bell's group, their pictures were among the most subtle and elegant of the period. Both men were fascinated by the shimmering radiance of light. While Davis's *A Pool in the Woods* explores the muted delicacy of a quiet sylvan scene, Chislett lovingly depicts the air itself incandescent with light and warmth.[268] In this impressionistic work, the anecdotal subjects of earlier Pictorialism were discarded for a kind of passionate pantheism.

The merit of much of this Salon Club work, and the later migration of figures such as Seeley and Bennett into the Photo-Secession, makes clear that the battle between the Stieglitz and Bell camps was more over tactics than aesthetics. The leaders of both sides held positions of power in the photographic community and were men of strong opinions. As is often the case in such matters, their conflict was particularly sharp because they represented rival factions of the same movement.[269] Inevitably, several significant careers fell victim to this power struggle. Photographic history has been strongly biased in favor of the Stieglitz circle, and photographers allied with the "wrong" side—Bell's—have been largely forgotten.[270] While the importance of the Photo-Secession is indisputable, it should also be clear that this group did not represent the sum total of early-twentieth-century art photography in America.

Pictorialist photography crested as an important international movement in the middle of the first decade of the century. By the beginning of the First World War, it had largely run its course.[271] Like the Photo-Secession itself, Bell's American Salon movement just ran out of steam. Entries had fallen off significantly by 1907, and the program was discontinued five years later. While each of the American Salon exhibitions brought significant new talent to national attention, it was widely agreed that the overall quality had not been of Photo-Secession caliber.[272] However, one of the positive results of Bell's organization was to encourage the activity of regional groups. In upstate New York, for example, the Photo-Pictorialists of Buffalo, a group of enthusiastic amateurs led by Wilbur H. Porterfield, produced moody, reductive landscape photographs that were widely praised. In 1907, an exhibition of the group's work traveled to the Photographic Society of Philadelphia, the Corcoran Gallery of Art in Washington, D.C., the Art Institute of Chicago, and the Albright Art Gallery in Buffalo.[273]

Apart from Stieglitz's activities, the most significant group exhibitions of the period were organized by a group headed by Clarence H. White. Their shows included ones at the Montross (1912) and Ehrich (1914) art galleries in New York City.[274] Participants in these exhibitions included Coburn, Davis, Genthe, Käsebier, Seeley, Struss, White, and Porterfield, as well as Paul L. Anderson, William B. Dyer, William J. Mullins, Edward R. Dickson, and Spencer Kellogg, Jr. These shows also provided an opportunity for work by young photographers, such as Imogen Cunningham and Paul Strand, to be seen on a national level. Following the lead of Bell's original 1904 American Salon, these exhibitions made a genuine attempt to create a market for artistic photographs. The Ehrich show was particularly successful in this regard, as nineteen of the eighty prints on view were sold for a total of nearly $500.[275]

The Decline of Pictorialism

After visiting the Pittsburgh Salon of 1914, Wilbur H. Porterfield reported that

> the first impression one receives upon entering the hall is the general effect of harmony and consistency which pervades the entire show. Freaks are not to be found. The morbid and the decadent are, to use a stereotyped expression, "conspicuous by their absence," and one is instantly conscious of a sincerity, a dignity, and a healthy renaissance which leave absolutely no doubt that every print represents the single intention of its maker to embody in his work the best and highest that is in him.[276]

For committed Pictorialists, this was high praise. For them, successful artistic photography represented a quasi-spiritual quest for "the beautiful," and a continuing attempt to express "an abstract idea of a lofty or ennobling character."[277] This relatively singular notion of beauty was based on a constellation of abstract concepts—unity, harmony, delicacy, elevating sentiment, and narrative associations—

derived from nineteenth-century aesthetics and from popular art. For them, words such as "faultless," "charming," "tasteful," "poetic," "picturesque," and "decorative" still had critical value.

However, it was becoming clear to many that the "harmony and consistency" of late Pictorialism reflected an increasingly enervated art form.[278] Both the strengths and weaknesses of Pictorialism lay in its idealized quest for balance and grace. By the First World War, the once-provocative subjectivity of turn-of-the-century work had turned, all too often, into formula. Any subject, from babies to locomotives, could be pleasingly framed and rendered in a soft-focus glow. However, this style had diminishing relevance to either the content or "elevating" potential of the image. Routine Pictorialism thus became a genuinely popular art, the aesthetic of choice for "middlebrow" camera club enthusiasts.

The gradual deviation of the photographic "avant-garde" from the tenets of Pictorialism represented an important transition. Pictorialism was essentially a late Victorian style, embodying ideas that could not be sustained long into the twentieth century. While late Pictorialism has been denigrated as simply banal and reactionary, the issue is, in fact, more complex. Later Pictorialism does not represent a failed aesthetic so much as a highly refined "premodern" one, typified by an adherence to commonly accepted notions of aesthetic value and a conception of the artist as an agent of moral improvement.[279] While individuality had its place in this work, it was understood that personal vision should always be subordinated to the "timeless" laws of art and to accepted social values. As a critic of this era wrote, "To be eminent [art] must not only be individual, but must also be typical; must not only represent a notable species, but also in some sense the whole genus to which it belongs."[280] This reverence for the authority of tradition, and longing for a comfortingly harmonious world, represented a diluted version of earlier antimodernist themes. The dividing line between the Victorian and modern eras is marked by the shift from a collective and idealizing aesthetic to one based on subjective expression and deliberate ruptures with the past.

Stieglitz in Transition

The culmination of Stieglitz's interest in Pictorialism came in 1910, when he organized the "International Exhibition of Pictorial Photography" for the Albright Art Gallery in Buffalo. Conceived as a historical survey of the achievements of artistic photography, the exhibition represented a summation of Stieglitz's interests of the previous two decades. The nearly 500-print invitational section began with forty works from the mid-1840s by David O. Hill, a Scottish calotypist whose work represented for Stieglitz the first flowering of artistic photography.[281] All the other photographers represented by large selections of work were familiar members of the Photo-Secession: Steichen, White, Eugene, Annan, de

Meyer, Seeley, Käsebier, Keiley, Demachy, Kuhn, Evans, Brigman, and of course, Stieglitz himself.[282] The show also included a 101-print "open" (juried) section with work by younger or less renowned photographers such as Struss, Genthe, Post, Bennett, Anderson, Francis Bruguière, and Pierre Dubreuil.

The show generated great praise as well as the usual controversy. It was widely acknowledged to be "the finest exhibition of pictorial photography ever held," and even Stieglitz's opponents admired its overall level of quality.[283] However, his direction of the show opened many old wounds and most photographers opposed to the Photo-Secession refused to participate (including, ironically, the Photo-Pictorialists of Buffalo).[284] Despite the considerable variety of work on view, it was clearly Stieglitz's show. One critic observed accurately that the exhibit was "primarily a monument to Alfred Stieglitz," and described him with grudging admiration as a "Napoleon of pictorial photography [who] put into the movement for internal progress and external recognition the fanaticism of a Mad Mullah, the wiles of a Machiavelli, the advertising skill of a P. T. Barnum, the literary barbs of a Whistler, and an untiring persistence and confidence all his own."[285]

This effort marked the end of Stieglitz's active promotion of Pictorialist photography. Numerous rifts had formed within the Photo-Secession by this time: Käsebier had fallen out with Stieglitz, and the increasingly strained relationship between Stieglitz and White had been severed. In large part, the unraveling of the Photo-Secession was the result of Stieglitz's shift in enthusiasm from photography alone to the larger realm of contemporary art. After 1907, modern painting, drawing, and sculpture increasingly occupied his interest. On trips to Europe in that year and in 1909, he was introduced by Steichen to the work of the leading avant-garde artists of the day. From 1909 to 1917, photography played only a minor role in his exhibition calendar. Instead, he showed the work of Paul Cézanne, Pablo Picasso, Georges Braque, Henri Matisse, Francis Picabia, and Constantin Brancusi, as well as young American painters such as John Marin, Marsden Hartley, Arthur B. Dove, and Georgia O'Keeffe. Much to the consternation of subscribers, non-photographic works by many of these artists also appeared in the final few years of *Camera Work*.

Stieglitz's own photographs suggest the variance between his artistic ideas and those of his compatriots. It is revealing that most of his early-century photographs reveal only a passing interest in the manipulated techniques and allegorical subjects he championed in others. And, while his favored photographers generally avoided picturing contemporary urban life, Stieglitz was strongly attracted to this subject. Of course, it was the idea of the city rather than its real confusion and grit (as, for example, in figure 3) that fascinated him. Stieglitz's 1901 picture *Spring Showers* (fig. 18) uses meteorological conditions, rather than overt technical manipulation, to create a sense of picturesque indeterminacy. While this image had relatively clear symbolic content—the

Fig. 18 Alfred Stieglitz, *Spring Showers, New York*, 1901, gravure, 9 x 3⅝″

isolated tree suggesting the fragility of life and a heroic struggle for individual self realization—its subject was present-day New York.

Numerous other pictures of this period reveal Stieglitz's keen interest in the vitality of modern life. Even though they were often muted by soft-focus, Stieglitz's subjects included locomotives, tugboats, and skyscrapers. By 1912 this penchant for modernist themes had become clearer in his images of office buildings under construction, a power shovel at work, an ocean liner in the busy New York harbor, and airplanes and dirigibles soaring above the earth. In defending the creative potential of the camera in the hands of an artist like Stieglitz, a sympathetic critic suggested that "the highest expression of the imaginative and inventive genius of our time...is the machine, in all its beautiful simplicity."[286] Stieglitz clearly agreed that the camera—as optical machine—was the paradigmatic artistic tool of the age. More importantly, however, his work also suggested that the appropriate subject of twentieth century art was, on some level, the machine age itself.

Stieglitz was also interested in that other paradigmatic expression of modernity: abstract art. In *The Steerage* (fig. 19), the work that Stieglitz considered the most important of his career, he produced a provocative synthesis of sociology and abstraction.[287] Stieglitz used bold geometry to emphasize the physical and emotional gap between the well-to-do

Fig. 19 Alfred Stieglitz, *The Steerage*, 1907, gravure, 13⅛ x 10⅜″

tourists on the upper deck and the poorer passengers huddled below in the steerage section. The interlocking diagonals of deck, gangplank, mast, and ladder create an image of abstract tensions and complexity. Stieglitz made this negative in the summer of 1907, but apparently did not immediately recognize its full meaning.[288] In fact, he did not present *The Steerage* in any public form until four years later when it was reproduced as a gravure in the October 1911 issue of *Camera Work*. Significantly, this issue also included the first of several abstract works by Picasso that would appear in *Camera Work* over the next two years. Apparently, Stieglitz came fully to appreciate *The Steerage* only after absorbing the lessons of form contained in the most challenging painting and sculpture of the day.

Lewis Hine and the Human Document

While Stieglitz's interest in working-class subjects dated from his earliest use of the camera, his concern was always artistic rather than social. In 1896, he noted,

> Nothing charms me so much as walking among the lower classes, studying them carefully and making mental notes. They are interesting from every point of view. I dislike the superficial and artificial, and I find less of it among the lower classes. That is the reason they are sympathetic to me as subjects.[289]

In fact, despite its protomodern visual sensibility, *The Steerage* reflects a decidedly Pictorialist social awareness: vaguely idealized, with little concern for specifics. This image

reminds us that Stieglitz remained far more interested in a singular and abstract "human condition" than in the great variety of conditions in which actual human beings lived, worked, and suffered.

In marked contrast to this kind of detached aestheticism is the work of Lewis Hine.[290] Hine's various menial jobs while struggling to put himself through school gave him a great empathy for the working class and a firm belief in the empowering nature of education. In 1901, Hine was hired by his friend and mentor Frank A. Manny to teach nature study and geography at the Ethical Culture School in New York City. This progressive school emphasized moral conduct and the inherent dignity and creativity of man. The school's student body included many recent immigrants or first-generation Americans. In 1904, at Manny's suggestion, Hine began using the camera as an educational tool. To encourage his students to look more perceptively at their world, Hine formed the "Commerce Camera Club" and conducted photographic excursions through New York's busy commercial areas. Hine emphasized the economic significance of what they saw, the mastery of photography as a practical skill, and the understanding of basic artistic principles. Hine's emphasis on aesthetics is documented in a 1908 article in which he wrote that "the fundamental aim of the course is to...give the artist's point of view, for, in the last analysis, good photography is a question of art."[291] Included as an illustration for this article was one of Hine's own pictures, *A Tenement Madonna: A Study in Composition*, based directly on a tondo painting by Raphael. While few of Hine's other pictures were so clearly influenced by art-historical precedents, his work as a whole reflected a broad interest in art and photography.

During the first decade of his photographic career, Hine was strongly influenced by various associates. He began photographing at Ellis Island in about 1904 due, in large measure, to Manny's interest in the social issue of immigration and the difficulties faced by new arrivals to America.[292] In fact, Manny often accompanied Hine to Ellis Island to assist in the operation of his 5x7-inch tripod-mounted camera and magnesium powder flash. In 1906, Hine began photographing on a freelance basis for the National Child Labor Committee, an organization headed by the Ethical Culture School's founder, Felix Adler. In his dozen years of work for the N.C.L.C., Hine traveled many thousands of miles across the country to record children working under primitive conditions in mines, mills, workshops, and factories. Hine's career was also strongly influenced by his friendship with Arthur Kellogg and Paul U. Kellogg, both of whom were active in the social-reform movement of the period. Paul Kellogg worked closely with Hine for thirty-five years and often used his pictures in the various publications he edited, including *Charities and the Commons, The Survey*, and *Survey Graphic*.[293] In 1907-08, Kellogg directed "The Pittsburgh Survey," the first comprehensive sociological study of an American city, and chose Hine as the project's photographer.

Hine's photographs were widely distributed in various forms and had considerable public impact.[294] They were reproduced in innumerable newspaper and magazine articles, the publications of the N.C.L.C. and organizations such as the Child Welfare League, the six volumes of the *Pittsburgh Survey*, and the various periodicals edited by the Kellogg brothers. Hine produced lantern slides and prints of his images for use in lectures and exhibitions. He was able to shape the presentation of his work by writing descriptive captions, and by carefully arranging his images (usually with text) in sequences, books, exhibitions, and portfolios.

The enormous strength of Hine's photographs stems from their union of fact and empathy. Hine strove to convey the physical and emotional reality of his subjects and to render them memorable as both individuals and symbols. His depictions united the aims of the ethnographic image and the formal studio portrait by combining an attention to the details of clothing and context with a deep respect for individual dignity.[295] The patience and warmth of Hine's approach emphasized the singularity of those who were too easily thought of only en masse. He evoked both the plight and the humanity of immigrants and the working poor by suggesting that, despite weariness and exploitation, they remained thinking, feeling beings.

The elegant simplicity of this approach is exemplified in his *Albanian Woman with Folded Head Cloth, Ellis Island*, 1905 (plate 27). Despite the baldly descriptive title, this woman was not reduced to a simple "type." By depicting her in half-figure, Hine created a perfect balance between costume and face, ethnicity and individuality. His viewing position may be characterized as politely familiar: close enough to monumentalize his subject but, at an arm's length distance, respectful and unobtrusive. This young Albanian woman responds with a remarkable sense of openness and engagement, looking directly through Hine's lens and, in effect, through space and time at *us*. Hine fully understood the power of the gaze, and knew that eye contact forced viewers to acknowledge the humanity of those who were too often unseen.

Hine applied the lessons learned in working at Ellis Island to the great body of child labor pictures he made from 1908 to 1917. His assignments for the N.C.L.C., which took him thousands of miles each year, were accomplished under daunting conditions. His presence in factories, fields, and sweatshops was rarely welcomed by those in charge. Out of necessity, Hine devised a set of subterfuges, gaining entry to workplaces as a salesman or by stating his interest in photographing machines rather than children. Once inside, Hine worked rapidly to record his subjects and to make notes on their age, size, and working conditions. A typical image, *Spinner and Foreman in a Georgia Cotton Mill*, 1908 (plate 26), made during his first year with the N.C.L.C., suggests Hine's working method. This carefully posed photograph records, on one hand, a relatively clean working environment and kindly relations between overseer and employee. However, as Hine well knew, its power stems from simple

contrasts of scale. Dwarfed by her adult foreman and over-whelmed by a seemingly endless row of spindles, the youth and frailty of this unnamed girl are made painfully clear. Hine's mid-distance camera position is perfectly chosen to emphasize the smallness of the child and the monolithic wall of machinery she faces.

Hine's Ellis Island and child labor pictures suggest the basic themes of his life's work. As cultural historian Alan Trachtenberg has observed, "Ellis Island represented the opening American act of one of the most remarkable dramas in all of history: the conversion of agricultural laborers, rural homemakers, and traditional craftsmen into urban industrial workers."[296] Thus, the movement of immigrants from the Old World to the New was accompanied by a cultural transition from an agrarian age to that of the machine. The social-welfare movement arose as an attempt to cope with the massive dislocations caused by the great overlapping phenomena of immigration, urbanization, and industrialization. Hine's work ultimately sought the human meaning of this new world by criticizing the deadening routines of unskilled factory labor and by celebrating human creativity in the face of the anonymity of the machine.

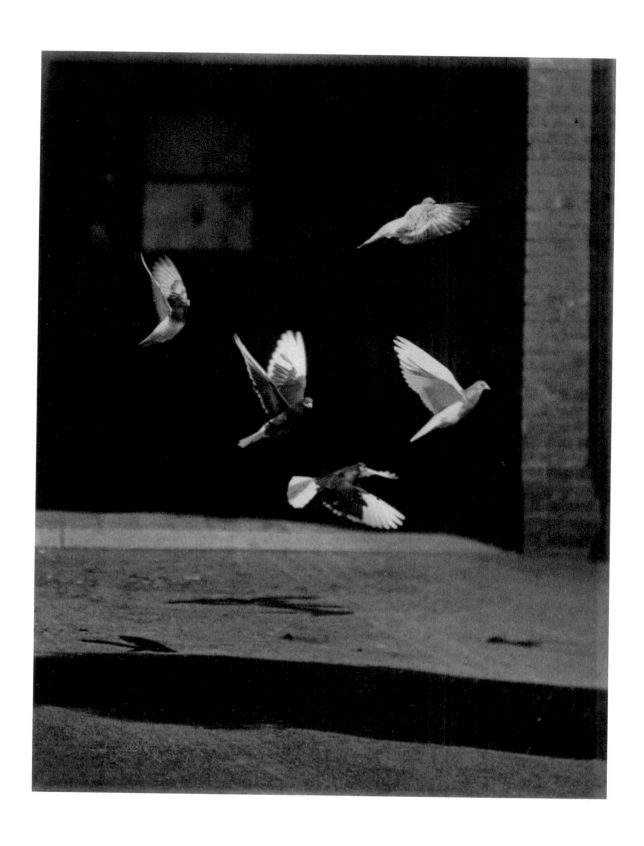

3 **Francis Blake,** *Pigeons in Flight,* ca. 1889-90, 8 x 6"

4 **Clifton Johnson**, *Kitchen, Chesterfield, Massachusetts*, 1895, 4⅝ x 6⅝″

5 **Arnold Genthe**, *Street of the Gamblers*, ca. 1896 (print probably made ca. late 1920s), 9⅞ x 12½"

6 **Adam Clark Vroman,** *The Moqui Snake Dance (the people, the place, and the snakes),* 1895, 6 x 8"

7　Frank A. Rinehart and Adolph F. Muhr, *Shot-in-the-Eye, Ogalalla Sioux*, 1899, platinum print, 9 x 7¼″

8 **William H. Rau,** *York Narrows, on the Susquehanna, Lehigh Valley Railroad,* ca. 1895, albumen print, 17 x 20³⁄₈″

9 **Robert S. Redfield,** *Near Lake Waramaug, Connecticut,* June 10, 1890, platinum print, 7½ x 9½″

10　**F. Holland Day,** *"I Thirst,"* 1898, glycerine-developed platinum print, 3¾ x 3″

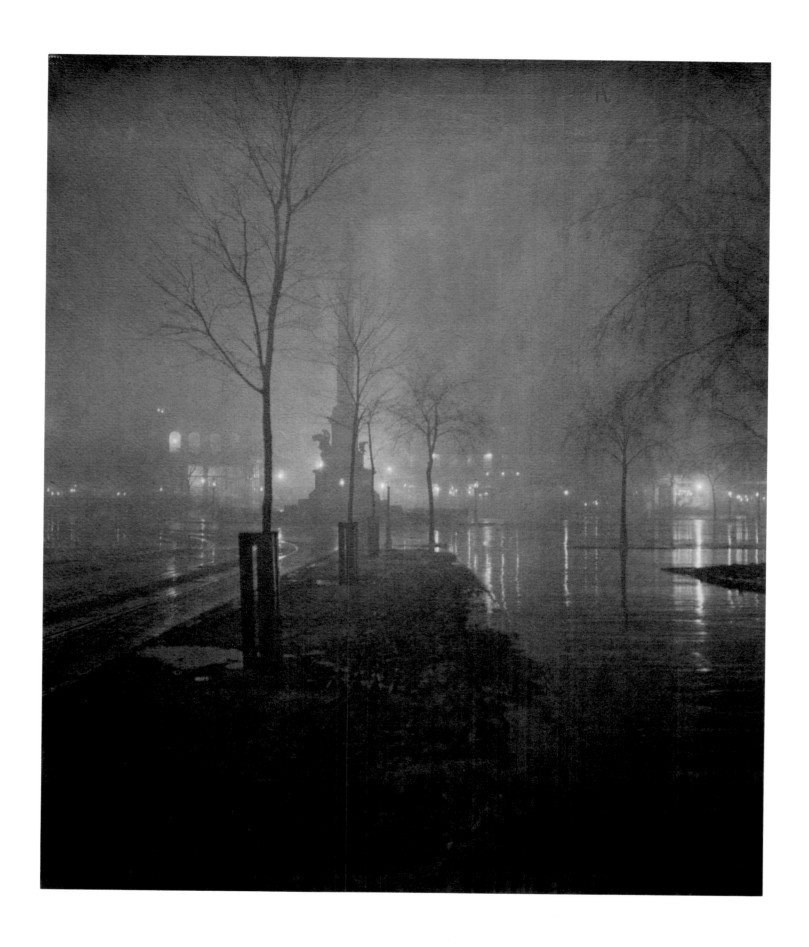

11 William A. Fraser, *A Wet Night, Columbus Circle*, ca. 1897-98, 26¾ x 23¼″

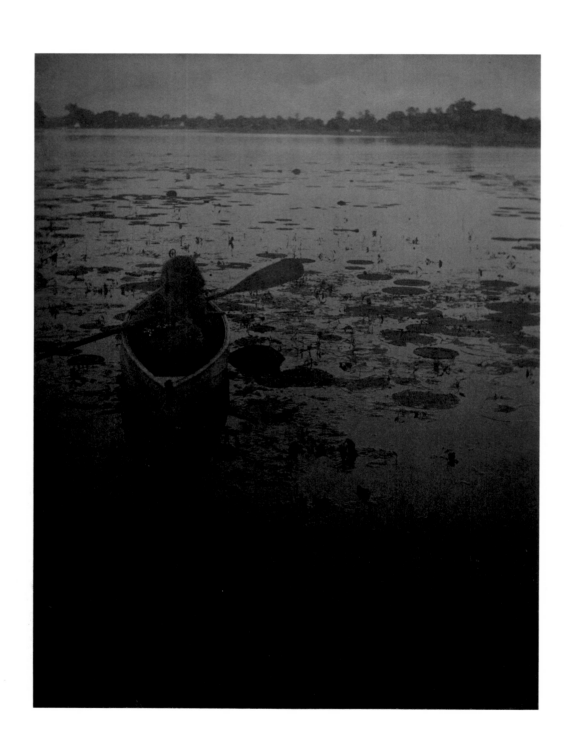

12 **Ema Spencer,** *Girl in Canoe,* ca. 1900, platinum print, 8 1/16 x 6″

13 **William B. Post,** *Intervale, Winter,* 1899, platinum print, 7⅜ x 9⅜″

14 **Benjamin J. Falk**, *Thomas A. Edison*, ca. 1905, platinum print, 9¼ x 6⅞"

15 Gertrude Käsebier, *Auguste Rodin*, 1905, gum print on tissue, 12¼ x 9½″

16 **John Chislett**, *Untitled*, 1910, platinum print, 9⅝ x 7¼″

17 Clarence H. White, *The Orchard*, 1902, platinum print, 9³⁄₄ x 7⁵⁄₈″

18 Clarence H. White, *Self-Portrait*, ca. 1905, 13⅝ x 10½"

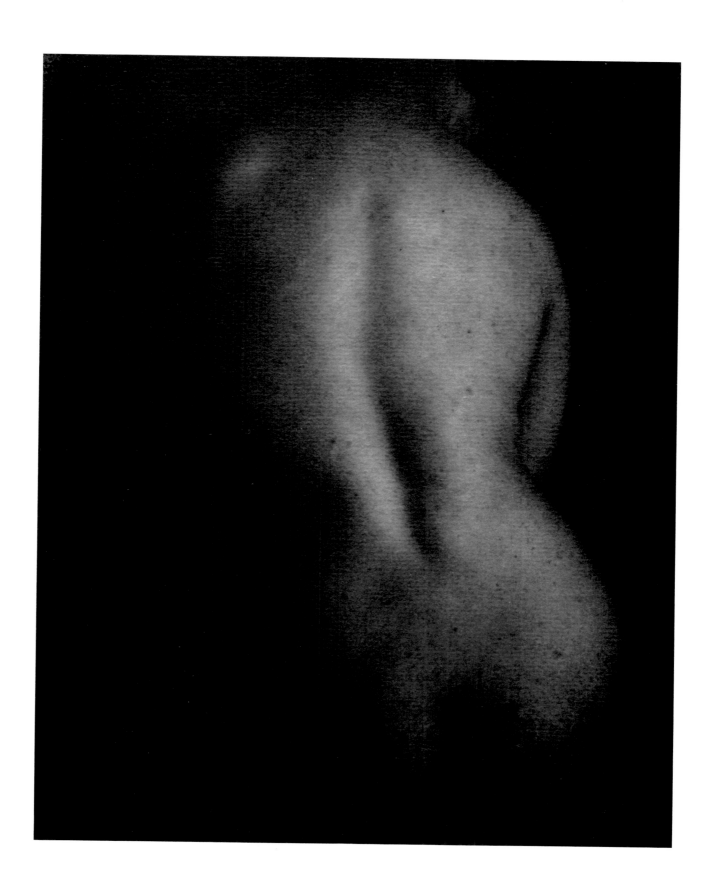

19 **Thomas O'Conor Sloane**, *Mme. Sato*, ca. 1908, gum-platinum print, 9⅝ x 7⅞″

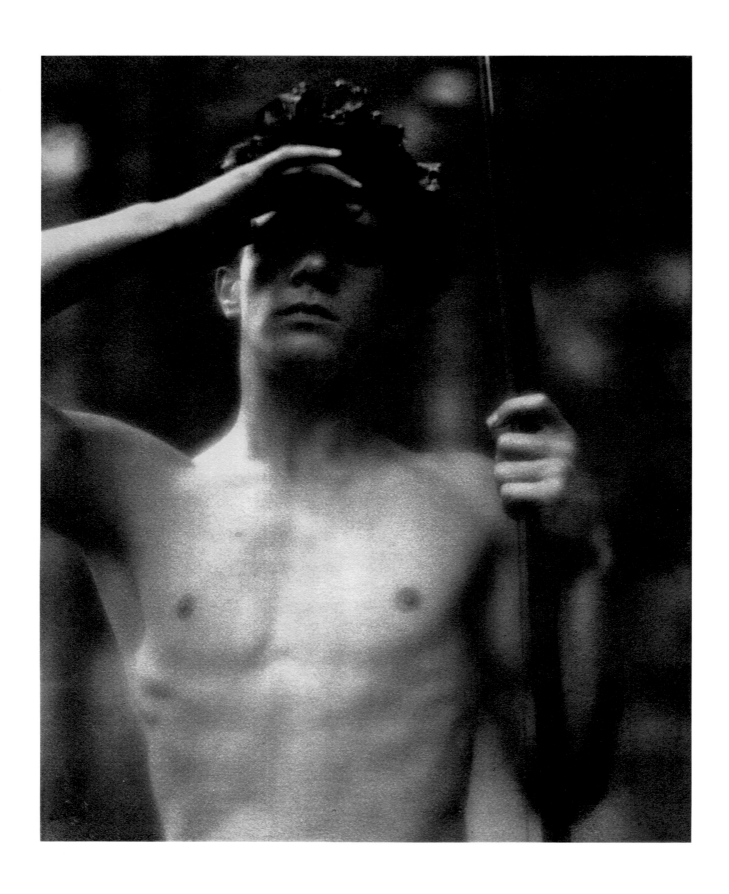

20 **F. Holland Day,** *Youth with Staff Shielding Eyes*, 1906, gum-platinum (?) print, 9⅝ x 7⅝″

21 George Seeley, *Autumn*, 1905, platinum print, 13⅜ x 10⅜″

22 **Anne W. Brigman,** *The Pine Sprite*, 1912, platinum print, 7³⁄₈ x 9¹⁄₂″

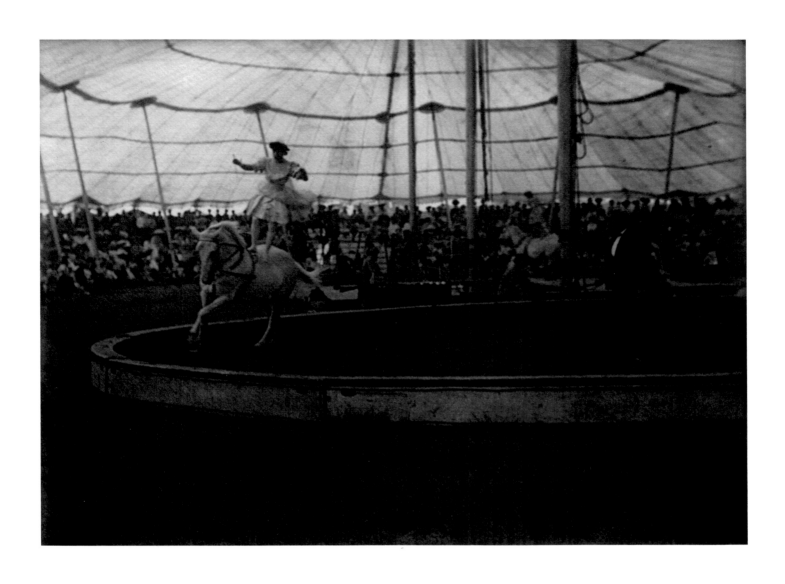

23 Harry C. Rubincam, *In the Circus*, 1905, platinum print, 6¼ x 8⅜″

24 **Karl Struss**, *Brooklyn Bridge from Ferry Slip, Evening*, 1912, platinum print, 4½ x 3¾"

25 **Alvin Langdon Coburn,** *The House of a Thousand Windows,* 1912, platinum print, 16⅛ x 12⅜"

26 **Lewis Hine,** *Spinner and Foreman in a Georgia Cotton Mill,* 1908, 4¾ x 6¾″

27 Lewis Hine, *Albanian Woman with Folded Head Cloth, Ellis Island*, 1905, 6¾ x 4¾″

28 **Edward Steichen,** *Triumph of the Egg,* 1921, 9⅝ x 7½″

CHAPTER II Abstraction and Realism
1915-1940

The quarter-century after 1915 produced changes of unprecedented magnitude in American life. The era began and ended with the nation on the verge of devastating international wars. Between these conflicts, Americans experienced the giddy boom of (in Carl Van Vechten's words) "the splendid, drunken twenties," and the worst economic crisis in the nation's history. At the same time, the United States underwent dramatic demographic shifts. As the nation grew from about 100 million to 131 million people, blacks migrated from South to North, and many whites left farms for factory jobs in cities. The 1920 census confirmed that the United States had become an urban nation, with fewer than half its citizens living in rural areas. This population was also remarkably diverse in ethnic composition: by 1930, about one-third of the nation's citizens were either first- or second-generation immigrants.

This quarter-century was distinguished by remarkable discoveries, improvements, and achievements. The characteristic hero of the age was the engineer, the analytical problem-solver who used technology to extend mankind's dominion over time and space. The Panama Canal, which opened in 1914 after years of work, was a massive example of American engineering genius and ambition. And New York City, with its skyscraper architecture and sheer exuberance, came to epitomize the expansive energies of the modern age. The Woolworth Building, completed in 1913, reigned as the world's tallest occupied structure before being topped by the Empire State Building in 1931. New York's George Washington Bridge (1931) and San Francisco's Golden Gate Bridge (1937) were universally hailed as extraordinary feats of engineering and as beautiful symbols of the machine age. The airplane also carried potent symbolic meaning, and the public was fascinated by such feats as Richard E. Byrd's crossings of the North Pole (1926) and the South Pole (1929), and the solo transatlantic flight of Charles Lindbergh (1927).

This era also initiated a communications revolution. Wireless transmissions, which were common by 1915, gave rise to the radio boom of the 1920s. The nation's first radio station, KDKA in Pittsburgh, went on the air in 1920; within two years some 500 other stations were in operation nationwide. Telephone service grew with similar rapidity, resulting in the initiation of regular transatlantic service in 1926. And, after the release of the first "talkie" in 1927, the motion-picture industry was almost immediately transformed from the silent era to sound.

The 1920s was an age of speed, abundance, and relentless change. The nervous pace of life seemed typified by the intoxicating sounds of jazz and the exuberance of such "animal" dances as the fox trot and jitterbug. Travel by train and airplane grew ever faster, but the automobile became a key symbol of this new speed and efficiency. After establishing its first assembly line in 1913, the Ford Motor Company produced its millionth Model T in 1915 and its ten millionth in 1924. By the 1920s, the automobile had irrevocably altered the nature of travel and Americans' perception of their national landscape. With the construction of limited access parkways, which began in the 1920s, the population of the United States became increasingly mobile. The automobile sped the growth of suburbs and created a new roadside culture, including the nation's first suburban shopping center (Kansas City's Country Club Plaza, 1923-25) and the first fast-food chain restaurants (such as White Castle).

New modes of industrial organization allowed an unprecedented expansion in the variety and quality of manufactured items available to consumers. This cornucopia of machine-made goods was accompanied by the rise of modern advertising, which sought to orchestrate and focus the desires of the public. These forces, in combination with the provocative ideas of Einstein, Freud, and a host of iconoclastic modern artists, eroded what remained of the seeming stability of Victorian truths.

While exciting to many, this new world was fraught with discord and uncertainty. To traditionalists, the youth of this era seemed decadent and materialistic. On a larger scale, labor unrest, racial dissent, and women's struggles for equal

rights provided visible evidence of the tensions lying beneath the progressive surface of American culture. Resistance to change came in various forms. The rise of Prohibition, the anti-immigration movement, and racist factions such as the Ku Klux Klan were reactionary attempts to roll back social change. A more benign reaction, though equally expressive of a deep nostalgia for an idealized, premodern America, was the widespread fascination with early American culture, and the re-creation of such historical sites as Colonial Williamsburg, Greenfield Village, and Old Sturbridge Village.

This complex mood of nationalistic celebration and isolationist reaction was shattered by the stock market crash of 1929. Wall Street's shocking collapse rippled through the national and international economic communities, creating the worst financial crisis in history. Within three years, 75 percent of the value of all American securities had vanished. The nation's entire financial system came unhinged as thousands of banks failed and millions of workers were laid off or given wage cuts. National unemployment rates reached at least 24 percent in 1932, and remained painfully high for the remainder of the decade. By some accounts, fully two-thirds of the nation's population was either unemployed or underemployed at the depth of the Depression. To make matters worse, this economic calamity coincided with a prolonged period of ecological catastrophe. Vast sections of the nation's agricultural heartland were plagued by droughts between 1930 and 1940. The low point came in April 1934, when the Midwest was struck by the first of an extended series of dust storms. Powerful winds began lifting dry soil off the ground and depositing it far away in drifts. The effects of this Dust Bowl were devastating, and innumerable farm families were forced to simply abandon their land. The uncertainty and privation of this era profoundly affected the most basic attitudes of middle- and working-class Americans for at least a generation.

The tumultuous twenty-five years between 1915 and 1940 produced art of unprecedented vitality and complexity. In the decade before the stock market crash, the most progressive art was characterized by intellectual confidence, formal invention, abstraction, irony, and an estrangement (physical or critical) from popular culture. After 1929, many artists and photographers turned to more objective techniques and to subjects of broad social interest. The facts of American social life and history became newly important, and many artists now embraced realist and humanistic approaches. In this era of boom and bust, the arts explored the extremes of the modern condition: the liberating excitement of pure ideas and the sobering consequences of vast economic and political forces.

"A World Bursting With New Ideas"

The second decade of the twentieth century was one of restless exploration in nearly every facet of American cultural life. A growing network of progressive or radical thinkers promoted new ideas in politics, race relations, women's rights, psychology, education, and the arts. The most vital years of this "Little Renaissance" were 1913 to 1917, or roughly from the time of the Armory Show to the nation's entry into the First World War.[1] Critic Hutchins Hapgood observed in early 1913,

> We are living at a most interesting moment in the art development of America. It is no mere accident that we are also living at a most interesting moment in the political, industrial, and social development of America. What we call our "unrest" is the condition of vital growth, and this beneficient agitation is as noticeable in art and in the woman's movement as it is in politics and industry. "Art" has suddenly become a matter of important news.[2]

In the visual and literary arts, this enthusiasm for the new was expressed by a loosely organized international network of artists, patrons, and partisans. Harriet Monroe's magazine *Poetry*, founded in Chicago in 1912, showcased the emerging talents of such writers as Sherwood Anderson, Vachel Lindsay, Edgar Lee Masters, Carl Sandburg, and William Carlos Williams. Ezra Pound, an American poet who moved to London in 1908, served as foreign correspondent for *Poetry*, and provided an important link between the English and American literary avant-gardes. He introduced American readers to the work of such important young writers as T. S. Eliot and James Joyce. In Paris, writer Gertrude Stein (and her brother Leo, an important collector of new art) held salons that provided a meeting place for visiting Americans and members of the French avant-garde.

New York City was the center of activity for this international network of American avant-gardists. The particular vitality of New York's "Little Renaissance" stemmed from the mutual idealism of individuals with widely divergent interests. Painters, poets, photographers, musicians, playwrights, actors, critics, suffragettes, labor activists, anarchists, and all manner of bohemians and free thinkers saw themselves as part of a movement dedicated to social and intellectual change. For a brief time, a desire to challenge the status quo in itself provided a feeling of common cause. While this sense of collective purpose was soon lost, it constituted an extraordinarily vital moment in American cultural history.

Of course, the unique energy of this period did not arise in a vacuum. The basic tenets of these interrelated avant-garde movements reflected the influence of such European writers as George Bernard Shaw, Henrik Ibsen, and Friedrich Nietzsche. Timely visits to America by prominent European intellectuals such as Sigmund Freud (in 1909), Carl Jung (in 1912), and Henri Bergson (in 1913) also notably affected the cultural climate, as did the work of the leading painters and sculptors in France and Italy.

Although the most radical changes in the visual arts were occurring in Europe, they had dramatic effects on the art scene in the United States. In 1908, Robert Henri and several other Realist painters known as "The Eight" broke away from the tradition-bound National Academy of Design and

mounted an exhibition of their own, more progressive work. Also in 1908, Alfred Stieglitz first showed the work of a major European avant-garde artist at his gallery. This exhibition of drawings by Auguste Rodin was followed by important shows of work by Paul Cézanne, Pablo Picasso, Francis Picabia, Henri Matisse, and Constantin Brancusi. Between 1908 and 1917, Stieglitz also introduced the work of younger American modernists such as Arthur B. Dove, Marsden Hartley, John Marin, Max Weber, and Georgia O'Keeffe, and presented the first display of African sculpture in this country. While the general public paid little attention, these exhibitions had great impact on New York's artistic community, and prepared that audience for the Armory Show, the most important art exhibition in American history. "The International Exhibition of Modern Art," as it was officially known, was held at the 69th Street Armory in New York from February 17 to March 15, 1913. It later traveled in reduced form to Chicago and Boston. Well over 1,000 paintings and sculptures by European and American artists were included in the New York installation. The great majority of these were uncontroversial. However, American audiences were stunned by the daring modernist works of Matisse, Picasso, Braque, Brancusi, and Duchamp. Those sympathetic to the new art were overwhelmed by the radical intensity of these paintings and sculptures while skeptics had a field day, ridiculing them as "mad."

The Armory Show had an immediate impact on the reception of modern art in America. Leading museums took a new interest in the most challenging contemporary painting, and important private collections were begun by individuals such as John Quinn and Walter Arensberg. Several galleries specializing in the new work also opened in New York, including the Daniel Gallery, the Carroll Gallery, and Marius de Zayas's Modern Gallery.[3] In fact, approximately 250 exhibitions of progressive American and European works were presented between 1913 and 1918 by no fewer than thirty-four New York galleries, organizations, and private clubs.[4] This does not mean, of course, that modern art won overnight popular acclaim. On the contrary, reactionary attacks on unconventional art appeared regularly in both the popular and academic press. In 1917, for example, the American Magazine of Art fulminated against the "madmen" whose works could only be understood as "the manifestations of a feverish and sickened age."[5] The new art was routinely associated with anarchy, insanity, and immorality. In response to the Armory Show, for example, the New York Times suggested that the new art was "surely a part of the general movement, discernible to all of the world, to disrupt, degrade, if not destroy, not only art but literature and society too."[6]

Despite such rantings, these new forms of expression were embraced by a growing segment of the public. The scope of this audience is suggested in the intelligent coverage given to modern art and artists by Vanity Fair, a mass-market, if clearly "highbrow," magazine. Under the editorship of Frank Crowninshield, Vanity Fair published reviews of many avant-garde exhibitions in New York, as well as

essays on new art movements, such as Futurism and Vorticism, and profiles of the most-discussed painters, sculptors, writers, and composers of the day.[7] Through these generously illustrated articles, the magazine gave broad exposure to the most challenging creative ideas, while also generating public interest in the modern artist as celebrity.

The avant-garde community in New York was characterized by a sense of experimentation, and the blurring of boundaries between disciplines. Visual artists wrote poetry and published literary journals, poets were inspired by modern painting, and everyone took an interest in theater, politics, and psychology. The vitality of this interchange is suggested by the profusion of small literary journals and artist-produced magazines that flourished in the middle of the decade. One of the most important of these was Stieglitz's Camera Work, which appeared steadily from 1903 through 1913, then irregularly until its demise in 1917. Stieglitz's enthusiasm for Camera Work lessened, in part, because the arts were now receiving sympathetic coverage in journals such as The Smart Set (1913-23), New Republic (founded 1914), and The Seven Arts (1916-17). Eccentric and short-lived magazines were also issued by artists: Glebe (1913-14) was edited by the poet Alfred Kreymborg with the assistance of the young painter Man Ray; 291 (1915-16) was edited by Stieglitz's associate Marius de Zayas with assistance from Paul Haviland and Francis Picabia; its successor, 391, was issued intermittently (1917-24) by Picabia from Barcelona, New York, Zurich, and Paris; Rogue (1915-16) was edited by Allen Norton; and Others (1915-19) was edited by Kreymborg and financed by the poet and art patron Walter Arensberg. Man Ray published the Ridgefield Gazook (1915), and collaborated with Marcel Duchamp on Rongwrong (1917) and with Adolf Wolff on TNT (1919); The Blind Man (1917) was edited by Duchamp, Henri-Pierre Roché, and Beatrice Wood. While these fleeting experiments had little public impact, they were essential to those "in the know," and provided an important outlet for the most advanced poetry, art, and criticism of the period.

This intellectual cross-pollination was, in part, a product of the active social life of the New York avant-gardists. Interconnected circles of allegiance grew up around several influential figures, such as Alfred Stieglitz. From the cramped domain of his gallery, Stieglitz showed the work of his favorite painters, philosophized with visitors, and, in general, promoted the modernist cause.[8] His associates in the mid-1910s included the caricaturist and theorist Marius de Zayas; the photographer and wealthy arts patron Paul B. Haviland, and for a short time, the French Dadaist Francis Picabia.[9] Stieglitz also championed the work of younger photographers, such as Paul Strand, Charles Sheeler, and Morton Schamberg.

Stieglitz and his circle often met other avant-gardists at the apartment of Mabel Dodge. A woman of considerable wealth and energy, Dodge had become a supporter of the modern movement after meeting Gertrude Stein in Paris in 1911. Fascinated by Stein's challenging prose experiments

(which were first published in *Camera Work* in 1912), Dodge resolved to play a role in the creative life of the era. After returning to New York, she began holding weekly "evenings" at her Greenwich Village apartment. Dodge's friends Hutchins Hapgood, a journalist and passionate modernist, and Carl Van Vechten, a critic of music and dance who later become a novelist and photographer, were central to the life of these gatherings. Dodge's now-legendary evenings—which have been described as "a combination of town meeting, bohemian Chautauqua, and cocktail party"—were attended by many of the most prominent artists, poets, actors, journalists, critics, and social reformers of the day.[10]

Another important artistic salon met in the New York apartment of Walter and Louise Arensberg. Walter Arensberg was a major collector of new art and a supporter of both the visual and literary avant-gardes. The Arensbergs' all-evening soirées were attended by a stimulating mixture of talented individuals: the poets Wallace Stevens, William Carlos Williams, and Alfred Kreymborg; the young American painters Charles Sheeler, Morton Schamberg, Charles Demuth, and Man Ray; and visiting members of the French avant-garde, including artists Marcel Duchamp and Francis Picabia, composer Edgar Varése, and critic Henri-Pierre Roché.[11]

While remarkably diverse in experience and outlook, the members of this avant-garde community were united by a basic set of ideas.[12] In varying degrees, all were in revolt against the Victorian world view and the genteel tradition in the arts. These were understood to represent bourgeois culture at its most stultifying: unreflective, repressive, and conformist, and built on systems of belief that had been discredited by recent science and philosophy. Gone, too, was the faith that art should (or could) reflect any single standard of morality, truth, or beauty. The avant-gardists felt that the complexity of modern experience called for a corresponding diversity of artistic subjects and methods, including new critical standards by which to judge these achievements. Edward Steichen expressed his generation's mixture of excitement and uncertainty in a 1913 letter to Stieglitz: "One is conscious of unrest and seeking—a weird world hunger for something we evidently haven't got and don't understand. …Something is being born or is going to be."[13] Or, as critic Walter Lippmann wrote of this process of transformation, "Instead of a world once and for all fixed with a morality finished and sealed…we have a world bursting with new ideas, new plans, and new hopes. The world was never so young as it is today, so impatient with old and crusty things."[14]

With fervent devotion, the modernists sought to replace Victorian conventions with a utopian celebration of subjectivity and spontaneity. By reintegrating the rational and intuitive faculties, they felt, a life of mind and spirit could be created from the mundane materialism of American culture. The key for them was the inherent creative potential of the individual. While an earlier generation of American artists had placed their faith in "timeless" laws, dutiful study, and

the rules of the Academy, those of the Stieglitz circle looked only to their inner selves for inspiration. They found support for their belief in an intuitive creative force not only in the most radical art of the European avant-garde, but also in the art of "primitives" and children.[15] For Stieglitz, in particular, the artistic impulse was sacred and life-affirming. He regarded artists as seers and prophets, and frequently used words such as "Truth," "Life," and "Spirit" to describe the fundamental meaning of art. Symbolically, his lifelong fight for the recognition of photography represented a metaphysical struggle for the liberation of the self from all forms of imposed authority. After the shocking disillusionment of World War I, this highly romantic notion, a clear extension of Symbolist thought, was maintained by few except for Stieglitz and his closest followers.

Paradoxically, alongside this celebration of individual creativity there arose a revitalized sense of artistic nationalism. Leading artists and thinkers sought spiritual renewal in a self-consciously American art. These cultural nationalists were led by Herbert Croly, Walter Lippmann, and Randolph Bourne of the *New Republic*; James Oppenheim, Waldo Frank, Van Wyck Brooks, and Paul Rosenfeld of *The Seven Arts*; and Robert J. Coady, editor of the small magazine *The Soil*. In various ways, these writers all claimed cultural independence from Europe and encouraged the search for uniquely American subjects and styles. As one recent historian noted, this nationalist criticism was not "analytical or historical but a kind of religious proselytizing."[16] Often using utopian or mystical rhetoric, these critics envisioned an organic relationship between the American experience and its art, arguing that art had the power to heal the schisms of modern society. They sought to construct their own historical lineage—in Brook's famous phrase, a "usable past"—in order to establish a sustaining national aesthetic.[17] They celebrated the achievements of Emerson, Thoreau, Melville, and Whitman, and encouraged contemporary writers and artists to build on this heritage. Radical critics like Coady even went so far as to praise such "lowbrow" forms of Americana as vaudeville, jazz, department stores, window displays, neon lights, motion pictures, and sports. But such a broad acceptance of democratic and commercial culture ran counter to the spiritual idealism of Stieglitz and his circle. Ultimately, however, all these critics shared a "hope that from honest soul-searching, a genuine American culture might emerge, a unitary culture derived from the American plurality, self-aware, tough-minded, yet based on spiritual rather than material values."[18]

For those who felt that America's uniqueness lay in its pragmatism and mechanical genius, this quest for an indigenous national aesthetic prompted a new interest in modernity. The machine—or at least an idealized concept of technological efficiency—became a subject of increasing intellectual and artistic interest. The avant-garde interest in the clean, functional beauty of the machine was paralleled by a new photographic emphasis on technical purism. Now, for the first time in a generation, photographic artists sought

to celebrate rather than subvert the camera's mechanical nature. As Paul Strand wrote in an essay published in both *The Seven Arts* and *Camera Work*, "[Photography] finds its raison d'être, like all media, in a complete uniqueness of means. This is an absolute unqualified objectivity." Rejecting "tricks of process or manipulation," Strand argued that "a living expression" could only result from the photographer's genuine respect for both his subject and his medium.[19]

In hindsight, it seems somewhat ironic that photographic "purism" could have been regarded as a radical artistic stance in 1917. The great majority of commercial and amateur photographers made nothing but "straight" images, and the artistic potential of the unmanipulated image had been promoted more than a decade earlier by the critic Sadakichi Hartmann.[20] In fact, however, the new purism of the late 1910s rejected both the mundane factuality of commercial photography and the genteel idealism of typical Pictorialism. Underlying this new objectivity was a faith in the correspondence between objects and ideas, and the desire to see *through* physical reality to much larger truths. Stieglitz's influence is clear in Strand's description of this new objectivity as a quest for "Life," "a universal expression," and "an ever fuller and more intense self-realization." In short, the artistic goals for photographers remained as idealistic as ever, but now form was emphasized rather than muted impressions.

"The *Trinity of Photography*"

These radically modern ideas found their most immediate photographic expression in the work of Paul Strand, Charles Sheeler, and Morton Schamberg. All three achieved artistic recognition in the mid-1910s and were championed by Stieglitz. Their work of 1916-17, in particular, seemed to synthesize the varied styles then understood as Cubist, and to advance the newest ideas on the techniques and subjects of photographic art.[21]

Paul Strand, the youngest of the three, was the first to gain national prominence. As a student, Strand had been influenced by Lewis Hine, his teacher at the Ethical Culture School in New York, and by Alfred Stieglitz, whose gallery Strand visited as part of Hine's class. After working through a relatively typical Pictorialist phase, Strand developed a powerfully individual vision in the years 1914 to 1917. Stimulated by *Camera Work*, the Armory Show, exhibitions at 291 and the Modern Gallery, and by an expanding circle of art-world acquaintances, he explored the expressive potential of photography in three related bodies of work.

The first group of images, created from 1914 to about 1916, consists of street scenes which contrast the bold geometry of architectural forms with the random patterns of moving vehicles and pedestrians. Using the geometric and the organic to suggest notions of permanence and flux, these photographs convey a sense of the vibrant complexity of the modern city. One of the most remarkable of these pictures, *Woman Carrying Child* (plate 29), was made in New Orleans in 1915. This image powerfully unites the central elements of Strand's mature vision, formalism and humanism. The anonymous mother and child appear painfully vulnerable in this harsh and oppressive urban environment. Splatter marks on the wall suggest an air of violence, while the empty black window—just large enough to engulf the pair—creates an ominous, deathly vacancy. The slight asymmetry of Strand's framing also gives the scene a sense of tension or urgency. This work combines Pictorialist and modernist devices to genuinely new effect; while the mother and child theme had been a Pictorialist staple, Strand here treats it unsentimentally, integrating it into a complex, abstract composition.

In the summer of 1916, during a vacation at Twin Lakes, Connecticut, Strand extended the formal aspect of his work in a second group of photographs, the most nonobjective images he would ever make. From the simplest of subjects—kitchen crockery, fruit, and the front porch of his cottage—he fashioned pictures that function as almost total abstractions. As he later recalled, he was seeking to understand "the underlying principles behind Picasso and the others in their organization of the picture's space, of their unity of what that organization contained, and the problem of making a two-dimensional area have a three-dimensional character."[22] In this period, Strand employed a similar close-up vision in images of automobile wheels and fenders. While the subjects of these images remained recognizable, the treatment of this typically modern machine was boldly unconventional.

Strand's third series was a group of candid street portraits begun in the fall of 1916. By fixing a right-angle prism on his lens, Strand was able to record individual pedestrians in a powerful and immediate manner. "Detached from their surroundings," writes photographic historian Sarah Greenough, "these people assume monolithic proportions; they have the strength, solidity, singularity, and elegiac quality of tombstones."[23] While not perfectly sharp, these photographs have a bold structure and blunt naturalism that distinguishes them from all other photographs of the period.

Charles Sheeler and Morton Schamberg, working together during these years in their native Philadelphia, also found ways to unite "purist" photography and the principles of avant-garde art. Sheeler and Schamberg both were trained as painters and became friends while studying with William Merritt Chase at the Pennsylvania Academy of Fine Arts. During several joint visits to Europe, they studied the work of both the old masters and the avant-garde. As a result of these diverse influences, Sheeler recalled, "We began to understand that a picture could be assembled arbitrarily with a concern for design, and that the result could be outside time, place, or momentary considerations."[24] While Sheeler and Schamberg were working through the influences of Cézanne, Cubism, Futurism, and Synchromism in their paintings, both were also becoming proficient with the camera. Each turned to photography in about 1910 or 1911 as a means of earning a living that would not distract them from their painting.[25] Schamberg became a portrait photographer, while Sheeler specialized in photographs of art and architec-

ture. In Sheeler's case, at least, his use of the camera hastened his growth as an artist. By 1916, he was regularly photographing art works for the galleries of Stieglitz and de Zayas, and so was brought into intimate contact with a range of avant-garde paintings and sculpture, as well as important pre-Columbian and African artifacts.

Although the exact chronology remains unclear, by 1917 both Sheeler and Schamberg had begun to create important modernist photographs.[26] Sheeler's most notable work from this period consists of architectural studies of barns in rural Bucks County, Pennsylvania, and details of the rustic stone farmhouse that he and Schamberg rented as a weekend and summer retreat. Sheeler was fascinated by the affinities between the spare simplicity of this vernacular architecture and the formal language of modernism. On one level, his precisely controlled views of windows, doorways, staircases, and facades celebrate the elegant simplicity of a premodern, handcrafted aesthetic. At the same time, however, these photographs embody the avant-garde's quest for an artistically "usable past" by suggesting an intrinsically American lineage for modernism's reductive emphasis on form.[27]

While both Sheeler and Schamberg were part of the Arensberg circle, it was Schamberg who more quickly absorbed the proto-Dadaist ideas of the group's most celebrated artists, Duchamp and Picabia.[28] Schamberg's 1916 paintings of mechanical forms, typically bearing such generic titles as *Mechanical Abstraction* or *Machine*, strongly suggest the influence of Picabia's mechanistic "portraits" of 1915 and Duchamp's detached sense of irony.[29] Schamberg's painted machines are elegantly rendered, planar, and schematic—mere suggestions, rather than diagrams, of mechanistic function. Schamberg was most interested in the plastic and formal possibilities of this subject: the machine as an aesthetic idea rather than as a utilitarian object.[30]

If Sheeler's Bucks County photographs obliquely suggest human warmth and narrative by virtue of their intimate viewpoint and humble subjects, Schamberg's architectural photographs of this period are utterly devoid of such associations. Given the rarity of these views, it is uncertain how extensively Schamberg worked in this mode. What is clear, however, is the rigor and originality of his vision. A handful of surviving images, probably taken from or near Schamberg's downtown Philadelphia studio in 1916-17, treats urban architecture with the same austere formalism he used in his machine paintings. In one untitled photograph (plate 30), perhaps the most subtle and complex of this group, Schamberg avoids the steeply angled downward view he used in other images from this series. Yet, despite its apparent objectivity, this photograph deliberately avoids any structures of unusual topographic or pictorial interest. Instead, the city is portrayed as a maze of tightly interlocking geometric units arrayed against the negative space of a blank sky and the organic forms of two trees. This polyrhythmic arrangement of angles, planes, masses, and edges functions both as a description of the real world and as a self-contained, two-dimensional abstraction. The rigorous intelligence of Schamberg's vision,

and his success in balancing these two levels of depiction, were unsurpassed by any other photographer of his time.[31]

Strand, Sheeler, and Schamberg received considerable attention from Stieglitz and de Zayas between 1916 and 1918. In March 1916, Stieglitz gave Strand a one-man exhibition at 291, the first group of photographs shown at the gallery since Stieglitz's own retrospective three years earlier. Stieglitz also featured Strand's pictures in the last two issues of *Camera Work* (published in October 1916 and June 1917), and awarded him first prize in the 1917 Wanamaker Photographic Exhibition, a juried contest sponsored by a progressive Philadelphia department store. De Zayas showed "Photographs by Sheeler, Strand, and Schamberg" at the Modern Gallery in early 1917, and at the end of the year presented a one-man show of Sheeler's photographs.[32] Thanks to Stieglitz's control of the jury in the 1918 Wanamaker Exhibition, the three men swept the first five prizes. This result had been predicted by at least one less-favored entrant who was reported to have observed glumly that Strand, Sheeler, and Schamberg were "*the* Trinity of Photography—Mr. Stieglitz says so."[33]

Many Pictorial photographers found these prizewinning pictures bewilderingly radical. One conservative critic called Sheeler's rendering of a window in his Doylestown house "an orgy of rectilinearity," and railed against Strand's now-famous *White Fence* with the following words:

> It reminds us of the grand finale of a burlesque show, where the full strength of the company is displayed at once. We hardly see how more contrast, emphasis, eccentricity, and ugliness could be combined within the four sides of a print.[34]

However, more progressive critics found great value in these works. Photographer Grancel Fitz, for example, wrote a notably clear-headed review of the exhibit.[35] He praised the Wanamaker shows for their ability to "make us *think*" and for the way they "jar us loose from our barnacled ruts of rutty, complacent thought." Stating his belief that a great photographic picture was one "combining a really big idea with good execution," Fitz defended Strand's *Wheel Organization* (1917), a close-up of an automobile tire that was the most controversial of the winning pictures. After praising its technical merits, Fitz observed that the print successfully evoked the artist's belief that "this segment of wheel expressed not only the power of the thing itself, but also the cohesive strength of business, [and] the spirit of the industry which produces it."[36]

Coburn's Vortographs

This era's other important group of avant-garde photographs was produced in London by the American Alvin Langdon Coburn. After showing his powerful "New York from Its Pinnacles" series, Coburn continued his quest for an art that reconciled the physical and spiritual, and which expressed the inner harmony of existence. His work of the mid-1910s would be the most cerebral, poetic, and abstract of his entire

career. When Coburn arrived in London in late 1913, he encountered the Vorticists, a radical artistic group led by the writer and painter Wyndham Lewis and the poet Ezra Pound (both, curiously, American-born). Coburn was introduced to Vorticism by Pound, whom he met in the course of a portrait session in October 1913.[37] The two shared many ideas on art and literature, and soon became friends.[38]

Vorticism coalesced during the first half of 1914 with the organization of a group exhibition in March, and the publication of the first issue of Lewis's journal *Blast*, the movement's manifesto, in July. As a movement, Vorticism sought to evoke the dramatic process of technological and intellectual change that characterized the early twentieth century, and to reject any hint of Victorian sentimentality and romanticism. Highly nationalistic, the Vorticists also wanted to create a new and specifically English art from the ideas of French Cubism and Italian Futurism.[39] Pound, who coined the group's name, described the characteristic Vorticist image as "a radiant node or cluster...from which, and through which, and into which, ideas are constantly rushing."[40] Vorticist art was geometric, nonrepresentational, and coolly self-contained, suggesting both the efficiency and inhumanity of the machine. Hermetic and immobile, Vorticism used "precise linear definition [to enclose] the most explosive compositions and high-pitched tonal orchestrations in static contours." Thus, "a typical Vorticist design shoots outwards in iconoclastic shafts, zig-zags or diagonally oriented fragments, and at the same time asserts the need for a solidly impacted, almost sculptural order."[41] Vorticism drew much of its intellectual power from its paradoxical union of vitality and stasis, and the desire to convey a torrent of energy in hard, brittle forms. Unfortunately, Vorticism came into being just weeks before the outbreak of World War I, and the conflict soon eclipsed the vitality of the movement. Several leading Vorticists were called into military service, and it was clear that any artistic "call to arms" paled to insignificance in the face of real war. However, Pound continued to promote the Vorticist cause despite both critical and public disinterest.

Inspired by Vorticist ideas, Coburn began the most daring work of his career. In an important essay titled "The Future of Pictorial Photography," written for the 1916 edition of the English annual *Photograms of the Year*, Coburn articulated his radical vision of photography's expressive possibilities. Citing the achievements of Henri Matisse, Igor Stravinsky, and Gertrude Stein, he argued that the photographer was just as capable of revolutionary statements as the avant-garde painter, composer, or writer. Anticipating by nearly a decade the modernist aesthetic of the mid-1920s, Coburn asked,

> Why should not the camera also throw off the shackles [of] conventional representation and attempt something fresh and untried? Why should not its subtle rapidity be utilized to study movement? Why not repeated successive exposures of an object in motion on the same plate? Why should not perspective be studied from angles hitherto neglected or unobserved? Why, I ask you earnestly, need we go on making

Fig. 20 Alvin Langdon Coburn, *Vortograph (Ezra Pound)*, 1916, 3¼ x 4⅛"

commonplace little exposures of subjects that may be sorted into groups of landscapes, portraits, and figure studies? Think of the joy of doing something which it would be impossible to classify, or to tell which was the top and which the bottom!

Later in this essay, he noted that "the use of prisms for the splitting of images into segments has been very slightly experimented with, and multiple exposures on the same plate ...have been neglected almost entirely." After proposing an exhibition on the theme of "Abstract Photography," Coburn concluded with a statement of confidence in the medium's "infinite possibilities [to] do things stranger and more fascinating than the most fantastic dreams."[42]

The tone of Coburn's article, as well as its reference to the use of prisms, suggests that it was written at the beginning of his Vorticist experiments in the early autumn of 1916. This work had begun in September with Pound's encouragement and collaboration.[43] The two devised a triangular arrangement of mirrors (which they named the vortoscope) that was placed over the camera lens.[44] The refracted images created by this device seemed excitingly new, even when it was trained on such mundane objects as bits of wood and crystal. Coburn's vortographic experiments consist of two basic groups: portraits of Pound and more completely nonobjective images. The studies of Pound (fig. 20) were probably made first, as they suggest a relatively systematic exploration of a variety of techniques, including the use of the vortoscope in concert with multiple exposures and possibly even the multiple printing of negatives.[45]

While these refracted portraits are genuinely intriguing, it is clear that Coburn saw the most effective use of vortography in the production of fully abstract images. Thus, between October 1916 and January 1917, he fulfilled his own challenge "to do something impossible to classify." The resulting photographs, all but one titled simply *Vortograph*, represent the earliest self-consciously artistic abstractions in the history of photography.[46] For the first time, it seemed, the camera had been freed from the burden of representation and could be used as a means of pure pictorial invention. The

best of these vortographs (such as plate 31) are quite remarkable: boldly composed, mysteriously unreal, and intensely vibrant with light and energy. These images suggest both strength and fragility, the natural and the mechanical, and a scale at once cosmic and microscopic. Ultimately, they convey the beauty of pure structure, as seen in the largest bridges and buildings, and as imagined at the heart of the atom. These images come as close as any ever made to giving pictorial form to thought itself.

Coburn's vortographs consistently utilize the sharp diagonals and prismatic forms of Vorticist drawing and painting. In other respects, however, his vortographs diverge markedly from Vorticist aesthetics. While the paintings and drawings of Wyndham Lewis and his circle are hard-edged, two-dimensional, and static, the forms in Coburn's photographs are indistinct, suggestive of three dimensions, and vibrant. The forms in Vorticist paintings function on a primarily graphic level, while Coburn's shapes seem to be shifting and dissolving, and "glow with refracted light and nuances of shadow."[47] Thus, ironically, the artistic success of Coburn's work lay primarily in its divergence from Vorticist theory. The ultimate meaning of the vortographs stemmed from Coburn's fascination for light and his increasingly metaphysical inclinations. While motivated by his understanding of Vorticist practice and his friendship with Pound, Coburn's work was distinctly his own.

These revolutionary photographs, with a selection of Coburn's recent paintings, were exhibited at the Camera Club in London during February 1917. The critical response was generally disappointing. Pound, who had been asked to contribute an essay to the exhibition catalogue, could generate only faint enthusiasm for Coburn's work. Having decided that photography was intrinsically inferior to painting and sculpture, Pound implied that the vortographs were, at best, a weakly imitative art form. In his view, the best of Coburn's abstractions were simply "excellent arrangement[s] of shapes, and more interesting than most of the works of Picabia or of the bad imitators of Lewis."[48] Coburn's annoyance with his former collaborator was made clear in a postscript included in the catalogue. After alluding to the myopia of those "living exclusively in the rarified atmosphere of Vorticism," Coburn firmly defended the expressive potential of photography.

> I affirm that any sort of photograph is superior to any sort of painting aiming at the same result. If these vortographs did not possess distinctive qualities unapproached by any other art method I would not have considered it worth my while to make them. Design they have in common with other mediums, but where else but in photography will you find such luminosity and such a sense of subtle gradations?[49]

The bold originality of these pictures provoked much discussion in photographic circles. Most viewers were intrigued by them but undecided as to their meaning or ultimate importance. Even George Bernard Shaw, a sympathetic friend, found the images aesthetically pleasing but com-

Fig. 21 Mole and Thomas, *The Human American Eagle, 12,500 Officers, Nurses, and Men, Camp Gordon, Atlanta, Georgia,* 1918, 10⅛ x 13⅛"

plained that "the sense of these 'vortographs' has not yet been worked out."[50] A lengthy review published in the *Amateur Photographer* (and reprinted in the conservative American journal *Photo-Era*) also granted the seriousness of Coburn's intentions, but cited the general "perplexity" stimulated by the work. "The show," this writer observed, "marks an entirely new departure in camera-work, and for this reason, if for no other, should engage the attention of all who are interested in photographic progress."[51] The editor of *Photograms of the Year* featured a vortograph in the 1917-18 edition, noting its "uncanny" and haunting quality.[52] Americans such as Karl Struss were less sympathetic, and saw the work as an inconsequential novelty.[53] The decidedly mixed nature of this critical appraisal has changed little in the intervening years.[54]

The End of an Era

The four years from the Armory Show in 1913 to the nation's entry into World War I in 1917 were the most vital for this first American avant-garde. The war chilled the nation's artistic impulses and dissolved the network of artists, patrons, and activists that had given it such vigor. The patriotism and unity demanded by the mobilization effort (fig. 21) were simply antithetical to the climate of exploration and provocation in which the avant-garde thrived.[55] With a significant number of artists and photographers away in military service, many ties of friendship and influence were broken. In 1917 Stieglitz ended *Camera Work*, closed his gallery, and had a final falling-out with Steichen. Steichen, Struss, Strand, and other noted photographers spent time in military service, and were changed by the experience in varying ways. Further trauma was caused by the great influenza epidemic of 1918, which struck with deadly force just as the war in Europe was ending. Morton Schamberg was one of thousands of Americans who died from this disease.

While the war created hardships for civilian photographers in America, it also stimulated the development of

new photographic technologies and applications. Photographic chemicals and paper were in short supply and the embargo on German goods made fine lenses a precious commodity.[56] At the same time, however, military applications of photography expanded rapidly. The war created a great demand for documentary work (in both still and motion-picture formats), X-ray images, and such specialized applications as the transmission of photographs by wire. The most dramatic wartime use of photography involved aerial reconnaissance.[57] While most of this work was conducted from airplanes, aerial images were also made from balloons, small rockets, kites, and pigeons. By using the sharpest lenses available, airborne photographers at 15,000 feet were able to record details on the ground with remarkable accuracy.[58] The abstract beauty of these purely informational images had a significant impact on the aesthetic of postwar art photography.

The war stimulated the production and public circulation of great quantities of photographs. While coverage of the conflict was heavily censored by all the warring nations, each country produced officially sanctioned images for its own public. Selections of these photographs were assembled into exhibits that toured extensively during and after the war. In 1916, for example, work by British military photographers was presented at the Louvre in Paris before traveling to various venues in the United States. Three years later, an exhibition by U.S. Army Signal Corps photographers opened to good reviews at the Corcoran Gallery of Art in Washington, D.C., and then toured nationally.[59] Exhibitions by French and Canadian military photographers were also widely viewed. The images included in these shows ranged from the most matter-of-fact records to romantic views of snowy battlefields and silhouetted ruins at sunset.[60]

The Signal Corps, which established its photographic section in July 1917, produced the majority of American war photographs.[61] These images were created for various purposes, ranging from the tactical (aerial reconnaissance, for example) to the political (domestic propaganda). War photographs were run in great numbers in the nation's newspapers and magazines. The *New York Times* printed them regularly in its Sunday edition and its *Mid-Week Pictorial* supplement. Mass-market magazines, such as *Collier's, Leslie's,* and the *Saturday Evening Post* also made generous use of war pictures. Since most of these images were obtained from official sources, gruesome, unsettling, or controversial subjects were not depicted. In order to maintain domestic morale, only the enemy's dead soldiers, downed aircraft, or blasted entrenchments were depicted in the American press.

Even though American losses in the war were considerably less than those suffered by its allies, the experience was sobering. World War I had begun with great idealism and the expectation that victory would be achieved quickly and easily. In fact, the conflict turned into a horrific and nearly static confrontation of highly mechanized armies. This was the first war to make full use of the airplane, submarine, tank, machine gun, poison gas, and wireless. These technologies, in concert with nineteenth-century tactics and a generous supply of official stupidity, resulted in the slaughter of the best and brightest of this century's first generation. The absurdity and horror of this massive sacrifice called into question a variety of received values, and instilled a powerful sense of skepticism and irony in many survivors. To make matters worse, the world was far more volatile at the end of the fighting in 1918 than it had been in 1914. The breakup of the German and Austro-Hungarian empires, the Bolshevik Revolution in Russia, and the harsh terms of the Versailles Treaty all ensured that the following decades would be fraught with political tension.

The European avant-garde reacted to this shattering experience in various ways: through the nihilism of Dada, the liberating irrationality of Surrealism, and the utopian purity of Constructivism. While Europe rebuilt, American society turned inward, away from the complications of international politics to a newfound prosperity and hedonism. Some artists, such as Alfred Stieglitz, retreated in disgust from the banalities of American popular culture to a private and spiritual artistic realm. Others sought to unite personal expression with practical realities by applying the lessons of art to the demands of commerce. A handful of the most adventurous Americans, including Man Ray, emigrated to Paris, taking up residence in the midst of the international avant-garde. In their different ways, each of these responses produced work of importance and influence.

Purism and Pictorialism

Eight years after closing 291, Stieglitz resumed mounting exhibitions, first at his Intimate Gallery (1925-29) and then at An American Place (1929-46). In these years, he presented only seven exhibitions of photography: two shows of Strand's work (1929, 1932), three of his own (1932, 1934, 1941), and one each by Ansel Adams (1936) and Eliot Porter (1941). Most of this twenty-one-year exhibition schedule was devoted instead to Stieglitz's favorite painters: O'Keeffe, Marin, Dove, and Hartley.[62]

The most productive stage of Stieglitz's own artistic career began around 1917, the year he discontinued *Camera Work,* closed 291, and fell in love with the young painter Georgia O'Keeffe. Over the next twenty years, he produced a cumulative photographic portrait of O'Keeffe, whom he married in 1924. In their intensity, ambition, and number, these 500 or so images form perhaps the most extraordinary series in the history of photography. The success of these pictures stems not only from the couple's intense emotional relationship but also from their keen intellectual interaction. O'Keeffe often challenged or enriched Stieglitz's artistic ideas, and the resulting images represent an unprecedented collaborative dialogue. In fact, such a body of work could only have been made by the pairing of a photographer of Stieglitz's unmatched talent and a model with O'Keeffe's

charismatic presence and ability to project a host of expressive "selves."

In his images of O'Keeffe, Stieglitz charged the simplest of themes—the portrait of a loved one—with unprecedented intensity and universality. He explored all aspects of O'Keeffe's figure and personality: clothed and nude, whimsical and solemn, demure and shamelessly sexual, implacably serene and tense with energy. Yet, the power of these images stems, most of all, from their intimacy. Most were made inside, in soft natural light, with Stieglitz's large camera only an arm's length from his subject. In many cases, Stieglitz magnified O'Keeffe's hands, breasts, thighs, or neck to fill completely the frame of his 8x10-inch camera. Overall, these pictures serve to remind us of the profound complexity of simple things, the inventive potential of the straight photograph, and the variety of moods that constitute a single life.

O'Keeffe was the perfect subject for Stieglitz. Talented, self-assured, and beautiful in an elegantly unaffected way, O'Keeffe projected a sense of self that was simultaneously timeless and modern. Born in the Midwest, and recently arrived from the plains of Texas, she seemed to Stieglitz emblematic of a profoundly American simplicity and integrity. O'Keeffe embodied an artistic and cultural ideal, a fundamentally American mixture of individuality, courage, and desire. She was bold, sensual, and independent, a person of action rather than talk, and a product of nature more than of society.[63] Stieglitz's depiction of O'Keeffe as an elemental force mingles nationalist ideal and universal abstraction. As Paul Rosenfeld wrote in 1921, on the occasion of the first exhibition of these pictures, "Here, symbolized by the head and body of a woman, herself a pure and high expression of the human spirit…, there is registered something of what human life was, not only in America, but all over the globe, during the last few years; perhaps, also, something of what human life always is."[64]

This quest for the universal produced some pictures that now seem mannered and overwrought, but it also accounts for the genuine profundity that is found in many of them. In *Georgia O'Keeffe: A Portrait*, 1918 (plate 32), for instance, Stieglitz used his characteristic technique—soft natural light, deep focus, and a relatively long exposure—to produce an image of sculptural presence and iconic power. The simplicity of O'Keeffe's dress and pose ensure that the viewer's attention is focused almost completely on her magnificent face, and, by implication, on the serene intensity of her inner life. Seated in front of one of her own drawings, O'Keeffe is presented as an embodiment of the creative force. The drawing presents an inverted echo of the graceful shape of her arms and shoulders, subtly reinforcing O'Keeffe's dual role as artist and work of art. In addition, the dark tones of Stieglitz's platinum print produce a feeling of great mass from flesh and fabric. As Rosenfeld observed, "Breasts and arms become like pieces of primitive sculpture, simple and gigantic. A head is heavy as a cannon-ball."[65] This visual weight underlines the gravity and timelessness of the themes Stieglitz was tracing in this work.

Stieglitz's O'Keeffe pictures had an enormous impact on later photographers. The first to respond to these images was Strand, who began photographing his wife-to-be, Rebecca Salisbury, soon after they met in 1920.[66] Though similar in approach to Stieglitz's, Strand's pictures nonetheless reveal a distinct artistic voice. The best of these works, such as *Rebecca, New York*, 1922 (plate 35), effortlessly unite formal and emotional concerns. The tight cropping and canted frame create an almost dreamlike spatial ambiguity, while the image's slight blurring conveys a feeling of sensuous physicality. Strand's later work never approached the moody intimacy of these pictures. Also interesting in this context is the work of Marjorie Content (plate 34), which reveals the impact of her close friendship with both Stieglitz and O'Keeffe.

Stieglitz continued his O'Keeffe pictures for many years, but in the fall of 1922 he began a series of photographs of clouds.[67] Over the next eight years, he produced at least 350 of these cloud pictures.[68] The project began with a group of rather baroque images titled "Music: A Sequence of Ten Cloud Photographs." In these works, traces of landscape allow the viewer to retain a sense of spatial orientation. Within a year, however, Stieglitz's interest in the sky evolved markedly. In addition to shifting from his 8x10-inch camera to the more intimate 4x5-inch format, he eliminated the landscape altogether. The effect of these decisions was to significantly decrease the descriptive naturalism of the images. Marking the conceptual reorientation of these photographs, Stieglitz changed the title of this growing body of work, first to "Songs of the Sky," with its obvious musical allusion, and then to the more metaphysical "Equivalents."

Stieglitz claimed to have begun this series to disprove a critic's statement that his artistic success stemmed from his "hypnotic" power over human subjects.[69] This spur hardly seemed necessary, however. In fact, the Equivalents represented a logical extension of his most basic idea: the use of the camera in a self-referential and transcendental quest. Even in his 1921 review of the O'Keeffe pictures, Rosenfeld had noted that "Stieglitz has caught many moments, some apparently the most fugitive, some apparently the most trivial…and in each of them, he has found a symbol of himself."[70] Symbolist aesthetic theory, which formed the root of Stieglitz's artistic philosophy, held that the artist transformed the objective facts of the world into the subjective poetry of personal expression. Thus, the abstract forms of art—the shapes in a painting or the melody of music, for example—corresponded to real, but otherwise inexpressible, states of mind. For Stieglitz and the artists of his circle, a painting was "the pictorial equivalent of the emotion produced by nature."[71]

If Stieglitz's photographs of O'Keeffe depicted the transcendent beauty of life through the example of a single, protean being, his Equivalents (plate 33) were at once more abstract and more literal. In these cloud photographs, Stieglitz looked skyward to the most traditional symbol of infinity and transcendence. There, he found tones and

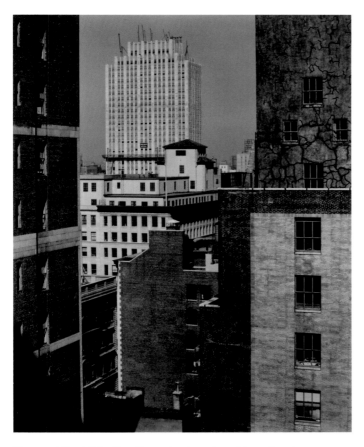

Fig. 22 **Alfred Stieglitz**, *From An American Place, Southwest*, 1932, 9½ x 7½"

Fig. 23 **Alfred Stieglitz**, *Grasses, Lake George*, 1933, 7¼ x 9⅜"

textures analogous to the equally evanescent and changeable states of the human soul. As richly nuanced passages of visual music, the Equivalents were eloquent metaphors for the human condition.[72] Their complex orchestration of light and dark connoted "the generalizations—ideas of attraction and repulsion, struggle and unity, peace and conflict, tragedy and deliverance—that emerge from every individual experience."[73] But what is more, they suggested a profoundly mystical connection between the subjective self and the world outside it. Ultimately, the Equivalents implied that the coordinates of the soul could be mapped on the surface of the world, and, conversely, that the universe was knowable, intuitively, as an intimate aspect of the self.

These mystical and intensely subjective notions underlay Stieglitz's last important series of photographs: views of New York City and of his family property at Lake George. These pictures, made primarily in the early 1930s, represent an attempt to find aesthetic order and personal meaning in the realms of both nature and culture. The New York pictures were the culmination of a life-long interest in the city. Stieglitz had photographed New York since the early 1890s, and first used his 8x10-inch camera to make precisely composed formal studies of its buildings in 1915. The 1915 images blend an interest in the inherent geometry of urban structures with the picturesque effects of snow, rain, and nightfall. His later city pictures, such as *From An American Place, Southwest*, 1932 (fig. 22), dispense with impressionistic effects to focus on the interplay of architectural forms,

and on the way sunlight and shadow caress, reveal, and engulf the works of man. From the windows of his high-rise gallery and apartment (figuratively halfway to the clouds), Stieglitz employs a point of view at once all-embracing and aloof. The human vitality of the street is not depicted. Instead, these pictures suggest the grand rhythms of creation and dissolution through architectural symbols: a new building rises above the skyline as an older one, nearer at hand, crackles with age.

In his Lake George images, Stieglitz uses the simplest of subjects—water, sky, grass, and trees—to fashion an artistic vision of clarity, harmony, and spirituality.[74] Through his eyes, the accepted symbolism of natural forms was amplified and deepened. Poplar trees, for example, had long been seen as "green church spires of nature, pointing steadfastly upward,...like perpetual symbols of aspiration toward the light."[75] But in Stieglitz's images, poplars take on a more obviously personal, rather than merely anecdotal, meaning. Similarly, in his finest picture of grasses (fig. 23), Stieglitz celebrates the logic of natural life—at once complexly tangled and elegantly ordered. This image, made on a summer morning in 1933, depicts the rays of the rising sun refracted through delicate droplets of dew. Stieglitz's camera is focused on the grass at the bottom of the frame, and his controlled depth of field softens the image with distance. As we read this photograph from foreground to background, we slide imperceptibly from naturalism to abstraction, from physical reality to a disembodied radiant glow. The sun's heat will soon evaporate the dewdrops, with the cycle to be endlessly repeated. From the simplest subject matter, Stieglitz has fashioned a profoundly moving statement on both the brevity and comforting continuity of life.

Stieglitz's complex career reveals a steady shift from collective to individual concerns, from democratic to aristocratic notions of the artist, and from a largely pragmatic to an increasingly mystical view of the world. In the first half of his artistic life, Stieglitz was devoted to making fine images widely available through graphic art processes. After 1917,

he concentrated on making just a few exquisitely crafted prints on the most beautiful photographic papers available.[76] It was said that each of these later prints was the result of "fifty, of one or even two hundred attempts at printing satisfactorily."[77] These precious images were exhibited sparingly and rarely sold. At the same time, the subject of his photographs "moved steadily away from the social to the abstract, from man as the center to form as the center."[78] Despite his dedication to a democratic ideal, Stieglitz's passion, egotism, unwillingness to compromise, and devotion to mystical absolutes meant that his work would be seen and appreciated by a relatively elite audience.

"Visions of Forms, Unit by Unit": *The Clarence H. White School*

A truly democratic alternative to Stieglitz's sublime but insular aesthetic was offered by Clarence H. White. Both men were dedicated to artistic expression, but only White felt that serious photography had a place in practical life. While Stieglitz rejected all forms of compromise and commercialism, White (who, unlike Stieglitz, always had to work for a living) helped train a generation of professional photographers. For his influence on the field and his encouragement of a variety of approaches, White deserves a central position in the history of modern American photography.[79]

White's teaching career began in 1907 when he was hired by Arthur Wesley Dow to lecture on photography at the Teacher's College of Columbia University. White took on teaching duties at the Brooklyn Institute of Arts and Sciences in 1908, and two years later he began a summer school course in Maine with the assistance of the painter Max Weber. White's students from these years included Karl Struss, Doris Ulmann, and Margaret Bourke-White. In 1914, again with Weber's collaboration, White founded the Clarence H. White School of Photography at his home in New York City. This school, the most important of its kind in the country, attracted a broad range of students, including Edward R. Dickson, Ira W. Martin, Clara Sipprell, Laura Gilpin, Dorothea Lange, Ralph Steiner, Paul Outerbridge, and Anton Bruehl. White was assisted in his teaching duties by Weber, Paul L. Anderson, and former students such as Struss, Bernard Shea Horne, Margaret Watkins, Alfred Cohn, and Arthur D. Chapman.

After a final break with Stieglitz in 1912, White became the center of a loose-knit group (which included Käsebier and Coburn) dedicated to promoting a more inclusive definition of artistic photography. This effort took various forms, including the organization of several important exhibitions. A large survey of modern photography was presented at the Montross Galleries in 1912, and in 1914 two exhibits were organized for the Ehrich Galleries, one of contemporary photography and another of nineteenth-century pioneers selected by Coburn. Two years later, White's group assembled an even more ambitious historical survey for the National Arts Club. In 1921 White also oversaw the estab-

lishment of the Art Center, an amalgam of seven New York arts and crafts organizations that provided space for photographic exhibitions and a site for lectures and workshops.

Between 1913 and 1917, White's group published *Platinum Print: A Journal of Personal Expression* (later renamed *Photo=Graphic Art*). This elegant publication, designed by typographer Frederick W. Goudy, included reproductions of contemporary work and articles on the art and technique of photography. Under the editorship of White's protégé Edward R. Dickson, *Platinum Print* was, in essence, a *Camera Work* for those more interested in photography than avant-garde painting. In 1916, this group also founded the Pictorial Photographers of America (PPA), a national organization dedicated to the cause of artistic photography. White was made its first president. Chapters were established in seventeen states, and all interested parties—amateurs and professionals alike—were encouraged to join. The PPA created exhibitions for national tour and organized monthly shows at the Art Center. Between 1920 and 1929, the PPA published five editions of its journal *Pictorial Photography in America*, each containing useful essays and numerous reproductions.[80] The effect of these varied activities was to create a sense of shared purpose among the nation's more progressive photographers.

The White School's teaching philosophy was pragmatic and useful to students of widely varying abilities. White was a great admirer of Arthur Wesley Dow's pedagogical views and, in his own classes, drew liberally from Dow's influential book *Composition*. White intuitively embraced Dow's emphasis on *notan* (the harmonious balance of both form and tone), as well as his faith in the unity and social utility of the arts. Weber, also a disciple of Dow's, played a critical role in the White School curriculum. His lectures emphasized the structural principles common to all successful images. This formalism is conveyed clearly in his *Platinum Print* essay "The Filling of Space."

> It lies within the domain of the plastic arts to reorganize forms, to reconstruct and interpret nature, to create or realize forms and visions of forms, unit by unit. And intervals between—the interval, the mind pause, the contemplation, the generating energy make yield the material whether in two or three dimensions, for matter yields in measure with and in degree of the intensity of the creative power of the artist or artisan.
>
> The photographer's art lies supremely in his choice or disposition of visible objects, as prompted and guided by his intellect and his taste. His mind is his screen. He may shift objects, he may choose his position, he may vary the spaces between moveable objects, and finally he may vary the proportion and size of the rectangle bounding the picture or print.[81]

Years later, one of the White School students remembered Weber's teaching as a kind of Zen parable: "Don't go out and photograph things, photograph the in-betweeness of things."[82]

The photographers of the White School strove for an evocative balance between the objects of the outer world and

Fig. 24 **Milton Lefkowitz,** *Interior of the Clarence White School,* ca. 1925, platinum print, 3⅝ x 4⅝"

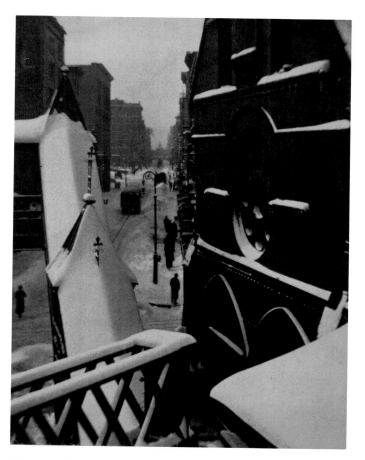

Fig. 25 **Arthur D. Chapman,** *Diagonals,* 1914, platinum print, 7⅞ x 6"

the synthetic harmony of the abstract image. As Weber's reference to the "screen" indicates, this approach celebrated the photograph as a two-dimensional graphic creation. This emphasis on visual relationships—the subtle balancing of light and dark, mass and void—represented one of the major differences between the White aesthetic and Stieglitz's. While every bit as masterful in "composing" his pictures as any in the White group, Stieglitz was primarily concerned with the Form (as he would have expressed it) of his subject rather than the graphic form of the image. This Form was both objective and transcendent, with the photograph simply the most appropriate transcription of an outer reality. Subject matter was thus of critical importance to Stieglitz, while White's disciples would happily photograph almost anything, beginning with the school itself (fig. 24). The White School's complete openness to various stylistic approaches, and its linkage of photography to other modes of picture making, further distinguished it from the stern purism of the Stieglitz circle. As photographic historian Bonnie Yochelson has observed, Stieglitz's

> rhetoric of straight photography was metaphysical—concerning the unique powers of the camera to penetrate reality —and moral—concerning the photographer's purity of expression and honest use of his remarkable tool. To discuss the structure of photographs in terms equally applicable to other two-dimensional images denied photography's unique properties and was therefore taboo.[83]

Advocates of "straight" photography considered the White approach conservative and shallow, an exercise in design rather than in "real" photographic seeing. The case against the White School aesthetic was made forcefully in 1918 by Grancel Fitz:

> The work of this group is notable for the following characteristics: It is usually good in arrangement and tone, and shows an amazing facility for making pictures out of nothing. This facility is nobly abetted by the too wide-open use of soft-focus lenses, which, like charity, can cover a multitude of sins. The workers usually know how to print and mount, and seem to have, as their ideal, the exaltation of the

trivial, wherefore they also make, not pictures, but exercises. Their work is as a class unforgivably anaemic. I have never seen a print, with the possible exception of one or two by Struss, which has the slightest chance to endure, nor have I seen a single print produced by this group which in its conception had a full quota of he-man guts.[84]

From the point of view of the predominantly male Stieglitz circle, the photographs of the White School were too "feminine."[85] The characteristic White School pictures were subtle rather than bold, idealist but not transcendent, and contemplative rather than provocative. These represented a kind of "romantic modernism" that sought to blend old and new ideas in an evolutionary, rather than a revolutionary, way of seeing. In these works, the photographers used pictorial harmony as a symbol for human accord, and sought a balance between individual expression and collective values.[86]

The White School emphasis on graphic composition and "space filling" is abundantly clear in the work of Karl Struss (plate 24) and Arthur D. Chapman (fig. 25). Both photographers created highly refined formal arrangements that strike a graceful balance between description and abstraction.[87] Design itself is the subject of still lifes by Margaret Watkins (plate 36) and Bernard S. Horne (plate 37). Watkins and Horne both studied and taught at the White School, and their work typifies the sort of compositional explorations that were encouraged in the classroom. Though they carefully maintained references to a world of familiar things, these highly reductive photographs were among the most experimental of

Fig. 26 **Alfred Cohn**, *Shadows*, ca. 1920, 6¼ x 8⅜″

the period. Both photographers were widely exhibited and published, with particular praise given to Watkins's ability to create modernist abstractions from the contents of her kitchen sink.[88] Alfred Cohn's *Shadows*, ca. 1920 (fig. 26), extends this exploration of graphic form even further in the direction of nonobjectivity. From this disembodied image of light and shade, it would be a relatively short step to the cameraless photogram, the most radical expression of the modernist photographic vision of the 1920s.

Perhaps the most talented of the White School students was Paul Outerbridge, Jr. After studies at the Art Students' League and a brief stint in the Army, Outerbridge enrolled in the White School in 1921. Finding White himself a "great inspiration," Outerbridge made rapid progress.[89] His capacity for visual invention was unmatched, and he excelled in the creation of exquisitely crafted still life photographs depicting familiar things in strikingly unconventional ways. One of the most important of his early pictures is *Saltine Box*, 1922 (plate 39). This image of an inverted tin box was the second of two slightly different versions. The first and better known of the pair is a tightly cropped view in which the simple metallic shape is both defined and complicated by Outerbridge's intense lighting.[90] The planes of reflected light and cast shadow, together with the stark form of the box itself, create a curious geometric and perceptual puzzle.[91] For the second picture, Outerbridge added two elements: a table-top edge (in the bottom right corner), and a fragment of one of his dark slides (in the upper right corner). These subtle changes add considerably to the graphic dynamism and spatial ambiguity of the image.[92] The cool formalism of these pictures exemplifies Outerbridge's belief that photography was primarily an "intellectual" art.[93]

Outerbridge's *Piano Study*, 1924 (plate 38), is similarly complex. Through his careful choice of viewpoint, Outerbridge creates a polyrhythmic arrangement of line and shape which plays back and forth between three-dimensional description and a purely graphic abstraction. From a rather pedestrian and sentimental subject—his family's Steinway piano—Outerbridge fashioned a remarkably elegant state-

ment on the analytical pleasures of seeing. This stylistic refinement quickly brought Outerbridge recognition in the worlds of both art and commerce. His earliest commercial assignment, an Ide Collar advertisement, was published in *Vanity Fair* in 1922. Within two years his pictures were featured in such publications as *Arts and Decoration, International Studio*, and *Harper's Bazaar*. Capitalizing on this acclaim, and eager for new challenges, Outerbridge left for Europe in early 1925. After returning to New York in 1929, he became celebrated for his pioneering work in the difficult carbro color process.

Ralph Steiner, a classmate of Outerbridge's, studied with White in 1921-22, before beginning an influential career as a photographer, picture editor, and filmmaker. In later life, Steiner downplayed the influence of White and his teachings, expressing bemused annoyance with the program's relentless emphasis on "design, design, design."[94] It seems clear, however, that Steiner absorbed White's lessons.[95] His commercial work of the later 1920s, for example, made consistent use of bold forms and patterns—as well as a robust sense of humor—to create visual impact from the most familiar objects (plate 41). The White School embraced the application of artistic principles to commercial work, recognizing the relevance of "the new, direct attitude" in photography to the needs of advertiser and art director. As Watkins observed in her essay "Advertising and Photography," the confluence of art and business created a new visual climate in which "stark mechanical objects revealed an unguessed dignity; [and] commonplace articles showed curves and angles which could be repeated with the varying pattern of a fugue."[96] This understanding is evident in Steiner's amusing study of alarm clocks and coffee cups.

The career of Doris Ulmann reveals a very different application of White School design principles. Ulmann studied and lectured at the school in its first years of operation, and was also active in the Pictorial Photographers of America. Her work of the late 1910s and early 1920s clearly reveals her adherence to the design concepts promoted by the White circle. However, unlike the younger and more sleekly modern photographers, who were interested primarily in abstract form, Ulmann applied these lessons in the architecture of picture making to the documentation of America's cultural past. Beginning in the mid-1920s, Ulmann traveled thousands of miles in a preservationist quest to record vanishing ways of life. While the majority of this work was done in Appalachia, Ulmann's studies of rural life took her to Dunkard, Mennonite, and Shaker communities in Virginia, Pennsylvania, New York, and New England. She also photographed the Gullah people of South Carolina and the French Creole and Cajun communities in Louisiana. The retrospective mood of Ulmann's photographs was enhanced by her anachronistic technique. Long after more advanced equipment was available, she worked with a 6½ x 8½-inch view camera and a soft-focus lens without a shutter. She made each exposure by manually removing and replacing her lens cap, so her subjects had to be carefully—and self-consciously—

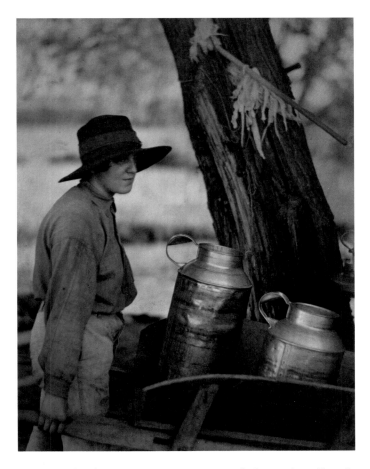

Fig. 27 **Doris Ulmann**, *Farmerette, ca.* 1925, platinum print, 7⅞ x 6″

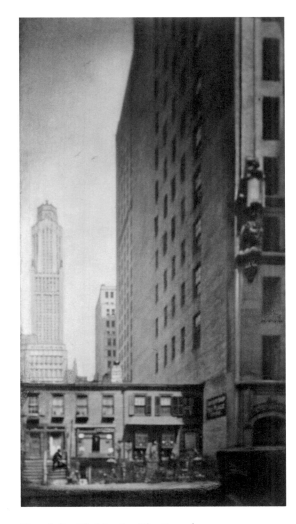

Fig. 28 **Ira W. Martin**, *The Dwarfs*, ca. 1923, platinum print, 9⅜ x 4⅞″

posed. This resulted in a style, at once quaint and heroic, that transformed anonymous craftsmen (plate 43) and farm laborers (fig. 27) into icons of simplicity and industry. By synthesizing a concern for the abstract principles of pictorial design with a romantic quest for a largely premodern past, Ulmann created a body of work uniquely poised between early twentieth-century Pictorialism and 1930s social realism.

Laura Gilpin's work reveals a similar sensitivity to the vestiges of time and tradition. Gilpin studied at the White School between 1916 and 1918, and was strongly influenced by White, Weber, Anderson, and Horne. She was especially dedicated to the craft of photography—she printed on platinum paper long after American firms ceased producing it—and to the importance of pictorial design.[97] Returning to her native Colorado, Gilpin embarked on a professional career as a portrait and architectural photographer. Her interest in the American West led her to record many of the region's most spectacular sites—including the Grand Canyon, Canyon de Chelly, Zion Canyon, and Bryce Canyon—in photographs that are delicately seen and boldly structured (plate 42). In later years, she devoted considerable energy to recording the indigenous cultures of the Americas as shown through the archaeological ruins of the Yucatan and the lives of the Navajo and Pueblo.[98]

Other aspects of the White School aesthetic are revealed in the works of lesser-known photographers such as Wynn Richards, Eleanor Ludeman, Ira W. Martin, and Frances M. Bode. Richards studied with White in the late 1910s before embarking on a successful career in commercial and fashion photography in Chicago and New York.[99] Her *Woman with Veiled Hat,* ca. 1918 (plate 44), uses delicate tones, a shallow plane of focus, and a hint of solarization to create an unexpectedly dynamic and dreamlike effect. Urban and technological landscapes are the subject of Martin's *The Dwarfs,* ca. 1923 (fig. 28), which focuses on incongruous juxtapositions of scale and wealth, and Bode's *Repetition,* 1925 (plate 40), which uses a moderate downward perspective to transform a catalogue of modern industrial subjects—automobiles, railyards, factories, and bridges—into a tapestry of rhythmic angularity.[100] Ludeman's boldly minimal 1926 picture (fig. 29) is typical of the White School penchant for finding the abstract in the ordinary. In its almost surrealistic conjunction of the human and mechanical, both are reduced to generic fragments.[101]

White's enthusiasm for artistic discovery is revealed clearly in his own work. One of his most remarkable late pictures, *Croton Reservoir,* 1925 (plate 45), was made only two months before his death.[102] Although this print embodies the warmth and craftsmanship of White's most celebrated Pictorialist work, it has little in common with his earlier domestic idylls. Here, the oblique perspective, selective use of focus, and tight cropping all transform this quintessentially

Fig. 29 Eleanor L. Ludeman, *Hand Abstraction*, 1926, platinum print, 4¾ x 3⅝"

modern subject—the spillway of a large dam —into an abstract puzzle. Space seems to collapse on itself as foreground and background are enmeshed in a complex network of graphic incident. There is nothing sentimental or picturesque about this image. It is, rather, a provocative exploration of pure lenticular vision, as radical as any of László Moholy-Nagy's camera images of the same period. This picture suggests the generous breadth of White's aesthetic, which embraced new ideas without discarding old virtues.

The Salon Aesthetic

Inclusiveness was the hallmark of the Pictorialist salons between the wars. These exhibitions presented all manner of artistic photography, from straight to manipulated, and from the most provocatively modern to the most comfortingly traditional. White and his associates were particularly active in promoting a range of photographic styles, and they contributed to the boom in photographic exhibitions and publications after World War I. For example, in the winter of 1917-18, the Pictorial Photographers of America organized a national survey of artistic photography that was presented in the leading art museums in Minneapolis, Milwaukee, Chicago, St. Louis, Toledo, Detroit, Cleveland, Cincinnati, Worcester, Syracuse, and New Orleans.[103] Similarly, the five issues of *Pictorial Photography in America* were crucial in documenting the most interesting work of the era. These activities bolstered the cause of artistic photography nationwide and encouraged a diversity of approaches and subjects.

Artistic photographers of this era had many opportunities to exhibit their work. Since its beginning in 1914, the Pittsburgh Salon of Photographic Art was regarded as the nation's most prestigious annual salon. Presented in the galleries of the Carnegie Institute, the Pittsburgh Salon provided a forum for the leading Pictorialist work of the era. Important annual salons were also hosted by organizations or museums in Los Angeles, Buffalo, Portland (Maine), Portland (Oregon), Seattle, Syracuse, and San Francisco. In addition, many Americans regularly submitted work to international salons in London, Glasgow, Edinburgh, Liverpool, Paris, Turin, Montreal, Toronto, and elsewhere.[104] The salon movement enjoyed considerable growth in the years between the world wars. During the 1925-26 exhibition season, for example, Americans participated in some forty-four international salons. A dozen years later, the number of exhibitions had more than doubled to a total of ninety-one.[105]

In this same twelve-year span, the number of American exhibitors grew from slightly less than 500 to just over 600. Although located across the country, these men and women had a clear sense of collective identity, thanks in large measure to the annual "Who's Who in Pictorial Photography" published in the *American Annual of Photography*. These exhaustive rosters provided statistics on the number of salons successfully entered and the total number of prints shown by every exhibitor. The quantitative emphasis of these rankings created a competitive climate in which photographers sought to outscore each other. In the 1925-26 season, twenty-five individuals showed in ten or more salons. Twelve years later, this mark was reached by no fewer than 122 photographers. The clear winner in this numbers game was the tireless Max Thorek of Chicago, a surgeon and dedicated artistic photographer. Thorek showed 316 prints in eighty-two salons during the 1937-38 exhibition season alone, having exhibited a staggering total of 1,555 prints in 341 salons in the previous five years.[106]

Before this inflation diluted their significance, the salons provided an important forum for most of the nation's artistic photographers. In the years after World War I, for example, some of the most noted salon exhibitors included George W. Harting, John Wallace Gillies, Edward R. Dickson, Dwight A. Davis, Wilbur Porterfield, Dr. Rupert S. Lovejoy, John Paul Edwards, James N. Doolittle, P. Douglas Anderson, Dr. D. J. Ruzicka, Dr. Amasa Day Chaffee, Paul L. Anderson, Laura Gilpin, Imogen Cunningham, Clara Sipprell, Louis Fleckenstein, Doris Ulmann, Arthur F. Kales, Nicholas Muray, Anne Brigman, W. E. Dassonville, Forman Hanna, William H. Zerbe, and O. C. Reiter. Photographers of this caliber all worked in clearly distinguishable styles. For example, Lovejoy was considered the master of the multiple gum print and Chaffee of the bromoil, while Hanna was renowned for his Arizona landscapes and nudes.

The postwar salon movement was characterized by a stimulating diversity of techniques and subjects. Sentimental images were common, but the leading salons showed more varied and progressive work than has been generally acknowledged. Harting, Gillies, and Dickson, for example, continued the Dow/White tradition of "space filling," producing consis-

tently subtle and elegant photographs. And, while domestic and allegorical themes remained popular, many photographers of the late 1910s and early 1920s turned their cameras on the geometric forms of the city and the restless energy of the street.[107] Unusual perspectives and processes were also explored in this period. For example, John Word Caldwell created a stir when he exhibited a negative print of a geometric urban subject, seen from above, in the 1928 Pittsburgh Salon.[108] Other salon exhibitors, such as the New York City newspaper photographer William H. Zerbe, found aesthetic form in the dramatic incidents of urban life.

The complexity of the postwar salon aesthetic is further revealed in the movement toward "straight photography," sharply focused images printed without manipulation on simple bromide or chloride papers. Usually defined as a reaction against Pictorialism, the straight photograph was in fact an integral element of the salon aesthetic.[109] In 1916, for example, a writer in the *Photographic Journal of America* noted approvingly that "the straight print...stands for what it is, a simple, direct, straightforward piece of photographic craftsmanship, to which is coupled an artistic ideal of the best that the medium will allow."[110] In the 1924 Pittsburgh Salon, Gillies created a "startling departure in exhibition-work" by exhibiting glossy bromide prints. A critic reported that, "evidently taken by his audacity, the jury accepted three of these; for sheer beauty they compare favorably with anything in the show."[111] Another observer noted that in the American section of that year's Paris Salon "straight photography was very prominent, and there was little of that diffused work which we were led to expect."[112] This trend continued, and by the late 1920s, bromide and chloride prints greatly outnumbered the processes favored earlier in the decade, such as bromoil, gum, carbon, and platinum.[113]

The heterogeneous nature of the salons provided a forum not only for various processes and subjects, but for diverse groups of photographers as well. It is notable, for example, that the talents of Japanese-American photographers in the 1920s were most fully recognized in the Pictorialist salons and publications. These photographers, some U.S. citizens and some temporary residents, lived primarily on the West Coast.[114] In Seattle, photographers of Japanese heritage gathered around Kyo Koike, an active exhibitor and writer on photography.[115] Koike was a founding member of the Seattle Camera Club (1924), editor of the club's bimonthly bulletin *Notan*, and the guiding spirit behind the club's five annual Salons (1925-29). Similarly important were the Japanese Camera Club of San Francisco and the Los Angeles-based Japanese Camera Pictorialists of California. The L. A. organization, founded by Kaye Shimojima, included such notable members as K. Ota, K. Asaishi, and Kentaro Nakamura.

One of the most admired Japanese-American photographers was Toyo Miyatake. After studying photography in Los Angeles with Harry Shigeta, Miyatake became one of the city's leading portraitists. He befriended Edward Weston about 1920, and subsequently arranged four highly success-

ful exhibitions of Weston's work in the Los Angeles Japanese community.[116] Miyatake's own photographs (plate 46) exemplify the traits for which the Japanese-American photographers were known: a reductive emphasis on line, pattern, and geometry to create elegantly formal, poetic effects.

Kentaro Nakamura's *Evening Wave*, ca. 1927 (plate 47), was one of the best-known images produced in this era by a Japanese-American photographer. Reproduced in American, English, German, and even Russian photographic journals, this work found favor with Pictorialists and modernists alike.[117] *Evening Wave* represents an eloquent blend of naturalism and abstraction. Its massive swell of water suggests both tranquility and power, providing an apt metaphor for the Japanese-American aesthetic as a whole.

It is not surprising that such work was widely exhibited and admired.[118] Japanese-American photographers brought to bear on the issues of artistic photography a clear understanding of their own artistic heritage, aspects of which had been "translated" by the Pictorialists as part of the formalist/modernist aesthetic. Progressive Western photographers had been introduced to the idea of *notan* through Arthur Wesley Dow and the White School, but the work of the Japanese-Americans expressed such notions in "first generation" form. Thus, while criticized by some as overly reductive, such work was in fundamental harmony with the most progressive Pictorialist ideas of the time. Unfortunately, this same strong cultural identity led to the loss of much of this work in the anti-Japanese hysteria of World War II.[119]

While the salons remained a step behind the most avant-garde work of the era, to the most traditional Pictorialists, this seemed a very small step. Indeed, in 1930 Ira W. Martin, then president of the Pictorial Photographers of America, argued that meaningful artistic photography could only result from an embrace of modern life. His standard for such work would have appealed to even the most radical modernist: "beautiful textures, commonplace subjects portrayed in unusual and interesting ways, steel structures, dynamic compositions..., significant shapes and forms—all done with the precise, direct reality of the age in which we now live."[120] While many American photographers accepted this point of view and worked accordingly, others, such as the venerable Pictorialist Paul L. Anderson, vehemently rejected what they considered an impoverished new orthodoxy. In an essay in *American Photography* as late as 1935, Anderson ridiculed

> the worm's-eye views of helical staircases; the fire-escapes; the coils of rope; the interiors of alarm clocks; the ghastly abominations of photo-montage; the rows of ploughshares; the under-exposed and over-developed things of chalk and soot; the worm's-eye views of the Empire State Building, taken with a red filter, so that the whole structure seems to be falling backward into a black sky; the bird's-eye views of the same building, which look like a Cubist's design for a child's toy; the nightmares of toy balloons and confetti![121]

For such critics, modern photography lacked humanity, replacing personal feeling with the "purely mechanical."[122]

Fig. 30 **William Mortensen,** *Fragment of the Black Mass,* 1926, 7¼ x 5¾″

Fig. 31 **Adolf Fassbender,** *City Symphony,* ca. 1930, 13½ x 10¾″

This represented a rejection of the basic ideas of classic Pictorialism, which had established that artistic photographs were a matter of temperament rather than technique. It was a fear of losing hard-won ground that prompted old-timers such as Anderson to exhort photographers of the 1930s to be artists rather than factories, "pouring out prints as an automatic machine pours out nuts and bolts."[123]

This rejection of the inherently mechanistic nature of photography lay at the heart of the most characteristic late Pictorialist work. Three of the most notable figures in this movement were William Mortensen, Max Thorek, and Adolf Fassbender. In addition to exhibiting extensively, each exerted considerable influence through their writings. Among their most important books were Mortensen's *Monsters and Madonnas* (1936), Thorek's *Creative Camera Art* (1937), and Fassbender's *Pictorial Artistry: The Dramatization of the Beautiful in Photography* (1937).[124] All three advocated an aggressively "impure" approach to the medium. For them, the straight photograph was a stark record which merely provided the starting point for genuine creative expression. Mortensen, in particular, was known for his flamboyantly manipulated style (fig. 30). His melodramatic images began in the studio, where he created theatrical tableaux based on artistic or literary models. He transformed his models through generous applications of makeup, and then heavily retouched his negatives and prints to create images that look more like lithographs or engravings than photographs. The high artifice of Mortensen's images reflected, in his mind,

their function as intellectual creations with universal and timeless appeal. Similarly, both Fassbender and Thorek (figs. 31, 32) used retouching and paper internegatives to evoke the look of drawings or fine-art prints. While rejected by modernists as hopelessly retrograde, this work was widely admired by traditionalists of the era.

The Weston Circle

The complex nature of 1920s Pictorialism is suggested by the early work of Edward Weston and that of his most notable associates of the period, Margrethe Mather, Johan Hagemeyer, and Tina Modotti. Weston's career as a photographer began in 1911, the year he opened his first portrait studio in the Los Angeles suburb of Tropico (now Glendale), California. Talented and ambitious, Weston quickly established a national reputation for his "romantic and decorative" photographs, and won numerous awards in the salons of the time.[125] In the late 1910s and early 1920s, Weston's artistic ideas evolved rapidly. His most important early intellectual influence was Mather, who was far more knowledgeable than Weston about contemporary art, literature, and social issues. Mather was also Weston's model, studio assistant, and occasional collaborator. Weston and Mather met Johan Hagemeyer in about 1917. Hagemeyer, who had left his native Amsterdam in 1911, was a worldly figure with a passion for photography, radical political causes, and classical music. The two men became very close, and, for a time,

Fig. 32 Max Thorek, *Europe*, 1939, 15¾ x 12¾"

Hagemeyer lived with Weston's family and assisted him in the studio. Together, Mather and Hagemeyer encouraged Weston's bohemian inclinations and increased his artistic sophistication.

Mather's exhibition career as a photographer was relatively short, lasting essentially from only 1917 to 1921. Nonetheless, she was a photographer of exceptional talent. Mather was singled out for the "excellent taste" of her work in the 1917 Pittsburgh Salon.[126] Later, she was praised as "a worker of strong individualism" whose pictures were deemed "refreshingly original."[127] In 1921, a critic noted, "[Mather] shows a great appreciation for the value of space and handles it admirably."[128] All these qualities are apparent in her 1921 double portrait of Hagemeyer and Weston (plate 50). Besides capturing the individuality and close friendship of the two men, the picture has a strikingly original composition that stems from the radical cropping of the faces and the centrality of the richly toned shadow between them. Mather's fragmentation of the figures and her use of "negative space" were distinctly unusual, in many ways more daring than Weston's own pictures of this time.

Hagemeyer also received great critical praise for his work, the best of which was produced in 1921-22. In his most original photographs, Hagemeyer focused on the forms and rhythms of urban life. His 1921 images of the jaw of a steam shovel and a detail of a truck wheel were celebrated as "very suggestive of [the] gigantic industrial enterprise...of this mechanical and constructive age."[129] Hagemeyer's work

had a "decided individuality" and "a bigness" that distinguished it from that of his contemporaries.[130] In a 1922 essay, Hagemeyer himself dismissed much of the artistic photography of the day as "mediocre," and typified by "a decided similarity of idea—or rather a lack of any original idea."[131]

Just what Hagemeyer meant by original ideas is eloquently revealed in two of his most celebrated pictures, *Castles of Today* (plate 52) and *Pedestrians* (plate 53), both of 1922. In both images, shadows play an important graphic and compositional role. *Pedestrians* focuses on the dynamic flux of the modern city street: Hagemeyer uses focus, viewpoint, and light to transform passersby into shimmering specters, at once real and illusory, frozen in pictorial amber. In *Castles of Today*, Hagemeyer creates a boldly geometric harmony from the disparate architectural forms of the San Francisco skyline. As he explained in a later interview, the title of this image carried considerable meaning for him.

> I became interested in industrial subjects before I did in portraits. I started to make them with the intention of putting them in book form to show the beauty in American industrial work. I am interested in everything contemporary and believe that we should live in our own time—seeing the beauty of today instead of worshipping that of the past. Modern factories and buildings are as beautiful as old castles. They are the castles of today.[132]

Despite his skill as an artistic photographer, Hagemeyer's need to earn a living forced him to turn his energies to portraiture in 1923. He opened a studio in Carmel, California, and his subsequent artistic work never equaled his earlier efforts. In truth, his pictures of 1921-22 represent a brilliant but transitional synthesis of new and old. While Hagemeyer's modern subject matter and rigorous formalism anticipate the finest achievements of the photography of the later 1920s, his soft-focus aesthetic stemmed from the previous decade. The avant-garde's increasing penchant for optical sharpness soon made Hagemeyer's work seem anachronistic, despite its real complexity.

While Mather and Hagemeyer created profoundly original work in the first years of the 1920s, Weston eventually grew far beyond them. From the mid-1910s, when he first began exhibiting internationally, to the late 1920s, when he came to full artistic maturity, Weston worked his way through an interest in tonal delicacy and graphic design to a precisionist rendition of sculptural form. His early influences included *Camera Work*, the modern European paintings he saw at the 1915 Panama-Pacific International Exposition in San Francisco, and the ideas of friends such as Mather and Hagemeyer. In the years up to 1923, Weston's pictures were exhibited widely in the leading salons, and were praised as "sometimes startling in their originality" and as "ultra-modern" in conception.[133] Based on his reading of essays by the Stieglitz circle, Weston grew to appreciate the power of the camera to "truthfully represent natural objects [without] trick, device, or subterfuge."[134] In the fall of 1922, Weston made his first photographs of modern industry, a subject

familiar to him from Hagemeyer's work. He then visited New York, where he met Strand, Sheeler, White, and, most importantly, Stieglitz. These experiences reinforced Weston's progress toward a "purist" aesthetic, though this evolution was gradual and deliberate. A good example of Weston's late Pictorialist style is his exquisite 1923 portrait of Karl and Ethel Struss (plate 51), which blends a sense of warm intimacy with a boldly simple composition.[135]

In July 1923, Weston left Los Angeles for Mexico, seeking the freedom he felt he needed to come to full artistic maturity.[136] Accompanying him on this voyage of self-discovery was Tina Modotti, a part-time actress and a member of the Los Angeles art community. Modotti had volunteered to work as Weston's apprentice in order to learn photography herself. The two remained together in Mexico for most of the next three years, a period of great artistic importance for both of them.[137]

Modotti's photographs quickly achieved a high degree of sophistication and originality. By 1925, she was producing elegant close-ups of roses and lilies, architectural details of her house in Mexico City, and at least one forceful composition of rows of telegraph poles. One of the most beautiful of these early images, *Staircase, Mexico*, 1925 (plate 54), is a masterful combination of boldness and delicacy. Modotti's *Campesinos*, 1926 (plate 55), records peasants marching through the streets of Mexico City, and reflects her growing political beliefs. Before long, Modotti's commitment to leftist causes forced her to choose, in effect, between art and activism. Weston advised her to "solve the problem of life by losing [herself] in art," but Modotti could not do that. She wrote,

> I am forever struggling to mould life according to my temperament and needs—in other words *I put too much art in my life*—too much energy—and consequently I have not much left to give to art.[138]

This devotion to revolutionary causes resulted in a brief period of imprisonment and Modotti's deportation from Mexico in 1930. She spent the next decade in Berlin, Moscow, Paris, and Spain before returning to Mexico, where she died in 1942.[139]

Weston came to artistic maturity in Mexico. His Mexican-era photographs fall into several interrelated series: monumental portraits made with a hand-held camera; crisp images of clouds, landscapes, and buildings; and boldly geometric still lifes and nudes. Common to all these photographs is a new intensity of vision, a concentration on simplified forms, and a resolutely "purist" use of the photographic medium. With his more abstract approach, Weston was able to find expressive sculptural form in subjects as diverse as his enamel toilet, earthenware jugs in the marketplace, and the great pyramids at Teotihuacán.

When Weston returned to California in late 1926, he was primed for the most innovative period of his career. In the next few years, he created some of his most memorable nudes, as well as a remarkable series of close-ups of shells, peppers, onions, eggplants, artichokes, and cabbages. At the

Fig. 33 Edward Weston, *Kelp*, 1930, 7½ x 9⅜"

Point Lobos nature preserve, he made similarly direct studies of rocks, gnarled cypress trees, and kelp (fig. 33). Weston's close-up vision removes these objects from their everyday context, and renders their scale ambiguous. Common things are seen as if for the first time, and with such microscopic precision that they take on an almost surreal intensity. As Weston wrote of his now-famous *Pepper No. 30* (plate 57),

> It is a classic, completely satisfying,—a pepper—but more than a pepper: abstract, in that it is completely outside subject matter. It has no psychological attributes, no human emotions are aroused: this new pepper takes one beyond the world we know in the conscious mind.[140]

These monumental still-life images were inspired by a variety of influences, including Weston's love for the music of Bach, the elegant simplicity of Brancusi's sculpture, and the work of other painters and photographers.[141] In 1926, the year he returned to California, Weston described his approach:

> I have recorded the quintessence of the object or the element in front of the lens, without subterfuge or evasive acts, either technically or spiritually—instead of offering an interpretation or a superficial or passing impression of it.
>
> Photography is not worth anything when it imitates another medium of expression, when it avails itself of technical tricks or foreign points of view. Incoherent emotionalism must be replaced by serene contemplation; tricky dexterity must give way to honesty...[142]

The technical aspect of Weston's philosophy—an unmanipulated use of the medium—had been advocated earlier by Stieglitz, Strand, and others. What was most significant about Weston's approach was his application of straight photography to an overtly mystical project: the depiction of timeless and universal life rhythms. Weston amplified these ideas in numerous later statements. In 1931, for example, he wrote,

> I am not trying to express myself through photography, impose *my* personality upon nature (any manifestation of life) but without prejudice or falsification to become identified with nature, to know things in their very essence,

so that what I record is not an interpretation—*my* idea of what nature should be—but a *revelation* or a piercing of the smoke-screen artificially cast over life by irrelevant, humanly limited exigencies, into an absolute, impersonal recognition.[143]

At its most basic, this "absolute recognition" involved the sublime truth that

clouds, torsos, shells, peppers, trees, rocks, smoke stacks, are but interdependent, interrelated parts of a whole, which is Life. Life rhythms felt in no matter what, become symbols of the whole.... To see the *Thing Itself* is essential: the quintessence revealed direct without the fog of impressionism....[144]

Weston's vision of the unity of apparently disparate objects stemmed from a long and venerable philosophical tradition.[145] Nearly a century earlier, for example, Ralph Waldo Emerson had suggested that, with close observation, "the world shall be to us as an open book, and every form significant of its hidden life and final cause."[146] What was new, however, was Weston's union of extreme objectivity of technique with an equally extreme subjectivity of purpose. While Pictorialists had sought to evoke universals by obscuring details in an impressionistic mist, Weston found transcendence through a hyperreal magnification of visual fact.

This intense concentration of vision dominated Weston's photographs from about 1927 to 1934, but subsequently his work grew broader in both subject and viewpoint. His later nudes often included the entire figure rather than simply details of a breast or knee, and his landscapes shifted from intimate vignettes of a single rock or tree trunk to vistas of considerable scale (plate 58). While his earlier work had celebrated the whole through magnification and fragmentation, in the 1930s and 1940s Weston more often stressed the interrelatedness of things. This new attitude resulted, in part, from the sheer variety of his subjects. As the first photographer to receive Guggenheim fellowships (in 1937 and 1938), Weston traveled across the western United States, recording anything that stirred his interest. The fruits of this labor (some 1,500 negatives in two years) were published in 1940 as *California and the West*. In 1941, he was commissioned to make photographs for a limited edition of Walt Whitman's *Leaves of Grass*. For this project, Weston traveled through the American South, along the Atlantic coast and into New England, recording a great number of subjects. Weston's late work is both complex and majestic. While continuing to focus on the beauty of the natural world, his pictures of the late 1930s and 1940s contain notes of irony and surrealism, and frequent signs of death and decay (plate 59). Weston's artistic vision remained undiminished until the effects of Parkinson's disease forced him to put the camera aside in 1948.

Group f/64

By the late 1920s, Weston had achieved international fame as an artist. His work was exhibited widely and influenced many other photographers. In 1929, he was drafted to help organize the American contribution to the important "Film und Foto" exhibition, for which he chose twenty of his own prints. In both 1930 and 1932, his work was shown to considerable acclaim at the Delphic Studios in New York. In 1931, he was given a one-man exhibition in San Francisco; his book *The Art of Edward Weston* was published a year later. As an essayist, Weston was a spirited advocate of straight photography in articles such as "Photography—Not Pictorial."[147]

Soon, Weston became the focus, if not the actual organizer, of a loose association of purist photographers called "Group f/64." Besides Weston, the original members were Ansel Adams, Imogen Cunningham, John Paul Edwards, Sonya Noskowiak, Henry Swift, and Willard Van Dyke. These seven resolved to exhibit their work jointly at the de Young Museum in San Francisco, and invited four others to join them: Preston Holder, Consuelo Kanaga, Alma Lavenson, and Brett Weston. The photographs in the exhibition (which remained on view from November 15 to December 31, 1932) were characterized by a sharp-focus rendition of simple subjects, often seen in close-up and printed on glossy paper. The group's manifesto stated their desire to reject the influence of other mediums in favor of "a simple and direct presentation [of] purely photographic means."[148] The use of filters and such basic printing techniques as burning and dodging were allowed, but anything beyond these was rejected as nonphotographic.

The members of this loosely organized group worked in similar, but distinctive, styles. Close-ups of organic forms, for example, were made by several of them. Weston's influence can be seen clearly in the work of Noskowiak, his assistant and companion at the time. What distinguishes Noskowiak's *Leaf*, 1931 (plate 60), however, is the intimate scale and distinctive balance of strength and delicacy that she employs. Lavenson's *Chrysanthemum*, 1931 (plate 61) uses a similar point of view to create an image of almost radiant luminosity. The warmth of this picture contrasts markedly with the cool objectivity of most f/64 work, and may reflect the lingering traces of Lavenson's former Pictorialist style. One of the most experimental of the Group f/64 photographers was Imogen Cunningham, who had begun making bold close-ups of flowers in 1923. These were admired by many photographers, including Weston, who selected several for "Film und Foto." Cunningham's *Amaryllis*, 1933 (plate 62) is characteristic of her work of this period. Utterly unsentimental, this image effortlessly unites description and abstraction while creating figure-ground tensions that are both tonal (black versus white) and spatial (mass versus pattern).

The youngest member of Group f/64 was Weston's son, Brett, who became an accomplished photographer in 1925, at the age of 14, while living with his father in Mexico. Inevitably, the economy and directness of Brett's vision echoed Edward Weston's assertive style, but, to prove his independence, the youngster "deliberately looked for subjects his father hadn't done."[149] Thus, Brett was drawn to the unpicturesque and modern: oblique downward views of tin

Fig. 34 **Ansel Adams**, *Icicles, Ahwahnee Hotel, Yosemite National Park*, ca. 1934, 9⅜ x 7"

roofs, rows of sewer pipe segments, or stacks of kindling wood. His 1927 industrial image (plate 63), made after the Westons returned to California, is a bold and distinctive treatment of a subject to which the elder Weston gave relatively little attention. This image conveys clearly the natural sympathy between a purist use of photography and the hard-edged functionality of modern industry.

Each member of Group f/64 perceived its mission differently. At the time of the original f/64 exhibition, Cunningham was experimenting with multiple exposures and producing celebrity portraits for *Vanity Fair*, refusing to be constrained by dogma of any kind. Even Weston himself, often perceived as the archetypal purist, rejected a too-literal interpretation of straight photography. When he photographed a shell that he had carefully positioned on the rocks at Point Lobos in 1931, his purist friends were disturbed by the "artificiality" of the gesture. But Weston pointedly reserved the right to define for himself what was authentic in photography.[150]

For young Ansel Adams, Group f/64 represented nothing less than a crusade for honest photography.[151] While he had used the camera for years, Adams had only recently made a definitive career choice between photography and music. By 1929, when he began work on *Taos Pueblo*, a collaboration with writer Mary Austin, Adams had abandoned his early Pictorialist style in favor of a clean, sharp-focus vision (plate 56).[152] The twelve images of the *Taos* portfolio were printed

on warm-toned matte-surface paper, but Adams soon committed himself to "the simple dignity of the glossy print."[153] By the time of his one-man exhibition at the de Young Museum in early 1932, Adams's "straight" aesthetic was fully formed and promoted with an almost religious zeal. All his work thereafter was characterized by meticulous technique and a dramatic celebration of the natural world (fig. 34).

The most crusading Group f/64 members exhibited a similar passion for purity. In 1933, Willard Van Dyke and Mary Jeannette Edwards (the daughter of John Paul Edwards) opened a gallery in Oakland at 683 Brockhurst, the former studio of Anne Brigman. Not surprisingly, their first show was an Edward Weston retrospective. In 1934, the gallery presented the "First Salon of Pure Photography," an attempt to recognize straight photographers outside the membership of Group f/64. The jurors—Weston, Van Dyke and Adams—received over 600 prints and selected work by thirty-four photographers, including Edward Quigley, Arthur Racicot, Fred P. Peel, Luke Swank, and Sibyl Anikeef. In 1933, Adams opened his own gallery in downtown San Francisco, inspired by the example of Stieglitz's An American Place, which he had visited earlier that year. Adams also published a series of articles on photography in *Camera Craft* in 1934, and the following year issued his first book, *Making a Photograph*. These publications articulately promoted the f/64 approach.[154]

While enormously influential, this purist aesthetic also met with significant dissent. The principal opponent of the f/64 philosophy was William Mortensen, an enormously prolific photographer and writer. Throughout the 1930s, Mortensen maintained a running debate with several of the Group f/64 photographers, largely in the pages of *Camera Craft*. He infuriated Adams, Weston, and others with his outrageously contrived pictures and his polemical writings. For example, in his essay "Fallacies of 'Pure Photography,'" Mortensen defined straight photography as a regressive, rather than a progressive, movement.

> There have always been purists in art just as there have been puritans in morals. Purists and puritans alike have been marked by a crusading devotion to self-defined fundamentals, by a tendency to sweeping condemnation of all who over-step the boundaries they have set up, and by grim disapproval of the more pleasing and graceful things in life.[155]

Mortensen then proceeded to challenge the basic assumptions of photographic purism. Was complete purity in any medium possible or desirable? Wasn't it true that Michelangelo's paintings were informed by his understanding of sculpture, while Rembrandt utilized his knowledge of both painting and etching to mutual advantage? Mortensen called the purist emphasis on simplicity hypocritical, alluding to the "technical obsession" evidenced in Adams's complex array of cameras and lenses. Most tellingly, he attacked the notion that the photographer was free to control the tones of his print for "emotional" effect, but that no other manipulations were legitimate.

If tone is granted to be subject to control, why not line also, which has equal emotional significance? And if line, why not shapes and forms? And if shapes and forms, why not allow elision or emphasis of detail? And if all these things are allowed, what becomes of the "record of actuality"?...Sunk without a trace![156]

The Purist approach was misguided, Mortensen concluded, because it valued facts over ideas and emotions, strove for a rendering of "things-as-they-are" instead of "things-as-they-are-experienced," and stressed scientific accuracy over psychological truth. Ultimately, he pronounced, the purist movement as had produced little but "a series of excellent finger exercises in technique"—images that were "uniformly hard and brittle" and utterly lacking in "subjective interest."[157] This dispute over the artistic nature of the medium continued throughout the decade, ultimately producing much heat and a little light.[158]

The New Vision

While Americans were occupied with debates over the proper use of photography, avant-garde artists in Europe were exploding and reinventing it. While this "new vision" took a variety of forms, it was characterized by an unfettered exploration of the image-making potential of both the optical and chemical components of the process. This attitude of experimentation resulted in a variety of expressive techniques, including the photogram, photomontage, solarization, negative image, multiple exposure, aerial perspective, extreme close-up, and other unusual and disorienting effects. Important aspects of this new vision were embraced by the worlds of design, advertising, and illustrated journalism, giving these experimental strategies widespread exposure and influence by 1930.

This dynamic and inventive approach to photography, which originated in Russia, Germany, and France, was generated by a complex variety of factors.[159] The trauma of World War I and its aftermath produced a widespread sense that the slate of history had been wiped clean. With the stability of the Victorian past irretrievably gone, artists felt free to embrace contemporary experience as both the means and subject of their work. The result was an enthusiastic use of modern processes in an effort to convey the complexity of an urban and technological world.

In Russia and Germany this new work, now known as Constructivism, was conceived as a means of remaking society. Following the Russian Revolution in October 1917, avant-garde artists used a variety of media—including painting, graphic design, typography, architecture, film, and photography—to further what they zealously believed to be a glorious new epoch in human history. The primary aim of artists such as El Lissitsky and Alexander Rodchenko was not to create "art" or to forge a distinctive personal style. Rather, they used photography (in concert with all the other means at their disposal) to effect a revolution in perception that would, they hoped, provide the catalyst for a new social order. Defamiliarization was central to this project. By using unusual techniques and viewpoints, photographers sought to reinvent the visible world and, by making familiar things newly strange, hoped to prod viewers out of their dull habits and prejudices.[160] In revolutionary Russia, this work carried an explicitly political agenda: the creation of an ideal socialist state. The work produced in Germany tended to reflect a more science-oriented inquiry into the nature of vision and the intrinsic capabilities of materials and tools. In both countries, however, Constructivism embodied a highly utopian faith in the ability of art to transform society.

Surrealism, the dominant avant-garde movement in France in the 1920s, used the aesthetics of defamiliarization for different purposes. Extending the nihilistic and nonsensical outlook of the Dada movement, the Surrealists placed little faith in the liberating potential of technology, politics, or logical thought. Rather, the Surrealists sought psychic freedom in dreams, automatism, and the subconscious. Chance, melancholy, and desire are frequent themes in Surrealist art, giving it a wholly different tone than the rational optimism of Constructivism.

One of the most startling expressions of this new vision was the photogram, an image produced directly on photographic paper without the use of the camera. While such shadow-images had been made throughout the history of photography, it was only in the years after World War I that the technique began to be used as a means of avant-garde artistic expression. At least three independent "discoveries" of this process took place almost simultaneously. In about 1918, Christian Schad, a German painter and graphic artist living in Switzerland, produced small photograms of torn paper and fabric that reflected his interest in Cubist collage. Man Ray, who had recently arrived in Paris from New York, began using the process in the winter of 1921-22 as a means of creating dreamlike juxtapositions of everyday objects. Finally, in Berlin in 1922, László Moholy-Nagy, in collaboration with his wife Lucia Moholy, made photograms exploring the themes of transparency and light, concerns derived from his abstract paintings of the period.[161]

Man Ray and Moholy-Nagy both worked extensively with this process for a number of years, and exhibited and published their images widely. Man Ray was particularly aggressive in promoting his work. In 1922, for example, his "rayographs" were reproduced in American publications such as *The Little Review* and *Vanity Fair*, and issued in a limited-edition portfolio.[162] A year later works by both Man Ray and Moholy-Nagy were included in the avant-garde journal *Broom*.[163]

The appeal of the photogram is easy to understand. The simplicity of the technique allowed pictures to be made quickly and cheaply in the comfort of the darkroom. Artists simply arranged objects on a sheet of photographic paper and exposed it briefly to light. When processed, each area of the print was darkened in proportion to the amount of light it had received. Because it was so simply done, the process

Fig. 35 László Moholy-Nagy, *Composition with Circle*, 1922, 5 x 7"

had few controls. The look of the finished image could be known only after it was developed, and successful effects were never precisely repeatable. Each photogram or rayograph was a one-of-a-kind creation in which chance and intuition played as important a role as the artist's conscious intentions.

Their commitment to this process allowed both Man Ray and Moholy-Nagy to produce images of remarkable originality (fig. 35, plate 67). As works of art, these cameraless pictures profoundly transform visual experience and contradict our understanding of the codes of representation. Because they are negative images, these prints present a strange inversion of visible reality: light produces darkness, and shadows register as white. The process is at once entirely objective and bafflingly abstract. When flat objects, such as keys, are placed on the paper, they are recorded in silhouette, clearly recognizable and lifesize. However, images produced by dimensional objects or built up through successive layers of exposure can be utterly indecipherable. The ambiguous pictorial space of these images—at once shallow and vast, and unsubmissive to the logic of one-point perspective—is also confounding. Ultimately, the best photograms and rayographs unite the functions of document and dream as they both register and disembody the real. Mysterious and hallucinatory, the cameraless image provided a truly radical interpretation of the expressive possibilities of photography.

The Avant-Garde in Germany

László Moholy-Nagy was a central figure in the German avant-garde of the 1920s. After serving in the army in his native Hungary, Moholy-Nagy decided to become a painter. He moved to Berlin in 1920, and soon became part of the city's avant-garde community. Interested in a variety of artistic mediums, Moholy-Nagy took up photography in 1922 with the technical assistance of his wife, Lucia Moholy. His first works in the medium were photograms; apparently, he did not use a camera until 1925.[164] In 1923, at the invitation of director Walter Gropius, Moholy-Nagy began teaching at the Bauhaus. The slogan of this school, "Art and

Technology—A New Unity," was one that he enthusiastically embraced. The Bauhaus offered workshops in a variety of disciplines (including typography, graphic design, printing, pottery, textiles, metal, furniture, wood and stone carving, bookbinding, and mural painting), with considerable emphasis placed on the integration of these skills and the exploration of new technologies.

While photography was never officially part of the curriculum during Moholy-Nagy's tenure at the Bauhaus, he and his students gave it considerable attention. Beginning in 1922, Moholy-Nagy wrote and lectured with missionary zeal on the potentials of photography.[165] His views were most fully expressed in his influential book *Painting Photography Film* (first published in 1925, and revised in 1927). In this forward-looking volume Moholy-Nagy described photography's "amazing possibilities, which we are only just beginning to exploit."[166] He cited three primary examples of such possibilities. First, he celebrated the picture-making potential of light-sensitive materials themselves, as revealed in the photogram and rayograph. Second, he pointed to the power of scientific and technical photographs (such as astronomical, microscopic, and X-ray images), as well as unusual points of view, to vastly enlarge the range of human vision. And finally, he argued passionately that the photograph, as a new standard of objective truth, held the key to momentous social changes. Through the "hygiene of the optical," society could be cleansed of its irrationalities and conflicts.[167]

> In the photographic camera we have the most reliable aid to a beginning of objective vision. Everyone will be compelled to see that which is optically true, is explicable in its own terms, is objective, before he can arrive at any possible subjective position. This will abolish that pictorial and imaginative association pattern which has remained unsuperseded for centuries.... The traditional painting has become a historical relic and is finished with. Eyes and ears have been opened and are filled at every moment with a wealth of optical and phonetic wonders. A few more vitally progressive years, a few more ardent followers of photographic techniques and it will be a matter of universal knowledge that photography was one of the most important factors in the dawn of a new life.[168]

These utopian ideas provoked both excitement and controversy, and provided an ideological impetus for the "new vision."

Moholy-Nagy's unorthodox and broad-minded attitude toward photography is revealed in the pictures he selected, as well as in those he made. Illustrated in *Painting Photography Film* was an eclectic assortment of photographs originally produced for scientific, journalistic, artistic, and commercial purposes. These included X-rays, photomicrographs, astronomical images, photograms, extreme close-ups, aerial perspectives, negative images, multiple exposures, distortions and reflections, time exposures, and photomontages. These varied images were not meant to reflect a single style, or even to be seen as "art." Rather, they demonstrated Moholy-Nagy's belief that photography was producing a radically new and transformative climate of visual information.

His own photographic production was no less radical, embracing the photogram and photomontage, as well as many permutations of the camera-made image. Moholy-Nagy's earliest photograms (fig. 35) utilize the simple geometric forms of his paintings of the period.[169] These are almost always nonobjective and reveal his concern for light and transparency; he was enthralled by "the optical miracle of black into white [which results from] the dematerialized radiation of light."[170] A similar concern for light-dark relationships and pictorial structure is evident in his "straight" images. He was fascinated by the difference between the vision of the camera and that of the human eye. In *Marseilles*, 1928 (fig. 36), for example, he shot through a decorative iron grillwork to a nondescript street below. Since the camera lens can only focus on one plane at a time, the grille is blurred, while the street scene is crisply detailed. A human viewer in this position would not have consciously seen this foreground subject out of focus; instead, the ever-moving and refocusing eye would have registered the entire scene, from foreground to infinity, as equally sharp. Thus, as Moholy-Nagy clearly understood, the camera produces images that are scientifically objective yet alien to normal visual experience. Similarly, in order to challenge common assumptions about the relationship between reality and representation, Moholy-Nagy made extensive use of negative images (plate 64). These tonal inversions highlight his fascination for the abstract play between light and dark, form and structure, that photography so easily revealed.

Moholy-Nagy often used dramatic or unusual vantage points in order to reinvent visual experience. One of his most remarkable photographs is *Rothenburg ob der Tauber*, 1928 (plate 65). To make this view, Moholy-Nagy climbed a shaky ladder to the top of the spire above the Rothenburg town hall.[171] Though this vantage point provided a panoramic view of the medieval village and the surrounding countryside, Moholy-Nagy characteristically ignored the picturesque in favor of the disorienting, and aimed his camera steeply downward. The tilted frame and dizzying viewpoint charge the picture with dynamism and instability, transforming a quiet street scene into a complex arrangement of form, texture, and light. New graphic relationships are revealed by turning the image on its various sides, but the orientation of the original scene remains uncertain. This elegant image fully conveys the power of Moholy-Nagy's unconventional vision, and his fascination for the pictorial realm that lay between the conventional categories of "realism" and "abstraction."

Two other key proponents of the new vision in Germany were Martin Munkacsi and Gyorgy Kepes. Both, like Moholy-Nagy, were born in Hungary. Munkacsi worked as a news photographer in Budapest before moving to Berlin in 1927. His dynamic and spontaneous images, reproduced regularly in *Berliner Illustrirte Zeitung* and other publications, won him considerable acclaim. Munkacsi's *Street Shadows*, 1928 (fig. 37), reflects the dynamic modernity of his vision, while depicting a subject of social realist interest. Kepes studied painting at the Academy of Fine Arts in

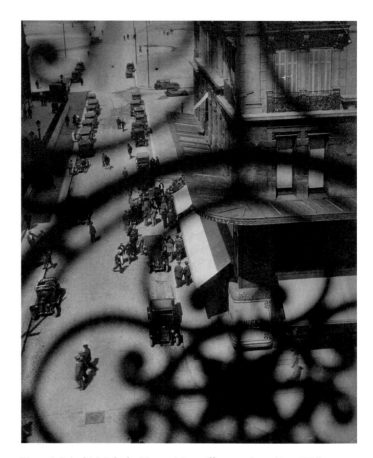

Fig. 36 László Moholy-Nagy, *Marseilles*, 1928, 11½ x 8⅞"

Budapest before turning to motion pictures in 1929. He moved to Berlin in 1930 at Moholy-Nagy's request, and subsequently worked as both a still and motion picture photographer. His small but powerful *Berlin*, 1930 (fig. 38) clearly reflects Moholy-Nagy's interest in unusual viewpoints and the contrast of light and shadow.

The high point of the new vision in Germany was the celebrated "Film und Foto" exhibition in Stuttgart in 1929.[172] Sponsored by the Deutsche Werkbund, an organization dedicated to the union of art and technology, this was the most important of several exhibitions of modern photography and film mounted in Germany in the 1920s. The influence of Moholy-Nagy was clear in the structure of "Film und Foto." In addition to presenting a survey of ninety-seven of his own photographs, Moholy-Nagy assembled an eclectic group of images for the exhibition's introductory gallery. This visual primer, based on the concepts contained in his book *Painting Photography Film*, contained a stimulating mix of artistic, journalistic, scientific, and advertising images. Ignoring the original purposes and contexts of these photographs, Moholy-Nagy sought to highlight the medium itself as a richly plastic mode of communication. Most of the exhibition, however, was devoted to contemporary avant-garde photography. This selection featured such important European photographers as Herbert Bayer, John Heartfield, Albert Renger-Patzsch, El Lissitsky, Alexander Rodchenko, Man Ray, André Kertész, and Florence Henri. In this context, American photographers made an impressive showing. This section, jointly assembled by Edward Steichen and

Fig. 37 **Martin Munkacsi**, *Street Shadows*, 1928, 11³/₈ x 8⁷/₈

Fig. 38 Gyorgy Kepes, *Berlin*, 1930, 3 x 4¼"

Edward Weston, featured their own work as well as that of Sheeler, Outerbridge, Steiner, Cunningham, and Brett Weston. While not as technically adventurous as European work, the American selection was admired for its precisionist intensity and lack of romanticism.

The Avant-Garde in France

While the leading figure in German photography in the 1920s was Moholy-Nagy, a Hungarian, the most progressive photographer in France was also an expatriate, the American Man Ray. With the vitality of the New York avant-garde scene at a low ebb, Man Ray moved to Paris in the summer of 1921. He quickly became part of the city's artistic elite, joining old friends such as Duchamp and Picabia, and making new ones of André Breton, Paul Eluard, Tristan Tzara, and Jean Cocteau. Man Ray arrived at the time the Dada movement was evolving into Surrealism. Breton's *Manifesto of Surrealism* was issued in 1924, and Man Ray's work in painting, photography, film, and sculpture played an integral role in this movement.

Man Ray had taken up photography in 1915, in New York, as a means of documenting his own art work. In Paris, he used his skill with the camera to earn a living. Thanks in part to his contacts in the city's art and literary communities, Man Ray soon established a lucrative practice as a portrait and fashion photographer. While much of this work was routine, it nonetheless increased his understanding of the medium, and peaked his interest in it as a creative tool.

While developing fashion photographs in the winter of 1921-22, for example, he inadvertently discovered for himself the principle of the photogram. As he developed the pictorial possibilities of this process, which he christened "rayography," word spread quickly of his curious and ethereal images. Within months, the rayographs established Man Ray's credentials as an avant-garde artist of international stature.

Man Ray's first cameraless images made liberal use of objects close at hand, including combs, keys, kitchen utensils, a gun, lace, wire springs, prisms, a magnifying glass, and a small mannequin figure. These objects were often placed in full contact with the photographic paper and were thus clearly recognizable in the final image. Soon, however, this sense of "realistic" depiction, which encouraged anecdotal or narrative associations, was tempered by an interest in more mysterious and abstract effects. In the greatest of these images (plate 67), Man Ray's objects are highly ambiguous and their contact with the photographic paper is tenuous. The rayographs are classic Surrealist creations: unexplainable and otherworldly, at once the trace of the real and the stuff of dreams.

At the same time, Man Ray explored a wide range of other photographic effects. He set up odd juxtapositions of figures and objects to be recorded, drew on his images, and printed through textured screens. Unusual viewpoints and tight croppings were also used in a continuous project to subvert the essential realism of the medium. In 1929, Man Ray discovered one of his most memorable effects, solarization, with the aid of his assistant and lover, Lee Miller. Produced by exposing a developing print to a burst of white light, this process creates a partial reversal of tone. Shadows may turn white, for example, while the midtones of the image remain unaffected. Man Ray so treasured this uncanny effect that he jealously guarded the technique for years.

His ghostly and disembodied photograph of lips, *Les Amoureux*, 1929 (plate 66), was produced by greatly enlarging a segment of a portrait of Miller. Her lips become a poetic emblem of beauty and desire floating free of all constraints. The image is at once intimate and vast, suggesting

both a lover's dream of union and an astronomical record of a distant galaxy.[173] This photograph was subsequently used as the source for one of Man Ray's major paintings, *A l'heure de l'observatoire—Les Amoureux* (1934).

Man Ray's photographs were widely celebrated and influential. In addition to appearing in the leading exhibitions of the period, his work received broad circulation in print. His photographs were featured in avant-garde publications such as *La Révolution surréaliste, The Little Review,* and *Broom;* the literary journal *Variétés;* illustrated magazines such as *Vu, Jazz, L'Art vivant,* and *Vanity Fair;* and fashion publications such as *Vogue* and *Harper's Bazaar.* Throughout the 1920s and 1930s, Man Ray adroitly balanced art and commerce to achieve avant-garde status as well as financial success.

By the last half of the 1920s, Paris had become home to many other photographers of international stature. One of the most important of these emigrés was André Kertész. In his native Hungary, Kertész had taken up photography as a hobby in 1912. To escape the dull routine of his job at the Budapest stock exchange, the young Kertész spent all his free time photographing in the city and surrounding countryside. Working solely for his own pleasure, without any formal art training, he recorded the transient events of everyday life in a fresh and spontaneous style. Hoping to earn a living doing what he loved, Kertész moved to Paris in 1925. The influences he absorbed in the next few years gave new depth to his vision without changing its essential character. On arrival in Paris, Kertész was embraced by a circle of expatriate Hungarians. These friends—artists, musicians, journalists, and poets—were interested in both the most avant-garde ideas of the day and the richly expressive folk-art traditions of their native land. This complex synthesis of "high" and "low"— the provocative and the simple, the coolly formal and the warmly human—would characterize Kertész's work throughout his long career.

Kertész flourished in this new environment. His first gallery exhibition in Paris, in 1927, was a success. A year later, he was included in a major international exhibit in the city, the first "Salon Indépendant de la Photographie," with such leading contemporaries as Man Ray and Paul Outerbridge. He was also well represented at "Film und Foto." By the time of the Stuttgart show, Kertész had established himself as a leading photojournalist, with work frequently published in *Variétés, Bifur, Berliner Illustrierte Zeitung,* and *Art et Médecine.* The most important publications with which he was associated were the *Münchner Illustrierte Presse,* under the editorship of Stefan Lorant in Munich, and *Vu,* which was based in Paris under the direction of Lucien Vogel. Both editors understood Kertész's style and gave him great freedom in carrying out assignments. While Kertész worked as both a professional photojournalist and as an artist, he drew little distinction between these roles. With few exceptions, the same quality of effort was given to both. Some of his greatest pictures were produced in the course of magazine projects, and editors such as Lorant and Vogel often made use of his most challenging personal images.

Kertész's photographs are varied in subject but unified in sensibility. He made portraits, candid street pictures, architectural views, and still lifes, and worked in daylight, the rain and fog, and at night. While many of his pictures have the directness of the amateur snapshot, Kertész also made extensive use of such modernist devices as the aerial view, the extreme close-up, and optical distortion. Common to all his work is an exquisite sense of timing and pictorial structure, as well as the implication that the simplest gestures and most familiar objects are resonant with meaning. For example, *Fork,* 1928 (plate 70), one of Kertész's most important pictures, records the simplest of subjects, a common dinner fork. At once realistic and abstract, intimate and monumental, *Fork* exemplifies the transformative power of Kertész's vision. One of his best-known images, *Fork* was included in such important shows as the 1928 "Salon Indépendant de la Photographie" and "Film und Foto" of 1929; Kertész also used it to illustrate an article he wrote on contemporary photography for the German magazine *Uhu* in 1929.[174]

Other important members of the community of expatriate photographers in Paris were Florence Henri and Ilse Bing. Though born in New York City, Henri was taken to Europe at an early age by her father. After developing an interest in art, she studied painting in Berlin and Paris. In the summer of 1927, she attended classes at the Bauhaus taught by Moholy-Nagy. This experience, and the encouragement of Lucia Moholy, spurred Henri to take up photography. Her first works utilized mirrors to fracture and complicate space. The hermetic mystery and perceptual perplexities of these images are also seen in her straight photographs of the next few years. Henri's *Reclining Woman,* 1930 (plate 68), for example, reveals various spatial ambiguities: a subtle disjunction between foreground and background, an uncertain orientation of the floor plane, and the curious foreshortening of the woman's arm.[175] Henri used similar points of view, at once intimate and disorienting, in other studies of female figures to create an evocative synthesis of abstraction and dreamy sensuality.

German-born Ilse Bing received a doctorate in art history before taking up photography in 1928. In 1929, she purchased a Leica, the first successful 35mm camera and an invention that revolutionized the practice and aesthetic of photography. This "miniature" camera allowed pictures to be made rapidly and unobtrusively, precisely matching the expressive interests of photographers like Bing, Kertész, and Henri Cartier-Bresson. Indeed, Bing was so well-known for her use of this camera that she was dubbed the "Queen of the Leica" by French photographer and critic Emmanuel Sougez.[176] In late 1929, Bing viewed an exhibition of modern photography in her home city of Frankfurt. Stimulated by the work of the French photographers—Henri, in particular—Bing promptly moved to Paris, where she established a successful commercial and journalistic practice. A superb example of her more personal work is *Champ-de-Mars from*

Eiffel Tower, 1931 (plate 71), in which the dizzying perspective and complex play of geometric patterns combine to suggest both the dislocating abstraction and the everyday adventure of modern urban life.

Among the many other photographers who matured in Paris's vital artistic climate was the Austrian-born Lisette Model. In 1933, Model turned away from her interest in music to pursue a career in photography. While she received encouragement from several friends, including Henri, Model was largely self-taught. Her first important work was created in the summer of 1934, when she made a series of bluntly direct images of vacationers on the promenade at Nice (plate 69). These photographs provided a sardonic commentary on the lazy luxury of the rich, while revealing Model's keen eye for the awkward physicality of the human body.

American Precedents and Resistance to the New Vision

The European new vision had a discernible impact in America in the 1920s. What is most interesting, however, is the limited and delayed nature of this influence. While the leading photographers in America were aware of the work of artists such as Moholy-Nagy and Man Ray, they remained almost wholly unimpressed.[177] With few exceptions, Americans were committed to realist and idealist uses of the medium rather than to synthetic or experimental ones.[178] They also had a narrower—though perhaps deeper—understanding of the medium's artistic potential. By contrast, European proponents of the new vision considered photography merely one of several expressive tools at their command. Unlike the Americans, most of the noted European photographers were "amateurs" with no orthodox technical training or professional experience. Consequently, they came to the medium without the conceptual limits that traditional practice necessarily encouraged.

In his influential book *The Structure of Scientific Revolutions*, Thomas Kuhn argues that important discoveries in the sciences result from "paradigm shifts"—changes in the conceptual perspectives or underlying assumptions of a whole field—that allow familiar things to be seen in revolutionary ways.[179] In science, such radically transformative ideas often come from researchers who are young or new to the field—those whose views are not fully conditioned by what professional consensus deems "true." The new vision of the European avant-gardists constitutes such a paradigm shift in the history of photography. Unconstrained by earlier standards of "art" or by chronic embarrassment over the mechanistic nature of the medium, these artists pursued photography with unparalleled freedom. By the early 1930s, however, this once-revolutionary vision had become an accepted international style. It was in this form—as a dominant, if still relatively fresh paradigm—that the new vision had the greatest impact on American photography.

As Kuhn's thesis posits, the shift effected by the new vision depended on a foregrounding of familiar, but previously marginal, techniques and effects. Odd vantage points

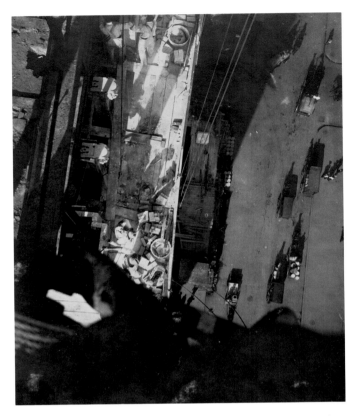

Fig. 39 Horace D. Ashton, *Bricklayer 16 Stories from Ground, New York*, 1906, 4½ x 3⅝"

and the photogram process, for example, had been utilized for years by amateurs everywhere, but experienced photographers "knew" these to be the amusements of children or evidence of artistic incompetence. It was precisely because these techniques were so familiar—and technically simple —that American photographers had difficulty taking the European avant-garde work seriously. A cursory review of photographic and general-interest publications reveals innumerable examples of "new vision" traits in images made decades before the advent of the new vision. X-ray photography, for example, was widely reported as early as 1896. While many of the published X-rays were purely descriptive (e.g., a frog or a human hand), others were remarkably nonobjective.[180] Other "abstract" images were produced by a variety of means; in hindsight, scientific photographs of the patterns of frost or chemical crystallization look surprisingly Cubist or Futurist.[181] Unusual points of view were also relatively common, as both amateur and professional photographers utilized abrupt upward or downward perspectives to render everyday subjects newly dynamic (fig. 39).[182] Dramatic natural phenomena, such as lightning, were also favorite subjects. While numerous photographers made straight records of single flashes of lightning, a handful of others exaggerated these patterns by exposing multiple images on a single plate or by deliberately moving their cameras during exposure to create a jagged blur.[183] Numerous other methods of creating abstract or nonnaturalistic pictures were well known.[184]

By 1920, the American public was quite accustomed to the use of photography to produce visual tricks or to depict

realities invisible to the naked eye. For example, early motion pictures exploited a variety of spatial and temporal illusions, including accelerated or reversed action, the disappearance of figures in mid-scene, and the use of distorting mirrors to change a person's size or shape.[185] The "cyclographs" of Frank B. Gilbreth and Lillian M. Gilbreth received considerable attention beginning in 1916 precisely because of their accuracy in tracking "invisible" movements. Each of these photographs used controlled lighting and a time exposure to map the rhythm of a single human action. To analyze a golf swing, for example, a light was placed at the head of the club. The result was a graceful, luminous tracing of the club's path through space—an image at once objective and unreal.[186]

The very prevalence of such nonobjective images played a part in forcing art photography to stay within relatively narrow confines during the heyday of Pictorialism. Most art photographers of this era deliberately avoided incorporating any trace of the mechanical, utilitarian, analytical, amusing, or unusual in their work. Instead, the goals were idealism, refinement, and a moody subjectivity. While a handful of photographers and critics protested this orthodoxy, they had little effect. For example, when a group of wildly unconventional photographs was included in the 1904 members' show of the Camera Club of New York, they were widely regarded as a joke. However, these images, which would have fit comfortably in avant-garde exhibitions a quarter-century later, were vigorously defended by Sadakichi Hartmann.

> A shocking and yet not entirely unpleasant note is struck by J. Oscoe Chase. He seems to strive for the most unconventional effects. He is interested in freaks of nature, "Luna Park at Night," and weird electrical light effects. He even tries to falsify nature. In his "Nocturne," for instance, he makes a sail (placed plumb in the center of the picture just beneath the rising moon) whiter than the sky, which is contrary to all natural laws. His "Madison Square at Night," is, despite all laughter and criticism it arouses, quite a creditable performance. I admire the way in which he has ignored all rules of composition. It is a fragment of uncouth realism which stands and falls on its own merit, and I am not ashamed to say that I wish more of this kind were done. Not for its pictorial value, but rather for its non-pictorial value, its lawlessness. Understand me right, I would like to launch the question why a photograph must always conform to artistic canons? Why should it not suffice to represent a bare fact as this or that individual sees it, without any obedience to conventional pictorialism?[187]

It was, in fact, this fundamental American resistance to artistic "lawlessness" that delayed and muted the impact of the most radical European work.

An American New Vision

Despite such resistance, an indigenous strain of abstract and modernist photography began to take root in the United States. Isolated experiments by photographers like Fred R. Archer, who was reputed to have made nonobjective images of reflected light in about 1917, were probably stimulated by reports of Coburn's vortographs.[188] Prior to the mid-1920s, however, such investigations were extremely uncommon and received no support from the photographic establishment.

Among the most provocative experimental photographs of this period were those made by Edward Steichen following World War I. Created during "a time of deep, earnest soul-searching" in relative isolation in France, these images represent a critical transition in Steichen's vision.[189] To demonstrate his new commitment to photography, Steichen burned his paintings, rejected forever the values of Pictorialism, and taught himself the "basic discipline" of the medium in an exhaustive series of technical experiments.[190] To explore the camera's ability to render volume, for instance, he recorded simple forms with varying light intensities and exposure times; his monumental *Three Pears and an Apple* (1921) was the result of a thirty-six-hour exposure under dim, indirect illumination. He also studied mathematical principles of organic growth in order to understand the continuity of form from the microscopic to the cosmic level.[191]

As part of this process, in 1920-21, Steichen produced a group of pictures that were stimulated by Einstein's theory of relativity.[192] Articles on relativity had just begun to appear in popular journals, and phrases such as "time-space continuum" were *au courant*. The theory was poorly described in these general articles, however, and its impact on the lay public was limited.[193] Most artists inferred from the theory little more than vague but provocative notions concerning the interrelatedness of things and the inherent lack of fixity in the universe. In his enthusiasm for this new scientific vocabulary, Steichen created futuristic still lives of glass, metal, and simple organic forms. These were recorded in tight close-up to create a sense of monumentality and mystery.[194] Some of his photographs emphasized the disembodied effects of reflected or refracted light; others, such as *Triumph of the Egg*, 1921 (plate 28), were more sculptural, and strongly suggested the influence of Steichen's friend Constantin Brancusi. Steichen soon found these images unsatisfactory, however, because viewers were "completely bewildered" by them. "Not understanding the symbolic use to which I was putting the objects," he reported, "they had no clue to the meaning of the pictures. I began to realize that abstraction based on symbols was feasible only if the symbols were universal. Symbols that I invented as I went along would not be understood by anyone but myself."[195]

In fact, Steichen's future direction was more clearly indicated by another group of pictures made at this time. In between his experiments with abstraction, Steichen traveled to Athens to photograph the famous dancers Isadora and Thérèse Duncan performing on the Acropolis (plate 48). The exuberant theatricality of these images would later become a principal characteristic of Steichen's commercial work and celebrity portraiture for the Condé Nast publications. Even after his return to the United States in 1923, Steichen's long career continued to be shaped by the powerful lessons of experimentation and communication that he learned in Europe.

Another important influence on photographic abstraction was the Danish-born musician, artist, and poet, Thomas Wilfred. He first became interested in light as an independent artistic medium in 1905, when he made experiments with an incandescent lamp and pieces of colored glass.[196] After moving to the U.S. in 1916, Wilfred began devoting all his time to perfecting the "clavilux," a keyboard device that produced mesmerizing "symphonies" of colored light. One early viewer described the bands and veils of color produced by the clavilux as "always and constantly swirling and whirling and curling, twisting and untwisting, folding and unfolding, gliding, approaching and retreating, in [a] haunted and inexplicable space."[197] In subsequent years, Wilfred's invention received widespread attention, and his work was of great interest to Moholy-Nagy and other members of the international avant-garde.[198]

Wilfred's first public performance of the clavilux was not until January 10, 1922, but photographs of his light projections were published as early as December 1920.[199] While intended as records of the kinetic performances, these images were compelling in their own right and stimulated others to create nonobjective photographs. One of the first photographers influenced by Wilfred was Ira Martin, a talented associate of Clarence White. By mid-1921, Martin had made elegantly abstract photographs of patterns formed by projected or refracted light. Four of these were published in the July 1921 issue of *Vanity Fair*, bearing such pretentious titles as *Elégie* and *Mort de Matelot*.[200] Martin apparently regarded these abstractions only as diverting experiments, however, and there is no evidence of subsequent work by him in this vein.

Wilfred's light projections had a greater impact on the work of Francis Bruguière, one of the most original photographers of this era. Bruguière's photographic career began in his native city of San Francisco, where he worked in a typically Pictorialist style. However, in 1912, he began experimenting with the multiple-exposure technique. After his move to New York in 1918, Bruguière expanded this unconventional work to include abstract explorations of light itself. This interest could only have been reinforced by an assignment to photograph Wilfred's clavilux projections for an essay in *Theatre Arts Magazine* in 1921.[201]

In the next few years, while earning a living as a portrait and theater photographer, Bruguière devoted great energy to his experimental work. His "designs in abstract forms of light," as he called them, were made with several techniques. These included the recording of patterns of projected light, as well as the use of long exposures in conjunction with the movement of either his subject or his camera. But Bruguière's most remarkable pictures were made by playing light across the surface of intricately cut sheets of paper (plate 72). These images unite the flickering patterns of light and shadow with the geometric linearity of the incised surface. The paper functions strictly as a light modulator and the resulting images, while perfectly "straight" in technique, are provocatively abstract. Bruguière's goal, as one critic of the period

Fig. 40 **Grancel Fitz**, *George Gershwin*, 1929, 8½ x 4⅝"

suggested, was to "give body to light, to give light solidity and weight and volume."[202]

A one-man exhibition of Bruguière's work was held at the Art Center in New York in 1927 and received a great deal of attention. A year later, he moved to London, where he continued his work in photography, film, painting, and stage design. Eleven of his photographs were shown at "Film und Foto" in 1929. In that year Bruguière also published the remarkable and abstruse book *Beyond This Point*, a synthesis of images and text created in collaboration with writer Lance Sieveking. This work, which explores the psychology of three human crises (death, jealousy, and ruin) in highly abstract form, was followed two years later by another collaborative volume, *Few Are Chosen*.[203]

One of this era's most intensive explorations of photographic abstraction was conducted by the Philadelphian Edward Quigley. After opening his own studio in 1930, Quigley quickly established himself as both a successful commercial photographer and an active salon exhibitor. He kept abreast of the most challenging international work and incorporated a broad range of modernist ideas in his pictures. In 1931, Quigley produced an important group of light abstractions (plate 73). These complex photographs were the result of a careful deployment of prisms, lenses, selective focus, and

Fig. 41 **Grancel Fitz**, *Glass Abstraction*, 1929, 9¾ x 7¾"

Fig. 42 **Harold Haliday Costain**, *Securing the Anchor Chain*, 1919 (print ca. 1933), 10⅞ x 14"

camera motion, as well as the occasional use of two negatives to make a single final print. Quigley's work of the early 1930s demonstrates the pervasive influence of European modernism on American photography. He used photograms, odd perspectives, extreme close-ups, reflections, multiple exposures, and bold geometric designs with great facility, creating a body of work that constitutes a veritable catalogue of modernist traits.

The vocabulary of European avant-garde photography was adopted in America by both the commercial and artistic worlds. The result was a pluralist climate in which f/64 purism and new vision experimentation were united in an eclectic international style. The work of Grancel Fitz is typical of this applied modernism. After achieving renown in the late 1910s as a Pictorialist, and absorbing the influence of Stieglitz and his circle, Fitz turned to commercial work.[204] His sophisticated style found favor with Chrysler, Westinghouse Electric, and other corporations. Fitz's portrait of George Gershwin (fig. 40), apparently made for the Steinway piano firm, uses a bold diagonal composition to suggest the jazzy modernity of Gershwin's music.[205] Fitz's *Glass Abstraction* (fig. 41), produced for Corning Glass, solved the difficult problem of presenting glass itself as an alluring product. By exploiting the material's dual qualities of reflection and transparency, Fitz created a sense of mystery and dynamism.[206]

Harold Harvey's photographs are similarly eclectic. His successive careers in illustration, commercial photography, and photographic chemistry gave Harvey an unusually broad

interest in the expressive possibilities of the medium.[207] Restlessly experimental, he worked with all manner of cameras, films, papers, and toners. His *Reflections*, ca. 1930 (plate 74), is a perfectly straight image of a perceptual puzzle: a rippled surface of water which both reflects and is dissolved in light. The graininess of this greatly enlarged print (probably from a Leica negative) frustrates any clear reading of the photograph's content. Instead, the image suggests a metaphor for the photographic process itself: the interaction of light and light-sensitive surfaces in a process at once mundane and magical.

In the pluralistic climate of the early 1930s, formerly radical points of view had become the familiar ingredients of a mainstream modernist aesthetic.[208] Pictures that once would have been considered playful snapshots were now accepted as sophisticated artistic statements. Harold Haliday Costain's *Securing the Anchor Chain* (fig. 42), for example, was originally taken in 1919, but Costain apparently did not make exhibition prints of the image until about 1933, by which time the vertiginous perspective had acquired impeccable modernist credentials.[209] John Gutmann's *Triple Dive*, 1934 (plate 75), uses a similarly disorienting point of view to convey a sense of exuberant energy. Gutmann, who arrived in San Francisco from his native Germany in 1933, was fascinated by the dynamism of American culture. Applying a European sense of timing and framing to such characteristically American subjects as street life, automobiles, sports, advertising signs, and graffiti, Gutmann produced a body of

work that deftly merged documentary intentions with Surrealist inclinations.[210]

One conspicuously underrepresented element of the new vision in America was photomontage.[211] Relatively few Americans made use of this technique for purely expressive purposes. Those who did, such as Barbara Morgan or the Chicago photographer Paul Heismann (plate 78), generally used it to create poetic or dreamlike effects. While the public and didactic use of this process never really took hold in the United States, it was not for lack of encouragement. In 1932, for example, the Museum of Modern Art organized the ambitious exhibition "Murals by American Painters and Photographers" under the direction of Lincoln Kirstein.[212] Photographers such as Berenice Abbott, George Platt Lynes, William Rittase, Thurman Rotan, Maurice Bratter, Charles Sheeler, Stella Simon, and Luke Swank were invited to create murals on the theme "The Post-War World." Faced with the problem of unprecedented scale, the photographers made liberal use of photomontage and multiple printing. After the show, however, few of them maintained any real interest in these techniques. Edward Steichen, one of the few who did, was commissioned in 1933 to produce photographic murals for the New York State Building at the Chicago World's Fair, and for a smoking lounge at Rockefeller Center. The latter work, on the theme of aviation, employed rhythmic sequences of large-scale images to create a compelling whole.[213]

Barbara Morgan made effective use of the multiple print in the late 1930s. One of her best-known photographs, *Spring on Madison Square*, 1938, was composed of three superimposed images: two from separate negatives and another made by the photogram technique. Morgan also used multiple exposures in her extended interpretation of the work of dancer and choreographer Martha Graham. *Martha Graham: American Document (Trio)*, 1938 (plate 76), uses the double exposure to evoke the kinetic and spatial complexity of dance in a still image. This technique specifically underscores the haunting universality of the narrative accompanying this passage of Graham's dance: "We are three women; we are three million women. We are the mothers of the hungry dead; we are the mothers of the hungry living."[214]

Will Connell, one of the most original photographers of this era, used an unusual variety of techniques. Before becoming a professional photographer in 1928, Connell had worked as a cartoonist, a pharmacist, and—after taking up the camera as an amateur—an "answer man" in the photo-supply business.[215] After some struggle in the early years of the Depression, he established himself as a successful advertising and color photographer. Connell was also an influential teacher and writer. He began the photography department at the Art Center School in Los Angeles, and contributed a regular column to *U.S. Camera* magazine. Connell's most notable work was the series "In Pictures," a pointed satire on the Hollywood film industry. This was begun as a personal project in 1933, when Connell's business

Fig. 43 Will Connell, *Yes-Men*, 1937, 11⅝ x 9½"

was at its lowest ebb. A remarkably ambitious project, "In Pictures" illustrates a variety of themes, including *Film, Sound, Politics, Star, Sex Appeal, Props, Melodrama, Publicity*, and *Critic*. After creating 400 thumbnail sketches of potential subjects, he made thirty-three pictures. Connell created elaborate studio setups and directed a varied cast of players. He also used diverse technical means—including photomontage, printing from sandwiched negatives, odd viewpoints, and optical distortions—to give visual form to his concepts. The "bite" of this work stemmed, in part, from its theatricality. Connell's exuberantly artificial stage sets, one-dimensional characters, and extreme points of view cleverly aped a long list of film clichés. These works were highly praised when exhibited in Paris in 1933. With subsequent additions, the series was published in book form in 1937.[216]

Connell's results range from lighthearted farce to dark cynicism. Critic Nicholas Ház accurately described Connell as a man "who prefers to be humorous, droll, sarcastic, sometimes even bitterly sardonic, to being sentimental, lyrical or romantic."[217] Arrogance, superficiality, pretension, and exploitation make frequent appearances in this work. In *Yes-Men*, 1937 (fig. 43), for example, a flurry of anonymous hands appear to light the boss's cigar. Other images, such as *Casting, Career*, and *Producer*, center on the theme of sexual exploitation. However, a photograph such as *Lights!*, 1937 (plate 77) functions more abstractly, suggesting the allure of the film experience with wit and an almost balletic grace.

George Platt Lynes, an even more unconventional photographer, staged subjects for his camera in order to achieve surrealistic rather than satirical effects. An intelligent

if somewhat dilletantish young man, Lynes traveled back and forth between New York and Paris and pursued an interest in avant-garde literature.[218] Then, in 1927, a friend who had graduated from the Clarence White School gave him a view camera and darkroom equipment, and Lynes turned his creative attention to photography.[219] After several years of self-instruction, he achieved both artistic and commercial success. He opened a studio in New York in 1932, specializing in portraiture and fashion work, and his photographs were published regularly in *Vogue*, *Harper's Bazaar*, and *Town and Country*. Lynes's reputation as a creative artist was established at the same time. In 1932, he was included in two exhibitions at the Julien Levy Gallery, and in the mural exhibition at the Museum of Modern Art. Over the following decade, his personal work received consistent exposure and praise.

Lynes's expressive style was distinctly his own. Strongly influenced by Surrealism, he created fantastic tableaux in the studio. In addition, much of this work is unambiguously homoerotic. In his portraits of friends and artists, Lynes sought to evoke a feeling of psychological complexity or tension. He also made brilliant use of the spare and indeterminate space of the studio to contrast the physical intensity of his subjects with the unreality of his dreamlike stage effects. In his portrait of the painter Paul Cadmus (fig. 44), for example, Lynes used five dangling light bulbs to add a curious psychological charge to an otherwise placid image.

Lynes's literary and surrealistic interests came together in the photographic series dealing with mythological subjects that he developed from 1936 to 1940. In these images, Lynes combined his interest in the nude with the challenge of casting ancient narratives into contemporary form. One of the most notable works in this series is *Endymion and Selene*, ca. 1937-39 (plate 79). This myth, which inspired a long poem by John Keats, tells the tale of the moon goddess Selene and a handsome young Greek shepherd. Selene fell in love with Endymion, causing him to lapse into an eternal sleep. The Greeks believed that whenever the moon passed behind a cloud, Selene was visiting Endymion. Lynes visualized this story in the form of a nude male model clutching a miniature moon while sleeping, Gulliver-like, in a paper landscape. The self-conscious artifice of Lynes's interpretation not only celebrates the myth as an elegant fiction but also alludes to the power of dream and the gravity of desire.

Working in the relative isolation of New Orleans, Clarence John Laughlin made similar use of staged images beginning in the late 1930s. Like Lynes, whose photographs he admired, Laughlin used the camera in a provocatively "impure" manner.[220] His vision was the product of a complex hybrid of art and literature, Symbolism and Surrealism, and personal and collective states of mind. He used multiple exposures, theatrical arrangements, and lengthy captions to bridge the gap between visible reality and a metaphysical realm of fantasy and intuition. His ultimate aim was enormously ambitious: to use the technological precision of lens and film to liberate the imagination and to create a new

Fig. 44 George Platt Lynes, *Paul Cadmus*, 1941, 7½ x 9½"

fusion of objective and subjective truths. One of Laughlin's earliest mature pictures, *Pineapple as Rocket*, 1936 (plate 80), exemplifies the transformative impulse at the heart of his vision.[221] This photograph is at once a record of mundane household objects and an oddly compelling suggestion of something else. This tension between fact and allusion creates a constellation of dichotomies—small and vast, stasis and motion, organic and mechanistic—in the mind of the sympathetic viewer. Laughlin felt that imaginative seeing was essential to any new insights into human nature or the state of the world.

In the fall of 1939, just as war was erupting in Europe, Laughlin began a series of photographs that he titled "Poems of the Interior World."[222] In this group, the theatricality and symbolism of his earlier work were raised to a new level of self-conscious intensity. These photographs were carefully choreographed to form a provocative union of figures, props, and environment. Every image in this series, including *The Unborn*, 1941 (plate 81), sought to depict the "symbolic reality" of the era in its undercurrents of confusion, fear, and sterility.[223] Laughlin's troubling pictures were exhibited by Julien Levy in 1939, but won few other admirers in the photographic establishment of the day.

In hindsight, the work of Laughlin, Lynes, and a handful of others may be best understood in terms of its overt theatricality. In the late nineteenth and early twentieth centuries, the works of Ibsen, Chekhov, Pirandello, Brecht, and other influential playwrights challenged the naturalistic conventions of the theater. New importance was given to symbols, dreams, and unspoken subtexts of meaning. Brecht's plays, for example, used a strongly nonnaturalistic style to address contemporary social issues. Masks, surreal effects, grotesque exaggerations, and actors not pretending to "be" the characters they portrayed were all typical of his work. Like Brecht, Laughlin and Lynes used the paradoxical "reality" of artifice to address the basic dilemmas of human existence.[224]

Fig. 45 Sonya Noskowiak, *Train Wheels*, ca. 1935, 7½ x 9⅝"

The Themes of Modernism

A fascination for invention and mechanization permeated the world of the 1920s and 1930s.[225] Young boys collected Tom Swift books and played with Erector sets. Over 800,000 Americans read *Popular Mechanics* magazine, "with its simplified but trustworthy review of new inventions and scientific discoveries."[226] At the same time, the life of the middle class was transformed by radio, the automobile, and a host of other mechanical devices. This era's respect for efficiency and power was embodied in the figure of the engineer. As a rational problem-solver, the engineer appeared to point the way to a society untainted by prejudice, delusion, and "emotional aberration."[227] While many thoughtful critics perceived the machine age as a decidedly mixed blessing, there was broad agreement that America's unique character was a result of its enthusiastic acceptance of technology.[228] Evidence of this engineered world was everywhere: in automobiles, airplanes, skyscrapers, bridges, radio towers, dams, and factories. New York City, the site of the Empire State Building (1930-31) and the George Washington Bridge (1927-31), provided the most exciting expression of these new forces and powerfully shaped the outlook of artists and intellectuals.[229] Influenced by the engineer's vision, William Carlos Williams even described the poem as "a mechanism that has a function which is to say something as accurately...as possible."[230] For Williams and his friends, the artist was an aesthetic engineer who made precise use of the tools of his chosen medium; modern works of art were to be austere and impersonal revelations of one's surroundings.[231]

The engineered world represented functionality, efficiency, and logic, as well as a cooperative synthesis of industry, science, and technology. The resulting vision of society as a "dynamic, integrated assembl[y] of component parts" reflected a political desire for cultural harmony.[232] Herbert Hoover, himself a renowned engineer, stated this view with characteristic directness: "The attitude that marks the success of America [is] the attitude of the business man, of the engineer, and of the scientist."[233] This technological zeal gave rise to a new cultural and artistic aesthetic. As painter Louis Lozowick noted in 1927,

> The dominant trend in America of today, beneath all the apparent chaos and confusion is toward order and organization which find their outward sign and symbol in the rigid geometry of the American city: in the verticals of its smoke stacks, in the parallels of its car tracks, the squares of its streets, the cubes of its factories, the arc of its bridges, [and] the cylinders of its gas tanks...

From "this underlying mathematical pattern," Lozowick observed, the artist could construct "a solid plastic structure of great intricacy and subtlety."[234] The universality of this "mathematical pattern" resulted in remarkable mergers of elite and mass culture, and of art and commerce. In the "Machine-Age Exposition" of 1927 and the Museum of Modern Art's 1934 "Machine Art" exhibition, mass-produced objects such as boat propellers, ball bearings, and large springs were presented for purely aesthetic effect. Conversely, respected artists increasingly applied their talents to such utilitarian ends as industrial design and advertising.

Photographers responded to this enthusiasm for the machine in a variety of ways. Some recorded tightly cropped mechanical details as self-contained aesthetic studies: form divorced from function. In the early 1920s, for example, Paul Strand produced monumental studies of high-precision machine parts while Ralph Steiner recorded the keys of a typewriter as a White School exercise.[235] This approach is also seen in the later f/64 work of photographers such as Sonya Noskowiak (fig. 45). Images such as these celebrate the machine as a symbol of rational order—timeless, austere, and impersonal.

Lewis Hine, on the other hand, viewed technology almost exclusively in human terms. His 1932 book, *Men at Work: Photographic Studies of Modern Men and Machines*, depicted skilled workers at the center of the great drama of technology. In his introduction to this volume, Hine reminded his readers that

> Cities do not build themselves, machines cannot make machines, unless back of them all are the brains and toil of men. We call this the Machine Age. But the more machines we use the more do we need real men to make and direct them.[236]

Hine viewed this labor as a heroic combination of ingenuity, stamina, and courage. To his mind, "the motors, the airplanes, [and] the dynamos upon which the life and happiness of millions of us depend" were of special significance only because they were imbued with the character of those who created and maintained them.[237] Hine's celebratory viewpoint was driven by a desire to present the industrial world with a positive image of itself.[238] In projects such as his documentation of the construction of the Empire State Building (1930-31), Hine consistently portrayed workers with great sympathy and respect.

It is so difficult for us to recapture the sincerity of Hine's faith in technology that his intended meanings are often mis-

read. In his iconic *Powerhouse Mechanic*, ca. 1925 (plate 82), for example, Hine almost certainly meant to show the dominion of man over machine. However, in this carefully posed photograph, the vitality of the worker and the passivity of the machine seem eerily inverted. The worker conforms to the relentless arc of the dynamo, forever frozen in a posture of servitude, while the machine commands the entire space of the photograph, alive with light and energy. Ironically, Hine's photograph seems to illustrate an important antimodernist theme of the period: the machine's dehumanization of man. Fritz Lang's film *Metropolis* (1926), for example, conveys a grimly dystopian view of the technological future, while Charlie Chaplin's *Modern Times* (1936) presents a more comic, but equally alienating, vision of the monotonous routine of industrialized labor. Riddled with ambiguities, Hine's photograph offers no panacea, despite his own optimism. Ultimately it simply raises that central modernist dilemma: Does our technology free or enslave us?

Few bodies of photographic work in the 1920s or early 1930s tackled such difficult questions. For the most part, the skyscraper, the railroad, the factory, and the city street were simply seen as timely subjects by modernist photographers of both the avant-garde and Pictorialist persuasions. Both of these strains are evident in the work of E. O. Hoppé. The London-based Hoppé achieved international fame as early as 1909 as a portraitist and salon exhibitor.[239] The lingering elements of Pictorialism are evident in his 1927 book *Romantic America*, which displays a curious blend of realism and abstraction.[240] The result of numerous photographic excursions across the United States, *Romantic America* celebrates the picturesque appeal of subjects as diverse as the Grand Canyon and the Ford Motor Company factory. In his *Ohio River from the Point, Pittsburgh*, 1926 (plate 84), Hoppé depicts an industrial scene through the taut framework of a steel bridge. An effective contrast is established between the crisp geometry of the bridge and the impressionistic obscurity of the scene beyond. This image also illustrates Hoppé's artistic predilection for elevated vantage points and internal framing devices.[241]

Leonard B. Loeb's *Structural Abstraction*, ca. 1929 (fig. 46), provides a more forceful study of the anatomy of a steel bridge. This image focuses solely on structural power by isolating a detail of the bridge's supporting framework from all sense of surrounding context. Loeb was best known as a professor of physics at the University of California at Berkeley, and the author of several volumes on electricity, magnetism, atomic structure, and similar technical subjects. His extensive circle of friends included Johan Hagemeyer, Edward Weston, and Albert Einstein. While his body of surviving photographs is relatively small, Loeb's images suggest a fascinating synthesis of modernist traits with a deep understanding of fundamental structural principles.

Charles Sheeler was also fascinated by the logic of structure and the aesthetics of technology. In 1920, he collaborated with Paul Strand on *Manhatta*, a short experimental film that captured the dynamism of New York's harbor and

Fig. 46 **Leonard B. Loeb**, *Structural Abstraction*, ca. 1929, 7⅛ x 9¼″

streets.[242] To finance his personal work, Sheeler began a career in advertising and commercial photography. Between 1926 and 1929 he worked with Edward Steichen at Condé Nast, contributing frequently to both *Vanity Fair* and *Vogue*. As a result of these commercial contacts, Sheeler obtained his most memorable photographic commission. In 1927 Vaughn Flannery, the art director of the N.W. Ayer & Son advertising firm, asked Sheeler to photograph Henry Ford's new River Rouge manufacturing plant outside Detroit. Ford had just introduced the Model A and Flannery wanted images for a major promotional campaign. Oddly enough, Sheeler's assignment was to photograph the plant rather than the car. Flannery's plan was to celebrate the monumental beauty of manufacturing, or, as recent scholars have noted, to present "a generic image of Ford as a quiet colossus, as *the* great American machine."[243] It was a subject perfectly suited to Sheeler's interests, and the resulting photographs received worldwide recognition.[244]

Ford's River Rouge plant was the most advanced industrial operation in the world. Its twenty-three main buildings, ninety-three miles of rail line, twenty-seven miles of conveyors, and 75,000 employees all united to transform ore into autos with awesome efficiency.[245] Sheeler spent six weeks exploring the site before making thirty-two carefully considered images. His meticulously composed views of smokestacks, coke ovens, blast furnaces, slag buggies, dynamos, and stamping presses emphasize the vast scale of the complex and the precision of its operation. Workers are sometimes included as minor elements in these images, but Sheeler's real interest lay in the plant's majestic formal beauty. Sheeler perceived the Ford plant uncritically as a paradigm of order, harmony, and reason. While social critics of the day pointed to the human toll of modern industry, Sheeler took a cooler and more idealized view, depicting River Rouge as a brilliant union of men and machines working together for the advancement of civilization. As with his earlier photographs of preindustrial Bucks County, Sheeler recognized here the aesthetic manifestation of harmonious

collective enterprise, the timeless balance between function and structure. He was thus able, at once, to find inspiration in the complexity of modern industry and in the simplicity of vernacular buildings and artifacts. In parallel ways, each represented the "external evidence" of deeply held beliefs and ordered ways of life.[246]

Sheeler's only significant photographs outside the United States were taken in the spring of 1929 on the way to the opening of the "Film und Foto" exhibition. En route to Stuttgart, Sheeler visited the great Gothic cathedral at Chartres. The experience was profoundly moving for him, and resulted in a powerful series of fourteen photographs. Sheeler depicted Chartres as a perfect union of architectural innovation and spiritual expression. He paid particular attention to the most radical elements of the cathedral's engineering: its flying buttresses. The strongest of these views, *Chartres—Buttresses, from South Porch*, 1929 (plate 85), emphasizes the structure's machinelike precision. In fact, this photograph seems to make a direct analogy between these static stone supports and the pistons of a modern engine. Sheeler understood what a later art historian, Jean Bony, would express in these words: "Power is the key word at Chartres: power in constructional engineering, power in the carving of space, power too in the whole vocabulary of forms."[247] For Sheeler, Chartres represented nothing less than the casting of intellectual and spiritual power into monumental physical form.

The great engineering works of the twentieth century provided ample opportunity for the expression of similar sentiments. For example, Sheeler's associate Maurice Bratter was one of several noted photographers who were fascinated by the George Washington Bridge.[248] In a prodigious era of bridge construction, the George Washington was the most dramatic bridge of its time.[249] Not only did its 3,500-foot span nearly double the previous record for a suspension bridge, but the George Washington Bridge was renowned for its radically "pure" form. In fact, when plans were announced to clad the steel towers in granite, officials were forced by "widespread popular protest" to abandon the idea.[250] So powerfully did the bridge's sleek skeleton embody the functional aesthetic of the day that it seemed inconceivable to drape it in stone. Bratter's photograph (fig. 47), taken from a relatively unusual viewpoint, depicts the bridge as at once powerful and graceful, and a source of both public and private inspiration. A few years later, Peter Stackpole documented the construction of the San Francisco-Oakland Bay Bridge (fig. 48). This complex 8½-mile-long structure, built at the same time as the nearby Golden Gate Bridge (1933-37), was composed of several linked spans and a tunnel. Stackpole clambered all over the evolving framework with his small Leica camera, often working at dizzying heights. Unlike Sheeler or Bratter, Stackpole paid particular attention to the human side of engineering and made many images of the project's workmen.

The 1930s was also an important era in the construction of large dams, the most notable of which included the Shasta,

Fig. 47 Maurice Bratter, *George Washington Bridge*, ca. 1931, 9¾ x 7¾"

Grand Coulee, and Fort Peck Dams. The most famous, however, was Hoover Dam.[251] Upon its completion in 1936, Hoover Dam claimed a number of records: it was the highest dam in the world (726 feet), it held the largest reservoir, it was composed of the greatest volume of concrete, and it had the largest power capacity. While most of these statistics were surpassed by subsequent American dams, Hoover has remained an icon of engineering might.[252] The renown of Hoover Dam was due in no small measure to Ben Glaha, the project's official photographer. As a professional engineer with a lifelong interest in photography, Glaha was uniquely qualified for this role.[253] He produced motion-picture footage and a vast body of photographs of every stage of the construction, often working under the most challenging conditions. His work was used to illustrate technical reports and was also given broad public distribution. An admirer of Sheeler, Glaha aimed for "the beauty of pure function" in even the most utilitarian of his images.[254] As Willard Van Dyke noted, "Glaha's technic is clean and precise, like the machinery he works with."[255] Glaha admired both the machines in use at Hoover Dam and the human skills required to operate them. While the sheer scale of these machines make them dominant in many of Glaha's pictures (plate 83), the guiding force of human intelligence is always felt.

The drama of industrial technology also formed the central theme of Margaret Bourke-White's work. In her studies at the Clarence White School, Bourke-White absorbed the lessons of "space-filling." Her early photo-

Fig. 48 Peter Stackpole, *Workers on the San Francisco-Oakland Bay Bridge*, 1935, 4½ x 6⅝"

graphs characteristicaly utilize a variety of modernist traits—dynamic viewpoints, bold close-ups, and the repetition of simple elements—to give bold aesthetic form to the most mundane subjects (plate 86).[256] She first achieved national recognition for her 1927-28 photographs of the Otis Steel foundry in Cleveland. In 1929, she was hired by Henry Luce as the chief photographer for his new business magazine *Fortune*. It was a fortuitous choice for both of them.

Sparing no cost, Luce made *Fortune* both the most important business publication and the most beautiful photographic journal of the era. Unusually large in format, and skillfully printed, *Fortune* was sold by subscription only at one dollar a copy. Although it debuted in February 1930, only months after the great stock market crash, the magazine maintained its high standards—and remained profitable—throughout the Depression. In large measure, *Fortune*'s appeal stemmed from its unprecedented use of modern photography. By reproducing most of its images in generous size, *Fortune* presented photographs as both information and art. Indeed, many of the photographs in *Fortune* were reproduced as full-page plates with ruled "frames" that suggested the elevated realm of the gallery or museum. This treatment was not unjustified, as many of the illustrations were indistinguishable from the most progressive artistic work of the era.[257]

Bourke-White's polished style was ideally suited to *Fortune*; indeed, both the photographer and her work were bold, dynamic, and glamorous, and thus perfectly evocative of the magazine's vision of the modern age.[258] Bourke-White traveled widely for *Fortune* to record a great variety of trades and technologies. These included the watch-making, garment, newspaper, natural gas, salt, steel, banking, telephone, automobile, paper, aluminum, glass, meat-packing, and shipping industries. She also produced photoessays on a limestone quarry, a salt mine, a hydroelectric plant, and a skyscraper, as well as on the speakeasies of New York. In 1930 Bourke-White photographed businesses in Germany and then became the first foreigner to record the industrialization of Russia. Her work so impressed Soviet authorities that she was invited back in 1931 and 1932. Bourke-White's

celebrity grew well beyond the photographic world; she not only recorded the great events of the day, but herself became a newsworthy figure.[259]

While Bourke-White was the most celebrated of the *Fortune* photographers, to Luce's credit, she was not the only one. In the 1930s, industrial views by William M. Rittase, aerial photographs by Alfred G. Buckham, candid hand-camera images by Erich Salomon, and photomontages by Arthur Gerlach were published, in addition to work by Ralph Steiner, Ben Glaha, Walker Evans, Torkel Korling, Carl Mydans, Otto Hagel, Dmitri Kessel, William Vandivert, and others.

Ultra High-Speed Photography

The engineering advancements of the 1910s and 1920s were reflected in the mechanization of vision itself. These technical refinements were shown most vividly in dramatic high-speed still and motion-picture photography. Stop-action photographs of bullets in flight had been made by the light of electric sparks since the late nineteenth century.[260] During World War I, Lucien Bull of the Marey Institute in Paris built a motion-picture camera that recorded 5,000 frames per second (more than 300 times the normal rate) by the light of repeated electric sparks. Bull used this technique to study the flight patterns of insects and bullets.[261] By 1922, Philip P. Quayle of the U.S. National Bureau of Standards was using a related process to make crisply detailed still photographs of bullets passing through soap bubbles.[262] The U.S. Army Ordnance Department had begun similar research in 1919, and by 1925, Captain S. P. Meek had recorded bullets in the air, and penetrating cardboard, with effective exposure times of 1/3,000,000 second.[263] By 1928, this kind of work was familiar enough that one writer noted that it was "not exactly a new field."[264]

High-speed photography was refined and made even more broadly known by Harold E. Edgerton, an electrical engineer long associated with the Massachusetts Institute of Technology.[265] Edgerton's work was seen internationally in the 1933 exhibition of the Royal Photographic Society in London, and was widely published in the later 1930s in both scientific and popular journals. In 1931, Edgerton perfected the stroboscope, a device which produced single or repeated bursts of intense light more efficiently than the crude electric sparks used previously. Over the next several decades, he employed the stroboscope to photograph falling water, birds and bullets in flight, and a variety of athletic activities. He devoted particular effort to recording the crownlike patterns created by the splash of droplets of milk (plate 87). Fascinated by the complexity of this action, Edgerton photographed milk drops over a period of twenty-five years. While he never achieved his goal of capturing a perfectly symmetrical coronet, his milk-drop studies remind us of the unexpected beauty hidden in the most mundane subjects.

The Documentary Urge

The culture of the 1920s and, to an even greater extent, the 1930s was characterized by a passion for the real. As historian William Stott has shown, a fundamentally documentary point of view permeated all levels of American society in this era.[266] Newsreels, "true confession" pulp fiction, radio soap operas, and movie-star fan magazines were popular expressions of the same broad movement that produced a rise in social science research, journals such as *Life* and *Look*, John Steinbeck's *The Grapes of Wrath*, and Martha Graham's ballets "American Lyric" and "American Document." These manifestations reflected a variety of viewpoints. From the mania for engineering came an almost evangelical faith in rational problem-solving based on the collection and analysis of objective data. From the rekindled interest in the American experience came a new attention to history and to the distinguishing traits of the many regional, ethnic, and religious groups that together comprised the nation. From the ever-expanding mass media came immediate access to the events and personalities of the day, with the news photographer playing an increasingly important role. Finally, artists and thinkers of all stripes were converted from abstract to realist concerns by the crisis of the Depression. The hard facts of widespread business failure, massive unemployment, and the Dust Bowl made the more cerebral and formalist concerns of the 1920s seem hopelessly effete. As Alfred Kazin observed in 1942, "Never before did a nation seem so hungry for news of itself."[267]

The camera's role in this vast fact-finding mission was multi-faceted. Press photographers and newsreel cameramen covered all the public events of the day, creating a visual record of unprecedented depth. The sweltering conditions and heated debate of the 1925 Scopes trial, for example, are aptly suggested in the photographs of Carl Nesensohn (fig. 49), one of several photojournalists to attend the twelve-day proceedings. A dozen years later, the catastrophic *Hindenburg* explosion was recorded by scores of reporters, photographers, and motion-picture cameramen, and memorialized in screaming headlines across the nation (fig. 50). The quest for sensation, scandal, and scoops produced ingenious strategies to record forbidden subjects. For example, Tom Howard's surreptitious image of a state-sponsored execution in the electric chair remains one of the most dramatic news photographs of the century (fig. 51).[268] The result of careful planning, this gritty image was produced with a small glass-plate camera that had been prefocused, loaded with a single negative, and strapped to Howard's ankle. Using a cable release that ran to the pocket of his trousers, Howard exposed this plate for a total of about five seconds.

A less spectacular form of realism was everyday portraiture, the essentially commemorative work that comprised the great bulk of professional practice. For a studio photographer such as James Van Der Zee, for example, the essence of documentation was the daily schedule of portrait sittings and commissions to record various social events (fig. 52).

Fig. 49 Carl Nesensohn, *Clarence Darrow Speaking at the Scopes Trial*, 1925, 5⅝ x 8⅞"

Fig. 50 Robert Seelig and Charles Hoff, *Hindenburg Explosion*, 1937, halftones in New York *Daily News*, May 7, 1937; 15⅜ x 22¾" overall

Fig. 51 Tom Howard, *The Electrocution of Ruth Snyder*, 1928, 4½ x 4"

Van Der Zee opened a studio in Harlem in 1912 and for decades pictured the residents of this vital segment of New York society. Van Der Zee's role as the official photographer for Marcus Garvey's Universal Negro Improvement Association gave him a unique perspective on the African-American struggle for social and economic progress in the years between the world wars. As a reflection of both his own ideas and the interests of his clients, Van Der Zee's work typically records a healthy and prosperous society structured by the institutions of family, church, and commerce.

At the other end of the economic scale were the celebrity images of this era. Publications such as *Vanity Fair* and *Life* presented a parade of talented, beautiful, or otherwise notable people for regular public inspection. Between 1923 and 1938, the years in which he operated his New York studio, Edward Steichen was the leading exponent of this kind of work. Since renouncing art-for-art's-sake after his experimental images of 1921-22, Steichen devoted himself to photography as a utilitarian and democratic art that served the needs of business while communicating to a broad audience. His celebrity portraiture used dramatic pose, lighting, and composition to create a glamorous union of inner self and public persona. In his portraits of Charlie Chaplin, Gloria Swanson, Greta Garbo, and scores of other notable personalities of the 1920s and 1930s, Steichen made generous use of the camera's inherent ability to merge description and invention. These photographs were praised as "dramatic and spectacular," with "an almost exaggerated realism."[269] One of the earliest of Steichen's portraits to appear in *Vanity Fair* was *"Mr. and Mrs.," The Sandburgs*, 1923 (plate 49).[270] This image depicts Steichen's sister Lillian with her husband Carl Sandburg, and is somewhat unusual in his work of this era for having been made outside the studio. However, it is emblematic of his later career by focusing on universal human emotions; at once heroic and tender, this photograph stands as a monument to the most intimate bonds of love and devotion.

The Art of Documentary

In the context of these and similar applications of relatively straight photography, a select number of artists had begun exploring other aspects of photographic realism by about 1930. This new style, exemplified in the austere clarity of Walker Evans's work, was both a reaction to and a logical extension of the new vision of the 1920s. For example, while this new aesthetic rested on Moholy-Nagy's celebration of the optical precision of the camera, it rejected his interest in unusual vantage points and manipulations. For Evans and other realists of his generation, the now-familiar new vision was no longer a viable means of artistic discovery: it was simply a style, as easily learned or imitated as any other. Similarly, the f/64 approach of Weston and his circle was viewed as too bound to issues of technique, too overly formal in its vision, and almost completely removed from social and historical realities. Stieglitz's work was seen as hopelessly

Fig. 52 James Van Der Zee, *Convention, Church of Christ*, 1928, 7¾ x 9¾"

melodramatic and precious, while Steichen's was simply too commercial. As an alternate model, Evans's work was cool and cerebral, rich in detail but deliberately restrained in expressive effect, and concerned exclusively with the cultural landscape.

Proponents of this new style looked to the past for an appropriate artistic lineage. Two historical figures, Eugene Atget and Mathew Brady, were celebrated as the progenitors of this modern sensibility. Atget, who recorded Paris and its surroundings from the late 1890s until his death in 1927, received widespread attention in Europe and America beginning just after his death.[271] His work was exhibited at "Film und Foto" in 1929 and a year later at the Weyhe Gallery in New York and the Harvard Society for Contemporary Art. Atget's burgeoning influence was made possible by the young American photographer Berenice Abbott, who (with the help of Julien Levy) rescued his prints and negatives from destruction and tirelessly promoted his work. Similarly, the Civil War-era photographer Mathew Brady was rediscovered at this time as a spiritual forefather of the new documentary aesthetic.

The symbolic importance granted these ancestor figures is clearly revealed in the praise they received at the time. In reviewing a new book on Atget in 1930, Evans observed that the Frenchman had worked in quiet isolation throughout "a period of utter decadence in photography." For Evans, Atget's sublime gift lay in his powerful engagement with worldly fact.

> His general note is lyrical understanding of the street, trained observation of it, special feeling for patina, eye for revealing detail, over all of which is thrown a poetry which is not "the poetry of the street" or "the poetry of Paris," but the projection of Atget's person.[272]

At about the same time, Lincoln Kirstein (who had commissioned this essay from his friend Evans) praised Brady's "sober and sensitive eye." He observed that Brady's photographs exhibit

a sincerity, clarity and honest brilliance not found in the work of his contemporaries....Brady's plates have the esthetic overtone of naked, almost airless, factual truth, the distinction of suspended actuality, of objective immediacy not possible, even if desirable, in paint. Brady's work is an example of the camera's classic vision, austere and intense.[273]

This Brady—the proto-modern artist/hero who risked life and limb to document the Civil War—was an almost complete historical fiction, a projection of the ideals of Kirstein's era rather than a product of serious scholarship.[274] To a lesser degree, Atget's career was also simplified in order to function most clearly as a symbolic model. Between them, however, this Atget and Brady—as well as Lewis Hine, also rediscovered at this time—pointed the way to a new photographic avant-garde that combined austerity and lyricism in varying proportions.

The Photo League

An important aspect of this era's documentary production stemmed from the radical political climate of the time. Spurred by the apparent failure of capitalism throughout the world, leftist political groups enlisted photographers and filmmakers to record the effects of this economic collapse and to campaign for a new social order. The Worker's International Relief, founded in 1921 by the Communist International to support strikers and workers around the globe, organized Workers Camera Leagues in major cities in Europe and America.[275] The New York Workers Film and Photo League, founded in 1930, became the unofficial flagship for similar chapters in Los Angeles, San Francisco, Chicago, Detroit, and other cities. After emphasizing documentary filmmaking in its early years, the New York organization split into several factions in 1935. The group's more artistically inclined documentary filmmakers, including Leo Hurwitz and Ralph Steiner, united with Paul Strand, Ben Maddow, and others to form Frontier Films; the still photographers of the original group, under the guidance of Sid Grossman and Sol Libsohn, reformed as the Photo League. Some of the most notable members of the Photo League in the following years were Walter Rosenblum, Lisette Model, Aaron Siskind, Morris Engel, Ruth Orkin, Louis Stettner, Jerome Liebling, Dan Weiner, Consuelo Kanaga, and Max Yavno. A self-supporting group of amateurs and professionals, the Photo League was dedicated to an honest use of the camera to record the "profound and sober" realities of their world.[276] Through the hard work of its most dedicated members, the Photo League presented classes, lectures, and exhibitions, and published a regular newsletter titled *Photo Notes*. The group also assumed responsibility for Lewis Hine's archive of prints and negatives after his death in 1940.

While the Photo League generally downplayed the radical origins of its parent organization, members knew that "they were sharing a common orientation and direction in their art, a documentary approach that was progressively left and

Fig. 53 **Walter Rosenblum**, *Three Children on Swings, "Pitt Street" Series, New York*, 1938, 7⅝ x 9½"

people-oriented."[277] The League's idealistic belief in collective effort and the transformative power of socially responsible art is suggested in the words of member Elizabeth McCausland, a noted critic of art and photography. When McCausland lectured at the League in 1938 on "Documentary Photography," few in attendance would have disagreed with her analysis of the art of the recent past.

> After the eccentricities of "art for art's sake," art returned to its historical roots, as the spokesman of human experience and life. After a decade or so, when subject-matter was declassé, suddenly subject-matter became the ultimate criterion of art. A painting, a sculpture, a print, a photograph MUST have *content*, and not merely content of a personal or romantic character, but *social* content.
>
> ...precisely because it will be incredible to future ages that human beings lived in squalor and filth, congested quarters, under-fed, illiterate, sickly with anemia and venereal disease, do we need today to record these facts. They are truth. But facing the truth, we summon up forces to change the facts and make them consonant with the dignity of human life. Refusing to face the truth, we become responsible for the ugly facts and perpetuate them in a dangerous locus of infection.[278]

This passion for "truth" and a belief in the dignity of human life lay at the root of the Photo League's activities.

Photo League members put their artistic and social ideals into practice in a series of documentary projects. In 1936, the League's Feature Group was organized by Siskind, an amateur photographer then employed as a high-school English teacher. Over the four years of its existence, the Feature Group produced collaborative bodies of photographs on such themes as "Portrait of a Tenement," "Dead End: The Bowery," and "Park Avenue: North and South." The largest of these projects, "Harlem Document," was produced between 1937 and 1940 by Siskind, Harold Corsini, Jack Manning, and other League members in collaboration with Michael Carter, a black writer and social worker. Other notable thematic studies of this period include Grossman and Libsohn's "Chelsea Document" and Rosenblum's "Pitt

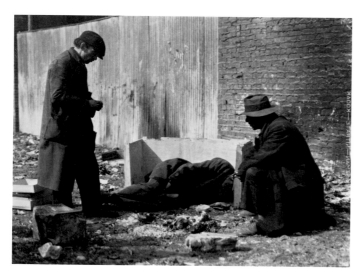

Fig. 54 **Consuelo Kanaga**, *The Bowery* (New York), 1935, 3⅝ x 4⅝″

Street" (fig. 53). The photographs from these projects were widely exhibited in New York, and reproduced in publications such as *Fortune, Look*, and *U.S. Camera*. Photo League photographers sought an emotional as well as political understanding of their subjects. As a result, their images depict the rhythms of daily life in a deeply sympathetic and humane manner. Even when their subject matter is gritty, as in Consuelo Kanaga's *The Bowery* (New York), 1935 (fig. 54), the images produced by the members of the Photo League reveal a deep respect for the essential humanity of those depicted.

Government Patronage

The era's documentary sensibility coincided with, and was enlarged by, the activist programs of Franklin D. Roosevelt's New Deal. After taking office in early 1933, at the depth of the Depression, Roosevelt created a variety of programs to put people back to work. While of varying success, these new agencies spurred a massive wave of official fact-gathering. Programs in all manner of historical and artistic disciplines were developed under the auspices of the Works Progress Administration (WPA). In 1935, the WPA initiated remarkably wide-ranging projects in writing, theater, art, and music. The Federal Writer's Project, for example, produced 378 books and pamphlets in its American Guide series. Volumes were published on all forty-eight states, major and minor cities, federal highways, tourist areas, scenic waterways, and regional folklore. The Federal Theater program dealt with contemporary issues in documentary plays called "Living Newspapers." At the same time, folklorists were transcribing traditional American songs, compiling oral histories, and writing ethnic studies.[279] The Index of American Design, the Historic American Buildings Survey, and the Historical Records Survey were also initiated to document the nation's art, architecture, and archives. The net effect of this staggering volume of activity was to engender a new respect for the diversity and vitality of American life.

There was also a Federal Art Project, but only one of its programs—in California—supported photography as a

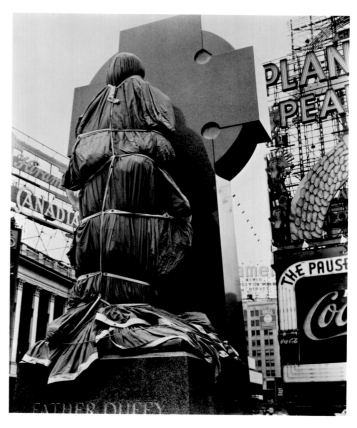

Fig. 55 **Berenice Abbott**, *Father Duffy, Times Square, Manhattan*, 1937, 9⅜ x 7⅝″

purely self-expressive medium. Under this project, Edward Weston, his sons Brett and Chandler, Sonya Noskowiak, Sybil Anikeef, and several others were paid to produce exhibitions of their work to tour to schools and museums. More characteristically, however, photography was employed in the federal projects as a purely documentary tool. Thousands of photographs were produced for the Historic American Buildings Survey, for example, and to illustrate the American Guide publications. Photographers were also hired to document the paintings, sculptures, and prints created by government-sponsored artists.

Despite the mundane, functional nature of this work, photographers such as Berenice Abbott were able to use government patronage to continue projects of personal interest. Abbott had taken up photography in the early 1920s in Paris, where she worked for a time as Man Ray's assistant. She was profoundly affected by the photographs of Eugene Atget, whom she met and photographed at the end of his life. His ambitious thirty-year documentation of Paris inspired Abbott to devote the same kind of attention to New York City. Her project, begun in 1929, represented an attempt to depict "the dual personality of a great city in which the past lives side by side with the incredible present."[280] Abbott gained the time, salary, and staff to fully pursue this work when she was hired in 1935 by the "Changing New York" unit of the Federal Art Project. Over the next four years she turned her large 8x10-inch camera on innumerable aspects of the city, including its residences, commercial buildings, docks, bridges, highways, street vendors, churches,

cemeteries. These images were carefully dated and accompanied by historical or technical data.

Two of her best-known photographs from this project are *Newsstand, 32nd Street and 3rd Avenue*, 1935 (plate 89) and *Father Duffy, Times Square*, 1937 (fig. 55). Both use a wealth of visual detail to describe specific subjects at precisely identified moments in time.[281] The notes accompanying Abbott's newsstand photograph indicate that it was "built in 1932 by James Stratakos and [is] still owned and operated by him." Further, the contents of this newsstand were identified as "typical of what the public reads. Over 200 magazines are handled, but it is sales from the metropolitan daily newspapers which keep the business going."[282] However, while this image presents the newsstand as both a singular example and a representative type, Abbott's photograph of the Father Duffy statue in Times Square is less typical. Tightly bound in protective fabric just prior to its public unveiling, this now-familiar statue is presented as a kind of Surrealist "found object," suggesting the lingering influence of Abbott's mentor, Man Ray.[283]

The Resettlement/Farm Security Administration

While many New Deal agencies actively produced or collected photographs, the most significant of these was the Resettlement Administration (RA).[284] This agency was founded in 1935 to oversee a variety of farm programs, including loans, debt adjustments, migrant camps, erosion and flood control, and the creation of cooperative rural resettlement communities. In 1937, the Resettlement Administration was transferred to the Department of Agriculture and gained the name by which it is best known today: the Farm Security Administration (FSA).

The Resettlement Administration's first director was Rexford Tugwell, an economist from Columbia University. Faced with the challenge of developing consensus on the nature of rural problems and the government programs intended to alleviate them, Tugwell embraced film and photography for their powers of realism and persuasion. A documentary film unit was established to allow Pare Lorentz to produce two feature-length motion pictures: *The Plow That Broke the Plains* (1936) and *The River* (1937). Photographers Ralph Steiner, Paul Strand, and Willard Van Dyke worked as cameramen on these film projects.[285]

To assist in his department's massive educational campaign, Tugwell hired Roy Stryker, a former student and colleague from Columbia, as head of the Historical Section-Photographic of the RA's Information Division.[286] Stryker's task was to collect visuals in support of the Administration's mission to make American agriculture more progressive and stable. To this end, Stryker sought photographs that documented the problems of rural America and the government's ability to solve them. These photographs were used within the FSA and other government agencies in posters, booklets, and filmstrips, circulated to various congressional committees, and published widely in the national press.

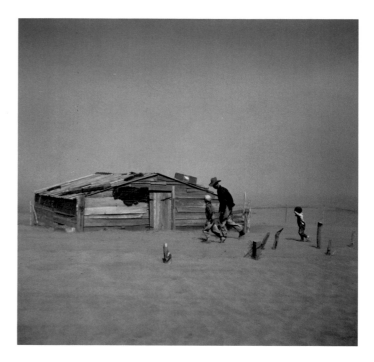

Fig. 56 Arthur Rothstein, *Farmer and Sons Walking in Dust Storm, Cimarron County, Oklahoma*, 1936, 8¼ x 8¼"

Stryker also created traveling shows of these images. By the end of 1936, for example, he had assembled twenty-three exhibits for venues as prominent as the Museum of Modern Art and that year's Democratic National Convention. The agency's most popular exhibition—on migrant workers—was requested more than eighty times in three years.[287]

This educational and essentially propagandistic function remained foremost in Stryker's mind throughout his tenure with the RA and FSA. However, the rather vague outline of his mission gave Stryker considerable latitude, and he developed a sense of direction in his first year on the job. He gradually came to view himself as a cultural historian building a visual archive for future generations. This larger perspective resulted in the recording of urban and small-town subjects with little obvious relation to farming problems, as well as myriad details that evoked the flavor of everyday life. As John Vachon later recalled, in addition to their official assignments, Stryker encouraged his photographers "to record whatever they saw, really saw: people, towns, road signs, railroad stations, barber shops, the weather, or the objects on top of a chest of drawers in Grundy Co., Iowa."[288] In hindsight, it seems clear that the real subject of Stryker's FSA file—which grew to include some 270,000 images by 1943—was the relentless transformation of American life as evidenced in the tensions between past and present, rural and urban, man and machine.

Despite the relative freedom given the photographers, the character of the FSA file was a direct reflection of Stryker's vision.[289] He directed the activities of his staff by issuing detailed shooting "scripts" (which nonconformists like Evans generally refused to follow), and deleted pictures from the file that he did not like. Since he valued photography as a documentary and persuasive medium, Stryker distrusted images that seemed overly artistic. He felt that art blunted

photography's didactic function by redirecting its thrust from the political to the contemplative, or, perhaps, from the timely to the timeless. To ensure that each image was tied to an unambiguous narrative, he insisted that his photographers submit detailed captions for every shot.

Stryker employed a total of eleven photographers between 1935 and 1943. Some worked for only a few months, and no more than four or five were ever on the payroll at once. These photographers ranged from some of the nation's most notable artists and professionals to relative neophytes. In the fall of 1935, Stryker's Historical Section "inherited" Carl Mydans, Ben Shahn, and Walker Evans from other units of the RA. Arthur Rothstein was the first photographer personally chosen by Stryker, followed soon after by Theo Jung and Dorothea Lange. Russell Lee replaced Mydans in the summer of 1936, and over the next few years Jung, Evans, Shahn, and Lange left or were dismissed. Stryker's photographic staff in the later years of the FSA included Marion Post Wolcott, Jack Delano, John Vachon, and John Collier.[290] In 1938, Edwin Rosskam was hired to design exhibitions of FSA work and to oversee the use of file images in books and magazines.[291]

The experience and talents of these photographers varied enormously. Ben Shahn, at 37, was an established painter when he joined Stryker's staff. With advice from Evans, Shahn had taken up photography in 1932, largely as an adjunct to his painting.[292] Shahn's favorite camera was the 35mm Leica with a right-angle viewer, a combination that allowed him to work quickly and unobtrusively. This technique produced pictures characterized by their spontaneity, "asymmetrical balance, compressed space, and dramatic cropping."[293] These traits, as well as Shahn's leftist political sentiments, are apparent in such images as *Sheriff During Strike, Morgantown, West Virginia*, 1935 (plate 90).[294]

The vision of more experienced artists and photographers such as Shahn, Lange, and Evans had enormous impact on younger RA photographers like Arthur Rothstein. Rothstein was only 21 years old, and without professional experience in photography, when he joined Stryker's staff. He learned quickly, however, and followed Stryker's guidance far more willingly than some of his seniors. By the spring of 1936, Rothstein had produced two certifiable icons of the Depression: *Farmer and Sons Walking in Dust Storm, Cimarron County, Oklahoma*, 1936 (fig. 56), and a close-up of a steer skull on a parched alkali flat in South Dakota. Both images became symbols of the vast human and environmental effects of the decade's prolonged drought.

Walker Evans and Dorothea Lange

While all of Stryker's photographers made powerful and effective images, the work of Walker Evans and Dorothea Lange was particularly emblematic of this era. But, aside from their disputes with Stryker, Evans and Lange had little in common. Evans's coolly cerebral photographs reveal layers of meaning in cultural artifacts, while Lange's center

on the expressiveness of the human face and form. Both were experienced photographers when they joined the FSA, with their style and working method firmly established. Because they held such different views of documentary photography, however, their works serve to highlight the heterogeneous nature of photographic realism in this era.

Evans is perhaps the best known and the least typical of the FSA photographers. Raised and educated in affluence, Evans rebelled at an early age against the smug prosperity of the 1920s. He developed an interest in literature as a young man, and became familiar with a range of avant-garde artistic ideas during a year in Paris and his subsequent residence in New York. After turning to photography in 1928, Evans used a small camera to produce typical new vision effects before developing a more straightforward approach. This change in direction was the result of several factors, including his admiration for the "objectivity of treatment" and "the non-appearance of the author" in the literature of Gustave Flaubert.[295]

In addition to admiring the work of Atget, Steiner, and the bluntest of Strand's *Camera Work* gravures, Evans was probably also influenced by a photographer who, until now, has gone almost completely unrecognized: his brother-in-law, Talbot M. Brewer.[296] A personnel administrator by profession, Brewer was an accomplished photographer by 1930. Fascinated by quirky expressions of vernacular and popular culture, Brewer photographed diners, advertising signs, and similar subjects in the U.S. and abroad. His photograph *The "Comics," Spain*, 1930 (plate 88), represents a bemused catalogue of popular melodrama, while documenting the international appeal of the most stereotypical American myths and icons. The precise intelligence of this image, and many more of his photographs, suggests that Brewer deserves more recognition than he has hitherto received.[297]

In the early 1930s, as a result of these influences, Evans began focusing on such unfashionable subjects as advertising signs, old houses and commercial buildings, and the streets of small towns. Rejecting the shiny optimism of the modern, Evans instead recorded the organic life of manmade things. Evans's devotion to simple vernacular subjects was part of a larger cultural interest in Americana and folk art, but his passion for these things was uniquely long-lived and unsentimental.[298] His use of a tripod-mounted view camera (in the 6½ x 8½-inch and then 8 x 10-inch format) necessitated a slow, precise, and contemplative mode of working. Prints made from these large negatives seemed almost magically transparent, creating an illusion of artless objectivity. In fact, this apparent simplicity was the product of a carefully honed artistic point of view, and Evans was keenly aware of the difference between documentary photography and his own "documentary style."[299] Thanks in part to support from Lincoln Kirstein, Evans's work was included in several prestigious exhibitions and publications in these years.[300]

From this background, Evans joined Stryker's staff as a respected and wholly self-motivated artist. As such, he often refused to follow Stryker's directions; this led to continuous

Fig. 57 **Walker Evans,** *Sharecropper's Wife, Hale County, Alabama,* 1936, 7½ x 2⅝"

friction between the two and, eventually, to Evans's dismissal. However, Evans put his time under Stryker to good use. The majority of his photographs for the Resettlement Administration—and the most celebrated pictures of his entire career—were produced in an intense fifteen months spanning the summers of 1935 and 1936. During this period, he photographed in West Virginia and Pennsylvania before traveling through Mississippi, Louisiana, Alabama, Georgia, and South Carolina. He recorded working-class houses, barber shops, general stores (plate 93), small-town main streets, gas stations, statues, churches, cemeteries, train stations, people at parades and picnics, a dump of rusted old cars, and, in Birmingham, Alabama, a local portrait photographer's display window.

Evans's intelligence and dispassionate intensity transformed these banal subjects into deeply moving emblems of human life in all its complexity. The power and originality of this work was evident to the most astute observers of the period. Literary critic Lionel Trilling noted that "what always immediately strikes me about [Evans's] work is its perfect taste, taking that word in its largest possible sense to mean tact, delicacy, justness of feeling, complete awareness and perfect respect. It is a tremendously impressive moral

quality."[301] Kirstein observed, "The power of Evans's work lies in the fact that he so details the effect of circumstances on familiar specimens that the single face, the single house, the single street, strikes with the force of overwhelming numbers, the terrible cumulative force of thousands of faces, houses and streets."[302] And finally, in the radiant commonplaces of these photographs, poet William Carlos Williams recognized that "It is ourselves that we see, ourselves lifted from a parochial setting. We see what we have not heretofore realized, ourselves made worthy in our anonymity."[303]

Evans's most memorable work was produced in collaboration with James Agee in July and August of 1936. Commissioned by *Fortune* to investigate the plight of Southern tenant farmers, Evans and Agee lived with one family in Hale County, Alabama, and were in intimate contact with two neighboring households, for slightly less than four weeks.[304] Agee talked at length with these subjects and made endless notes on the sights, sounds, and smells he encountered. Evans photographed the members of these families, individually and in groups, as well as their houses and environments (fig. 57, plate 92). Many of his most powerful images are devoid of people but poignantly evocative of the human presence. His pictures of bedrooms and kitchens reveal a painfully spare, but never squalid, way of life. Indeed, what is striking is that even in the midst of abject poverty, the farm families maintain a powerful sense of order and dignity. Through his choice of viewpoint and framing, Evans's pictures present the simplest things—a chair, towel, pair of shoes, child's grave, or grouping of kitchen utensils —as symbols of the most primal human realities: labor, sustenance, faith, family, and mortality.

The Agee-Evans collaboration was rejected by *Fortune*, but was later published in book form as *Let Us Now Praise Famous Men* (1941). As a reflection of the co-equal status of Evans's photographs and Agee's narrative, the book is divided into two sections: the photographs, presented full-page without captions, followed by the lengthy text. The combination is both startling and effective. Evans's quiet, intense, and precise images form the perfect foil to Agee's poetic and self-reflexive writing. Ultimately, the book describes the lives of the tenant families in exhaustive detail while holding the documentary process itself up to examination. This remarkable volume received little attention in 1941. Since its republication in 1960, however, it has been widely acclaimed as one of the most important American books of its time.[305]

The definitive presentation of Evans's photographs occurred three years prior to the appearance of *Let Us Now Praise Famous Men.* In 1938, Evans became the first photographer to be honored by a one-person exhibition at the Museum of Modern Art.[306] To accompany this show, the museum published *American Photographs,* a small but handsome book with an eloquent essay by Kirstein and eighty-seven reproductions. These images were selected and sequenced to extraordinary effect. Collectively, Evans's photographs constituted, in Kirstein's words, nothing less

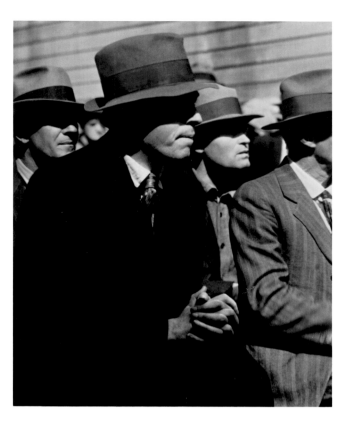

Fig. 58 **Dorothea Lange**, *White Angel Breadline, San Francisco*, 1933, 11⅝ x 10″

Fig. 59 **Dorothea Lange**, *San Francisco Waterfront*, 1934, 8¾ x 6⅞″

than the "physiognomy of a nation."[307] Unlike the many other photographic books on the United States produced in this period, Evans's work avoids nationalistic boosterism and picturesque clichés. Instead, his exacting pictures suggest the complexities and contradictions of American society through such themes as the effects of the machine age on agrarian ways of life, and the intersection of mass and vernacular culture. The America of *American Photographs* is thus a curious synthesis of vitality and exhaustion, the sublime and the mundane, the present and the past. While this book had its critics, Evans's impact on following generations of photographers has been very largely the result of this volume.[308]

The empathy so characteristic of Dorothea Lange's work stemmed, in part, from what she described late in life as "the most important thing that happened to me."[309] At age seven, Lange was stricken with polio in her right leg, resulting in partial paralysis and a lifelong limp. This disability both humiliated and strengthened her, while greatly increasing her sensitivity to the condition of those with whom she came in contact. Lange's photographic career began with entry-level positions in several New York studios, including that of Arnold Genthe, and a brief stint at the Clarence White School in 1917. In 1918, Lange relocated to San Francisco, where she met photographers such as Imogen Cunningham and Consuela Kanaga. By 1919, Lange had established herself as a portrait photographer of some note.[310] However, the next decade was significant more for her family life—her marriage to the painter Maynard Dixon and the birth of two sons—than for the originality of her photographs.

Lange finally came into her own as a photographic artist in 1932-33, the most desperate years of the Depression. After

weeks of watching unemployed men on the street below her second-floor gallery, Lange suddenly felt compelled to record the social tragedy around her. Her first important documentary image was made at a bread line established by a rich woman nicknamed the "White Angel." Lange made three exposures at this site, all focusing on a solitary figure who appears to have turned away from the line in a mixture of shame and hopelessness (fig. 58). His slumped shoulders, downcast eyes, shabby clothes, and battered tin cup suggested the physical and emotional state of many similar men across the nation. This man's anonymity only emphasized his role as the Depression's "Everyman."

In the following months, Lange produced many powerful images of San Francisco's demonstrations, strikes, and food lines (fig. 59, plate 91). Characteristically, her emphasis was on the telling detail that summed up the larger feelings of desperation, anger, and fear that lay so heavily on the nation. This work greatly impressed Willard Van Dyke, who exhibited Lange's photographs at his 683 Brockhurst Gallery in Oakland and wrote a glowing profile on her for *Camera Craft*.[311] The Oakland exhibition in the summer of 1934 marked a turning point in Lange's career. In addition to the praise it garnered, the exhibit precipitated Lange's introduction to Paul S. Taylor, an associate professor of economics at the University of California at Berkeley. Taylor, a recognized expert on labor subjects, used one of Lange's photographs to illustrate an article in *Survey Graphic* on the San Francisco general strike. A life-long professional and personal relationship ensued, and they were married at the end of 1935.

Taylor's influence gave Lange's work additional direction and depth. Taylor had made extensive use of the camera him-

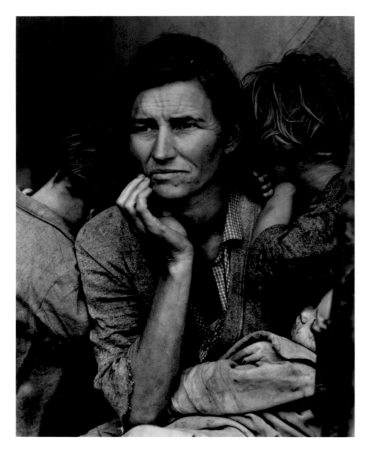

Fig. 60 **Dorothea Lange**, *Migrant Mother, Nipomo, California,*
1936, 13⅜ x 10¼"

self in the years 1927 to 1934 to document his field re-
search.³¹² As a result, he fully appreciated the power of
Lange's photographs, and their ability to give human dimen-
sion to his written summaries. Lange, in turn, admired
Taylor's grasp of social and economic issues and embraced
his belief in the union of words and pictures. In her sub-
sequent work for the Resettlement Administration, for
example, Lange was the most conscientious of Stryker's
photographers in writing captions for her images. Taylor and
Lange made a superbly effective team in their work for the
California State Emergency Relief Administration document-
ing the condition of migrant workers and Dust Bowl
refugees. The impact of their collaborative reports led to
Lange's transfer to the Western regional office of the Reset-
tlement Administration on September 1, 1935.

Lange worked under Stryker's authority until 1939, per-
severing through several layoffs and rehirings precipitated by
federal budget cycles. While maintaining her home base in
Berkeley, Lange traveled widely. In addition to the work she
did in California, she photographed in the American South
and Southwest, and traveled as far east as New York City.
She often worked in tandem with Taylor, who was then
employed as a researcher for the Social Security Board. While
Lange photographed a variety of subjects, she was particu-
larly attentive to certain situations and moods. Repeatedly,
she photographed people standing in fields or in front of
ramshackle farmhouses, desperately surveying their ex-
hausted land; drought refugees on the road west, in cars

loaded with belongings, or simply on foot; and families living
in tents or crude shelters in relief camps in California. Lange
used eloquent details—a glassy stare, a resigned pose, or a
tight-jawed look of stubborn endurance—to suggest both an
all-enveloping climate of hardship and the faith and determi-
nation necessary to survive hard times. Her *Migrant Mother,*
1936 (fig. 60), made on a cold March day in a migrant pea-
pickers camp near Nipomo, California, has become univer-
sally famous for just these symbolic reasons.

Between government assignments, Lange and Taylor
collaborated on one of the most significant documentary
books of the era, *An American Exodus* (1939). This volume
combined Lange's photographs, the words of her subjects,
and Taylor's economic and social commentary to convey the
human reality of the Dust Bowl. It follows migrants from
their desiccated lands in Oklahoma and Texas along Route
66 to California. Unlike the poetic documentation of *Let Us
Now Praise Famous Men* or the topical journalism of *You
Have Seen Their Faces* (1937) by Margaret Bourke-White
and Erskine Caldwell, *An American Exodus* reflected the
desire of Lange and Taylor to deal objectively with both
people and data. By adhering to the most rigorous standards
of documentary practice, they sought not only to record
human truths, but to effect social change.³¹³

Documentary Fact and Invention

The enormous production of the RA/FSA photographers has
much to tell us, not only about this historical era but also
about the practice of documentary photography itself. From
its inception, Stryker's agency was concerned with the collec-
tion and use of visual data for specific political ends. Many
of those sympathetic to this agenda may have felt that facts
were intrinsically persuasive and only needed to be gathered
in quantity. However, Stryker and his photographers took a
more subtle and strategic view of this process. In fact, it was
clear that the meanings of photographs were powerfully
shaped by the captions written to accompany them. Without
such supplemental information, each photograph possessed
the ability to tell many different stories, or none at all. To
varying degrees, Stryker's photographers understood the
complexity of the process in which they were engaged. Inevit-
ably, each was influenced by Stryker's coaching and shooting
scripts, images already in the file, and their own experiences
and expressive ideas. Most of the photographers favored a
straight, realist style, and avoided obviously subjective
approaches. But they all felt that some images were vastly
more powerful and persuasive than others, and that these
attributes were a function of the photographer's own skill
and point of view. They believed that the most memorable
images could transcend the specific circumstances of their
production and address larger issues. It was understood that
such photographs were always the result of a deliberate crea-
tive and interpretive process.

Critics then and now have been concerned by the tension
between an impartial or "objective" documentary ideal and

the "constructed" nature of many of these images. In May 1936, when Arthur Rothstein recorded the steer skull in South Dakota, he photographed it in two ways: first on a dry alkali flat and then, carrying it a few steps away, on a sparse background of scrubgrass and cactus. These were powerful images and Stryker had no qualms about placing both versions in the RA file. However, the public discovery of the two versions became a political scandal during the presidential campaign of 1936. Republicans interpreted Rothstein's placement of this skull as a blatant fraud, and proof that the Democratic administration could not be trusted to report the nation's true economic condition.

But aside from its political expediency, this debate struck at the heart of Stryker's method. Were photographs to be used in an editorial and expressive manner—as positive propaganda, in essence—or were they expected to be neutral bits of unmediated reality? The answer, despite the political brouhaha, was simple. In addition to being fundamentally impossible, the latter position would not have produced images that were *useful* in any obvious way. An expressive point of view was thus both inevitable and essential to the creation of photographs with any instrumental intention. This unavoidable aspect of documentary practice signals the complex planning that lay behind some of the most memorable photographs of this era. Rather than a spontaneous and candid image, Rothstein's *Dust Storm, Cimarron County, Oklahoma*, 1936 (fig. 56) was in fact merely one of some seventy-seven photographs he made during an afternoon of close collaboration with the farmer and his young sons.[314] Lange's *Migrant Mother* (fig. 60), the last of six exposures at this scene, was taken at the end of a ten-minute session in which these subjects willingly cooperated with Lange by arranging themselves for her camera. To increase the aesthetic power of this image, Lange later had an assistant spot out a distracting detail from her negative: the migrant mother's thumb grasping the support pole on the right side of the frame.[315] And finally, it has even been suggested that the exquisite order of Walker Evans's photographs may stem, in part, from his manipulation of some of the objects he recorded. For example, a comparison of his images with passages of Agee's text in *Let Us Now Praise Famous Men* suggests that Evans moved a variety of objects in the sharecroppers' houses for aesthetic effect.[316] If so, it should not be surprising that his photographs convey a relatively consistent sense of spareness and order. This awareness of the photographers' intervention should not decrease our respect for their achievement. In fact, it should only increase our interest in these images by reminding us of their inevitable union of fact and opinion.

The Triumph of Photography

The decade of the 1930s witnessed the rise of photography to an unprecedented level of popular and critical acclaim. This prominence was paralleled by the medium's relentless technical progress and increasing applications.[317] More Americans

Fig. 61 Carl Van Vechten, *Anna May Wong*, 1932, 13⅞ × 11″

than ever took up photography as a casual pastime, encouraged by the availability of precision small cameras, films with finer grain and increased speed, photo-electric exposure meters, and, in 1937, Kodachrome color transparency film. New techniques made the transmission of news photographs by telephone and radio more effective than ever, and even enabled the production of X-ray motion pictures of such medical subjects as the heart, the digestive tract, and the motion of the vocal chords during speech. In addition, advances in aerial photography facilitated the mapping of significant portions of the globe, while microfilm technology was applied on a large scale to the copying of documents.

The Leica played an important role in this technical revolution.[318] As the world's first successful 35mm camera, the German-made Leica was embraced by photographers such as Kertész, Bing, Shahn, and Helen Levitt. Its precision and simplicity of operation were exploited by countless American amateurs. One of the most passionate of these nonprofessionals was Carl Van Vechten, a former critic and novelist who, in 1932, began a thirty-year project photographing notable artists, writers, and theater personalities (fig. 61). The 35mm format was also used by such progressive commercial photographers as Lusha Nelson. Equally skilled with 8x10-inch and 35mm cameras, Nelson used the latter format to make a delightfully informal series of portraits of Alfred Stieglitz at his Lake George summer house in 1935 (fig. 62).[319]

Within this context of technical change and increased amateur participation, expressive photographs were seen and

appreciated by a steadily expanding audience. This new visibility was accompanied by an increasing number of photographic books and exhibitions, and a new interest in the history of the medium. Modern photographs were reproduced in mass-market publications as varied as *Vanity Fair, Scribner's,* and *Coronet;* in literary journals such as *The Little Review;* and in monthly photographic magazines and international annuals such as *Modern Photography.*[320] But by far the most popular photographic publication of the era was *Life,* the brainchild of Henry Luce. From its first issue, dated November 23, 1936, *Life* achieved enormous success by using photography to depict subjects of broad public interest. In the days before television, a remarkable number of people received their primary news of national and global events from *Life.* The entire *Life* operation was boldly oversized. By 1937, the magazine's editors received some 12,800 photographs per week and selected about 200 for each issue. Each weekly press run of one million copies required 750,000 pounds of paper and four days of round-the-clock printing.[321] The leading photographers on the magazine's early staff included Margaret Bourke-White, Alfred Eisenstadt, Tom McAvoy, Peter Stackpole, Carl Mydans, John Phillips, and William Vandivert, with many others subsequently employed. *Look,* which began publishing in January 1937, also made extensive use of photography. These two publications spawned numerous imitations with names such as *Click, Pic,* and *Foto.*

The print media's enormous appetite for news photographs was supplied largely by syndicated picture agencies such as Associated Press, Acme News Service, and Wide World Photos. For example, while justly celebrated for the quality of their work, *Life*'s own photographers contributed a mere 6 percent of the weekly pool of images considered by the magazine's editors in 1937. By contrast, about half of this total came from the picture services, with amateur work comprising most of the rest.[322] Improvements in the technology of wire transmission of photographs allowed the major picture agencies to inaugurate widespread use of this technology in 1935-36.[323]

For photographers, two of the most important publications of this decade were the *U.S. Camera* annuals and magazine, both published by Tom Maloney.[324] The first *U.S. Camera* annual appeared in 1935, while the magazine was begun in late 1938. These large-format publications presented more challenging work, and in a bolder manner, than the established journals of the day, such as Frank R. Fraprie's *American Photography* and *American Annual of Photography.*[325] The vitality of Maloney's publications reflected, in large measure, the stature of his advisors and supporters. Edward Steichen played a central role in both journals, while many leading figures of the day—including M. F. Agha, Arnold Genthe, Ira W. Martin, Will Connell, and Paul Outerbridge—served on the selection committee for the annual or on the magazine's editorial board.

This expansion of the literature of photography was accompanied by a new critical and historical sophistication.

Fig. 62 Lusha Nelson, *Alfred Stieglitz and Friends,* 1935, 6⅞ x 8⅞"

One of the most eloquent proponents of photographic modernism was Nicholas Ház, who contributed numerous articles to *Camera Craft, American Photography, American Annual of Photography,* and *Popular Photography.*[326] Elizabeth McCausland and others also wrote insightfully on the medium for newspapers and magazines. The history of American photography received unprecedented attention in the 1930s. Nineteenth-century figures such as William Henry Jackson were rediscovered (he lived until 1942), and innumerable profiles were written on more recent photographers. A truly scholarly approach to American photography was initiated by Robert Taft, a professor of chemistry at the University of Kansas. Taft's articles on daguerrean-era photographers such as Mathew Brady and John Plumbe were characterized by careful research in primary sources and a rejection of accounts based on anecdote and legend.[327] His work culminated in the 1938 publication of the still-remarkable book *Photography and the American Scene.* Working at the same time, in his position as librarian at the Museum of Modern Art, young Beaumont Newhall published *Photography 1839-1937* to accompany the large historical survey he organized for the museum. An expanded version of this text was released in 1938 as *Photography: A Short Critical History.* This, in turn, provided the basis for Newhall's standard text, *The History of Photography from 1839 to the Present Day,* published in 1949 (with revised editions in 1964 and 1982).[328] While Taft's volume took a technical and social perspective on the medium, Newhall's approach was based on an art-historical model and an essentially new vision aesthetic.

Contemporary and historic photographs became increasingly prominent in gallery and museum exhibitions beginning at the end of the 1920s.[329] In 1929, for example, the Arts Club in Chicago mounted a large survey of Man Ray's photographs. Between 1929 and 1934, the Delphic Studios in New York City presented one-person shows of the work of Ulmann, Weston, Richards, Moholy-Nagy, Adams, Quigley, Clara Sipprell, and Anton Bruehl. In 1930, Lincoln Kirstein assembled an exhibition of international photography for the

Harvard Society for Contemporary Art. Modeled on European precedents such as "Film und Foto," Kirstein's survey included work by Stieglitz, Strand, Sheeler, Steiner, Modotti, Weston, Ulmann, Bourke-White, and Bruehl; younger Americans such as Evans and Abbott; and a selection of astronomical, press, and X-ray images.[330] Other important group shows of this period include "Modern Photography at Home and Abroad," hosted by the Albright Gallery in Buffalo, and the Brooklyn Museum's "International Photographers," both of 1932. Museums across the nation hosted periodic surveys of modern photography. In 1934, for example, the Cleveland Museum of Art mounted a major exhibition of work by Steiner, Weston, Steichen, Bourke-White, Quigley, Stieglitz, and Bruehl.[331]

Among galleries, the Julien Levy Gallery in New York was perhaps the leading showcase for new photography.[332] Levy's first exhibition, "American Retrospective," mounted in late 1931, featured the work of the Stieglitz circle and Edward Weston. Atget and Nadar were the subject of his second show, "Old French Photography." In the first half of 1932 he mounted an impressive series of exhibitions: "Surréalisme" (which combined the work of artists such as Picasso, Max Ernst, and Salvador Dali with photographs by Herbert Bayer, Man Ray, Moholy-Nagy, and others), "Walker Evans and George Platt Lynes," "Modern European Photography" (which included Bing, Kertész, Moholy-Nagy, and Henri), "Man Ray," and "New York by New Yorkers" (featuring Abbott, Bourke-White, Martin, Steiner, and others). Over the next three years, Levy hosted several group exhibitions as well as one-person shows by Abbott, Lynes, Richards, Lee Miller, Henri Cartier-Bresson, and Brett Weston.

The end of the decade saw several large photographic exhibitions in New York. Newhall's seminal "Photography 1839-1937" included 841 items and filled all four floors of the Museum of Modern Art. This mammoth show took a catholic view of the medium's history, embracing the most refined artistic pictures as well as press photographs, X-rays, and astronomical images. This curatorial perspective, obviously indebted to the ideas of Moholy-Nagy and the example of figures such as Kirstein, was modified in Newhall's subsequent work, which shifted toward Stieglitz's more discriminating notion of photographic art.[333] Among the other large exhibitions of this period were the "First International Exposition of Photography," in 1938, which included a display of FSA work under the title "How American People Live," and yearly exhibitions of work submitted for Maloney's U.S. Camera annuals.[334]

As part of this expanding interest in photography, there was a remarkable concordance in the late 1920s and 1930s between the realms of art and commerce. Art directors and picture editors embraced contemporary photography as a dynamic expression of modern life, and purist and new vision-inspired images were seen in all manner of publications, from Harper's Bazaar to Farm Journal.[335] Advertisers embraced the modernist style for its ability to command attention through heightened contrasts and bold or unusual compositions. The power of the image-word union was effectively illustrated in a 1930 Young & Rubicam advertisement promoting its own business. Under the word "**IMPACT**," printed in large sans-serif type, was a page-filling photograph of a fist connecting with a boxer's chin. Smaller type below this image defined the word as "that quality in an advertisement which strikes suddenly against the reader's indifference and enlivens his mind to receive a sales message."[336] The domesticated radicalism of the modernist photograph was ideal for this task.

The best of these advertising images were admired as both utilitarian and aesthetic achievements. In 1929, for example, the Philadelphia advertising firm of N.W. Ayer & Son began hosting an annual exhibition of contemporary American photography. These shows, which were held at least three years in a row, included the work of such noted figures as Abbott, Bourke-White, Bruehl, Fitz, Sheeler, Steichen, Steiner, Evans, and Outerbridge.[337] In 1931, the Art Center in New York mounted a major exhibition of "Foreign Advertising Photography." Included in this 200-print display were images by Baron de Meyer, Man Ray, Moholy-Nagy, Bayer, and Henri. An even larger exhibition of contemporary "Commercial and Advertising Photography" was held in 1934 at the RCA Building at Rockefeller Center. As a result of this merger of commercial and artistic interests, photographers such as Steichen and Bourke-White were elevated to celebrity status, with many others achieving a notable level of both professional and popular renown.

The vitality of American photography in this era was only reinforced by the effects of the political and economic calamities in Europe. The global depression, rise of German Nazism, and beginning of World War II combined to drive waves of Europe's best and brightest to the United States. While some of these refugees stayed for only a few years, many others settled permanently, adding immeasurably to the nation's cultural life. Among the photographers who came to the United States in this decade were Herbert Bayer, Ilse Bing, Ruth Bernhard, Alfred Eisenstadt, Philippe Halsmann, Horst P. Horst, George Hoyningen-Huene, Lotte Jacobi, Gyorgy Kepes, André Kertész, Lisette Model, László Moholy-Nagy, Martin Munkacsi, Walter Peterhans, and Roman Vishniac. In addition, editors and art directors such as Mehemed Fehmy Agha, Alexey Brodovitch, Alexander Liberman, and Stefan Lorant also emigrated in this period.

By the time of photography's centennial in 1939, the medium enjoyed a level of popular and artistic acclaim unimaginable fifty years earlier. At this point, American photography still retained a singular—if inevitably contentious—sense of itself as an identifiable practice. Thus, to a remarkable degree, new vision modernism, late Pictorialism, art, and commerce were all seen as related facets of a larger whole. While this sense of singularity should not be exaggerated, this historical moment represented an unusual conjunction of diversity and harmony within the photographic world.

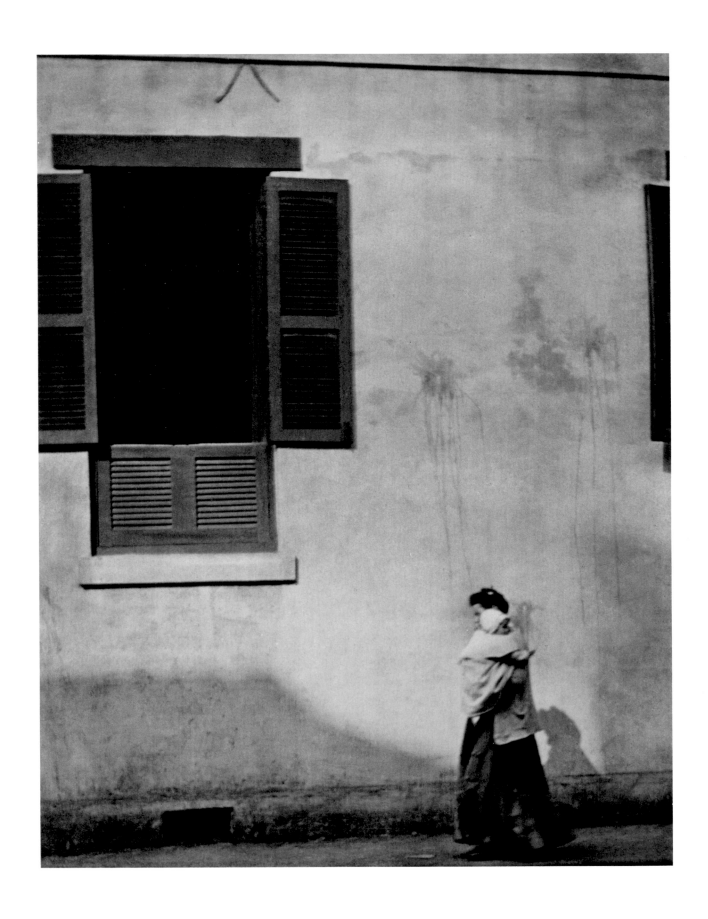

29 Paul Strand, *Woman Carrying Child*, 1915, platinum print, 12⅝ x 9½″

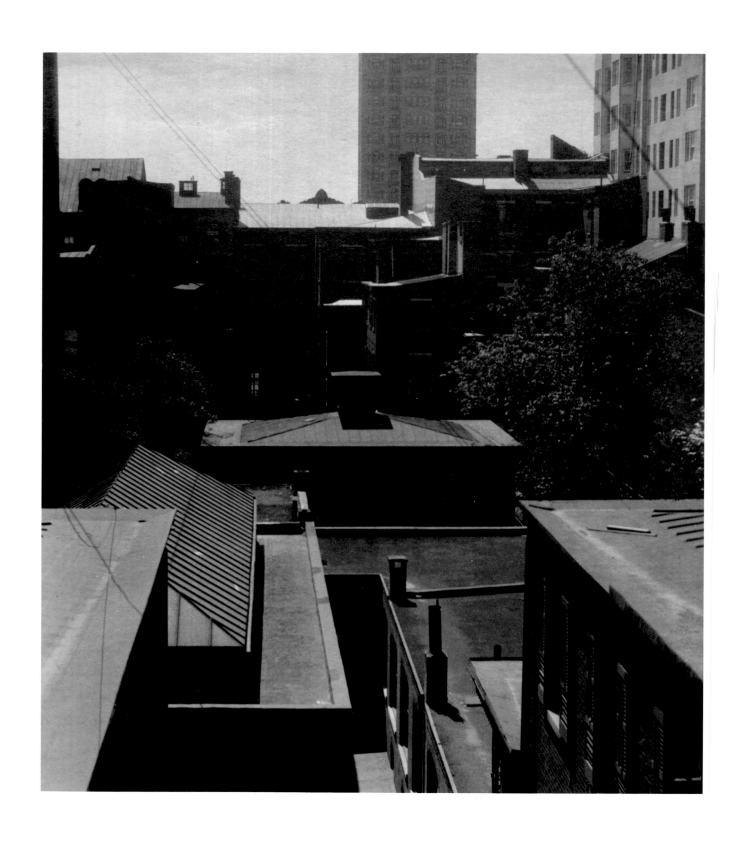

30 Morton Schamberg, *Untitled*, 1917, 8½ x 7⅜″

31 Alvin Langdon Coburn, *Vortograph*, 1917, 10⅞ x 8″

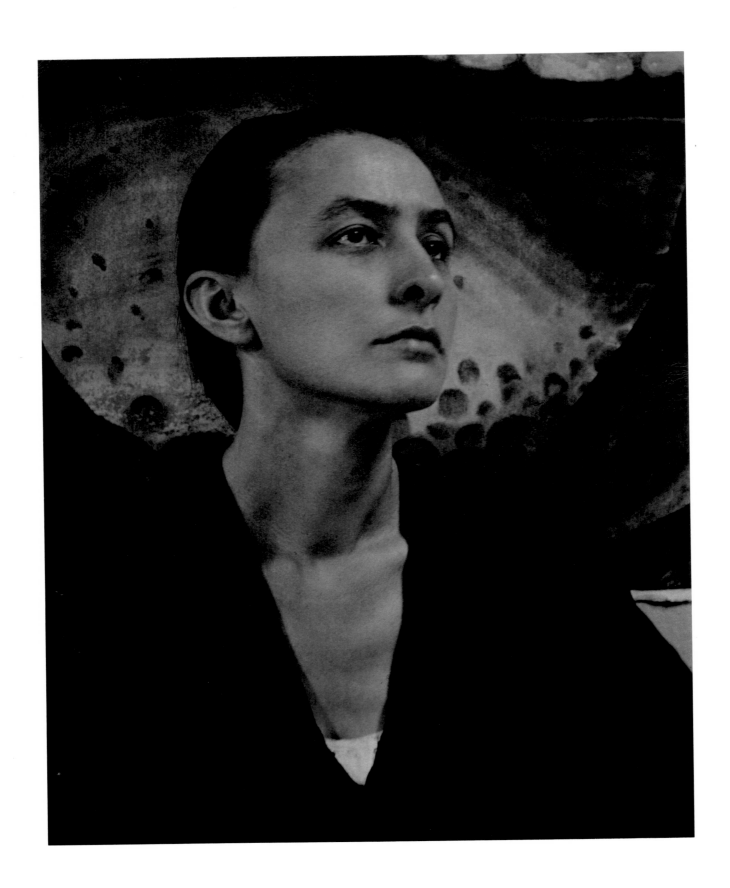

32 **Alfred Stieglitz**, *Georgia O'Keeffe: A Portrait*, 1918, platinum print, 9½ x 7½″

33 **Alfred Stieglitz,** *Equivalent,* 1929, 4⅝ x 3⅝″

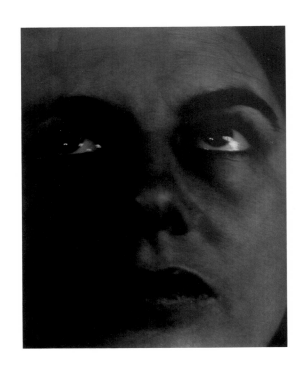

34 **Marjorie Content,** *Untitled (Helen Herendeen),* 1926, 3½ x 2⅞"

35 **Paul Strand**, *Rebecca, New York*, 1922, platinum print, 7¾ x 9¾"

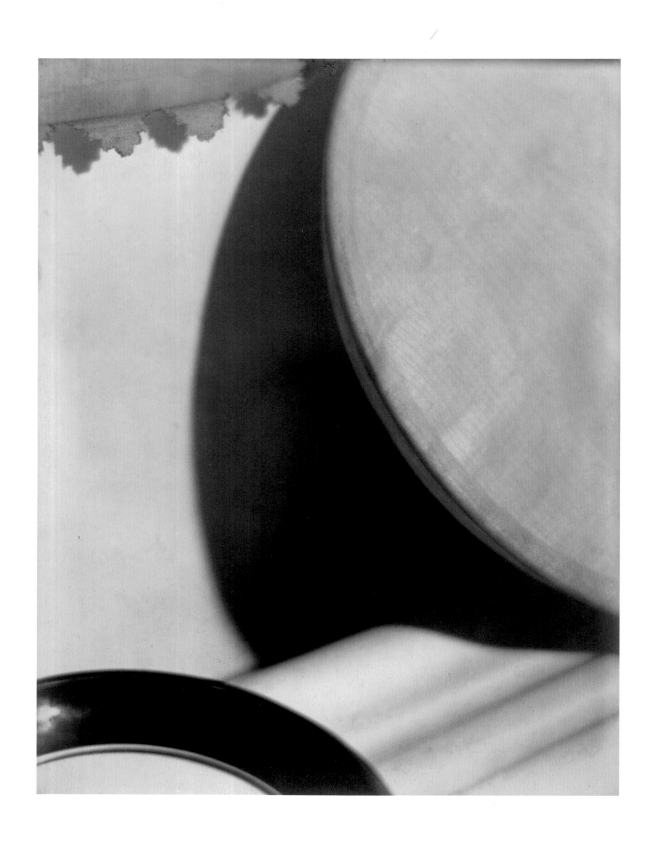

36 Margaret Watkins, *Design—Curves*, 1919, 8¼ x 6¼"

37 **Bernard S. Horne,** *Design*, ca. 1916-17, platinum print, 8 x 6″

38 **Paul Outerbridge, Jr.**, *Piano Study*, 1924, platinum print, 4½ x 3⅝"

39 Paul Outerbridge, Jr., *Saltine Box*, 1922, platinum print, 3 ⅜ x 4 ⅝"

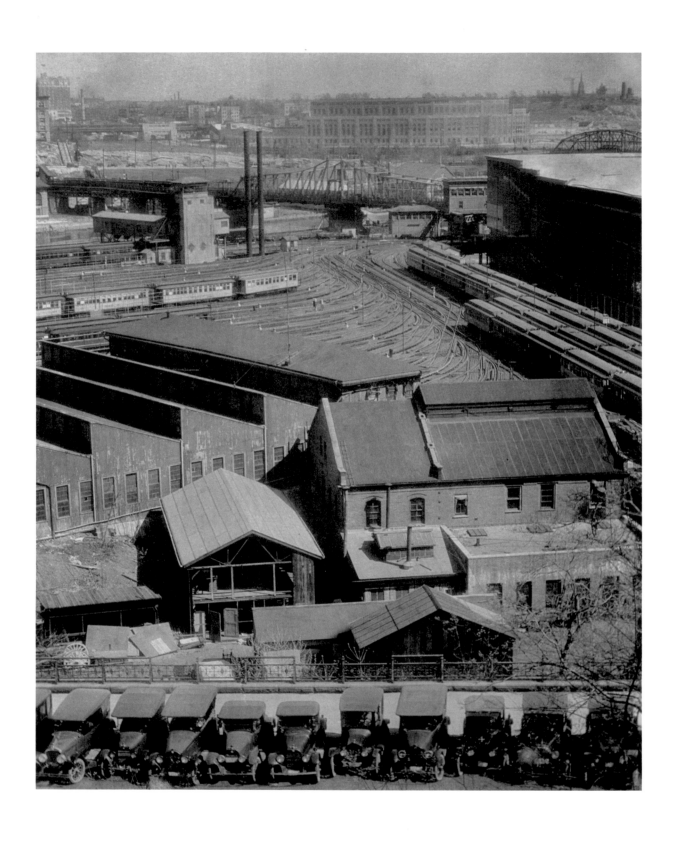

40 **Frances M. Bode**, *Repetition*, 1925, palladium print, 9½ x 7½"

41 **Ralph Steiner**, *Untitled*, ca. 1928, 7⅝ x 9½″

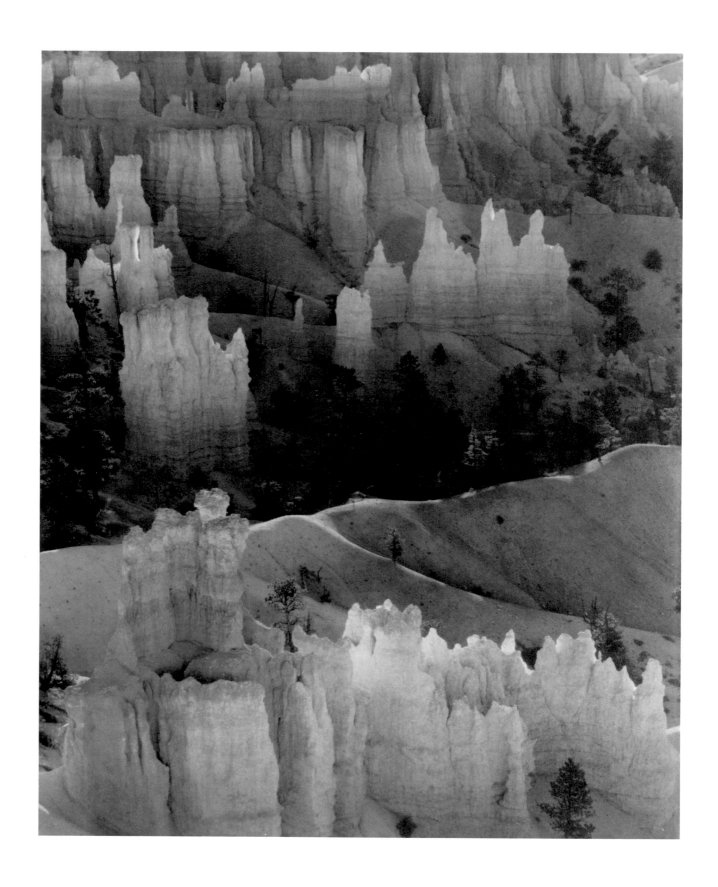

42 Laura Gilpin, *Bryce Canyon #2*, 1930, platinum print, 9⅜ x 7⅜"

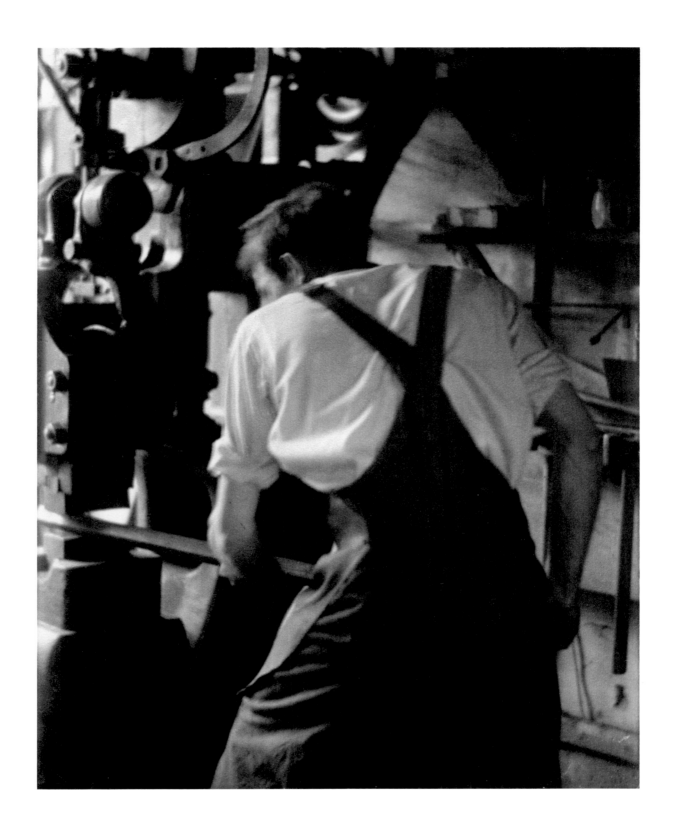

43 **Doris Ulmann**, *Untitled*, ca. 1925, 8⅜ x 7″

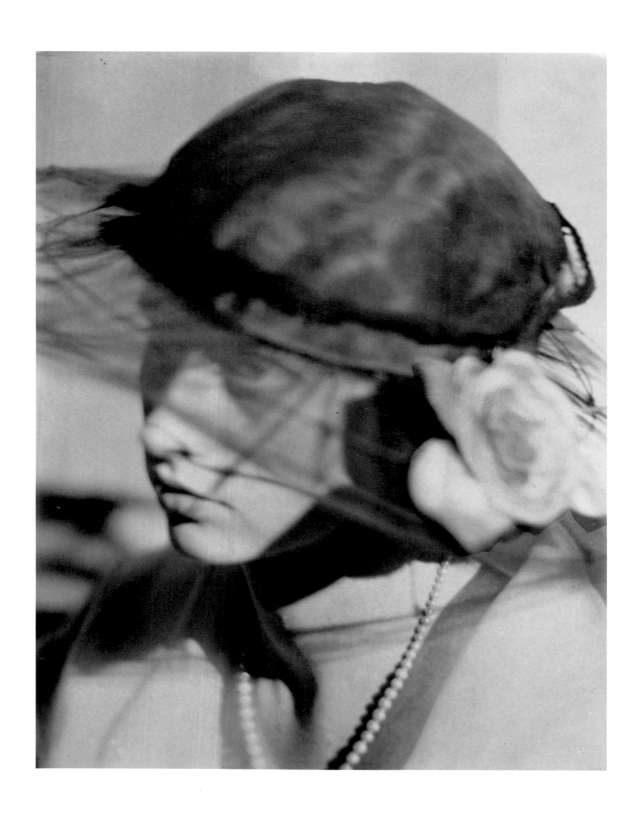

44 **Wynn Richards,** *Woman with Veiled Hat,* ca. 1918, 8 x 6⅛"

45 Clarence H. White, *Croton Reservoir*, 1925, platinum print, 3½ x 4½"

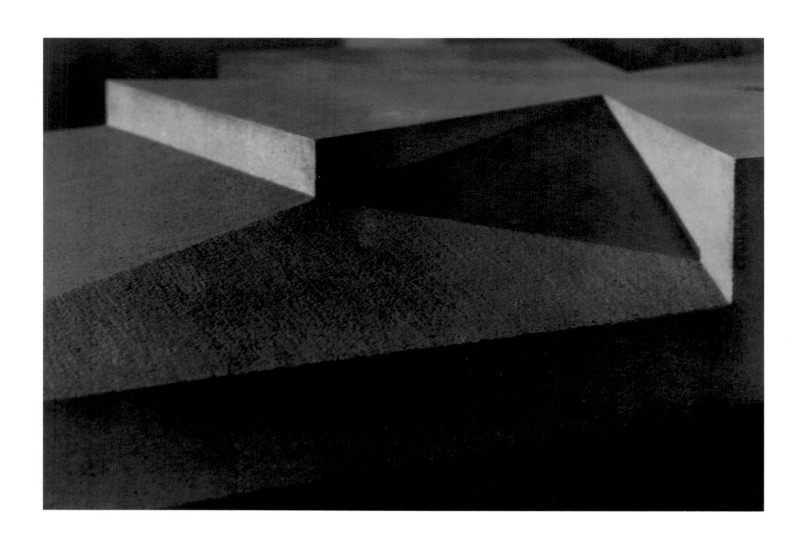

46 Toyo Miyatake, *Untitled,* 1925, 8⅞ x 12⅞"

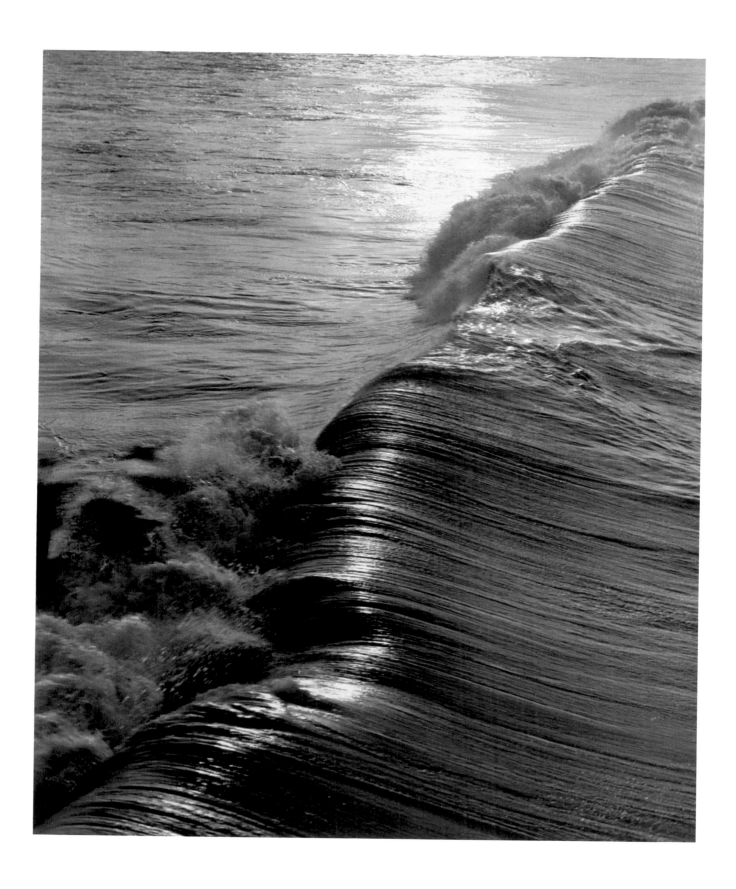

47 Kentaro Nakamura, *Evening Wave*, ca. 1927, 12½ x 10⅛"

48 Edward Steichen, *Thérèse Duncan on the Acropolis*, 1921, platinum print, 9⅜ x 7½″

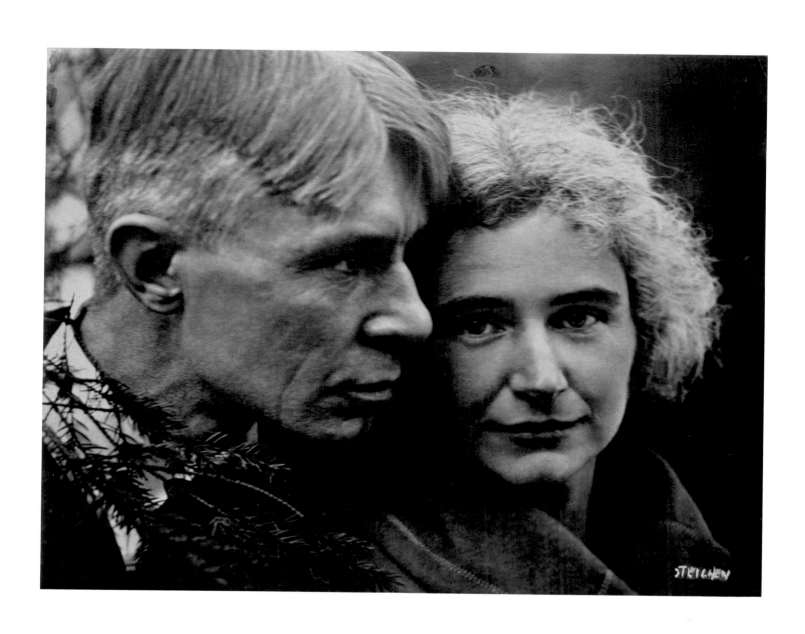

49 Edward Steichen, *"Mr. and Mrs.," The Sandburgs*, 1923, 10½ x 13½"

50 **Margrethe Mather,** *Johan Hagemeyer and Edward Weston,* 1921, platinum print, 7⅝ x 7⅜″

51 **Edward Weston**, *Karl and Ethel Struss*, 1923, platinum print, 9½ x 7½″

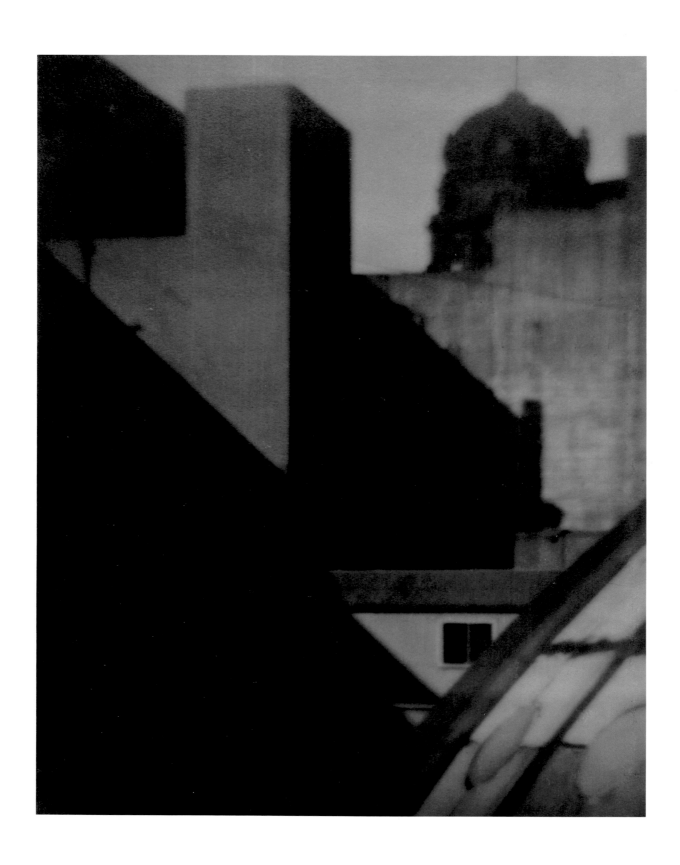

52 **Johan Hagemeyer**, *Castles of Today*, 1922, 9⅝ x 7⅜"

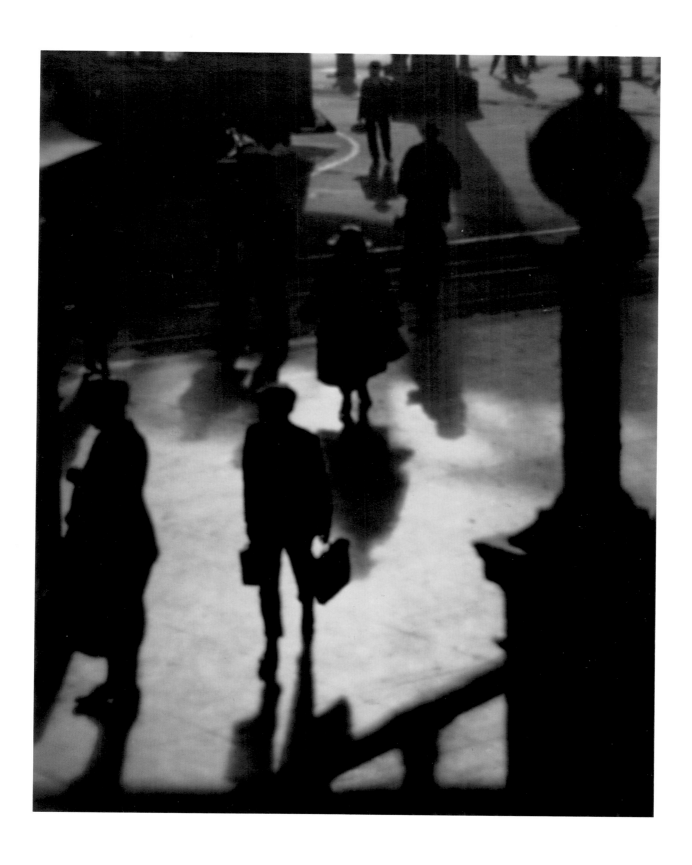

53 Johan Hagemeyer, *Pedestrians*, 1922, 9¾ x 7⅝″

54 **Tina Modotti**, *Staircase, Mexico*, 1925, platinum print, 7⅛ x 9⅜″

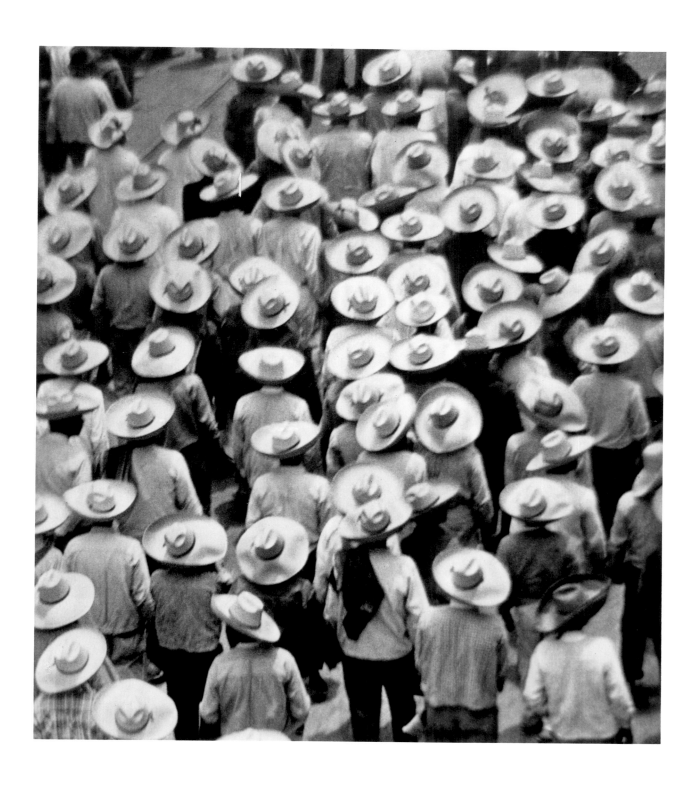

55 Tina Modotti, *Campesinos*, 1926, 8⅜ x 7⅜"

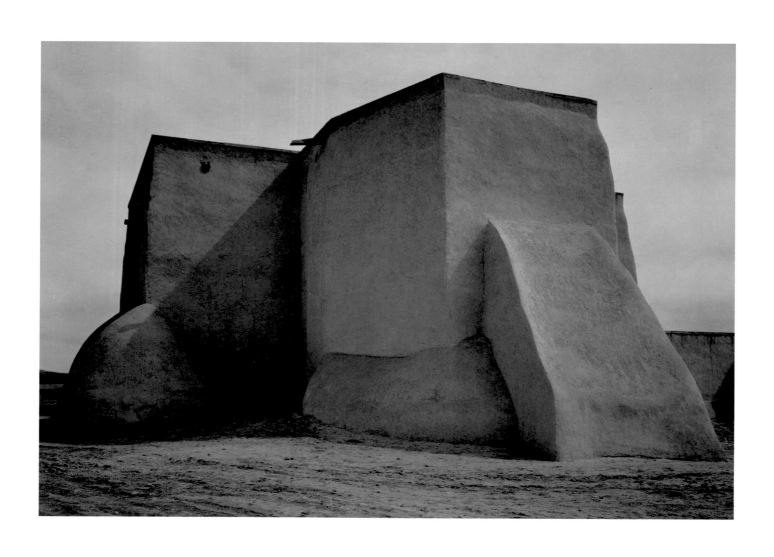

56 **Ansel Adams,** *Church at Ranchos de Taos, New Mexico,* ca. 1929, 5½ x 7"

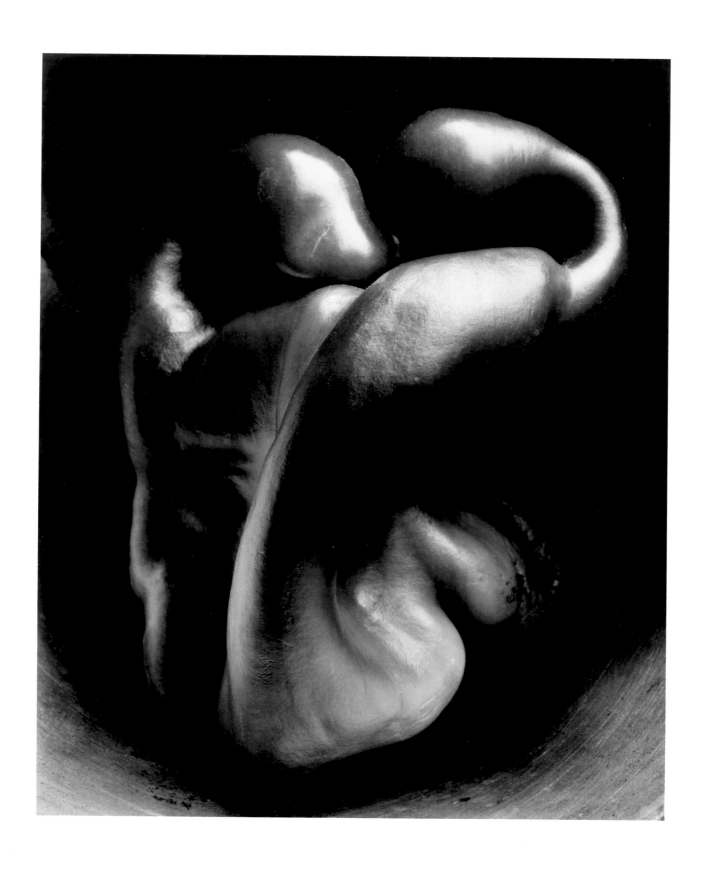

57 Edward Weston, *Pepper No. 30*, 1930, 9³⁄₈ x 7¹⁄₂"

58 Edward Weston, *Dante's View, Death Valley*, 1938, 7⅝ x 9½″

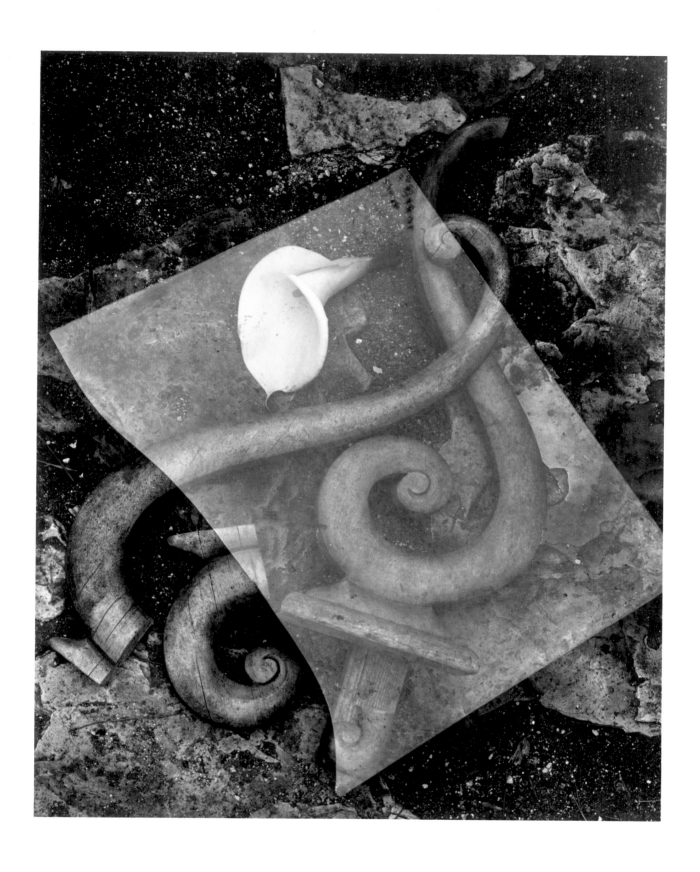

59 Edward Weston, *Glass and Lily*, 1939, 9⅝ x 7⅝″

60 **Sonya Noskowiak**, *Leaf*, 1931, 3¾ x 2⅞"

61 **Alma Lavenson,** *Chrysanthemum,* 1931, 7⅛ x 9⅝″

62 Imogen Cunningham, *Amaryllis*, 1933, 9½ x 7½"

63 Brett Weston, *Los Angeles*, 1927, 9⅝ x 6⅞"

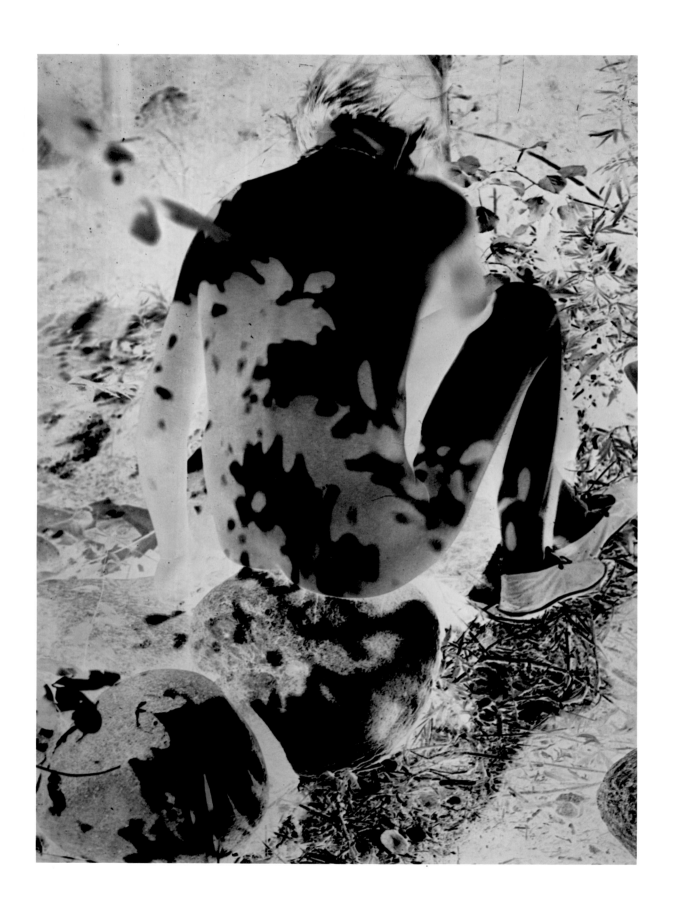

64 László Moholy-Nagy, *Nude*, ca. 1926, 14¾ x 10½"

65 **László Moholy-Nagy,** *Rothenburg ob der Tauber,* 1928, 14½ x 10⅛″

66 **Man Ray,** *Les Amoureux,* 1929 (print ca. 1940), 16½ x 23½"

67 **Man Ray,** *Rayograph,* 1925, 15¼ x 10¾″

68 **Florence Henri,** *Reclining Woman,* 1930, 9 x 11¾"

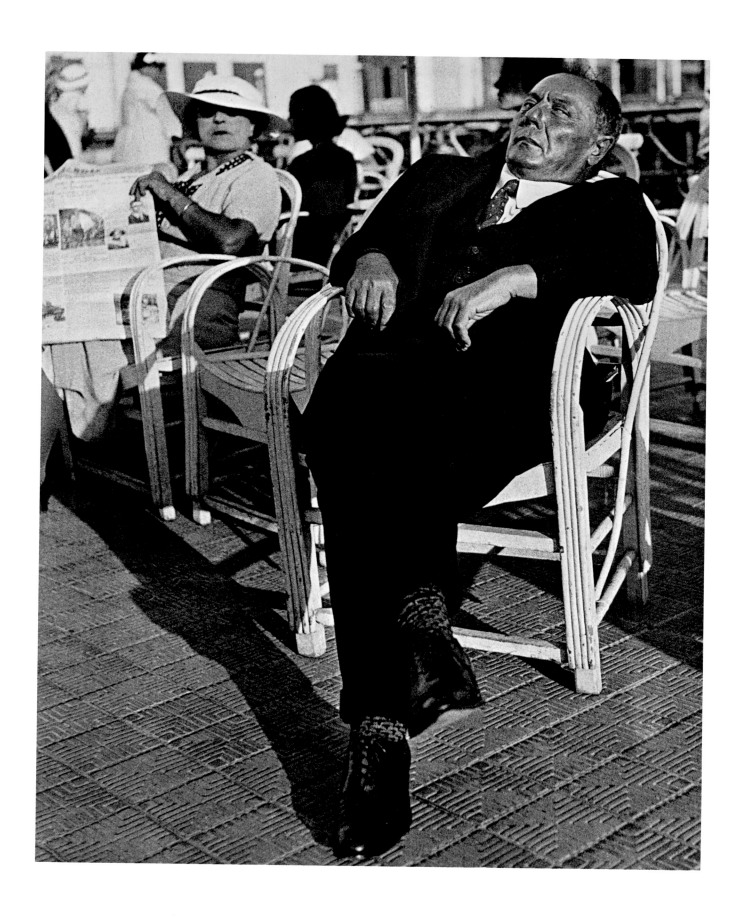

69 **Lisette Model,** *Promenade des Anglais, Nice,* 1934 (print ca. 1950s), 19½ x 15½"

70 André Kertész, *Fork*, 1928, 3 x 3⅝″

71 Ilse Bing, *Champ-de-Mars from Eiffel Tower, Paris*, 1931, 8¾ x 11⅛″

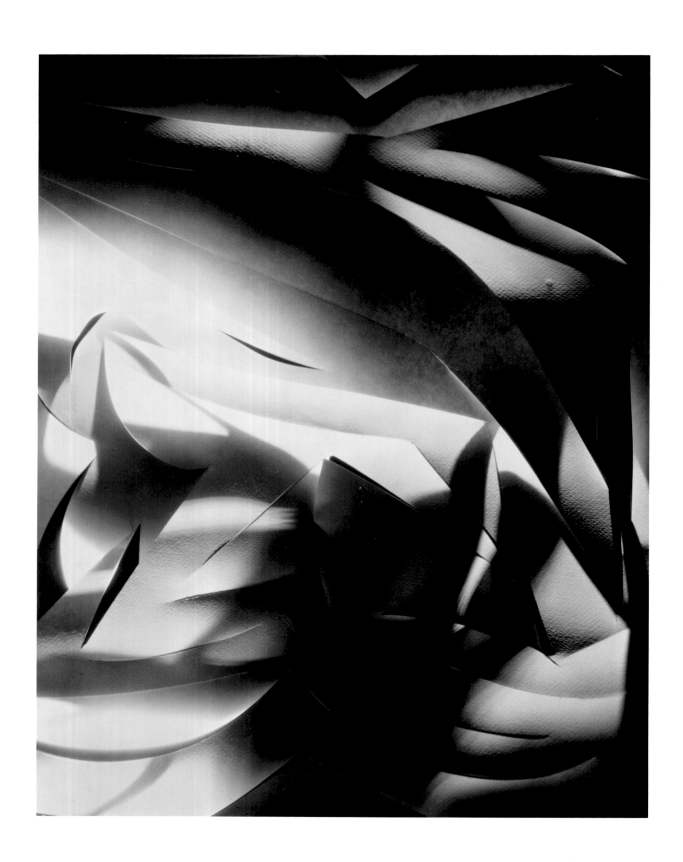

72 **Francis Bruguière,** *Cut Paper Abstraction,* 1929, 9⅜ x 7⅛″

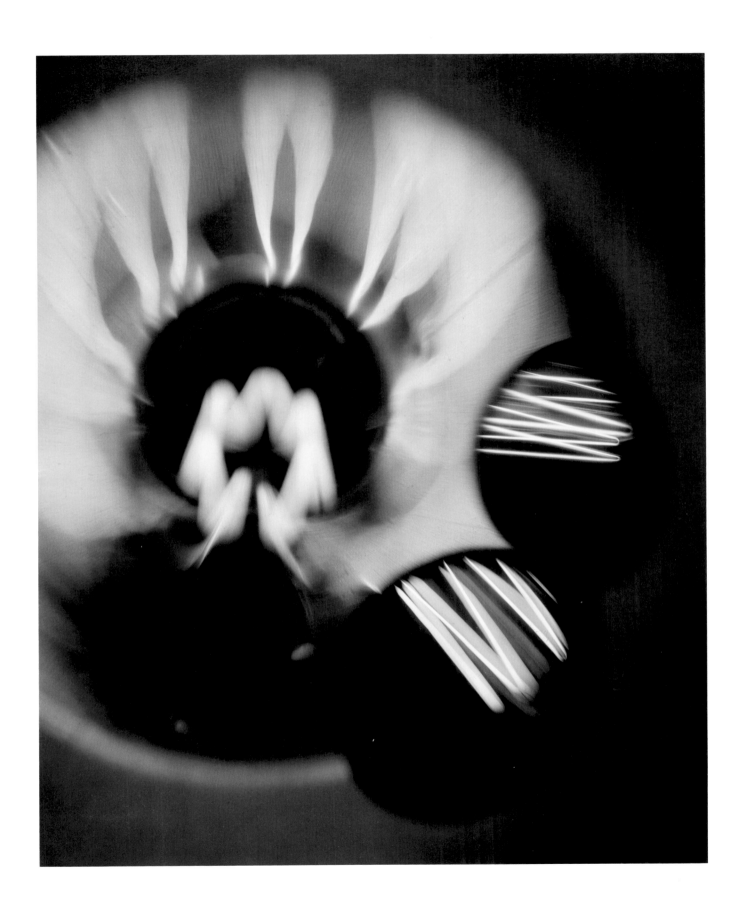

73 **Edward Quigley**, *Light Abstraction*, 1931, 12½ x 10″

74　Harold L. Harvey, *Reflections*, ca. 1930, 18¼ x 25⅛″

75 John Gutmann, *Triple Dive*, 1934, 7½ x 7″

76 **Barbara Morgan**, *Martha Graham: American Document (Trio)*, 1938, 15 x 19⅜"

77 Will Connell, "*Lights!*", 1937, 11½ x 9⅜"

78 Paul Heismann, *Nude Montage*, ca. 1935, 13½ x 16½"

79 George Platt Lynes, *Endymion and Selene*, ca. 1937-39, 9½ x 7½"

80 Clarence John Laughlin, *Pineapple as Rocket*, 1936, 7³/₈ x 9³/₄"

81 Clarence John Laughlin, *The Unborn*, 1941, 19¼ x 15″

82 **Lewis Hine,** *Powerhouse Mechanic,* ca. 1925 (print 1939), 19⅛ x 13⅛"

83 **Ben Glaha,** *Machinery at Boulder Dam,* 1933, 10⅜ x 13⅞″

84 **E. O. Hoppé,** *Ohio River from the Point, Pittsburgh,* 1926, 8 x 9⅞″

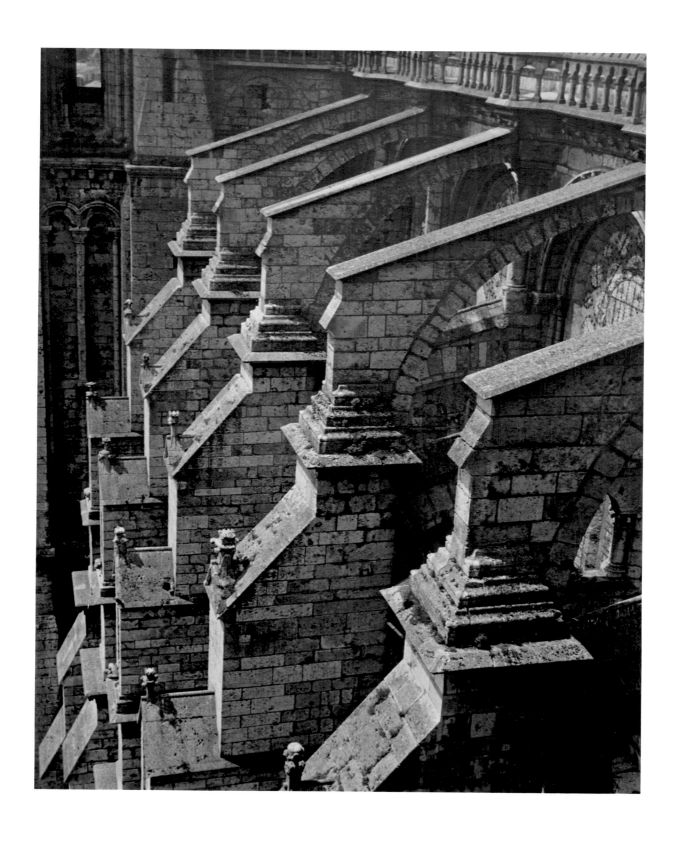

85 **Charles Sheeler,** *Chartres — Buttresses, from South Porch*, 1929, 7⅝ x 9⅝″

86 **Margaret Bourke-White,** *Plow Blades, Oliver Chilled Plow Company,* 1929, 13⅛ x 9″

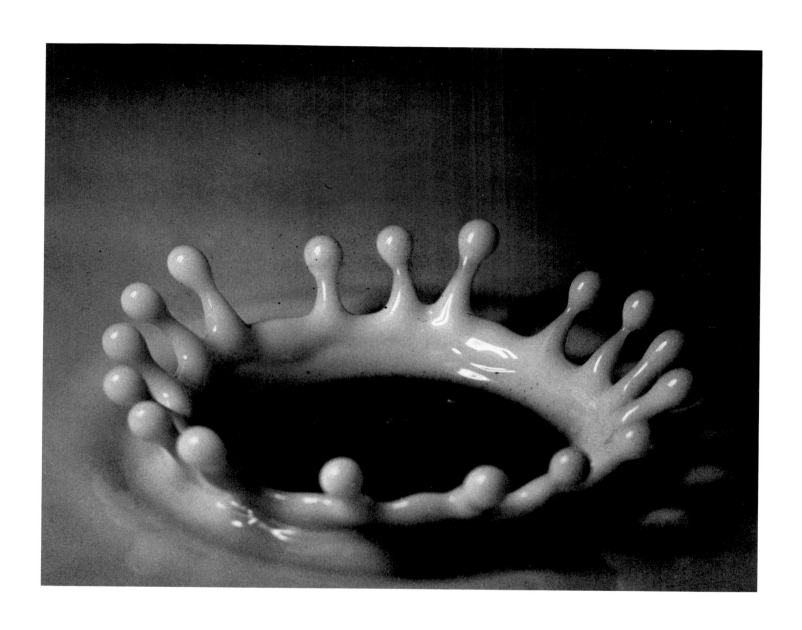

87 **Harold Edgerton,** *Milk Drop Coronet,* 1936, 7½ x 9⅝″

88 Talbot M. Brewer, *The "Comics," Spain*, 1930, 13⅝ x 10"

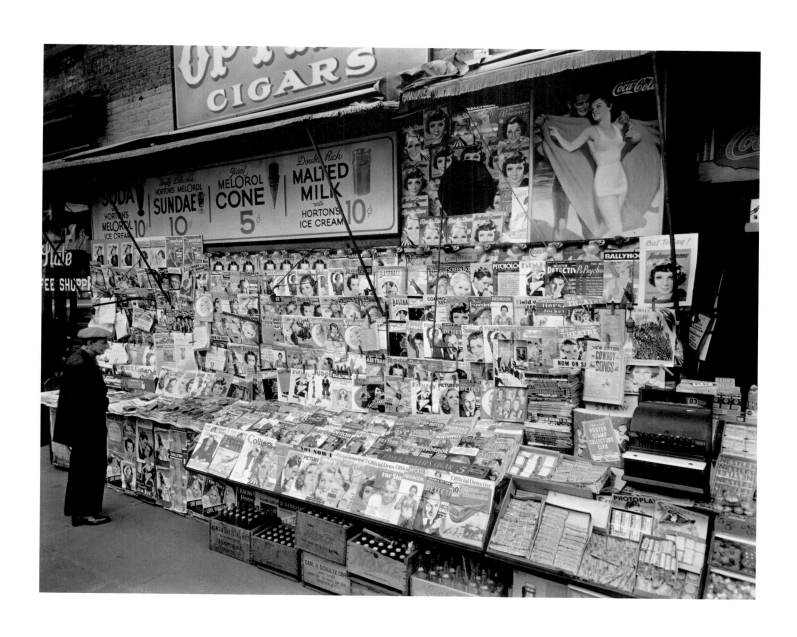

89 Berenice Abbott, *Newsstand, 32nd Street and 3rd Avenue, Manhattan, 1935, 7⅝ x 9⅝"*

90 **Ben Shahn,** *Sheriff During Strike, Morgantown, West Virginia,* 1935, 7⅛ x 9½″

91 **Dorothea Lange,** *Demonstration, San Francisco,* 1933, 7¼ x 6⅝″

92 **Walker Evans,** *Kitchen Wall in Bud Fields's Home, Hale County, Alabama,* 1936, 7³/₄ x 9³/₄"

93 **Walker Evans,** *General Store, Selma, Alabama,* 1936, 6¼ x 9⅛″

94 Louis Faurer, *Homage to Muybridge, Philadelphia*, 1937, 6½ x 11½"

CHAPTER III From Public to Private Concerns
1940-1965

America's already rapid pace of change was accelerated even further in the quarter-century between 1940 and 1965, a period that began in the last years of the Depression and ended in the Space Age.[1] In these years the United States achieved world leadership and unprecedented prosperity, but was beset by unexpected problems at home and abroad. This era, which spanned the administrations of FDR and LBJ, centered on the tranquil guidance of Dwight D. Eisenhower, the last American president born in the nineteenth century.

More than anything, this twenty-five year span was shaped by the trauma and consequences of World War II, which began in September 1939, when Nazi Germany invaded Poland. While the U.S. remained neutral for two years, its sympathies clearly lay with the beleaguered Allied powers of Britain and France. A surprise Japanese attack on the American naval base at Pearl Harbor on December 7, 1941, finally pushed the U.S. into a war that nearly every citizen agreed had to be fought and won. Accepting the fact that the conflict would be long and hard, Americans dedicated themselves to personal sacrifice and collective action in order to achieve victory. No use of arms after 1945 would receive such unanimous popular support. The U.S. successfully fought a two-front war, in Europe and the Pacific, emerging at the end of hostilities in mid-1945 as the world's foremost military and economic power. The war had broad effects on American society. Millions of men were called into the service, and a comparable number of women joined the industrial work force at home. And, while the economic stimulus of the war finally ended the Depression, the conflict also closed an era psychologically. The war resulted in the death of forty million people world-wide and produced massive physical destruction and political instability. The discovery of the full scope and horror of the Nazi concentration camps also raised profound moral questions about modern civilization. And while the use of atomic bombs on

Hiroshima and Nagasaki ended the war and proved America's scientific genius, it elevated the destructive potential of war to an ominous level.

The postwar political world was more complex than ever. America's wartime ally, the Soviet Union, was now its chief adversary. The Soviets installed puppet governments in the nations of Eastern Europe and threatened to spread their totalitarian rule around the globe. In 1949, the "loss" of China's vast population to Communism greatly heightened American concerns, contributing to the tenseness of what was termed the "Cold War." At home, hysteria over spies and traitors was cynically promoted by Senator Joseph McCarthy, who held televised congressional hearings to expose Communists in political and public life. A desire to contain Communist expansion led to the Korean War of 1950-53, which resulted in 137,000 American casualties. Tensions between the U.S. and Soviet Union eased slightly by the end of the decade, only to be inflamed again by the U-2 spy plane incident of 1960 and the Cuban Missile Crisis in 1962. By 1965, the U.S. was sending combat forces to the small Southeast Asian country of Vietnam in another effort to halt the spread of Communism.

Atomic weapons were the bargaining chips of the Cold War. After the Soviet Union's first atomic test in 1949, the U.S. and U.S.S.R. began stockpiling massive numbers of both fission (atomic) and fusion (hydrogen) bombs. These weapons were awesomely destructive: while a large conventional World War II bomb contained the explosive power of one ton of TNT, each atomic bomb represented 20,000 tons, with the hydrogen weapon generating an incredible 5,000,000 tons of explosive force. Mutual annihilation, rather than victory, now seemed the likely outcome of future hostilities. With science running so far ahead of man's moral capabilities, the idea of progress, and mankind's very survival, were dramatically called into question.[2] In the 1950s,

public concerns over the issues of war and peace were magnified, rather than alleviated, by air-raid drills in schools and the U.S. government's encouragement to build home fallout shelters.

Despite these political uncertainties, the postwar era was one of great human and scientific achievement. The powers of the body and mind were memorably demonstrated by the ascent of Mt. Everest by Edmund Hillary and Tenzing Norgay in 1953, and by history's first four-minute mile, achieved in 1954 by the British medical student Roger Bannister. The scientific highlights of this era include the development of the electron microscope, the 200-inch Mt. Palomar telescope in California, the first electronic digital computer, penicillin, the polio vaccine, and supersonic aircraft flight. The Space Age was inaugurated in 1957, when the Soviet Union launched Sputnik I, an unmanned communications satellite. Spurred by Cold War competitiveness, the U.S. orbited its own satellite in 1958. After two successful manned suborbital flights in 1961, NASA placed astronaut John Glenn into orbit around the earth in 1962. Manned flights grew increasingly complex, and the first tethered space walk was made in 1965. In addition, numerous communications satellites were deployed, and unmanned devices were sent on reconnaissance missions to the moon, Venus, and Mars.

Meanwhile, Americans strove for a sense of stability and security while, paradoxically, embracing a world of unprecedented prosperity and change. The nation's population rate surged with the postwar baby boom, creating an expanding market for domestic products of all kinds. New homes, automobiles, televisions, and refrigerators all became relatively affordable. The automobile became a key symbol of postwar American stylishness and wealth, and great attention was devoted to each year's new designs. Television also grew rapidly in popularity. By 1958, TV sets were in use in nearly 46 million homes, and performers such as Milton Berle, Arthur Godfrey, and Lucille Ball were household names. The rapidly expanding middle class gradually moved away from the cities to planned housing developments in the suburbs. The most famous of these suburban developments, Long Island's Levittown, was begun in 1946 and grew to include over 17,000 standardized homes.

The nation's shameful legacy of racial prejudice came to the political forefront in this era. The armed forces were largely desegregated during World War II, and Jackie Robinson broke the color barrier in professional baseball in 1947. But, in many other spheres of life, divisions between the races remained intact for years with change coming slowly as a result of both legal decree and individual action. In 1954, the U.S. Supreme Court ruled school segregation unconstitutional in its landmark *Brown v. the Board of Education* decision. Over the next decade, high schools and universities throughout the South were gradually desegregated, a process often accompanied by heated controversy. The Montgomery, Alabama, bus boycott of 1956, protesting segregated seating on municipal buses, was a pivotal event in this history. Triggered by the refusal of Rosa Parks to give up her seat,

this nonviolent protest brought young Martin Luther King, Jr. to national prominence.

Questions of identity permeated American culture in this era. After the wrenching changes brought on by years of depression and war, most Americans sought refuge in an outwardly bland normalcy. However, while success in the 1950s seemed to demand conformity in both professional and personal life, the self was being revealed as unexpectedly multifaceted. The psychic stresses of modern life were explored in such notable sociological studies as David Riesman's *The Lonely Crowd* (1950), C. Wright Mills's *White Collar* (1951), William Whyte's *The Organization Man* (1956), and Vance Packard's *The Status Seekers* (1959). The diversity of human thought and behavior was revealed with new candor in the publications of Alfred Kinsey and his colleagues on the sexuality of the human male (1948) and female (1953). In addition, the discomfort of many American women with their socially approved roles was suggested in Betty Friedan's pioneering book *The Feminine Mystique* (1963).

The 1950s was a decade of contrasts. The prosperous and patriotic Eisenhower era (1953-60) was also a time of public concern over lurid comic books, violent pulp fiction, crime, alcoholism, drug use, juvenile delinquency, and the harmful influence of rock-and-roll music. Performers such as Elvis Presley, Marlon Brando, and James Dean epitomized a sense of visceral, if undirected, rebellion against the strictures of polite society. Similarly, Beat poets and writers such as Allen Ginsburg and Jack Kerouac advocated a withdrawal from mainstream culture into more individualistic realms of experience. Popular publications such as *Playboy* magazine (begun in 1953) and Grace Metalious's scandalous best-seller *Peyton Place* (1957) exemplified a growing mood of secular licentiousness. In fact, the very uniformity and conservatism of American society—shaped by the mass media, advertising, and the high-pitched patriotism of the Cold War—stimulated a compensatory movement toward introspection and cultural fragmentation. A relatively singular notion of community, shaped by the Depression and World War II, gradually gave way to the celebration of innumerable private realities.

This shifting sense of both public and private experience was accelerated in the early 1960s. For many, the election of John F. Kennedy in 1960 promised a renewed sense of idealism and collective purpose. His assassination in 1963 was profoundly shocking and traumatic. The magnitude of this crime seemed to demand an equally grand and complex explanation, which, for many Americans, the Warren Commission report did not satisfy. The shock of the assassination, combined with the popular feeling that the truth was lost in a labyrinth of conspiracy, shook national confidence in a world of rationalism and progress. The race riots and growing protests over the escalating war in Vietnam, as well as the assassinations of Malcolm X (in 1965), Martin Luther King, Jr., and Robert Kennedy (both in 1968), all suggested that society itself was spinning out of control. By the mid-1960s, it became clear to many that the national unity of a quarter-century earlier had become severely strained.

Photography in the 1940s

At the end of 1940, the Museum of Modern Art established an important precedent by becoming the first major museum to form a full-fledged department devoted to photography. The impetus for this move came from David H. McAlpin, a wealthy stockbroker who had begun collecting photographs with the guidance of Alfred Stieglitz and Ansel Adams.[3] When McAlpin had earlier given $1,000 to the Metropolitan Museum of Art to buy photographs, the Metropolitan's board of trustees had to meet to decide if the medium was, in fact, an art. But McAlpin's cousin, Nelson Rockefeller, assured him that the decade-old Museum of Modern Art would be more receptive to such innovative thinking.[4] The Modern immediately formed a Committee on Photography and named McAlpin as chairman and Adams as vice-chairman.[5]

Under the deft curatorship of Beaumont Newhall, the Modern's new photography program attempted to unite a broad educational function with a more refined notion of connoisseurship. The department's inaugural exhibition, "60 Photographs: A Survey of Camera Esthetics," provided a concise overview of photographic art and technique. Prints made by a variety of historical processes were shown, as well as Civil War images, Victorian landscapes, turn-of-the-century Pictorialist works, abstractions by Moholy-Nagy and Man Ray, and purist images by Stieglitz, Weston, and Adams.[6] Newhall's announced goals for the department included many that are now accepted as the standard practice for museums: the creation of a gallery reserved for photography, the mounting of special exhibitions, the circulation of traveling exhibits, the development of a permanent collection of photographs, and the creation of a library of photographic books and periodicals. Interestingly, Newhall also spoke of the need to make the department "a clearing house for esthetic thinking in relation to photography," a place to which photographers could come for a broad range of information. To this end, it was originally proposed that the department develop a technical section including "examples of all photographic papers being marketed, together with sample prints made from the best negatives obtainable and with the greatest possible skill."[7] However, this practical concept (probably the brainchild of Ansel Adams) was not implemented.

Because of Newhall's academic background, such technical programs were discouraged in favor of a more scholarly and historical approach to the medium.[8] Indeed, Newhall's treatment of photography as a branch of art history and his valuation of the photographic print as an expression of personal vision were crucial in shaping the way the medium is treated in art museums today.[9] During Newhall's tenure as curator (1940-47), the Modern presented historical surveys, such as "Photography of the Civil War and the American Frontier" (1942) and "French Photographs—Daguerre to Atget" (1945); individual exhibitions by younger artists, including Helen Levitt and Eliot Porter (both 1943); and

retrospectives of established figures, such as Strand (1945), Weston (1946), and Cartier-Bresson (1947). Unfortunately, Newhall's work at the museum was interrupted by his service in World War II. During those years, his wife, Nancy Newhall, became acting curator, with Willard Morgan (the husband of photographer Barbara Morgan) serving briefly as acting director of the department.[10]

While the activities of the Museum of Modern Art dominated the world of artistic photography in these years, other museum programs were also being formed. The American Museum of Photography, a private institution established in Philadelphia in 1940 by Louis Walton Sipley, included many items related to the history of photography and the photomechanical arts.[11] The American Museum presented a number of significant exhibitions, including a restaging of the 1898 Philadelphia Salon in 1941.[12] At the beginning of World War II, the Eastman Kodak Company purchased the collection of Gabriel Cromer of Paris, the world's largest private holding of historical photographs. This acquisition formed the basis for the George Eastman House, which opened in Rochester in 1947. In 1951 this collection was substantially expanded by the voluminous holdings of Alden Scott Boyer, an eccentric Chicago businessman who had begun collecting photographic books and ephemera in 1938.[13]

Young photographers received institutional affirmation from the John Simon Guggenheim Memorial Foundation. After years of supporting scientists, poets, composers, painters, and writers, the Guggenheim Foundation first recognized photography in 1937, with a grant of $2,500 to Edward Weston for his project "California and the West." Walker Evans was the second photographer to be so honored, in 1940, with Dorothea Lange (1941), Eliot Porter (1941), Wright Morris (1942), Jack Delano (1945), Brett Weston (1945), Ansel Adams (1946), G. E. Kidder Smith (1946), Wayne Miller (1946), and Beaumont Newhall (1947) rounding out the first decade of Guggenheim Fellows.[14] The fact that these awards were made strictly on artistic and scholarly merit, with no other requirements or conditions, ensured that Guggenheims were highly coveted and respected by the photographic community.

World War II

The camera played a critical and ubiquitous role in the Second World War. The overall demand for photographs was enormous, and by the middle of the war it was reported that at least 10,000 photographers were employed by the Army, with about 3,000 in the Navy.[15] Every branch of the military maintained its own photographers.[16] The Army Signal Corps developed a special thirteen-week training course for still- and motion-picture cameramen and technicians, while the Navy set up a special training facility for photographers in Pensacola, Florida.[17] Inductees were often encouraged to use their professional skills: David Douglas Duncan became a photographer for the Marine Corps, for example, while

Victor Keppler's service was spent supervising photography for the Army newspaper *Yank*.[18] Aerial photography had developed enormously in sophistication since World War I, and recruits with appropriate visual training (including the Museum of Modern Art's Beaumont Newhall) were given such assignments as deciphering high-altitude images for evidence of bomb and enemy troop movements. [19]

One of the most memorable facets of the military's photographic enterprise was the Naval Aviation Unit, headed by Edward Steichen. Eager to contribute to the war effort, the sixty-three-year-old Steichen was commissioned in 1942 to head a select photographic unit. The plan was to use the images produced by this group for Navy recruiting and publicity. Steichen's original unit consisted of still photographers Wayne Miller, Charles Kerlee, Horace Bristol, Charles Fenno Jacobs, and Victor Jorgensen, and motion-picture cameraman Dwight Long. Most of these men were experienced professionals: Bristol and Jacobs had both worked for *Life* and *Fortune*, while Kerlee was a leading West Coast commercial photographer. The group was given unprecedented freedom to travel wherever the Navy had a presence, and it produced many of the most frequently reproduced images of the war (plate 97). The impact of these photographs was increased by the high technical standards Steichen demanded. While many of these emages were made under challenging conditions, all were carefully printed to exhibition quality.[20]

In addition to the legions of military photographers, many civilian photojournalists also covered the war. *Life* magazine went to great lengths and expense to put its photographers close to the action. As W. Eugene Smith later recalled, "*Life* was really the only outfit to work for if you covered a war. They had the greatest freedom, the greatest power, and the best expense accounts!"[21] In addition to Smith, the war was covered for *Life* by such noted photographers as Ralph Morse, George Rodger, George Silk, Eliot Elisofen, Robert Capa, Frank Scherschel, William Vandivert, Carl Mydans, and Margaret Bourke-White. Each of *Life*'s photographers produced distinctive and powerful images. Morse and Smith worked in the Pacific, both under conditions of some peril. Morse covered the Battle of Midway, landed with the Marines at Guadalcanal, and was on the warship *Vincennes* when it was torpedoed and sunk.[22] Smith accompanied Navy pilots on combat missions and photographed battles on Saipan, Guam, Iwo Jima, and Okinawa, before being severely wounded in May 1945. Elisofen's reputation as a war photographer was established in North Africa, while Vandivert recorded the determination of British civilians in the face of bombings, blackouts, and shortages.[23] Robert Capa, already renowned for his coverage of the Spanish Civil War in 1936, worked throughout the European theater and was one of the first cameramen to land with Allied troops on D-Day. Margaret Bourke-White's assignments were similarly varied and noteworthy. Even before the U.S. entered the war, Bourke-White was in Moscow taking dramatic shots of a nighttime bombing raid by German aircraft (plate 96).[24] From 1942 to 1945, she photographed

extensively throughout England, Italy, and Germany, even becoming the first woman to accompany an Air Force crew on a bombing mission.[25]

Despite the vast number of war photographers and the enormous breadth of their subjects, the pictorial record seen by the public was carefully monitored and censored. Military control over war photography was based in large part on the formal accreditation of civilian cameramen and the establishment of a Still Photographic War Pool. The original participants in this pool included the three leading American picture agencies (the Associated Press, Acme Newspictures, and International News Syndicate) and *Life* magazine. To eliminate competition and to ensure overall fairness, the pool included photographers from each organization and—with few exceptions—the resulting pictures were made available to all participants.[26] An integral part of this system—and of the military's own photographic production—was the process of review and censorship to which every image was subjected. Photographs were released to the public only after military censors determined that they would not aid the enemy or harm domestic morale.[27] American war photography thus served a consciously propagandistic function in the struggle for victory.[28] Photographers willingly accepted this premise, often regarding themselves as participants in—rather than mere observers of—the conflict. For them, any other attitude was unthinkable.

This intricate process of production and review, flavored by the photographers' inherently partisan role, resulted in a complex kind of documentation. Many photographers placed themselves at great risk in order to record the gritty truth of combat. Indeed, the casualty rate for correspondents and photographers in World War II was four times higher than for military personnel.[29] However, in their quest for dramatic images, some photographers used their repertoire of professional skills to enhance the drama of their subject, or even to create outright fakes. The young W. Eugene Smith, for example, simulated combat scenes by posing himself and his assistant as soldiers, and timing his exposure to the detonation of carefully placed dynamite charges.[30] In 1943, *Life* staffer Elisofen claimed that it was impossible to deal with the subject of war photography "without a discussion of honesty. The question of faked and staged pictures has come up at every front. I have seen many pictures in reputable publications which were without any doubt completely staged."[31]

The artifice employed was not always deliberate, however. For example, the circumstances surrounding Joe Rosenthal's famous photograph of the flag-raising on Iwo Jima (fig. 63) are well known.[32] Rosenthal, an experienced photojournalist then working for the Associated Press, arrived on the scene in time to record the second enactment of that stirring event, as soldiers replaced a small American flag with a larger one. Given the great symbolic power of this Pulitzer Prize-winning image—in which victory is achieved through patriotic cooperation— the specific details of its making seem incidental. In the end, Rosenthal, like most other war photographers, aspired to make images that would inspire and motivate, not simply document

Fig. 63 Joe Rosenthal, *Raising of the Flag on Iwo Jima*, February 23, 1945, 9¼ x 7⅝"

and inform. The power of this image was remarkable. Only four weeks after it was made, *Life* reported that "schoolboys wrote essays about it, newspapers played it for full pages and business firms had blow-ups placed in their show windows. There have been numerous suggestions that it be struck on coins and used as a model for city park statues."[33] The appeal of this image was summarized by editor Frank Fraprie, who featured it on the cover of his magazine, *American Photography*: "Every action is the spontaneous result of heroic determination and the composition, perfect in every detail, makes this *the* picture of the war, the everlasting token of a great American victory and an inspiration to every American."[34]

Given the didactic and persuasive intent of many of these images, it is not surprising that art played an important part in their making. In fact, the modernist techniques of 1930s artistic and commercial photography were widely used in the production of war photographs. Dynamic vantage points and bold compositions dramatized and clarified the image of war (plate 97).[35] The familiar new vision predilection for simple, repeated forms was employed to emphasize the power represented by rows of artillery shells, or of precise formations of airplanes, ships, and soldiers. As the editor of *Popular Photography* observed in a 1942 essay, "Patterns for Victory,"

> This war is one of huge numbers of fighting men and mass production on home fronts. Both of these things suggest repetition and vast patterns, and it is only natural that such effective photographic themes be put to good use in picturing the nation's gigantic and irresistible march to victory.[36]

The modernist penchant for unusual points of view is exemplified by Herbert Gehr's fascinating documentation of African-American soldiers on home leave (plate 95). Although Gehr was a *Life* staffer, he undertook this photographic project on his own initiative; none of the images were published in *Life*. His use of a wide-angle lens and odd vantage points lends these photographs a curious "fly's-eye" intimacy. At the same time, the scenes are illuminated and choreographed with cinematic precision to create richly detailed narratives, a reflection of Gehr's background in film.[37]

The confluence of expression and persuasion in war photography created an effective marriage of art and politics. Just as every facet of American society mobilized for the war effort, so the nation's artists and museums did their bit to support the cause. American painters, sculptors, designers, and printmakers formed a group called Artists for Victory and sponsored the touring exhibition "America in the War."[38] Museums mounted similarly patriotic displays, with the Museum of Modern Art particularly active in this regard. Its 1941 show "Britain in the War" included work in a variety of media, and, a year later, William Vandivert's photographs were exhibited under the title "Two Years of War in England."

But the most dramatic wartime exhibitions at the Modern were created by Edward Steichen. In the fall of 1941, Steichen was encouraged by McAlpin to assemble a photographic show on the theme of national defense. The resulting exhibition, which opened at the museum on May 20, 1942, under the title "Road to Victory," was unlike anything ever seen before. The experience of the exhibition was overwhelming, at once visual and spatial, intellectual and emotional. To illustrate the great sweep of the American land and the character of its people, Steichen selected some 150 photographs from the files of Time-Life, the Associated Press, U.S. Steel Corporation, and the Farm Security Administration. These were printed in large scale, sequenced for powerful narrative effect, and accompanied by text panels written by poet Carl Sandburg. The installation of the exhibition by designer Herbert Bayer was startlingly innovative. One critic wrote enthusiastically,

> The photographs are displayed by Herbert Bayer as photographs have never been displayed before. They don't sit quietly against the wall. They jut out from the walls and rise up from the floors to assault your vision as you move from room to room and over a long curving ramp. You are bowled over by pictures as big as all out-doors—none look less than a yard wide and one is 40 feet across.[39]

A similar technique was used in Steichen's second photographic extravaganza, "Power in the Pacific," in 1945. That exhibition contained enlarged images by Navy, Marine, and Coast Guard photographers, and was designed by the architect and photographer G. E. Kidder Smith. Both "Road to Victory" and "Power in the Pacific" drew from Steichen's work in photomontage a decade earlier, while anticipating

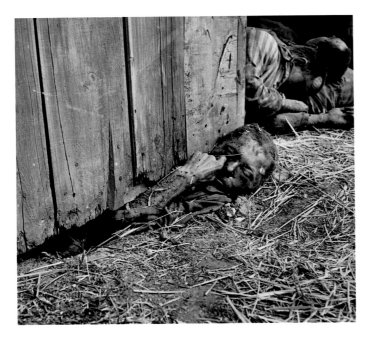

Fig. 64 William Vandivert, *Dead Prisoner, Gardelegen*, April 17, 1945, 9¾ x 10⅜"

the ambition and design of his "Family of Man" exhibition of 1955.

While Steichen continued to emphasize images that were heroic and uplifting, the content of photographs released to the public changed significantly midway through the war. In the first years of combat, military censors had forbidden the circulation of images of dead American soldiers (although those of other nationalities were frequently published). However, in September 1943, the War Department reversed that policy, arguing that the public needed to understand the ferocity of the struggle and the sacrifices being made on their behalf. As a result, the September 20, 1943 issue of *Life* featured a full-page image of the bodies of three American soldiers killed while storming Buna Beach in New Guinea. Although it was by then seven months old, the photograph stirred much debate and marked the beginning of a tougher standard of reportage in the nation's press. Despite the increasingly ghastly nature of these combat images, the pictures of Nazi concentration camps that emerged after the Allies occupied Germany were horrific beyond words. The troops who liberated these camps in the final weeks of the war in Europe were stunned and sickened. Under the simple heading "Atrocities," the May 7, 1945 issue of *Life* included six pages of gruesome pictures from various concentration camps by George Rodger, Bourke-White, Johnny Florea, and Vandivert. Particularly gut-wrenching was Vandivert's subject, a warehouse near Berlin that had held political prisoners. When forced to retreat in the face of Allied advances, German soldiers had set fire to the locked structure. Vandivert described the tragic subject of one of his photographs (fig. 64) in these words: "Trying to escape the flames, a young political prisoner squeezed head and arm under wooden door of warehouse. The rest of his body was burned."[40] When Vandivert arrived with the first American

troops on April 17, four days after this fire, the corpses were still smouldering.

Scenes such as these eroded any remaining faith the American public may have had in a sanitized, glorifying image of war.[41] This new attitude, in conjunction with the ambiguous nature of the conflict itself, shaped the photographic record of the Korean War (1950-53).[42] Once again, *Life* magazine produced the finest coverage of the war, thanks in large measure to the talents of David Douglas Duncan and Carl Mydans. Both men shunned simple, propagandistic approaches to focus on the experience of the common soldier. As Duncan stated in 1951,

> My objective always is to stay as close as possible and shoot the pictures as if through the eyes of the infantryman, the Marine, or the pilot. I wanted to give the reader something of the visual perspective and feeling of the guy under fire, his apprehensions and sufferings, his tensions and releases, his behavior in the presence of threatening death.[43]

The resulting images were powerful and deeply human, but rarely heroic. They depicted soldiers who were lonely, miserably hot or cold, and dazed with shock or exhaustion. While the troops in Korea fought courageously, the whole undertaking was shrouded in a mood of disappointment and uncertainty.

The Education Boom

In the years after World War II, the nation's colleges and universities experienced a massive rise in enrollment, thanks in large part to the Servicemen's Readjustment Act of 1944, popularly known as the GI Bill. Nearly eight million World War II veterans used this bill to further their education, followed in later years by another eight million veterans of the Korea and Vietnam eras. These men and women studied all manner of subjects. In 1946, for example, William Garnett used the GI Bill to learn to fly.[44] He went on to become the most notable aerial photographer of the American landscape (fig. 65). The students of Garnett's generation were far more inclined than their parents to consider courses in the arts and humanities. As a result, photography enjoyed a surge of interest, undergoing a gradual shift from a primarily technical and professional subject to an artistic one. The medium's growing acceptance within the university had much to do with its subsequent development in the United States.

These postwar photographic programs owed a considerable debt to earlier ones. The Clarence White School of Photography, for instance, remained active in New York until 1942, although it had lost some momentum after its founder's death in 1925. In Los Angeles, the Art Center School of Design, founded in 1931, trained a large number of professional photographers both before and after the war. The Art Center's faculty included Will Connell, Charles Kerlee, Fred Archer, Edward Kaminski, and such visiting lecturers as Ansel Adams.[45] Ohio State University offered a major in photography in 1938, and established a master's degree program in 1946.[46] The programs at Indiana Univer-

Fig. 65 William Garnett, *Erosion, Death Valley, California,*
ca. 1953, 13⅜ x 10½"

Fig. 66 Arthur Siegel, *Photogram,* 1937, 13 x 10¼"

sity and at Brooklyn College, under the direction of Henry
Holmes Smith and Walter Rosenblum, respectively, attracted
a number of talented students in the years after the war.
Other prominent postwar programs included those at the
California School of Fine Arts in San Francisco, founded in
1946 under the direction of Ansel Adams and Minor White,
and at San Francisco State College, begun in the same year
by John Gutmann. In the mid-1950s, the previously technical
emphasis of the Rochester Institute of Technology's cur-
riculum was expanded to encompass the art and history of
photography, with courses taught by Minor White, Ralph
Hattersley, Beaumont Newhall, and Charles Arnold. By
1960, notable courses in photography were being taught at
the University of Louisville by Lou Block, at the University of
Minnesota by Allen Downs, and at the University of Florida
by Van Deren Coke.[47]

However, the most influential photographic program of
this era was the one founded in Chicago by László Moholy-
Nagy. In 1937, Moholy-Nagy was brought to Chicago by a
group of local industrialists to open a "New Bauhaus" and
to carry on the role of its illustrious namesake. The specific
mission of this New Bauhaus was to train designers to
enhance the appeal and marketability of American prod-
ucts.[48] While Moholy-Nagy must have subscribed to this
goal in principle, he viewed it as the end result of a process of
experimentation and self-discovery. He thus encouraged each
student to "forget the beaten path, quit imitating others, and
give his own interests and his own personality free rein."[49]

This was hardly the most efficient way to train industrial
designers, and tensions inevitably arose with the school's
original backers. The New Bauhaus closed in early 1938, to
be reborn a year later, with more enlightened business sup-
port, as the Chicago School of Design.[50]

Despite continued financial problems, the school became
widely known and attracted faculty and students of consider-
able talent. Moholy-Nagy used his art-world celebrity to pro-
mote the school and its principles. He wrote articles for the
popular photographic press, gave interviews, and made sev-
eral recruiting trips across the country.[51] Moholy-Nagy
brought his friend Gyorgy Kepes to America to serve as head
of the school's Light Workshop. In this position, Kepes
taught many subjects, including photography. The young
American Henry Holmes Smith, hired in 1937 as Kepes's
assistant, subsequently taught the school's first class devoted
solely to photography. The school's initial semester, in the
fall of 1937, was attended by thirty-three students, including
Nathan Lerner and Arthur Siegel, both of whom later
returned to teach at the school.

Not surprisingly, the collective aesthetic of these artists
was heavily indebted to Moholy-Nagy's work and ideas.
Moholy-Nagy emphasized that the photogram was "the real
key to photography with the camera," and cameraless images
were made by nearly everyone at the school, including Siegel
(fig. 66).[52] Indeed, Smith spent most of his artistic life pursu-
ing the expressive possibilities of nonobjective imagery (plate
98). In addition to photograms, the school encouraged

experimentation with a range of new vision techniques, including negative images, multiple exposures, and photomontage.[53]

After several lean years, the school (now called the Institute of Design) benefited enormously from the impact of the GI Bill. Between 1945 and 1946, returning war veterans swelled the school's enrollment from about thirty to over 350.[54] Harry Callahan began his teaching career there in the summer of 1946, and, despite Moholy-Nagy's untimely death later that year, the program continued to flourish. Callahan's early students included Art Sinsabaugh, Davis Pratt, Yasuhiro Ishimoto, and Marvin Newman. Several other noted photographers, including Ferenc Berko and Wayne Miller, served as visiting faculty members in the late 1940s. After Aaron Siskind was hired in 1951, the program reached a new level of importance. Although very different in experience and personality, Callahan and Siskind formed a highly effective team, inspiring many of their students to prominence in artistic, educational, and commercial careers.

Beyond its own program, the Institute of Design played a central role in the development of photographic education in America. As early as 1946, the school presented photography workshops with instructors as varied as Moholy-Nagy, Abbott, Newhall, Strand, Stryker, and Weegee. In the summer of 1951, three of the school's faculty members— Callahan, Siskind, and Siegel—were invited to teach at Black Mountain College in North Carolina; there they interacted with fellow instructors such as painters Ben Shahn and Robert Motherwell, and with such talented students as Robert Rauschenberg and Cy Twombly. The "New Bauhaus" methodology was also disseminated through the publications and teaching activities of faculty members and graduates. Kepes published his influential book *The Language of Vision* in 1944, and later went on to teach at the Massachusetts Institute of Technology; Smith began the University of Indiana's photography department in 1947. Over the following decades, the Institute's faculty members and alumni would exert an enormous impact on American photography.[55]

From Document to Metaphor

In the years after World War II, American photography reflected the mixed mood of the society at large. Mass-market publications such as *Life* and *Look* presented a largely progressive and optimistic vision of the United States and its people. Problems were undeniable, but a brighter future seemed assured thanks to the powers of human reason and technology. While this progressive ideology dominated the outlook of most Americans, it was not universal. A growing mood of disenchantment and alienation provided a counterpoint to the sunny optimism of "official" culture. This mood of anxiety and estrangement is evident in a spectrum of cultural expressions, from hard-boiled detective

stories to the existential angst of Abstract Expressionist painting.

The disillusion of the postwar years stemmed from several factors, including the realization that the heroic effort of the war had produced a newly unstable world in which political ideology itself seemed dangerous. American leftists were disenchanted by Stalin's pact with Hitler in 1939, and by the Soviet Union's territorial aggression after the war. In addition, Senator Joseph McCarthy's hysterical search for "reds" in American society rendered suspect any political sentiments outside the mainstream. The Photo League was one of several organizations that fell victim to this paranoia: placed on an official list of "subversive" groups in 1947, the League was forced to disband in 1951. The prosperity and increasing homogeneity of American life also provided cause for concern. The banality of mass society was roundly criticized by a minority of intellectuals and counterculturists.[56] How, these critics asked, could a society dedicated to unreflective consumerism, quick profits, and a lowest common denominator of taste encourage the flowering of higher instincts?

In response to these forces, many Americans withdrew from mainstream society in search of more "authentic" experiences. The work of many leading writers and artists became increasingly inscrutable to the general public. Beat poets and writers rejected rhetorical elegance for a frantic, stream-of-consciousness approach. Abstract Expressionist painters, like Jackson Pollock, discarded traditional notions of craft in favor of seemingly random splashes of paint. In be-bop jazz, Charlie Parker and others broke apart and accelerated familiar tunes to create an art of unprecedented nervous energy and improvisational genius. The new genre of rock-and-roll music was even more polarizing, becoming a potent symbol of generational rebellion.

At the heart of these cultural changes lay fundamental issues of identity, stemming from new tensions between the individual and society, but also reflecting divisions of race, class, and gender. While every age has pondered the meaning of the self, the postwar era raised this subject to a new level of importance. In fact, the word "identity" only came into its current social-science use in the 1950s.[57] In this era, the forces of modern secular culture reached a conceptual critical mass, producing a widespread sense of rootlessness, dehumanization, and anxiety. As *Life* reported in 1948, "the chief difficulty in America is an *inner one*—the modern individual is out of touch with the inner realities of life and is somehow 'lost.' He suffers from philosophical and spiritual confusions."[58] The ideas of Existentialism, imported from Europe, gave intellectual form to these feelings. Alienation— the separation of individuals from sustaining personal or social relationships—became a key concept in this period.[59]

The alienation of the postwar era was, as critic Lionel Trilling described, the result of a historical movement from sincerity to authenticity, from a definition of self based on an orientation outward toward family and community, to one directed fundamentally inward.[60] This social shift was accelerated by the forces of urban life. By its nature, the secular,

scientific, democratic, and technological modern age tended to dissolve the social glue of religion, tradition, and kinship. The unprecedented mobility of Americans—by the mid-1950s, the average family moved every four years—significantly reduced their sense of either regional or family identity. The sheer size and anonymity of the modern city effectively cleansed new arrivals of the obligations and inhibitions of small-town life. The city provided the opportunity to erase the past and to remake oneself from scratch. This release carried a price; freedom from others, and from the comforting patterns of tradition, often produced a sense of placelessness and moral disorientation.

Photography served as one of the most visible common denominators of this increasingly diversified culture. Still photographs were made by fully half of the nation's families—about 26,000,000—and 60 percent of camera owners stated that they used them "regularly."[61] Images of anecdotal or newsworthy subjects were published in endless number in newspapers and magazines, while the scientific uses of the medium expanded dramatically. By 1950, for example, the development of human embryos had been thoroughly photographed and "the biggest camera in the world," the new 200-inch Mt. Palomar telescope, was documenting the universe with astonishing precision.[62] The ability to generate photographs in vast quantities was typified by the coverage of the nation's 1946 atomic-bomb tests at Bikini Atoll. Cited as "the world's most photographed event," the first two of these test explosions resulted in a total of well over 3,000,000 feet of motion picture film and 100,000 still images.[63]

The sheer number and variety of these images made the camera the era's most effective medium of both information and persuasion. Unlike painting, music, or literature, the realism and directness of photography made it "the perfect propaganda form."[64] This potential was clearly recognized by the U.S. State Department's Office of International Information which, by 1951, was printing 20,000 still photographs each week of scenes illustrating the virtues of the U.S. and its people. These images, employed in the Cold War struggle against Communism, reached an overseas audience of some 90,000,000 people.[65] At the same time, the persuasive potential of many kinds of photographs—documentary, journalistic, and advertising images alike—was widely recognized.

A growing number of photographers responded to these influences by producing work of an increasingly private nature. Not wanting to become pawns in what they considered a vast rhetorical and manipulative enterprise, these photographers used the camera in a quest for personal rather than ideological meaning. Since the camera's propagandistic strength lay in its uplifting realism, they pursued a more subjective and abstract vision. While advanced technology allowed the depiction of the most distant and exotic subjects, they turned their cameras on the commonplace and elemental. Extending Stieglitz's notion of equivalence, they also sought to transcend mere record-making to evoke intangible

thoughts, moods, and emotions. Only by rejecting mainstream uses of the medium, these artists felt, could photography provide meaningful perspectives on the world and the self.

An Introspective Modernism

The lingering effects of the remarkably diverse aesthetic currents of the 1920s and 1930s—which included new vision experimentation, f/64 purism, Surrealism, and social documentary—interacted in complex ways in the photography of the 1940s and 1950s. The variety of these influences provided broad and fertile ground for visual discovery and personal expression. Many photographers pushed previously explored approaches, such as the photogram, to new levels of refinement; others explored the aesthetic terrain between formerly discrete approaches, creating, for example, works that united purist and Surrealist ideas.

The work of Val Telberg is emblematic in this regard. Born in Moscow, Telberg moved with his parents to East Asia after World War I, where he attended British, French, Japanese, and American schools in cities in China, Japan, and Korea. He studied chemistry at a college in the United States and subsequently pursued various careers in China and the U.S. After moving to New York in 1938, Telberg began studying art, and by 1945 he had turned almost exclusively to photography.[66] His eclectic and restless life found expression in an equally unorthodox vision. By combining negatives in his enlarger, Telberg created complex, dreamlike images based on Surrealism. Describing his technique in 1949, Telberg explained, "What interests me most is not what one can see, but what goes on unseen in one's mind. The mind blends many images and my pictures attempt to do likewise."[67] In Telberg's untitled work of about 1948 (plate 100), this blending of figurative and abstract elements creates an image that is mysterious and unsettling.

The impact of prewar modernist styles is clear in the work of many photographers who came to prominence in the 1940s and early 1950s, including Ruth Bernhard, Lotte Jacobi, and Carlotta Corpron. Bernhard, the daughter of a noted German designer and typographer, studied at the Berlin Academy of Art before arriving in the United States in 1927. She began photographing in 1930, and was powerfully influenced by Edward Weston, whom she met in 1935. In fact, her *Hand, Jones Beach, New York*, 1946 (plate 101), unites a purist interest in direct perception with a Surrealist mood of dislocation and ambiguity. Jacobi, also a native of Germany, became a noted portrait photographer there before fleeing the Nazi regime in 1935 to settle in New York. In addition to her portrait work, Jacobi made a large series of cameraless images between 1946 and 1955, which she termed "photogenics."[68] The distinctiveness of these images stems from their delicacy and subtlety (plate 99). Instead of emphasizing geometric forms and harsh contrasts of light and dark, Jacobi created lyrical veils of tone suspended in pictorial space. Corpron was equally fascinated by the subject of light. Her photographs, strongly influenced

Fig. 67 Carlotta Corpron, *Illusion of Male and Female*, 1946 (print ca. 1970), 13¾ x 10⅝"

Fig. 68 Frederick Sommer, *Ondine*, 1950 (print 1980), 7⅝ x 9½"

by her work with Kepes in 1944, utilize various techniques—ranging from straight photography to photograms, multiple exposures, and solarization—to explore the expressive possibilities of light. Her *Illusion of Male and Female*, 1946 (fig. 67), for example, uses light as an agency of both illumination and transformation.

Frederick Sommer was one of the most remarkable artists to come to maturity in this era. His powerfully original work is a product of an uncommon intellect and a mystical sense of the connectedness of all things. Born in Italy, Sommer first moved with his parents to Brazil, where he studied architecture.[69] After receiving a degree in landscape architecture from Cornell University in 1927, Sommer returned to practice this profession in Rio de Janeiro. However, a bout with tuberculosis cut short his work in 1930, forcing him to travel to Switzerland and then to Arizona in search of a clean, dry climate. These experiences changed Sommer profoundly, and when he settled in the American Southwest in 1931, his interests had turned to visual art. Sommer worked in a variety of media, including drawing, watercolor, and even musical composition, but his overriding interest in photography was confirmed by meetings with Stieglitz and Weston in the mid-1930s. At the end of the decade, Sommer began creating small, meticulously crafted photographs that reflect his wide-ranging interests in art history, philosophy, and science.

The diversity and originality of Sommer's photographs were stunning. With an 8x10-inch camera, he began a series of desert views in 1941 wholly unlike any other landscapes (plate 102). Sommer eliminated the horizon line and filled his frame with precisely described vistas of rock and cactus. The overall texture gives these pictures a strange pictorial duality, at once uneventful and agitated. These views are void of traditional compositional devices, such as a clear center of interest or a pleasing balance of subordinate forms. Such comforts are not to be found in Sommer's landscapes. Instead, his photographs suggest new ways of looking at, and thinking about, both pictures and nature.[70]

Sommer's working method involved the deliberate exploration of varied subjects and approaches, including still lifes, assemblages, and abstractions, and range from the horrific to the elegant. In fact, the charge of Sommer's work rests in large measure on the balance it strikes between the exquisite beauty of the photographic print, and the mundane, or occasionally grotesque, nature of his subjects. Beginning in 1939, for instance, Sommer produced a series of disturbingly seductive pictures of dead coyotes and rabbits and arrangements of chicken entrails. In 1946, he began a series of photographs of carefully constructed still lifes of found objects (fig. 68); these images, with titles drawn from literary and mythological sources, contain elements of whimsy, allegory, and drama, but defy easy interpretation. In 1949, Sommer began making prints from "negatives" created by such nonphotographic means as applying smoke to glass or oil paint to sheets of cellophane. In 1962, he began yet another group of photographic abstractions by using a knife to "draw" on large sheets of paper. The resulting forms were then carefully illuminated and photographed (plate 103). These images successfully unite seemingly opposite concerns—a "painterly" interest in the abstract beauty of line and tone, and a rigorous, f/64-type photographic purism—while reminding us that all photographs are, at once, both taken and made. This sense of synthesis and discovery lies at the heart of Sommer's difficult but remarkable work.

Like those of Sommer, the photographs of Harry Callahan, Aaron Siskind, and Minor White are rooted in a fundamentally subjective quest. Collectively, the work of these three photographers rejects both the social urgency and the narrative clarity of the documentary approaches of the 1930s. Instead of merely replicating the world, these photographers wanted to reinvent it and to give it personal and mythic resonance. They sought to discover the transcendent in the commonplace, to transform carefully chosen fragments of experience into emblems of a purer and more comprehensive image of life. The influence of these three photographers stemmed, in roughly equal measure, from their dual careers as artists and teachers. Callahan and Siskind both taught at the Institute of Design and at the Rhode Island School of Design. White's career included teaching positions at the California School of Fine Arts (now San Francisco Art Institute), the Rochester Institute of Technology, and the Massachusetts Institute of Technology.

Harry Callahan came to photography with no formal training in the arts. What he had, however, was far more important: a burning desire to express himself and an astonishingly rich visual imagination. Callahan bought his first camera in 1938, while living in Detroit, and worked with it casually for a few years.[71] Through a local camera club, Callahan became acquainted with Arthur Siegel, who had returned to Detroit after attending the 1937-38 session of the New Bauhaus. At informal gatherings at Siegel's house, Callahan discussed with him Moholy-Nagy's ideas and perused the examples of modernist photography in Siegel's collection of books and periodicals. However, Callahan's real breakthrough came in 1941, when he attended a workshop conducted by Ansel Adams. Callahan was struck by the brilliance of Adams's prints and by his reverential—indeed, almost spiritual—attitude toward the medium.

The encounter with Adams charged Callahan with a new commitment to photography, and unleashed a remarkable burst of creative energy. In the next few years, Callahan explored most of the themes and techniques that would characterize the next half-century of his photography. His work was enormously varied, encompassing nature, the architecture and human activity of the city, and his family. To this range of subjects, Callahan applied an equally varied set of technical approaches. He used cameras of various sizes, from 35mm to 8x10-inch formats, and made extensive use of multiple exposures, high-contrast printing, and color. Remarkably, Callahan used the camera to discover the world around him while, at the same time, investigating the grammar and syntax of photographic vision itself. From the influences of Stieglitz's sublime purism (absorbed via Adams) and Moholy-Nagy's relentless experimentation (gained, in part, through Siegel), Callahan forged a wholly original artistic voice.

In and of themselves, the subjects of Callahan's photographs were unremarkable. However, his vision of the every-

Fig. 69 Harry Callahan, *Weed Against the Sky*, 1948, 7¾ x 7½"

day was anything but common. Callahan was a homebody who found adventure in a world of familiar things: his own house, neighborhood buildings, or the trees, grass, and fallen leaves in a nearby park.[72] When printed on high-contrast paper, a weed in the snow became for him the equivalent of a Zen drawing, irreducibly simple and perfect (fig. 69). His images of anonymous pedestrians (plate 104) avoid anecdote and social comment to focus on the linear and graphic effects of light and shadow, and the spaces between them. Callahan's multiple exposures use a simple mechanical technique to transform the solidity of familiar things into a vision of transparency, instability, and weightlessness (plate 105). These wholly synthetic images fold reality back on itself, or shatter it into crystalline fragments. Finally, Callahan's many images of his wife Eleanor (and, after her birth in 1950, his daughter Barbara) conflate the intimate and the universal to create a mythic realm of fertility and nurture (plate 107; fig. 70). While understated and emotionally restrained, Callahan's pictures in fact reflect an attitude of love and respect for the world. They suggest that meaning can be found in any subject, if it is approached with reverence and patience.

Callahan exerted a great influence on other photographers through his teaching and his art. In 1946, he was hired by Moholy-Nagy to teach at the Institute of Design. Instructing largely by example, Callahan inspired a generation of students in Chicago before moving to Providence in 1962 to head the photographic program at the Rhode Island School of Design. In his fifteen years at RISD, Callahan trained yet another generation of photographers who, in turn, have gone on to influential careers. Since the late 1940s, Callahan's photographs have been widely exhibited and admired. Under Steichen's direction, for example, his prints were included in no fewer than eight major exhibitions at the Museum of Modern Art between 1948 and 1962.[73] He

Fig. 70 Harry Callahan, *Eleanor, Chicago*, ca. 1947, 4⅛ x 3⅜"

also had a critically acclaimed one-man exhibition at the Art Institute of Chicago in 1951.[74]

Aaron Siskind began taking photographs before Callahan, but he reached his mature style at about the same time. In the 1930s, as a member of the Photo League, Siskind worked in a social-documentary mode. By the end of the decade, however, Siskind's devotion to this approach had begun to wane. Increasingly, his work revealed a predilection for unpeopled scenes, with great emphasis given to formal concerns. By 1940, Siskind was experimenting with highly reductive, almost abstract images with negligible documentary content, such as a coil of rope against the planks of a pier. He broke with the Photo League in 1941, after his exhibition of architectural photographs, "Tabernacle City," was criticized by League members as socially irrelevant.[75]

The threads of Siskind's photographic experimentation came together in the summer of 1944. He described this experience several months later in an important essay titled "The Drama of Objects":

> Last year I spent the summer at the famous New England fishing village of Gloucester, and made a series of photographic still-lifes of rotting strands of rope, a discarded glove, two fishheads, and other commonplace objects which I found kicking around on the wharves and beaches. For the first time in my life subject matter, as such, had ceased to be of primary importance. Instead, I found myself involved in the relationships of these objects, so much so that these pictures turned out to be deeply moving and personal experiences....
>
> For some reason or other there was in me the desire to see the world clean and fresh and alive, as primitive things

are clean and fresh and alive. The so-called documentary picture left me wanting something....

> As the saying goes, we see in terms of our education. We look at the world and see what we have learned to believe is there. We have been conditioned to expect. And indeed it is socially useful that we agree on the function of objects.
>
> But, as photographers, we must learn to relax our beliefs. Move on objects with your eye straight on, to the left, around on the right. Watch them grow large as you approach, group and regroup themselves as you shift your position. Relationships gradually emerge, and sometimes assert themselves with finality. And that's your picture.
>
> What I have just described is an emotional experience. It is utterly personal: no one else can ever see quite what you have seen, and the picture that emerges is unique, never before made and never to be repeated. The picture—and this is fundamental—has the unity of an organism. Its elements were not put together, with whatever skill or taste or ingenuity. It came into being as an instant act of sight.
>
> Pressed for the meaning of these pictures, I should answer, obliquely, that they are informed with animism—not so much that these inanimate objects resemble the creatures of the animal world (as indeed they often do), but rather that they suggest the energy we usually associate with them. Aesthetically, they pretend to the resolution of these sometimes fierce, sometimes gentle, but always conflicting forces.
>
> Photographically speaking, there is no compromise with reality. The objects are rendered sharp, fully textured, and undistorted (my documentary training!). But the potent fact is not any particular object; but rather that the meaning of these objects exists only in their relationship with other objects, or in their isolation (which comes to the same thing, for what we feel most about an isolated object is that it has been deprived of relationship).
>
> These photographs appear to be a representation of a deep need for order. Time and again "live" forms play their little part against a backdrop of strict rectangular space—a flat, unyielding space. They cannot escape back into the depth of perspective. The four edges of the rectangle are absolute bounds. There is only the drama of the objects, and you, watching.
>
> Essentially, then, these photographs are psychological in character. [This] may or may not be a good thing. But it does seem to me that this kind of picture satisfies a need. I may be wrong, but the essentially illustrative nature of most documentary photography, and the worship of the object *per se* in our best nature photography, is not enough to satisfy the man of today, compounded as he is of Christ, Freud, and Marx. The interior drama is the meaning of the exterior event. And each man is an essence and a symbol...[76]

This essay is remarkably insightful. While clearly articulating his own motivations at the time, Siskind also managed to summarize the ideas that would define a larger movement in creative photography over the next twenty years, from document to metaphor. Siskind sought a newly purified way of seeing, unconstrained by habit or convention. From this perspective, the most trivial subjects had the potential to serve as symbols of the human condition. Thus, the tension, asymmetry, and ambiguity of Siskind's pictures were understood to evoke the confusion, longing, hope, and dread that characterize every life. From fragments and shards, Sis-

Fig. 71 Aaron Siskind, *Jerome, Arizona*, 1949, 19½ x 14¼"

kind created an artistic order that was both beautiful and revelatory. The compositions of his pictures, which often teeter on the edge of chaos, underscore an existentialist belief that life is uncertain, meaning conditional, and survival a function of individual will.

Siskind's mundane subject matter was utterly removed from the progressive desire for newness typical of the prosperous world of 1950s suburban experience. Many of his best-known pictures depict close-cropped details of torn posters, bits of graffiti, or peeled paint (fig. 71), hieroglyphics of the human presence. In 1950, he began an extended series of photographs of stone walls on Martha's Vineyard (plate 108). These images orchestrate form, tone, and texture to suggest a primal relationship between the things of the world and mankind's constructive impulses.[77] Siskind's only important group of pictures to employ the human figure, his remarkable "Pleasures and Terrors of Levitation" series, was begun in 1953.[78] By his choice of viewpoint and printing technique, Siskind removed his subjects—teenagers jumping into a lake—from their real-world surroundings (plate 109). Each figure is depicted in isolation, flying or falling through a space that is as psychological as it is physical. The duality of Siskind's title suggests the contradictory feelings of exhilaration and fear generated by these existential leaps into the void.

Of all the photographers of this era, Siskind had the closest ties with avant-garde painters. He was friendly with many of the leading Abstract Expressionists, including Franz

Kline, Barnett Newman, Adolph Gottlieb, Mark Rothko, Robert Motherwell, and Willem de Kooning. Siskind showed regularly at the Charles Egan Gallery in New York, which specialized in the work of this circle, and in 1948 he was given a one-man show at Black Mountain College.[79] This acceptance reflected the regard these artists had for Siskind's work, as well as their collective sense of purpose.[80] While Siskind's photographs were superficially similar to some of the paintings of the era, they were not imitative; he was ahead of his painter friends in some respects and in tandem with them in others.[81]

Minor White brought to his photography an unusual combination of science, poetry, and mysticism. In college, he had been interested in both botany and literature. White's earliest significant photographs were documentary images of nineteenth-century buildings in Portland, Oregon, produced under the auspices of the WPA's art program. While he remained dedicated to a "purist" use of photography throughout his career, White's expressive interests soon became more subjective and abstract. White's mature work represented a complex synthesis of influences, including Stieglitz's idea of equivalence, Weston's clarity and formalism, and Adams's devotion to the natural landscape. White came to know these and other figures in the photography community following his discharge from the Army in 1945. After assisting Beaumont and Nancy Newhall at the Museum of Modern Art for a year, White began teaching with Ansel Adams at the California School of Fine Arts in 1946. His work developed rapidly in this period.[82]

As one of his biographers has observed, White's creative life was "one sustained effort, more and more successful as time went on, to find a spiritual home."[83] Aside from a year of formal study in art history at Columbia University in 1945-46, this quest was highly intuitive and eclectic. White was inspired by a great variety of ideas throughout his career, including, at various times, Catholicism, Christian mysticism, Zen, Tao, hypnosis, astrology, and Jungian psychology. His favorite books included Evelyn Underhill's *Mysticism: A Study in the Nature and Development of Man's Spiritual Consciousness* (1911), Richard Boleslavski's *Acting: The First Six Lessons* (1923), Eugen Herrigel's *Zen in the Art of Archery* (1948), Aldous Huxley's *Doors of Perception* (1954), the *I Ching*, and the works of Mircea Eliade, G. I. Gurdjieff, P. D. Ouspensky, and Carlos Castaneda.[84] The central thread of White's life was a probing search for metaphysical truths and enlightened self-awareness. He did not think of himself as a traditional photographer; instead he saw the camera as a "medium and catalyst for [an] intensely personal, emotional, spiritual, and mystical expression."[85] As White wrote in his journal in 1947, "Understand only yourself. The camera is first a means of self-discovery and then a means of self-growth. The artist has one thing to say—himself..."[86]

With this goal in mind, White perceived the world through a language of symbols and analogies. He was attracted to elemental subjects—rocks, trees, water, sky, the

Fig. 72 Minor White, *Matchstick Cove, San Mateo County, California*, 1947, from the sequence "Song Without Words," 3⅝ x 4⅝"

human figure—and found in each of them suggestions of larger forces and evocations of his own feelings (fig. 72). White's *Easter Sunday, Stony Brook State Park*, 1963 (plate 111), addresses the world at its most primal: rock and water, darkness and light. By using a slow shutter speed, White created an elegant calligraphy from the sun's reflection on an undulating surface of water. The resulting photograph is a visual haiku, intensely spiritual, and at once intimate and sublime. This interest in acute observation and mystical transformation also underlies White's urban pictures. *Warehouse Area, San Francisco*, 1949 (plate 110), was originally made as part of a series of "Movement Studies" exploring the idea of people "caught in the act of becoming something else."[87] While clearly recognizable, the blurred boy and the sheet of paper create a mood of otherworldliness that is underscored by the enigmatic "face" in the doorway.

White's quest for nontraditional meanings led him to explore the expressive potential of groups of pictures. During his year in New York, White's interest in the photographic sequence was stimulated by conversations with Stieglitz and by his work at the Museum of Modern Art, assisting Nancy Newhall with the layout of Edward Weston's 1946 retrospective. By 1947-48, White was assembling nonnarrative sequences of images, such as "Amputations" and "Song Without Words," that, like Stieglitz's Equivalents, evoked open-ended sensations and emotions. He wrote,

> A sequence of photographs is like a cinema of stills. The time and space between photographs is filled by the beholder, first of all from himself, then from what he can read in the implications of design, the suggestions springing from treatment, and any symbolism that might grow from within the subject itself....The meaning appears in the space between the images, in the mood they raise in the beholder. The flow of the sequence eddies in the river of his associations as he passes from picture to picture.[88]

Just as White wanted these sequences to suggest a fluid stream of associations, so too did he feel free to restructure them in order to reflect changes in his own ideas and moods.

For example, four different versions of "Song Without Words" from 1947, 1950, 1960, and ca. 1963 contain, respectively, twenty-four, fifteen, twelve, and thirteen prints in varying order.[89] Clearly, White considered these sequences organic, with their own capacity for growth and change.

As a corollary to his extension of the idea of equivalence, White stressed the need to "read" photographs. This reading was based on an acknowledgment of the complexity of the creative photograph and of its role as a catalyst for psychological and spiritual insight. White emphasized that the meanings of images lay beyond subject matter per se in a realm of simile, metaphor, and symbol. Moreover, these meanings were dynamic rather than fixed, reflecting the ideas and moods of each viewer. The extreme subjectivity of this approach struck many photographers as pretentious and arcane. For example, White's friend Ansel Adams agreed that "perhaps all photographs have meanings because of conscious or unconscious connotations," but argued that "the connotations *imposed* by the photographer, or by groups of photographers, are questionable."[90] Nonetheless, White's ideas provided a considerable motivational force for a small band of devoted associates and students, including Walter Chappell, Nathan Lyons, and Paul Caponigro.[91]

White's influence was broadcast in the pages of *Aperture* magazine. Begun as a quarterly in 1952 by a group that included Ansel Adams, Dorothea Lange, Beaumont and Nancy Newhall, Barbara Morgan, and White, *Aperture* was one of a number of avant-garde visual and literary magazines of the 1950s.[92] White was chosen as the journal's editor and production manager, and, from its beginning, used it as a forum for his own interests and ideas. Although the original founders voted to discontinue the journal in 1954, White located new funding and continued to publish. As a result of its independence, *Aperture*'s perspective on the art of photography differed greatly from that of more mainstream publications. It featured portfolios by a variety of contemporary photographers, including Adams, Caponigro, Cunningham, Lange, Siskind, Sommer, and Wynn Bullock, as well as essays and book reviews by White, Lyons, Henry Holmes Smith, and many others. For years, *Aperture* held a singular position in the photographic community as the principal forum for serious, noncommercial work.[93]

The City of Idea and Image

The psychological condition of modernity was symbolized most clearly in postwar America by the idea and image of the city. For photographers, as well as artists in other mediums, the city represented both the best and worst of modern life: enterprise, innovation, and integration, as well as alienation, fragmentation, and decay. This dichotomy would underscore the photographic representation of postwar city life by artists of widely varying sensibilities.

The city's restless human energy was conveyed most memorably by Weegee, a uniquely talented tabloid news

photographer. Born Arthur Fellig, in Poland, Weegee came to the U.S. with his parents at the age of ten. An impoverished childhood left him with little but an instinct for survival and a hard-boiled sympathy for his fellow man. In 1935, after a decade of darkroom work for Acme Newspictures, Weegee became a free-lance news photographer. He photographed on retainer for the progressive newspaper *PM* and sold pictures to several other New York dailies, including the *Herald Tribune, Daily News, Post,* and *Sun.* The leading photographic syndicates were also regular customers and distributed his photographs to newspapers across the country.

Early on, Weegee was given his nickname—after the Ouija board, a popular amusement of the period—for his uncanny ability to sense breaking news. Repeatedly, Weegee was the first photographer to arrive on the scene of a fire, accident, or murder. While he encouraged belief in his psychic powers (when something was about to happen, Weegee said, his elbow itched), it is clear that his success lay more in preparedness than portents.[94] Specializing in the calamities and crimes of New York City night life, Weegee typically began his workday in the evening at police headquarters. He would check the police teletype and depart immediately for the scene of any noteworthy incident. Weegee was prepared for rapid action even when sleeping in his apartment; a shortwave radio near his bed, tuned to the police band, notified him of breaking events. In the field, Weegee worked rapidly with his 4x5-inch Speed Graphic camera and flash to create blunt records of urban trauma and vice. In his 1961 autobiography, he described his stock-in-trade:

> Being a free-lance photographer was not the easiest way to make a living. There had to be a good meaty story to get the editors to buy the pictures. A truck crash with the driver trapped inside, his face a crisscross of blood…a tenement-house fire, with the screaming people being carried down the aerial ladder clutching their babies, dogs, cats, canaries, parrots, monkeys, and even snakes…a just-shot gangster, lying in the gutter, well dressed in his dark suit and pearl hat, hot off the griddle, with a priest, who seemed to appear from nowhere, giving him the last rites…just-caught stick-up men, lady burglars, etc.[95]

After gathering information for his captions, Weegee returned to his darkroom to process and print the evening's film. Around 6 a.m., he would start his rounds of the newspapers and picture agencies, selling prints as he went. In an average week, this routine earned him about one hundred dollars, a respectable income at the time.[96]

While Weegee recorded an enormous number of sensational subjects—he claimed to have photographed 5,000 murders in the first ten years of his free-lance career—his continuous quest for salable pictures led him to record many facets of city life. He photographed circuses, parades, theater openings, nightclubs, people in movie theaters and at Coney Island, celebrities, lovers on park benches, and the homeless. His pictures depict the city as chaotic, exhilarating, and tragic—a home to both pleasure and danger. With a vision at once cynical, sentimental, and voyeuristic, Weegee recorded

urban life as a "carnival of human comedy."[97] Two of his most famous photographs are *The Critic*, 1943 (plate 115), and *Girl Shot from Cannon*, ca. 1943 (plate 114). The first of these images (reproduced here in its less common uncropped form) records two society ladies on their way to the opera. As they present well-practiced smiles to the camera, they remain unaware of their "critic," a resentful—and perhaps deranged—woman standing to their left. The resulting photograph suggests a complex dynamic between the seen and the unseen—within the image itself, and in the very structure of society. The latter image, at once absurd and energetic, documents a famous circus act of the day.[98]

Weegee's work had a uniquely broad appeal, spanning the worlds of the tabloid press and the art museum. When his work was first exhibited at the Museum of Modern Art in 1943, and he was asked to lecture there a year later, he reveled in his hard-won celebrity status. Weegee's fame was confirmed with the publication of his first book, *Naked City* (1945), a brilliant collage of text and pictures that was as popular with the critics as it was with the general public. The *Saturday Review* called *Naked City* "a magnificent album of snapshots and love letters…a wise and wonderful book."[99] As a mark of the respect accorded Weegee by other photographers, in 1946 he was invited to conduct a summer seminar at the Institute of Design in Chicago. At that point, Weegee was so famous that when he took his students outdoors to show them how to photograph a corpse (in this case, a mannikin), the session was deemed worthy of detailed coverage by *Life* magazine.[100] Ironically, the praise lavished on Weegee for his gritty and unpretentious news photography induced him to turn to increasingly gimmicky, "artistic" effects. As a consequence, neither of his subsequent books—*Weegee's People* (1946) and *Naked Hollywood* (1953)—approached the raw vitality of *Naked City*, and his years in Hollywood, from 1947 to 1952, were largely wasted.[101]

The sweaty intimacy of Weegee's vision of the city stands in marked contrast to the distanced formalism of Andreas Feininger's work. Feininger grew up in the cultural milieu of the Bauhaus, where his father, expatriate American painter Lyonel Feininger, was a founding instructor. After studying architecture and structural engineering, the younger Feininger took up photography in 1927. His earliest pictures, exhibited in such prestigious exhibitions as "Film und Foto," embodied the experimental tenets of the new vision. In 1934, Feininger developed the extreme telephoto technique that would become his artistic trademark. After moving to the U.S. in 1939, and joining the staff of *Life* in 1943, Feininger used this technique to depict the vast scale and dynamism of postwar America. *Life* published so many of Feininger's bold photographs as two-page spreads that his friends began referring to him as "Double Truck Feininger."[102] In one of the most famous of these images, *Fifth Avenue, New York*, 1949 (plate 112), Feininger's long lens collapses space dramatically, transforming the city into a dense tapestry of human and mechanical energy. For many New Yorkers, this image of the

city as a congested beehive of activity captured perfectly the psychological impact of the modern urban experience.

Ralston Crawford's vision of the city was even more astringently formal and graphic. While Feininger's subjects were vast in scale, Crawford's tended to be intimate. Crawford was well known as a Precisionist painter when he took up photography in 1938. Focusing primarily on simple architectural and industrial forms, he used many of his photographs as sources for his drawings, paintings, and prints. His work in all mediums was characterized by a directness of perception, an interest in geometric form, and a desire to find precise aesthetic balance in the contingencies of the urban experience. Crawford was particularly fascinated by the forms of the Third Avenue Elevated rail line (plate 113). Beginning in 1948, he made many photographs of the steel supports of the El and the patterns of light and shadow they cast. Some of these reductive images were translated into other media, undergoing further distillation in the process.[103] Unfortunately, the hermetic logic of Crawford's art was out of step with both popular and avant-garde tastes, and he received only modest recognition during the last thirty years of his life.

Multitude, Solitude

Weegee, Feininger, and Crawford are representative of the many photographers of the 1940s and 1950s who took the city as their central motif. Among the urban themes explored by artists of widely varying sensibilities were these: the physical city, an artifact shaped by the impress of innumerable lives; the symbolic city, in which issues of community and identity are reflected in solitary figures and masses of anonymous faces; and the poetic city, in which the larger meaning of modern existence is revealed in the disjunctions, flux, and contingencies of urban life. The work of many of these photographers reveals a basic sympathy with the much earlier observations of the poet Charles Baudelaire on the relationship of the modern artist to the spectacle of urban life:

> For the perfect flâneur, for the passionate spectator, it is an immense joy to set up house in the heart of the multitude, amid the ebb and flow of movement, in the midst of the fugitive and infinite. To be away from home and yet to feel oneself everywhere at home; to see the world, to be at the centre of the world, and yet to remain hidden from the world...the lover of universal life enters into the crowd as though it were an immense reservoir of electrical energy...[104]

For Baudelaire, the key words were:

> Multitude, solitude: equal and convertible terms for the active and fecund poet. He who does not know how to people his solitude will not know either how to be alone in a bustling crowd.
>
> The poet enjoys the incomparable privilege of being able as he likes to be himself and others. Like those wandering souls which search for a body, he can enter every person

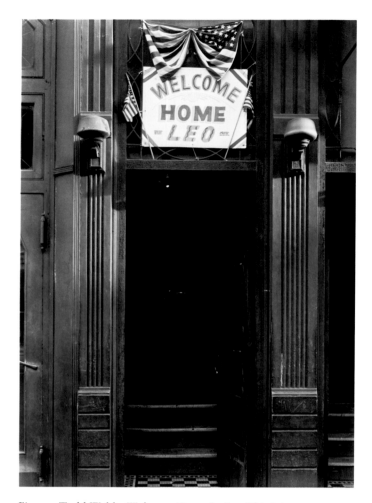

Fig. 73 Todd Webb, *Welcome Home Series: Third Avenue, New York*, 1945 (print ca. 1980), 6¾ x 4¾"

whenever he wants....The solitary and pensive walker draws from this universal communion a singular sense of intoxication.[105]

No photographer is more typical of this approach than Helen Levitt, whose lyrical work was a direct result of her love of walking and her desire to immerse herself in the "fugitive and infinite" vitality of the street. A deeply private person, Levitt photographed strictly for her own pleasure and belonged to no organized groups. She was influenced by her close friendships with Walker Evans and Ben Shahn, and later, by certain visual techniques she developed in her work in film.[106] In 1935, she was strongly impressed by the work of Henri Cartier-Bresson, the great exponent of the 35mm Leica camera. Levitt's own photographs were also made with a Leica, which she often equipped with a right-angle viewfinder. This practice allowed her to work unobtrusively — almost invisibly — in the poor or working-class communities of New York City. In these neighborhoods, the rhythms of daily life were played out in full view on public sidewalks. Levitt responded to this protean theater of the street by creating photographs that are lyrical, uncontrived, and mysterious. Fascinated by the simplest marks and the most fleeting gestures, Levitt made images of children's graffiti (plate 116) that suggest the timeless human need for self-expression, as well as the surprising insights of unselfconscious artists.

Fig. 74 **Todd Webb**, *Sixth Avenue Between 43rd and 44th Streets, New York*, 1948 (print ca. 1980), 13 x 103"

Other works, like *New York*, ca. 1942 (plate 117), subtly explore the complex network of connections between individuals and their surroundings. In this case, Levitt creates a gentle mystery from the evidence of touch, expression, and glance, while using internal framing devices to hint at the constraints of these lives.[107] Levitt received high critical praise in the 1940s: her pictures were published in *U.S. Camera* and elsewhere and exhibited at the Museum of Modern Art. Unfortunately, however, the first book of her photographs did not appear for many years: *A Way of Seeing*, a selection of forty-four uncaptioned images with an eloquent essay by James Agee, was assembled in 1946 but not published until 1965.

Unlike Levitt's works, Todd Webb's views of New York centered on its buildings and artifacts, which he recorded with large 5x7-inch and 8x10-inch cameras. A native of Detroit, Webb's interest in photography had been stimulated by his friendships with Harry Callahan and Arthur Siegel, and by the impact of a 1941 workshop conducted by Ansel Adams. After wartime service in the Pacific, Webb arrived in New York in late 1945 and made many friends in the photographic community. While influenced by Stieglitz, Evans, and Levitt, Webb soon established his own artistic voice. Among his first subjects were the simple "Welcome Home" signs posted above doorways throughout the city to greet returning soldiers (fig. 73). These warm evocations of kinship and community spoke eloquently of the desire for a return to normalcy after years of war. At once public and private in meaning, these simple declarations hinted at the complex emotions of Webb's fellow veterans and of the families who awaited them.[108] Webb also sought evidence of the human presence in storefront churches in Harlem, the Third Avenue El, graffiti, advertising signs, and shop facades.[109] As he wrote in 1954,

> I have an intense interest in and feeling for people. And often I find subject matter with no visible persons to be more peopled than a crowded city street. Every window, doorway, street, building, every mark on a wall, every sign, has a human connotation. All are signs and symbols of people—a way of living—living in our time.[110]

Webb's interest in the breadth and vitality of New York City culminated in his ambitious *Sixth Avenue*, 1948 (fig. 74), a panorama of one side of an entire city block. This work, a careful composite of eight individual views, unites a wealth of specific detail with a Whitmanesque embrace of the city's amazing expanse and energy.[111]

This interest in the rhythms and artifacts of everyday life—shared by Evans, Levitt, Webb, and others—represented

a conscious artistic focus. Turning away from signs of wealth, competition, and power, values generally celebrated by "progressive" American society, these photographers sought in vernacular culture a source of genuine emotion, natural creativity, and timeless human truths. Agee, for instance, believed that Levitt's proletarian subjects possessed "more spontaneity, more grace, than…human beings of any other kind."[112] And Lincoln Kirstein noted that a central motif in Evans's work was "the naive creative spirit, imperishable and inherent in the ordinary man."[113] Such statements harbored an implicit criticism of such "unreal" aspects of American life as big business, advertising, elite culture, and middle-class conformity.

This sort of sympathetic realism characterized the work of photographers influenced by the Photo League. Until its forced dissolution in 1951, the Photo League played an important role in nurturing a broadly humanistic artistic vision. Directly or indirectly, many noted photographers of the 1940s and 1950s were shaped by the Photo League's moral stance. Morris Engel, for example, who joined the League in the late 1930s, recorded the fundamental patterns of urban life with warmth and clarity (fig. 75); Paul Strand praised his "compassionate understanding" of people.[114] Dan Weiner was also devoted to the poetry of the everyday (fig. 76). While working as a commercial and fashion photographer in the years after World War II, Weiner also photographed for his own pleasure, using a 35mm camera to record lyrical vignettes of New York City street life.[115] Max

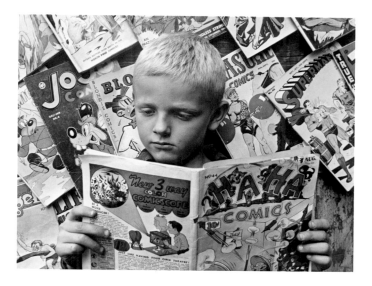

Fig. 75 **Morris Engel**, *Comic Book Stand, New York*, ca. 1945, 10½ x 13⅜"

Fig. 76 Dan Weiner, *Stickball, New York*, ca. 1947-48, 9⅜ x 65″

Fig. 77 Jerome Liebling, *Boy and Car, New York City*, 1949, 10½ x 10½″

Yavno took up photography in New York in the late 1930s. His early influences included Consuelo Kanaga and Aaron Siskind, both of whom he met at the Photo League. Yavno's successful union of these seemingly divergent approaches is reflected in the documentary content and formal precision of pictures such as *San Francisco*, ca. 1947-48 (plate 118).[116] Like Yavno, Jerome Liebling created a personal synthesis of formal and realist influences (fig. 77). His studies at Brooklyn College included classes in a design program founded on Bauhaus principles and photography courses with Walter Rosenblum, a staunch exponent of the realist vision of the Photo League.[117] Liebling's work of this period focuses intently on the human condition while avoiding sentimentality.

While many white photographers (including Siskind and other Photo League members) recorded life in Harlem with compelling sympathy, their vision inevitably differed from that of African-Americans such as Roy DeCarava or Gordon Parks. DeCarava, who was born and raised in Harlem, was recognized for his artistic talent at an early age. Initially drawn to painting and printmaking, he turned seriously to photography in 1947. His sensitive and poetic images drew considerable acclaim and, in 1952, he became the ninth photographer to receive a Guggenheim Fellowship.[118] In 1955, he published his first book, *The Sweet Flypaper of Life*, a small but eloquent volume produced in collaboration with the poet Langston Hughes. DeCarava's photographs

powerfully unite realist and expressive concerns; their content is always clear, but they nonetheless bear rich symbolic or psychological meanings. His *Hallway, New York*, 1953 (plate 132), for example, is at once reality and dream, comforting and threatening, depressing and beautiful. As DeCarava himself recalls,

> It's about a hallway that I know I must have experienced as a child. Not just one hallway; it was all the hallways that I grew up in. They were poor, poor tenements, badly lit, narrow and confining; hallways that had something to do with the economics of building for poor people.[119]

DeCarava's love of the lower registers of the photographic scale—his celebration of the velvety beauty of shades of gray and black—is apparent here, as it is in *Coltrane No. 24*, 1963 (plate 133). This latter image, from his extended documentation of jazz artists, utilizes blur and underexposure to convey the passionate intensity of John Coltrane's music.

While usually less private in sensibility than DeCarava's, the photographs of Gordon Parks are just as deeply felt. A man of extraordinarily diverse talents, Parks has achieved recognition as a photographer, writer, musician, and filmmaker. Self-educated in photography, Parks worked as a freelance fashion photographer from 1937 to 1942, and then with Roy Stryker in the last year of the FSA, 1942-43. He photographed for *Life* from 1948 to 1961, covering such widely varying subjects as Harlem street gangs, Paris fashions, Winston Churchill, and the civil rights movement. His famous image *Emerging Man*, 1952 (fig. 78), was created as an homage to Ralph Ellison's great book, *Invisible Man* (1952). Ellison's novel explores the quest for identity of an unnamed African-American protagonist who lives alone in an underground room, his "invisibility" the result of a soci-

Fig. 78 Gordon Parks, *Emerging Man*, 1952, 14⅞ x 19⅛"

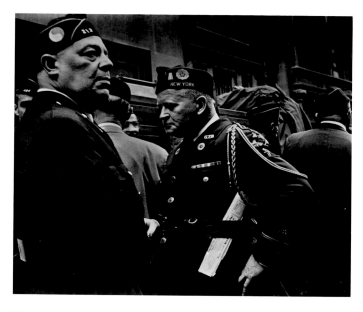

Fig. 79 Sid Grossman, *Legion Major*, ca. 1947-48, 10¾ x 10⅜"

ety that refuses to acknowledge his existence. Parks's photograph of a man emerging from a manhole—a poetic fiction created in collaboration with Ellison—powerfully evokes this sense of both physical and emotional isolation.[120]

The work of photographers such as DeCarava and Parks signaled an artistic point of view that would become increasingly central to the expressive mood of the 1950s. This was a more intense and subjective vision of the city than that associated with the Photo League, for example. This work tended to be more introspective or ironic in mood, and to emphasize feelings of displacement and fragmentation. Through the use of harsh contrasts, odd juxtapositions, and various technical manipulations, the urban world was often depicted as a place of inchoate energy or of inhuman silence. Photographers like Levitt and Webb had recorded the city as a vibrant collection of neighborhoods, each structured by the bonds of kinship and acquaintance, but this newer vision suggested the power of the urban environment to isolate individuals and to erode traditional notions of identity. Thus, instead of Baudelaire's "immense reservoir of electrical energy," the city street became (in Nathaniel Hawthorne's prescient phrase) "a paved solitude between lofty edifices" populated by David Riesman's "lonely crowd."[121] One response to this alienating and unforgiving environment was to turn inward, to protect one's fragile inner self behind a facade of unconcern. Many of the urban photographs produced in this latter vein thus portray voids, silences, and social masks.

In his comments during the symposium "What Is Modern Photography?" held in 1950 at the Museum of Modern Art, photographer Homer Page stressed the difference between these two approaches.

> There has been a trend away from the old documentary standby of objective reporting toward a more intimate, personal and subjective way of photographing…There are two trends…one trend has a positive note…it records life as healthy, vigorous and even sometimes humorous. It does this without being insipid.…I think two people particularly,

Ruth Orkin and Tosh Matsumoto, are important here…The other trend leads off, I think, in the opposite direction. These people are breaking up their images—they are concerned, I think, not so much with the "what" of life, but with the "why." They ask questions rather than answer them…Louis Faurer is very good and representative…Both of these trends…are healthy. The first is overly so and the second because it records the turmoil and perhaps confusion that we all feel to some extent in this world today…[122]

Louis Faurer, described by Page as one of the most important proponents of this new sensibility, had taken up photography in 1937, while studying commercial art in Philadelphia. One of his earliest pictures, *Homage to Muybridge, Philadelphia*, 1937 (plate 94), exemplifies his complex, unsentimental approach.[123] This image of a faceted mirror above a storefront creates a fragmented, almost surrealistic vision of city life: space shifts abruptly from frame to frame, while the pedestrians remain immobile, forever isolated from one another. The alienations of street life are also suggested in the work of Sid Grossman (fig. 79), N. Jay Jaffee (plate 119), and Louis Stettner (plate 134).[124] While rather different in mood, each of these images depicts individuals who are physically close, yet who occupy utterly private realms.

Many artists and writers of the 1950s were fascinated by this paradoxical tension between physical intimacy and psychological distance. The congestion of the streetcar, the subway, or the city sidewalk created, by necessity, a world of silence, averted glances, and private reverie. This state of crowded isolation seemed emblematic of modern life itself. As critic Leo Braudy has observed, the literary presumption of the era held that "the art of fiction making demands a solitary sensibility speaking to another solitary sensibility."[125] Thus, he suggests, the broad appeal of the detective novel in the 1940s and 1950s "was due less to the interest in crime or in puzzle solving, than to the feeling that another America of family and friends and trust between strangers has been lost

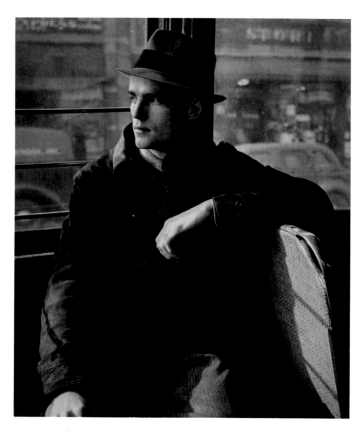

Fig. 80 Edmund Teske, *Chicago*, ca. 1938-39, 9½ x 7¾"

kaleidoscope of commodities. Siegel's use of color for strictly self-expressive purposes was distinctly unusual in this era.

Harry Callahan has always been fascinated by the visual potential of the city street. Rejecting images that seem simplistically narrative in content, Callahan has focused instead on people "lost in thought." He is captivated by the visual rhythms of people walking, the spaces carefully preserved between them, and the linear and graphic effects of light and shadow (plate 104). At several points in his career, most notably in 1950, he used a telephoto lens to magnify and isolate the faces of nameless pedestrians, creating images that perfectly blend specificity and universality. Yet another facet of the psychological meaning of the city is suggested in Callahan's remarkable *Bob Fine*, ca. 1952 (plate 106). This minutely detailed image (a contact print from an 8x10-inch negative) records a diminutive figure standing at the end of a deeply shadowed alleyway. At once mysterious, claustrophobic, and humorous, this photograph suggests, on the most primal level, something of the emotional experience of the vast modern city.

The influence of Callahan's experimental approach is seen clearly in the work of Marvin Newman, one of his first graduate students at the Institute of Design.[131] For his thesis project, Newman produced a striking series of photographs of shadows cast by pedestrians on Michigan Avenue (plate 128). These were conceived and presented in inverted form, a simple manipulation that suggests the metaphysical potential of the most familiar subject matter. These existential apparitions were shown at the Museum of Modern Art in 1953, but since that time have rarely been exhibited or reproduced.

By the early 1950s, a whole group of photographers in New York had begun to record street scenes with a new sense of technical daring, making provocative use of blur, grain, and contrast. Saul Leiter's photographs are typical of this new approach. A painter by training, Leiter took up the camera in the late 1940s with the encouragement of Richard Pousette-Dart, W. Eugene Smith, and Sid Grossman. His *Street Scene*, 1951 (plate 126), employs an extremely tight cropping and slow shutter speed to create a graphic poem of moody self-absorption. In another image, *New York*, ca. 1952 (plate 127), Leiter used blur and harsh contrasts of light and dark to create a similarly subjective feeling of private reverie within the inhospitable geometry of the city. (Significantly, this image was originally titled *Private World* when published in 1954.[132])

The street pictures of Leon Levinstein are characterized by bold, frame-filling compositions. He took up photography in 1948, and was strongly influenced by classes at the Photo League and by his friendship with Sid Grossman. An advertising layout artist by trade, Levinstein photographed strictly for his own pleasure on weekends and holidays. His artistic interest in evidence of the human presence and touch was apparently a compensation for the solitary nature of his life; he never married and had few friends. As a result, perhaps, Levinstein's work evokes a deep tension between engagement and estrangement, a desire to both embrace the world and to

and that the only guardians of its empty treasury are these tender, armored professionals of loneliness."[126] Loneliness was conceded to be a fundamental aspect of modern urban life and thus, ironically, an emblem of commonality. As Thomas Wolfe wrote in *Of Time and the River* (1935), "We walk the streets, we walk the streets forever, we walk the streets of life alone."[127] Walking the streets alone thus symbolized both individual solitude and an existential form of universal kinship.

A number of photographers tried to capture this mood of isolated introspection. Edmund Teske, for example, made a series of semicandid photographs of streetcar passengers in Chicago in 1938-39 (fig. 80). These photographs, at once documentary and psychological in intention, reflect the realist currents of the day while anticipating the extreme subjectivity of his later work. At about the same time, Walker Evans photographed riders on the New York City subway.[128] These images, taken surreptitiously with a Leica hidden beneath his coat, record anonymous subjects in stoic passivity, staring blankly into space, at once guarded and vulnerable (plate 124).[129] Evans continued this idea of candid portraiture in loosely organized images of sidewalk pedestrians produced in 1941 and 1946.[130] Arthur Siegel's views of anonymous pedestrians, made on State Street in Chicago, were more overtly psychological in intention. His "In Search of Myself" series, produced while he was undergoing Freudian analysis, used strangers as emblems of his own multifaceted self (plate 125). The most compelling of these images utilize shop-window reflections to create a complex visual space in which lone faces or figures are engulfed in a

hold it at bay. The complexity of his vision is suggested in the boldness (plate 129) or dynamism (plate 131) of his best pictures. While such images are derived from a fundamentally naturalistic aesthetic, their strength lies in their profound subjectivity. In his most definitive artistic statement, written in 1955, Levinstein observed,

> The photographer should seek a deeper reality than appears on the surface. He should seek a structural truth, an essential character in whatever he photographs. It is the photographer's duty to divine and convey. He should forget about imitating or representing nature; he must apprehend a sort of essential reality in whatever he is dealing with and express in esthetic form the emotion he has felt.[133]

After garnering considerable recognition in the 1950s, Levinstein subsequently withdrew from the art world, photographing steadily, but keeping his work to himself. Beginning in the early 1980s, however, the importance of his achievement has been increasingly acknowledged.[134]

This trend toward technical and compositional daring in urban photography was epitomized by the work of William Klein. Klein grew up poor, the son of a New York merchant who lost nearly everything in the crash of 1929.[135] As a child, Klein was both fascinated and alienated by the city. Most of New York, as he later recalled, "seemed foreign to me—hostile and inaccessible, a city of headlines and gossip and sensation."[136] After serving in the Army, Klein used the GI Bill to study painting in Paris; he arrived in 1948 and has lived there ever since. In Paris, Klein was exposed to a wide range of provocative ideas on the nature and means of art. His first use of photography, in 1952, reflected this climate of aggressive experimentation: he made abstract photograms enlarged to mural size. Completely self-taught, Klein employed the camera in similarly unconventional ways. In 1954, his bold and dynamic images caught the attention of Alexander Liberman, the art director of *Vogue*, who offered Klein a contract to come to New York. This marked the beginning of Klein's career as a photographer of the city and, slightly later, of fashion.

Klein returned to New York for eight months in 1954-55, and used the opportunity—with *Vogue*'s blessing—to create a remarkably subjective and frenetic record of the city. As he recalls,

> It was a period of incredible excitement for me—coming to terms with myself, with the city I hated and loved, and with photography. Every day for months I was out gathering *evidence*. I made up the rules as I went along and they suited me fine.

While photographers like Levitt or Cartier-Bresson wanted to record the world almost invisibly, without intruding on their subjects, Klein's working method was as abrasive and provocative as New York itself:

> I wanted to be visible in the biggest way possible. My aesthetics was the New York *Daily News*. I saw the book I wanted to do as a tabloid gone berserk, gross, grainy, over-inked, with a brutal layout, bull-horn headlines. This is what New York deserved and would get.[137]

The remarkable book that resulted, officially titled *Life Is Good & Good for You in New York William Klein Trance Witness Revels* (1956), is all this and more. Klein's photographic style was astonishingly raw, aggressive, and muscular. His pictures, jammed with activity and abruptly cropped, represented veritable explosions of pictorial and graphic energy (plate 130). Disregarding accepted canons of "good" technique, he also used grain, blur, contrast, wide-angle distortion, and various darkroom manipulations to achieve powerful expressive effects. The resulting vision—in equal measure exuberant, claustrophobic, and foreboding—was unlike that of any other photographer of the period. It was also far too radical for American publishers. Klein's New York book was ultimately produced in Europe, followed by three similar studies of *Rome* (1958), *Moscow* (1964), and *Tokyo* (1964).

Home Places

At a considerable remove from the modern city, Wright Morris, Paul Strand, and W. Eugene Smith produced photographs that provide a striking contrast to the highly expressionist visions of urban photographers. Although their approaches vary considerably, Morris, Strand, and Smith each focus on issues of tradition and community. Yet, their perceptions of personal and cultural wholeness are strongly inflected by their acute awareness of the corresponding themes of alienation and fragmentation.

Wright Morris spent his childhood in the small farming town of Central City, Nebraska. At the age of nine he moved with his father to Omaha, and then later to Chicago. In his early twenties, Morris decided to become a writer. At about the same time, he began photographing, at first casually, then with increasing purpose. Fascinated by the power of both words and pictures, Morris began exploring their union in what he termed "photo-texts." In 1939-40, he made a meandering, 10,000-mile journey across America, photographing simple buildings and objects as he went. A Guggenheim Fellowship, received in 1942, allowed him to traverse the country once again. The result of this second photographic excursion was his book *The Inhabitants*, completed in 1942 but not published until 1946. In this volume, Morris combined photographs of vernacular structures with his own fictional text evoking the lives and thoughts of the people who lived there. The originality of this approach was immediately clear; as one reviewer noted, "*The Inhabitants* is more than a sum of text and pictures. Properly it belongs to no existing literary classification."[138]

While *The Inhabitants* sought to suggest the underlying threads of an American identity, Morris's second photo-text was a poetic evocation of his own heritage. With the aid of a second Guggenheim, Morris spent several weeks in the spring of 1947 on his uncle's farm near Norfolk, Nebraska. In *The Home Place* (1948), Morris used the simple eloquence of familiar things—chairs, doorways, tools, family photographs,

Fig. 81 **Wright Morris,** *Drawer with Silverware, The Home Place, near Norfolk, Nebraska,* 1947 (print ca. 1980), 7½ x 9⅜"

a drawer of silverware (fig. 81)—to suggest the rhythms and spare comforts of a vanishing way of life. These images are about time, memory, and mortality; they carry an undercurrent of melancholy, but are never sentimental. Warmer in emotion than the earlier work of Walker Evans, they are also more deeply personal and varied in viewpoint. Unfortunately, the poor sales of both *The Inhabitants* and *The Home Place* discouraged Morris from publishing a third photo-text volume for more than twenty years.[139] It is clear, however, that his exceptional ability to meld words and images provided an important model for others.[140]

The book *Time in New England* (1950), a collaboration between Paul Strand and Nancy Newhall, represented an even more ambitious union of words and pictures. This project, which marked Strand's reemergence as a still photographer after more than a decade in film, attempted to define the essential spirit of America through the visual and literary evidence of its New England roots.[141] While Newhall scoured libraries for evocative writings from 1620 to the present, Strand photographed the region's coastline, forests, farms, and villages. In these subjects he found timeless symbols of hardship, faith, ingenuity, transcendence, and, above all, of human dignity. Strand's vision was highly formal and richly narrative. For example, *Meeting House Window, New England,* 1945 (plate 120), transforms a simple window into both an elegant geometric abstraction and a moody meditation on the past. In such images, Early American architecture becomes an eloquent symbol for the collective achievements and ideals of ordinary people. The careful sequencing of these photographs with Newhall's selections of text produced a book of singular scope and dignity.

Beyond its manifest subject, *Time in New England* constituted an indirect commentary on the nation's political climate in the late 1940s. The anticommunist hysteria of those years stood in marked contrast to the America evoked by Strand and Newhall, a communal culture bound together by the universally acknowledged right to political dissent and by the power of individual conscience. Strand, who held

rigidly Marxist views to the end of his life, was so troubled by the poisoned political atmosphere that he left the United States to live in France in early 1950, several months before the publication of *Time in New England.*[142] In the years that followed, he attempted to give form to his own cultural and ideological ideal: a simple, preindustrial world in which nature and culture, individual and family, past and present, coexist in organic harmony. To demonstrate this view, he photographed village life in France, Italy, the Outer Hebrides Islands, Egypt, and Ghana, in each case producing a book that combined his images with a writer's text.[143] Strand's best photographs from this late period, such as *The Family, Luzzara, Italy,* 1953 (plate 121), represent exquisitely refined orchestrations of reality. The complexity of this small image stems from the individuality of each figure, the implied relationships between them, the rich textures of their environment, and the almost musical rhythms of the overall composition. Most of Strand's late works are less successful, however. All too often, his "morose heroicism" and formal control reduced his subjects to earnest, one-dimensional types.[144]

Like Strand, W. Eugene Smith was motivated by deeply felt ideals and a passion for truth. He believed that photography provided "a great power for betterment and understanding," and that each photographer "must bear the responsibility for his work and its effect." Thus, as he stated in 1948, "Photography is not just a job to me. I'm carrying a torch with a camera."[145] This zeal contributed to his numerous disagreements with employers, and to his reputation for difficulty.[146] It also made him the finest photojournalist of his era. Smith demonstrated his ability and courage in World War II, which he covered for Ziff-Davis Publications, *Life,* and on a free-lance basis. Badly wounded on Okinawa in May 1945, Smith spent two years recuperating before he returned to full-time work.

Smith was at his creative prime between 1947 and 1954, when he created the most distinguished of *Life*'s photoessays. These included "Folk Singers" (1947), "Country Doctor" (1948), "Spanish Village" (1951), "Nurse Midwife" (1951), "Chaplin at Work" (1952), and "A Man of Mercy" (1954). The thread uniting these various subjects was Smith's humane celebration of the virtues of intelligence, commitment, and compassion. His admiration for heroic self-sacrifice is seen clearly in his most famous subjects: a small-town doctor in Colorado, an African-American midwife in the deep South, and Albert Schweitzer's charity work in Africa. "Spanish Village," the broadest of Smith's subjects, suggests an entire culture's life, tradition, and faith in microcosm. Like Strand, Smith sought to portray the harmony of culture and nature, and to suggest the universal rhythms of life, labor, and death.

Smith's working method was complex and avowedly subjective. In 1948, he wrote,

> Those who believe that photographic reportage is "selective and objective, but cannot interpret the photographed subject matter" show a complete lack of understanding of the problems and the proper workings of the profession. The jour-

nalistic photographer can have no other than a personal approach, and it is impossible for him to be completely objective. Honest—yes! Objective no![147]

On another occasion, he stated, "I do not seek to possess my subject but rather to give myself to it."[148] This approach necessitated a complete physical and emotional immersion in each project. He sought to learn everything he could about his subject and to convey that complexity in both factual and emotional terms. He shot more than 2,500 negatives apiece for his "Country Doctor," "Spanish Village," and "Nurse Midwife" essays, and more than 4,000 for "A Man of Mercy."[149] In the darkroom, he made liberal use of burning, dodging, and bleaching to orchestrate the tonal relationships of his prints for expressive effect. Paradoxically, perhaps, Smith created photographs that are individually beautiful and powerful, while at the same time interdependent facets of a narrative whole. For example, his *Woman with Bread, Spain*, 1950 (plate 122), succeeds on several levels: as a purely graphic composition, as a suggestion of organic continuities (curiously, the loaves of bread echo the shapes of the stones that form the village's very foundation), and as part of the essay's larger description of the village's production of food.[150]

Smith's perfectionism, his emotional involvement in his projects, and his disinterest in conforming to deadlines created inevitable problems. Ultimately, his desire for authorial control over the presentation of his work was simply incompatible with the realities of magazine photojournalism. Although the editors of *Life* often went to unusual lengths to accommodate his demands, Smith was rarely satisfied with their use of his pictures.[151] He ultimately resigned from the magazine in 1954 in protest over the handling of his Schweitzer essay.[152] The remainder of his career was uneven, a mixture of commercial assignments, personal projects, grants, awards, and museum exhibitions, as well as much personal turmoil and ill health. His ambitions remained grand. As photographic historian William Johnson has written, Smith sought to force the genre of the photo-essay into "an epic poetic mode."[153] From the nearly 10,000 negatives made in the course of his "Pittsburgh" project (1955-56), Smith created an "essay" of 2,000 images which evoked the collective life of the city in astonishing scope and vitality. But, of course, no magazine could accommodate such detail and complexity.[154]

During this period, Smith also covered "hard news" events such as the sinking of the Italian ocean liner *Andrea Doria* (plate 123). Other series included the Ku Klux Klan (ca. 1951-58), poetic visions of the city from the window of his studio (1957-58), Haiti (1958-59), the Japanese firm of Hitachi Limited (1961-62), and the Hospital for Special Surgery (1966-68). Smith's final project, "Minamata" (1971-75), documented the tragic effects of industrial pollution on a small Japanese city. He recorded the ominous discharges of tainted water into the ocean, the deformed children born to women who had eaten mercury-tainted fish, and the attacks on peaceful protestors. This work, which appeared at a time

Fig. 82 O. Winston Link, *Hagerstown Meeting of Norfolk and Western No. 1 and 2*, 1957, 15 x 19⅛"

of rising environmental concerns, had enormous international impact and provided a powerful demonstration of Smith's concerned and compassionate use of photography.

A radically different aspect of the postwar era's perspective on tradition is revealed in the delightfully eccentric work of O. Winston Link. A successful industrial photographer based in New York City, Link was a lifelong train enthusiast. In 1955, he began an intensive personal documentation of the steadily vanishing steam trains of the Norfolk and Western Railway.[155] Most of this project's 2,200 images were made by 1957, although Link continued photographing until the line's last steam engine was replaced by a diesel locomotive in 1960. Many of these photographs were made at night, illuminated by complex arrangements of as many as fifteen flash units (fig. 82).[156] Link's nostalgic photographs represent a kind of "technological pastoral" aesthetic best understood in the context of the earlier work of Rau, Johnson, and Hine.

Art and Commerce

Photographers of this era could not survive on personal expression alone. A few—like Grossman, Callahan, Siskind, and White—derived most of their meager income from teaching. Even more rarely, in cases such as Levinstein's, they eked out a living in an unrelated field, completely separating their photography from financial considerations. Most of the leading creative photographers of the postwar era worked in the commercial fields of photojournalism, advertising, fashion, or portraiture. This meant that, with remarkably few exceptions, their work was made for reproduction on the printed page. The primary patrons and forums for these photographers were the illustrated magazines. These magazines reached an extraordinary audience; each weekly issue of *Life* sold 7,000,000 copies, for example, and was read by three times as many people. Photographers had never before had

such a forum for their work, and many flourished within this system. In 1950, Irving Penn observed,

> The modern photographer stands in awe of the fact that an issue of *Life* magazine will be seen by 24,000,000 people. It is obvious to him that never before in the history of mankind has anyone working in a visual medium been able to communicate so widely. He knows that in our time it is the privilege of the photographer to make the most vital visual record of man's existence. The modern photographer, having...the urge to communicate widely is inevitably drawn to the medium which offers him the fullest opportunity for this communication. He then works for publication, he has become in fact a journalist....The modern photographer does not think of photography as an art form or of his photograph as an art object. But every so often in this medium, as in any creative medium, some of the practitioners are artists. In modern photography that which is art, is so as the by-product of a serious and useful job, soundly and lovingly done.[157]

The magazines provided an enormous and surprisingly varied market for photographs. For example, in addition to its standard reportage and photo-essays, *Life* regularly featured purely artistic photographs. These portfolios included work by certified masters such as Stieglitz, younger artists like Cartier-Bresson, experimental talents such as Feininger and Siegel, and previews of exhibitions at the Museum of Modern Art. Besides *Life*, many other American magazines regularly commissioned photographs, including *Fortune*, *Look*, *Collier's*, *Pageant*, *Parade*, *Esquire*, *Redbook*, *House and Garden*, and *Ladies' Home Journal*. The leading fashion magazines, *Harper's Bazaar* and *Vogue*, made particularly bold use of photography while providing a livelihood for some of the most talented photographers of the era. While the vitality of the photography in *Harper's Bazaar* and *Vogue* was, in part, a natural reflection of their subject—the ever-changing dynamics of style—it was, more specifically, a product of the unique talents of their editors and art directors.

A central figure in the history of the American fashion magazine was Alexey Brodovitch. Born in Russia, Brodovitch worked as a graphic designer in Paris before arriving in the U.S. in 1930. From 1934 to 1958, he held the powerful position of art director at *Harper's Bazaar*. Brodovitch's influence was also exerted through his Design Laboratory, a series of weekly evening classes that he taught, under various auspices, for many years.[158] A remarkable number of noted photographers attended these classes, including Diane Arbus, Richard Avedon, Lillian Bassman, Ted Croner, Bruce Davidson, Louis Faurer, Robert Frank, Leslie Gill, Hiro, Saul Leiter, Leon Levinstein, Lisette Model, and Irving Penn. Brodovitch later commissioned many of these students to photograph for *Harper's Bazaar*. He also published work by such important European photographers as Bill Brandt, Brassai, and Cartier-Bresson. A series of Brodovitch's own photographs—images of the Ballet Russes that made provocative use of blur, grain, and contrast—was published in his legendary book *Ballet* (1945). As that book demonstrates,

Brodovitch rejected purist standards of technique and the dull conventionality of the salon-style photograph in favor of experimentation, novelty, and graphic boldness. His often-quoted message to photographers was "Astonish me!" His advice on how to achieve this was both simple and mysterious: "When you look into your camera, if you see an image you have ever seen before, don't click the shutter."[159] This influential philosophy provided a critical link between the era's most subjective personal photography and its most visible commercial applications.

Another figure who played an important role in the direction of the fashion magazines of his era was Alexander Liberman. Born in Russia, Liberman came of artistic age in Paris in the 1920s.[160] From 1933 to 1936, he was associated with the important Parisian picture magazine *Vu* as art director and managing editor. This experience gave him a great appreciation for the dynamism of the unposed photograph. Liberman's long and influential career in American publishing began in 1943, when he was named the art director of *Vogue*; in 1962, he became editorial director of all Condé Nast publications. Among the most celebrated photographic talents that Liberman nurtured over the years were Irving Penn and William Klein.

Other noted art directors of this period include Lillian Bassman, who worked at *Harper's Bazaar* and *Junior Bazaar* before turning to photography herself in 1947; Henry Wolf, who succeeded Brodovitch at *Harper's Bazaar* (1958-61); and Marvin Israel, who followed Wolf (1961-63). Israel made particularly brilliant use of photography during his tenure as art director of the magazine; he introduced the work of artists such as Diane Arbus, Lee Friedlander, and Duane Michals, and published a series of remarkable portfolios including, in 1962, a six-page selection of Walker Evans's twenty-year-old subway pictures.[161]

Fashion and Portraiture

By the mid-1940s, the look of fashion magazines had clearly begun to change, as more inventive applications of type and page layout called for similarly fresh uses of the camera. During the war, fashion photography in New York had been dominated by European émigrés such as Horst P. Horst and Erwin Blumenfeld at *Vogue*, and Martin Munkacsi and George Hoyningen-Huene at *Harper's Bazaar*. While all were immensely talented, by the end of the war their styles had become relatively polished and predictable.[162] As one writer in 1954 observed, a bit uncharitably,

> At their best these pictures mingled a kind of cold chromium splendor with vivid lighting and Rembrandtesque masses of shadows. Models were impassive, sculptural, the most formidable clothes horses ever to canter between the rows of perfume and lingerie ads. Studio shots were impossibly stiff.[163]

By the end of the war, a younger generation of Americans had began to revitalize the genre. These photographers

Fig. 83 Leslie Gill, *Fishing Fleet, Amalfi, Italy*, 1947, 10⅞ x 13¾"

included Louise Dahl-Wolfe, Frances McLaughlin, Toni Frissell, George Platt Lynes, and Leslie Gill. The latter, best-known for his influential still life photographs, also produced serene, poetic images outside the studio (fig. 83).[164] By far, however, the most influential of this younger generation of photographers were Richard Avedon and Irving Penn.

As a teenager, Avedon was powerfully impressed by the dynamism and naturalism of the photographs of Munkacsi. In 1944, after a stint in the merchant marine, he enrolled in Brodovitch's Design Laboratory. Inspired and challenged by Brodovitch's teaching, Avedon's remarkable talent soon blossomed. He began working for Brodovitch at *Harper's Bazaar* in 1945, at the age of twenty-two, and quickly established a reputation for inventive and provocative work.[165] The freshness and energy of his photographs stemmed, in part, from an interest in the models he recorded, not just their clothes. As a critic noted in 1949, "One feature that distinguishes Avedon's fashion photographs [is] the life and vitality seen in the model's face. Before he appeared on the scene, few photographers dared to make their models look human—beautiful dummies were the rule."[166] Following Brodovitch's lead, Avedon was also highly experimental, employing various technical or logistical means to create a feeling of surprise. For one of his most famous fashion photographs, *Dovima with Elephants, Paris*, 1955 (plate 138), Avedon went to the menagerie of a Parisian circus with his 8x10-inch camera, the model Dovima, and—the nominal subject of the image—a Dior evening dress. The result is a surrealistic play of contrasting sizes, shapes, and textures that brilliantly evokes a sense of otherworldly elegance.[167]

By this time, Avedon had achieved almost unprecedented celebrity. As one critic astutely noted in 1955, "Avedon is both in and beyond fashion."[168] His career inspired the 1957 motion picture *Funny Face*, which starred Fred Astaire as a fashion photographer and Audrey Hepburn as his model; Avedon worked on the film as a consultant. Moreover, Avedon seemed to embrace all facets of photography, work-

ing with equal brilliance in fashion, portraiture, and street photography. His restless drive resulted in extraordinary growth and change. By the late 1950s, he was working almost exclusively in the stark white space of the studio, creating images that were simpler and more graphic than his earlier work. These photographs also engaged increasingly complex notions of style and mortality by contrasting, for example, physical beauty and decay. His work of the late 1950s and early 1960s is recorded in two powerful and ambitious books. *Observations* (1959) united the considerable talents of Avedon, writer Truman Capote, and designer Brodovitch, and included many of Avedon's most famous portraits of the period: Charlie Chaplin, Ezra Pound, Marcel Duchamp, Marion Anderson, and the Duke and Duchess of Windsor, among others. In *Nothing Personal* (1964), designed by Marvin Israel, Avedon's photographs are paired with a text by James Baldwin. More clearly political than *Observations*, this book reflects the concerns of the civil rights movement in a way that is both critical and cautiously hopeful.

Irving Penn was also strongly influenced by Brodovitch. He first met Brodovitch in 1935, in one of the early Design Laboratory classes at the Philadelphia Museum School of Industrial Art, and worked with him in various capacities over the next few years.[169] Although trained as a commercial artist, Penn began making personal photographs in the late 1930s. He took up photography professionally in 1943, after he was hired as Liberman's assistant at *Vogue*. Following his service in the war, Penn hit his stride at *Vogue*, working with equal facility on assignments involving fashion, portraiture, and still life.

The components of Penn's vision are unmistakable: a beautifully soft and even light, seemingly casual poses and props, a calligrapher's sensitivity to line, and a seductive technical precision. Above all, his photographs are spare, serene, and elegant.[170] His 1948 depiction of Duke Ellington (plate 143) is characteristic: Ellington is shown sitting in a "corner," a device specially constructed in Penn's studio to create a dramatic sense of space and to emphasize the physical presence of the subject. Many of Penn's best-known fashion images, such as *Woman with Umbrella, New York*, 1950 (plate 139), are remarkably abstract, evoking an aura of high style rather than precisely describing items of clothing. In his monograph on Penn, curator John Szarkowski eloquently described the revolutionary effect of these photographs:

> The best of the earlier [fashion] work—by de Meyer, Steichen, Beaton, Hoyningen-Huene, and others—now seems close to theater, with the dress and its model playing a role. But Penn's 1950 pictures provide no references to plot or circumstance, no suggestions of old châteaux, or perfect picnics, or delicious flirtations in Edwardian drawing rooms, or footlights, or *avant* Freudian dream worlds. They are not stories, but simply pictures.[171]

By discarding most of the narrative trappings and associations of this earlier style, Penn discovered an equally expressive formal vocabulary. The sheer visual intelligence of these

pictures—at once dynamic and restrained, descriptive and abstract—gives them an artistic interest that far transcends their original function.

Penn's expressive ambitions, like Avedon's, lay beyond the traditional bounds of fashion and portrait photography. With Liberman's encouragement, Penn explored the aesthetics of vernacular and ethnic dress, recording the costumes of New York's "small trades" and those of natives of Peru, West Africa, Nepal, Morocco, and New Guinea.[172] In 1949, he began an unconventional series of nudes, photographing unidealized, weighty figures from close, often oblique, perspectives. His prints from these negatives were made by greatly overexposing the photographic paper, and then bleaching and redeveloping it. The resulting images are at once ethereal and earthy. In the early 1970s, this experimental inclination led Penn to master the elegant but anachronistic platinum process, a technique he then used to reinterpret earlier negatives and to print his subsequent personal work.

In the heyday of fashion photography, a broad range of styles and techniques found its place on the magazine page. The diversity of these approaches is suggested in the work of Lillian Bassman and William Klein. After studying with Brodovitch, Bassman was hired as his assistant at *Harper's Bazaar* in 1939.[173] In this capacity, and as art director of *Junior Bazaar*, Bassman worked with Avedon, Faurer, Frank, Newman, and many other talented young photographers. In 1947, she left art direction and took up photography, forging a uniquely delicate and impressionistic style. By employing unusual techniques, such as printing through tissue, she was able to eliminate detail in her images and to create a mood of graceful vitality (plate 140).

By contrast, Klein's fashion photographs of the same period were harsh and provocative. After his stint in New York, Klein returned to Paris in 1955 and worked for *Vogue* for the next decade. Applying the same ideas to his commercial photographs that are evident in his personal work, Klein produced images of unprecedented rawness and vitality. As Liberman has observed,

> In the fashion pictures of the Fifties, nothing like Klein had happened before. He went to extremes, which took a combination of great ego and courage. He pioneered the telephoto and wide-angle lenses, giving us a new perspective. He took fashion out of the studio into the streets, trying anything, stopping traffic, photographing models in waxworks, repainting shop fronts, hiring actors and dwarfs. He functioned like a Fellini, sensing the glamorous and the grotesque.[174]

In *Pedestrian Crossing, Piazza di Spagna, Rome (Vogue)*, 1960 (plate 141), Klein made brilliant use of the street, the telephoto lens, and chance itself to create a memorable slice of naturalistic fiction. As historian Martin Harrison has written of this photograph,

> [T]he alternating black and white stripes of the pedestrian crossing...fill the frame from top to bottom: against this Op background (a reference from his own kinetic art?) the two women cross, the black and white stripes of their dresses picking up the alternating horizontals of the road-markings. Simone d'Aillencourt steps straight at the viewer; the other model, Nina de Vos, walks out of the frame, glancing over her shoulder, registering mock surprise at the similarity of the dresses. This much is staged, but Klein has left room for accidental elements to come into play: passers-by, cropped at the thigh, move out of the frame, and a Vespa, ubiquitous symbol of Italy, intersects the models, adding a plausible note of realism.[175]

The celebrated portraitist Arnold Newman was also influenced by Brodovitch's ideas. Newman studied art in high school and college before beginning work with a portrait studio in Philadelphia in 1938. While he learned photographic technique on the job, Newman came to know some of the young artists studying with Brodovitch at the Philadelphia School of Industrial Arts. While he quietly assimilated Brodovitch's ideas, Newman educated himself by studying *Vanity Fair* magazine and Walker Evans's *American Photographs*. After work, Newman made personal experiments with the camera, recording subjects in both social realist and abstract veins. Newman spent the winter of 1941-42 in New York making portraits of the city's most noted artists and sculptors. The success of his 1945 exhibition, "Artists Look Like This," at the Philadelphia Museum of Art, prompted him to move to New York permanently in 1946. Newman's fame as an inventive and influential portraitist increased rapidly in the following years; his work was frequently published in *Life*, *Harper's Bazaar*, and elsewhere, and his prints were included in many important museum exhibitions.

The originality of Newman's portraits stems from their provocative synthesis of description and invention. Believing strongly that meaningful portraits inevitably reflect a collaborative dialogue between sitter and photographer, Newman sought to convey both literal and metaphoric truths in his pictures.[176] He used the objects and space surrounding his subjects to powerful expressive effect, creating compositions that are both precise and allusive. These qualities are evident in one of his earliest mature works, *Yasuo Kuniyoshi, Fourteenth Street Studio, New York*, 1941 (plate 142). This portrait of the noted painter combines an air of relaxed refinement with an exquisitely realized structural order. The logic of Kuniyoshi's art is suggested in the casual formality of his pose, the simple table-top still life beside him, and, of course, the quiet perfection of Newman's composition.

"The Family of Man" and The Americans

As soon as it was achieved, it seemed, the productive harmony between art and commerce that the illustrated magazines provided slowly began to unravel. As John Szarkowski has noted,

> By the 1950s editors and art directors had come to think in terms of the principle of collage, even when that form was not explicitly evoked; that is, the content of a given photograph came to be less interesting than the ways in which that content could be revised by careful adjustment of the

context in which the picture was placed. This was a very interesting problem, but photographers were generally not asked to contribute to the solution.[177]

Smith quit *Life* magazine in 1954 because he felt he did not have sufficient control over the use of his pictures. André Kertész, who worked unhappily for various magazines for twenty-five years, only regained a sense of artistic direction after he retired from commercial work in 1962. Even Irving Penn, who had spoken so eloquently about the communicative potential of the mass-market magazine in 1950, eventually grew disillusioned. By 1964, he felt that the printed page had come to "something of a dead end for all of us," and that the photographic print should be considered "a thing in itself, not just a halfway house on the way to the page."[178] In 1967, Szarkowski summarized these attitudes in his essay, "Photography and the Mass Media," stating flatly that "many of today's best photographers are fundamentally bored with the mass media, and do not view it as a creative opportunity."[179]

This disenchantment with picture magazines stemmed from the conflicting desires for self-expression and broad public communication. It seemed to be a devil's bargain: a photographer's work could be seen by millions if editors and art directors were allowed a free hand; but if the photographer demanded complete creative autonomy, he or she would not be able to work within the magazine system. Increasingly, therefore, many commercial photographers evolved a bifurcated practice, dividing their time between work for hire and the expression of their own artistic vision. This conflict between individual expression and mass communication is exemplified by the sharp contrast between two key monuments of 1950s photography: Edward Steichen's "Family of Man" exhibition and Robert Frank's book *The Americans*. The first marked the culmination of a collective artistic ideal while the latter represented a sharp turn toward a newer and more subjective use of photography.

"The Family of Man" represented a logical summation of the ethos of postwar culture and of Edward Steichen's own artistic attitudes and ambitions. The terrible toll of World War II and the Cold War threat of nuclear annihilation had prompted many to recognize and celebrate the essential unity of the human experience. Significantly, the first major project undertaken by Magnum, the photographic cooperative formed in 1947, was called "People Are People the World Over." This series, published over a year's time in *Ladies' Home Journal*, focused on the daily activities of farm families in twelve countries.[180] Steichen, who had long been fascinated by the notion of photography as a universal language and as a tool of mass communication, must have looked approvingly on this project. During his wartime service for the Navy, Steichen spoke of "photography's great opportunity to render a service to mankind," and for his "Road to Victory" and "Power in the Pacific" exhibitions at the Museum of Modern Art, he used innovative design ideas to garner widespread public interest.[181] Steichen extended these concepts in his work as picture editor for Tom Maloney's

yearly *U.S. Camera* compilations; the 1947 annual, in particular, represents a clear attempt to orchestrate artistic and journalistic photographs to reveal universal truths.[182] After he was named head of the photography department at the Museum of Modern Art in 1947, Steichen remained fascinated by a vision of photographic communion; he called it "this dream of mine." He spoke repeatedly of "recruiting the nation's photographers"—initially, all 20,000,000 of them—in a grand effort to create "an image of America such as no one has ever seen."[183] And, even while he paid close attention to the most advanced artistic uses of the medium, Steichen remained enthralled by a notion of photography as "the first universal pictorial folk art."[184]

These ideas are evident in the complex logistics and international scope of "The Family of Man." After reviewing individual portfolios for several years, Steichen issued a "worldwide appeal" for work in 1954.[185] The resulting flood of images, in conjunction with the various commercial picture files he consulted, produced a pool of more than 2,000,000 photographs.[186] Steichen's initial selection of 10,000 was eventually pared down to a final total of 503 images by 257 photographers, representing scenes in sixty-eight countries. To emphasize the seamlessness of these varied works, the exhibition was composed of commercially produced enlargements from the photographers' original negatives; the artists' own prints were not used. Duplicate editions of the exhibition were made to go on display "simultaneously in Europe, Asia, and Latin America" soon after the show's opening in New York.[187] An accompanying book, reproducing all 503 images, was also published. The ambitions of this project were as vast as these numbers would suggest. In his opening remarks, Nelson A. Rockefeller, the museum's chairman of the board, described the exhibition in these words:

> Here are a variety of elemental human experiences common to all the peoples of the earth. These experiences derive from a set of human relationships that are the common heritage of all.... In pattern these relationships are as varied as the shape of snowflakes, but in quality they are as immutable as the laws of gravity. In their universal applicability to all human beings, they cut across the barriers of time, place, climate, race, language, religion, nationality, ideology and culture pattern.[188]

As proof of this universality, the exhibition was ultimately seen by some 9,000,000 viewers in forty countries.[189]

"The Family of Man" conveyed its grand vision of universal kinship through a highly sophisticated use of images, text, and space. In the clever exhibition design of architect Paul Rudolph, each photograph became a unit in a precisely choreographed visual procession. The show was constructed of about forty thematic sections, with the layout of each grouping and the size of every print precisely determined in advance. The exhibition's overarching theme, reinforced by text panels and captions, was illustrated in juxtapositions of images emphasizing the similarities of life in diverse cultures. The timeliness of this simple concept was made unmistakably clear. As one reviewer wrote,

Although the exhibition literally begins with love and birth—after a prologue which presents visual symbols of the creation of life such as the stars—it does not end with death. A most impressive turning point is reached near the end of the series of many exhibition panels and rooms. As the spectator turns a corner into a dark room he faces an immense color transparency blow-up of a hydrogen bomb explosion. After such an intensified witnessing of life in the living and in the making, the realization that man is capable of annihilating himself brings to a sudden awareness, visually clarified, the biggest problem confronting the family of man. Facing this threat, in an opposite area, are faces from all races and stages of human life. Beyond this room is the epilogue, in which are seen men in council, the spirit of a rebirth, the images of the magic of children.[190]

The show stimulated mixed responses. General viewers embraced it wholeheartedly, while photographers were largely critical or indifferent. In his review of the show, Minor White wrote sarcastically, "How quickly the milk of human kindness turns to schmaltz."[191] More objectively, photography critic Jacob Deschin observed, "The show is essentially a picture story to support a concept [and] an editorial achievement rather than an exhibition of photography in the usual sense."[192] In its simple didacticism, the exhibition deliberately emulated the storytelling techniques of a WPA mural or special issue of *Life* rendered in gigantic, three-dimensional form. (Not surprisingly, many of the exhibition's photographs were drawn from the *Life* files.) The essential truth of Steichen's thesis was not challenged, but the show's combination of archetypal vagueness and melodramatic brassiness left most photographers cold. Many of those included in the exhibition were bothered, in varying degrees, by the complete subordination of their own artistic points of view to Steichen's unifying thesis. From this perspective, "The Family of Man" represented the same editorial conflicts that photographers had encountered with mass-market magazines. While "The Family of Man" may have been the ultimate triumph of this sort of editorial vision, it was not one shared by the most thoughtful photographers of the time.

Of all the photographers included in "The Family of Man," Robert Frank may have had the most negative reaction to it. His response stemmed from his own unsatisfying experiences with the magazines and from his strong desire for a more personal use of the camera. Born and raised in Zürich, Frank had rebelled at an early age against the quiet comforts of his family and homeland. He arrived in New York in 1947, and was almost immediately hired by Brodovitch to work for *Harper's Bazaar* and *Junior Bazaar*. Louis Faurer, a fellow *Harper's* photographer, became a close friend and significant influence. In the next several years, Frank's work also appeared in *McCalls*, *Vogue*, *Life*, *Look*, *Time*, and *Fortune*.[193] In addition to this magazine work, Frank intently pursued his own artistic vision, employing the spontaneity of the 35mm camera to capture lyrical or poignant vignettes of everyday life.

Frank's artistic quest was a restless one. He photographed in Peru and Bolivia for six months in 1948, and spent a large portion of his time in Europe between 1949 and 1953. In 1954, on Walker Evans's advice, he applied for a Guggenheim Fellowship, in his words,

> To photograph freely throughout the United States, using the miniature camera exclusively. The making of a broad, voluminous picture record of things American, past and present. This project is essentially the visual study of a civilization and will include caption notes; but it is only partly documentary in nature: one of its aims is more artistic than the word documentary implies.[194]

Frank received a Guggenheim grant in 1955 to begin this project, and a second one in 1956 to complete it. With the freedom afforded by this backing, Frank embarked on a journey of cultural and personal discovery. Throughout 1955 and 1956, he traced a meandering route across the United States. After visits to Detroit and to the Savannah-Charleston area, Frank drove from New York to Florida, across the South and Southwest to Los Angeles, north through California, Nevada, Idaho, and Montana, and then back to New York by way of Chicago and Indianapolis.[195] In the course of this journey, he exposed about 800 rolls of 35mm film.[196] From this mass of images, he created *The Americans*, the most important photographic book of the era.

In many respects, Frank's work was as in tune with the time as "The Family of Man." In technique and mood, his pictures represented the logical culmination of the "more intimate, personal and subjective way of photographing" that Homer Page described in 1950. Just as important, in this respect, was the nature of his artistic odyssey. Since the 1930s, numerous photographers—as well as artists, writers, and other researchers—had taken to the road to document America and to discover themselves.[197] Roy Stryker alone, in his work overseeing the photographic archives of the FSA (1935-43) and Standard Oil of New Jersey (1943-50), was responsible for the production of many thousands of images from the nation's roadways. In the late 1940s, Henri Cartier-Bresson traveled throughout the U.S., producing images that anticipate significant aspects of Frank's work.[198] The theme of travel was intimately linked to ideas of both personal and national identity. Nervous, endless movement characterized the vision of the Beat writers, as recorded in novels such as John Clellon Holmes's *Go* (1952) and Jack Kerouac's *On the Road* (1957).[199] Todd Webb's Guggenheim Fellowships, received at the same time as Frank's, supported his own project to trace the route of the nation's first roads: the Santa Fe and Oregon trails. Other photographers of the period, such as Frank's friend Elliott Erwitt, made reference either obliquely or directly to the national cult of the automobile (fig. 84) and to the hypnotic lure of the road (plate 135). His *Wyoming*, one of a group of pictures made during a long drive west in 1954, suggests the peculiar visual experience of an automobile journey in America: an endless, flickering stream of banal places and objects, half-seen and soon forgotten.[200]

Frank's artistic vision had been honed during his travels in South America, Europe, and the U.S prior to 1955. His pictures

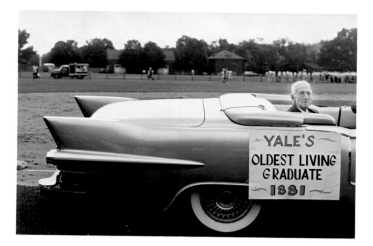

Fig. 84 Elliott Erwitt, *New Haven, Connecticut,* 1955, 9⅜ x 13½"

Fig. 85 Robert Frank, *View from Hotel Window, Butte, Montana,* 1956 (print ca. 1975), 8⅞ x 12½"

of these years are characterized by a simple, fluid approach (stemming from his use of the 35mm camera and natural light), and a moody, even melancholy, sensibility. This work was highly regarded. In 1950, Frank was included in the first of several exhibitions at the Museum of Modern Art. By 1954, his photo-essay on a Welsh miner prompted *U.S. Camera* to praise Frank's ability to combine "intellectual insights with a poetic sense of the revealing moment," concluding that he was "one of the few artists of the photographic story."[201] Although highly self-motivated, Frank was inevitably influenced by others. His friendships with Brodovitch and Faurer, and the work of Kertész and Brandt, all made significant impressions. But Frank's friendship with Walker Evans was particularly important. Frank was influenced as much by Evans's personal style, his intelligence and uncompromising attitude, as by his work.[202] In addition, Evans provided assignments for the younger man, and strongly supported his Guggenheim application.[203] Finally, Frank was powerfully motivated by the complete devotion to their art that he sensed in the Abstract Expressionist painters, such as Willem de Kooning, who lived near him in New York.[204]

While these influences affected the general shape of Frank's work in 1955-56, they cannot fully explain its extraordinary quality. Frank's vision of the American cultural landscape was that of a brilliantly intuitive, fiercely independent, and highly opinionated émigré. He depicted many things that progressive American society had taught itself not to see, while ignoring the most familiar signs of the nation's virtue and beauty. Rejecting his former experiences in topical journalism, he deliberately avoided "newsworthy" subjects, evidence of the "good life," and signs of modern technology. Instead, he recorded a resolutely common world of cars, jukeboxes, shabby diners, and cemeteries, as well as people in various states of boredom, wariness, or vacancy. His photographs were often grainy and harsh, and evoked a sense of bleakness and malaise. Despite this overriding mood, Frank's vision touched on an extraordinary range of themes: birth and death, national and personal identity, youth and age, class and privilege, political sloganeering and power, race, advertising, the mass media, labor, and religion. He was

particularly attentive to those Americans who lived outside the cultural mainstream: alienated teenagers, the elderly, African-Americans. He also depicted certain American archetypes—cowboys, movie stars, politicians, businessmen, bikers—to both evoke and critique familiar myths. One of his cowboys, for example, is a rodeo performer photographed on a sidewalk in New York—an anachronistic "urban cowboy" reenacting a national fable of frontier individualism.

One remarkable aspect of the images that Frank produced in these years is the broad range of expressive forms they embrace. For example, his *View from Hotel Window, Butte, Montana,* 1956 (fig. 85), evokes complex and contradictory moods from an exceedingly simple experience. At once lyrical in viewpoint and depressing in content, this photograph captures the simultaneous feelings of adventure and loneliness that attend most long journeys. His *Look at William S.,* 1956 (plate 136), is more complexly structured. By recording a graphic fragment of an oddly constructed campaign poster, Frank emphasizes the unreality of the political process. This image is all frenetic disjunction and exclamation, the candidate himself only a generic abstraction ("HE") who slips from public view into a shadowy interior realm. Frank uses selective focus to extraordinary effect in *Movie Premiere, Hollywood,* 1956 (plate 137), a view of an unnamed movie starlet walking past a group of fans. The out-of-focus celebrity becomes merely an elegant shell without personality or thought. By contrast, the "average" women behind her are very real, their faces radiant with expressions of doubt and desire. This inverted juxtaposition emblematizes the notion of the modern entertainer as an empty vessel to be filled with the projected longings of the anonymous public.

Despite the strength of so many of his individual pictures, Frank's greatest achievement is his book *The Americans.*[205] Many powerful images (such as *Look at William S.*) were edited out of the book's final selection. However, the eighty-three images that are included comprise an astonishingly rich poetic whole. Frank created a visual narrative that is simpler in form, but far more complex in meaning, than other picture

sequences of the period. Rejecting the bold design concepts of the fashion magazines, which he knew so well, Frank instead simply placed one image on each right-hand page, allowing each to be given equal weight in his visual narrative. The repetition of certain motifs—images of the American flag, for example—lends a subtle rhythmic logic to the book. Ultimately, the experience of *The Americans* is akin to a brilliant jazz improvisation: an intuitive process of exploration in the minor chords, exhilarating, mournful, richly textured, and deeply human. Like the finest jazz or Beat prose of the period, the book strikes a tone of "exalted suffering" by forging a new kind of beauty from alienation, dissonance, and melancholy.[206] As Frank himself stated in 1958, "It is important to see what is invisible to others. Perhaps the look of hope or the look of sadness. [It] is always the instantaneous reaction to oneself that produces a photograph."[207] Three years later, he observed,

> Black and white are the colors of photography. To me, they symbolize the alternatives of hope and despair to which mankind is forever subjected. Most of my photographs are of people; they are seen simply, as through the eyes of the man in the street. There is one thing the photograph must contain, the humanity of the moment. This kind of photography is realism. But realism is not enough—there has to be vision, and the two together can make a good photograph. It is difficult to describe this thin line where matter ends and mind begins.[208]

As with William Klein's work, the moody subjectivity of *The Americans* was of little immediate interest to American publishers. The first edition of the book, published in France by Robert Delpire as *Les Américains* (1958), paired Frank's photographs with texts emphasizing the absurdity of American life.[209] In the first domestic edition, published in 1959 by Grove Press, these texts were dropped in favor of an introductory essay by Beat novelist Jack Kerouac. Despite this change, reviews in the photographic press were almost unanimously negative. The book was reviled as "an attack on the United States," "images of hate and hopelessness," "a sad poem for sick people."[210] Some of the dissent was triggered by Frank's seemingly all-inclusive title. As one critic observed, "Most Americans will have a difficult time finding *their* images on these pages. A more appropriate title might have been 'My Americans' or 'Why I Can't Stand America.'"[211] Others were offended by his stylistic transgressions: "So many of the prints are flawed by meaningless blur, grain, muddy exposure, drunken horizons, and general sloppiness. As a photographer, Frank shows contempt for any standards of quality or discipline in technique."[212]

Since *The Americans* is now regarded as a key monument in the history of photography, it is difficult to imagine the hostility with which it was originally greeted. However, it is important to recall that Frank's work represented the negative pole of a bifurcated vision of postwar America, one that challenged the more comforting view symbolized in Steichen's "Family of Man." This contrast was made explicit by Walker Evans, who wrote,

> [Frank] shows high irony towards a nation that generally speaking has it not...This bracing, almost stinging manner is seldom seen in a sustained collection of photographs. It is a far cry from all the woolly, successful "photo-sentiments" about human familyhood; from the mindless pictorial sales-talk around fashionable, guilty and therefore bogus heartfeeling.[213]

Similarly, Frank expressed contempt for the compromises and mediocrity of the commercial world: "I have a genuine distrust [of] all group activities. Mass production of uninspired photo journalism and photography without thought becomes anonymous merchandise...I feel that only the integrity of the individual photographer can raise its level."[214] Thus, the difficulties Frank's work encountered were the result of several factors: his union of apparently "documentary" means with an unapologetically subjective point of view, his disregard for traditional standards of technique, his insistence on authorial control of his photographs, and his overtly critical view of American society.

New Perspectives: Into the 1960s

While Frank's work ran against the grain of the standard photographic practice of the mid-1950s, it anticipated important aspects of the artistic climate of the next twenty years. Frank's technique, subjects, and penchant for travel are all echoed in the varied work of Garry Winogrand, Lee Friedlander, Elliott Erwitt, Charles Harbutt, Burk Uzzle, Nathan Lyons, and Bill Dane. His interest in marginal social groups is seen in the photographs of teen gangs by Bruce Davidson and Joseph Sterling, motorcycle riders by Danny Lyon, and in the majority of Diane Arbus's subjects. The narrative power and artistic integrity of *The Americans* also prompted a reconsideration of the expressive potential of the photographic book, as evidenced by the later productions of Ralph Gibson's Lustrum Press. Finally, the very gravity of Frank's work served to underscore the seriousness of the photographic artist's quest for personal truth, contributing to a new respect for the medium's artistic integrity.

In the mid-1950s, Frank's independence from the magazines was willful. For later photographers, however, this autonomy became less a matter of choice than of necessity. In the years after Frank's Guggenheim trip, the American picture magazine underwent major changes, due to rising printing costs, declining circulation figures, and the competition posed by television. *Collier's* was discontinued in 1957, followed by *Coronet* (1961), *American Weekly* (1963), the *Saturday Evening Post* (1969), *Look* (1971), and—in its weekly format—*Life* (1972).[215] Other publications were begun in these years, of course, and many photographers continued to earn a living doing the kind of commercial and reportage work that had been common in the 1950s. However, the changing nature of this market, in combination with an increasing desire by photographers for

creative autonomy, significantly widened the gap between art and commerce. This tension is especially evident in the careers of Winogrand, Friedlander, and Arbus. All three began in the magazine world, but achieved their greatest impact in their own publications or in major museum exhibitions.

Garry Winogrand became interested in photography in 1948, while studying painting at Columbia University on the GI Bill. His formal education was completed by 1949, when he attended Brodovitch's classes at the New School for Social Research. Winogrand began working professionally in the early 1950s, producing pictures for magazines such as *Collier's*, *Sports Illustrated*, *Pageant*, and *Argosy*. While he achieved a reasonable degree of success with this work, both commercially and artistically (two photographs were included in "The Family of Man"), Winogrand sought a more personal form of expression. In 1955, after seeing Evans's *American Photographs* for the first time, Winogrand took an extended trip across the country, spurred by a vague sense that "there were pictures to be made out there."[216] The demise of *Collier's*, his most consistent employer, and his own troubled personal life accelerated this shift in Winogrand's artistic outlook. He worked increasingly for himself, rather than for hire, and was rewarded by prestigious institutional support. He was included in such important exhibitions as the Museum of Modern Art's "Five Unrelated Photographers" (1963) and "New Documents" (1967), and received his first Guggenheim Fellowship in 1964 for an open-ended project "to make photographic studies of American life." After 1967, Winogrand supported his personal work with teaching stints at Parsons School of Design, the School of Visual Arts, Cooper Union, the Institute of Design, the University of Texas, and other institutions.

From the time of his earliest public recognition, Winogrand's work was characterized by a bold, gritty naturalism. In the early 1950s, working with grainy film and available light, he created visceral, powerfully composed images of boxers, ballet dancers, strippers, and musicians. As photographic critic Arthur Goldsmith observed in 1954, these were "paradoxical pictures, at the same time brutal and tender, poetic and violent." Goldsmith noted, "a recurring theme in [Winogrand's] pictures is the human body and the designs it makes, not as a posed figure but as a living organism." Winogrand himself observed that "bodies speak in attitudes, in the way they move, walk, sit, lie. They are almost as expressive as when a person opens his mouth and talks."[217] These concerns were fully expressed in a group of pictures made in 1961 on the sidewalks of New York (plate 149). The physicality of these images is apparent in the insistent presence of the people depicted (usually women) as well as in the dynamism of Winogrand's vision. These pictures employ close viewpoints, abrupt croppings, tilted horizons, and other visual devices to suggest the nervous unpredictability of the street, its restless ebb and flow, and its diversity of human and graphic incident. These are fragments of reality, disruptions of lived experience shaped in equal measure by choice and chance. A complex mood of vitality, longing, and alienation attends these pictures, perhaps a product of Winogrand's own brusque hyperactivity and deep melancholia.[218] In his subsequent work—which depicted zoos, airports, press conferences, demonstrations, social gatherings, and a variety of other public activities—these qualities were supplemented by a predilection for odd juxtapositions of people and objects, and for a dense, often chaotic, profusion of visual incident.[219]

Lee Friedlander's interest in photography began at the age of fourteen, in his hometown of Aberdeen, Washington.[220] After studies with Edward Kaminski at the Art Center School in Los Angeles, Friedlander moved to New York in 1956 to establish himself as a professional. He began a lifelong friendship with Winogrand soon after his arrival, and also came to know Evans, Frank, Levitt, and Arbus. In the following years, Friedlander worked for magazines such as *Sports Illustrated*, *Esquire*, and *Holiday*, and sold portraits of jazz musicians to the Columbia, RCA, and Atlantic labels for use on album covers.[221] His warm portrayals of New Orleans musicians, made primarily in 1958-59, were the first of his personal pictures to receive widespread artistic recognition.[222] Friedlander was awarded Guggenheim Fellowships in 1960 and 1962, and had his first one-man museum exhibition at the George Eastman House in 1963.

By this time, the subject matter of Friedlander's personal work had expanded to include, in his words, "the American social landscape and its conditions."[223] From the influence of the photographers he knew in New York, and the earlier pictures of Atget, Kertész, and Weegee, Friedlander fashioned an altogether original style. With his characteristic tool—a Leica with a wide-angle lens—he began a remarkable exploration of the camera's simultaneous powers of description and invention. Friedlander's subjects include many familiar aspects of the "social landscape": shop windows, signs, telephone booths, cars, listless pedestrians. While presented without obvious emotion, Friedlander's ironic vision charges these subjects with unease, revealing them as inert yet ominous. This mood is clearest in his 1962-63 images of television screens. While earlier photographers, such as Frank, had taken the now-ubiquitous TV set as an artistic subject, none made pictures as intense or unnerving as Friedlander's.[224] Photographs such as *Nashville*, 1963 (plate 148), evoke television's hypnotic allure as well as the nature of its presence—at once banal and malevolent—in virtually every American home. In 1963, six of these remarkable TV pictures were published in *Harper's Bazaar*, accompanied by a short text by Walker Evans (who described them approvingly as "deft, witty, spanking little poems of hate").[225]

In his later work, Friedlander recorded a great variety of subjects in his seemingly continuous travels across the country. His inventive self-portraits of the late 1960s, which typically use shadows or reflections to signal his presence, greatly influenced younger photographers. By this time, Friedlander was creating intricate images of controlled chaos. These

pictures use odd juxtapositions and compressed space to create unexpected pictorial wholes from natural "collages" of disparate fragments. Like the free jazz of John Coltrane and Ornette Coleman or the "combine" paintings of Robert Rauschenberg, these photographs convey a paradoxically lyrical dissonance. But, above all, Friedlander underscores the pleasure of discovery. In the tradition of other great photographic *flâneurs*, Friedlander exhibits an endless curiosity for the rich variety of the real. His photographs are witty puzzles of disclosure, concealment, and camouflage. And if, as photographic historian Jonathan Green has written, his photographs "play an elaborate game of hide-and-seek with the world," they do so with both cunning and grace.[226]

Diane Arbus's work is distinguished by an even more voracious curiosity for the world. Arbus (née Nemerov) grew up in New York City in a sheltered realm of wealth and privilege. At the age of eighteen, she married Allan Arbus. The two became successful fashion photographers, with their work appearing in *Glamour*, *Vogue*, and other magazines. By the mid-1950s, however, she became unsatisfied with commercial work. In 1957, after brief studies with Brodovitch, she enrolled in a series of workshops taught by Lisette Model. This experience accelerated and gave direction to Arbus's artistic fascination for odd or "forbidden" subjects. By 1959, she was photographing Hubert's Museum, a flea circus in a dingy 42nd Street penny arcade, and Club 82, a hangout for female impersonators in lower Manhattan. Portfolios of this work were published in *Esquire* in 1960, and in *Harper's Bazaar* a year later.[227] Over the next decade, Arbus earned a considerable portion of her income from assignments for these publications, and for others such as *Show*, *Glamour*, the *New York Times Magazine*, and the *Sunday Times Magazine* (London).

Arbus's style and subject matter evolved markedly in the early 1960s. By 1962, she had switched from 35mm to the square 2¼-inch format, a change that gave added clarity to the intense and unsettling images she produced in the following years of nudists, transvestites, circus performers, twins, midgets, and giants. Arbus spoke eloquently about her attraction to these subjects:

> There's a quality of legend about freaks. Like a person in a fairy tale who stops you and demands that you answer a riddle. They've passed their test in life. Most people go through life dreading they'll have a traumatic experience. Freaks were born with their trauma. They've already passed it. They're aristocrats.[228]

Her photographs of putatively normal subjects, recorded on the sidewalks or in the parks of New York City, were no less disconcerting. Recorded with blunt immediacy, these individuals always seem imperfect, uneasy, or vacant. Yet, despite the "shocking" nature of many of her images, Arbus felt deep sympathy for the people she photographed. As photographic historian Anne Tucker has written, the power of Arbus's photographs lies

not [in] the discovery of something foreign, but [in] the recognition of something familiar. Beyond the uniqueness of her subject's physical person, costume, lifestyle, or job are the small, ubiquitous yearnings of our common humanity: the wish to be king or queen for the day, to look like Elizabeth Taylor or Marilyn Monroe or Mickey Spillane, to love one's son, to celebrate a special occasion.[229]

Ultimately, Arbus's viewed her subjects not as aliens, but as forlorn, forgotten cousins in the family of man.

Arbus's photographs represent a remarkable synthesis of her own opinions and desires, and the most challenging cultural ideas of the period. Her work stemmed from her fascination for danger and secrets; as her close friend Marvin Israel noted, Arbus thought of herself as an explorer or, perhaps, as "the first great female private eye."[230] In style and technique, her pictures are based on the most provocative work of the preceding years by photographers such as Weegee, Faurer, and Levinstein. As she became increasingly aware of the history of photography, Arbus came to appreciate even earlier work: Brassai's documents of nighttime Paris in the early 1930s, and August Sander's visual catalogue of the people of Germany during the Weimar era. Her fascination for the "underworld" of society undoubtedly reflected her own reaction to a protected upbringing, and a larger, countercultural resistance to the bland "normalcy" of the Eisenhower era. In the tradition of Romantic thought, this view held that life was fully authentic only in its most extreme manifestations. Finally, Arbus's work paralleled the "New Journalism" of Gay Talese, Norman Mailer, and Tom Wolfe in which the flat descriptiveness of earlier styles of reportage was discarded for a more subjective—even novel-istic—approach. *Esquire*, one of Arbus's best clients during the 1960s, was a leader in this journalistic movement.

The New Formalism

Against this tendency toward edgy experimentation stood a cooler strain of photographic expression typified by the work of graduates of the Institute of Design. After Siskind's arrival in 1951, the Institute's program diverged significantly from Moholy-Nagy's original curriculum. While Callahan, in particular, made great use of techniques such as multiple exposures and high-contrast printing, neither he nor Siskind were interested in solarization, negative images, or other aspects of the New Bauhaus approach.[231] Instead, they emphasized various graphic, tonal, and structural permutations of the "straight" photograph. This fundamental approach is reflected in the work produced in the early 1960s by the Institute's most notable graduates, including Art Sinsabaugh, Joseph Sterling, Kenneth Josephson, Joseph Jachna, Charles Swedlund, and Ray K. Metzker.[232]

Sinsabaugh was one of Callahan's first students at the Institute. He taught at the school between 1949 and 1957, before taking a position at the University of Illinois in Champaign. Sinsabaugh came to maturity as an artist after he purchased and began experimenting with an old 12 x 20-inch

Fig. 86 Art Sinsabaugh, *Midwest Landscape #10, No. 24*, 1961, 2½ x 19⅜"

banquet camera. By 1961, while living in central Illinois, Sinsabaugh had succeeded in using this unwieldy format to make compelling pictures of the flat, seemingly uneventful landscape around him (fig. 86). Focusing on the subtle rhythms of telephone poles, houses, trees, and the horizon itself, Sinsabaugh cropped these views radically to produce contact prints twenty inches long and as little as one inch high. By echoing the relentless horizontality of the landscape itself, these photographs contained and intensified the formal relationship of the objects within the frame. The resulting pictures are fascinating hybrids of purist, documentary, and abstract concerns. In 1964, Sinsabaugh began a three-year project to document the city of Chicago (plate 146). These photographs, which generally utilize the full 12 x 20-inch frame, describe the city in meticulous detail, while functioning as highly abstract arrangements of graphic and geometric units.

The Institute of Design's program was highlighted in 1961, when *Aperture* devoted an entire issue to the thesis work of five graduate students: Sterling, Josephson, Swedlund, Jachna, and Metzker.[234] While the influence of Callahan, Siskind, and Siegel was clear, the work of these five was both original and varied. Drawing from the example of Frank and other street photographers of the 1950s, Sterling made bold documents of the tensions and rituals of adolescent life (plate 144). Josephson experimented broadly with the effects of focus and multiple exposures, while also making highly reductive straight images of the play of light and shadow on the city street (plate 145).[235] Jachna's thesis topic, photographs of water, involved a poetic quest for meaning in this most elemental of substances, while Swedlund used multiple exposures, high-contrast film, slow shutter speeds, and out-of-focus imagery to reinterpret the human figure. Both Jachna and Swedlund continued these thematic pursuits in later years (figs. 87 and 88).

The Institute's rigorously formal, problem-solving approach to photography is perhaps most powerfully expressed in the work of Ray K. Metzker. His characteristic interest in the pictorial relationships of light and dark, his strong sense of design, and his technical precision are already evident in the photographs made for his thesis project, "The Loop," in 1957-58. During an extended trip through Europe in 1960-61, Metzker's vision grew increasingly refined. One of the most noteworthy images produced on this trip, *Frankfurt*, 1961 (fig. 89), utilizes a vertical perspective and high-contrast printing to transform a casual view of a canoeist into an image of exquisite simplicity. After relocating to Philadelphia in 1962, Metzker began a concerted

Fig. 87 Joseph Jachna, *Blurred Waterscape, Door County, Wisconsin*, 1970, 8 x 9"

Fig. 88 Charles Swedlund, *Multiple Exposure*, 1970, 7½ x 7½"

Fig. 89 Ray K. Metzker, *Frankfurt*, 1961 (print ca. 1980),
6 x 8¾"

exploration of the possibilities of the multiple image. In his
"Double Frame" series (1964-66), Metzker printed consecu-
tive frames of 35mm film as a single picture, evoking a sense
of both connection and discontinuity between each half of
the final image. His series of "Composites," begun in 1964,
dramatically extended this concept. By systematically
assembling rows of individual photographs, Metzker created
complex image-fields that range from 12 x 12 inches to
75 x 38 inches in size. At the time, these works were unpre-
cedented in scale and effect. When viewed from a distance,
works such as *Composite: Atlantic City*, 1966 (plate 147),
read nonobjectively, as rhythmic patterns of light and dark.
On closer inspection, however, these "abstract" works are
seen to be composed of a succession of crisply descriptive
images. The "Composites" function somewhat like short
loops of motion-picture film, which, when projected, create a
hypnotic ballet from the repetition of a simple action. The
mystery and fluidity of these brief narratives is further
enhanced in some works (such as *Composite: Atlantic City*)
in which the original roll of film was double-exposed in the
camera. Here, the rhythmic multiplicity of the overall image
is combined with a more delicate sense of interpenetration
and disembodiment. As Metzker himself noted, these ambiti-
ous works provided a unique opportunity "to deal with com-
plexity of succession and simultaneity, of collected and
related moments."[236] In his later series, including "New
Mexico" (1971-72) and "Pictus Interruptus" (1976-80),
Metzker explored further permutations of the graphic and
optical possibilities of the photographic image.

Beyond Formalism: Meatyard, Uelsmann, Michals

By the early 1960s, photographers were exploring new facets
of the medium's expressive possibilities in images that were
clearly constructed, fictional, or fantastic. Departing from
both the f/64 and new vision traditions, these willfully
fraudulent photographs reflected a direct intervention of the
artist's hand in the subject or form of the image. Moreover,
they established a provocative tension between widely held
beliefs in the fundamental realism of the photograph and the

extreme subjectivity of the artist's vision. To some degree,
this work represented a logical extension of various currents
of the 1950s, including Minor White's idea of equivalence, as
well as a new respect for earlier artists (from Henry Peach
Robinson and Oscar Gustave Rejlander in the mid-
nineteenth century to Clarence John Laughlin in the 1940s)
who had freely manipulated the medium to create elaborate
fictions. In the early 1960s, the various strains of this new
approach were exemplified by the work of Ralph Eugene
Meatyard, Jerry N. Uelsmann, and Duane Michals.

Meatyard's life and work represent a fascinating conjunc-
tion of the mundane and extraordinary. Born in Normal,
Illinois, in 1925, Meatyard served in the Navy, married, and
briefly studied philosophy on the GI Bill before settling down
in Lexington, Kentucky, where he worked as an optician
until his death in 1972. He first purchased a camera in 1950,
to record his newborn son. Fascinated by photography,
Meatyard soon joined the Lexington Camera Club, a pro-
gressive group led by the photographer (and later educator,
art historian, and museum curator and director) Van Deren
Coke.[237] With Coke's encouragement, and with the stimulus
provided by a 1956 workshop with Henry Holmes Smith,
Minor White, and Aaron Siskind, Meatyard developed a
highly unusual artistic vision reflecting his own varied liter-
ary and philosophical interests. Beginning in the late 1950s,
he worked intently, and often simultaneously, on a number
of related projects: a series of lyrical, abstract photographs of
light on water; a large group of completely unfocused
images; the "Zen twigs" series, which utilized an extremely
shallow depth of field to throw most of the image out of
focus; his "Motion-Sound" pictures, which used repeated
multiple exposures to make static subjects increasingly
abstract; and his "Romances," which employ carefully posed
human figures for symbolic effect.

For many of the "Romances," Meatyard used dime-store
Halloween masks to create a heightened sense of ritual,
ambiguity, and paradox (plate 150). The ultimate subject of
these staged, surreal images is "the strenuous and perilous
voyage from youth to old age to death."[238] Like Zen riddles,
these photographs employ overt contradictions and blatant
absurdities to prod viewers to new understandings of
identity, memory, and time. As in Laughlin's work from
twenty years earlier, Meatyard's photographs combine real
settings with unreal effects in order to create a charged,
hybrid image: a documentary fiction. The strange power of
this approach is seen in Meatyard's last major project,
The Family Album of Lucybelle Crater, an extended, halluci-
natory meditation on that most familiar of photographic
genres, the family snapshot.[239]

In the late 1950s, Jerry N. Uelsmann began making his
own brand of photographic fictions. He reached his mature
style after studying with Minor White and Ralph Hattersley
at Rochester Institute of Technology, and then with Henry
Holmes Smith at Indiana University. By 1959, Uelsmann was
producing mysterious, allegorical photographs by printing
from multiple negatives. Initially, he overlapped negatives in

Fig. 90 **Jerry N. Uelsmann**, *Apocalypse II*, 1967, 10½ x 13¼"

Fig. 91 **Duane Michals**, *Magritte Front and Back*, 1965 (print ca. 1980), 4⅞ x 7¼"

his enlarger to create images that resembled conventional double exposures; typical is his *Mechanical Man*, 1959, which superimposes a man's head on a machine. But Uelsmann's multiple-printing technique soon grew far more sophisticated. Instead of simply overlaying images, he now fused them so seamlessly that the effects were both stunning and confounding. Unlike the collages and multiple exposures of other photographers, each of Uelsmann's photographs read as a natural, unmanipulated whole, without visible evidence of the splices between its component parts. His photographs seemed to represent optically objective records of the impossible: trees floating in mid-air, a human face looming out of the earth, bizarre contrasts of scale, abrupt juxtapositions of positive and negative imagery, and other effects too complex to describe. In 1965, Uelsmann eloquently summarized his artistic philosophy in a paper titled "Post-Visualization":

> It is my conviction that the darkroom is capable of being, in the truest sense, a visual laboratory, a place for discovery, observation, and meditation.... Let us not delude ourselves by the seemingly scientific nature of the darkroom ritual; it has been and always will be a form of alchemy. Our over precious attitude toward that ritual has tended to conceal from us an innermost world of mystery, enigma, and insight...[240]

The mystical and hallucinatory nature of Uelsmann's work is evident in two photographs from 1967, *Apocalypse II* (fig. 90) and *Small Woods Where I Met Myself (final version)* (plate 151). Both are brilliant technical achievements. In *Apocalypse II*, he united a straight shot of a group of people on a beach with a colossal mirror-image rendition of a tree (in negative) looming above them in the sky. The result, a quiet allusion to a nuclear blast, is simultaneously mesmerizing and sinister. In *Small Woods Where I Met Myself*, Uelsmann created a powerful, introverted vision of the complexities of the modern self by repeating a single figure five times, in both positive and negative, within a synthetic dreamscape. The highly ambiguous content of Uelsmann's

pictures, coupled with their tantalizingly allusive titles, made them perfect subjects for the kind of analytical "readings" that White advocated. Indeed, in the essays of William E. Parker and John L. Ward, Uelsmann's work received more extended study than that of nearly any other photographer of the period.[241] These critics found Uelsmann's pictures teeming with correspondences to motifs from art history, mythology, and comparative religion. Their interpretations of Uelsmann's work drew liberally from the writings of Carl Jung, Mircea Eliade, Joseph Campbell, Erich Neumann, and others who explored the symbolism of the collective unconscious.

Like Meatyard and Uelsmann, Duane Michals uses the camera to make, in his words, "real dreams." Michals began his professional life as a graphic designer. Inspired by Frank's work, Michals first used a camera in 1958, on a trip to Russia, where he made simple portraits of working-class subjects. He subsequently devoted himself to the medium, rapidly achieving renown as a professional fashion, advertising, and portrait photographer, and as an artist. While Michals's personal work has evolved markedly since 1958, his entire oeuvre is based on a single motivating idea: "I believe in the imagination. What I cannot see is infinitely more important than what I can see."[242] Thus, paradoxically, he uses photography to register what is "logically" beyond its means: moods, memories, emotions, desires. In the early 1960s, Michals made still, contemplative images of subjects such as a vacant restaurant booth, an empty hotel room, and a deserted subway car. Through his eyes, these unoccupied spaces were charged with a latent human presence, lending them a considerable poignance and mystery.

An important event in Michals's life came in August 1965, when he visited René Magritte, the noted Surrealist artist, at his home in Brussels. Magritte's flatly descriptive paintings of physical and perceptual impossibilities—a room-filling rose, loaves of bread floating in the sky like clouds, a gentle rain of bowler-hatted men—significantly influenced photographers such as Uelsmann and Michals. During his visit, Michals paid homage to his host by documenting the

experience in true Surrealist fashion. One of the most powerful of these photographs, *Magritte Front and Back*, 1965 (fig. 91), uses a double exposure to evoke the artist's curious duality of spirit and flesh, at once fantastic in imagination and conventional in mien. Magritte was enchanting, in large measure, precisely because his appearance revealed so little of his inner life. This lesson—that the meaning of things may have little to do with what we can see—has provided the motivating force for all of Michals's subsequent photographs. And, of course, the strength of this work is derived in large part from the paradox that Michals uses photography to critique the limitations of vision.

The Photographic Establishment

The world of photographic magazines, galleries, and museum programs evolved gradually in complexity between the early 1940s and the mid-1960s. Mass-circulation periodicals such as *Popular Photography, Modern Photography, U.S. Camera*, and *Camera 35* served the general photographic community, while the American Society of Magazine Photographers' *Infinity*, the George Eastman House's *Image*, the Swiss magazines *Camera* and *Du*, and Minor White's *Aperture* catered to more specialized markets. Significantly, beginning in the early 1940s, prominent art periodicals such as *Artnews, Art in America*, and *Magazine of Art* frequently carried articles by Newhall, Steichen, Abbott, Morris, Adams, White, Coke, and other writers on historical or contemporary photography. The most prolific and knowledgable newspaper critic of photography in this era was Jacob Deschin of the *New York Times*.

Although a real market for fine-art photographs was still nearly two decades away, several notable attempts were made in the 1950s to present photography as a commercially viable art. From 1954 to 1956, for example, Roy DeCarava ran A Photographer's Gallery, a small but dignified showcase for some of the finest work of the period. Limelight Gallery, operated by Helen Gee in New York's Greenwich Village, also opened in 1954. Aware that a photography gallery could not hope to be self-supporting, Gee combined her exhibition space with a European-style coffeehouse, creating a relaxed environment for viewing fine prints and for socializing. Before closing Limelight in 1961, Gee showed the work of some 150 photographers, including one-person exhibitions by Stettner, White, Weiner, Moholy-Nagy, Levinstein, Adams, Cunningham, Erwitt, Faurer, Liebling, Parks, W. Eugene Smith, and Arnold Newman.[243] In 1959, the quiet but durable Carl Siembab Gallery of Photography opened in Boston.

As a museum art, photography remained in a comparable state of infancy through the early 1960s. In this period, the nation's most prestigious and influential venue for serious photography was unquestionably the Museum of Modern Art. As director of the museum's department of photography from 1947 to 1962, Steichen presented an ambitious and highly influential series of exhibitions. Although he is best remembered for "The Family of Man," Steichen's vision encompassed a broad range of concerns.[244] His thematic exhibitions included "Music and Musicians" (1947), "Photographs of Picasso by Mili and Capa" (1950), "Korea" (1951), "Abstraction in Photography" (1951), "Memorable *Life* Photographs" (1951), and "70 Photographers Look at New York" (1957). In addition, he presented such historical exhibitions as a survey of news photography titled "The Exact Instant" (1949), "Roots of Photography: Hill-Adamson, Cameron" (1949), "Roots of French Photography" (1949), "Newly Acquired Photographs by Stieglitz and Atget" (1950), "Lewis Carroll Photographs" (1950), and "Forgotten Photographers" (1951). But the bulk of Steichen's prodigious energy was devoted to contemporary work, which he presented in a sequence of group shows. Typical of his large contemporary exhibitions were "In and Out of Focus" (1948), "50 Photographs by 50 Photographers" (1948), "51 American Photographers" (1950), "Always the Young Strangers" (1953) and "Post-War European Photography" (1953). Steichen avoided one-person exhibitions, instead featuring his favored artists in groups of two to six. Exhibitions of this nature included "Three Young Photographers: Leonard McCombe, Wayne Miller, Homer Page" (1947), "Four Photographers: Lisette Model, Bill Brandt, Ted Croner, and Harry Callahan" (1948), "Realism in Photography: Ralph Steiner, Wayne Miller, Tosh Matsumoto, and Frederick Sommer" (1949), the five "Diogenes with a Camera" exhibitions mounted between 1952 and 1961, and "Photographs by Harry Callahan and Robert Frank" (1962). A major survey of Steichen's own photographic work opened at the museum in 1961, on his eighty-second birthday. His final exhibition was "The Bitter Years: 1935-1941, Rural America as Seen by the Photographers of the Farm Security Administration" (1962).

During this period, large-scale photographic exhibitions were rarely mounted by other institutions. A key exception was the George Eastman House, which established itself as a force in contemporary photography through the activities of staff members Walter Chappell and Nathan Lyons. In addition to regular shows from its growing collection of original prints, the Eastman House organized such notable exhibitions as "Photography at Mid-Century" (1959), "Seven Contemporary Photographers" (1961), and "Photography 63" (1963). Occasional photographic exhibitions were presented by a handful of general art museums, including the Worcester Museum of Art and the San Francisco Museum of Fine Arts. In addition, the photography program of the Art Institute of Chicago achieved a new stature during the curatorship of Hugh Edwards (1959-70).

Less well-regarded by the photographic establishment was the series of six exhibitions presented at various museums between 1959 and 1967 under the collective title "Photography in the Fine Arts." This project, the brainchild of photographer Ivan Dmitri, represented a grandiose attempt to promote fine photography to the general public, and to encourage its broader acceptance by art museums.[245]

To this end, Dmitri assembled a panel of distinguished jurors and enlisted the collaboration of both the *Saturday Review*, which published a selection of winning images, and the Metropolitan Museum of Art, which exhibited the prints. Created in multiple editions for touring, these shows were viewed widely; the first, for example, traveled to twenty-six museums and galleries over two years and was seen by 2,000,000 persons.[246] In all, the six exhibitions were seen by some 8,000,000 viewers. Despite this popularity, and the inclusion of individual works of real merit, Dmitri's project received harsh criticism. For photographers such as Frank, Leiter, Friedlander, and Winogrand, the miscellaneous nature of these exhibitions perpetuated a discredited view of the medium: "photography deprived of [its] subleties and meanings because it is deprived of its context and motivation."[247] These shows taught museum directors that photography shows could be popular; otherwise, they had little impact on the field. By this time, such bombastic attempts to "sell" photography to the general public were considered simply irrelevant by the medium's most original practitioners.

95 Herbert Gehr, *Untitled*, ca. 1943, 10⅝ x 13½″

96 Margaret Bourke-White, *The Kremlin, Moscow, Night Bombing by the Germans*, 1941, 10½ x 13½"

97 **Charles Kerlee,** *Dawn Attack by Douglas Dauntless Dive Bombers — Wake Island Burns Below,* December 1943, 7³⁄₈ x 9⁵⁄₈"

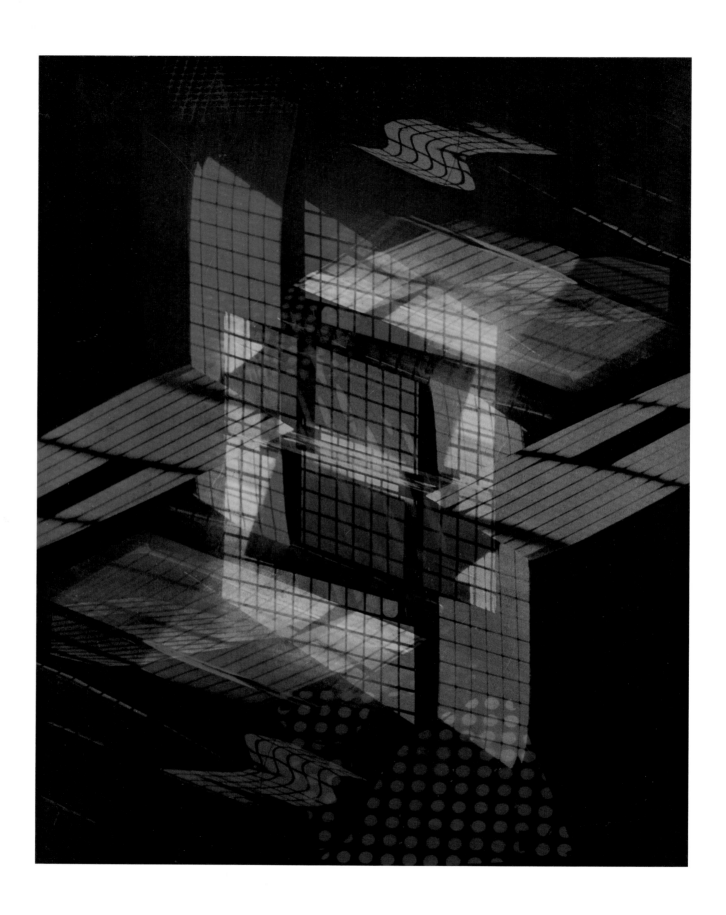

98 Henry Holmes Smith, *Light Study (Color)*, 1946, dye transfer (print made 1984), 13⅛ x 10″

99 **Lotte Jacobi,** *Photogenic,* ca. 1950, 9½ x 7¾″

100 Val Telberg, *Untitled*, ca. 1948, 10½ x 9"

101 Ruth Bernhard, *Hand, Jones Beach, New York*, 1946, 7⅞ x 9⅞"

102 Frederick Sommer, *Arizona Landscape*, 1943, 7⅝ x 9½"

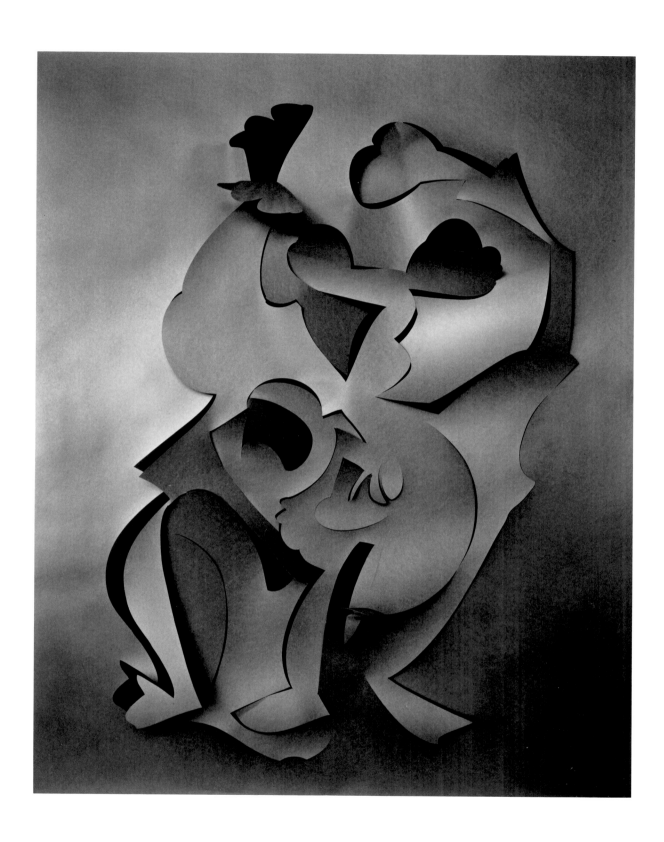

103　Frederick Sommer, *Cut Paper*, 1977, 9½ x 7½"

104 Harry Callahan, *New York*, 1945, 2⅞ x 4⅜"

105 Harry Callahan, *Chicago*, 1953, 10½ x 10⅝"

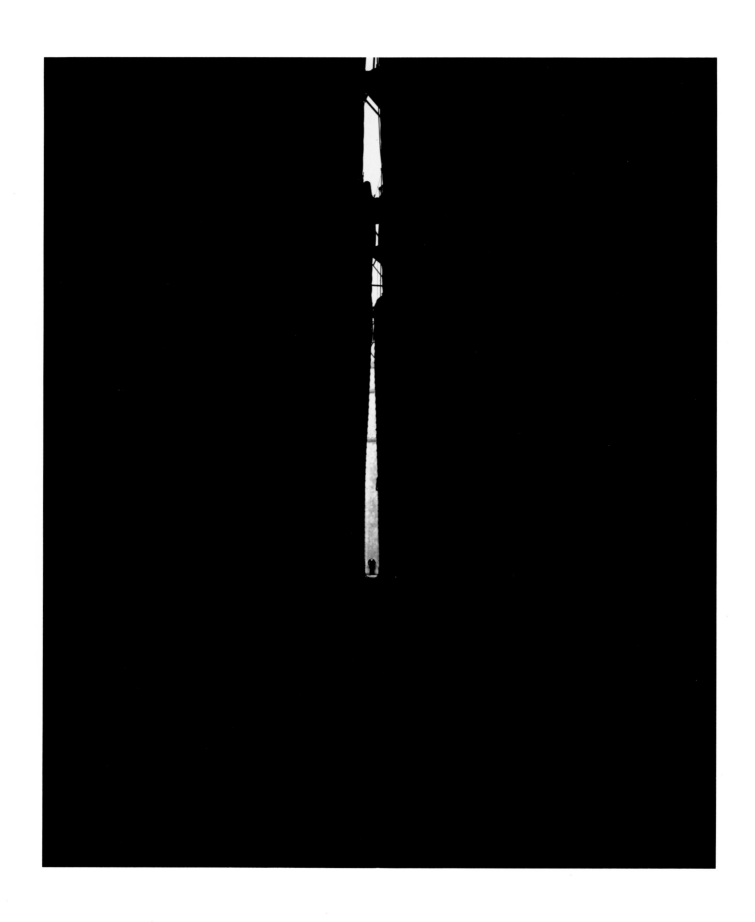

106 **Harry Callahan**, *Bob Fine*, ca. 1952, 9¾ x 7¾"

107　**Harry Callahan,** *Eleanor, Chicago,* 1948, 2¼ x 2¼″

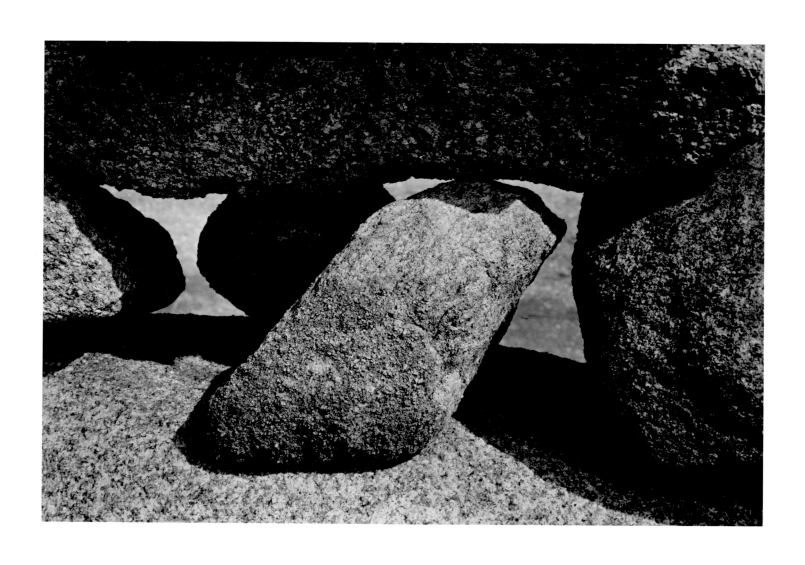

108　Aaron Siskind, *Martha's Vineyard 6*, 1950, 9⅜ x 13⅜"

109 **Aaron Siskind,** *Pleasures and Terrors of Levitation 99,* 1961, 11 x 10½"

110 **Minor White,** *Warehouse Area, San Francisco,* 1949, 10⅜ x 11⅜"

111 **Minor White**, *Easter Sunday, Stony Brook State Park*, 1963, 8¼ x 3″

112 Andreas Feininger, *Fifth Avenue, New York*, 1949, 10⅝ x 13½"

113 Ralston Crawford, *Third Avenue Elevated*, 1949, 13½ x 9⅛"

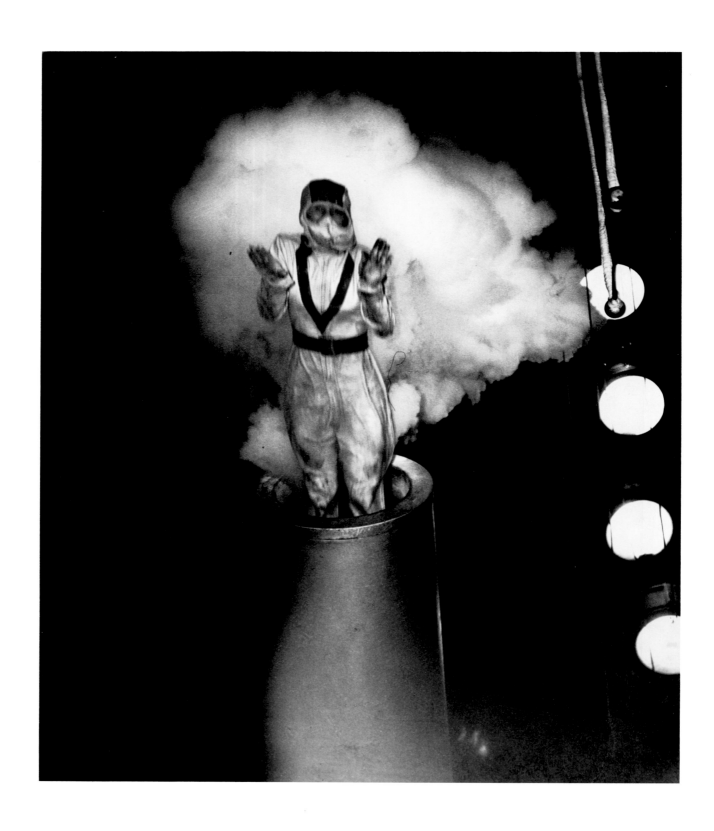

114 **Weegee,** *Girl Shot from Cannon,* ca. 1943, 9⅜ x 7⅞"

115 Weegee, *The Critic*, 1943, 13⅛ x 16½"

116 Helen Levitt, *New York*, ca. 1940, 7⅝ x 6⅛"

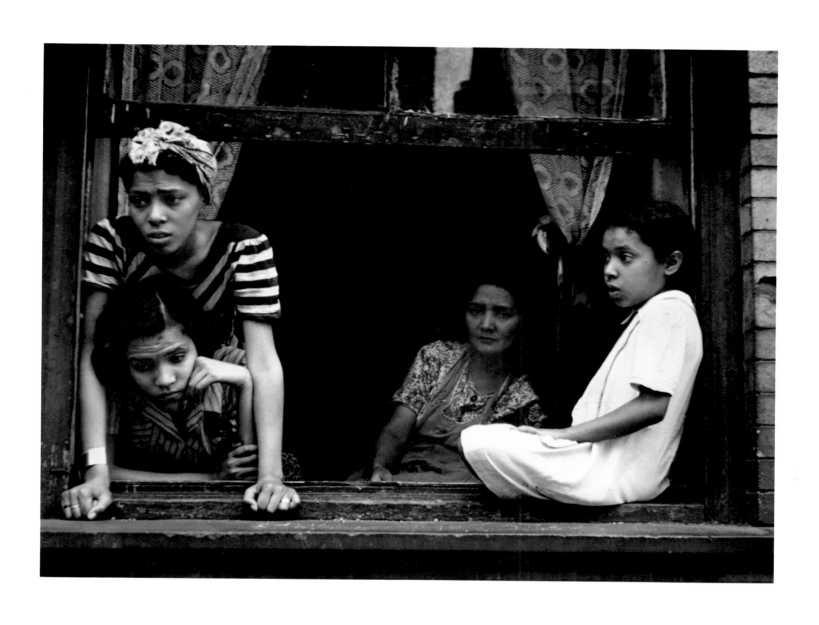

117 Helen Levitt, *New York*, ca. 1942, 6⅜ x 8⅜"

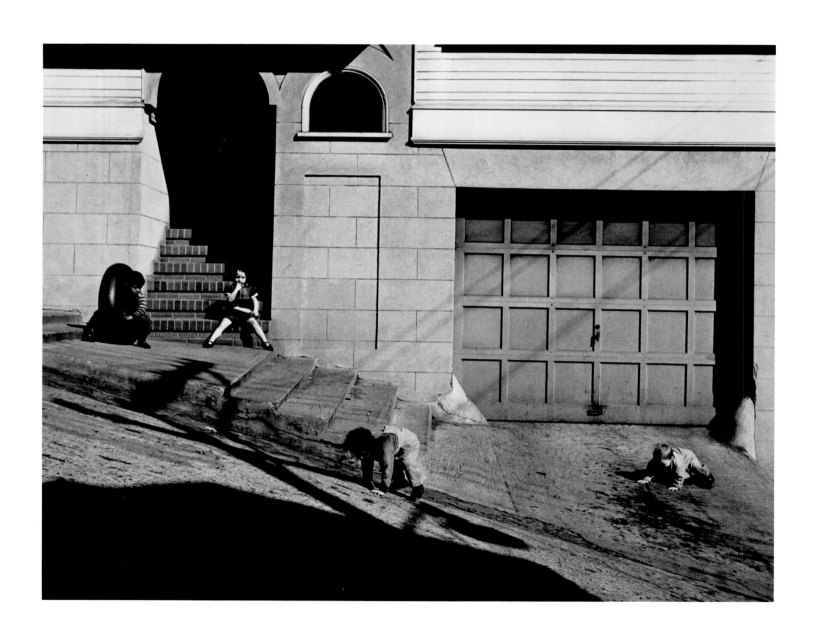

118 **Max Yavno,** *San Francisco,* ca. 1947-48, 7½ x 9½"

119 N. Jay Jaffee, *Bryant Park, New York City*, 1953, 7⅜ x 9″

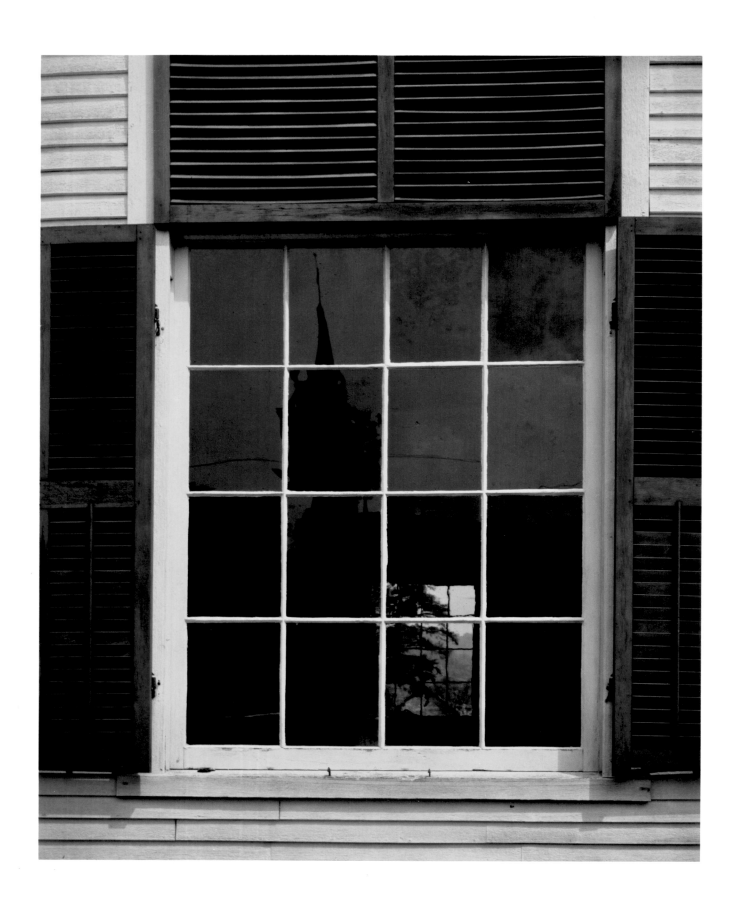

120 **Paul Strand,** *Meeting House Window, New England,* 1945, 9½ x 7⁹⁄₁₆"

121 **Paul Strand**, *The Family, Luzzara, Italy,* 1953, 4⅝ x 5¹³⁄₁₆″

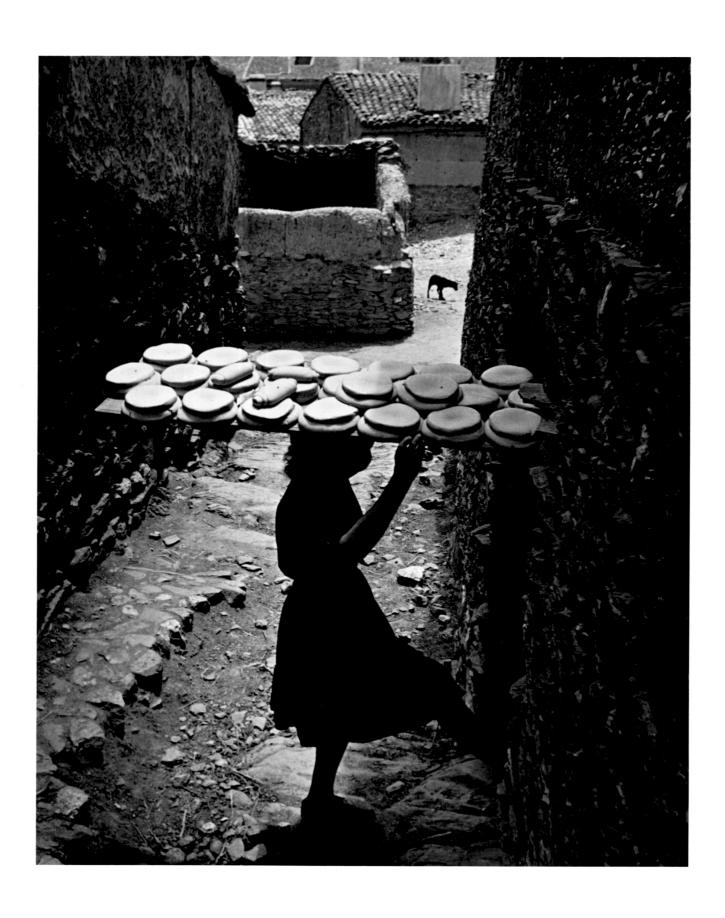

122 W. Eugene Smith, *Woman with Bread, Spain*, 1950, 13³⁄₈ x 10³⁄₈″

123 **W. Eugene Smith,** *Waiting for Survivors of the Andrea Doria Sinking,* 1956, 8½ x 13⅜"

124 **Walker Evans,** *Untitled,* ca. 1941, 6¾ x 6⅞"

125 **Arthur Siegel**, *In Search of Myself*, 1951, dye transfer print, 6½ x 10″

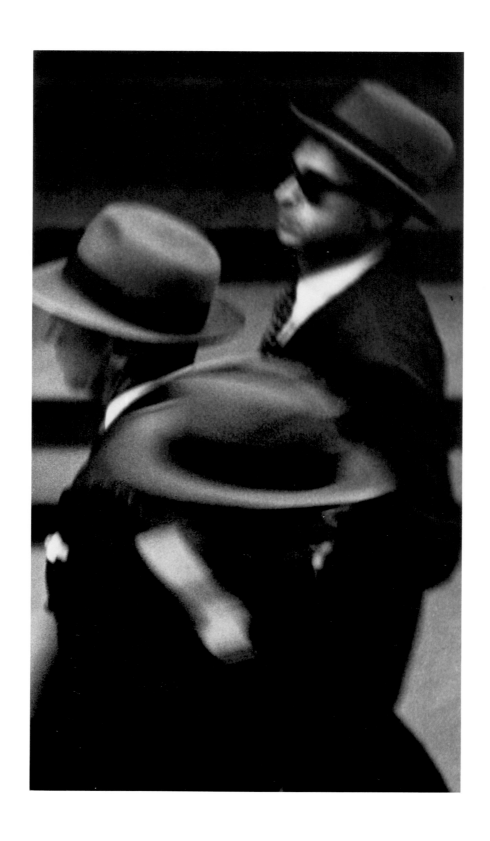

126 Saul Leiter, *Street Scene*, 1951, 8⅞ x 5″

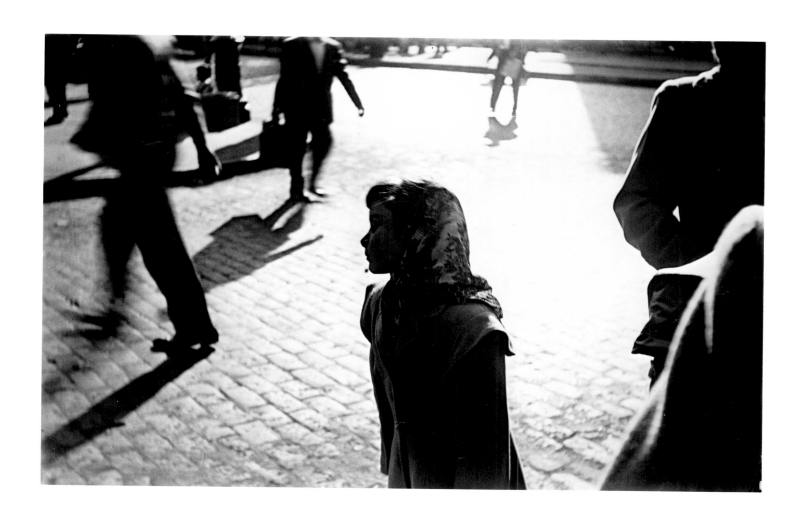

127 **Saul Leiter**, *New York*, ca. 1952, 11 x 16⅞"

128 Marvin E. Newman, *Untitled*, 1951, 9⅝ x 7¾"

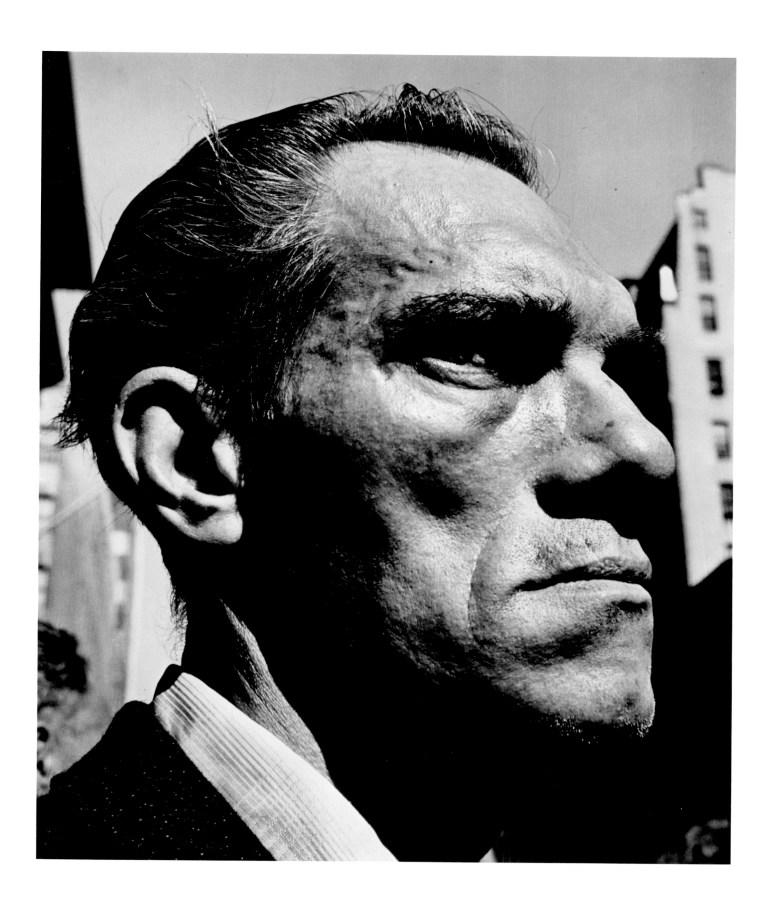

129 Leon Levinstein, *Fifth Avenue*, 1959, 17 x 14″

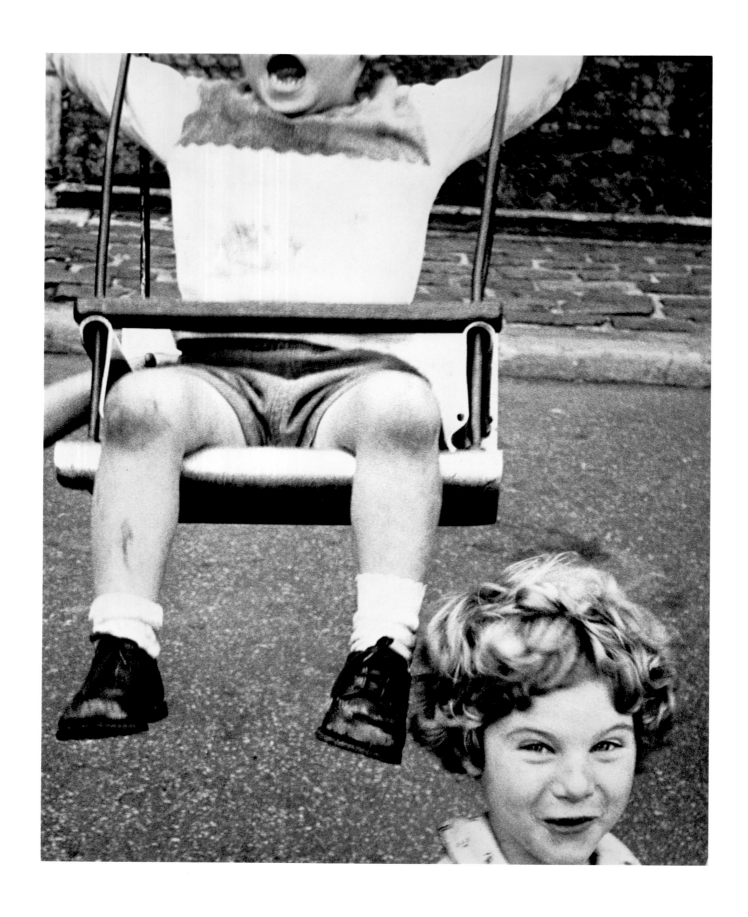

130 **William Klein,** *Swing & Boy & Girl*, New York, 1955, 13⅞ x 11″

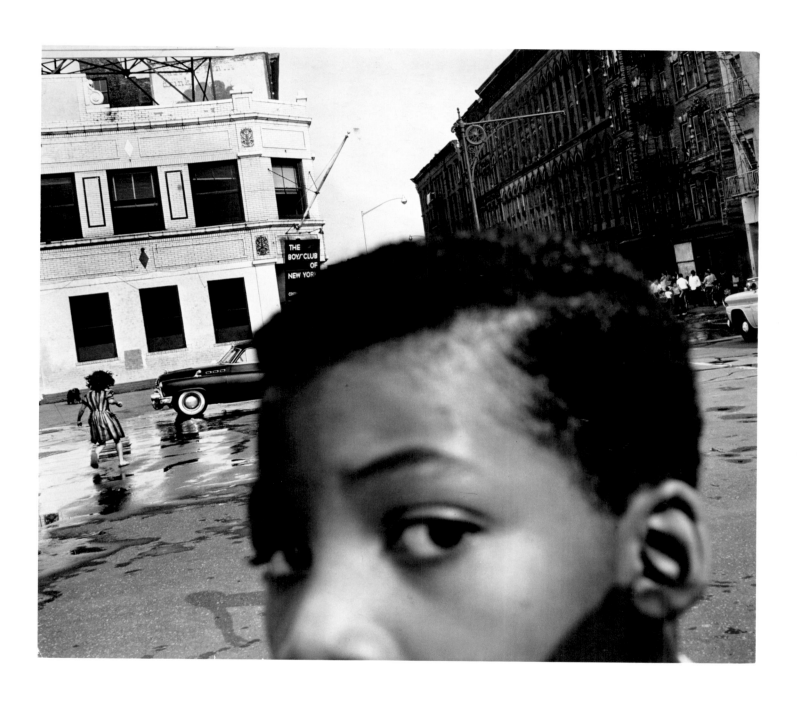

131 Leon Levinstein, *Untitled*, ca. 1960, 13¾ x 15⅜"

132 **Roy DeCarava**, *Hallway, New York*, 1953 (print ca. 1984), 13 x 8⅝″

133 **Roy DeCarava,** *Coltrane No. 24,* 1963 (print ca. 1984), 13 x 9″

134 **Louis Stettner,** *Parking Lot, Volendam, Holland,* ca. 1959, 10⅜ x 15⅛"

135 Elliott Erwitt, *Wyoming*, 1954, 8½ x 13½"

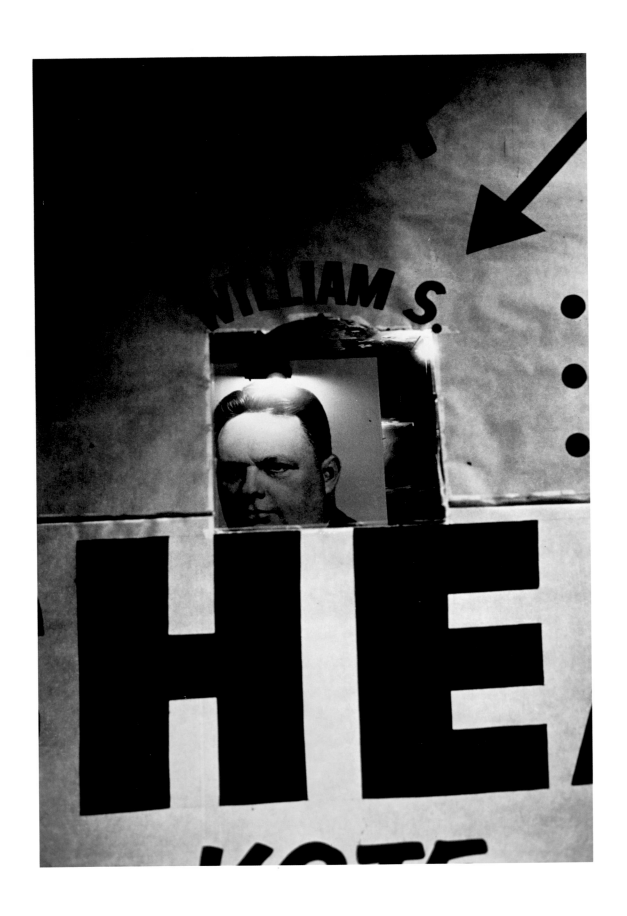

136 Robert Frank, *Look at William S.*, 1956, 11³⁄₈ x 7½"

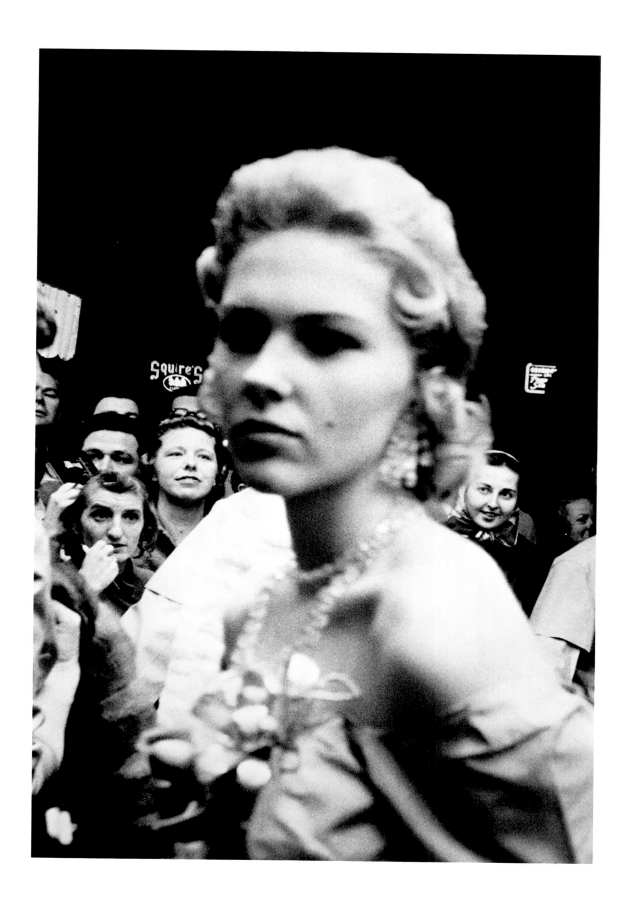

137 **Robert Frank**, *Movie Premiere, Hollywood*, 1956 (print ca. 1975), 12³⁄₈ x 8¼″

138 **Richard Avedon**, *Dovima with Elephants*, *Paris*, 1955 (print ca. 1980), 10 x 8″

139 **Irving Penn**, *Woman with Umbrella*, *New York*, 1950 (print 1984), 15 x 14¼″

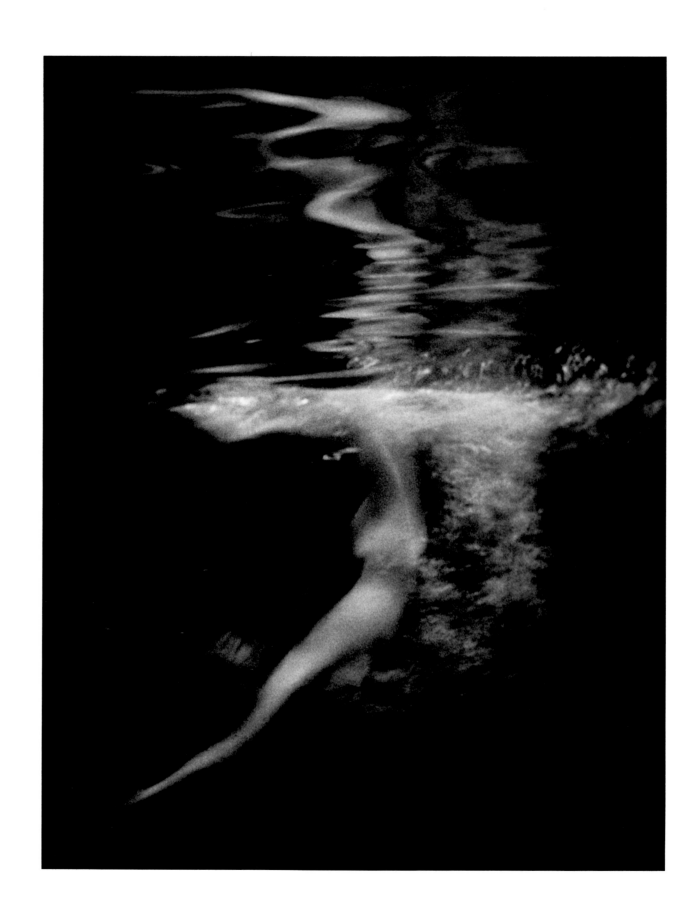

140 Lillian Bassman, *The Wonders of Water*, 1959, 12⁷/₈ x 9½″

141 **William Klein**, *Pedestrian Crossing, Piazza di Spagna, Rome (Vogue)*, 1960, 14 x 10¾″

142 **Arnold Newman,** *Yasuo Kuniyoshi, Fourteenth Street Studio, New York,* 1941, 7¾ x 9¾"

143 Irving Penn, *Duke Ellington, New York*, May 19, 1948, 9½ x 7⅜"

144 Joseph Sterling, *Untitled*, 1961, 7½ x 7½"

145 Kenneth Josephson, *Chicago*, 1961, 5 ¾ x 8⅞″

146 Art Sinsabaugh, *Chicago Landscape*, ca. 1964, 11⅝ x 19½"

147 Ray K. Metzker, *Composite: Atlantic City*, 1966, 41 x 41″

148 Lee Friedlander, *Nashville*, 1963, 6³⁄₁₆ x 9¹⁄₄"

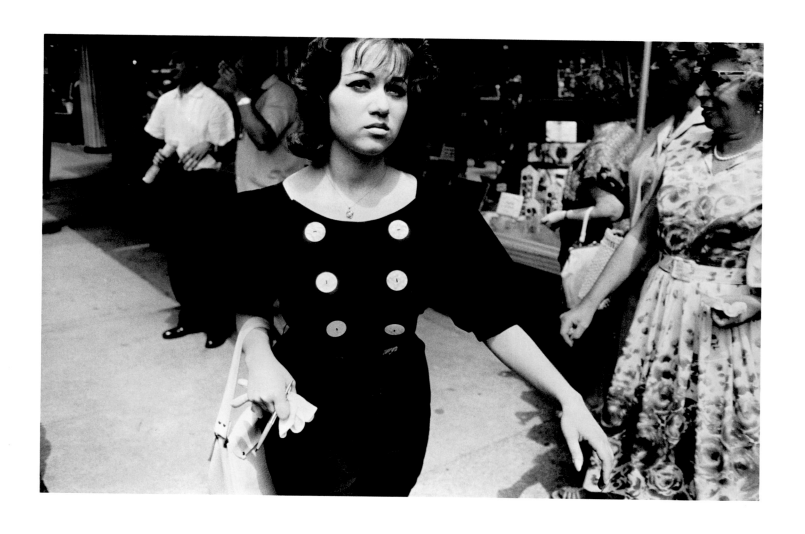

149 Garry Winogrand, *New York*, 1961, 9 x 13⅜″

150 Ralph Eugene Meatyard, *Untitled*, 1963, 7 x 7"

151 **Jerry N. Uelsmann,** *Small Woods Where I Met Myself (final version),* 1967 (print ca. 1980), 10⁷⁄₁₆ x 12³⁄₄″

152 **NASA,** *Day 018, Survey W-E,* ca. 1966-68, 9 x 27¾"

CHAPTER IV The Image Transformed: 1965-Present

The mid-1960s marked a clear turning point in American cultural life. Between 1963 and 1968, a sequence of traumatic and divisive events jolted the nation. The assassinations of John F. Kennedy, Malcolm X, Martin Luther King, Jr., and Robert F. Kennedy seemed to threaten the very foundation of the democratic process. The escalating war in Vietnam stimulated heated debate over the moral direction of the country and the credibility of the government, leading to a climate of deep social division. By 1965, the U.S. was engaged in full-fledged combat in Vietnam, a war that polarized the country and ultimately drove President Lyndon Johnson from office. In 1970, four student demonstrators were killed by National Guardsmen at Kent State University in Ohio. A year later, the nation was riveted by the trial of an army lieutenant who had ordered the massacre of Vietnamese civilians at My Lai. U.S. troops were brought home in 1972, and the war was officially ended a year later, but the Communist occupation of Saigon in 1975 underscored the tragic futility of the entire enterprise. In the bitter aftermath of the war, the Watergate hearings further eroded public confidence in American leaders and institutions. When President Richard Nixon resigned in disgrace in 1974, he left the country in an unprecedented state of polarization.

The national controversy over the Vietnam War coincided with a variety of other contentious domestic issues, including President Johnson's ambitious Great Society program and the African-American struggle for civil rights. Despite the 1964 Civil Rights Act, which prohibited job discrimination based on sex, race, or religion, racial injustices remained, and the late 1960s were marked by civil rights marches and protests in numerous cities. As Martin Luther King, Jr. urged, this movement was predominantly peaceful, but as frustrations mounted, increasing numbers of violent incidents took place. Riots in the Watts district of Los Angeles in 1965, and in Atlanta, Chicago, Newark, and Detroit over the next two years, resulted in widespread

destruction and some deaths. The Black Panthers, founded in Oakland, California, in 1966, inflamed the fears of maintream white society by aggressively advocating militant action in the name of social justice.

This movement for racial equality was only the most prominent feature of a larger climate of rebellion against the status quo. The youth culture of the era—symbolized by sex, drugs, and rock and roll, as well as a surprising commitment to political activism—posed an urgent, if often unfocused, challenge to the personal and social values of the previous generation. Raised in relative affluence and security, the youth of the 1960s had little in common with their parents, who had come of age during the austerity of the Depression and the patriotism of World War II. Instead, the rebellious mood of the late 1960s was rooted in an eclectic synthesis of ideas from other eras: the antimodernism of the 1890s, the giddy utopianism of the avant-garde of the mid-1910s, the hedonistic indulgences of the "splendid, drunken twenties," and the Beat alienation of the 1950s.

A variety of social groups challenged traditional modes of thought and behavior. Women in the 1960s protested unequal labor practices and denigrating gender representations. Betty Friedan's *The Feminine Mystique* (1963), which virtually launched the feminist movement, argued that women's roles were unfairly centered around their husbands and housework. When women did work outside the home, they earned only 63 percent of what men were paid for the same positions. Fair pay and equal opportunity were key issues for the National Organization of Women (NOW), which was founded in 1966. Other milestones in this movement included Kate Millett's book *Sexual Politics* (1970), the inauguration of *Ms.* magazine in 1972, and the Supreme Court's legalization of abortion in 1973. In addition, the Gay Pride movement came to national prominence in 1969, resulting in slow but real gains in acceptance in the following years. However, the ramifications of these and related move-

ments were met with strong resistance by cultural conservatives, contributing to a charged climate of division and confrontation. In the following years, heated debate raged around a series of social issues, including abortion, the Equal Rights Amendment, homosexual rights, affirmative action, school prayer, censorship, and public funding of the arts.

The environmental cause, spurred by books such as Rachel Carson's *Silent Spring* (1962), made Americans aware of the lethal dangers of the by-products of industrial technology. The use of the pesticide DDT was banned in residential areas in 1969, and the first Earth Day, held in the spring of 1970, attracted widespread public interest. As a result, considerable public attention was paid to such diverse issues as acid rain, global warming, oil spills, damage to the ozone layer, the effects of chemical wastes, and—after the partial meltdown at the Three Mile Island generating plant in 1979—the safety of the nuclear-power industry. For many, the almost apocalyptic nature of this crisis—highlighted in books such as Jonathan Schell's *The Fate of the Earth* (1982)—seemed so vast and complex as to defy solution.

This overarching sense of insecurity was heightened by a sequence of political and economic crises in the 1970s and 1980s. The oil embargo of 1973, for example, underscored the vulnerability of the energy-hungry American way of life, while the Iran hostage crisis of 1979-81 provided a frustrating lesson in the limitations of political and military power. A variety of other critical issues came to the fore in the late 1970s and early 1980s: high inflation, the growing national debt, the decline of American manufacturing, rising unemployment, farm foreclosures, homelessness, and the AIDS epidemic. For American businesses and workers alike, the tough realities of the global market produced a spectrum of challenges. On a brighter note, the international political climate was transformed at the turn of the decade by the end of the Cold War, an event marked by the fall of the Berlin Wall in 1989, and the official dissolution of the Soviet Union two years later.

A constant factor throughout this period of upheaval, uncertainty, and change was the revolution in communication and information technologies. Television grew steadily in importance to become the nation's primary source of information and entertainment. With the launching of the first Telstar satellite in 1962, which allowed transatlantic television broadcasts, the flow of information increased steadily in both volume and speed. By 1970, televisions were in 95 percent of all U.S. homes. This communications revolution was the topic of such widely discussed books as *The Medium is the Massage* (1967), by Marshall McLuhan and Quentin Fiore. By the early 1980s, 25,000,000 subscribers were hooked up to cable television, providing access to a bewildering variety of new channels, including MTV, the first all-music-video station, which went on the air in 1981.

The electronics revolution brought remarkable technical sophistication to other aspects of domestic life. The invention of the microprocessor, or "computer chip," in 1971 led to the development of the personal computer, introduced by IBM in 1981. This and other miniaturized technologies opened the way for the vast cultural shift from the production of consumer goods to the production of information. The speed of electronic communications and the volume of data available for retrieval were overwhelming, creating a widespread feeling of immersion in an ocean of images, codes, and simulations. In this apparently all-encompassing universe of representations, the nature of reality itself—the distinction between original and copy, or between truth and fiction—was blurred, if not, as some have suggested, erased completely.

The Photography Boom

The present status of photography as a broadly accepted art of the gallery and museum is almost entirely a function of the last quarter-century. During the twenty years after World War II, photography enjoyed only a very gradual increase in institutional acceptance. This growth increased markedly in the mid-1960s, and by the mid-1970s the field was in a phase of nearly explosive development. By the time of its official sesquicentennial in 1989, it was abundantly clear that photography had achieved a status almost unthinkable a generation earlier, let alone in 1889.

The reasons for the sudden expansion in exhibitions, publications, and scholarship on photography are complex, and attributable to a variety of broad cultural factors as well as to the activities of individual artists, curators, critics, and educators. One general argument, however, might be that the artistic status of the photograph could only be widely accepted once its day-to-day utility had begun to decline. From this perspective, it is not coincidental that the universal recognition of photography's artistic value came at precisely the moment when television conclusively supplanted the still image as the primary source of visual information about the world. For Americans, this turning point may be conveniently symbolized by the discontinuance of *Life* magazine in 1972. In the previous decade, photography and television had battled for supremacy, with photography more than holding its own. Indeed, our most vivid symbols of the achievements and traumas of this era are still photographs: the blurred frames of the Zapruder film of the 1963 assassination of President Kennedy, Eddie Adams's shocking record of the execution of a Viet Cong spy on a street in Saigon in 1968, Neil Armstrong standing on the surface of the moon in 1969, and John Filo's 1970 document of the killings at Kent State University.

Two of the most memorable journalistic photographs of this tumultuous period are Charles Moore's *Birmingham Riots*, 1963 (plate 153) and Larry Burrows's *Reaching Out, First-Aid Center During Operation Prairie*, 1966 (plate 154). Moore's powerful image records the use of high-pressure firehoses by police to break up a civil rights march in Birmingham, Alabama, on May 3, 1963. Later that same day, officials unleashed police dogs on the bruised and soggy

protestors. When published in a dramatic eleven-page photo-essay in *Life*, Moore's pictures sickened the nation and helped galvanize national support for the civil rights movement.[1]

Similarly, Larry Burrows's Vietnam War photograph of one wounded soldier reaching out to another has become a veritable icon of the times.[2] Like all Americans, the journalists and photographers who covered the war had strong opinions on it. As critic Mark Johnstone has noted, "This was the first large war that was depicted in highly individual ways by photographers who wished to express their experience of the land, the people and the war, rather than showing only the circumstances, events and victims of it."[3] Burrows, who covered Vietnam from 1962 until his death in Laos in 1971, began as a firm supporter of the American cause. However, by 1969, when his photoessay "A Degree of Disillusion" was published in *Life*, he had developed serious doubts.[4] His ambivalence is powerfully evoked in *Reaching Out*, which celebrates the survival of fundamental human values in a horrific quagmire of mud and blood. The complex organization of this image was not fortuitous: Burrows had a strong interest in Old Master paintings, and he tried to replicate their richness and subtlety in his photographs.[5] This knowledge of art history made him particularly attentive to the emotional and pictorial functions of color, which he used to consistently powerful effect.

Since the Vietnam era, however, most dramatic or newsworthy incidents have been seen first on television. Memories of key historical events of the last two decades are generally derived from moving images rather than from still ones. This shift in emphasis has not eliminated the role of the photojournalist, but it has clearly altered the nature of his or her work. Unable to report spot news events with the same immediacy as television, photojournalists have turned their attention instead to less immediately topical subjects or to those with more complexity or depth than television can accommodate. They have also devoted new energy to the expressive and narrative potential of the picture story.

Ironically, perhaps, this movement from still photography to television freed the earlier medium to be appreciated as art. Only when photography ceased to be seen first as an objective, information-bearing medium—a ubiquitous and passive witness to reality—could it be broadly understood as a highly subjective means of making *pictures*, that is, as a medium of invention and expression. By the early 1970s, television had created a new paradigm for the realistic depiction of contemporary events. The very difference between the rapidly changing television image and the still photograph served to highlight the basic syntax of photography: the preservation of a single fragment of time, as seen from one point in space; the inherent abstraction of black-and-white materials; and the beauty and variety—the insistent *objectness*—of photographic prints. By emphasizing these intrinsic traits, television prompted many to view the still photograph as a synthesis of fact and personal opinion, and as worthy of serious contemplation.

An Expanding Field

The photography boom of the late 1960s and 1970s was, in part, the result of interrelated developments in popular culture. On the most general level, the public's fascination for the medium was reflected in such diverse manifestations as Michelangelo Antonioni's film *Blow-Up* (1966), the multivolume Time-Life Library of Photography (begun in 1970), and *Newsweek*'s glowing cover story on photography (October 21, 1974). This coverage both reflected and stimulated a new attention to the medium by artists, collectors, historians, critics, and the museum-going public.

One measure of this new interest was the sheer number of photography exhibitions, which increased significantly in the late 1960s. In 1969, for example, it was considered remarkable that twenty-four photographic exhibitions were on view at the same time in New York City.[6] This "explosion" of photographic exhibitions was made possible, in part, by the variety of institutions that displayed the medium. In addition to the Museum of Modern Art and the Metropolitan Museum of Art, photography exhibitions were hosted at this time by the Museum of the City of New York, the Riverside Museum, the Museum of Natural History, the Jewish Museum, and the Museum of Contemporary Crafts, as well as by various educational institutions, such as the New School and the School of Visual Arts. Several New York businesses, including IBM, *Parents Magazine*, and Hallmark Cards, maintained nonprofit galleries in which photographs were frequently displayed. The Hallmark Gallery, in the lower level of the firm's store at 720 Fifth Avenue, was particularly notable: its inaugural exhibition, a 141-print Harry Callahan retrospective in 1964, was followed in later years by surveys of the work of Cartier-Bresson, Kertész, and others.

In addition to this diversity, the photography programs at key museums were increasingly active. The Museum of Modern Art mounted between five and eight photographic exhibitions per year in the 1960s, reaching a peak of ten shows annually in 1970 and 1976.[7] In order to reach the largest possible audience, the George Eastman House in Rochester astutely combined its exhibition program with various extension activities, including the production of books and catalogues, the circulation of traveling exhibitions from the permanent collection, the sale of slide sets of contemporary and historical work for teaching purposes, and the regular publication of the journal *Image*. Outside New York, this photo "boom" was exemplified in the programs of institutions such as the Boston Museum of Fine Arts, the Houston Museum of Fine Arts, the Amon Carter Museum in Fort Worth, the Smithsonian Institution and the Corcoran Gallery in Washington, D.C., the Philadelphia Museum of Art, the San Francisco Museum of Modern Art, and the Art Institute of Chicago. In addition, the University of Texas at Austin made a quiet but important move in 1964, when it acquired the voluminous collection of the noted photographic historian, Helmut Gernsheim. Included in this hold-

ing was the world's first known photograph, an image made by Joseph Nicéphore Niépce in ca. 1826-27.

Another testament to the growing popularity of photography was the increasing viability of commercial galleries specializing in the medium. All earlier attempts to sell photographs to the public had been unprofitable labors of love, like Norbert Kleber's Underground Gallery, opened in New York's East Village in 1963.[8] But, in 1969, Lee D. Witkin opened the Witkin Gallery, which proved to be the first of a new generation of photo galleries. In 1971, Castelli Graphics began representing photographers, and Rinhart Galleries and Light Gallery were opened.[9] Between 1970 and 1974, the number of photographic galleries in New York City alone grew from four to fifteen.[10] While New York was clearly the heart of the nation's art market, a handful of other pioneering photo galleries emerged in other cities. While Carl Siembab remained active in Boston, Helen Johnston's Focus Gallery was opened in San Francisco in 1966, and Tom Halsted's 831 Gallery was begun in Birmingham, Michigan, in 1969.

The auction market for photography also began to develop in these years. Despite the early Marshall sale at Swann's in 1951, the auction houses essentially ignored photography until the sale of the Sidney Strober collection at Parke-Bernet in 1970. That sale, which netted nearly $70,000, was an unexpected success. Over the next few years, Parke-Bernet's New York book department organized intermittent photography sales. Regular semiannual photographic sales were begun in New York by Sotheby Parke-Bernet in 1975 and by Christie's in 1978. These sales marked the beginning of a general photography market, a status confirmed by the 1979 publication of *The Photograph Collector's Guide*, by Lee D. Witkin and Barbara London.

In the 1970s, interest in the emerging photography market was stimulated by reports of the rapidly rising prices paid for the well-known work of Ansel Adams. After Adams announced his decision to stop making prints on demand at the end of 1975, the prices of his best-known images rose dramatically. The value of his classic *Moonrise, Hernandez* (1941), for example, went from approximately $150 to $10,000 per print in the 1970s, an increase that was widely remarked upon at the time. While Adams's popular renown made him a decidedly atypical example of the market, prices for the work of other photographers also rose steadily after the mid-1970s. In addition, increasing standards of connoisseurship—stimulated by the discrimination of buyers such as Pierre Apraxine, curator of the Gilman Paper Company Collection—split the market into two basic categories: relatively inexpensive contemporary works and expensive vintage prints by the most noted historical figures. Public sales of individual prints rapidly passed the benchmarks of $50,000 (in 1983), $100,000 (in 1989), and $150,000 (in 1991).[11] By the fall of 1993, an exceptional Stieglitz portrait of O'Keeffe was sold at auction for $398,500.

Among the most notable private collectors of the early 1970s were Arnold Crane, a colorful Chicago lawyer, and Sam Wagstaff, a former curator of contemporary art. Wagstaff began buying photographs in early 1973 after seeing the exhibition "The Painterly Photograph" at the Metropolitan Museum. Just five years later, he had built a superb and eclectic collection that was featured in an influential book and a major traveling exhibition.[12] Leading art museums also began adding photographs to their permanent collections in the early 1970s. In 1973, for example, the New Orleans Museum of Art began a concerted program of photographic acquisitions under the guidance of its director, E. John Bullard. In addition, a select number of corporate collections were initiated in this era. The Hallmark Photographic Collection was begun in 1964. This was followed by the establishment of important holdings by the Exchange National Bank in Chicago in 1967, by Joseph E. Seagram & Sons in 1972, and by the Gilman Paper Company in 1974.[13] The Polaroid Corporation, which had first acquired fine photographs in the 1950s, began a formal collection of artistic work created with Polaroid materials in the late 1960s.[14] In addition, in 1977-78, Polaroid constructed five 20x24-inch format cameras that were made available to leading artists for experimentation.

Photography received other forms of institutional support in the 1970s. In 1971, the National Endowment for the Arts conferred its official stamp of approval by establishing a separate category for the medium. Twenty-three photographers received grants that year, with hundreds more awarded in the following decades.[15] In 1967, the Friends of Photography was formed in Carmel, California, through the efforts of Ansel Adams, Beaumont Newhall, and others. The California Museum of Photography in Riverside was founded in 1973, followed a year later by the International Center of Photography in New York. In 1975, the Center for Creative Photography was established in Tucson by the University of Arizona as the repository for the estates of such noted photographers as Adams, Weston, Sommer, Callahan, Siskind, and W. Eugene Smith. This era of institutional growth peaked in 1984, when the J. Paul Getty Museum, in Malibu, California, established a department of photography with the dramatic acquisition of several of the world's finest private collections, including those of Crane and Wagstaff. Under the direction of Weston J. Naef, former curator of photography at the Metropolitan, the Getty's program emphatically confirmed photography's new artistic status.

These developments were paralleled by the medium's increasingly secure place in the academic world. The 1960s and early 1970s were something of a golden age in American higher education, and photography was one of numerous disciplines to benefit from the overall expansion of curricula.[16] Teachers of photography first achieved a sense of collective identity at a conference at the George Eastman House in 1962; that event led to the organization of the Society for Photographic Education (SPE) a year later. The SPE, whose founding members included Lyons, Henry Holmes Smith, Siskind, White, and Uelsmann, provided a sense of common cause for the nation's growing number of photographic

educators. In the following years, established photography programs flourished and many new ones were begun. After his arrival in Providence in 1962, Harry Callahan transformed the photography department of the Rhode Island School of Design into one of the most important in the country. Three years later, Minor White shaped his own program at the Massachusetts Institute of Technology. Through the efforts of Robert Heinecken, UCLA became an important center for nontraditional approaches to photography. The multifaceted program of the Visual Studies Workshop, founded by Nathan Lyons in Rochester in 1969, was equally influential. At the University of New Mexico, in Albuquerque, Van Deren Coke created a program that became famous for its courses in the practice and history of photography.[17] In the early 1970s, Coke bolstered the already strong UNM faculty by adding Beaumont Newhall (who retired as director of the George Eastman House in 1971) and Thomas F. Barrow. The history of photography was given the ultimate academic recognition in 1972, when Princeton University awarded the David H. McAlpin Professorship, the first endowed chair in the field, to Peter C. Bunnell. By 1980, according to photographic historian Jonathan Green, "there were photography and history of photography programs in universities in every state of the union."[18]

This expanded interest in photography brought with it a more sophisticated scholarly and critical discourse on the subject. Beginning in the fall of 1973, the eminent cultural critic Susan Sontag published a series of provocative essays on photography in the *New York Review of Books*. While Sontag was resolutely critical of photography's fine-art status and its potential for conveying meaning, the very fact of her attention served to legitimize the medium as a subject worthy of consideration within the context of larger social, artistic, and philosophical issues. These essays, in slightly revised form, comprised Sontag's book *On Photography*, which was released in 1977 to considerable fanfare and controversy.[19] The intellectual appeal of photography in this era is also underscored by books such as *Camera Lucida* (1981), a poetic meditation on the medium by the noted French literary critic and theorist Roland Barthes. At the same time, mainstream venues like the *New York Times*, the *Village Voice*, and the *New Yorker* offered regular coverage of photographic exhibitions. These were written by a new breed of photography critics, including A. D. Coleman, Ben Lifson, Leo Rubinfien, and Andy Grundberg, as well as by art critics like Douglas Davis and Max Kozloff. More specialized or academic analysis of photography was provided by journals such as *Afterimage, Exposure, Untitled, Image, History of Photography*, and *October*.

As this activity suggests, the literature of photography began an almost exponential rate of growth in the 1960s. A revised edition of Newhall's *History of Photography*, released in 1964, sold 3,000 copies in just a few months; the 1949 edition of the book had taken nearly ten years to sell as many.[20] This growing scholarly audience provided a market for such significant historical or critical studies as Van Deren

Coke's *The Painter and the Photograph* (1964), Nathan Lyons's anthology *Photographers on Photography* (1966), Richard Rudisill's *Mirror Image* (1971), William Stott's *Documentary Expression and Thirties America* (1973), and Estelle Jussim's *Visual Communication and the Graphic Arts* (1974). Important monographs on many leading photographers were also published, including *Photographs: Harry Callahan* (1964), Minor White's *Mirrors Messages Manifestations* (1969), *Walker Evans* (1971), *Paul Strand: A Retrospective Monograph* (1971), *André Kertész: Sixty Years of Photography* (1972), *Diane Arbus* (1972), and Arnold Newman's *One Mind's Eye* (1974). Finally, an unprecedented number of books by younger artists were published, including Danny Lyon's *The Bikeriders* (1968), Garry Winogrand's *The Animals* (1969), and Lee Friedlander's *Self Portrait* (1970). Especially significant in this regard was Lustrum Press, founded by photographer Ralph Gibson, which published such notable books as Larry Clark's *Tulsa* (1971), Mary Ellen Mark's *Passport* (1974), and Gibson's own trilogy: *The Somnambulist* (1970), *Deja-Vu* (1973), and *Days at Sea* (1974).

Szarkowski and the Modern

Clearly, then, the photography scene of the 1960s and 1970s was a distinctly collective enterprise. Nonetheless, it was widely agreed that the most powerful influence was wielded by John Szarkowski of the Museum of Modern Art. In 1962, when Szarkowski was chosen to succeed Edward Steichen as only the third director of the Modern's department of photography, he was highly qualified, though relatively little known.[21] After studying art history at the University of Wisconsin, Szarkowski had worked at the Walker Art Center from 1948 to 1951. He then taught at the Albright Art School in Buffalo, assembling at the same time a subtle and powerful book of his own architectural photographs, *The Idea of Louis Sullivan* (1956). A second volume of his photographs, *The Face of Minnesota* (1958), was published in celebration of the centennial of Minnesota's statehood. These volumes demonstrated Szarkowski's eloquence as a writer, as did such key essays as "Photographing Architecture."[22] His own use of the camera was strongly indebted to the strain of nonexperimental photography typified by the work of Evans, Lange, Morris, and others. By the time of his appointment at the Modern, Szarkowski's understanding of photography had grown to include this earlier tradition as well as a larger interest in the visual syntax of the medium, its unique technical and expressive characteristics. The result was a curatorial vision distinctly different from Steichen's, and even more influential.

One of Szarkowski's first major exhibitions at the museum was "The Photographer's Eye" in 1964. In this exhibition (and in the accompanying book, published two years later), he sought to identify the medium's essential formal traits, "what photographs look like, and...why they look that way."[23] Szarkowski defined five qualities common

to all photographic images: the thing itself, the detail, the frame, time, and vantage point. He then presented a variety of photographs, from artistic masterpieces to anonymous vernacular images, to illustrate each of these five aspects. In sharp contrast to Steichen's best-known exhibitions, Szarkowski's approach emphasized the aesthetic means of the medium rather than the anecdotal content of individual pictures. More radical yet, Szarkowski's thesis posited that the meaning of photographs lay, most fundamentally, in their unique and peculiar relation to the world. Photographs have an unmatched ability to describe certain aspects of visual experience, but by their very nature they remain approximations, two-dimensional abstractions of the fluid reality which they record. Within that intrinsic process of abstraction, the syntax of photography—as outlined in Szarkowski's five categories—imposes its own formal order upon the subjects recorded by the camera. Thus, the process creates an uncanny pictorial realm, one that is similar to, but always distinctly different from, the world of perceptual experience. The result, as Jonathan Green has observed, is a complex tension between

> fact and artifact, belief and disbelief, reality and illusion.... The camera cannot lie, neither can it tell the truth. It can only transform. The very nature of the medium forces a disjuncture between the photograph and the world, yet the habits of perception—our everyday use of photography—force us to see the image as a surrogate reality. *Disjuncture* yet *resemblance* are photography's defining characteristics.[24]

This sophisticated vision of the medium provided the underlying rationale for all of Szarkowski's activities. One of the most influential of his early exhibitions, "New Documents" (1967), featured the work of Winogrand, Friedlander, and Arbus. By its title alone, this exhibition signaled the end of a 1930s vision of the basic objectivity and persuasive power of the documentary photograph. Instead, the confrontational or oddly oblique images of the New Documentarians highlighted the inherently expressive nature of photography itself. As Szarkowski stated in his exhibition text,

> Most of those who were called documentary photographers a generation ago...made their pictures in the service of a social cause...to show what was wrong with the world, and to persuade their fellows to take action and make it right...A new generation of photographers has directed the documentary approach toward more personal ends. Their aim has not been to reform life, but to know it...What they hold in common is the belief that the commonplace is really worth looking at, and the courage to look at it with a minimum of theorizing.[25]

The dispassionate formalism of this attempt to know life is exemplified in Winogrand's *Hard Hat Rally*, 1969 (plate 155). This astonishingly complex image evokes the confrontational politics of the day, emphasizing in particular the theatricality of such public protests and the mass media's collaborative role as both witness and catalyst. This image takes no obvious side in the issue under debate, and does not reveal Winogrand's own political views. Instead, it uses the

spectacle of contemporary life for personal and artistic ends. The tensions at the heart of this new documentary vision were most powerfully evoked in the Modern's retrospective of Diane Arbus's photographs in 1972. The disquieting intensity of Arbus's work—its subjectivity and skepticism, combined with an apparent stance of descriptive neutrality—left an indelible mark on the many viewers who passed slowly through the exhibition, in almost total silence.

The disavowal of narrative and the emphasis on formal relationships evident in the work included in "New Documents" was even more pronounced in Szarkowski's 1973 exhibition "From The Picture Press." This project, for which Diane Arbus worked as a picture researcher, considered tabloid news photographs as strictly aesthetic artifacts, presenting them, in essence, as surrealistic found objects. Stripped of the meaning provided by their original contexts or captions, these photographs from the 1930s and 1940s did indeed echo the ambiguities and formal complexities of the most challenging work of the early 1970s. By deliberately reinterpreting these historical and vernacular images in the light of contemporary pictorial concerns, projects such as this continued a venerable modernist tradition: the search for, or wholesale invention of, a suitable artistic lineage.[26]

With his subtle eye and elegant writing style, Szarkowski was uniquely prepared to introduce complex ideas about the meaning of photographs to a broad audience. His exhibitions of the work of Kertész, Lange, Evans, Callahan, Atget, Adams, and others were invariably sympathetic yet rigorous, providing new insights into seemingly familiar work. Similarly, his bold and controversial exhibition of William Eggleston's photographs in 1976 made a brilliant case for a body of work that would otherwise have seemed obstinately difficult or, at worst, simply thoughtless. In addition to exhibitions such as these, Szarkowski's general writings on the nature of photography provided richly-nuanced primers for the general public. His influential book *The Photographer's Eye* (1966) was followed by *Looking at Photographs* (1973), a selection of one hundred works from the museum's collection, each accompanied by a paragraph or two of pithy prose. Then, in 1975, at a time of unprecedented enthusiasm for the medium, his essay "A Different Kind of Art" in the *New York Times Magazine* made a strong argument for the uniqueness of photography's expressive means and for the almost magical power of its finest achievements.[27]

A New Pluralism

Photographers of the late 1960s and 1970s responded to the social conflicts of the era in a variety of ways, embracing both documentary and expressionistic styles, purist and manipulated means. The range of these responses may be suggested in the disparate work of Arthur Tress and Richard Avedon. Tress made his *Boy in Ruined Building, Newark, N.J.*, 1967 (plate 157), just a few months after Newark was

decimated by riot and fire. In an abandoned structure in a ruined part of the city, Tress found an old furniture sign that he leaned against the wall. He recruited a nearby child to stand beside it, with his arm placed strategically against the image of the sofa. The resulting photograph suggests the dream of a happy domestic life blasted by the realities of a harsh and desolate world. The photograph's deliberate tension between reality and artifice reflected Tress's feeling that traditional documentary means were inadequate to express the "extreme social realities of these contradictory and violent times."[28] Artifice was a means to suggest a higher level of documentary truth. This kind of theatrical fiction, based firmly in the tradition of Lynes, Laughlin, and Meatyard, anticipated much of the artistic photography of the next twenty years.

Richard Avedon's relentless artistic growth is revealed in his *Oscar Levant, Pianist, Beverly Hills, California,* 1972 (plate 156). This powerful image, made more than a quarter-century after he first achieved national recognition, demonstrates the dual symbolism inherent in Avedon's best work. On the one hand, his portraits evoke the fundamental tensions of vitality and mortality, achievement and entropy. These themes are especially evident in some of his more extreme subjects, such as his 1963 photographs taken in a Louisiana mental hospital or the haunting series of portraits, made between 1969 and 1973, of his own father dying of cancer. On the other hand, his portraits use the surface appearance of his subjects to convey his own vision of the mood of the culture. This ambition is apparent in his choice of subjects since the early 1960s. In 1963, Avedon traveled through the South, photographing civil rights demonstrators and the racists who opposed them. On the evening of November 22, 1963, he photographed passersby in Times Square, each holding a newspaper with the terrible headline "PRESIDENT SHOT DEAD." He went to Vietnam in 1971 in an attempt to understand the war that had so poisoned the nation's political climate. Between 1979 and 1985, he recorded laborers in the American West, creating a controversial body of work that sought to examine the myth of the frontier and the fate of the American Dream.[29] It is in this interpretive and political context that Avedon's 1972 portrait of the performer Oscar Levant may be best understood.[30] In this disturbing and enigmatic image, Levant seems to be at once laughing and screaming, living and dying. Avedon represents the inner turmoil of his subject as a tragic conflict between great vitality and equally powerful demons, a tension that also stands as a powerful metaphor for the national crisis of the Vietnam era.

Various strains of documentary photography continued to play an important role in the aftermath of Frank's *The Americans.* Group exhibitions such as "Toward A Social Landscape" (1966), curated by Nathan Lyons at the George Eastman House, and Szarkowski's "New Documents" (1967) at the Museum of Modern Art, stressed the personal approach to realistic representation. The first monographs of Winogrand, Friedlander, and Arbus, all published between

Fig. 92 **Richard Benson,** *Memorial to Robert Gould Shaw and the Massachusetts Fifty-Fourth Regiment, Boston,* 1972, platinum-palladium print, 12¾ x 10⅛"

1969 and 1972, had a marked impact on younger photographers. Their influence, as well as that of Evans and Frank, can be discerned in Danny Lyon's images of motorcycle riders and prison inmates (*The Bikeriders,* 1968, and *Conversations with the Dead,* 1971), Bruce Davidson's humanistic documentation of life in Harlem (*East 100th Street,* 1970), Larry Clark's disturbing first-person record of teenage drug addiction (*Tulsa,* 1971), and George Tice's photographs of the old industrial city of Paterson, New Jersey (*Paterson,* 1972). An abiding, even cynical, fascination for the absurdity of American culture is seen in volumes as diverse as Dennis Stock's *California Trip* (1970), Geoff Winningham's *Friday Night at the Coliseum* (1971), and Bill Owens's *Suburbia* (1973).

Markedly different in subject and approach from other documentary work of the period was the beautiful volume *Lay This Laurel* (1973), a collaboration between writer Lincoln Kirstein and photographer Richard Benson. But even this small book, in its celebration of African-American history, may be seen as a powerful response to the social issues of the day. In loving detail, *Lay This Laurel* documents Augustus Saint-Gaudens's *Shaw Memorial* (1897), located on the Boston Common, a sculptural tribute to the first black regiment in the Civil War and its white leader, Robert Gould Shaw. Benson's photographic details of this work (fig. 92) eloquently convey both Saint-Gaudens's genius and the human and historical importance of his subject.

Fig. 93 Richard Misrach, *Untitled*, 1977, 14¾ x 14½"

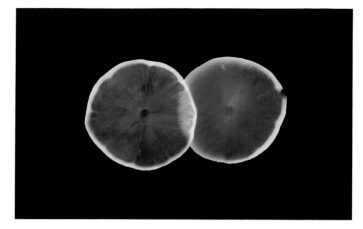

Fig. 94 Robert Heinecken, *L is for Lemon Slices*, 1971, hand-colored gelatin silver print, 5 x 8"

While such realist uses of the camera continued throughout the 1970s, another group of photographers was making gelatin silver prints by less conventional means. Uelsmann's sophisticated, surreal, and often humorous images presented a compelling alternative to the historic dominance of the "straight" aesthetic. The staged photographs of Tress and Michals and the composites of Metzker also challenged this tradition. Beginning in about 1970, Emmet Gowin began creating dreamlike vignetted images by using a 4x5-inch lens on his 8x10-inch camera. Other photographers, such as Paul Diamond, Roger Mertin, and Richard Misrach (fig. 93), employed a variety of techniques for expressive effect, including the use of flash in combination with lengthy exposures.

The appeal of such alternative practices stemmed in part from the rebellious mood of the era, which rendered suspect all forms of received authority, artistic as well as political. Just as important was the increasing presence of photography courses in university art departments. These programs encouraged innovation, individual expression, and a cross-pollination of ideas within the visual arts. The result, beginning in the middle of the 1960s, was a surge in work that employed various techniques to emphasize the uniqueness of the artist's hand and ideas. Photographers attempted to counter the dominance of the straight gelatin silver print by employing such unconventional techniques as hand-coloring and chemical staining; printing on fabric, vacuum-molded plastic, and other unusual materials; the use of the cyanotype, gravure, gum bichromate, and other archaic processes; and variations on conventional print techniques, like lithography, etching, and silkscreen. These innovative approaches were featured in such early exhibitions as "The Persistence of Vision" (1967), curated by Nathan Lyons at the George Eastman House, and "Photography Into Printmaking" (1968) and "Photography Into Sculpture"

(1970), both organized by Szarkowski's assistant, Peter Bunnell, at the Museum of Modern Art.

Typical of this spirit of technical and artistic experimentation is the work of Robert Heinecken and his circle. Trained in printmaking, drawing, and design, Heinecken began his lengthy teaching career at UCLA in 1960. In 1962, he instituted a graduate curriculum in photography as part of the university's department of art. This program soon became one of the most influential in the country. In words strongly reminiscent of Moholy-Nagy, Heinecken suggested a spectrum of ways in which the expressive possibilities of photography might be extended:

> The manipulation of time and space; experiments with various interpretations of motion and speed; the possibilities of repetition and changing images; the viewing condition of the print; the surface on which the image is formed; the reassembling of photographic images; the montage; and the multiple possibilities of combining photographs with other media and materials.[31]

Among the many experimental photographers who either taught or studied at UCLA were Robert Cumming, Darryl Curran, Robert Fichter, Judith Golden, Ellen Brooks, and Robbert Flick.[32]

Although he was known as a photographer, Heinecken rarely used conventional photographic materials, or even a camera.[33] Instead, his work took a variety of unorthodox forms: film transparencies hung several inches from the wall, photographic sculptures that could be rearranged by viewers, and hand-colored photograms of food items (fig. 94). Heinecken was particularly interested in appropriating and transforming images from the mass media. During the mid-1960s, he made contact prints from individual magazine pages, creating enigmatic montages of the words and pictures on both sides of the page. In other cases, he randomly inserted pages of pornographic magazines into reconstructed copies of weekly news journals. This media-oriented approach to photography—as a critical method for gathering, rearranging, and transforming the images endlessly generated by contemporary culture—would prove especially relevant to other photographers in the 1970s and 1980s.

Technology and Process

This interest in the nature of imagery was stimulated by all manner of cultural images, including those produced for scientific purposes. The widely published photographs generated by the U.S. space program, particularly those made by unmanned satellites and robot landing craft, were fascinating for the strangeness of both their subjects and their technical means.[34] For example, each photograph that the Viking lander beamed back from the surface of Mars was composed of hundreds of sequential vertical scans made over an interval of some sixteen minutes. The elaborate panoramas made between 1966 and 1968 by the Surveyor landing craft, as part of NASA's search for a suitable site for a manned landing on the moon, were particularly interesting. Each Surveyor probe made a lengthy series of still television images with the aid of a rotating mirror assembly. These numerous exposures were individually televised back to earth, rephotographed from video monitors, reconstituted as standard gelatin silver prints, numbered, and assembled into complex composites on a specially prepared grid (plate 152).[35]

Spurred by images such as these, photographers of the time explored the picture-making possibilities of many new technologies and imaging systems, including photocopy machines, which were pressed into artistic service by Keith Smith, Sonia Landy Sheridan, and others.[36] Despite the enthusiasm with which such devices were embraced, however, the artistic results were relatively meager. Far more successful in this regard was the work of William Larson. While still a graduate student at the Institute of Design, in 1967, Larson devised a camera that made images by slowly scanning across its subject, the human figure. The duration of these exposures allowed Larson's models to move repeatedly, creating odd figurative "landscapes." In 1969, he became interested in the visual potential of the Graphic Sciences Teleprinter, a sophisticated descendant of the wire-photo transmitters of the 1930s. This teleprinter scanned photographs, transforming their visual data into a sequence of sounds which, as electrical impulses, were transmitted over telephone lines and reconverted into pictorial form as electrocarbon "drawings." In his 1971-78 "Fireflies" series, Larson utilized the peculiarities of this device to make pictures composed of old snapshots, bits of text, and the marks made by the sounds of music and speech (fig. 95). The results are ethereal and poetic, with the quirks of the process suggesting "the imperfect operations of memory or dreams."[37]

The career of Thomas F. Barrow synthesizes many of these themes.[38] Fascinated by the variety and meaning of mass-produced images, Barrow has worked in a number of related series since the early 1960s. In 1963, during his studies with Siskind at the Institute of Design, he began making photogram prints of the pages of fashion magazines. By 1968, he was recycling images from popular culture by producing complex multiple exposures of pictures on television screens, and by making murky, negative collages of found images on an antiquated Verifax photocopy machine.

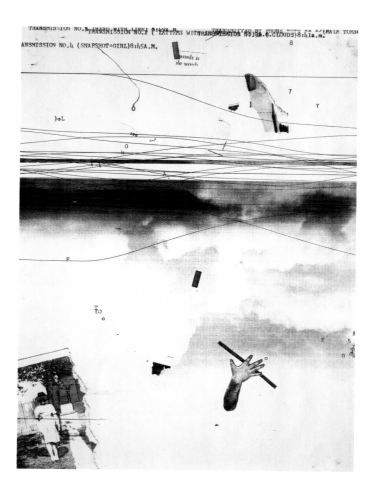

Fig. 95 William Larson, *Electrocarbon Drawing* ("Fireflies" series), 1975, electrocarbon print, 10⅞ x 8½"

This curiosity about the fundamental nature of photographic images led Barrow to perhaps his most important series, his "Cancellations" of the mid-1970s. Each of these flatly descriptive records of artifacts or places is scarred by a deliberate, hand-rendered "X" (fig. 96). This seemingly simple act of negation creates images of considerable intellectual tension that simultaneously assert and deny their own veracity. The result is a provocative reminder of the difference between the world and our representations of it. The importance of this theme in modern art and philosophy may be suggested, for example, in the observation of literary critic Gerald Graff that "it is characteristic of literature 'in its essence' to put a sign of cancellation upon its own apparent referentiality."[39]

The most witty and elegant meditation on the self-reflexivity of representation may be Kenneth Josephson's work of the late 1960s and early 1970s. The most remarkable of these pictures is his *Stockholm*, 1967, a deceptively complex record of a parked automobile (plate 158). The subject of this unmanipulated photograph is easily described: an overnight dusting of snow was partially melted by the morning sun; incoming clouds then stopped the process, preserving those patches of snow that had not been struck directly by the sun. As Josephson recognized, this conjunction of object and image—the car and its shadow—provides an uncanny metaphor for photography itself. In fact, Josephson's picture documents the most primal form of the process: a

Fig. 96 **Thomas F. Barrow,** *f/t/s Cancellation: Art site,* 1977, 13½ x 19¼"

natural photogram. The correspondence between the car and its shadow emphasizes both photography's tracing of the real and its inherent abstraction: three dimensions are reduced to two and (as in the production of a photographic negative) light and dark tones are reversed. This line of thought prompts the further realization that Josephson's photograph bears approximately the same relationship to the original scene as the curious shadow of snow bears to the car. The result is a deft reminder of both the "realism" and the profound strangeness of a medium too easily taken for granted.

A very different, but equally compelling meditation on the nature of representation is the work of Hiroshi Sugimoto, a Japanese-born resident of New York City. In the late 1970s, Sugimoto began photographing the interiors of Art Deco movie theaters, using a large 8x10-inch camera to achieve pellucid clarity (plate 159). Beyond the superb documentation they provide of these vanishing architectural spaces, Sugimoto's photographs represent metaphors for the film experience itself. The exposure for each of these images matched the actual running time of the feature film being projected, about ninety minutes. Thus, the white rectangle of the screen reduces an entire narrative—the incidents, emotions, and pleasures of a complete film—to a single, radiant moment. Simultaneously empty and full, the glowing screen suggests the magic of light and the infinite possibilities of vision.

Color

One of the consequences of the experimental climate of the 1960s and 1970s was a new interest in the artistic uses of color photography. Since the introduction of the first practical color processes in the 1930s, color had been considered almost entirely unsuitable for serious art photographers. This resistance stemmed from the instability of early color materials, the technical difficulties involved, and the cost of the processes themselves. These constraints placed a heavy burden on those few pioneering photographers, like Arthur Siegel, who chose to devote themselves to color. In the late 1940s and early 1950s, Siegel showed his work primarily in the form of projected slides in his public lectures. When he

made color prints from some of these slides for a one-man exhibition at the Art Institute of Chicago in 1954, the extreme cost of the dye-transfer process prohibited him from printing more than a handful of images. Even at that, it took Siegel "years to pay off the debts he incurred in producing these prints and he never had another group of dyes made."[40]

Color was also stigmatized by its close identification with commerce. Color photography arose in the 1930s as a tool of advertising, and was typically employed in garish, decorative ways. As one recent critic notes, commercial photographers of the 1930s—such as Paul Outerbridge, Nicholas Muray, and Anton Bruehl—specialized in "adventurous, campy photographic illustration that laid on color like maple syrup."[41] In the years after World War II, most commercial photographers made some use of color in their assignments. In addition, the Eastman Kodak Company encouraged several noted photographers to take up color—including Weston, Adams, Strand, Sheeler, and Evans—by giving them free boxes of 8x10-inch Kodachrome film.[42] Despite some initial enthusiasm, however, most of these photographers remained unconvinced of color's artistic merits. André Kertész, who used color without enthusiasm in his commercial work, felt it was fundamentally impure and hampered by a variety of negative associations. In 1951, he observed,

> In all of our color work, we cannot help but be influenced by thousands of years of great painting; this history of art in our consciousness imposes itself upon color work. Black and White photography, on the other hand, is pure photography. It is a well developed medium that stands by itself, different from painting, but just as pure.[43]

Walker Evans's comments on color photography, in 1969, were even more scathing:

> Color tends to corrupt photography and absolute color corrupts it absolutely. Consider the way color film usually renders blue sky, green foliage, lipstick red, and the kiddies' playsuit. These are four simple words which must be whispered: color photography is vulgar.[44]

Given the prevalence of these sentiments, it is not surprising that only a few photographers made serious artistic use of color. In the final years of the FSA, Stryker had his photographers experiment with the new Kodachrome process and some 700 color images were added to the vast files of the agency. Naturalist Eliot Porter took up color photography in the late 1930s, working almost exclusively with the laborious dye-transfer process until his death in 1990.[45] Significantly, however, his work received little attention until the publication of his first book in 1962. In the 1950s and early 1960s, a smattering of museum exhibitions and publications recognized such photographers as Siegel, Porter, Ernst Haas, Eliot Elisofon, Syl Labrot, and Marie Cosindas for their dedication to color.[46] By and large, however, most photographers considered color simply unworthy of serious attention.

This state of affairs changed radically in the early 1970s. By that time, many of the technical difficulties had been

eliminated from the color process and the cost of materials greatly reduced. Further interest was generated by the availability of new formats, such as the Polaroid SX-70, introduced in 1972. More than anything, though, it was the sheer ubiquity of color imagery in American life that forced photographers to think chromatically. Color motion pictures were the norm by this time and color television was growing rapidly in popularity. By 1965, the sale of color film had surpassed that of black and white in both the amateur and commercial markets.[47] Color photography's former liabilities had now become distinct advantages: color marked a clear break with the artistic values of photography's past, while engaging contemporary life on its own visual terms. The abruptness of this shift in attitude is symbolized by Walker Evans's enthusiastic turn to color in 1972, only three years after he had declared it unspeakably vulgar.

A young friend of Evans's, painter William Christenberry, began making color photographs in 1960. For many years, he used a simple Brownie camera to take pictures that served as references for his paintings; color was a natural part of his essentially documentary process. When he turned from the simple Brownie to an 8x10-inch camera in 1977, it was only to achieve a higher level of specificity. The central theme of Christenberry's art has always been his own geographic and cultural roots: he was born in Hale County, Alabama, in 1936, the year Evans and Agee visited there. Even while living and teaching in Memphis (1962-68), and Washington, D.C. (since 1968), Christenberry has returned to Hale County every year to record its slowly changing landscape and structures. He has recorded many buildings and sites repeatedly, capturing progressive stages of their physical decrepitude. These straightforward and unpretentious photographs represent an extended meditation on time, memory, mortality, and entropy. The abandoned farmhouse depicted in Christenberry's *Window, near Stewart, Alabama, 1988* (plate 173), had once been the home of his grandparents. While this association explains Christenberry's interest in the structure, his photograph achieves a universal significance by suggesting myriad similar images that live in the flickering light of individual memory.

Joel Meyerowitz, one of the best-known color photographers of the 1970s, began in the black-and-white, 35mm street-photography tradition of Cartier-Bresson, Frank, and Winogrand. By the late 1960s, however, Meyerowitz had turned to color for its increased power of description and invention. As he later recalled,

> When I committed myself to color exclusively, it was a response to a greater need for description.... Color plays itself out along a richer band of feelings—more wavelengths, more radiance, more sensation....Color suggests more things to look at [and] it tells us more. There's more content [and] the form for the content is more complex.[48]

After producing an influential series of 35mm street pictures in color, Meyerowitz dramatically shifted format and subject. Beginning in the summer of 1976, he used an 8x10-inch cam-

era to photograph in and around his family's cottage on Cape Cod. Discarding the ambiguities of his street images for a more poetic, even romantic, celebration of the pleasures of seeing, Meyerowitz's Cape Cod photographs concern themselves with the rhythms of day and season. In his "Bay Sky" series (plate 172), Meyerowitz photographed repeatedly from the same vantage point, exploring the ever-changing appearance of sand, water, and sky from morning until dusk and in all kinds of weather. The central subject of these images is the mercurial, endlessly transformative beauty of light itself. From the precise description of the most fleeting and subtle visual effects, these photographs celebrate a new subjectivity based on the "discovery of charged moments of luminescence in the real world."[49] This work was collected in *Cape Light* (1978), one of the most popular photographic books of the era.

William Eggleston's turn to color, in the late 1960s, was triggered by his appreciation for the early color work of Christenberry and Meyerowitz. Eggleston had begun making black-and-white photographs in about 1959, inspired by Cartier-Bresson's famous book, *The Decisive Moment* (1952).[50] His pictures of the 1960s suggest the subsequent influence of Frank, Winogrand, Friedlander, and Arbus. Then, in the late 1960s, Eggleston began a powerfully idiosyncratic documentation of the American South. Working in relative isolation in and around his home in Memphis, Eggleston made what appeared to be casual—even careless—pictures of thoroughly banal subjects: parked cars, a dog lapping water from a puddle, the inside of an oven, unnamed subjects posing warily on the street or in backyards, a child's tricycle on a suburban sidewalk (plates 170, 171).

This work remained relatively unknown until 1976, when the Museum of Modern Art mounted a large, seventy-five print exhibition of Eggleston's pictures.[51] The catalogue, *William Eggleston's Guide* (1976), contained forty-eight reproductions and a polemical text by John Szarkowski. In his essay, Szarkowski claimed that Eggleston had virtually invented the art of color photography. Prior to Eggleston, Szarkowski wrote, color photographs were "either formless or pretty," that is, they used color either as an unnecessary addition to an essentially monochromatic vision or to make pictures that were merely attractive, without real content. In Szarkowski's view, Eggleston's importance lay in his bold acceptance of the fact that "the world itself existed in color, [that] the blue and the sky were one thing." The result, he pronounced, were pictures that were "perfect: irreducible surrogates for the experiences they pretend to record, visual analogues for the quality of one life."[52] This extravagant praise triggered a flurry of heated responses. Art critic Hilton Kramer wrote of Eggleston's pictures, "Perfect? Perfectly banal, perhaps. Perfectly boring, certainly."[53] Photography critic Gene Thornton cited the exhibition as "the most hated show of the year."[54] Despite the unevenness of his subsequent pictures, Eggleston's obstinately intelligent work has come to be recognized as a powerful extension of the artistic tradition epitomized by Evans, Frank, and the New Documents photographers.

Art and Photography

A new interchange between art and photography began to develop around 1970, strongly influenced by the use of photographs in the work of artists such as Robert Rauschenberg, Andy Warhol, and Ed Ruscha. As early as the mid-1950s, Rauschenberg (who began his career as a photographer) incorporated photographs and photographic reproductions into both his paintings and the painting/sculpture hybrids he called "combines." In 1962, he began making large silk-screen paintings consisting of collages of photographic imagery overlaid with gestural strokes of paint. Rauschenberg's choice of photographic subjects ranged from the personal and enigmatic to images of current events and personalities lifted from the daily press. This "aesthetic of heterogeneity" provided an enormously fertile means of picturing the vitality, complexity, and confusion of contemporary life.[55]

In 1962, Andy Warhol adopted the photo-silkscreen process to make huge paintings composed of enlarged and repeated photographs taken from the tabloid press. Characteristic of these were his "Disaster Paintings" of 1963, which presented flat, multiplied depictions of car wrecks, electric chairs, and other scenes of real or implied violence. The idea of mass production lies at the heart of both the subject and the means of Warhol's art. He was interested in the sheer quantity of images in modern life, and in the way meaning is flattened and abstracted through repetition. As suggested in such characteristic late works as *Lana Turner*, 1976-86 (plate 163), Warhol was also fascinated by our media-fueled cult of celebrity, a phenomenon at once reverential and ghoulish in nature.

Avoiding the often charged subject matter, expressionist gestures, and ambitious scale of the works of Rauschenberg and Warhol, Los Angeles artist Ed Ruscha instead used photography for its most basic, record-making function. Throughout the 1960s, Ruscha created a series of small photographic books, including *Twenty-Six Gasoline Stations* (1962), *Various Small Fires and Milk* (1964), *Some Los Angeles Apartments* (1965), and *Every Building on the Sunset Strip* (1966). These inventories of supremely banal visual "facts" are both delightful and absurd, suggesting the lingering influence of the Dadaist Marcel Duchamp. The apparent stylelessness of these photographs—their utter lack of emotional engagement and visual sophistication—was central to Ruscha's purpose. Uninterested in photographic art, he instead made art from what appeared to be the most anonymous, automatic, and unexpressive of mediums: the vernacular photograph.[56]

Among the most literal examples of the influence of photography on art are the Photorealist paintings of Chuck Close. Between 1968 and 1970, Close produced seven 9x7-foot paintings, each made by carefully copying the data from a gridded photograph onto a canvas. His first painting was a self-portrait; the others record the faces of friends. More precisely, the paintings depict Close's photographs of these sub-

jects; his "models" were pictures, not individuals. As a result, the paintings are as monochromatic and as unflatteringly "democratic" in their description as passport photographs. Fascinated by such peculiarities as the "sharp-focus data within a sandwich of blur" created by the camera's limited depth of field, Close painted the forehead, eyes, and mouth of each of his giant faces in crisp detail, while the tip of the nose and the ears were muted.[57] Indeed, a central theme in Close's work is the abstract nature of photography, the way it turns familiar faces into strangely foreign topography. One of his early subjects, artist Joe Zucker (plate 162), responded in kind, transforming his appearance in order to "participate in the painting." As Close recalls,

> When I went to pick [Zucker] up to photograph him, I didn't recognize him. He has curly, blond, bushy hair—but he had bought a jar of Vaseline, greased his hair down, borrowed someone's white shirt and tie, someone else's glasses and he looked like a used car salesman. He understood that all he had to do was provide me with the evidence that someone like that existed for a 100th of a second. It didn't necessarily have to be him, he didn't have to identify with it. After the photo session he went home and washed the grease out of his hair and went back to life as usual.[58]

Zucker's deliberate alteration of his appearance astutely underscored one of the central themes of Close's work: photographs are not reality, but they are a real and ubiquitous part of modern life.

If Close's works are deliberately cool and neutral, Lucas Samaras's are intensely subjective, theatrical, and expressionistic. Though he works in a variety of artistic mediums, including sculpture, painting, and photography, Samaras has always taken himself as his subject; as critic Peter Schjeldahl has written, Samaras is "the artist laureate of narcissism."[59] His larger theme is the modern self, which he views as multiple in nature, and open to almost endless reinvention. As Samaras has written, "When I say 'I,' more than one person stands up to be counted."[60] Not surprisingly, then, Samaras's first major body of photographs was a series of "AutoPolaroids," begun in 1969, which depict him in a great variety of poses, clothed and nude.[61] In 1973, he began using the Polaroid SX-70, and discovered that by kneading the print with his fingers he could manipulate the emulsion of the developing image. This technique created highly expressionistic images that combine bits of photographic detail within painterly smears of color. Samaras's *Figure*, 1978 (plate 165), is an 8x10-inch Polaroid treated in a similarly unconventional manner: it combines a single exposure on the left half of the image, a double exposure on the right half, and a layer of ink dots applied over the entire surface. Like much of Samaras's work, this fractured, obsessive image suggests a hallucinatory meditation on the tensions between presence and absence, fact and fantasy, madness and invention.

Among artists using photography in the 1960s and 1970s, Samaras's intense focus on the expressive self-portrait was strikingly unusual. More typical was an interest in the

cultural uses of photography or, even more generally, an acceptance of photographs as simple documents. Thus, the photographic elements in the paintings of Rauschenberg and Warhol were primarily generic images taken from the mass media. Similarly, Ruscha's photographs of gas stations and Close's portraits of friends looked utterly anonymous, devoid of any sign of traditional aesthetic intent. This notion of the archival photograph or the casual snapshot as loaded with cultural information, but untainted by the complexities or pretensions of traditional art, held a powerful appeal for other artists of the early 1970s. Rejecting accepted notions of the art work as commodity, these artists made extensive use of photography for documenting performances, site-specific Earthworks, or process art. For example, knowledge of Robert Smithson's celebrated *Spiral Jetty* (1970), a 1,500-foot-long spiral of earth and rock in the Great Salt Lake, is due almost entirely to the photographs made of it by Smithson and others. Similarly, many temporary or remote Earthworks by Michael Heizer, Dennis Oppenheim, Nancy Holt, and others were primarily experienced through photographs displayed in galleries or reproduced in magazines and books.

The sculptor Gordon Matta-Clark went further in his use of photography, treating it as a means of expression as well as documentation. Matta-Clark studied architecture at Cornell in the mid-1960s, but rejected it for an artistic career dedicated, ironically, to the "deconstruction of architecture."[62] Matta-Clark's signature work, *Splitting* (1974), involved the physical transformation of a small, abandoned house in Englewood, New Jersey. Matta-Clark literally sawed this nondescript dwelling in half, from rooftop to basement. He then canted one side of the structure slightly, opening a narrow, V-shaped wedge in the middle. The "cuts" into the structure created a strange new sense of light and space as the normal boundaries between inside and outside were broken. The result was an object of surprising conceptual and visual power: a vacated home, stripped of its associations of shelter and family, transformed into something provocative, unstable, and ephemeral. Matta-Clark memorialized this work in a series of powerful photographs, including *Splitting: Interior*, 1974 (plate 164), a composite of three partially overlapping views. The eccentric form and twisting perspective of this photograph perfectly evoke the disjunctures of the altered house, and confirm artist Joseph Kosuth's observation that Matta-Clark "used the camera like he used a buzz saw."[63] Sadly, Matta-Clark's career ended only four years later, when he died of cancer at the age of thirty-five.

Conceptual artists like Kosuth, Dan Graham, Hans Haacke, and Douglas Huebler used photography simply to give tangible form to their otherwise purely cerebral works of art. For Huebler, the camera was a neutral recording device. The text of his *Variable Piece No. 70*, 1971, reads: "Throughout the remainder of the artist's life he will photographically document, to the extent of his capacity, the existence of everyone alive in order to produce the most authen-

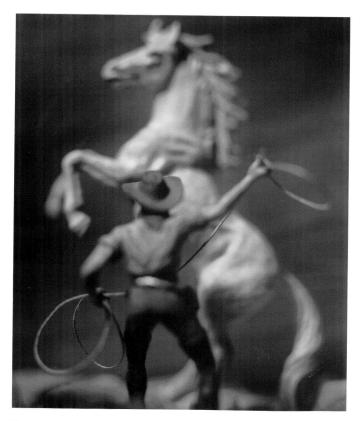

Fig. 97 David Levinthal, *Untitled* ("Western Series"), 1988, Polaroid print, 24 x 20"

tic and inclusive representation of the human species that may be assembled in that manner."[64] Of course, Heubler's point was not to actually record the entire world's population, but to stimulate thought on the impossible scale of the project, the meaning of visual documents, and the illusory order of the archive. The aesthetic banality of Huebler's photographs only emphasized the primacy of these larger, abstract goals.

Questions of reality and illusion also underlay Robert Cumming's photographic work of the early 1970s. Although primarily interested in painting and sculpture during his M.F.A. studies at the University of Illinois in the mid-1960s, Cumming took photography courses with Art Sinsabaugh. At that time, Sinsabaugh's purist approach was of little interest to Cumming. But by 1970, Cumming had turned to photography as the primary medium for his increasingly conceptual art. Using his experience in sculpture, Cumming constructed odd subjects specifically to be photographed. The themes of the resulting images included "out-and-out illusionism and magic tricks, satires on the misreading of natural phenomena, and sardonic commentaries on the history of art and photography."[65] Cumming's *Mishap of Minor Consequence*, 1973 (plate 166), for instance, consists of two 8x10-inch contact prints that appear to represent Edgerton-like, stop-action images of a bucket being thrown from a falling chair. On close inspection, however, the fictional nature of this subject becomes obvious: the strings that hold the bucket and chair in place are clearly visible. Thus, the diptych is seen to represent sequential views of a static subject, not simultaneous records of a single moment in time. The

patently "fraudulent" nature of the events Cumming records is undercut by the meticulous detail of his 8x10-inch prints, creating a situation in which the viewer is compelled to first question and then to affirm the "truth" of visual experience.

William Wegman also sought to undercut the solemnity of much Conceptual Art with absurdity, mock scientific data, and a self-deprecating acknowledgment of failure. His *Three Mistakes*, 1971-72, is a flat-footed black-and-white photograph of three puddles of milk beside three empty glasses. By traditional standards, Wegman's photographic skill appeared to be as inept as the spills he recorded. In fact, of course, the "mistakes" were deliberate and the seemingly straightforward photograph a constructed fiction. The result is a sly commentary on the idea of artistic mastery, control, and ambition. Wegman went on to make similarly wry photographs and videotapes of his dog, Man Ray, in a variety of farcical situations. Wegman's technically pristine 20x24-inch Polaroids of Man Ray, begun in 1979, brought him widespread popular recognition.

Another young artist who made constructed photographs in the early 1970s was David Levinthal, a student at Yale School of Art. Fascinated by the power of the camera to both document and transform, Levinthal began recording miniature toy soldiers in simple "landscapes" of his own devising in 1972. When this series came to the attention of fellow student Garry Trudeau, the two decided to collaborate on a book, which they titled *Hitler Moves East: A Graphic Chronicle, 1941-43* (1977). At once factual and metaphoric, lyrical and ominous, these purported "documents" of the eastern theater of World War II highlight the slippery nature of photographic truth. Levinthal's "Wild West" series, begun in 1986, was inspired by his childhood love of western films and television programs. He recorded miniature cowboys and horses with a large 20x24-inch Polaroid camera, using this device's shallow depth of field to heighten the ambiguity of his subjects (fig. 97). These images, like the frontier myths they evoke, are both artificial and iconic, a product of documentary fact and nostalgic invention.

John Baldessari was less interested in making photographs than in choosing them from the vast image-bank of popular culture. He was particularly fascinated by the theatricality and narrative ambiguities of old film stills, which were available in great quantity in Los Angeles, where he has lived and taught for many years. In the early 1980s, Baldessari achieved widespread recognition for his witty juxtapositions and transformations of these found images. *Life's Balance (With Money)*, 1989-90 (plate 167), is characteristic of the wise playfulness of Baldessari's approach. A montage of three black-and-white images with applied color, *Life's Balance (With Money)* suggests a fractured narrative involving such themes as public performance, odd skills, uncertainty, giddy decadence, and the power of money. Works such as this convey Baldessari's deep interest in the dualities of order and chaos, meaning and nonsense, and demonstrate why he had such a strong influence on the subsequent generation of Postmodern artists.

The interchange between the worlds of art and photography represented an active, two-way dialogue. Just as painters and sculptors made increasing use of the camera, so too did many photographers draw from the techniques or concepts of the art world. Due in part to the influence of the university, young photographers became increasingly aware of the issues being explored in contemporary painting and sculpture. They applied these concerns to their own medium in various ways, from the literal application of paint on photographic prints to the making of "straight" images inspired by specific artistic concerns. One example of this artistic influence may be seen in the impact on photography of the Minimalist movement of the late 1960s and early 1970s. In various ways, for example, the photographs of Leland Rice, Lewis Baltz, and Ralph Gibson are informed by a sympathy for the rigorous simplicity of Minimalist painting and sculpture. Rice's *Untitled (White Door)*, 1973 (fig. 98) focuses intently on a scene that, by traditional standards, seems devoid of content. In fact, the "content" of Rice's image is largely its form: the graceful interplay of shape and tone. Baltz's rectilinear *West Wall, Unoccupied Industrial Structure*, 1974 (plate 160), is equally concerned with precisely-delineated formal relationships. While Baltz eschews any hint of emotion or subjectivity, Gibson employs a highly reductive vision to evoke a sense of mystery and dream. Gibson's *Face*, 1981 (plate 161) eloquently demonstrates his ability to create poetic, allusive images from disembodied vignettes of visual experience.

Postmodernism

Postmodernism is a critical and cultural movement born from the artistic pluralism of the 1970s and fueled by a wide range of linguistic, Marxist, and feminist theories.[66] While resistant to easy summary, Postmodernism sought to use literary and visual "deconstruction" to subvert modernism's "mythologies" and to illuminate the social context of production and reception which structures the meaning of all representations. The Postmodern view rests on several basic concepts. These include the centrality of the structure of language to our understanding of the world, and the corollary idea that all representations only refer to other representations in a circular process of signification. Postmodernism highlighted the idea that the governing "codes" or "myths" of culture are embodied in and transmitted by the mass media. By subverting these representations in various ways— such as displacing them from their original context—it was hoped that one could expose or critique their ideological function. Such key modernist notions as the singularity of artistic genius, the significance of originality, and the purity of individual mediums were understood to be undercut by the use of such self-conscious Postmodernist practices as appropriation, pastiche, and montage.

As an omnipresent element of postwar visual culture, photography plays a central role in Postmodern art. For Postmodernists, however, the goal is to investigate the cultural

Fig. 98 Leland Rice, *Untitled (White Door)*, 1973, 17⅜ x 13⅝"

functions of photography rather than to create their own purist images. In 1977, for instance, Richard Prince began rephotographing details of magazine advertisements, presenting cropped and enlarged images of the Marlboro Man or the Kool-Aid pitcher in order to highlight both their strange, weightless perfection, and their fundamentally mythic nature. Even more extreme were the appropriations of Sherrie Levine, who targeted celebrated male photographers such as Walker Evans and Edward Weston. When she exhibited unaltered photographic copies of their works under her own name, she sought to challenge fundamental assumptions about creativity and originality. Prince and Levine suggest that, in a world glutted with images, all depictions of "reality" are shaped by preexisting models. For artists, then, one meaningful course of action lay in attempting to understand the way these models shape assumptions and stereotypes, and to challenge them by recycling existing images with an explicitly critical intent.

Cindy Sherman also employs photography to explore ideas of stereotype, myth, and identity. In her first important body of work, the "Untitled Film Stills" of 1977-80 (plate 184), Sherman used herself as the model for a group of about seventy-five 8x10-inch black-and-white photographs. With the aid of wigs, makeup, thrift-store outfits, and other props, Sherman transformed herself into a cast of half-imagined, half-remembered "types" based on characters from 1950s B-movies, television shows, and fashion magazines: dancer, student, working-class housewife, decadent sophisticate, and lonely professional woman. As critic

Andy Grundberg points out, this work is deliberately gender-specific, relating "to female cultural roles and to female sexuality, to the glances and body language that signal availability, vulnerability, narcissism, hurt and resentment."[67]

These pictures are remarkably complex in meaning. Sherman's poses are so ambiguous and replete with narrative possibilities that they encourage the imaginative engagement of viewers. These images create a curious synthesis of authenticity and artifice, "irony and an almost sentimental sincerity."[68] Sherman earnestly and accurately recreates characters that are meaningful only for their fundamental unreality as stilted, generic abstractions. She mimics these "types" with both facility and sympathy, thus generating an intriguing tension between the dualities of performance and performer. As critic Peter Schjeldahl has written,

> To say that Sherman "gets inside" her characters is to state the simple truth. In each case, the "outside"—costume, wig, makeup, props—is a concise set of informational cues for a performance that is interior, the dream of a whole, specific life registering in a bodily and facial expression so right and eloquent—albeit "blank," "vacant," and "absent-minded"—as to trigger a shock of deep recognition.[69]

What Sherman seems to deny is the existence of any stable, singular identity behind these masks: there is no "real" Cindy Sherman. Instead, she suggests, the contemporary (postmodern) self is an amalgam of cultural echoes and reflections, kaleidoscopic in its possibilities, but without a unifying sense of subjective identity.

Since the "Untitled Film Stills," Sherman has continued to create photographs of unexpected and unsettling power. Her subsequent series include the "Rear Screen Projections" of 1980, which combine Sherman's characters with deliberately flattened and unconvincing cinematic backdrops; the "Centerfolds" of 1981, which utilize the elongated format of the magazine pinup; and her "History Portraits" of 1988-90, in which she cleverly depicts herself in the guise of Old Master paintings, playing both male and female roles with the aid of elaborate costumes and makeup. Since the mid-1980s, Sherman has exhibited an increasing preoccupation with monsters, sex, death, and decay, creating images that range in mood from the melancholy to the deliberately vulgar. Sherman has increasingly removed herself from these most recent scenes, focusing instead on mannikins and detritus. These various series made Sherman one of the most notable photographic artists of the 1980s. She received a Guggenheim fellowship in 1983, and was the subject of major retrospectives at the Stedelijk Museum in Amsterdam in 1982 and at New York's Whitney Museum in 1987.

Barbara Kruger's work reveals a similar concern for the process by which individual identities are constructed through representations and stereotypes. During her studies at Parsons School of Design in the mid-1960s, Kruger took classes with Diane Arbus and Marvin Israel. With Israel's encouragement, she expanded her awareness of contemporary photography and design, and secured a job as graphic

designer for the Condé Nast magazine *Mademoiselle*. In her four years in this position, Kruger grew adept at the manipulation of typography and pictures for maximum visual impact. In addition, she became familiar with what author Kate Linker calls advertising's "choreography of seduction," or, in Kruger's own words, its "brand of exhortation and entrapment."[70]

A decade later, Kruger applied these experiences to a series of bold, graphic works that combine words and pictures (plate 195). These highly confrontational images deliberately suppress any obvious evidence of the artist's hand or personality. As critic Allan Sekula observed in an influential essay in 1975, "The overwhelming majority of messages sent into the 'public domain' in advanced industrial society are spoken with the voice of anonymous authority and preclude the possibility of anything but affirmation."[71] By mimicking and transforming this mode of address, Kruger strives to both exploit and undercut its effectiveness. Kruger gives this voice of anonymous authority an accusatory, feminist tone, most often addressed to a "you" that may be either singular or plural, but which is implicitly male. Her phrases are crisp, oblique, and allusive, suggesting a pervasive climate of sins and subjugations: "Who is bought and sold?," "Who is beyond the law?," "We won't play nature to your culture," "Your gaze hits the side of my face," "Your manias become science." The themes of this work include surveillance, control, consumption, and all manifestations of power: physical, sexual, financial, and military. In *Untitled (You Get Away With Murder)*, 1987 (plate 195), Kruger transforms what appears to be a World War II-era poster (for recycling?) into an evocation of individual and cultural violence. The ominous ambiguity of this image provides ample room for the free play of both the resentments and the guilty consciences of viewers.

While Kruger's art bristles with accusation and challenge, James Casebere's photographs are coolly contemplative. Before he turned to photography, Casebere worked briefly as a studio assistant to Claes Oldenburg, the Pop artist best known for his monumental sculptures of such mundane objects as clothespins, umbrellas, and badminton birdies.[72] This influence may be sensed in the sculptural aspect of Casebere's mature work, and in his own subtle transformations of scale. In about 1979, Casebere began creating generic scenes or environments in the form of tabletop sculptures of foamcore and plaster. These were made to be photographed, with the black-and-white print—rather than the sculpture—serving as the work of art. Since the mid-1980s, he has also presented this work in the form of backlit transparencies and has occasionally exhibited his "models" as finished sculptures.

Casebere's subjects are distinctly American: rooms in bland suburban dwellings, mid-nineteenth-century factories and churches of the East Coast and South, and the ghost towns and landscapes of the West. In every case, Casebere renders these subjects as colorless, generic abstractions. His sculptures of these stereotypical settings are at once too

simplified to be "real" and too moody to be mistaken for toys. This curious slippage between reality and artifice suggests the mechanisms of memory, and the inevitable tendency of both individuals and cultures to cleanse, simplify, and revise the past. Like Casebere's other subjects, *Tenement*, 1992 (plate 193) is wholly synthetic, yet eerily familiar. It suggests a rich lineage of social-documentary photographs by Riis, Hine, Levitt, Davidson, and many others. But unlike that work, Casebere's photograph emphasizes the abstraction of this "tenement," its utter lack of specificity, in order to function as a generalized signifier of poverty and of home. We are thus prodded to reconsider all these previous photographs of tenements, to question the very meaning of that category, and to ponder other ways impoverishment might be recorded and interpreted. As with other Postmodernist photographers, Casebere explores the nature of representation itself and the ways in which images are inflected with intentions, opinions, and uses.

Although representation forms a central theme in Postmodern art, no definitive Postmodern "style" exists. Significantly, the use of certain formal strategies—such as rephotography, simulation, appropriation, pastiche, and the hybridization of mediums—was generally linked to a critical enterprise rather than a stylistic one. In 1983, for example, critic Hal Foster argued for a Postmodern art of active "opposition" to the cultural status quo, rather than one of merely "reactionary" affirmation. He wrote, "A resistant postmodernism is concerned with a critical deconstruction of tradition, not an instrumental pastiche of pop- or pseudo-historical forms, with a critique of origins, not a return to them. In short, it seeks to question, rather than exploit cultural codes, to explore rather than conceal social and political affiliations."[73] The value of this art was understood to lie exclusively in its "potential for institutional and/or representational critique, analysis, or address."[74]

The successes of this "pure" form of Postmodernism stem, in large measure, from its emphasis on the plurality of culture, and on the inherent worth of a broad range of life experiences and values. Beyond this, however, the artistic achievements of this oppositional mode of Postmodernism rarely matched the ambition of its rhetoric. A fundamentally academic movement, this art takes the model of the classroom critique and turns it on culture at large. In essence, the intuitive rebellion of the 1960s is refashioned as a scholarly, quasi-scientific enterprise—a romance of revolution acted out in the protected realm of the library, the lecture hall, and the gallery.[75] The primary medium of this branch of Postmodernism is criticism itself, with visual works too often employed primarily as textual illustrations. While these critical texts bristle with expressions of action (describing art with the ability to "ruin," "disrupt," "dismantle," "challenge," and "expose"), much of the work created in the service of this ambition is surprisingly inert, smugly moralistic, and political only in sentiment, not practice. The prickly thickets of theory on which this work is based are too often taken at face value, with little effort given to "deconstruct-

Fig. 99 **Lois Conner**, *St. George's Hotel, Brooklyn, New York*, 1991, platinum-palladium print, 6¾ x 16⅝"

ing questionable premises, inconsistencies of logic, and the obfuscations of jargon.[76]

Today, the gap between the modern and Postmodern seems narrower than it may have appeared a decade ago. While distinct as both an artistic movement and a mode of cultural thought, Postmodernism clearly has roots that extend deep into the soil of modernism. Thus, claims for an absolute rupture with the past are unconvincing, and the changes of the past twenty years may be best understood as differences of degree rather than of kind, evolutionary rather than revolutionary. As French philosopher Jean-François Lyotard has written,

> What, then, is the Postmodern?…It is undoubtedly a part of the modern. All that has been received, if only yester-day…must be suspected. What space does Cézanne challenge? The Impressionists. What object do Picasso and Braque attack? Cézanne's. What presupposition does Duchamp break with in 1912? That which says that one must make a painting….A work can become modern only if it is first postmodern. Postmodernism thus understood is not modernism at its end but in the nascent state, and this state is constant.[77]

Themes and Variations: Photography Until Now

What seems most characteristic of the photography of the last ten or twenty years is its sheer heterogeneity. The best recent work is both modern and Postmodern in outlook, personal and political in intention, purist and hybrid in technique. No compelling evidence suggests that any one of these approaches is more (or less) capable of worthy expression than any other. One artist's use of a computer, for example, does not invalidate the choice of another to use the most cumbersome and anachronistic techniques: in Lois Conner's case, for example, a 7x17-inch view camera and hand-made platinum paper (fig. 99). In many respects, the creative flavor of the time depends precisely on such contrasts—the realization that, at the time young Cindy Sherman was first showing her photographs, octogenarian André Kertész was still avidly working, producing the best pictures of the last half of his long career (fig. 100). Therefore, rather than identifying a single dominant sylistic trend over the past

decade or more, a better way to understand the variety and complexity of recent American photography may be to concentrate on three broad thematic patterns: representation, landscape, and identity.

Representation and Invention

The expressive vocabulary of the photographic process has continued to provide a fruitful means of expression for artists such as John Gossage. His interest in photography began at an early age and was nurtured by private studies with W. Eugene Smith, Lisette Model, Alexey Brodovitch, and Bruce Davidson.[78] Gossage's first exhibition, mounted in 1963, when he was only seventeen years old, was comprised of Frank-inspired street pictures. His work since that time

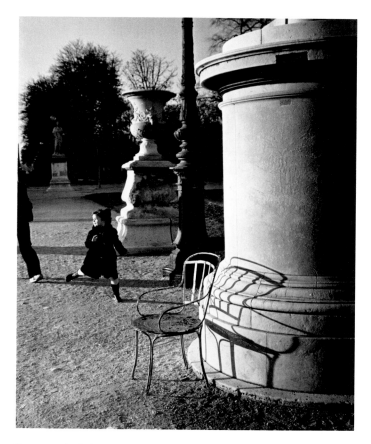

Fig. 100 **André Kertész**, *Paris*, November 9, 1980, 9¾ x 7¾"

Fig. 101 **John Gossage**, *Zimmerstrasse Richtung Osten Blickend*, 1984, 22 x 18″

Fig. 102 **Michael Spano**, *Fruit Cup*, 1989, 45¼ x 35⅜″

demonstrates complexity, irony, and austere intelligence. In the mid-1980s, Gossage often photographed in Berlin, where he made a total of some 10,000 images. The most powerful of these, collected in a limited-edition book titled *Stadt des Schwarz* (1987), are hand-held night exposures that explore the bottom registers of the photographic scale. For example, his image of the Berlin Wall, *Zimmerstrasse Richtung Osten Blickend*, 1984 (fig. 101), made at a time of tense diplomatic relations between the super powers, is appropriately haunting and oppressive. Gossage uses the subtleties of exposure to depict the wall as both a presence and an absence, a physical barrier as well as a sign of political and intellectual bankruptcy.

A penchant for experimentation, inspired by the new vision photographers of the 1920s, underlies the varied work of Michael Spano and Ruth Thorne-Thomsen. In the past decade, Spano has created significant bodies of panoramic street photographs, solarizations, and photograms. In the late 1980s, he made particularly effective use of an odd, multi-lens camera that produced eight sequential exposures on a single sheet of film. For *Fruit Cup*, 1989 (fig. 102), Spano used this strange camera to reconstitute the experience of a quiet domestic vignette. Between the first and last exposures, Spano moved his camera aggressively, rotating it on its axis and moving it back and forth in space. This radical motion transformed the tranquil scene into a new, exuberantly dynamic whole. The expressive effects of camera motion are also explored in Ruth Thorne-Thomsen's *Messenger #20,*

France, 1989 (fig. 103), which records the muted features of a marble statue at Versailles.[79] Here, the use of blur creates a poetic sense of metamorphosis and dream.

Very different approaches to photographic abstraction are revealed in the works of Carl Chiarenza and Adam Fuss. Chiarenza was strongly influenced by two of the major figures in American photography, Minor White and Aaron Siskind. He studied with White in the 1950s, absorbing his penchant for a purist but subjective use of the camera. Siskind was the subject of Chiarenza's doctoral dissertation, a lengthy project that culminated in the definitive monograph *Aaron Siskind: Pleasures and Terrors* (1982). Chiarenza's own photography extends the traditions of these two artists. Since 1979, Chiarenza has worked almost exclusively in the studio, using scraps of paper and foil to create miniature "landscapes" for his camera. Although recorded with a classically purist technique, these subjects result in photographs that appear almost completely nonobjective. In the Stieglitz-White tradition of equivalence, Chiarenza's moody images provide highly subjective symbols for a range of inner emotions. Often, as in *Noumenon 283/287*, 1984-85 (fig. 104), Chiarenza combines two or more individual views to create a more complex sense of pictorial movement, space, and balance. Works such as these suggest vast scale, deep time, and a primordial sense of form coalescing from chaos.

The abstract photographs of Adam Fuss also recall very specific artistic precedents: the cameraless images of Man Ray and Moholy-Nagy of the 1920s. First drawn to photog-

raphy in the 1970s, Fuss has since conducted a remarkably varied exploration of the medium's technical means. "I was attracted to photography," Fuss says, "because it was technical, full of gadgets, and I was obsessed with science."[80] One of Fuss's first mature bodies of work, created between 1984 and 1986, utilized a pinhole camera to make dreamlike images of statues and architectural interiors. In the late 1980s, he began a series of direct-positive color photograms on large sheets of Cibachrome paper. His *Untitled*, 1992 (plate 191) is characteristic of the ambitious scale and hypnotic power of these works. Fuss creates these photograms by laying a sheet of photographic paper on the floor of a darkened room. Directly above it, on the end of a long string, a flashlight with a colored gel over its face is set in circular motion. Each circuit inscribes an oval band of color on the paper until the rings fuse in the center into a single glowing orb. The increasing brightness of the image from edge to center is a function of the relative speed of the light source. The curious impact of these pictures—at once grandly theatrical and oddly empty—makes them explicitly postmodern creations, both spiritual and entirely self-reflexive in meaning.

As these varied works suggest, the studio became a newly important site of creativity for many photographers of the 1970s and 1980s. This period witnessed a steep increase in the number of photographers working with narrative tableaux, still-life constructions, collaged or manipulated prints, and rephotographed or appropriated images. The intentions and effects of these approaches varied widely. Fundamentally, however, all of this work was united by a desire to transcend the perceived limitations of the straight, realist photograph. These artists sought to expand the creative act to include the construction of the image itself.

The photographs of Joel-Peter Witkin combine a studio working method with an intentional disruption of the medium's transparent realism. By scratching and gouging his negatives, and by selectively toning his prints, Witkin creates

Fig. 103 Ruth Thorne-Thomsen, *Messenger #20, France*, 1989, 42 x 30½"

photographs with a compelling physical presence. These images combine elegant (if unorthodox) craftsmanship with often disturbing subject matter, resulting in a darkly Gothic, highly theatrical vision of anxiety and anguish. Witkin's focus on the themes of religion, sex, physical deformity, and death has prompted one critic to dub him "the court portraitist of purgatory."[81] The subject of Witkin's *The Sins of*

Fig. 104 Carl Chiarenza, *Noumenon 283/287*, 1984-85, 18¾ x 29¾" overall

Joan Miro, 1981 (plate 168), for example, seems to be either the perpetrator or the imminent victim of some medieval punishment. Witkin's work combines an intuitive, often nightmarish quality with a sophisticated knowledge of art history, as suggested in his reference in the title of this work to Miro, the noted Surrealist painter of the 1920s. These provocative and controversial melodramas were among the most frequently exhibited and discussed artistic photographs of the period.[82]

At the opposite end of the stylistic spectrum, Jan Groover uses the studio environment to create spare, formal still lifes. Groover, who began her artistic career as an abstract painter, first made serious use of the camera in 1970. Initially, she produced color diptychs and triptychs of street scenes and suburban houses that focused on formal relationships of structure and hue. In 1977, she began working primarily in the studio, making color still lifes of kitchen utensils, vegetables, and plants. These highly praised works paid homage to a variety of historical precedents—including the still lifes of Strand in the 1910s and Weston's peppers of 1930—but she infused these traditions with new vitality. Groover's pictures create a subtle, unexpected order from diverse objects arrayed across a shallow pictorial field. These images are purist in technique and abstract in intention: spoons, bowls, and peppers are precisely described, but read primarily as formal elements of shape and color. Groover has since explored the expressive potential of the still life with remarkable persistence, using both color and black-and-white, as well as various camera formats. In a relatively recent work, *Untitled*, 1989 (plate 169), she creates elegant spatial and compositional tensions through a careful deployment of architectural fragments, various small objects, and a spray-painted background. Like all her best works, this image creates a compelling synthesis of order and disorder, sense and intellect, the painterly and the photographic.

While Groover's still lifes extend the traditions of Cubism and Constructivism, Sandy Skoglund's are exuberantly Surrealist. Skoglund studied art history and film before taking up photography in 1978. In 1980, she turned from photographing tabletop still lifes to fabricating entire room-size environments for her camera. With the help of a team of assistants, Skoglund has since created a series of sets in which every element is handmade or altered. Her *Revenge of the Goldfish*, 1981, for example, depicts a school of bright orange fish floating through a suburban bedroom in which the walls and furniture have been painted a watery blue. Similarly, Skoglund's *Fox Games*, 1989 (plate 194), records a group of luminously red ceramic foxes cavorting in a strangely colorless environment. These works are impressive by virtue of their dramatic scale, their dreaminess, their humor, and their flamboyant artifice. But, in addition, Skoglund's photographs consistently pose bizarre juxtapositions of nature and culture: goldfish in a bedroom, foxes in a restaurant, giant leaves blowing through an office, or a living room in which every surface is covered with green grass. Beyond being merely amusing or visually arresting, these hal-lucinatory visions provoke larger considerations of the relationship between the natural and manmade environments.

Like Groover and Skoglund, Zeke Berman also fabricates the subjects of his photographs. Trained as a sculptor, Berman took up photography in the late 1970s in order to transform a "physical construction into an optical one."[83] He uses both talents to exploit and deconstruct common codes of representation by making witty use of visual puns, figure-ground ambiguities, and trompe l'oeil illusions. Berman's *Inversion*, 1990 (plate 192), for example, depicts an assemblage of string, coffee cups, wood, and dark fabric. These elements are combined to suggest the optical principle of lenticular vision. A pair of coffee cups is depicted in refracted symmetry; strings connecting the two cups suggest the path of light rays converging through a camera's lens to create an inverted image on the film plane. The result is a disarmingly sophisticated meditation on the correspondence of representations to things.

In the work of Doug and Mike Starn, this interest in fabrication is redirected to the photograph itself as an object. The Starns employ an attitude of refined nonchalance in order to emphasize the physicality of photographic paper: prints are toned blue, yellow, or brown, and are creased, torn, scratched, or punctured. These "distressed" objects are then crudely Scotch taped together in collages of various sizes and nailed onto mounts or pinned directly to the wall. At the age of twenty-six, only two years after they arrived at their mature style in 1985, the Starns were among the stars of the 1987 Whitney Biennial, a leading showcase of avant-garde art in all mediums. This enthusiastic art-world reception contrasted markedly with that of photographic traditionalists, who tended to view the work as merely sloppy and pretentious.[84] At their best, the Starns draw great aesthetic effects from the manipulation of scale, a seductive physicality, and a nostalgic fascination for the marks of time and decay. In addition, their work makes repeated reference to their own status as twins, and to the related idea of the duplicated image. This interest in reflection and reciprocity is exemplified in *Double Rembrandt with Steps*, 1987-91 (plate 189). In this work, a photograph of a Rembrandt painting is doubled, as on a playing card, and surrounded by a similarly repeated and inverted image of steps (which by their nature lead simultaneously up and down). Finally, the piece itself is composed of two mirrored halves that, like the Starns themselves, combine to form an artistic whole.

Collaboration is also an important element of the work of David McDermott and Peter McGough. These artists carry their admiration for the past to an extraordinary length by surrounding themselves with the clothing and artifacts of the turn-of-the-century era. By choice, they even live in houses without electricity or running water. It is "logical" then, that the subject, means, and presentation of their art reflect this commitment to the anachronistic. *Very Popular Styled Collars, Comfortable and Sensible, Twenty-fifth instance of April, 1911*, 1991 (fig. 105), is characteristic of their work. These depictions of pairs of 1911-vintage

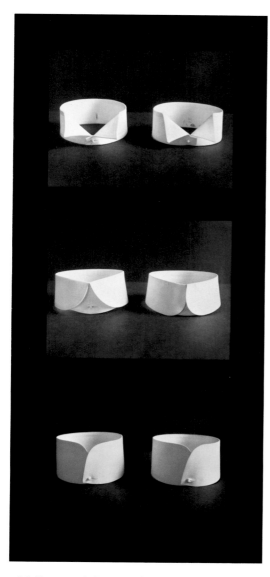

Fig. 105 **McDermott & McGough**, *Very Popular Styled Collars, Comfortable and Sensible, Twenty-Fifth Instance of April, 1911*, 1991, palladium prints, each 11 x 14"

starched Edwardian collars were made with an antique 11x14-inch view camera, and printed and framed according to the aesthetic of that era. By highlighting these simple permutations of form, this work evokes a long-vanished formality of style, as well as the Minimal art aesthetic of the late 1960s and early 1970s, with its emphasis on "primary structures." As a result, *Very Popular Styled Collars* challenges notions of artistic progress by blurring the distinctions between past and present, the art of fashion and the fashions of art.

Landscape Photography

While the American landscape has always been an important subject for photographers, it took on new meaning in the 1960s, as concern mounted over the environmental effects of population growth and industrial development. The early role of photography as a tool of political persuasion in the

conservation effort is exemplified by the work of Ansel Adams, Eliot Porter, and the Sierra Club. Adams's passion for the natural landscape began in his youth. He realized the political potential of his own photographs as early as 1936, when he used them to lobby government officials to establish a new national park.[85] By the late 1950s, the Sierra Club had begun to take a more activist stance on environmental issues, and began publishing a series of "exhibit format" photographic books.[86] The first of these was *This Is the American Earth* (1960), by Adams and Nancy Newhall. With a text by Newhall and reproductions of the work of thirty-two photographers, *This Is the American Earth* powerfully contrasted the beauty of the American landscape with the evidence of human encroachment. The Sierra Club also published Eliot Porter's first books, beginning with "*In Wildness Is the Preservation of the World*" (1962), which combined his color photographs with passages of text by Henry David Thoreau. The Sierra Club's release of *The Place No One Knew: Glen Canyon on the Colorado* (1963), with photographs by Porter and others, marked a turning point in the conservation movement. Conceived as a "battle book," *The Place No One Knew* documented a spectacular canyon that would soon be flooded by the construction of a dam. The beauty of these photographs helped turn public sentiment against the government's dam-building program of the period.[87] These and similar oversize photographic books sold well, establishing Adams and Porter as the best-known landscape artists of their generation. In addition, their work served to popularize romantic notions of the "cult of wilderness" and the redemptive—even sacred—value of the untouched landscape.

In the 1970s and 1980s, as environmental problems became increasingly apparent, the landscape became an even more important artistic subject. By this time, however, the approach and intention of photographers had shifted markedly. Artists such as Adams and Porter had usually depicted nature without any sign of the human presence, in the expectation that the pristine beauty of their subjects would motivate Americans to respect and preserve the land. This artistic strategy was questioned by younger artists, who chose to record, rather than to ignore, the intrusive effects of society. This newer work was motivated by an understanding of the landscape derived, in part, from the interdisciplinary writings of cultural historians and geographers such as D. W. Meinig, J. B. Jackson, and Yi-Fu Tuan.[88] These writers emphasized the impact of culture on the natural world and defined the landscape as a synthesis of man and nature. As Meinig wrote,

> Every landscape is a scene, but landscape is not identical with *scenery*. The very idea of scenery is limited, a conscious selection of certain prospects, locales, or kinds of country as having some attractive aesthetic qualities. Scenery has connotations of a set piece, a defined perspective,...a discrimination based upon some generally received idea of beauty or interest; whereas landscape is ubiquitous and more inclusive, something to be observed but not necessarily admired.[89]

Reflecting this point of view, the best photographers of this era depicted the landscape as a multifaceted interplay of nature and culture, past and present, place and idea. These photographers were often motivated by a genuine concern for the land, but the contradictions inherent in their approach ensured that their work would not be as widely popular as that of Adams and Porter.

This new attitude toward landscape photography was documented in the influential 1975 exhibition "New Topographics: Photographs of a Man-Altered Landscape," organized by William Jenkins at the George Eastman House. This exhibition featured flatly descriptive images of urban, suburban, and industrial landscapes by Robert Adams, Lewis Baltz, Bernd and Hilla Becher, Joe Deal, Frank Gohlke, Nicholas Nixon, John Schott, Stephen Shore, and Henry Wessel, Jr. In his catalogue essay, Jenkins observed that "the problem at the center of this exhibition is one of style...what it means to make a documentary photograph."[90] The collective style of these photographers—based on influences ranging from nineteenth-century topographic photographers to Walker Evans, Ed Ruscha, and Minimalism—appeared to be one of dispassionate neutrality. In citing Ruscha's influence, Jenkins described his work in terms that seemed applicable to the show as a whole: "The pictures were stripped of any artistic frills and reduced to an essentially topographic state, conveying substantial amounts of visual information but eschewing entirely the aspects of beauty, emotion, and opinion."[91] In fact, of course, this apparent lack of style represented a set of highly disciplined artistic choices (as demonstrated by the eloquence of the photographers' own statements, excerpted in the catalogue).[92] As these decisions included the selection of tract houses and roadside motels as worthy subjects, it is clear that the content of this work was as important as its form. For example, Baltz employed a stance of icy, uninflected neutrality in order to comment both on the generic nature of his subjects and on the values of the culture that created them.[93] The buildings he recorded (from a series published in the 1974 book *The New Industrial Parks Near Irvine, California*) are modern, functional, and almost eerily without character (plate 160). Ironically, the artistic life of Baltz's work stems precisely from the elegant vacancy and apparent placelessness of his subjects.

Of all the "New Topographics" photographers, Robert Adams has remained the most committed to the depiction of the American landscape. Adams received a doctorate in English and taught for several years before turning seriously to photography in the mid-1960s. While he recognized the achievements of earlier landscape photographers such as Porter and Ansel Adams (no relation), he made work that was markedly different from theirs.[94] Instead of simply celebrating an idealized landscape, Adams's bittersweet images unite a sense of promise and loss, transcendence and failure. His quietly passionate images depict the American West as majestic and resilient, but nonetheless deeply scarred and diminished by the short-sightedness of its inhabitants. As Adams writes, "A typical vacant lot today is likely to have in

Fig. 106 Robert Adams, *Longmont, Colorado,* 1979, 14½ x 14½"

it not only scattered vegetation but broken asphalt, Styrofoam, and abandoned appliances; the air may at times smell of wildflowers or rain, but as likely also of oil or sewage; there may be audible the call of a dove, but often against some sterility like the flapping of a plastic bag caught on barbed wire."[95]

This vision of the West is powerfully evoked in images such as *"Frontier" Gas Station and Pike's Peak, Colorado Springs, Colorado,* 1969 (plate 176). For generations, the purity and liberating potential of the frontier represented key elements of our guiding national myth. Now, however, the frontier is gone, the land domesticated, and the word itself (appropriately truncated in this photograph) transformed from vision to sign, idea to logo. Adams contrasts the aura of the setting sun with the smaller, harsher glow of an artificial light fixture. At the same time, however, Pike's Peak seems surprisingly unimpressive in stature, while the gas station presents itself as an eminently useful, even welcome, feature of the landscape. Adams's photograph suggests no simple problems or answers. Instead, it prods us to consider the contrast between our myths and our realities, and to think of the land as home rather than as scenic backdrop. Adams's subtle, eloquent work ranges between angry indictment and hopeful celebration. Not unexpectedly, his photographs of the litter and smog of Los Angeles, made in the early 1980s, are harsh in tonality and downbeat in mood.[96] On the other hand, images such as *Longmont, Colorado,* 1979 (fig. 106), suggest those moments of epiphany in which the grandeur of nature and the everyday achievements of human beings converge.

Much of the landscape photography of the 1970s and 1980s takes as its central theme the contesting powers of nature and culture. For example, Emmet Gowin's *Agricultural Pivot over Glacial Potholes near Moses Lake, Washington,* 1991 (plate 177), presents an aerial view of the

Fig. 107 Joe Deal, *San Bernardino, California* (from "The Fault Zone" series), 1978, 11 1/4 x 11 1/4"

overlay of a frail human geometry on the ancient surface of the land. Joe Deal's series "The Fault Zone," produced between 1978 and 1981, documents the path of geological faults without, of course, being able to show them. In such austere photographs as *San Bernardino, California*, 1978 (fig. 107), Deal generates an intellectual tension between the quietude of the scene depicted and the vast, unpredictable power lurking below. For similar reasons, photographers such as Gowin and Frank Gohlke were motivated to document the effects of the most dramatic natural forces. Gohlke recorded the destruction wrought by a tornado in Wichita Falls, Texas, in 1979, and both he and Gowin made repeated visits to Mount St. Helens after it erupted in a series of volcanic blasts in May 1980. The mysteries of the animal world form the subject of Joel Sternfeld's *Approximately 17 of 41 Whales which Beached (and Subsequently Died), Florence, Oregon*, June 18, 1979 (plate 174), a record of curious spectators at the site of a baffling mass suicide of whales.

John Pfahl's "Power Places" series, made in the early 1980s, strikes a deliberately fine balance between the powers of culture and nature. His *Indian Point Nuclear Plant, Hudson River, New York*, 1982 (plate 175), contrasts a traditional style of landscape depiction—recalling sources such as nineteenth-century Hudson River School painting and the photographic work of Eliot Porter—with an emblem of contemporary environmental controversy, a nuclear power plant. Pfahl's vision is ironic rather than propagandistic, and he enjoys the fact that both groups for and against nuclear energy can find their views confirmed in his pictures. By presenting conflicting messages in a single work, he aims "to make photographs whose very ambiguity provokes thought, rather than cuts it off prematurely."[97]

Other important bodies of landscape photography produced in the 1980s and early 1990s were motivated by a similar conflation of aesthetic and political concerns. Among Gowin's aerial photographs of the western landscape are numerous depictions of missile silos and toxic-waste reservoirs, for example. Richard Misrach and Peter Goin presented unambiguously critical visions of the abuse and poisoning of the deserts of the West caused by secret military tests of atomic and conventional weapons.[98] These projects were symbolic of the larger climate of anxiety in the 1980s over the threats of nuclear disaster and environmental catastrophe.[99]

Directly or indirectly, much of this recent landscape imagery acknowledges traditional notions of the sublime, the spiritual power of the landscape as experienced in its purest and grandest forms. This new vision of the sublime—evident even in the eco-conscious work of Misrach and Goin—synthesizes an awareness of art-historical precedents, a sympathy for the skepticism of Postmodernist thought, and a genuine experience of awe in the face of nature's ineffability. Since the mid-1980s, Lynn Davis has photographed colossal and mysterious objects, from the pyramids of Egypt to the icebergs of Greenland. These photographs are informed by specific nineteenth-century sources: the expeditionary work of Francis Frith, who recorded the monuments of the Middle East in the late 1850s, and the photographs of the Arctic regions made in 1869 by the team of Dunmore & Critcherson.[100] Davis's *Iceberg #1, Disko Bay, Greenland*, 1988 (plate 179), combines the majestic simplicity of a nineteenth-century vision with a distinctly contemporary mood of elegy. Begun at a time when her friends Robert Mapplethorpe and Peter Hujar were dying of AIDS, Davis's icebergs are symbolic of the grandeur and ephemerality of human life.[101] David Stephenson's *Untitled*, 1990 (plate 178) also relies on art-historical precedents, suggesting itself, paradoxically, as a Postmodern Equivalent: an image that at once confirms and questions the possibility of transcendent experience.

A key facet of the sublime is the idea of deep time, and many photographers have sought to represent geologic, cultural, or mythic versions of temporality in the evidence of the landscape. Linda Connor's photographs of ancient Southwest rock carvings and paintings evoke the presence of our ancestors while underscoring the timeless human need to communicate by leaving a mark (fig. 108). Connor says,

> I've come to believe that often the drawings were done to channel and mitigate the awe one feels in response to the powers of the surrounding universe. My photography is a similar attempt, a gesture of faith. The marks and photographs form a link, however slight and human, between our mortality and the continuance around us.[102]

Rick Dingus, who has also long been fascinated by Native American rock art, extends the notion of marking to his own photographs. By using a pencil to draw directly on the surface of his prints, as in *Notations (Caprock Canyon, Texas)*, 1989 (fig. 109), Dingus creates an imaginative union of past and present, fact and emotion, observer and observed. His gestural marks suggest what cannot be seen: the vibrant energy of the earth and the aura of the sacred.

Fig. 108 **Linda Connor**, *Hands, Canyon de Chelly, Arizona*, 1982, 8 x 10"

Fig. 109 **Rick Dingus**, *Notations (Caprock Canyon, Texas)*, 1989, gelatin silver print with graphite, 35 x 47"

A more scientific and historical meditation on the landscape was undertaken by the Rephotographic Survey Project of 1977-79. The members of this group—which included Dingus, Mark Klett, JoAnn Verburg, Ellen Manchester, and Gordon Bushaw—rephotographed with exacting precision scenes recorded a century earlier by Western landscape photographers such as William Henry Jackson, Timothy O'Sullivan, and William Bell.[103] The results of this project led to new understandings of the working methods of these nineteenth-century pioneers and of changes to the land in the intervening one hundred years. During the course of this project, Mark Klett made such personal images as *Perched Rock, Marble Canyon: From William Bell's Vantage Point Chosen 113 Years Before*, 1983 (fig. 110). Trained as a geologist, Klett was keenly attentive to the various levels of time represented in this image: the present (carefully noted as "9/14/83" on the print), Bell's visit 113 years earlier, and the eons of geologic time necessary to create the canyon itself.

The cultural and historical meaning of the landscape is further suggested in quite different works by Lee Friedlander and Carrie Mae Weems. Friedlander's *Gettysburg*, 1974 (plate 180), a distant depiction of Civil War monuments seen through a screen of budding branches, stimulates a variety of thoughts on time, the cycle of life and death, and the nature of our national memory and ideals.[104] Similarly, Weems's *Sea Islands Series (Ebo Landing)*, 1992 (plate 181), uses the historic resonance of a particular place, the Sea Islands off the coast of Georgia, to address the meaning of the American past. This work reflects Weems's identity as an African-American while suggesting the influence of oral history and folklore on the content of her art. In this highly effective union of photographs and text, Weems evokes the historic tragedy of slavery and the fierce pride of the Africans who were brought to this country in chains. Her powerful, pointed text charges the quietude of these otherwise unremarkable landscapes with a tone of outrage, mourning, and commemoration.

New Identities

Weems's work also exemplifies the multicultural currents of the art of the early 1990s. Stimulated by the earlier women's and civil rights movements, the 1980s witnessed an increasing emphasis on cultural diversity: the recognition of values and views derived from differences of gender, race, ethnicity, class, and sexual orientation. By its nature, multiculturalism stresses the tolerance of difference and the celebration of heterogeneity. In an era of fluid international boundaries and a fully global economy, such a multicultural perspective seems not only logical but inevitable. The controversies over multiculturalism stem, in large part, from the natural differences of values that arise when a putatively singular world view is challenged by a profusion of contending visions. In recent years, this debate over values has fixed on such questions as whether Christopher Columbus should be regarded as a hero or a mass murderer, or whether the literary works of "dead white European males" can have any relevance for readers who share few, if any, of these attributes. In fact, the essential question posed by the debate over multiculturalism is an old one: are we ultimately fragmented and isolated by our awareness of difference, or can an acceptance of diversity result in a richer, more generous sense of community?[105] When viewed in the broadest light, multiculturalism may be seen as an important part of a larger quest to know the self in all its facets: emotional, intellectual, physical, political, and social. This quest for identity is strongly flavored by the critical climate of Postmodernism, but its roots extend at least as far back as the political activism of the 1960s and the alienation of the 1950s.

At the same time that Cindy Sherman was creating her first mature works, photographers such as Francesca Woodman and Tseng Kwong Chi were also exploring new ways of representing identity and the self. The 500 photographs that Woodman produced in her brief but precocious career (she died in 1981, at the age of 22) represent an obsessive quest to

Fig. 110 Mark Klett, *Perched Rock, Marble Canyon: From William Bell's Vantage Point Chosen 113 Years Before, 9/14/83,* 1983, 16 x 20"

find, in her words, "where I fit in this odd geometry of time."[106] In works such as *Easter Lily, Rome,* 1978 (plate 183), Woodman employed simple, allegorical settings to convey the uncertainties of youth and gender. Due, in part, to the very simplicity of their artifice, these images convey powerful feelings of isolation, vulnerability, and psychological self-absorption. By contrast, Tseng Kwong Chi's exploration of the theme of identity took place on a vast public stage. Born in Hong Kong, and a resident of New York from 1978 until his death in 1990, Tseng traveled widely throughout the U.S. and overseas. For his "Expeditionary Series: East Meets West," begun in 1979, Tseng recorded himself before a great variety of cultural and natural landmarks, including the Statue of Liberty, Disneyland, Niagara Falls, the Lincoln Memorial, Mount Rushmore, and the Golden Gate Bridge (plate 185).[107] In all of these images, Tseng assumes the guise of his alterego, a fictional emissary or self-appointed ambassador, by dressing in a Chairman Mao worker's suit complete with ID card. These oddly powerful images suggest the status of Tseng's "ambassador" as both friend and spy, a man of the world and a perpetual alien.

In its evocation of the most basic issues of beauty, sexuality, and mortality, the image of the body forms a central motif of this quest for identity. Annie Leibovitz, best known for her striking celebrity portraits for magazines such as *Rolling Stone* and *Vanity Fair,* gave memorable visual form to the idea of the face as a mask in her *Meryl Streep, New York City,* 1981 (plate 182). Friedlander's unidealized photographs of the female nude (fig. 111) create a curious tension between the self-consciousness of the pose, the informality of the surrounding context, and the abstractive effects of the photographic process itself. By both recalling and contradicting traditional representations of the female body, Friedlander encourages us to see this most exploited subject with fresh eyes, as at once familiar and strange. Somewhat differently, in the work of W. Snyder MacNeil and John Coplans, closely cropped details of the body take on an unexpected

expressive power. MacNeil began photographing the hands of friends and family members in 1977, rendering the final images as platinum-palladium prints on sheets of translucent vellum (plate 188). Each of these haunting, ethereal images functions as a sign of monumentality and frailty, the universal and the particular.[108] Many of these qualities are also evident in the self-portraits of John Coplans. Coplans turned to photography in 1980, at the age of sixty, after a varied and distinguished career as a painter, teacher, critic, scholar, curator, and museum director.[109] His greatly enlarged depictions of his own body explore the topography of flesh in astonishing detail. His back and thighs become veritable landscapes; a hand is transformed into a work of monumental sculpture (fig. 112). By recording his own body as both colossal and unidealized, Coplans strives to remind us of the essential reality of our physical existence.

The human figure also forms the central motif of Robert Mapplethorpe's artistic career. One of the most controversial photographers of the 1980s, Mapplethorpe studied painting and sculpture before taking up the camera in the mid-1970s. He became very knowledgeable about the history of photography, and drew particular inspiration from the images of Day, Weston, Man Ray, and Lynes.[110] Mapplethorpe mastered the traditional genres of portraiture, floral still life, self-portraiture, male and female nudes, and erotica. It was the explicitness and overtly homosexual content of his erotic images that triggered heated public debate over the issues of obscenity and public funding of the arts in the late 1980s. Despite the provocative nature of this aspect of his work, however, Mapplethorpe's vision is fundamentally classical in form and technique. There are no accidents in his exquisitely crafted pictures; everything is precisely ordered to evoke a sense of utopian clarity, a complete removal from the imperfections of the ordinary world. In Mapplethorpe's *Ken Moody,* 1983 (plate 187), this faultlessness takes on an unnerving and almost surreal intensity. Depicted in glowing, symmetrical perfection, Moody's hairless body seems more machine than human, conveying a hyperreal sense of physical and erotic potency. Mapplethorpe's unashamedly gay perspective and his death from complications brought on by AIDS in 1989 ensured that his work would be central to some of the most urgent and contentious social issues of the era.

David Wojnarowicz's work also deals with the themes of homoerotic desire and the AIDS epidemic. Entirely self-taught, Wojnarowicz transformed the experiences of a troubled upbringing into a powerful and provocative artistic vision expressed through writing, painting, film, and photography.[111] His symbolic self-portrait, *I Was Sitting in a Coffeeshop,* 1990 (plate 186), combines a brief text alluding to his loss of physical appeal with an image of a dead chameleon preserved in formaldehyde. In stark contrast to the idealizing vision of Mapplethorpe, Wojnarowicz's photograph conveys a disturbing, even grotesque, sense of physical decay and death. The subjects of Andres Serrano's art include the most basic elements of human life: the body's own fluids,

Fig. 111 Lee Friedlander, *Nude*, 1978, 18½ x 12¼"

Fig. 112 John Coplans, *Self-Portrait (Hand)*, 1987, 39¼ x 36¼"

which he recognizes as "visually and symbolically charged with meaning."[112] His lushly abstract *Precious Blood*, 1989 (plate 190), is at once seductive and ominous, and symbolic of both life and death. Serrano's choice of such inherently charged subject matter underscores his ambition to deal with such large issues as the tension between spirit and flesh, the sacred and the profane.

The social component of identity stems from the formative influence of the family. Ironically, perhaps, while families in America have grown smaller in average size and less stable in composition over the last thirty years, photographers have increasingly turned to them as the subject of their art. Some photographers, such as Jed Devine (fig. 113) and Abelardo Morell (plate 207), depict the domestic realm as a space of private reverie and discovery. Others, including Emmet Gowin and Nicholas Nixon, record the endless permutations of personal contact. Gowin began photographing his extended family in the mid-1960s, inspired in part by the example of his teacher, Harry Callahan. Characteristic of this early work is Gowin's photograph of his wife and son, *Edith and Isaac, Newtown, Pennsylvania*, 1974 (plate 204), which makes the intimacy of a family snapshot universal. Since the mid-1970s, however, Gowin has turned his attention largely to the landscape (plate 177). Nixon, on the other hand, first

achieved recognition in the mid-1970s for his urban images but has since largely devoted himself to photographing people. His warmly sensitive image of a blind student and his teacher (plate 205) is characteristic of this work, which is accomplished, remarkably enough, with a cumbersome 8x10-inch view camera. Nixon has also paid close attention to his own family, and since 1975 has been taking a series of annual portraits of his wife and her three sisters.

The way families change and reconfigure over time is central to the work of Milton Rogovin and Andrea Modica. Rogovin, who began using the camera seriously in 1958 under the influence of Minor White, has photographed the residents of the Lower West Side of Buffalo for several decades.[113] His *Triptych*, 1973, 1985, 1991 (fig. 114), which unites three views of a man and his granddaughter made over a span of eighteen years, documents the cycle of life with poignant clarity. For some time, the primary subject of Andrea Modica's work has been several rural families in upstate New York. Her photographs, such as *Treadwell, New York* (plate 202), present a wise, gentle vision of the rhythms of these lives, and of the tensions between childhood and adolescence.

The domestic scenes of Tina Barney and Larry Sultan are the product of a complex synthesis of documentation and stage-direction. To different degrees, each organizes the scene before their camera in order to convey personal, artistic truths. In direct contrast to the working-class subjects of Rogovin or Modica, Barney depicts the calm, comfortable world of the upper class. Typical of her work is *The Skier*, 1986 (plate 199), a scene devoid of obvious action, but full of details suggesting the rhythms and rituals of a privileged way of life. Larry Sultan's project "Pictures From Home"

was inspired by his rediscovery of home movies and snapshots made by his parents during his childhood. Sultan responded to the ambiguity of these nostalgic records by creating his own deliberately ambiguous "documents" of his parents' life in retirement. With their (often puzzled) cooperation, Sultan posed his parents in tableaux that he felt expressed emotional if not literal truths about their lives (plate 198). When his father flatly observed, "For the most part that's not me I recognize in those pictures," Sultan responded, "Don't you think that a fiction can suggest a truth?"[114]

The truths sought by many artists of Sultan's generation center on the anxieties and disconnections of family life. In 1991, Szarkowski's successor at the Museum of Modern Art, Peter Galassi, organized an exhibition on this theme titled "Pleasures and Terrors of Domestic Comfort." In describing the work of photographers such as Barney and Sultan, Galassi observed, "Often in their pictures life is unresolved, under stress, a mess of one sort or another; people are at loose ends, or awkward, or sad; very often they are alone if not also lonely. But the photographer's affection is abiding."[115] In the work of lesser artists, this vision of anomie suggests a simplistic inversion of Steichen's earlier optimism: a hopelessly dysfunctional Family of Man.

Sally Mann's depiction of her family is based on a clear understanding of the fluid boundary between fact and invention. She has said, "Sometimes I think the only memories I have are those that I've created around photographs of me as a child. Maybe I'm creating my own life. I distrust any memories I do have. They may be fictions, too."[116] Mann's provocative photographs of her own young children, begun in 1984, range in mood from the whimsical to the ominous (plate 203). These beautifully crafted prints combine a Victorian-era romanticism with a wholly contemporary, post-Arbus edginess, and in the process suggest both innocence and worldliness, fantasy and reality. The result, as Mann writes, are pictures that are intended to "tell truths, but truths 'told slant,'" just as Emily Dickinson commanded."[117]

In the work of Wendy Ewald and Jeffrey Wolin, pictures are combined with hand-written texts to create an evocative dialogue within the frame of the image. Since the mid-1970s, Ewald has taught photography to elementary-school age students as a means of self-exploration. In various schools in the U.S., Colombia, India, Mexico, and South Africa, Ewald has encouraged children to use simple cameras to document and interpret their surroundings. One of her more recent projects involved the establishment of a Literacy Through Photography program for the public schools in Durham, North Carolina. In the course of this work, a series of collaborative portraits was made: after photographing each student, Ewald encouraged them to inscribe their image in some meaningful way. In works such as *Hello, Hello, Hello*, 1990 (plate 200), this notion of speaking through one's own likeness produces a remarkable sense of immediacy. Jeffrey Wolin inscribes eloquent narratives on the surface of his photographs in

Fig. 113 Jed Devine, *Horse, Daylight*, ca. 1980, palladium print, 7½ x 9½"

order to suggest meanings that the images alone cannot convey. In picture-text combinations such as *My Father*, 1988 (plate 201), Wolin creates a powerful synergy from these very different modes of description, uniting the photographic "present" with his own memories and interpretations of the past.

Coda: The Digital Revolution

In 1991, *Fortune* magazine boldly predicted, "A storm of technological innovation and new products is gathering over the world of photography [that] will blow away much that is familiar—including film, chemicals, and darkrooms—replacing it with a technology that seems both dazzling and old hat: computers."[118] Modern photography was born just over a century ago from the impact of three fundamental technical innovations: the dry-plate, the hand camera, and the halftone. Now, in the 1990s, it seems evident that the computer is creating a revolution of similar magnitude in the production and dissemination of pictures.

These old and new processes operate in fundamentally different ways. In conventional photography, images are created by the action of light passing through a lens to strike a piece of light-sensitive film. This film is chemically developed to produce a unique negative, from which reasonably identical positive prints can be made. In digital photography, sensors convert lens-formed images into a binary numerical code that is stored electronically, and which may be retrieved at any time to be translated back into tonal values and rendered as a print. This binary code can also be manipulated at will to create fundamental reconfigurations of the data of the original photograph. These alterations can range from the simple removal of unwanted details to the creation of entirely synthetic images. The digitally produced picture retains no evidence of these alterations; there are no "seams" between its component parts. The speed and flexibility of

Fig. 114 **Milton Rogovin**, *Triptych* (from series "Buffalo's Lower West Side Revisited"), 1973, 1985, 1991, 7³/₁₆ x 6⁵/₁₆″, 6⁷/₈ x 6³/₄″, 7³/₁₆ x 6³/₈″

digital processes make them ideal for many applications in print journalism, advertising, and commercial photography. Already, digital-imaging processes have thoroughly changed the look of Hollywood films, making the most fantastic special effects seem almost routine. In the consumer market, however, change comes slower. The first electronic still camera, marketed by Sony in 1984, sold poorly, and, so far, the world's amateur photographers remain committed to traditional films and processes.

In the late 1970s, however, some artists began to take serious interest in the expressive potential of the digital image. Nancy Burson and Peter Campus are among the most significant of these electronic picture makers. Burson became fascinated by the idea of using the computer to create artificially aged "portraits"—manipulating an old photograph of a missing child, for example, to suggest what he or she might look like five years later.[119] In 1982, Burson began using the computer to create composite portraits such as *Big Brother*, 1983 (plate 196). This image merges the faces of Stalin, Mussolini, Mao, Hitler, and Khomeini to create a generic portrayal of twentieth-century despotism. Another noted work, *First and Second Beauty Composites*, 1982, contrasts the "ideal" look of film personalities of the 1950s and the 1970s by blending the faces of five stars from each era into single images. In works such as these, Burson produces "portraits" of ideas rather than people, visual averages that are unreal, yet eerily familiar. Since the early 1970s, the primary means of Peter Campus's art has changed roughly each decade, from video to still photography to the digital image. In his recent computer-generated photographs, such as *decay*, 1991 (plate 197), Campus contrasts the synthetic space and definition of this electronic "world" with a fragile emblem of the natural one, a leaf.

As the title of Campus's work suggests, the digital image represents the final erosion of any remaining assumptions about the "simple" nature of representation. The creative possibilities of the digital image are enormously exciting; as

one artist has said, "Working with a computer is the closest thing to pure thought."[120] In this light, it is easy to draw parallels between contemporary digital work and the desire of earlier photographers, such as Day and Coburn, to transcend the limitations of the visible. Less certain, however, is the relationship of this new medium to conventional photography. Critics have variously identified the digital revolution as either the death or the rebirth of photography.[121] What does seem certain, however, is the fundamental difference between these processes. Computer technology produces "wonderful things," says Campus, "but they're not photographs. There isn't really even a name for them yet—people call them digital photographs, or computer-manipulated images. I don't think computer art is a medium. It's a tool, but a very sophisticated and powerful one."[122]

What particularly fascinates Campus is the ability provided by this electronic tool to "control every nook and cranny of a picture."[123] It is the nature of this control that distinguishes the digital image from the photographic image. In fact, the unlimited elasticity of the digital process suggests that it has more in common with painting or drawing than photography. In both hand-rendered and digital processes, the resulting picture is wholly synthetic. But, while the painter begins with a blank canvas and builds an image through an accumulation of marks, the electronic artist begins with a full "canvas" of one or more photographic images. On the computer screen, the components of these original photographs become completely fluid, open to endless alteration, deletion, and recombination. The effect of this manipulation is monumental: all remaining links between the image and the world of optical and physical fact are severed. Despite all the abstractions inherent in the photographic process, it remains true that photographs represent optical fact—and thus the world—in reasonably consistent and understandable ways. This does not mean that photographs can be understood simply or at face value; skepticism and interpretation are always required to decipher their messages.

But, however qualified and complex it might be, photography has an essential "truth function"—a connection to direct visual experience—that is eliminated by the digital process.

The power of the traditional photograph is generated, in large measure, from the dynamism of its inherent tensions. Photographers seek to shape the world into meaningful vignettes that conform, on some level, to our ideas of reality. To do this, we exercise a great variety of choices, beginning with where we stand and what equipment we use. However, the world is obdurate and actively defiant, resisting our desire for absolute clarity, perfection, and closure. Photographs usually convey both more and less information than we want, slipping through our net of intentions to reveal chaos or formlessness. Successful photographs are born of this struggle between opinion and fact, desire and restraint, simplicity and complexity, achieving some just balance of the things under and beyond our control. However, the digital image sidesteps this struggle entirely, disarming the world's power of resistance at a stroke, allowing us to refashion it effortlessly in our own image. This is the difference between reality and virtual reality: one is infinitely varied, unpredictable, dangerous, inconvenient, and instructive; the other provides considerable room for the free play of the imagination, but ultimately is only what we program it to be. As an artistic tool, the digital image is genuinely exciting; as a means of understanding the world, its potential is less clear.

Unlike the introduction of the dry-plate in the early 1880s, the computer will not result in the overnight elimination of photography as we know it. In 1990, Americans made some 17,000,000,000 photographs, a volume of activity that cannot be quickly redirected from one technology to another.[124] More importantly, a significant number of picture makers will continue to embrace the expressive potential of photography, its unique capacity to describe, interpret, and interact with the world. Photography has shaped our vision of life in fundamental ways, and it remains rich with aesthetic possibilities, some comfortably familiar, others deeply mysterious or unexpected. "However varying their points of view," Wright Morris has written, "all photographers share the common field of vision that the mind's eye, and the camera's eye, has imposed on this century. Quite beyond the telling of it, as well as the seeing of it, exceeding both our criticism and our appreciation, the camera's eye combines how we see with whatever is there to be seen. What it has in mind for us may not at all be what we have in mind for ourselves."[125]

153 Charles Moore, *Birmingham Riots*, 1963, 10½ x 13¼″

154 **Larry Burrows**, *Reaching Out, First-Aid Center During Operation Prairie*, 1966, dye transfer (printed 1993), 15½ x 23″

155 Garry Winogrand, *Hard Hat Rally*, 1969, 9 x 13½"

156 Richard Avedon, *Oscar Levant, Pianist, Beverly Hills, California, 4/12/72,* 1972, 16½ x 15¾"

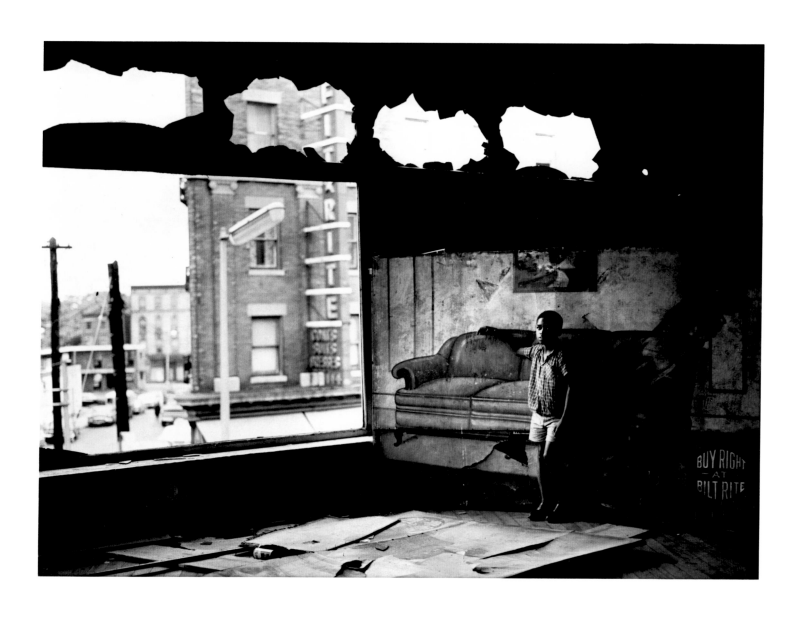

157 **Arthur Tress,** *Boy in Ruined Building, Newark, N.J.,* 1967, 10¼ x 13⅜"

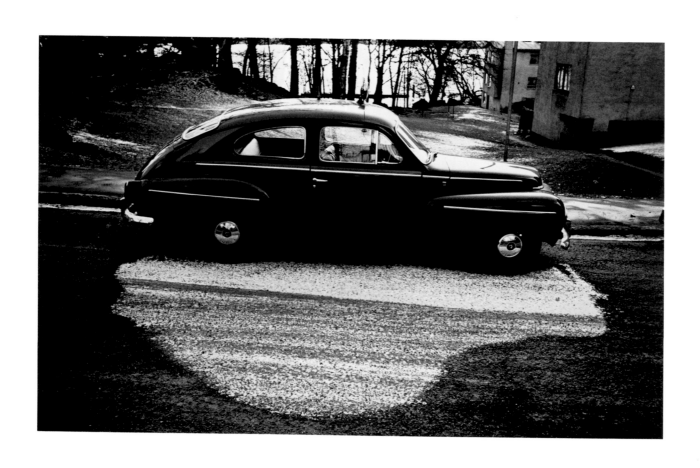

158 **Kenneth Josephson,** *Stockholm,* 1967, 8 x 12"

159 Hiroshi Sugimoto, *U.A. Walker, New York*, 1978, 16⅝ x 21½"

160 **Lewis Baltz,** *West Wall, Unoccupied Industrial Structure, 20 Airway Drive, Costa Mesa*
(from series "The New Industrial Parks Near Irvine, California"), 1974, 6 x 9″

161 Ralph Gibson, *Face*, 1981, 12⅜ x 8⅛"

162 Chuck Close, *Joe Zucker*, 1969, 15¾ x 12¼"

163 **Andy Warhol**, *Lana Turner*, 1976-86, gelatin silver prints with thread, 27 x 21½"

164 Gordon Matta-Clark, *Splitting: Interior*, 1974, 29¾ x 39½"

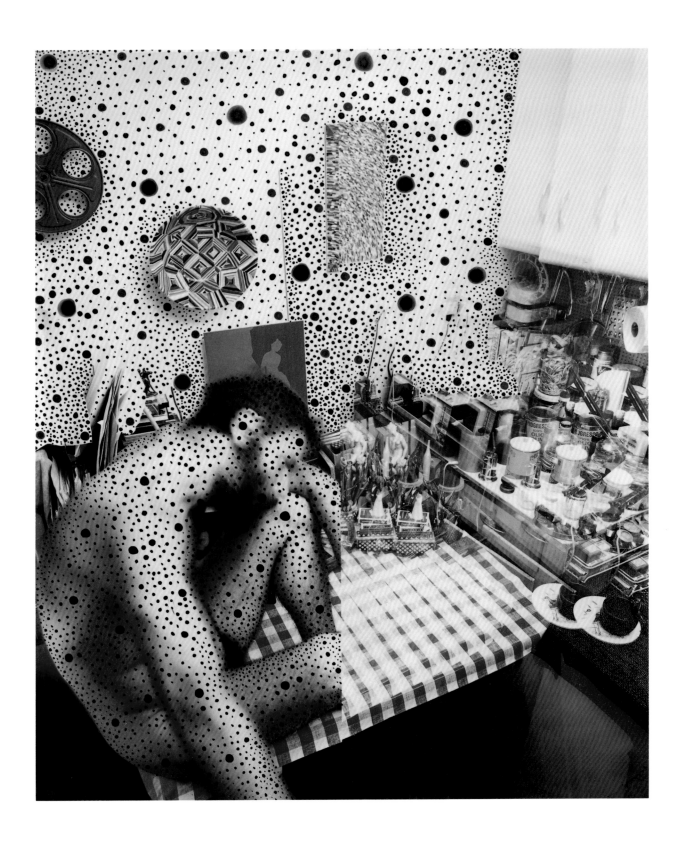

165 **Lucas Samaras**, *Figure*, 1978, Polaroid print with ink, 9½ x 7½″

166 Robert Cumming, *Mishap of Minor Consequence*, 1973, 7⅝ x 9⅝" each

167 **John Baldessari**, *Life's Balance (With Money)*, 1989-90, photogravure with color aquatint, 49 x 40½"

168 **Joel-Peter Witkin**, *The Sins of Joan Miro*, 1981, 14⅝ x 14¾"

169 **Jan Groover**, *Untitled*, 1989, dye coupler print, 22¾ x 28½″

170 **William Eggleston**, *Tricycle*, ca. 1971, dye transfer (printed 1980), 12 x 17½″

171 **William Eggleston**, *Jackson, Mississipppi*, 1971, dye transfer (printed 1986), 13½ x 21″

172 **Joel Meyerowitz**, *Bay Sky Series, Provincetown*, 1977, dye coupler print, 7⅝ x 9⅝"

173 **William Christenberry**, *Window, near Stewart, Alabama*, 1988, dye coupler print, 29 x 36¼″

174 **Joel Sternfeld,** *Approximately 17 of 41 Whales which Beached (and Subsequently Died), Florence, Oregon,*
 June 18, 1979, dye transfer (printed 1983), 13½ x 17⅛″

175 **John Pfahl**, *Indian Point Nuclear Plant, Hudson River, New York*, 1982, dye coupler print, 16 x 22″

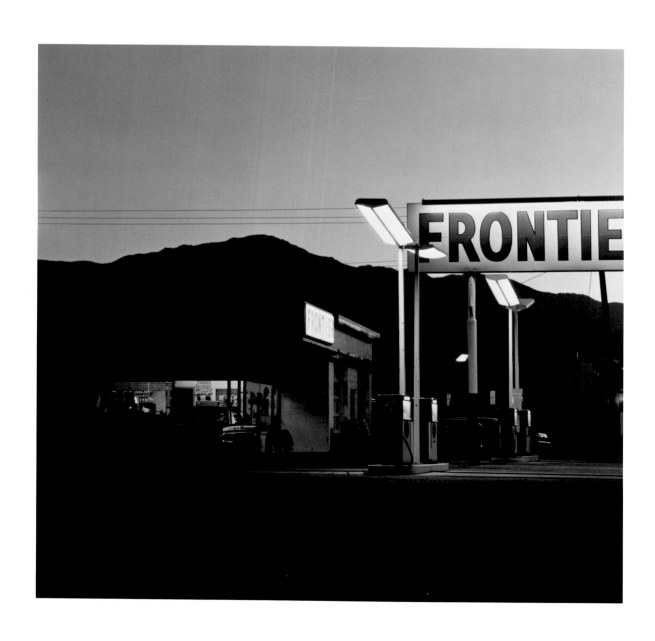

176 **Robert Adams,** *"Frontier" Gas Station and Pike's Peak, Colorado Springs, Colorado,* 1969 (print 1990), 6 x 6″

177 **Emmet Gowin,** *Agricultural Pivot over Glacial Potholes, near Moses Lake, Washington,* 1991, 9¾ x 9¾″

178 David Stephenson, *Untitled*, 1990, 24¾ x 33⅞"

179 Lynn Davis, *Iceberg #1, Disko Bay, Greenland*, 1988, 28 x 28"

180 Lee Friedlander, *Gettysburg*, 1974, 7½ x 11"

EBO LANDING

One midnight at high tide a
ship bringing in a cargo of Ebo (Ibo)
men landed at Dunbar Creek on the
Island of St. Simons. But the men refus-
ed to be sold into slavery; joining hands
together they turned back toward the
water, chanting, "the water brought us,
the water will take us away." They all
drowned, but to this day when the
breeze sighs over the marshes and
through the trees, you can hear the
clank of chains and echo of
their chant at Ebo Landing.

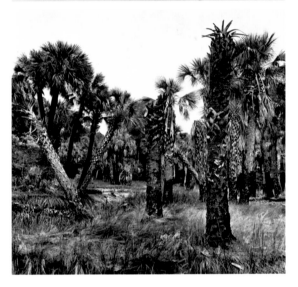

181 **Carrie Mae Weems,** *Sea Islands Series (Ebo Landing),* 1992, two gelatin silver prints and text panel, 60 x 20″ overall

182 **Annie Leibovitz,** *Meryl Streep, New York City,* 1981, Cibachrome print, 10¼ x 10¼″

183 **Francesca Woodman,** *Easter Lily, Rome,* 1978, 6¼ x 6¼"

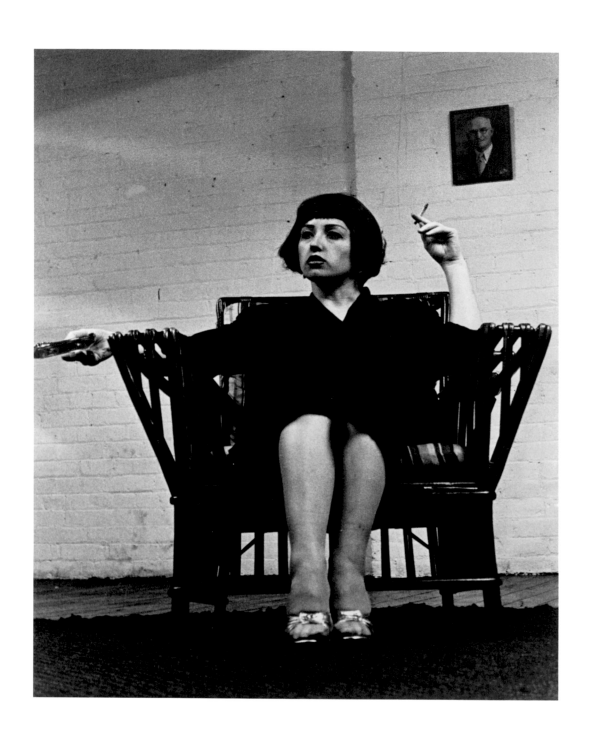

184 Cindy Sherman, *Untitled Film Still #16*, 1978, 10 x 8″

185 **Tseng Kwong Chi**, *San Francisco, Golden Gate Bridge* (from "Expeditionary Series, East Meets West") 1979, 36 x 36″

I was sitting in a coffeeshop having a cup of coffee and a cigarette. Two people at a nearby table were talking about me. I knew one of them years and years ago. I heard him say to his friend: "When he was younger he was kind of beautiful, but as he got older it was like a cake fell in the oven."

186 David Wojnarowicz, *I Was Sitting in a Coffeeshop*, 1990, 13¾ x 19⅛"

187 Robert Mapplethorpe, *Ken Moody*, 1983, 15⅛ x 15¼"

188 **W. Snyder MacNeil,** *Adrian Sesto,* 1977, platinum and palladium on vellum (print 1987), 18¾ x 16½″

189 **Doug and Mike Starn**, *Double Rembrandt with Steps*, 1987, toned gelatin silver prints with ortho film,
tape, glue, silicone, and Plexiglass (printed 1991), 26½ x 26½″ overall

190 **Andres Serrano**, *Precious Blood*, 1989, Cibachrome print, 40 x 27½″

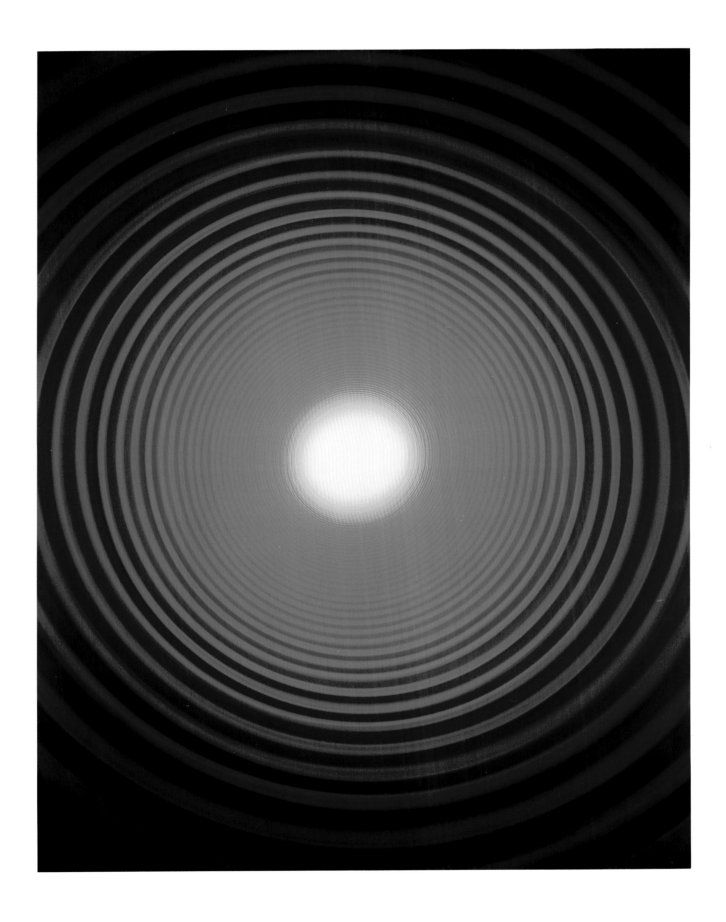

191 **Adam Fuss**, *Untitled*, 1992, Cibachrome print, 64 x 49½"

192 Zeke Berman, *Inversion*, 1990, 25½ x 36¾"

193 James Casebere, *Tenement*, 1992, 40 x 50"

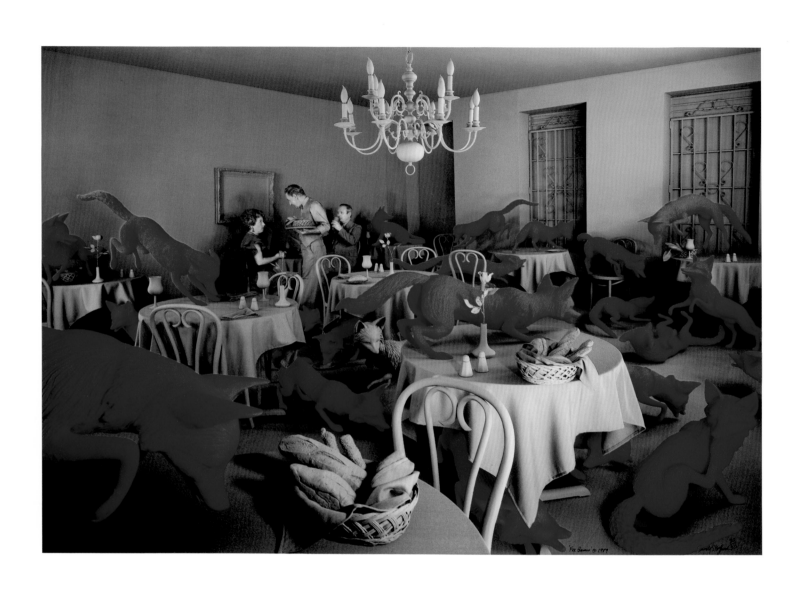

194 **Sandy Skoglund**, *Fox Games*, 1989, Cibachrome print, 47 x 63¾″

195 **Barbara Kruger**, *Untitled (You Get Away With Murder)*, 1987, dye coupler print with silkscreen lettering, 30⅛ x 30″

196 **Nancy Burson**, *Big Brother*, 1983, 12 x 14¾″

197 Peter Campus, *decay*, 1991, 23 x 18½"

198 **Larry Sultan,** *My Mother Posing for Me* (from series "Pictures from Home"), 1989, dye coupler print, 17¼ x 21¼"

199 **Tina Barney**, *The Skier*, 1986, dye coupler print, 28¾ x 36⅝"

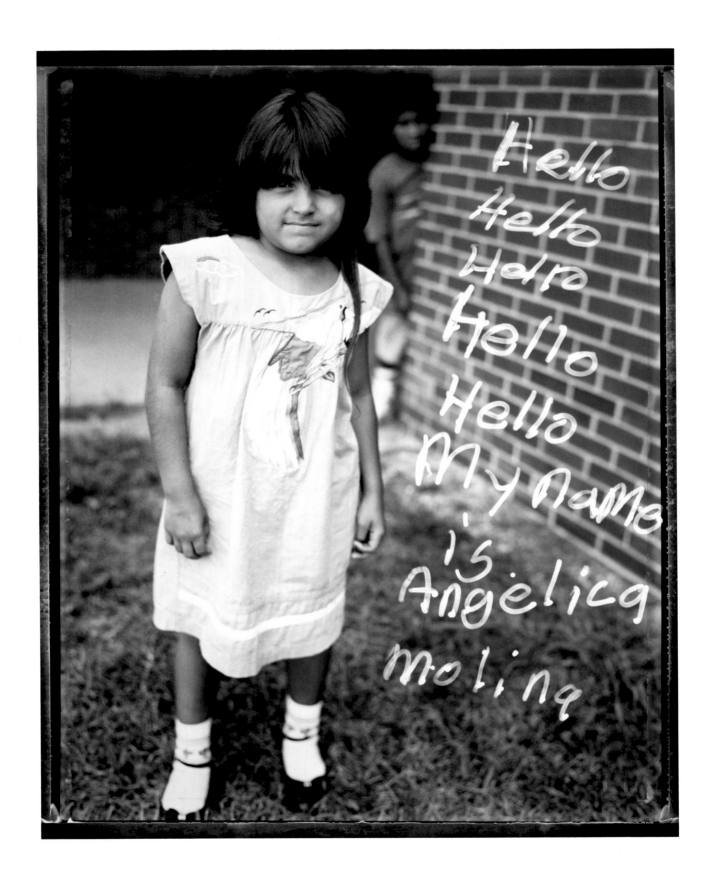

200 **Wendy Ewald (with Angelica Molina),** *Hello, Hello, Hello, Benson, North Carolina,* 1990, 17½ x 13⅝"

201 Jeffrey Wolin, *My Father*, 1988, gelatin silver print with ink, 14¾ x 18¾"

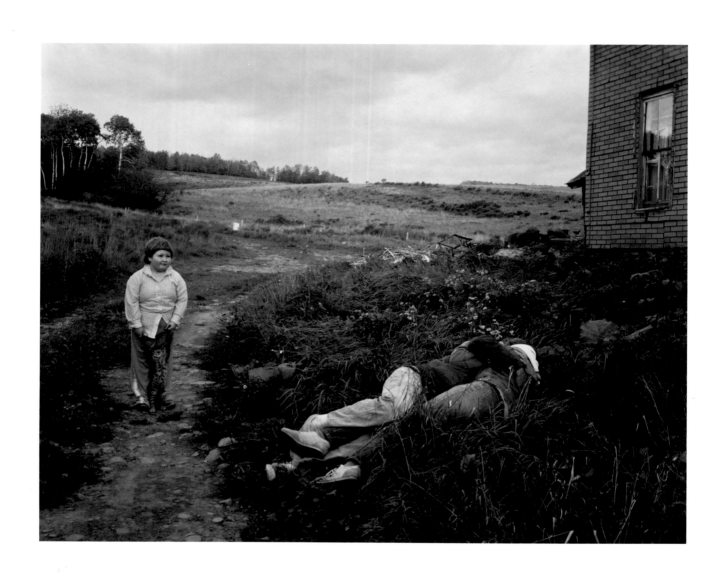

202 **Andrea Modica,** *Treadwell, New York*, 1987, platinum print, 7⅝ x 9½"

203 Sally Mann, *Gorjus*, 1989, 19½ x 23¾"

204 **Emmet Gowin,** *Edith and Isaac, Newtown, Pennsylvania,* 1974 (print 1982), 6¼ x 6¼"

205 **Nicholas Nixon,** *Joel Geiger, Perkins School for the Blind,* 1992, 7⅝ x 9⅝"

206 Keith Carter, *Fireflies*, 1992, 15 × 15″

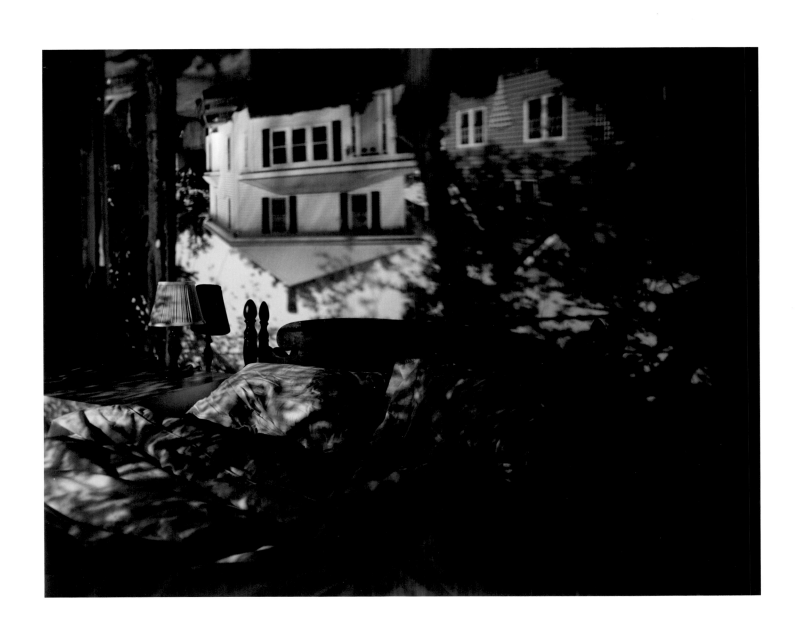

207 **Abelardo Morell,** *Camera Obscura Image of Houses Across the Street in our Bedroom,* 1991, 17⅞ x 22½″

Endnotes

Preface and Acknowledgments

[1] This phrase is carefully chosen. The photograph is wholly objective in its record of "optical fact." However, this is not at all the same as narrative truth, and thus requires extensive interpretation to become meaningful. Despite this gap, many photographs do indeed reveal historical "truths" that other forms of depiction—such as paintings—cannot. Arguments that photographs are essentially like all other kinds of pictures rest on mistaken assumptions that the objectivity of the optical-chemical process (evidence) and the subjectivity of narrative (meaning) are, or should be, one and the same.

[2] Following conventional usage, the words "America" and "American" are used throughout this volume to describe the United States of America and its citizens and residents. No attempt has been made to deal with the photography of the Americas, an enormously rich topic that lies far beyond the scope of this study.

[3] "On Creating a Usable Past," *The Dial* 64(April 11, 1918): 339.

[4] David Lowenthal, *The Past is a Foreign Country* (Cambridge: Cambridge University Press, 1985), p. xvii.

[5] Cited in Morris Dickstein, *Double Agent: The Critic and Society* (New York: Oxford University Press, 1992), p. 106.

CHAPTER I A Reluctant Modernism 1890-1915

[1] George Cotkin, *Reluctant Modernism: American Thought and Culture, 1880-1900* (New York: Twayne Publishers, 1992).

[2] J. Wells Champney, "Fifty Years of Photography," *Harper's New Monthly Magazine* 74(June-November 1889): 357. For a brief biography of Champney, see "J. Wells Champney," *Camera Notes* 6 (December 1903): 196-97.

[3] Champney, "Fifty Years of Photography," p. 364.

[4] Ibid., p. 366.

[5] Robert Taft, *Photography and the American Scene: A Social History, 1839-1889* (New York: Macmillan Company, 1938; reprint by Dover Publications, 1964), p. 371.

[6] Ibid., p. 374.

[7] William Welling, *Photography in America: The Formative Years, 1839-1900* (New York: Thomas Y. Crowell, 1978), p. 286.

[8] Ibid., p. 271.

[9] For an excellent survey of Marey's career, see Marta Braun, *Picturing Time: The Work of Etienne-Jules Marey (1830-1904)* (Chicago: University of Chicago Press, 1992). For an early report of Anschutz's work in the American photographic press, see *Philadelphia Photographer* 23(November 20, 1886): 686-88.

[10] While this work is firmly entrenched in photographic history and legend, details of the production remain somewhat vague. It has been generally assumed that the sophisticated electrical and mechanical engineering required for this series was largely Muybridge's own creation. However, Terry Ramsaye, in his 1926 history of the motion picture, goes to great, and perhaps excessive, lengths to downplay Muybridge's role in this effort. According to Ramsaye, the complex timing and triggering mechanisms were the work of John D. Isaacs, a brilliant young engineer with the Southern Pacific railway, and Muybridge was merely a photographic technician. See Terry Ramsaye, *A Million and One Nights* (New York: Simon & Schuster, 1926; reprinted by Touchstone Books, 1986), pp. 21-49. My thanks to George Rinhart for bringing this reference to my attention.

[11] For a contemporary review of this work, see "New Publications," *New York Times* (March 5, 1888): 3.

[12] An excellent examination of this theme is Marta Braun, "Muybridge's Scientific Fictions," *Studies in Visual Communication* 10(Summer 1984): 2-21.

[13] A good capsule biography of Blake is included in the *National Cyclopaedia of American Biography* (New York: James T. White, 1955), vol. 22, pp. 25-26.

[14] Blake noted that this work was done with Mr. John G. Hubbard, "who has been my almost constant companion and coadjutor." For technical data on this work, see Blake's article "Photographic Shutters" in the February 1891 issue of *American Amateur Photographer*, pp. 67-73. Included as the frontispiece of this issue is a variant of *Pigeons in Flight*. This essay, which was first presented as a lecture at the Boston Camera Club on April 14, 1890, was also published in *Anthony's Photographic Bulletin* 22(1891): 144-46, 174-77, 234-36.

[15] For a listing of Blake's subjects, see for example, *Report of the Eighteenth Triennial Exhibition of the Massachusetts Charitable Mechanic Association held...October and November, 1892* (Boston: Rockwell and Churchill, 1893), pp. 175-76, 182. In the Photographic Exhibition of this fair, Blake exhibited instantaneous images of Mr. E. L. Hall, Jr. ("winner of the Longwood and several other tennis tournaments"), Mr. R. D. Sears ("Champion of the United States, 1881-1889, and Double Championship, 1882-1889"), Dr. James Dwight ("Double Championship of the United States, 1882, 1883, 1884, 1886, 1887"), and Mr. Thomas Pettitt ("Professional Court Tennis Champion of the World, Professional Lawn Tennis Champion of America"), as well as two views of *Pigeons in Flight*, *Boy on a Bicycle*, and *Engine of New York Express; Speed, forty-eight miles an hour*. The jurors of this exhibition presented Blake a silver medal for "especial excellence in instantaneous work" with the official comment:

> Mr. Blake's exhibit is worthy of especial mention from a scientific point of view, showing the wonderful possibilities of photography in the taking

of express trains going at full speed, horses running, birds flying, etc., etc. Next we may look for the photographing of persons at a distance, speech, and possibly our very thoughts. Some of Mr. Blake's pictures were made in the one-thousandth part of a second.

Thanks to Chris Steele of the Massachusetts Historical Society for bringing this citation to my attention.

[16] Taft, *Photography and the American Scene*, p. 375.

[17] *New York Times* (November 11, 1883): 5.

[18] *New York Times* (August 20, 1884):4. On this subject, see Robert E. Mensel, "'Kodakers Lying in Wait': Amateur Photography and the Right of Privacy in New York, 1885-1915," *American Quarterly* 43(March 1991): 24-25.

[19] Reprinted in *Philadelphia Photographer* 22(November 1885): 366.

[20] Alexander Black, "The Amateur Photographer," *Century Magazine* 34(September 1887): 722-29; repr. in Beaumont Newhall, ed., *Photography: Essays & Images: Illustrated Readings in the History of Photography* (New York: Museum of Modern Art/New York Graphic Society, 1980), pp. 148-53.

[21] *Wilson's Photographic Magazine* 27(1890): 230.

[22] For an excellent summary of Eastman's role in this period, see Reese Jenkins, "Technology and the Market: George Eastman and the Origins of Mass Amateur Photography," *Technology and Culture* 16(January 1975): 1-19.

[23] Jenkins notes (ibid., pp. 12-13) that by 1887 merely 11 percent of Eastman's business came from the sale of dry plates. As Jenkins observes, "By 1887 the Eastman company had largely failed with both the production of dry plates and with the roll film system but maintained its financial integrity through its pioneering production of bromide paper and the provision of a developing and printing service."

[24] *Philadelphia Photographer* 25(1888): 634.

[25] This phrase quickly became one of the best-known slogans in American business history. It is amusing to note that Eastman's competitors used it as the model for such derisive retorts as "You jab the jigger and we'll finish the mess." See Colin Ford, *The Story of Popular Photography* (North Pomfret, Vt.: Trafalgar Square Publishing, 1989), p. 64.

[26] "Hand Cameras," *American Amateur Photographer* 2(1890): 136-43, 170-73. See also "Detectives at the Convention," *American Amateur Photographer* 1(1889): 94-96.

[27] *American Amateur Photographer* 11(August 1899): 324.

[28] For a short history of the Brownie, see Eaton S. Lothrop, Jr., "The Brownie Camera," *History of Photography* 2(January 1978): 1-10.

[29] Harry R. Terhune, "A Ramble with the Camera in the Lower Delaware Valley," *Outing* 12(July 1888): 340.

[30] Jenkins, "Technology and the Market," p. 18.

[31] For a colorful outline of the vast "underbelly" of New York City life in this era, see Luc Sante, *Low Life: Lures and Snares of Old New York* (New York: Farrar, Straus Giroux, 1991).

[32] In many respects, of course, Riis was representative of his time. He thus held attitudes that would not be considered particularly "enlightened" today. His mixed attitudes toward those he was trying to help, and his frequent thnic stereotying, are apparent in the most casual reading of his works. As Sante observes in *Low Life* (p. 34), Riis "was a moralist who ignored economic causes and who did not hesitate to judge the people he was helping by the same lofty standards of conduct he applied to those he reproved..." See also Louis Fried, "Jacob Riis and the Jews: The Ambivalent Quest for Community," *American Studies* 20(Spring 1979): 5-24.

[33] Peter Bacon Hales, *Silver Cities: The Photography of American Urbanization, 1839-1915* (Philadelphia: Temple University Press, 1984), p. 168. The discussion of Riis's work in chapter 4 of this book is particularly informative for its perspective on larger issues of social work and the representation of urban subjects in this era. A rather different, but excessively tendentious, interpretation of Riis's work is provided in Maren Stange's *Symbols of Ideal Life: Social Documentary Photography in America, 1890-1950* (Cambridge: Cambridge University Press, 1989), pp. 1-29. For example, Stange observes that "the idea of photography as surveillance, the controlling gaze as a middle-class right and tool, is woven throughout Riis's lectures and writings" (p. 23).

[34] Jacob A. Riis, *The Making of an American* (New York: Macmillan Company, 1918; first published 1901), p. 268.

[35] "Flashes from the Slums: Pictures Taken in Dark Places by the Lightning Process," *New York Sun* (February 12, 1888); repr. in Newhall, ed., *Photography: Essays & Images*, pp. 155-57.

[36] Riis, *The Making of an American*, p. 271.

[37] Ibid., p. 265.

[38] For an eloquent reading of this image, see Hales, *Silver Cities*, p. 192.

[39] While the slum provided a relatively common subject for writers and illustrators of this era, Riis's photographs were distinguished by unsentimental specificity. On this subject, see David M. Fine, "Abraham Cahan, Stephen Crane, and the Romantic Tenement Tale of the Nineties," *American Studies* 14(Spring 1973): 95-107; and chapter 4 of Hales's *Silver Cities*.

[40] Riis's numerous other subsequent volumes include *The Children of the Poor* (1892), *A Ten Years' War* (1900), his best-selling autobiography *The Making of an American* (1901), and *The Battle with the Slum* (1902).

[41] While Riis's career continued until his death in 1914, he apparently ceased photographing by 1898. Given his merely functional interest in the medium, it is not surprising that his photographs fell into obscurity for many years. It was not until 1946 that Riis's original negatives were found by Alexander Alland. Modern prints made from these glass-plate negatives were included in a number of influential exhibitions and publications, leading to Riis's rediscovery as a pioneering documentary photographer.

[42] For a summary of the activity of Krausz, Austen, and others, see chapter 5 of Hales, *Silver Cities*.

[43] See Ralph F. Bogardus and Ferenc M. Szasz, "Reality Captured, Reality Tamed: John James McCook and the Uses of Documentary Photography in *fin de siécle* America," *History of Photography* 10(April-June 1986): 151-67.

[44] This point is emphasized in Estelle Jussim, "'The Tyranny of the Pictorial': American Photojournalism from 1880 to 1920," in Marianne Fulton, ed., *Eyes of Time: Photojournalism in America* (Boston: New York Graphic Society, 1988), p. 44.

[45] For example, in her *Visual Communications and the Graphic Arts* (New York: R.R. Bowker, 1974), p. 262, Estelle Jussim notes that the first book illustrated solely by halftones, Henry Goodyear's *A History of Art*, was published in 1888. The difficulty of the process resulted in the curious fact that the second edition of this volume, published in 1889, reverted largely to the earlier line-drawing engraving process. Similarly, Alexander Alland, in *Jacob A. Riis: Photographer & Citizen* (Millerton, N.Y.: Aperture, 1974), p. 30, notes that "the first large-scale use of halftones occurred in a picture magazine, *Sun and Shade*, which began publication in July 1888 and had to abandon the practice a year later because of the high costs." See also Christopher R. Harris, "The Halftone and American Magazine Reproduction 1880-1900," *History of Photography* 17(Spring 1993): 77-80.

[46] It is still surprising, however, how gradually the process was adapted. In her essay "'The Tyranny of the Pictorial,'" Jussim notes (p. 44) that the first regular use of halftones in a newspaper did not occur until January 21, 1897. As late as 1899, *Wilson's Photographic Magazine* (36[February 1899]: 64) found it newsworthy enough to note that two of the leading newspapers in New York "are now using halftones more or less regularly in their columns."

[47] The following is indebted to Ulrich Keller's "Photojournalism Around 1900: The Institution of a Mass Medium," in Kathleen Collins, ed., *Shadow and Substance: Essays in the History of Photography in Honor of Heinz K. Henisch* (Bloomfield Hills, Mich.: Amorphous Institute Press, 1990), pp. 283-303.

[48] Frederic Felix, "Getting the News Photographs," *American Annual of Photography 1921*, p. 194. In this article Felix provides a good short description of the early evolution of this business:

As illustrating with the half-tone process advanced to its modern plan the firm [of Underwood & Underwood] was repeatedly called upon to supply a view of some scene, place or building that would improve a book or article.... The continuation of such calls for photographs induced them to develop all the possibilities of a business thrust upon them. They next provided lay-out groups, that is collections of from

several to a dozen prints showing some certain customs, industry, peoples or activities, and sold them to publications wishing to illustrate special articles. Next came a collection of all the prominent men of the day, and after that they added the taking of events of news interest as they were happening daily all over the world [p. 196].

[49] See, for example, "Batteries of Cameras for Celebrities," *American Amateur Photographer* 18(September 1906): 437-42.

[50] See, for example, "Picture Making in San Francisco After the Fire," *American Annual of Photography* 1907, pp. 158-68.

[51] "The Work of a Press Photographer," *Camera Craft* 21(April 1914): 164. For similar points of view, see "Adventures of Daring Photographer," *The World's Work* 14(May 1907): 8834-48, and "The Press Photographers," *American Annual of Photography* 1915, pp. 186-88.

[52] Dugmore contributed to *The World's Work* and other journals of the period, and was also well known for his photographs of fish and other wildlife. For data on Beals's career, see Alexander Alland, Sr., *Jessie Tarbox Beals: First Woman News Photographer* (New York: Camera/Graphic Press, 1978).

[53] Peter Daniel and Raymond Smock, *A Talent for Detail: The Photographs of Miss Frances Benjamin Johnston, 1889-1910* (New York: Harmony Books, 1974), p. 87.

[54] Johnston's work at Hampton Institute is documented in *The Hampton Album* (New York: Museum of Modern Art, 1966).

[55] Constance Glenn and Leland Rice, *Frances Benjamin Johnston: Women of Class and Station* (Long Beach: Art Museum and Galleries, California State University, 1979), p. 13. In 1901-02, Johnston also wrote a series of profiles of leading women photographers for *Ladies Home Journal*. For related references see the bibliography of Peter Palmquist, ed., *Camera Fiends & Kodak Girls* (New York: Midmarch Arts Press, 1989).

[56] Cecil Carnes, *Jimmy Hare, News Photographer: Half a Century with a Camera* (New York: Macmillan Company, 1940). This must represent one of the earliest biographies of an American photographer.

[57] For an early description of the Underwood & Underwood business, see *Wilson's Photographic Magazine* 31(February 1894): 66-69. More recent studies of the stereograph in this era are "Mass Production of Stereographs," in William C. Darrah, *The World of Stereographs* (Gettysburg, Pa.: W.C. Darrah, 1977), pp. 45-52; and Edward W. Earle, ed., *Points of View: The Stereograph in America—A Cultural History* (Rochester, N.Y.: Visual Studies Workshop Press, 1979).

[58] The basic approach of early photojournalists was outlined as early as 1891 in "Photography and Illustrated Journalism," *Wilson's Photographic Magazine* 28(June 6, 1891): 321-25. For example:

The one dominating idea [the photojournalist] has to entertain is this: The photograph or photographs must correctly tell their tale, so that he who runs may read it there. You cannot put soul or sentiment easily into a photograph, but you can arrest action so that a glance thereat will tell you what was occurring at the time. The photograph must convey some idea of the culminating or central object of the gathering. For instance, take a ceremony in which a historical monument is to be unveiled by some person of eminence, with an imposing ceremonial. The photographer who undertakes to procure views of the ceremony which will accurately convey to the minds of those who are not present some idea of the grouping and general aspect of the scene, must have this object always in mind, and not be led away by attractive-looking "bits" here, there, and all over the place...

[59] Though innumerable examples could be cited, an unusually powerful cinematic use of news photographs is "The President on His Tours," *The World's Work* 5(November 1902): 2754-60. In this article, pictures and words are given equal weight: each page includes one column of text and one with three equal-size photographs. The images record President Roosevelt's expressions and gestures while suggesting the vast crowd around him. The result is a compelling sense of his physical energy and the excitement of his public appearances.

[60] For a description of these, see Roger Hull, "The Traditional Vision of Rudolf Eickemeyer, Jr.," *History of Photography* 10(January-March 1986): 49-53.

[61] See Beverly Seaton, "Beautiful Thoughts: The Wallace Nutting Platinum Prints," *History of Photography* 6:3(July 1982): 273. See also Joyce P. Barendsen, "Wallace Nutting, an American Tastemaker: The Pictures and Beyond," *Winterthur Portfolio* 18(Summer-Autumn 1983): 187-212.

[62] For a summary biography, see the *National Cyclopaedia of American Biography* (New York: James T. White, 1955), vol. 40, pp. 387-88.

[63] Charles A. Madison, "Preface to the Dover Edition," *How the Other Half Lives* (New York: Dover Publications, 1971), p. viii. Johnson's name is given here as "Clifton H. [sic] Johnson" rather than Clifton C[hester] Johnson.

[64] Johnson's many publications are listed in *The National Union Catalog Pre-1956 Imprints*, vol. 282, pp. 17-25.

[65] Clifton Johnson, *The New England Country* (Boston: Lee and Shepard, 1893), p. 1.

[66] See the chapter "Deserted Homes," in Johnson's *A Book of Country Clouds and Sunshine* (Boston: Lee and Shepard, 1896), pp. 173-96.

[67] Johnson's traditional aesthetic interests are revealed in his article "Photography and Art," *American Amateur Photographer* 13(1901): 78-82. In this piece, first published in the *Saturday Evening Post*, Johnson warned beginning photographers against the "disadvantages of too much truth." His concern with precise composition is revealed by his comment that "the shifting of the camera a few feet this side or that, front or back, often makes all the difference between poetry and prose."

[68] This attention to detail gives Johnson's volumes a sense of mimesis more characteristic of texts of the 1930s. For example, in *A Book of Country Clouds and Sunshine*, Johnson follows a lengthy transcription of a conversation with the comment, "I have not reported all the afternoon's conversation; but these were real people, and I have kept very close to their real words and manner" (p. 132). He then describes in meticulous detail the room in which this conversation had taken place.

The sitting-room... had a vertical-patterned wall-paper of light tone, and the woodwork was a grained yellow. On the floor was a large-figured carpet, in which red, green, and black were the predominant colors. A bit of oilcloth before each of the two doors, and a braided rag mat, and a long strip of rag carpet, protected the most travelled parts of the room from wear. Two small-paned windows looked out on the roadway. Before one of them, on a stand, were two wooden boxes, with young tomato-plants sprouting in them. On another stand, against the wall, were a Bible, a photograph album, a lamp, and two pairs of spectacles [etc.]....

[69] This volume contains six photographs of stoves as sources of heat and food, or as the focus of the community's social life.

[70] James A. Kaufmann, "Arnold Genthe: Gentleman Photographer," *Image* 20(September-December 1977): 2.

[71] Ibid., p. 3. Genthe's sympathy for his subject is suggested by the fact that his images were used to illustrate a 1901 article defending Chinese immigration at a time when "anti-immigration sentiment was running high in America."

[72] Ibid. Genthe's high valuation of these images is revealed in the fact that his negatives, which had been stored carefully in a vault, were among his very few possessions to survive the earthquake.

[73] *Old Chinatown: A Book of Pictures by Arnold Genthe*, with text by Will Irwin (London: Sidgwick & Jackson, 1913), pp. 205-08.

[74] See such studies as Thomas Vander Meulen, *F. I. Monsen* (Tempe: Arizona State University, 1985); Turbese Lummis Fiske, *Charles F. Lummis: The Man and His Work* (Norman: University of Oklahoma Press, 1975); and Ward Jerome, "Karl Moon's Photographic Record of The Indian Life of Today," *The Craftsman* (April 1911): 24-32.

[75] According to Karen Current in *Photography and the Old West* (New York: Harry N. Abrams/Amon Carter Museum, 1978), Vroman became interested in photography through the influence of Charles Lummis (p. 236).

[76] In 1897, Vroman reported some 200 whites in attendance at this ceremony. See William Webb and Robert A. Weinstein, *Dwellers at the Source: Southwestern Indian Photographs of A.C. Vroman, 1895-1904* (New York: Grossman, 1973), p. 85.

[77] Most of the information on this congress, and Rinehart's work, is drawn from Robert Bigart and Clarence Woodcock, "The Trans-Mississippi Exposition & The Flathead Delegation," *Montana: The Magazine of Western History* 24(Autumn 1979): 14-25.

[78] *Rinehart's Indians* (Omaha: F.A. Rinehart, 1899), n.p.

[79] Barbara A. Davis, *Edward S. Curtis: The Life and Times of a Shadow Catcher* (San Francisco: Chronicle Books, 1985), p. 78. Even this mammoth project did not constitute the sum total of Curtis's work.

See Mick Gidley, "From the Hopi Snake Dance to 'The Ten Command-ments': Edward S. Curtis as Filmmaker," *Studies in Visual Communication* 8(Summer 1982): 70-79.

[80] For a critical appraisal of Curtis's method, see Christopher M. Lyman, *The Vanishing Race and Other Illusions: Photographs of Indians by Edward S. Curtis* (New York: Pantheon Books, 1982). For a critique of Lyman's approach, see Bill Holm's review of this book in *American Indian Art* 8(Summer 1983): 68-73. See also Beth Barclay DeWall, "Edward Sheriff Curtis: A New Perspective on 'The North American Indian,'" *History of Photography* 6(July 1982): 223-39.

[81] Lyman, *The Vanishing Race and Other Illusions*, p. 125.

[82] For a short comparative study of a photographer hired by the Bureau of Ethnology, see James R. Glenn, "De Lancey W. Gill: Photographer for the Bureau of American Ethnology," *History of Photography* 7(January 1983): 7-22.

[83] *Wilson's Photographic Magazine* 42(May 1905): 240.

[84] *Wilson's Photographic Magazine* 44(August 1907): 361.

[85] Davis, *Edward S. Curtis: The Life and Times of a Shadow Catcher*, pp. 66, 68.

[86] For a brief summary of this theme, see William E. McRae, "Images of Native Americans in Still Photography," *History of Photography* 13(October-December 1989): 321-42.

[87] Davis, *Edward S. Curtis: The Life and Times of a Shadow Catcher*, p. 37.

[88] Neil Harris, *The Artist in American Society: The Formative Years, 1790-1860* (Chicago: University of Chicago Press, 1966; repr. 1982), p. xi. The following discussion owes a considerable debt to this superb study.

[89] Ibid., p. 69.

[90] On the latter, see, in particular, Franklin Kelly, *Frederick Edwin Church and the National Landscape* (Washington, D.C.: Smithsonian Institution Press, 1988).

[91] For a very useful discussion of this theme, see the first chapter of Richard Rudisill, *Mirror Image: The Influence of the Daguerreotype on American Society* (Albuquerque: University of New Mexico Press, 1971).

[92] Brooks Atkinson, ed., *The Selected Writings of Ralph Waldo Emerson* (New York: Modern Library, 1940), p. 6.

[93] For concise studies of this complex issue, see, for example, Anne Farmer Meservey, "The Role of Art in American Life: Critics' Views on Native Art and Literature, 1830-1865," *American Art Journal* 10(May 1978): 73-89; and H. Barbara Weinberg, "Late-Nineteenth-Century American Painting: Cosmopolitan Concerns and Critical Controversies," *Archives of American Art Journal* 23(1983): 19-26.

[94] Carol Troyen, "Innocents Abroad: American Painters at the 1867 Exposition Universelle, Paris," *American Art Journal* 16(Autumn 1984): 14.

[95] Annette Blaugrund, ed., *Paris 1889: American Artists at the Universal Exposition* (Philadelphia: Pennsylvania Academy of the Fine Arts/Harry N. Abrams, 1989), p. 7.

[96] H. Barbara Weinberg, "Cosmopolitan Attitudes: The Coming of Age of American Art," in ibid., p. 33.

[97] For background on this important exhibition, see Blaugrund, ed., *Paris 1889*; Lois Marie Fink, *American Art at the Nineteenth-Century Paris Salons* (Cambridge: Cambridge University Press/National Museum of American Art, 1990); and Fink's article "American Art at the 1889 Paris Exposition: The Paintings They Love to Hate," *American Art* 5(Fall 1991): 34-51.

[98] For example, Mathew Brady, one of the most renowned and awarded daguerreotype portraitists of the day, published the following notice in *Humphrey's Journal* in 1853:

Address to the Public—New York abounds with announcements of 25 cent and 50 cent Daguerreotypes. But little science, experience, or taste is required to produce these, so called, cheap pictures. During the several years that I have devoted to the Daguerrean Art, it has been my constant labor to perfect it and elevate it. The results have been that the prize of excellence has been accorded to my pictures at the World's Fair in London, the Crystal Palace in New York and wherever exhibited on either side of the Atlantic...

Being unwilling to abandon any artistic ground to the producers of inferior work, I have no fear in appealing to an enlightened public as to

their choice between pictures of the size, price, and quality, which will fairly remunerate men of talent, science, and application, and those which can be made by the merest tyro. I wish to vindicate true art, and leave the community to decide whether it is best to encourage real excellence or its opposite; to preserve and perfect an Art, or permit it to degenerate by inferiority of materials which must correspond with the meanness of the price.

[99] *Photographic and Fine Art Journal* 8(May 1855): 158-59. For a more extended discussion, see Keith F. Davis, *George N. Barnard: Photographer of Sherman's Campaign* (Kansas City: Hallmark Cards, Inc., 1990), particularly pp. 29-37.

[100] "The Present Aspect of Photography," *American Amateur Photographer* 1(July 1889): 5.

[101] Enoch Root, "The Artistic Spirit in Photography," *Philadelphia Photographer* 24(January 15, 1887): 35.

[102] Charlotte Adams, "An Answer to Mr. W. J. Stillman's Opinion of Photo Art," *Philadelphia Photographer* 23(July 3, 1886): 386.

[103] *Wilson's Photographic Magazine* 26(July 6, 1889): 296.

[104] "Science and Art," *Wilson's Photographic Magazine* 26(June 1, 1889): 323-27. See also Emerson's *Naturalistic Photography* (London: Sampson Low, Marston, Searle & Rivington, 1889).

[105] These American publications took their place within a much larger body of international photographic literature. In his 1894 article "Photographic Journalism," Charles W. Canfield notes that no fewer than 143 regularly issued photographic publications were then in existence, "in thirteen different languages, in twenty-one countries, from Australia to Japan, from Finland to South Africa." Canfield, "Photographic Journalism," *American Amateur Photographer* 6(December 1894): 549. For a concise overview of this subject, see William and Estelle Marder, "Nineteenth-Century American Photographic Journals: A Chronological List," *History of Photography* 17(Spring 1993): 95-100.

[106] For a good study of this subject, see Sarah Greenough, "'Of Charming Glens, Graceful Glades, and Frowning Cliffs': The Economic Incentives, Social Inducements, and Aesthetic Issues of American Pictorial Photography, 1880-1902," in Martha A. Sandweiss, ed., *Photography in Nineteenth-Century America* (New York: Harry N. Abrams/Amon Carter Museum, 1991), pp. 259-81.

[107] In a notice announcing the formation of new photographic clubs in Iowa City, Duluth, Wheeling, and Medford (Mass.), the *American Amateur Photographer* observed that "there cannot be less than seventy-five such clubs now in active existence in the United States." See *American Amateur Photographer* 1(August 1889): 60.

[108] See "American Photographic Societies," *American Amateur Photographer* 1(July 1889): 42-45; and the report of the November 1889 meeting of the Hawaiian Camera Club in *American Amateur Photographer* 2(January 1890): 33.

[109] For a recent study of this important club, see Mary Panzer, *Philadelphia Naturalistic Photography, 1865-1906* (New Haven: Yale University Art Gallery, 1982). For a short contemporary history of the society, see "The Oldest American Photographic Club," *American Photography* 2(September 1908): 486-92.

[110] "The Society of Amateur Photographers of New York," *American Amateur Photographer* 6(April 1894): 157-69.

[111] This figure is cited in Greenough, "'Of Charming Glens, Graceful Glades, and Frowning Cliffs,'" p. 268.

[112] "The Cincinnati Camera Club," *American Amateur Photographer* 2(February 1890): 53-54.

[113] For example, while their work was exhibited and praised in the mid-1880s, photographers such as E. L. Coleman of the Boston Camera Club, M. L. Corlies of The Photographic Society of Philadelphia, and R. W. DeForest of the Society of Amateur Photographers of New York, have left little historical trace. See *Philadelphia Photographer* 23(January 2, 1886): 25; *Philadelphia Photographer* 24(February 5, 1887): 83; and *Philadelphia Photographer* 24(April 16, 1887): 252.

[114] This figure is cited in Jeanne Moutoussamy-Ashe, *Viewfinders: Black Women Photographers* (New York: Writers & Readers, 1993), p. 17. Six of these 2,201 women were African Americans.

[115] *American Amateur Photographer* 2(January 1890): 13.

[116] *American Amateur Photographer* 1(December 1889): 224.

117 *American Amateur Photographer* 3(November 1891): 435.

118 Barnes's "Lancelot and Elaine" pictures were reproduced as frontispieces in the August 1891 and October 1891 issues of the *American Amateur Photographer*.

119 Barnes's most significant essays were published in the *American Amateur Photographer*. The most important of these from 1889 to 1892 include: "The Study of Interiors" (1[1889]: 91-93), "Why Ladies Should be Admitted to Membership in Photographic Societies" (1[1889]: 223-24), "Photography from a Woman's Standpoint" (2[1890]: 10-13), "Under the Sky-Light" (2[1890]: 87-88), "A Woman to Women" (2[1890]: 185-88), "Illustrating Poems by Photography" (2[1890]: 260-63), "A Photographer at the Washington Convention" (2[1890]: 347-50), "The Real and the Ideal" (3[1891]: 58-61), "Photography as a Profession for Women" (3[1891]: 172-76), "Art in Photography" (3[1891]: 179-81), "Women as Photographers" (3[1891]: 338-41), "The Buffalo Convention and its Lessons" (3[1891]: 393-96), "Artistic Photography" (3[1891]: 434-39), "The Question of Selection" (4[1892]: 4-8), "Amateur Photography in America" (4[1892]: 344-50), "Photographic Limits" (4[1892]: 448-52), and "The Object of Photography" (4[1892]: 484-88).

120 Catherine Weed Barnes Ward died at her English home in Kent in 1913 at the age of 62. For a brief biography, see "Catherine Weed Barnes Ward," *American Photography* 7(October 1913): 593. On the subject of women in turn-of-the-century American photography see Madelyn Moeller, "Ladies of Leisure: Domestic Photography in the Nineteenth Century," in Kathryn Grover, ed., *Hard at Play: Leisure in America, 1840-1940* (Amherst: University of Massachusetts Press, 1992), pp. 139-60.

121 "The Chicago Camera Club," *American Amateur Photographer* 1(October 1889): 154-56.

122 *American Amateur Photographer* 2(January 1890): 33.

123 "The Cincinnati Camera Club," p. 57.

124 For concise overviews of the larger uses of lantern slides in this era, see Howard B. Leighton, "The Lantern Slide and Art History," *History of Photography* 8(April-June 1984): 107-18; and Elizabeth Shepard, "The Magic Lantern Slide in Entertainment and Education, 1860-1920," *History of Photography* 11(April-June 1987): 91-108.

125 The rules for participation in the New England Slide Exchange, published in the *American Amateur Photographer* 2(January 1890):29, note that "all slides must be of the standard size of 3¼ x 4 inches." By the end of the 1890s lantern slides were also made in the 3¼ x 3¼-inch format.

126 *American Amateur Photographer* 1(July 1889): 38.

127 *American Amateur Photographer* 1(November 1889): 180.

128 "A Photographic Outing with Mr. E. P. Roe in the Highlands of the Hudson," *Photographic Times and American Photographer* 17(December 23, 1887): 646-47. See also such articles as "A Ramble with the Camera in the Lower Delaware Valley," *Outing* 12(July 1888): 337-41; and "How to Prepare for a Photographic Outing," *Outing* 12(September 1888): 502-03.

129 For a superb study of this subject, see Julie K. Brown, *Contesting Images: Photography and the World's Columbian Exposition* (Tucson: University of Arizona Press, 1994).

130 *Philadelphia Photographer* 22(December 1885): 397.

131 *Philadelphia Photographer* 23(March 20, 1886): 183-84.

132 *American Amateur Photographer* 5(May 1893): 201.

133 Alfred Stieglitz, "The Joint Exhibition at Philadelphia," *American Amateur Photographer* 5(May 1893): 201-09.

134 *American Amateur Photographer* 6(May 1894): 209.

135 *American Amateur Photographer* 6(April 1894): 153.

136 *Philadelphia Photographer* 22(January 1885): 23-25.

137 F.C. Beach, "The New York May Exhibition," *American Amateur Photographer* 3(August 1891): 283-91.

138 See, for example, Stieglitz's essay "A Plea for a Photographic Art Exhibition," *American Annual of Photography 1895*, pp. 27-28.

139 For a full listing, see "Artistic Photography at Vienna," *American Amateur Photographer* 3(July 1891): 268-69.

140 George Davison, "The Photographic Salon," *American Amateur Photographer* 5(November 1893): 495, 498.

141 For a fine study of this publication, see Christian A. Peterson, *Alfred Stieglitz's* Camera Notes (New York: W.W. Norton/Minneapolis Institute of Arts, 1993).

142 *Camera Notes* 1(July 1897): 3.

143 Ibid.

144 One of the most baffling and esoteric of these articles is William M. Murray's "The Music of Colors, the Colors of Music and the Music of the Planets," in the January 1898 issue. With the assistance of graphs and calculations, Murray demonstrates that "the characteristic elements of the harmonies of music and of light are included within the compass of the octave," proving that each musical tone corresponded to a color of the spectrum.

145 *Wilson's Photographic Magazine* 35(February 1898): 89. For further data on this show, see pp. 89-92 and 113-18 of this volume.

146 From the catalogue for the first Salon. Cited in Joseph T. Keiley, "The Decline and Fall of the Philadelphia Salon," *Camera Notes* 5(1902): 282.

147 Cited in Panzer, *Philadelphia Naturalistic Photography*, p. 14; *Wilson's Photographic Magazine* 25(December 1898): 529; and *Camera Notes* 2(1899): 113.

148 *Camera Notes* 2(1899): 126. Similarly, *Wilson's Photographic Magazine* (35[December 1898]: 531) pronounced Käsebier's display "perhaps the most remarkable exhibit made by any single exhibitor."

149 *Camera Notes* 2(1899): 126.

150 For example, see Gabriel P. Weisberg, "From the Real to the Unreal: Religious Painting and Photography at the Salons of the Third Republic," *Arts Magazine* 60(December 1985): 58-63; and Fink, *American Art at the Nineteenth-Century Paris Salons*, pp. 168-75.

151 Fink, *American Art at the Nineteenth-Century Paris Salons*, p. 168.

152 At about the same time, a Mr. H. McMichael of Buffalo, New York, did a series of studio images of an actor dressed as Christ. See "Christ-Heads," *Wilson's Photographic Magazine* 31(November 1894): 515-17; and "Christ in Art," *Wilson's Photographic Magazine* 32(January 1895): 6-9. Day was not the only exhibitor in the 1898 Philadelphia Salon to deal with sacred subjects: a theatrical work titled *Weeping Magdalen* was shown by John E. Dumont.

153 From a review of the time, cited in Fink, *American Art at the Nineteenth-Century Paris Salons*, p. 172.

154 Rose G. Kingsley, "The Ideal in Modern Art," *Art Journal* (1901); cited in Weisberg, "From the Real to the Unreal," p. 58.

155 For an early essay on this subject, see "The Application of Photography to Mythological and Other Ideal Subjects," *Wilson's Photographic Magazine* 28(January 3, 1891): 10-12.

156 "Christ-Heads," p. 515.

157 For the most detailed study of this work, see Estelle Jussim, *Slave to Beauty: The Eccentric Life and Controversial Career of F. Holland Day* (Boston: David R. Godine, 1981), pp. 121-35.

158 A description of this process is given in Stieglitz and Keiley, "The 'Camera Notes' Improved Glycerine Process for the Development of Platinum Prints," *Camera Notes* 3(April 1900): 221-37.

159 Sadakichi Hartmann, "A Decorative Photographer, F. H. Day," *Photographic Times* 32(March 1900): 102.

160 *American Amateur Photographer* 10(December 1898): 554.

161 Charles H. Caffin, "Philadelphia Photographic Salon," *Harper's Weekly* (November 5, 1898): 1087.

162 In *Camera Notes* (2[January 1899]:130), Keiley noted that
> The night pictures by Mr. Wm. A. Fraser are among the most remarkable pictures in the exhibition. Technically they are faultless, and bespeak years of the most careful work. As one regards these pictures he becomes conscious that Mr. Fraser has made a most careful study of the night effects, under the conditions of fog, mist and rain. His "Wet Night, Columbus Circle," is distinctly his masterpiece. It has a charm that is all its own, a local feeling that is pronounced, and a pictorial value that is beyond dispute.

In his review of this exhibition, Caffin wrote:
> Among the landscapes are three pictures by Mr. William A. Fraser, of

New York, which, to a layman at any rate, have a surprising interest. They represent night scenes in New York City—two of a snowy street, apparently Fifth Avenue, and the third of Columbus Circle on a wet night. The last received the Royal Society's medal...so that it is fair to assume that the picture has exceptional interest. The humidity of the atmosphere, the drippiness of the whole scene, is marvelously rendered, while the pin points and streaks of light from the lamps, the looming monument and blur of buildings beyond, combine to make a composition that is mysterious and fascinating.

Harper's Weekly (November 5, 1898): 1087.

[163] Martin began his night work in 1895 and presented lantern slides of London by night in that year's Royal Photographic Society annual exhibition. See his *Victorian Snapshots* (London: Country Life Limited, 1939), pp. 24-29. Stieglitz exhibited a night photograph in the London Salon of 1895 and continued working in this vein for several years. While the work of Stieglitz, Martin, and Fraser marks the first artistic exploration of night photography, innumerable references to earlier night images may be found. See, for example, John A. Frith, "Photography by Moonlight and Kerosene Lamps," *Anthony's Photographic Bulletin* 18(1887): 589-90. However, the night photographs made prior to 1895 were almost invariably one-shot technical feats rather than aesthetically considered bodies of work. For a contemporary discussion of the work of Martin, Stieglitz, and Fraser, see James B. Carrington, "Night Photography," *Scribner's Magazine* 22(November 1897): 626-28.

[164] *Camera Notes* 2(January 1899): 123.

[165] For example, see *Camera Notes* 2(July 1898): 31. The print of *Wet Night, Columbus Circle* was also exhibited in May 1898 at the Camera Club of New York and in September 1898 at the American Institute (see *American Amateur Photographer* 10[June 1898]: 280; and 10[October 1898]: 461). Fraser was also known for his flower photographs; see his article "Floral Photography," *American Annual of Photography 1898*, pp. 51-56; and the reproductions of his work in W. I. Lincoln, *In Nature's Image: Chapters on Pictorial Photography* (New York: Baker & Taylor Company, 1898), pp. 96-102.

[166] The following quotes are taken from Fraser's article "Night Photography," *Photographic Times* 29(April 1897): 161-63. This provides the best summary of his technique and also contains reproductions of six images.

[167] In his *Photographic Times* essay, Fraser wrote:

Before starting out one's mind must be made up to bear with equanimity all sorts of chaff and uncomplimentary remarks, which are sure to be showered upon the photographer by the majority of the passers by. I have received a great deal of advice and sympathy concerning my mental make-up and condition...

This is varied by a multitude of inquiries ranging from the sublime to the ridiculous, and also indication that an interest in science is abroad on the streets of New York, as I have more than once heard John explaining to Mary as they passed that I was taking a picture by those X-rays the papers have been talking about.

One very stormy night towards the end of November, when making one of my earliest attempts, I was standing by my camera vainly (as it turned out) trying to get a bit which had pleased me, when I heard a voice outside my umbrella saying, "Say, mister, take my picture." On turning round I found it was my good friend, W. B. Post. Even he had not been able to resist the inclination to chaff a fellow-worker when he found him in what seemed a ridiculous position (pp. 162-63).

[168] *Camera Notes* 3(January 1900): 154.

[169] *Camera Notes* 4(January 1901): 225.

[170] *Photo-Era* 5(December 1900):165.

[171] *American Amateur Photographer* 12(December 1900):567.

[172] For a lengthy history of the Philadelphia Salon, and the circumstances of its demise from the viewpoint of the Stieglitz and Redfield camp, see *Camera Notes* 5(April 1902): 279-307. For more objective analyses of the history of the Salon, see Panzer, *Philadelphia Naturalistic Photography*; and William Innes Homer et al., *Pictorial Photography in Philadelphia: The Pennsylvania Academy's Salons, 1898-1901* (Philadelphia: Pennsylvania Academy of Fine Arts, 1984).

[173] Alex. Eddington, "The Modern School of Photography," *Wilson's Photographic Magazine* 35(May 1898): 225.

[174] Ibid., p. 229.

[175] Frank M. Sutcliffe, "How to Look at Photographs," *Wilson's Photographic Magazine* 29(October 1892): 621.

[176] Rau provided 250 photographs for the Pennsylvania Railroad's display at the 1893 Columbian Exposition in Chicago (Brown, *Contesting Images*, p. 21).

[177] For a stimulating study of this theme, see Albert Boime, *The Magisterial Gaze: Manifest Destiny and American Landscape Painting, 1830-1865* (Washington, D.C.: Smithsonian Institution Press, 1991).

[178] Cited in Leo Marx, *The Machine in the Garden: Technology and the Pastoral Ideal in America* (New York: Oxford University Press, 1964; repr. 1978), p. 3.

[179] William Rau, "Railroad Photography: Details of a Novel Expedition Recently Fitted Out," *Philadelphia Public Ledger* (September 26, 1891); cited in *William Herman Rau: Lehigh Valley Railroad Photographs 1899* (Bethlehem, Pa.: Lehigh University Art Galleries, 1989), n.p. See also Rau's articles, "Railroad Photography," *American Journal of Photography* (February 1897), and "How I Photograph Railroad Scenery," *Photo-Era* 36(June 1916): 261-66.

[180] In addition to Marx's justly celebrated study, see also John A. Kouwenhoven, *The Arts in Modern American Civilization* (New York: W.W. Norton, 1967; first published as *Made In America*, 1948), and John F. Kasson, *Civilizing the Machine: Technology and Republican Values in America, 1776-1900* (Harmondsworth: Penguin Books, 1977).

[181] Gerald R. Bastoni, "William Herman Rau (1855-1920)," in Jay Ruby, ed., *Reflections on 19th Century Pennsylvania Landscape Photography* (Bethlehem, Pa.: Lehigh University Art Galleries, 1986), pp. 9-11.

[182] Rau, "Railroad Photography: Details of a Novel Expedition," n.p.

[183] For a fine study of this theme, particularly as it relates to Rau's subject, see Susan Danly and Leo Marx, eds., *The Railroad in American Art: Representations of Technological Change* (Cambridge, Mass.: MIT Press, 1988).

[184] For an interesting study of this theme, see Angela L. Miller, "Nature's Transformations: The Meaning of the Picnic Theme in Nineteenth-Century American Art," *Winterthur Portfolio* 24(Summer-Autumn 1989): 113-38.

[185] For a brief biographical outline of Redfield, see Panzer, *Philadelphia Naturalistic Photography*, p. 41.

[186] See Post's article "Picturing the Lily-Pond," *Photo-Era* 33(August 1914): 73-76.

[187] *Camera Notes* 4(April 1901): 277-78.

[188] Charles H. Caffin, *Photography as a Fine Art* (1901; repr. ed., Hastings-on-Hudson: Morgan & Morgan, 1971), p. 166. For a summary of this period of Steichen's work, see Dennis Longwell, *Steichen: The Master Prints, 1895-1914* (New York: Museum of Modern Art, 1978).

[189] It is important to note that there was no fine line between these "schools" of portraiture. In 1902, an English observer noted:

The old school includes the "straight," honest photography. Thoroughly grounded in technique, and with a wide knowledge of things pictorial, the leaders of the old school hold by beautifully finished work, careful lighting, and retouching with a tendency to flatter. The old school is the more numerous and the wealthier division of the American profession. The new school is the more interesting in that it is an aggregation of individualities formed by personal effort. Between the two there is no strong line of demarcation; they blend insensibly into each other. The new school clings to its technique and does not supplant good work with eccentricity; the old school is ever trying new things—new lightings, styles, poses. And many men are equally at home with either class of work. *Wilson's Photographic Magazine* 39(1902): 441.

[190] For a description of this space, see *Wilson's Photographic Magazine* 37(April 1900): 161-66.

[191] *Wilson's Photographic Magazine* 37(March 1900): 97.

[192] Sidney Allen, "An Exquisite Temperament—B.J. Falk," *Wilson's Photographic Magazine* 43(April 1906): 148. This profile provides interesting insights into Falk's character.

[193] The relaxed intimacy of this portrait may, in part, reflect the fact that Falk and Edison had known one another for some time. An earlier Falk portrait of the noted inventor had been reproduced as the frontispiece of the *American Annual of Photography 1890*.

[194] Interestingly enough, Käsebier had learned the fundamentals of portraiture during an apprenticeship with Samuel H. Lifshey, a

Brooklyn photographer who had earlier studied with Falk. See Barbara L. Michaels, *Gertrude Käsebier: The Photographer and Her Photographs* (New York: Abrams, 1992), pp. 26, 168 (n. 8).

[195] *Wilson's Photographic Magazine* 41(1904): 366.

[196] Jackson Lears, *No Place of Grace: Antimodernism and the Transformation of American Culture, 1880-1920* (New York: Pantheon Books, 1981), pp. 42. The following summary of these ideas is significantly indebted to this fine study. See also Cotkin, *Reluctant Modernism: American Thought and Culture, 1880-1900*.

[197] Lears, *No Place of Grace*, p. 91.

[198] Charles Baudelaire, "The Temple of Nature," in Richard Ellman and Charles Feidelson, Jr., eds., *The Modern Tradition: Backgrounds of Modern Literature* (New York: Oxford University Press, 1965), pp. 59-60.

[199] Stéphane Mallarmé, "Poetry as Incantation," in ibid., pp. 110-11.

[200] See, for example, Michael Marlais, "In 1891: Observations on the Nature of Symbolist Art Criticism," *Arts Magazine* 61(January 1987): 88-93.

[201] Lears, *No Place of Grace*, p. 142.

[202] The following discussion is indebted to Christian A. Peterson's fine study, "American Arts and Crafts: The Photograph Beautiful 1895-1915," *History of Photography* 16(Autumn 1992): 189-234.

[203] For a brief summary of Copeland & Day, see John Tebbell, *A History of Book Publishing in the United States*, vol. II: *The Expansion of an Industry* (New York: R.R. Bowker, 1975), pp. 402-07.

[204] See "Photographic Printing by Machinery," *American Amateur Photographer* 7(September 1895): 407-12.

[205] Jonathan Green, ed., *Camera Work: A Critical Anthology* (Millerton, N.Y.: Aperture, 1973), p. 13.

[206] Estelle Jussim, "Technology or Aesthetics: Alfred Stieglitz & Photogravure," *History of Photography* 3(January 1979): 87.

[207] In "Modern Photographic Processes of Illustration," *American Amateur Photographer* 6(December 1895): 529-38, it is noted:

> In the printing of photogravures great care is required. No successful method of printing by machinery has as yet been devised. A skillful printer can only pull off about 500 impressions as a day's work; hence the process, compared with others, is a very expensive one, and cannot be used for all kinds of work.

[208] "Craig Annan on Picture Making," *American Amateur Photographer* 12(April 1900): 167.

[209] Roger Hull, "The Traditional Vision of Rudolf Eickemeyer, Jr.," pp. 52-55.

[210] J. P. Mowbray, *A Journey To Nature* (New York: Doubleday, Page and Co., 1902). The twenty-five chapters of this book were originally published in the *New York Evening Post*.

[211] In a profile of Lincoln titled "A New England Flower Lover," *The Craftsman* 27(March 1915) commented:

> It is only occasionally today that we encounter what we would call the old-fashioned flower lover, the man who seeks the flowers by brookside, on the top of a crag, blossoming timorously under a snow bank or lifting their beauty shyly through faded leaves. Mr. Edwin Hale Lincoln is such a one, and fortunately for the world he not only loves the flowers, but he leaves them to grow in peace and visits them year after year as the season for their beauty comes round, occasionally gathering a few blossoms very carefully and tenderly so that the growth might not be disturbed. And these flowers he takes to his studio where he makes lovely photographic studies of them that the rest of the world may know the New England wild flowers and enjoy them with this man who undoubtedly is their greatest friend and historian." (pp. 630, 635)

[212] For a brief sketch of Lincoln's career, see Wm. B. Becker, "'Permanent Records'; The Arts and Crafts Photographs of Edwin Hale Lincoln," *History of Photography* 13(January-March 1989): 22-30.

[213] Wilson A. Bentley, "Glimpses of Snow and Frost Photography—Winter of 1904," *American Annual of Photography 1905*, p. 59.

[214] Bentley's first essay, "A Study of Snow Crystals," appeared in *Popular Science Monthly* 53(May 1898): 75-82. Beginning in 1903, Bentley published regular updates of his work in the *American Annual of Photography*. See also his article "Photographing Snowflakes," *Popular Mechanics* 37(February 1922): 309-12; and Mary B. Mullett, "The Snowflake Man," *American Magazine* 99(February 1925): 28-31, 173-75.

[215] Peterson, "American Arts and Crafts," p. 205.

[216] Alfred Stieglitz ended the 1908-09 exhibition season of 291 with a show of Japanese prints.

[217] Arthur Wesley Dow, *Composition: A Series of Exercises Selected from a System of Art Education* (New York: Baker and Taylor Co., 1900), p. 36.

[218] Maurice Denis's often-quoted statement of 1890 exemplifies the ideas in European art that supported Dow's later work:

> It is well to remember that a picture—before being a battle horse, a nude woman, or some anecdote—is essentially a plane surface covered with colors assembled in a certain order.

Reprinted in Herschel B. Chipp, ed., *Theories of Modern Art* (Berkeley: University of California Press, 1968), p. 94.

[219] This collection is documented in Weston J. Naef, *The Collection of Alfred Stieglitz: Fifty Pioneers of Modern Photography* (New York: Metropolitan Museum of Art, 1978).

[220] *Camera Notes* 2(January 1899): 96.

[221] For an excellent contemporary description of this collection, see *American Amateur Photographer* 8(July 1896): 297-303. See also Christian A. Peterson, "George Timmins' Early Collection of Pictorial Photography," *History of Photography* 6(January 1982): 21-27.

[222] For a useful overview of photographic collecting, see John Pultz, "Collectors of Photography," in *A Personal View: Photography in the Collection of Paul F. Walter* (New York: Museum of Modern Art, 1985), pp. 11-24.

[223] For example, see Sadakichi Hartmann's "Random Thoughts on Criticism," *Camera Notes* 3(January 1900): 101-04. In this harsh but perceptive piece, Hartmann observes that "the trouble with photographic criticism at present is that it is maudlin and insignificant, without the slightest pretense to any educational or inspirational power" (p. 102).

[224] See, for example, Alexander Black, "The Artist and The Camera: A Debate," *Century Magazine* 44(October 1902): 813-22.

[225] Caffin's book *Photography as a Fine Art* has been reprinted (Morgan & Morgan, 1971), with an introduction by Thomas F. Barrow. For a concise analysis of Caffin's career, see John Loughery, "Charles Caffin and Willard Huntington Wright, Advocates of Modern Art," *Arts Magazine* 59(January 1985): 103-09.

[226] See Harry W. Lawton and George Knox, eds., *The Valiant Knights of Daguerre: Selected Critical Essays on Photography and Profiles of Photographic Pioneers by Sadakichi Hartmann* (Berkeley: University of California Press, 1978). For brief analyses of Hartmann's criticism, see Alexander S. Horr, "Sadakichi Hartmann as a Photographic Writer," *Photo-Beacon* 16(October 1904): 307-09; and Peter Plagens, "Hartmann, Huneker, De Casseres," *Art in America* 61(July-August 1973): 67-70.

[227] Rood judged Hartmann to be one of the three most important influences on American photography in his article "The Three Factors in American Pictorial Photography," *American Amateur Photography* 16(August 1904): 346-49.

[228] While most critics of the time celebrated Käsebier's use of Old Master sources, Sadakichi Hartmann noted pointedly that she "*imitates*...the old masters with a rare accuracy," and was "absolutely dependent on accessories." This unusual negative review was published in the same issue of *Camera Notes* (3[July 1899]: 16) that included laudatory essays on her work by Arthur Wesley Dow and Joseph T. Keiley. See also Hartmann's "Gertrude Käsebier: A Sense of the Pictorial," *Photographic Times* 32(May 1900): 195-99; reprinted in Lawton and Knox, eds., *The Valiant Knights of Daguerre*, pp. 198-201. For a good recent analysis of Käsebier's style, see William Innes Homer, "Käsebier and the Art of the Portrait," in *A Pictorial Heritage: The Photographs of Gertrude Käsebier* (Wilmington: University of Delaware/Delaware Art Museum, 1979), p. 19.

[229] As high as this price seemed at the time, it is worth noting that it was only four times Käsebier's "minimum charge" of $25 for a professional portrait sitting. See "A Visit to Mrs. Käsebier's Studio," *Wilson's Photographic Magazine* 40(February 1903): 73. However, this kind of

price was clearly the exception to the rule. For example, at a 1900 auction of works by members of the Camera Club of New York, prints sold for prices ranging from 15 cents to $8.25 (for a Käsebier). The results of this sale reveal that lantern slides, which fetched from 5 cents to a high of $4.00 (for a Stieglitz), were valued at about half the price of prints. *Camera Notes* 4(July 1900): 49-54.

230 Giles Edgerton [pseud. for Mary Fanton Roberts], "Photography as an Emotional Art: A Study of the Work of Gertrude Käsebier," *The Craftsman* 12(April-September 1907): 88.

231 In his review of the Salon, Joseph Keiley described Steichen's *The Lady in the Doorway* as

> original, if not artistic or serious. I am inclined to think that Mr. Steichen himself rather regarded it as a puzzle picture, for he on more than one occasion, I am told, set it on end and asked his friends to guess what it was. There were those who termed it *ultra impressionistic*; to me it seemed ridiculously freakish.

Camera Notes 3(January 1900): 145.

232 *Camera Notes* 4(January 1901): 215-16.

233 Weston Naef describes Steichen's printing techniques in *The Collection of Alfred Stieglitz*, pp. 443-68. For a period summary of the impact of Steichen's prints see, for example, Roland Rood, "Eduard J. Steichen: A Study of the Artistic Attitude Toward Art and Nature," *American Amateur Photographer* 18(April 1906): 157-62.

234 *Wilson's Photographic Magazine* 39(April 1902): 121.

235 "The Photo-Secession Exhibition at the Carnegie Art Galleries, Pittsburgh, Pa.," *Camera Work*, no. 6 (April 1905); reprinted in Lawton and Knox, eds., *The Valiant Knights of Daguerre*, p. 99.

236 *Camera Craft* 2(March 1901): 417.

237 Sadakichi Hartmann, "Clarence H. White: A Meteor Through Space," *Photographic Times* 32(January 1900): 18-23; reprinted in Lawton and Knox, eds., *The Valiant Knights of Daguerre*, p. 180.

238 *American Amateur Photographer* 11(November 1899): 493; and *Camera Notes* 3(January 1900): 123.

239 F. Dundas Todd in *Photo-Beacon* 7(June 1900): 161-63. See also, for example, a harsh criticism of White's work in *American Amateur Photographer* 13(April 1901): 176.

240 Roland Rood, "The First American Salon at New York," *American Amateur Photographer* 15(December 1904): 520.

241 George Dimock, *Intimations and Imaginings: The Photographs of George H. Seeley* (Pittsfield, Mass.: Berkshire Museum, 1986), p. 20.

242 Giles Edgerton, "The Lyric Quality in the Photo-Secession Art of George H. Seeley," *The Craftsman* 13(December 1907): 303.

243 For variants of this image, see *Camera Work*(January 1907); and Thomas Weston Fels, *O Say Can You See: American Photographs, 1839-1939. One Hundred Years of American Photographs from the George R. Rinhart Collection* (Cambridge, Mass.: MIT Press/Berkshire Museum, 1989), p. 96. For background on Rubincam's artistic ideas, see his article "Originality in Photography," *American Annual of Photography 1904*, pp. 25-26. In this essay he wrote:

> To study the pictures of those photographers admittedly artistic, is good for the amateur's welfare so long as he keeps constantly in mind the necessity for originality; but when he studies them with the idea of duplicating them, he is descending the steps of failure. Remember, then, that above all other things you must be original.

244 Naef, *The Collection of Alfred Stieglitz*, p. 278.

245 For an early essay on Brigman's work, see Emily J. Hamilton, "Some Symbolic Nature Studies from the Camera of Anne W. Brigman," *The Craftsman* 12(September 1907): 660-64; reprinted in Palmquist, ed., *Camera Fiends & Kodak Girls*, pp. 181-84.

246 Emily J. Hamilton, "Some Symbolic Nature Studies from the Camera of Annie W. Brigman," *The Craftsman*, 12(September 1907); reprinted in Palmquist, ed., *Camera Fiends & Kodak Girls*, p. 184.

247 For a short study of this period in Struss's work, see Toby A. Jurovics, "Karl Struss: Composing New York," *History of Photography* 17(Summer 1993): pp. 193-201.

248 Susan Harvith and John Harvith, *Karl Struss: Man with a Camera* (Bloomfield Hills, Mich.: Cranbrook Academy of Art/Museum, 1976), p. 10.

249 For an overview of these ideas, see Mike Weaver's *Alvin Langdon Coburn: Symbolist Photographer, 1882-1966: Beyond the Craft* (New York: Aperture, 1986).

250 The friendship between Coburn and Weber is discussed in Percy North, *Max Weber: The Cubist Decade, 1910-1920* (Atlanta: High Museum of Art, 1991).

251 "The Relation of Time to Art," *Camera Work*, no. 36 (October 1911); repr. in Green, *Camera Work: A Critical Anthology*, pp. 215-16.

252 Repr. in Sarah Greenough and Juan Hamilton, *Alfred Stieglitz: Photographs & Writings* (Washington, D.C.: National Gallery of Art, 1983.), pp. 181-82.

253 Repr. in ibid., pp. 185-89.

254 Ulrich F. Keller, "The Myth of Art Photography: A Sociological Analysis," *History of Photography* 8(October-December 1984): 256.

255 This is a chapter title in Lawrence W. Levine's *Highbrow/Lowbrow: The Emergence of Cultural Hierarchy in America* (Cambridge, Mass.: Harvard University Press, 1988). The following discussion is drawn largely from this work, and from the chapter "William Shakespeare and the American People: A Study in Cultural Transformation," in Levine's *The Unpredictable Past: Explorations in American Cultural History* (New York: Oxford University Press, 1993), pp. 139-71.

256 Levine, *The Unpredictable Past*, p. 164.

257 Ibid., p. 168.

258 Reprinted Greenough and Hamilton, *Alfred Stieglitz: Photographs & Writings*, p. 190.

259 The following owes much to Ulrich Keller's essays "The Myth of Art Photography: A Sociological Analysis," and "The Myth of Art Photography: An Iconographic Analysis," *History of Photography* 9 (January-March 1985): 1-38.

260 It is interesting to note the generally positive reception originally given the Photo-Secession by the mainstream photographic press. See, for example, *American Amateur Photographer* 15(1903): 213, 232, and 521-24.

261 The following discussion is drawn largely from Sarah Greenough, "Alfred Stieglitz and the Opponents of the Photo-Secession," *New Mexico Studies in the Fine Arts* 2(1977): 13-19; and Gillian Greenhill Hannum, "Photographic Politics: The First American Salon and the Stieglitz Response," *History of Photography* 15(Spring 1991): 61-71.

262 For background on this organization, see the articles cited above, and Gillian B. Greenhill Hannum, "The Salon Club of America and the Popularization of Pictorial Photography," in Kathleen Collins, ed., *Shadow and Substance*, pp. 245-53.

263 Bell responded heatedly: "The person who has done more than any man living to injure the interests of photography in America is now engaged in the congenial task of insulting the entire photographic fraternity of America, outside of his own little clique of would-be monopolists, by a foolish slur upon the First American Photographic Salon..." See *Photo-Beacon* 16(September 1904): 287.

264 "Juvenal," "Little Tin Gods on Wheels," *Photo-Beacon* 16(September 1904): 282-86.

265 *Photographic Times-Bulletin* 36(December 1904): 534.

266 Fels, *O Say Can You See*, p. 131.

267 See Roland Rood, "The Press View of the Second American Salon," *American Amateur Photographer* 17(December 1905): 546-56.

268 See Chislett's article, "Photographing Light," *American Annual of Photography 1910*, pp. 233-34.

269 Greenough, "Alfred Stieglitz and the Opponents of the Photo-Secession," p. 18.

270 For example, see Roger Hull's articles "Rudolf Eickemeyer, Jr., and the Politics of Photography," *New Mexico Studies in the Fine Arts* 2(1977): 20-25; and "Myra Wiggins and Helen Gatch: Conflicts in American Pictorialism," *History of Photography* 16(Summer 1992): 152-69.

271 In England, for example, the Linked Ring's annual Salons ceased in 1909 due to internal disagreements, giving rise to the London Salon of Photography. Founding American members of this new group included C. Yarnall Abbott, Gertrude Käsebier, and Wilbur Porterfield. These photographers, as well as F. Holland Day and Francis Bruguiére, exhibited in the first of these Salons. See H. Snowden Ward, "The London Salon of Photography," *American Photography* 4(December 1910): 692-98.

272 Paul L. Anderson, "The Development of Pictorial Photography in the United States During the Past Quarter Century," *American Photography* 8(June 1914): 330.

273 For an insightful study of this group, and a short biography of Porterfield, see Anthony Bannon et al., *The Photo-Pictorialists of Buffalo* (Buffalo: Media Study, 1981).

274 Anderson, "The Development of Pictorial Photography," p. 332.

275 Paul L. Anderson, "The International Exhibition of Pictorial Photography," *American Photography* 8(April 1914): 184.

276 W. H. Porterfield, "The Pittsburgh Salon of 1914," *American Photography* 8(March 1914): 118.

277 Paul L. Anderson, *The Fine Art of Photography* (Philadelphia: Lippincott Company, 1919), p. 15.

278 See, for example, the downbeat assessments of American Pictorialism written in the early 1910s by Frank Roy Fraprie and Wilbur Porterfield for the British annual *Photograms of the Year*.

279 For example, in the introduction to his book *The Fine Art of Photography* (1919), Paul L. Anderson counters "the popular belief that the artist must necessarily be more or less neurotic and morally loose," with the prediction that "within a few more years painters, sculptors, musicians, and other workers in the fine arts will come to be regarded as an exceptionally healthy and athletic class" (pp. 17-18).

280 William D. MacColl, "International Exhibition of Pictorial Photography at Buffalo," *International Studio* 43(March 1911): xv.

281 Historians now treat this work of the 1840s as a collaboration between Hill and his younger associate Robert Adamson.

282 Naef, *The Collection of Alfred Stieglitz*, p. 190.

283 MacColl, "International Exhibition of Pictorial Photography at Buffalo," p. xi.

284 *American Photography* 4(August 1910): 476.

285 F. Austin Lidbury, "Some Impressions of the Buffalo Exhibition," *American Photography* 4(December 1910): 676.

286 J. Nilsen Laurvik, "Alfred Stieglitz, Pictorial Photographer," *International Studio* 44(August 1911): 22.

287 For Stieglitz's later recounting of the events surrounding this photograph, see *Twice A Year*, nos. 8-9(Spring-Summer 1942/Fall-Winter 1942): 127-31.

288 For a concise study of this issue, see James S. Terry, "The Problem of 'The Steerage,'" *History of Photography* 6(July 1982): 211-22.

289 "Alfred Stieglitz and His Latest Work," *Photographic Times* 28(April 1896): 161.

290 For a good comparison of these photographers, see chapter 4, "Camera Work/Social Work," of Alan Trachtenberg's *Reading American Photographs: Images as History, Mathew Brady to Walker Evans* (New York: Hill and Wang, 1989), pp. 164-230.

291 Lewis W. Hine, "Photography in the School," *Photographic Times* 40(August 1908): 230. Hine continues,

> As the study progresses and the pupils realize that a real photograph is not a "lucky hit," but the result of intelligent, patient effort, they are given instruction in the choice of subject and in the principles of composition. This is done by means of a study of good examples of art, photographs and paintings, even to the length of making sketches, from the works of these masters, for the purpose of impressing the points studied.

292 This work was begun at a time of great public interest in the issue of immigration, and in the experiences of new arrivals to America. Study of journals of the period makes it clear that Hine was by no means the first photographer to work at Ellis Island, or to document the living conditions of recent immigrants in the city. See, for example, articles in *The World's Work* such as "Americans in the Raw" 4(October 1902): 2644-55; and "The Russian Jew Americanized" 7(March 1904): 4555-61. The first of these articles contains photographs at Ellis Island by Arthur Hewitt, while the second is accompanied by photographs by A. W. Scott.

293 This relationship is illuminated in Daile Kaplan's *Photo Story: Selected Letters and Photographs of Lewis W. Hine* (Washington, D.C.: Smithsonian Institution Press, 1992).

294 It is worth noting the variety of ways in which Hine's photographs were reproduced. In the October 2, 1909, issue of *The Survey*, for example, eight of Hine's images of child laborers in the South were reproduced in portfolio format. This dignified presentation—relatively good quality, full-page halftones on special coated paper stock—emphasized the integrity of Hine's original vision. In this same issue, however, many other Hine images were reproduced in small size on *The Survey's* normal inexpensive stock. Still others were published as silhouetted vignettes—isolated figures (newsboys holding newspapers, for example) shorn of all surrounding context. These varied uses only point up the fundamentally persuasive intent of these images.

295 Miles Orvell, "Lewis Hine: The Art of the Commonplace," *History of Photography* 16(Summer 1992): 88-90.

296 Alan Trachtenberg, "Ever—The Human Document," in *America and Lewis Hine: Photographs 1904-1940* (Millerton, N.Y.: Aperture, 1977), p. 123.

CHAPTER II **Abstraction and Realism 1915-1940**

1 The following discussion is indebted to such studies as Arthur Frank Wertheim, *The New York Little Renaissance: Iconoclasm, Modernism, and Nationalism in American Culture, 1908-1917* (New York: New York University Press, 1976); Edward Abrahams, *The Lyrical Left: Randolph Bourne, Alfred Stieglitz, and the Origins of Cultural Radicalism in America* (Charlottesville: University Press of Virginia, 1986); Steven Watson, *Strange Bedfellows: The First American Avant-Garde* (New York: Abbeville Press, 1991); Adele Heller and Lois Rudnick, eds., *1915, The Cultural Moment: The New Politics, the New Woman, the New Psychology, the New Art & the New Theater in America* (New Brunswick, N.J.: Rutgers University Press, 1991); William Innes Homer, *Alfred Stieglitz and the American Avant-Garde* (Boston: New York Graphic Society, 1977); and Dickran Tashjian, *Skyscraper Primitives: Dada and the American Avant-Garde, 1910-1925* (Middletown, Conn.: Wesleyan University Press, 1975).

2 Cited in Marius de Zayas, "How, When, and Why Modern Art Came to New York," *Arts Magazine* 54(April 1980): 106.

3 See Elizabeth McCausland, "The Daniel Gallery and Modern American Art," *Magazine of Art* 44(November 1951): 280-85.

4 Judith Zilcer, "'The World's New Art Center': Modern Art Exhibitions in New York City, 1913-1918," *Archives of American Art Journal* 14:3(1974): 2-7. For an interesting first-hand recollection of this era, see de Zayas, "How, When, and Why Modern Art Came to New York," pp. 96-126.

5 "Frightfulness in Art," *American Magazine of Art* 8(April 1917): 244.

6 *New York Times* (March 16, 1913); cited in Watson, *Strange Bedfellows*, p. 172.

7 See, for example, "The World's New Art Centre: The Most Startling Moderns Are to Be Shown in New York this Winter" (January 1915): 31; "What The New Art Has Done and the Universally Disturbing Influence of the 'Moderns'" (April 1915): 30-31; "Max Weber: A Leader in the New Art" (September 1915): 36; "Francis Picabia and His Puzzling Art" (November 1915): 42; and "At Last, The Vorticists!" (November 1916): 72.

8 For example, see Judith Zilcer, "Alfred Stieglitz and John Quinn: Allies in the American Avant-Garde," *American Art Journal* 17(Summer 1985): 18-33.

9 For data on de Zayas, see Douglas Hyland, *Marius de Zayas: Conjurer of Souls* (Lawrence, Kan.: Spencer Museum of Art, 1981), and de Zayas's own reminiscence of this period, "How, When, and Why Modern Art Came to New York."

10 Watson, *Strange Bedfellows*, p. 136.

11 For a short reminiscence of the Arensbergs, see Fiske Kimball, "Cubism and the Arensbergs," *Art News Annual* 24(1955): 117-22, 174-78.

12 For an excellent short summary of these ideas, see Daniel Joseph Singal, "Towards a Definition of American Modernism," *American Quarterly* 39(Spring 1987): 7-26.

13 Quoted in Abrahams, *The Lyrical Left*, pp. 1-2.

14 Quoted in Wertheim, *The New York Little Renaissance*, p. 6.

15 Stieglitz presented one show of African art and four of children's art at 291 between 1912 and 1916. For a good summary of this era's celebration of the divine nature of instinctive creativity, see Hutchins Hapgood's essay "In Memoriam," *Camera Work*, no. 39(July 1912), repr. in Jonathan Green, ed., *Camera Work: An Anthology* (Millerton, N.Y.: Aperture, 1973), pp. 230-31. For more recent accounts of the "primitivist" influence on the American avant-garde, see Gail Levin, "American Art," in William Rubin, ed., *"Primitivism" in 20th Century Art: Affinity of the Tribal and the Modern* (New York: Museum of Modern Art, 1984), pp. 452-73; and Levin, "Primitivism in American Art: Some Literary Parallels of the 1910s and 1920s," *Arts Magazine* 59(November 1984): 101-05.

16 Wanda M. Corn, "Apostles of the New American Art: Waldo Frank and Paul Rosenfeld," *Arts Magazine* 54(February 1980): 161.

17 Van Wyck Brooks, "On Creating a Usable Past," *The Dial* 64(April 11, 1918): 337-41.

18 Matthew Baigell, "American Art and National Identity: The 1920s," *Arts Magazine* 61(February 1987): 49.

19 *Camera Work*, no. 49-50(June 1917); repr. in Beaumont Newhall, ed., *Photography: Essays & Images* (New York: Museum of Modern Art, 1980), pp. 219-20.

20 S. Hartmann, "A Plea for Straight Photography," *American Amateur Photographer* 16(March 1904): 101-09; repr. in Newhall, ed., *Photography: Essays & Images*, pp. 185-88.

21 For a useful study of these varied ideas, see John Pultz and Catherine B. Scallen, *Cubism and American Photography, 1910-1930* (Williamstown, Mass.: Sterling and Francine Clark Art Institute, 1981).

22 From an interview quoted in Homer, *Alfred Stieglitz and the American Avant-Garde*, p. 246.

23 Greenough, *Paul Strand: An American Vision*, p. 37.

24 Constance Rourke, *Charles Sheeler: Artist in the American Tradition* (New York: Harcourt, Brace and Company, 1938), p. 25.

25 The exact date of their start in photography has been unclear. In his 1963 Schamberg monograph, Ben Wolf states that this occurred in 1913. More recent sources give dates of "about 1910" (Theodore E. Stebbins, Jr., and Norman Keyes, Jr.), "after 1910" (John Pultz and Catherine B. Scallen), and "about 1912" (Carol Troyen and Erica E. Hirschler). The 1910-11 date has been used to reflect the data provided by Stebbins and Keyes (p. 2) documenting that both Sheeler and Schamberg were proficient with the camera by 1911.

26 While Sheeler's Bucks County photographs have been typically dated ca. 1914-17, Stebbins and Keyes make a reasoned argument that few were made until 1917. Schamberg's important architectural views bear dates of 1916 and 1917. Letters to Sheeler and Schamberg in the Stieglitz Collection at the Beinecke Library, Yale University, reveal that the two became particularly close with Stieglitz in late 1916.

27 On this complex theme, see Karen [Davies] Lucic, "Charles Sheeler in Doylestown and the Image of Rural Architecture," *Arts Magazine* 59(March 1985): 135-39; and "Charles Sheeler: American Interiors," *Arts Magazine* 61(May 1987): 44-47.

28 The best critical discussion of Schamberg's career is William C. Agee's "Morton Livingston Schamberg (1881-1918): Color and the Evolution of His Painting," *Arts Magazine* 56(November 1982): 108-19.

29 Schamberg's sarcastic *God* (ca. 1918), an assemblage of a miter box and plumbing trap, is a uniquely American expression of the irony and skepticism characteristic of the work of Picabia and Duchamp. It is very likely an artistic response to Duchamp's comment of 1917 that "the only works of art America has given are her plumbing and her bridges." For a brief discussion of Schamberg's machine paintings, see Tashjian, *Skyscraper Primitives*, pp. 204-08.

30 However, Agee has determined that these paintings "were based on real and existing machines" and are not simply artistic inventions. See Agee, "Morton Livingston Schamberg (1881-1918)," p. 117.

31 Only five individual prints from this series are known to this writer. In addition to the work in the Hallmark Photographic Collection (dated 1917), prints of Schamberg's city views are held in the collections of the Metropolitan Museum of Art (1917), the George Eastman House (1916), the New Orleans Museum of Art (1916), and William H. Lane

(ca. 1916). These latter four images are reproduced, respectively, in the following volumes: Maria Morris Hambourg and Christopher Phillips, *The New Vision: Photography Between the Wars* (New York: Metropolitan Museum of Art, 1989), plate 4; Robert A. Sobieszek, *Masterpieces of Photography from the George Eastman House Collections* (New York: Abbeville Press, 1985), p. 235; *Diverse Images: Photographs from the New Orleans Museum of Art* (Garden City, N.Y.: Amphoto, 1979), p. 87; and Theodore E. Stebbins, Jr., and Norman Keyes, Jr., *Charles Sheeler: The Photographs* (Boston: Museum of Fine Arts, 1987), p. 6. Schamberg's deliberate working method is suggested by close examination of these five images, which together depict three distinct sites. The Hallmark and Metropolitan prints were made from nearly identical vantage points, but with radically different camera orientations. Changes in areas depicted in both prints suggest that they were probably taken weeks or months apart. The Eastman House and Lane prints were also made from similar vantage points, and utilize almost identical points of view. However, close study of these scenes reveals that they, too, were made over a significant interval of time. Schamberg's persistence in returning to favored sites to explore their visual potential suggests the importance of these photographs in the overall evolution of his artistic vision. The New Orleans Museum image stands somewhat apart from these four views for its relatively street-level perspective and the apparent use of a telephoto lens.

32 See de Zayas, "How, When, and Why Modern Art Came to New York," pp. 104-05, and 121.

33 In the 1918 Wanamaker exhibition Sheeler was awarded first (*Bucks County House, interior detail*) and fourth (*Bucks County Barn*), Strand second (*Wheel Organization*) and fifth (*White Fence*), and Schamberg third (*Portrait*). The "Trinity of Photography" quote was reported by Grancel Fitz in his review, "A Few Thoughts on the Wanamaker Exhibition," *The Camera* 22(April 1918): 202.

34 *American Photography* 12(April 1918): 231. For a sampling of negative responses to this show, see also W. R. Bradford's "Exhibitions I Have Met" (in which Stieglitz is parodied as "the redoubtable O. Grumblemdown"), and letters to the editor, *The Camera* 22(April 1918): 207-10, 220.

35 Fitz's viewpoint was flavored by his own success in the Wanamaker shows. He received seven $5 awards, and exhibited a total of fifteen prints in the 1916, 1917, 1918, and 1920 exhibitions (as documented in the Wanamaker catalogs for these years in the Paul Strand Archive, Center for Creative Photography, Tucson, Arizona).

36 Fitz, "A Few Thoughts on the Wanamaker Exhibition," pp. 203, 205.

37 For a good summary of this subject, see Frank DiFederico, "Alvin Langdon Coburn and the Genesis of Vortographs," *History of Photography* 11(October-December 1987): 265-96.

38 Pound had been greatly influenced by the ideas of Ernest Fenollosa, who in turn had influenced Dow. For a useful summary of this connection, see, for example, Marianne W. Martin, "Some American Contributions to Early Twentieth-Century Abstraction," *Arts Magazine* 54(June 1980): 158-65.

39 The following summary is drawn largely from Richard Cork's essay in the catalogue *Vorticism and its Allies* (London: Arts Council of Great Britain, 1974). A version of this essay is included in his *Vorticism and Abstract Art in the First Machine Age* (New York: Davis & Long Company, 1977).

40 "Vorticism," *Fortnightly Review* 102(September 1914), repr. in Harriet Zinnes, ed., *Ezra Pound and the Visual Arts* (New York: New Directions, 1980), p. 207.

41 Cork, *Vorticism and its Allies*, p. 22.

42 *Photograms of 1916*, p. 23. This essay was reprinted in the *Photographic Journal of America* 54(April 1917): 153-54.

43 Coburn's vortographs have often been dated to January 1917, a reflection, most likely, of his much later statement that "It was in January 1917 that I created these first purely abstract photographs." (Helmut Gernsheim and Alison Gernsheim, eds., *Alvin Langdon Coburn: Photographer, An Autobiography* [London: Faber & Faber, 1966], p. 104.) A more accurate dating of this work is revealed in Pound's letter to his father of September 22, 1916 (in Zinnes, *Ezra Pound and the Visual Arts*, p. 293), in which he states:

Coburn and I have invented *vortography*. I haven't yet seen the results.

He will bring them in tomorrow morning. They looked darn well on the ground glass, and he says the results are O.K.

The idea is that one no longer need photograph what is in front of the camera, but that one can use one's element of design; i.e., take the elements of design from what is in front of the camera, shut out what you don't want, twist the "elements" onto the part of plate where you want 'em, and then fire. I think we are in for some lark. AND the possibilities are seemingly unlimited. The apparatus is a bit heavy at present, but I think we can lighten up in time...

44 Coburn's most complete description of the mechanics of this device is included in his *Autobiography*, p. 102. The original vortoscope was soon redesigned to make it lighter and more effective. On October 13, 1916, Pound wrote to the New York collector John Quinn:

...Don't know that there is much to report save that Coburn and I have invented the vortoscope, a simple device which frees the camera from reality and lets one take Picassos direct from nature. Coburn has got a few beautiful things already, and we'll have a show sometime or other.

...First apparatus clumsy, second one rather lighter. Coburn doesn't want much talk about it until he has his first show.

One should see the results first, and then have explanations. At any rate it's a damn sight more interesting than photography. It would be perfectly possible to pretend that we'd discovered a new painter, only one's not in that line...

Reprinted in Zinnes, *Ezra Pound and the Visual Arts*, pp. 341-42.

45 DiFederico, "Alvin Langdon Coburn and the Genesis of the Vortographs," pp. 290-91.

46 Ibid., p. 291. DiFederico notes that one of the vortographs in the Eastman House collection is titled *The Eagle*. This collection includes prints from seventeen negatives with twenty-three additional duplicates and variants. In addition to making "straight" prints of his vortograph negatives, Coburn felt free to print many of these same negatives in reverse.

47 Ibid., p. 292.

48 Untitled and unsigned essay in *Vortographs and Paintings by Alvin Langdon Coburn* (London: The Camera Club, 1917). One can trace Pound's decreasing interest in the vortographs in his letters to the American art collector John Quinn. After his enthusiastic report of October 13, 1916, Pound wrote on December 17 that Coburn's results "are at least better than bad imitations of the few inventive painters." On January 24, 1917, he wrote that the vortoscope "is an attachment to enable a photographer to do sham Picassos. That sarcastic definition probably covers the ground." (Both letters repr. in Zinnes, *Ezra Pound and the Visual Arts*, pp. 242, 281.) It seems likely that Pound's enthusiasm for this work rested largely on its adherence to pure Vorticist theory, in which he had great vested interest. As the work developed into an expression of Coburn's own ideas and tastes, it seems inevitable that Pound's enthusiasm would have waned.

49 *Vortographs and Paintings by Alvin Langdon Coburn*, p. 6.

50 *Photographic Journal of America* 54(April 1917): 165.

51 Anthony Guest, "A.L. Coburn's Vortographs," *Photo-Era* 38(1917): 227-28.

52 *Photograms for 1917-1918*, p. 18.

53 In *American Photography* 11(August 1917): 437, Struss wrote
Many of us have deplored the lack of originality in the studies hung at the annual exhibitions....Newness of vision is very rare and one looks to new workers not only for inspiration but for new methods of expression...The result of this is that many who felt that the possibilities of the medium were, in a sense, exhausted, have stopped work entirely. Others have in seeming desperation gone to all sorts of extremes (as, for instance, Coburn's highly original and amusing "Vortographs").

54 See, for example, Mike Weaver's negative evaluation of these pictures in his Coburn monograph (p. 9, 68, 74), and John Szarkowski's amused dismissal of them in *Looking At Photographs* (New York: Museum of Modern Art, 1973), p. 62.

55 There were real consequences to dissenting from the patriotic fervor of the time. For example, *The Seven Arts* came to an end in 1917 due primarily to its antiwar articles by Randolph Bourne. See James Oppenheim, "The Story of *The Seven Arts*," *American Mercury* 20(June 1930): 156-64.

56 In early 1918, for example, the U.S. Signal Corps was calling for donations of lenses from civilian photographers to be used in "a fleet

of observation airplanes now being built." See "Enlist Your Lens in the Army," and "The War and Photographic Materials," in *Photographic Journal of America* 55(February 1918): 79-80.

57 In 1918, for example, the Signal Corps called for the training of one thousand men to comprise a ground force for its aerial photographic unit. See "Photographers Wanted," *The Camera* 22(April 1918): 222.

58 See, for example, "Photography in War," *Camera Craft* 25(September 1918): 341-48; "Aërial Fighting-Cameras," *Photo-Era* 41(1918): 247-52; and "Photography's Notable Part in the War," *Vanity Fair* 11(December 1918): 51, 78.

59 "Pictorial Photographs of the A.E.F. in France," *American Magazine of Art* 11(March 1920): 161-64.

60 "The Year's Work," *Photograms of 1916*, pp. 5-6. Civilians also used photography to do their bit to keep the soldiers' morale high. For example, Alvin Langdon Coburn, acting as a "sympathetic neutral" in England, volunteered for the "Snapshots-from-Home League," which encouraged the making of simple records of family and friends to send to loved ones at the front. A discussion of this project, as well as of propagandistic and fraudulent uses of photography in the war, is included in John Taylor's article, "Pictorial Photography in the First World War," *History of Photography* 6(April 1982): 119-41.

61 The following discussion is indebted to Susan D. Moeller, *Shooting War: Photography and the American Experience of Combat* (New York: Basic Books, 1989), particularly pp. 106-52.

62 For a listing of these exhibitions, see the appendix of Dorothy Norman's *Alfred Stieglitz: An American Seer* (Millerton, N.Y.: Aperture, 1973), pp. 236-38.

63 In his important article "On Creating a Usable Past" (p. 339), Van Wyck Brooks described the state of American culture in terms that suggest Stieglitz's artistic vision of O'Keeffe:
The spiritual welfare of this country depends altogether upon the fate of its creative minds. If they cannot grow and ripen, where are we going to get the new ideals, the finer attitudes, that we must get if we are ever to emerge from our existing travesty of a civilization? From this point of view our contemporary literature could hardly be in a graver state. We want bold ideas, and we have nuances. We want courage, and we have universal fear. We want individuality, and we have idiosyncrasy. We want vitality, and we have intellectualism. We want emblems of desire, and we have Niagaras of emotionality. We want expansion of soul, and we have an elephantiasis of the vocal organs.

64 Paul Rosenfeld, "Stieglitz," *The Dial* 70(April 1921): 408. Stieglitz's Anderson Galleries exhibition had an enormous impact on viewers and critics. For a particularly good summary of the impact of this exhibition see *Photo-Miniature* 16(July 1921): 135-39, which noted that "this exhibition...aroused more comment than any similar event since photography began, and deservedly, in that it was an exhibition of photography such as the world had never before seen....never was there such a hubbub about a one-man show."

65 Rosenfeld, "Stieglitz," p. 406.

66 For a good overview of this series, see Belinda Rathbone, "Portrait of a Marriage: Paul Strand's Photographs of Rebecca," in Maren Stange, ed., *Paul Strand: Essays on his Life and Work* (New York: Aperture, 1990), pp. 72-86.

67 See Sarah Greenough, "How Stieglitz Came to Photograph Clouds," in Peter Walch and Thomas F. Barrow, eds., *Perspectives on Photography: Essays in Honor of Beaumont Newhall* (Albuquerque: University of New Mexico Press, 1986), pp. 151-65.

68 Stieglitz's choice of clouds was, in itself, firmly in the most established traditions of American art and photography. For a brief summary of the role of clouds in nineteenth century American painting, see Barbara Novak, "The Meteorological Vision: Clouds," *Art in America* 68(February 1980): 102-17; and the corresponding chapter in her book *Nature and Culture: American Landscape, 1825-75* (New York: Oxford University Press, 1980). The popular photographic press was full of articles on cloud photography during Stieglitz's day. See, for example: "Hunting for Clouds," *American Photography* 17(January 1923): 1-5; "Cloudland," *American Photography* 19(March 1925): 121-31; and "Silver Clouds," *American Photography* 23(June 1929): 294-96. In general, these articles approached clouds from either a traditionally picturesque (sunsets and other dramatic effects) or a meteorological (distinguishing fractocumulus from cirrocumulus, etc.) point of view.

Also of interest are Alvin Langdon Coburn's illustrations for the 1912 edition of Percy Bysshe Shelley's *The Cloud.*

[69] Alfred Stieglitz, "How I Came to Photograph Clouds," *Amateur Photographer and Photography* 56(September 19, 1923); repr. in Sarah Greenough and Juan Hamilton, *Alfred Stieglitz: Photographs & Writings* (Washington, D.C.: National Gallery of Art, 1983), pp. 206-08.

[70] Rosenfeld, "Stieglitz," p. 399.

[71] This quote is from Marius de Zayas's discussion of the work of Picasso in *Camera Work*, no. 34-35(April-July 1911): 66.

[72] This understanding was, of course, not universal. In 1924, a prominent critic related his experience with these works:

> I shall not soon forget my amazement when, some months ago, Stieglitz showed me the series of cloud pictures to the making of which he devoted last summer. They were, it goes without saying, superior to anything that I had ever seen or dreamed was possible. I had not believed that such rendering of values...was possible to the camera. And, listening to Stieglitz, I tried to read into these studies something of what, according to his own confession, he had wished to express. It was hopeless. The more I looked, the more I admired, the more persistent rang the question, Why, Why, Why?...What perverse impulse drives an artist of Stieglitz's calibre to spend a precious year making—with consummate mastery—valueless documents? It seemed little short of tragic.

International Studio (May 1924): 149.

[73] Harold Clurman, "Alfred Stieglitz and the Group Idea," in *America & Alfred Stieglitz* (New York: Literary Guild, 1934), p. 271; cited in Estelle Jussim, "Thinking About Stieglitz, Once More, With Feeling," in Kathleen Collins, ed., *Shadow and Substance: Essays on the History of Photography in Honor of Heinz K. Henisch* (Bloomfield Hills, Mich.: The Amorphous Institute Press, 1990), p. 250.

[74] See Graham Clarke, "Alfred Stieglitz and Lake George: An American Place," *History of Photography* 15(Summer 1991): 78-83.

[75] *The Craftsman* 28(May 1915): 148.

[76] The distinctly bizarre tension between these utterly different artistic philosophies is revealed in Stieglitz's statement for his 1921 Anderson Galleries show. In it he wrote in consecutive paragraphs:

> Many of my prints exist in one example only. Negatives of the early work have nearly all been lost or destroyed. There are but few of my early prints still in existence. Every print I make, even from one negative, is a new experience, a new problem. For, unless I am able to vary—add—I am not interested. There is no mechanicalization, but always photography.
>
> My ideal is to achieve the ability to produce numberless prints from each negative, prints all significantly alive, yet indistinguishably alike, and to be able to circulate them at a price not higher than that of a popular magazine, or even a daily paper. To gain that ability there has been no choice but to follow the road I have chosen...

Reprinted in Newhall, ed., *Photography: Essays & Images*, p. 217.

[77] Rosenfeld, "Stieglitz," p. 405.

[78] Joseph Shiffman, "The Alienation of the Artist: Alfred Stieglitz," *American Quarterly* 3(Fall 1951): 255.

[79] A strong argument for White's importance is contained in Bonnie Yochelson's important essay, "Clarence H. White Reconsidered: An Alternative to the Modernist Aesthetic of Straight Photography," *Studies in Visual Communication* 9(Fall 1983): 24-44.

[80] These were issued in 1920, 1921, 1922, 1926, and 1929.

[81] "The Filling of Space," reprinted in Percy North and Susan Krane, *Max Weber: The Cubist Decade, 1910-1920* (Atlanta: High Museum of Art, 1991), p. 97.

[82] Ralph Steiner, quoted in Lucinda Barnes, Constance W. Glenn, and Jane K. Bledsoe, *A Collective Vision: Clarence H. White and his Students* (Long Beach: California State University Art Museum, 1985), p. 29.

[83] Yochelson, "Clarence H. White Reconsidered," p. 30.

[84] W. G. Fitz, "A Few Thoughts on the Wanamaker Exhibition," p. 203.

[85] It may not be a coincidence that White was exemplary in his support of women as photographic artists and professionals. See, for example, his article "Photography as a Profession for Women," *American Photography* 18(July 1924): 426-32.

[86] In his essay "The Exigencies of Composition," in the *American Annual of Photography 1920*, p. 168, Edward R. Dickson states that

> composing the picture is merely a matter of appreciating the relation which one object bears to another within the space of our ground-glass.

It is the means through which we arrive at harmony, and parallels man's effort to establish through union, a fine relationship with another human.

[87] Chapman had been a student at the White School before serving as an instructor. His working method is outlined in his article "Travel," published in the 1918 *American Annual of Photography*, pp. 235-39. *Diagonals*, at this time his most exhibited image, was made from a Sixth Avenue elevated station close to his home. This work exemplified his feeling that "there is too much searching after things strange and unusual in themselves, and not enough analysis and selection of new viewpoints from which to record familiar things."

[88] See the portfolio of Watkins's work, "Photography Comes Into the Kitchen," published in *Vanity Fair* 17(October 1921): 60.

[89] From a letter to *Popular Photography*, June 12, 1957; quoted in Graham Howe and G. Ray Hawkins, eds., *Paul Outerbridge, Jr.: Photographs* (New York: Rizzoli, 1980), p. 9.

[90] This work is illustrated in John Szarkowski's *Looking At Photographs*, p. 81; *Paul Outerbridge, Jr., Photographs*, p. 36; and Elaine Dines, ed., *Paul Outerbridge: A Singular Aesthetic* (Laguna Beach, Calif.: Laguna Beach Museum of Art, 1981), p. 47. The following discussion is based on information provided in *Paul Outerbridge, Jr.: Photographs*, p. 11.

[91] As Outerbridge himself noted,

> This abstraction created for aesthetic appreciation of line against line and tone against tone without any sentimental associations, utilizes a tin Saltine cracker box, so lighted that the shadow and reflections from its highly polished surface produced this result. Note especially the gradation at the top of the box.

Cited in *Paul Outerbridge, Jr., Photographs*, p. 11.

[92] For some viewers, the form of the box flickers back and forth between positive and negative—that is, between the appearance of a projecting spatial mass and an inverted, vacant volume.

[93] Paul Outerbridge, "Visualizing Design in the Common Place," *Arts and Decoration* 17(September, 1922): 320; cited in *Paul Outerbridge: A Singular Aesthetic*, p. 26.

[94] *A Collective Vision*, p. 27. For similar sentiments, see Judith Gerber, "Ralph Steiner: Enjoying the Interval," *Afterimage* 5(March 1978): 18-21. In this interview, Steiner stated that at the White School, "we had people stuffing design down our throats like you stuff a Strasbourg goose to make liver sausage."

[95] Photographs produced for his final project at the school are illustrated in Van Deren Coke and Diana C. DuPont, *Photography: A Facet of Modernism* (New York: Hudson Hills Press/San Francisco Museum of Modern Art, 1986), pp. 30-31. These semi-abstractions are entirely characteristic of the school's emphasis on design and *notan*.

[96] "Advertising and Photography," *Pictorial Photography in America: Volume 4* (New York: Pictorial Photographers of America, 1926), n.p.

[97] See, for example, her essay "The Need for Design in Photography," *American Annual of Photography* 40(1926): 154-56.

[98] See Gilpin's books *The Pueblos: A Camera Chronicle* (New York: Hastings House, 1941), *Temples in Yucatan: A Camera Chronicle of Chichén Itzá* (New York: Hastings House, 1948), *The Rio Grande: River of Destiny* (New York: Duell, Sloan & Pearce, 1949), and *The Enduring Navaho* (Austin: University of Texas Press, 1968).

[99] For contemporary profiles of Richards, see *Abel's Photographic Weekly* for 1931: October 3 (p. 407), October 17 (p. 455), October 24 (p. 483), and October 31 (p. 511); and Dora Albert, "Experiment Brought Her Success," *Popular Photography* 3(August 1938): 24-25, 67.

[100] This image was reproduced in *Camera Pictures* (1925), a collection of work by alumni of the Clarence White School.

[101] Ludeman apparently considered this her "masterpiece," as it was included in the 1926 White School class album now in the White Collection of the Art Museum, Princeton University.

[102] William Innes Homer, ed., *Symbolism of Light: The Photographs of Clarence H. White* (Wilmington, Del.: Delaware Art Museum, 1977), p. 28.

[103] *Pictorial Photography in America 1920* (New York: Tennant & Ward, 1920), p. 6.

[104] For a good summary of these exhibitions, see Frank R. Fraprie,

"Exhibitions and Exhibition Prints," *American Annual of Photography* 1927, pp. 132-35.

[105] Arthur Hammond, "Sending Pictures to Salons," *American Photography* 28(April 1934): 195.

[106] *American Annual of Photography 1939*, pp. 297, 298-301. This attempt to establish artistic merit through statistical analysis was carried to a curious extreme in the *American Annual's* "Numerical Evaluation of Pictorial Achievement," which created a "Print Value Factor" for each salon and a worldwide ranking based on the resulting "Weighed Average." By this measure Thorek ranked tenth worldwide and second among Americans.

[107] A great number of such images are reproduced in the journals of the day. *The American Annual of Photography 1917*, for example, includes pictures by Herman Gabriel, Bernard S. Horne, Blanche C. Hungerford, Thomas C. Martindale, G.H.S. Harding, and others.

[108] This fascinating image, titled *Jazzmania*, is reproduced in *Camera Craft* 35(June 1928): 257.

[109] It should be noted that this term initially referred to images made with a sharply focused lens, and later to the combination of sharp images on simple, untextured silver-gelatine papers.

[110] "The Straight Photograph, and Why," *Photographic Journal of America* 53(August 1916): 340-42.

[111] *Photo-Era* 52(June 1924): 307.

[112] *American Photography* 19(January 1925): 1.

[113] See, for example, the tally of print processes in the 1926 San Francisco Salon (*Camera Craft* 33[December 1926]: 556); or in the 1928 Pittsburgh Salon (*Camera Craft* 35[June 1928]: 254). By contrast, the 1923 Pittsburgh Salon featured no fewer than a dozen techniques: "Artatone, Bromide, Bromoil, Chloride, Carbon, Carbro, Gum, Kallitype, Oil, Platinum, Palladium, and Satista, as well as the various transfers which can be made from certain of these prints." *Photo-Era* 50(May 1923): 251.

[114] Much of the following data is drawn from Dennis Reed's valuable study, *Japanese Photography in America, 1920-1940* (Los Angeles: George J. Doizaki Gallery/Japanese American Cultural & Community Center, 1985).

[115] See, for example, his article "Japanese Art in Photography," *Camera Craft* 32(March 1925): 110-15.

[116] These occurred in 1921 (Weston's first one-man exhibition), 1925, 1927, and 1931. These exhibitions resulted in numerous print sales, and Weston greatly appreciated the Japanese community's understanding of his work.

[117] This image was reproduced in the *Photograms of the Year 1927*, *Photofreund Jahrbuck 1927-28* (here miscredited to H.R. Cremer), *Soviet Photography* (March 1928), *American Annual of Photography 1929*, and *Pictorial Photography in America 1929*. My thanks to Stephen White for several of these references. Helen Levitt may have been one of the many American photographers who was impressed by this image; see Sandra S. Phillips and Maria Morris Hambourg, *Helen Levitt* (San Francisco: San Francisco Museum of Modern Art, 1991), p. 47.

[118] For example, in the Third International Salon of the Pictorial Photographers of America, held at the Art Center in New York in 1929, fully 33 of the 172 American prints were by Japanese photographers and provided "the keynote to the entire show." This review (*American Photography* 23[July 1929]: 341) also suggests the resistance of some critics to the apparent domination of such exhibitions by the Japanese contingent.

[119] Reed notes (pp. 75-79) that a number of these photographers were part of the forced relocation of Japanese-Americans in the months after Pearl Harbor. Much of the personal property of these families, including artistic photographs, was consequently lost.

[120] Ira W. Martin, "Why Should Style In Pictures Change," *Camera Craft* 37(October 1930): 480-88. This article is illustrated with examples of his own work of the period.

[121] Paul L. Anderson, "Some Pictorial History," *American Photography* 29(April 1935): 212, 214.

[122] Alfons Weber, "The March of Progress," *Camera Craft* 24(January 1931): 4. Weber notes that "modernism seems to have a special tendency to destroy this quality [personal feeling] in pictures and instead of a work of art it recedes to purely mechanical photography."

[123] Anderson, "Some Pictorial History," p. 214.

[124] The title of Mortensen's book reflected his sense of the struggle between the powers of science and technology ("Monsters") and the organic virtues of growth, life, and creative energy ("Madonnas").

[125] *Photo-Era* 32(May 1914): 236. This aspect of Weston's work is summarized in articles such as his "Notes on High Key Portraiture," *American Photography* 10(August 1916): 407-12.

[126] *Photographic Journal of America* 54(May 1917): 189.

[127] *Photo-Era* 42(May 1919): 225, and *Photo-Era* 46(May 1921): 227, in regard to works shown at the Pittsburgh Salons of those years.

[128] *Camera Craft* 28(November 1921): 360.

[129] Ibid., p. 392.

[130] *Camera Craft* 29(June 1922): 258.

[131] Johan Hagemeyer, "Pictorial Interpretation," *Camera Craft* 29(August 1922): 361-66. This essay is accompanied by reproductions of some of Hagemeyer's most significant pictures of the period, including *Pedestrians* (here dated 1921). Hagemeyer's criticism of the state of photographic art was indicative of a restlessness for change that was shared relatively widely. For example, in his review of the 1923 International Salon, held at the Art Center in New York, John Wallace Gillies made the following observations (*American Photography* 17[July 1923]: 390):

> The thing which struck me most forcibly is that the prints which were hung, among the Americans, where those which fitted a pictorial formula. We have at last standardized pictorial photography. They must be so, or they will not be hung. The trend of fashion at the moment is toward sharper pictures, and so we must all make them a little sharper; not too sharp, as we move slowly, but just a little. Gradually we will get them sharper, until in about ten years we will be making them quite sharp, or as sharp as any pictorialist knows how to make a photograph, which is not very sharp. But we have a set way of making pictures. There is no question about it. Individualism has been set aside, and we have decided how it should be done. Technique is all set, the degree of diffusion is all set, and we make them just so, and they will hang. Good photography, or craftsmanship, has nothing to do with it...

[132] From an interview published in the *San Jose Mercury*, March 1927; cited in Richard Lorenz, "Johan Hagemeyer: A Lifetime of Camera Portraits," *Johan Hagemeyer* (Tucson: Center for Creative Photography, 1982), p. 14.

[133] *Photo-Era* 46(May 1921): 228; *Camera Craft* 29(February 1922): 62. In addition, his work in the 1919 Pittsburgh Salon prompted a reviewer to note that he was "experimenting with out-of-the-ordinary compositions" (*American Photography* 13[1919]: 328). Another review of this show noted accurately that Weston's "treatment and subjects were similar to those of Margrethe Mather" (*Photo-Era* 42[May 1919]: 226).

[134] "Statement" by Weston, in John Wallace Gillies, *Principles of Pictorial Photography* (New York: Falk Publishing Company, 1923), p. 29. Weston quotes from the essays of John Tennant (on a Stieglitz exhibition), Paul Strand, Sherwood Anderson, Herbert J. Seligman, and Paul Rosenfeld.

[135] After moving to Hollywood after World War I, Struss began a highly successful career as a cinematographer. Weston came to know Struss well, and this work was one of several portraits Weston made of him, either alone or with his wife. Weston gave this print directly to Struss, who held it in his personal collection until the end of his life.

[136] For background on the artistic appeal of Mexico, see for example, Henry C. Schmidt, "The American Intellectual Discovery of Mexico in the 1920's," *South Atlantic Quarterly* 77(Summer 1978): 335-51.

[137] Weston returned to California from December 1924 through August 1925. During some of this time he shared a studio with Johan Hagemeyer in San Francisco. He then returned to Mexico City until late 1926, when he returned permanently to California. Modotti remained in Mexico until early 1930, when she was deported for her political activities.

[138] Letter to Weston of July 7, 1925; cited in Amy Stark, ed., *The Letters from Tina Modotti to Edward Weston* (Tucson: Center for Creative Photography, 1986), pp. 39-40.

139 Modotti's entire photographic career seems to span the years 1923 to 1930, and only about 160 images have been firmly identified as hers. See Amy Conger, "Tina Modotti and Edward Weston: A Re-evaluation of their Photography," in Peter C. Bunnell and David Featherstone, eds., *EW:100, Centennial Essays in Honor of Edward Weston* (Carmel, Calif.: Friends of Photography, 1986).

140 Nancy Newhall, ed., *The Daybooks of Edward Weston: California* (New York: Horizon Press, 1966), pp. 181; entry for August 8, 1930.

141 In 1927 Weston reestablished contacts with photographers he had known for some time, including Hagemeyer, Brigman, and Cunningham. He was also powerfully affected by the work of Henrietta Shore, a precisionist painter he met in the early part of that year. Shore painted many of the subjects—including rocks, cypress trees, shells, and nudes—that Weston would embrace in the next few years. In fact, Shore introduced him to ocean shells as an artistic subject and loaned him the first ones he photographed. See Roger Aikin, "Henrietta Shore and Edward Weston," *American Art* 6(Winter 1992): 43-61.

142 Cited in Amy Conger, *Edward Weston: Photographs from the Collection of the Center for Creative Photography*(Tucson, Ariz.: Center for Creative Photography, 1992), p. 17.

143 Weston, "Statement," 1931, in Peter C. Bunnell, ed., *Edward Weston on Photography* (Salt Lake City: Peregrine Smith Books, 1983), p. 67.

144 Newhall, ed., *Daybooks of Edward Weston: California*, p. 154; entry for April 24, 1930.

145 See, for example, Estelle Jussim, "Quintessences: Edward Weston's Search for Meaning," in Bunnell and Featherstone, eds., *EW:100*, pp. 51-61; and Keith F. Davis, "Edward Weston in Context," in *Edward Weston: One Hundred Photographs from the Nelson-Atkins Museum of Art and the Hallmark Photographic Collection* (Kansas City: Hallmark Cards, Inc., 1982), pp. 62-65.

146 Nathanial Kaplan and Thomas Katsaros, *The Origins of American Transcendentalism* (New Haven: College and University Press, 1975), pp. 17-18.

147 *Camera Craft* 37(July 1930): 313-20.

148 "Group F. 64 Manifesto" (1932), repr. in Therese Thau Heyman, ed., *Seeing Straight: The f.64 Revolution in Photography* (Oakland: The Oakland Museum, 1992), p. 53.

149 F.H. Halliday, "Brett Weston Photographer," *Camera Craft* 47(March 1940): 118.

150 Responses to this photograph are detailed in Conger, *Edward Weston: Photographs from the Collection*, n.p. (figure 655).

151 In his autobiography, Adams describes the evening on which the group was formed. After he spoke for the concept with "extroverted enthusiasm, …we agreed with missionary zeal to a group effort to stem the tides of oppressive pictorialism and to define what we felt creative photography to be." Ansel Adams with Mary Street Alinder, *Ansel Adams, An Autobiography* (Boston: New York Graphic Society, 1985), p. 110.

152 This image, of one of the most photographed structures in the Southwest, was described by Adams in his book *Examples: The Making of 40 Photographs* (Boston: New York Graphic Society, 1983), pp. 90-93.

153 Nancy Newhall, *The Eloquent Light* (Millerton, N.Y.: Aperture, 1980), p. 69.

154 See also such articles as his "The New Photography," *Modern Photography 1934-35* (London: The Studio Limited, 1934), pp. 9-18.

155 William Mortensen, "Fallacies of 'Pure Photography,'" *Camera Craft* 41(June 1934): 257.

156 Ibid, pp. 260-61.

157 Ibid, pp. 257, 263.

158 See, for example, Albert Jourdan, "Sidelight #16, The Impurities of Purism," *American Photography* 29(June 1935): 348-56; Weston's various essays of 1939, including "What Is A Purist?" *Camera Craft* 46(January 1939): 3-9, and "What Is Photographic Beauty?" *Camera Craft* 46(June 1939): 247-55; and Roi Partridge's "What Is Good Photography?" *Camera Craft* 46(November 1939): 503-10, 540-42 (with readers' responses in the December 1939 issue, pp. 593-95).

159 Valuable studies of this complex subject include Maria Morris Hambourg and Christopher Phillips, *The New Vision: Photography Between the Wars* (New York: Metropolitan Museum of Art/Harry N. Abrams, 1989); Christopher Phillips, ed., *Photography in the Modern Era: European Documents and Critical Writings, 1913-1940* (New York: Metropolitan Museum of Art/Aperture, 1989); John Willett, *Art and Politics in the Weimar Period* (New York: Pantheon Books, 1978); David Mellor, ed., *Germany: The New Photography, 1927-1933* (London: Arts Council of Great Britain, 1978); and Van Deren Coke, *Avant-Garde Photography in Germany, 1919-1939* (San Francisco: San Francisco Museum of Modern Art, 1980).

160 On this theme see, for example, Simon Watney, "Making Strange: The Shattered Mirror," in Victor Burgin, ed., *Thinking Photography (London: Macmillan Press,* 1982), pp. 154-76.

161 It seems probable that Moholy-Nagy began his photograms after Tristan Tzara showed him samples of Man Ray's earliest rayographs. See, for example, Eleanor M. Hight, *Moholy-Nagy: Photography and Film in Weimar Germany* (Wellesley, Mass.: Wellesley College Museum, 1985), p. 49; and Neil Baldwin, *Man Ray: American Artist* (New York: Clarkson Potter, 1988), pp. 98-99.

162 Rayographs were published in the Autumn 1922 issue of *The Little Review*, and the November 1922 issue of *Vanity Fair*. Man Ray's portfolio, *Les Champs délicieux*, with a preface by Tristan Tzara, was published in December 1922.

163 *Broom* 4(March 1923).

164 Christopher Phillips, "Resurrecting Vision: The New Photography in Europe Between the Wars," in Hambourg and Phillips, *The New Vision*, p. 81. This essay provides an excellent overview of this entire subject.

165 His first two important essays ("Production—Reproduction" of 1922 and "Light—A Medium of Plastic Expression" of 1923) are reprinted, respectively, in Phillips, ed., *Photography in the Modern Era*, pp. 79-82; and Lyons, ed., *Photographers on Photography*, pp. 72-73.

166 László Moholy-Nagy, *Painting Photography Film* (Cambridge, Mass.: MIT Press, 1969; translation of second [1927] edition), p. 7.

167 Ibid., p. 38.

168 Ibid., pp. 28, 45.

169 It appears that the dates of at least some of Moholy-Nagy's early photographs were assigned later. On its reverse, this photogram bears the date 1921, written in pencil in an unknown hand. The revised date of ca. 1922 reflects scholarly consensus that Moholy-Nagy's photographic work did not begin until that year. The physical nature of this print (5x7-inches in size on printing-out-paper) is consistent with other examples of his earliest photograms.

170 Cited in Hight, *Moholy-Nagy*, p. 51.

171 Information derived from the author's visit to Rothenburg in 1986. Another of Moholy-Nagy's images from this vantage point, in the collection of the J. Paul Getty Museum, is reproduced as plate 50 in Hight, *Moholy-Nagy*.

172 For essays on this exhibition, see Beaumont Newhall, "Photo Eye of the 1920s: The Deutsche Werkbund Exhibition of 1929," in Mellor, ed., *Germany: The New Photography*, pp. 77-86; and Ute Eskildsen, "Innovative Photography in Germany Between the Wars," in Coke, *Avant-Garde Photography in Germany*, pp. 35-46. After its debut in Stuttgart, the show traveled to Berlin, Munich, Vienna, Zagreb, Basel, and Zürich.

173 Astronomers often view these images as negatives, thereby producing the effect seen here: dark pinpoints on a white ground.

174 For more information on this image, see its catalogue entry (number 65, p. 266) in Sandra S. Phillips et al., *André Kertész: Of Paris and New York* (Chicago: Art Institute of Chicago/Metropolitan/Thames and Hudson, 1985). Five vintage contact prints of this image are known to exist. The print in the Hallmark Photographic Collection was originally sent by Kertész to his future wife, Elizabeth, in Budapest, and subsequently remained in the artist's collection until his death in 1985.

175 As an added touch of unreality, Henri retouched her model's hair in the negative. She apparently made "free use of retouching" in her portraits. See Diana C. DuPont, *Florence Henri: Artist-Photographer of the Avant-Garde* (San Francisco: San Francisco Museum of Modern Art, 1990), p. 41.

176 Cited in Nancy Barrett, *Ilse Bing: Three Decades of Photography* (New Orleans: New Orleans Museum of Art, 1985), p. 9. For an earlier profile of Bing, see Mildred Stagg, "Ilse Bing: 35mm. Specialist," *U.S. Camera* 12(May 1949): 50-51.

177 For example, in an entry in his daybook on September 4, 1926, Edward

Weston dismissed Moholy-Nagy's work with the comment "It only brings a question—why?" Newhall, ed., *Daybooks of Edward Weston: Mexico*, p. 190.

[178] For an interesting essay on this theme, see Katharine Grant Sterne, "American vs. European Photography," *Parnassus* 4(March 1932): 16-20. Sterne describes "the pervading objectivity of American art" and Americans' "dominating reverence for the external fact," and even suggests that "the Russo-German cult of *sachlichkeit* is essentially an American invention."

[179] Thomas S. Kuhn, *The Structure of Scientific Revolutions*, second edition (Chicago: University of Chicago Press, 1970).

[180] See, for example, in the *American Amateur Photographer* 8(February 1896), "Roentgen or X Ray Photography," pp. 58-63, with curiously abstract images by Professor A.W. Wright of Yale University of *Pocket Book Containing Coins, Box of Aluminum Wire Weights*, and *Coins-Pill Box Containing Metallic Spheres*. See also "The New Radiography," *American Amateur Photographer* 8(March 1896): 108-09; and "The Röntgen Process in Medicine," *Wilson's Photographic Magazine* 33(April 1896): 174-76, with images by C. Swinton and J. W. Gifford.

[181] See, for example, "Photography and Crystallization," *American Annual of Photography 1897*, pp. 214-19, 221. This essay is illustrated with photographs of crystallization patterns produced by a variety of chemical compounds.

[182] For merely two examples of even earlier images that would have fit comfortably into "Film und Foto," see *A Daring Feat*, in *Wilson's Photographic Magazine* 33(October 1896): 449, and the aerial view of men playing cards in the *American Annual of Photography 1898*, p. 130.

[183] See "The Photography of Lightning," *American Annual of Photography 1909*, pp. 54-57; and "Lightning Flashes with Moving Camera," *American Photography* 2(April 1908): 190-92. The latter article reproduces four images by James Cooke Mills produced by deliberately swinging the camera during the time of exposure.

[184] Two diverse examples will suffice. Composite photography had been a popular amusement since at least the mid-1880s. This process involved the creation of a single collective "portrait" by printing numerous individual portraits in succession on the same sheet of photographic paper. See, for example, *The King of Finance*, produced by Oliver Lippincott from the images of 50 bank presidents, in *Wilson's Photographic Magazine* 47(January 1910): 16. It is also interesting to note that the Cirkut camera, which produced seamless 360-degree views, was introduced in 1905. Curiously, this camera's astounding manipulation of perspective was never utilized for "artistic" purposes. See *American Amateur Photographer* 17(March 1905): 136-38.

[185] "Moving Picture Tricks," *Vanity Fair* (September 1914): 63. For an important study of the film of this era, see Hugo Münsterberg, *The Film: A Psychological Study* (New York: Dover Publications, 1970; originally published by D. Appleton in 1916 under the title *The Photoplay: A Psychological Study*).

[186] See, for example, Walter Camp, "A Photographic Analysis of Golf," *Vanity Fair* 6(August 1916): 62-63.

[187] *American Amateur Photographer* 16(May 1904): 208.

[188] Archer's *Reflections of a Concave Mirror* is reproduced in an essay by Nicholas Ház in *American Photography* 31(October 1937): 716-18. Ház's text states that "this picture was made twenty years ago [and] was one of the first abstract photographs made in this country."

[189] Edward Steichen, *A Life in Photography* (Garden City, N.Y.: Doubleday & Doubleday, 1963), n.p.

[190] As Steichen later related in *A Life in Photography* (n.p.),

> One of my experiments has become a sort of legend. It consisted of photographing a white cup and saucer placed on a graduated scale of tones from pure white through light and dark grays to black velvet. This experiment I did at intervals over a whole summer, taking well over a thousand negatives. The cup and saucer experiment was to a photographer what a series of finger exercises is to a pianist. It had nothing directly to do with the conception or the art of photography.

[191] In his *A Life in Photography* Steichen reported that he was most impressed by Theodore Andrea Cook's book *The Curves of Life* (1914). For an interesting essay on this work's influence on Steichen and Weston, see Mike Weaver, "Curves of Art," in Bunnell and Featherstone, eds., *EW: 100*, pp. 81-91.

[192] Steichen, *A Life in Photography*, n.p. For a summary of the many articles on Einstein and his theory that appeared just prior to Steichen's series, see *Reader's Guide to Periodical Literature*, 1919-21, pp. 472-73.

[193] See, for example, the treatment of this subject in *Vanity Fair*: "All About Relativity" (March 1920): 61; "Rhyme and Relativity: A Page of Parodies..." (August 1921): 31; "Einstein the Man" (September 1922): 62, 104; "Einstein in the Movies" (August 1923): 48, 96; "How to Prove the Einstein Theory with the Aid of a Motor" (October 1923): 79; and "The New Understanding of the Einstein Theory" (March 1925): 29, 76. With the exception of the last, these are insubstantial attempts to explain Einstein's theory, personality profiles, or parodies. The author of the March 1925 essay, J.W.N. Sullivan, noted accurately that "most of the early expositions of the theory suffer from the greatest of defects, namely, that the authors do not quite know what they are talking about." See also the very unscientific "Relativity in Photography," *Photographic Journal of America* 59(April 1922): 166-67. These pieces remind us that complex ideas rarely find popular expression in their purest and most difficult form. Rather, it is as second- and third-hand reports, diluted and adulterated, that such concepts have broad cultural impact.

[194] Steichen reproduced four images from this series in his *A Life in Photography*, plates 68-71. These are titled *Time-Space Continuum, Harmonica Riddle, Triumph of the Egg* (a variant of the work reproduced in this volume), and *From the Outer Rim*.

[195] Steichen, *A Life in Photography*, n.p.

[196] A brief biographical sketch of Wilfred is included in the Museum of Modern Art's catalogue *15 Americans* (1952), which documents an exhibition in which he was featured.

[197] Virginia Farmer, "Mobile Colour: A New Art," *Vanity Fair* 15(December 1920): 53. This appears to be one of the earliest public accounts of Wilfred's clavilux. For other early reports, see Stark Young, "The Color Organ," *Theatre Arts Magazine* 6(January 1922): 20-32; Roderick Seidenberg, "Mobile Painting," *International Studio* 75(March 1922): 84-86; and George Vail, "Visible Music," *Nation* (August 2, 1922): 120-21, 124. Wilfred himself published an article titled "Prometheus and Melpomene" in *Theatre Arts Monthly* 12(September 1928): 639-41.

[198] Given the frequency of words such as "clouds" and "atmosphere" in descriptions of Wilfred's performances, one wonders if this work had any influence on a series begun soon after the first reports of the clavilux: Stieglitz's Equivalents. In 1933 Wilfred founded the "Art Institute of Light" in New York and gave regular Friday night clavilux concerts for several years (see *Reader's Digest* [June 1938]: 70). The Museum of Modern Art included Wilfred in the 1952 exhibition "15 Americans" and mounted a retrospective of his work in 1971. For an interesting summary of this theme in art, see Kenneth Peacock, "Instruments to Perform Color-Music: Two Centuries of Technological Experimentation," *Leonardo* 21(1988): 397-406.

[199] For example, in addition to its article in December 1920, *Vanity Fair* published updates on his work in the issues of March 1922 (p. 70) and May 1925 (p. 67). These three essays were accompanied by a total of eleven "abstract" photographs of projected patterns of light (one in 1920, and five each in 1922 and 1925). It is amusing to note that the 1925 essay contained the confident prediction that "ten years from now, we shall all have light organs in our homes tucked away in a corner of the drawing room, just as we now have phonographs and radios."

[200] "Experiments in Modern Photography," *Vanity Fair* 16(July 1921): 60. The brief text accompanying these images concluded with the statement that "these photographs...represent one of the most successful attempts on the part of an American to attack the same problems in which the modernistic painter is interested, and to attack them through the camera."

[201] *Theatre Arts Magazine* 6(January 1922): 23-26.

[202] *New York Times*, April 3, 1927.

[203] Lance Sieveking and Francis Bruguière, *Beyond This Point* (London: Duckworth, [1929]); and Oswell Blakeston and Francis Bruguière, *Few Are Chosen: Studies in the Theatrical Lighting of Life's Theatre* (London: Eric Partridge Ltd., 1931). Bruguière's contributions included cut-paper and multiple-exposure images.

[204] For several interesting mentions of Fitz's early career, see Gray Stone,

"The Influence of Alfred Stieglitz on Modern Photographic Illustration," *American Photography* 30(April 1936): 199-206. A capsule biography of Fitz is contained in Robert Sobieszek, *The Art of Persuasion: A History of Advertising Photography* (New York: Abbeville Press, 1988), p. 194.

205 This print was reproduced in *Modern Photography 1931* (London: The Studio Ltd., 1931), p. 37.

206 This image is reproduced as a vertical, reflecting the orientation of the photograph's stamp on the back of the print. Another print of this image is reproduced as a horizontal in Fels, *O Say Can You See*, p. 109.

207 For biographical detail, see the profiles "Has Harold Harvey Revolutionized Film Development," *Popular Photography* 2(May 1938): 55, 102-05; and "Pictures While I Walk," *Popular Science* (January 1941): 194-96; as well as the notes in Fels, *O Say Can You See*, pp. 134-35.

208 By 1932, for example, one critic observed that "the angle-shot is, by now, a device so common that it is viewed askance in the most advanced photographic circles." Sterne, "American vs. European Photography," p. 19.

209 A variant exposure of this scene, printed on postcard stock, is inscribed "Anchoring at Brest, France, May 13, 1919 at 2 P.M." In addition to his successful career as a commercial photographer, Costain exhibited widely in the salons of the period. *Securing the Anchor Chain* was one of his best-known salon prints. My thanks to Keith de Lellis for this information.

210 For a similar perspective on the American scene, see the essays on Bernd Lohse in *Studies in Visual Communication* 11(Spring 1985): 76-112.

211 Much of this discussion is indebted to the following recent publications: Cynthia Wayne, *Dreams, Lies, and Exaggerations: Photomontage in America* (College Park: University of Maryland Art Gallery, 1991), and Matthew Teitelbaum, ed., *Montage and Modern Life, 1919-1942* (Cambridge, Mass.: MIT Press, 1992). Of particular interest in the latter volume is Sally Stein's essay "'Good fences make good neighbors,' American Resistance to Photomontage Between the Wars."

212 *Murals by American Painters and Photographers* (New York: Museum of Modern Art, 1932). This catalogue illustrates a number of the works exhibited. The photographic section of the exhibit was coordinated by Julien Levy.

213 For an excellent article on the Rockefeller Center project, see Nicholas Hàz, "Steichen's Photo-Murals at New York's Radio City," *American Photography* 27(June 1933): 404-08. Hàz reported that Steichen "received the commission exactly three weeks before the murals were to be done" and that the final work was composed of "one hundred and fifty strips, [each] seven feet by three feet" in size. The dimensions of Steichen's Chicago mural were reported to be 16 x 140 feet. It appears that John Paul Pennebaker was also commissioned to create a photomontage for the Chicago fair (*American Photography* 28[December 1934]: 733). Alexander Alland was one of the most prolific photographic muralists. A brief biographic summary in *U.S. Camera Annual 1939* (n.p.) states:
> Mr. Alland specializes in Photo-Murals and Photo-Montage. Some of his murals are hung in the Newark Public Library and he has recently completed a mural of 325 square feet for the Riker's Island Penitentiary library. At present he is designing a Photo-Mural decoration for the New York State Hall of Medical Science, World's Fair, 1939.

See also Fred G. Korth, "Making Photomontages in the Enlarger," *American Photography* 31(January 1937): 22-26; and Will Connell, "Photo-Montage," *U.S. Camera* 2(October 1939): 50-51, 65. For examples of a more didactic use of photomontage in print, see, for example, Charles Cross, ed., *A Picture of America* (New York: Simon and Schuster, 1932); and M. Lincoln Schuster, *Eyes On The World* (New York: Simon and Schuster, 1935).

214 William Stott, *Documentary Expression and Thirties America* (New York: Oxford University Press, 1973), p. 125. See also Barbara Morgan, *Martha Graham: Sixteen Dances in Photographs* (Dobbs Ferry, N.Y.: Morgan & Morgan, 1980; originally published under the same title by Duell, Sloan & Pearce, 1941); and Morgan's essay "Dance Photography," *U.S. Camera* 3(February/March 1940): 52-56, 64.

215 For a contemporary essay on Connell's career, see Wick Evans, "Will Connell...Master of Pictorial Satire," *Popular Photography* 3(October 1938): 8-10, 68. For a late career profile see "Will Connell: Self-Titled

'Myth'," *U.S. Camera* 24(January 1961): 76-81, 84, 100.

216 *In Pictures: A Hollywood Satire* (New York: T.J. Maloney, Inc., 1937). This contains 48 images by Connell, as well as a fictional narrative by Nunnally Johnson, Patterson McNutt, Gene Fowler, and Grover Jones. This text, which is described in the introduction as "a separate entity," was apparently created for the *Saturday Evening Post*. For Connell's own essay on the creation of this work, see "Depression Island," *Camera Craft* 44(July 1937): 309-15.

217 Nicholas Hàz "Picture Analysis," *American Photography* 31(September 1937): 634.

218 The most useful biographical summary of Lynes's life is James Crump, "Photography as Agency: George Platt Lynes and the Avant-Garde," in *George Platt Lynes: Photographs from the Kinsey Institute* (Boston: Bulfinch Press, 1993), pp. 137-47.

219 For a brief summary of Lynes's early work in photography and his studio tools and techniques, see "George Platt Lynes: Photographer of Fantasy," *Popular Photography* 4(February 1939): 24-25, 166-67.

220 Most interesting in this regard was Laughlin's stated ambition "to create a mythology for our contemporary world." For an extended discussion of this and other aspects of Laughlin's career, see Keith F. Davis, ed., *Clarence John Laughlin: Visionary Photographer* (Kansas City: Hallmark Cards, Inc., 1990).

221 Laughlin's descriptive text for this image reads:
> Made to project my feeling that the form of a pineapple suggests a rocket. Here, the glass dish beneath the pineapple suggests the sphere of force around the rocket, while the pineapple leaves become the rocket blast.

222 This series first bore the title "The Burning Cities of Our Time."

223 Davis, ed., *Clarence John Laughlin: Visionary Photographer*, p. 153. Laughlin writes of this group:
> I tried to create a mythology from our contemporary world. This mythology, instead of having gods and goddesses—has the personifications of our fears and frustrations, our desires and dilemmas. By means of a complex integration of human figures (never presented as individuals, since the figures are intended only as symbols of states of mind), carefully chosen backgrounds, and selected objects, I attempted to project the symbolic reality of our time, so that the pictures become images of the psychological substructure of confusion, want, and fear which have led to the two great world wars, and which may lead to the end of human society...

Laughlin's descriptive caption for *The Unborn* (ibid., p. 162) reads:
> Against a background in which the feeling of barrenness is intensively conveyed, the figure—with her neurotic hand, and emotionally starved face—becomes a symbol of the many women in whom the desire for children has been defeated by conditions within our society. Note how the tiny head suggests both the head of an old man, and that of a child—expressing the unrealized promises of an unborn generation.

224 Brecht wrote: "...less than ever does the mere reflexion of reality reveal anything about reality.... So something must in fact be *built up*, something artificial, posed." Quoted in Walter Benjamin, "A Short History of Photography" (1931), in Mellor, ed., *Germany: The New Photography*, pp. 72-73.

225 For recent surveys of this theme, see, for example, Richard Guy Wilson, Dianne H. Pilgrim, and Dickran Tashjian, *The Machine Age in America 1918-1941* (New York: Harry N. Abrams/Brooklyn Museum, 1986); and Cecelia Tichi, *Shifting Gears: Technology, Literature, Culture in Modernist America* (Chapel Hill: University of North Carolina Press, 1987).

226 Clifton Fadiman, "What Does America Read?" in Fred J. Ringel, *America as Americans See It* (New York: Literary Guild, 1932), p. 77.

227 Louis Lozowick, "The Americanization of Art," *Machine-Age Exposition Catalogue* (New York: The Little Review, 1927), p. 18.

228 For an important, and ambivalent, reading of the role of technology, see Lewis Mumford, *Technics and Civilization* (New York: Harcourt, Brace & World, 1934; repr. 1963). For slightly later studies of this subject, see Siegfried Giedion, *Mechanization Takes Command: a contribution to anonymous history* (Oxford: Oxford University Press, 1948; repr. 1969 by W.W. Norton), and John A. Kouwenhoven, *Made in America* (New York: Doubleday & Co., 1948; repr. 1967 as *The Arts in Modern American Civilization* by W.W. Norton). Kouwenhoven's book is a justly famous celebration of the indigenous, "vernacular" style of American culture and art.

229 On this subject see, for example, Peter Conrad, *The Art of the City: Views and Versions of New York* (Oxford: Oxford University Press, 1984); Merrill Schleier, *The Skyscraper in American Art 1890-1931* (New York: Da Capo Press, 1986); and Anna C. Chave, "'Who Will Paint New York?': 'The World's New Art Center' and the Skyscraper Paintings of Georgia O'Keeffe," *American Art* 5(Winter-Spring, 1991): 87-107.

230 Cited in Lisa M. Steinman, *Made in America: Science, Technology, and American Modernist Poets* (New Haven: Yale University Press, 1987), p. 40.

231 The literature on Williams's work is extensive. However, the following studies provide an introduction to this complex subject: Rick Stewart, "Charles Sheeler, William Carlos Williams, and Precisionism: A Redefinition," *Arts Magazine* 58(November 1983): 100-14; chapter 2 of Steinman, *Made in America*; and Dickran Tashjian, *William Carlos Williams and the American Scene, 1920-1940* (New York: Whitney Museum of Art, 1978).

232 Tichi, *Shifting Gears*, p. xii.

233 Ibid., p. 170.

234 Lozowick, "The Americanization of Art," p. 18. See also Barbara Zabel, "Louis Lozowick and Urban Optimism of the 1920s," *Archives of American Art Journal* 14(1974): 17-21.

235 Steiner's photograph is dated 1921-22, while Strand's images of his motion-picture camera and various machine tools are dated 1922-23.

236 Lewis W. Hine, *Men at Work: Photographic Studies of Modern Men and Machines* (New York: Dover Publications, 1977), n.p. This book was aimed at an adolescent audience.

237 Ibid., n.p.

238 In the article "Treating Labor Artistically" in the *Literary Digest* 67(December 4, 1920): 32, it was noted that Hine

is planning a use for his work that has a combined artistic and sociological significance . . . [The photographs under discussion] are the first of a series of studies which Mr. Hine is planning to make for the purpose of presenting in photographs or lantern slides in the factories themselves, both to the workers and the managers, a picture record of the significance of industrial processes and of the people engaged in them. This is to be done under arrangement with various individual companies, and the experiment has already been tried in some plants.

239 For an early profile of Hoppé see, for example, *Wilson's Photographic Magazine* 46(1909): 300-02.

240 The following discussion is indebted to Bill Jay, "Emil Otto Hoppé, 1878-1972," and Mick Gidley, "Hoppé's Romantic America," both included in *Studies in Visual Communication* 11(Spring 1985): 5-41.

241 This theme is discussed in Gidley, "Hoppé's Romantic America," pp. 26, 28. In his autobiography, Hoppé noted his interest in viewing background subjects through a foreground screen: "I must confess to a strong propensity for making use of steel bridges" for this purpose. Cited in Conrad, *The Art of the City*, p. 242.

242 For an excellent study of this film see Jan-Christopher Horak, "Modernist Perspectives and Romantic Desire: Manhatta," *Afterimage* 15(November 1987): 8-15.

243 Stebbins and Keyes, *Charles Sheeler: The Photographs*, p. 27. For useful background on this project see pp. 24-33 of this volume, as well as S. Fillin-Yeh, "Charles Sheeler: Industry, Fashion, and the Vanguard," *Arts Magazine* 54(February 1980): 154-58; Karen Lucic, "Charles Sheeler and Henry Ford: A Craft Heritage for the Machine Age," *Bulletin of the Detroit Institute of Arts* 65(1989): 37-47; and M. J. Jacob and L. Downs, *The Rouge: The Image of Industry in the Art of Charles Sheeler and Diego Rivera* (Detroit: Detroit Institute of Arts, 1978).

244 These were presented in both fine-art and commercial contexts. For their use in Ford promotion see, for example, Edwin P. Norwood, *Ford Men and Methods* (Garden City, N.Y.: Doubleday, Doran & Co., 1931).

245 Stebbins and Keyes, *Charles Sheeler: The Photographs*, p. 25. Each new Model A was composed of 6,800 different parts (Norwood, *Ford Men and Methods*, p. 25).

246 Rourke, *Charles Sheeler: Artist in the American Tradition*, p. 130. In discussing his work at Chartres, Sheeler observed (p. 130):

Every age manifests itself by some external evidence. In a period such

as ours when only a comparatively few individuals seem to be given to religion, some form other than the Gothic cathedral must be found. Industry concerns the greatest numbers—it may be true, as has been said, that our factories are our substitute for religious expression.

This represents a relatively restrained endorsement of ideas that were widely held at the time. Calvin Coolidge, for example, pronounced that "The man who builds a factory builds a temple. The man who works there worships there." (Cited in Karen Lucic, *Charles Sheeler and the Cult of the Machine* [Cambridge, Mass.: Harvard University Press, 1991], p. 16). See also Henry Ford, "Machinery—The New Messiah," *The Forum* 79(March 1928): 363-64.

247 Jean Bony, *French Gothic Architecture of the 12th and 13th Centuries* (Berkeley: University of California Press, 1983), p. 233.

248 Margaret Bourke-White and Edward Steichen were two of several noted photographers to photograph this bridge. For a capsule biography of Bratter, see Fels, *O Say Can You See*, p. 134. Bratter's purist images were included in several prestigious exhibits of the early 1930s. See, for example, Sterne, "American vs. European Photography," pp. 18, 20.

249 Significantly, the Brooklyn Bridge, which had been completed in 1883, had been "rediscovered" as an aesthetic achievement by this time. See, for example, Alan Trachtenberg, *Brooklyn Bridge: Fact and Symbol* (Chicago: University of Chicago Press, 1979).

250 Kouwenhoven, *The Arts in Modern American Civilization*, p. 206.

251 Note that this was begun as Hoover Dam. It was renamed Boulder Dam in 1933, but reverted to its original name in 1947.

252 For a good introduction to this subject, see Richard Guy Wilson, "Machine-Age Iconography in the American West: The Design of Hoover Dam," *Pacific Historical Review* 54(November 1985): 463-93.

253 Glaha was Chief Photographer, U.S. Bureau of Reclamation. For information on his career see Willard Van Dyke, "The Work of Ben Glaha," *Camera Craft* 42(April 1935): 166-72; and Ben Glaha, "Boulder Dam: The Photography of Engineering Works," *U.S. Camera* 2(January-February 1939): 18-23, 78-79.

254 Glaha, "Boulder Dam," p. 18. In this essay Glaha suggests the challenge he faced in maintaining these aesthetic standards:

I can see no reason why a photograph, even though the reason for its being made is purely utilitarian and it is to receive no distribution beyond the pages of a technical report, should not be as attractive and as technically sound as it is possible to make it. After all, its purpose is to illustrate or to analyze; and it has gone a long way toward meeting this requirement if it is visually lucid and pleasing.

However, I once spent three days crawling around between the steel ribs of a huge gate photographing rivet holes. My ideals of photographic integrity and technical purity were at a low ebb at about the three hundredth hole and were practically nil when the job was over.

255 Van Dyke, "The Work of Ben Glaha," p. 166.

256 A variant of this image was published in the second issue of *Fortune* 1(March 1930): 108.

257 In addition to publishing powerful photographs, *Fortune* also made regular use of artwork by such leading painters as Charles Burchfield, Reginald Marsh, Thomas Hart Benton, Charles Sheeler, and Diego Rivera.

258 For a contemporary satire of *Fortune*'s characteristically upbeat tone, see "Mis-Fortune," *Vanity Fair* 42(March 1934): 22-23, 62.

259 See, for example, "Germany in the Workshop," *Fortune* 2(December 1930): 89-94, 126.

260 The literature of this period provides conflicting accounts of this technique, with the first successful photographs by this process dated between 1884 and 1893. See, for example, "Photographing Projectiles in Flight," *Scientific American* 103(July 10, 1910): 51, 58; and "Shooting Flying Bullets with a Camera," *Scientific American Monthly* 123(October 1920): 147-49.

261 In "Shooting Flying Bullets with a Camera," Bull is reported to have successfully shot footage at the rate of 5,000, 10,000, and even 20,000 frames per second. A later report, "High Frequency Photography for the Analysis of Motion," *Photo-Era* 60(June 1928): 360, stated that his camera worked at a rate of 2,500 frames per second. See also "Practical Kinematography," *Photo-Era* 55(October 1925): 207, for reports of similar research conducted in Great Britain.

262 See Philip P. Quayle, "Photography of Bullets in Flight," *Journal of the Franklin Institute* 193(May 1922): 627-40. Three of these photographs were reproduced in the *Photographic Journal of America* 59(September 1922): 338-39, 344.

263 Capt. S.P. Meek, "Tagging a Bullet on the Wing," *Scientific American* 133(September 1925): 158-59.

264 "High Frequency Photography for the Analysis of Motion," *Photo-Era* 60(June 1928): 360.

265 The numerous articles and books on Edgerton have devoted little attention to the important work done earlier in this field, creating the impression that he "invented" high-speed photography.

266 Stott's *Documentary Expression and Thirties America* (New York: Oxford University Press, 1973) remains the most valuable study of this important subject.

267 Alfred Kazin, *On Native Grounds: An Interpretation of Modern American Prose Literature* (New York: Reynal & Hitchcock, 1942; repr. New York: Harcourt, Brace Jovanovich, 1982), p. 486. The last chapter of this justly celebrated book studies the documentary urge of 1930s America and photography's central role in this movement.

268 For details on this image, see Jack Price, "How Ruth Snyder was Photographed in Electric Chair," *Popular Photography* 3(August 1938): 32; George A. Brandenburg, "Tom Howard Tells Story of Death Chair Picture," *Editor & Publisher* 85(December 27, 1952): 16-17; and John Faber, *Great News Photos and the Stories Behind Them* (New York: Dover Publications, 1978), pp. 44-45. When published on the front page of the January 13, 1928, issue of the New York *Daily News*, Howard's photograph was described as "the most remarkable exclusive picture in the history of criminology" and as "the first Sing Sing execution picture and the first of a woman's electrocution." For details on a similar series by William Vandivert, made in 1935 for the Chicago *Herald-Examiner*, see "William Vandivert: The Unspecialized Specialist," *U.S. Camera* 23(April 1960): 61, 63.

269 Matthew Josephson, "Profiles: Commander with a Camera—I," *New Yorker* 20(June 3, 1944): 26.

270 This was reproduced in the November 1923 issue of *Vanity Fair*.

271 See Maria Morris Hambourg, "Atget, Precursor of Modern Documentary Photography," in David Featherstone, ed., *Observations: Essays on Documentary Photography* (Carmel, Calif.: Friends of Photography, 1984), pp. 24-39.

272 Walker Evans, "The Reappearance of Photography," *Hound and Horn* 5(October/December 1931): 125-28; cited in Hambourg, "Atget, Precursor of Modern Documentary Photography," pp. 35-36.

273 Lincoln Kirstein, "Photography in the United States," Holger Cahill and Alfred H. Barr, Jr., eds., *Art in America in Modern Times* (New York: Museum of Modern Art, 1934; reprinted 1969).

274 For a typically "inventive" description of Brady's war activities, see, for example, the review of Julien Levy's "Retrospective Exhibition of American Photography," *Time* 18(November 16, 1931): 26, 28, 30. The Brady myth today remains remarkably durable both among the general public and—distressingly—among many historians. While he was clearly a great portraitist, and one of several influential figures in the larger sponsorship of Civil War photography, little is actually known of Brady's role in making Civil War photographs or in personally directing their production. Clear documentation of his activity is sorely needed. Until this is achieved, however, his continued invocation as the generic author of Civil War photography only delays serious analysis of the subject. The protean "Mathew Brady" of myth lends an utterly false sense of unity to what was, in fact, a richly multifaceted endeavor. For this writer's attempts at an understanding of this mammoth subject, see Keith F. Davis, *George N. Barnard: Photographer of Sherman's Campaign* (Kansas City: Hallmark Cards, Inc., 1990), and "'A Terrible Distinctness': Photography of the Civil War Era," in Martha A. Sandweiss, ed., *Photography in Nineteenth-Century America* (New York: Harry N. Abrams/Amon Carter Museum, 1991), pp. 131-79.

275 For an excellent summary of this subject, see the first chapter of William Alexander, *Film on the Left: American Documentary Film from 1931 to 1942* (Princeton: Princeton University Press, 1981). Also valuable is Leah Ollman's *Camera as Weapon: Worker Photography between the Wars* (San Diego: Museum of Photographic Arts, 1991).

276 Elizabeth McCausland, "Documentary Photography," *Photo Notes* (January 1939):6. Information on the Photo League is drawn largely from the following sources: Anne Tucker, "Photographic Crossroads: The Photo League," special supplement to *Afterimage* 5(April 1978): n.p.; Anne Tucker, "Aaron Siskind and the Photo League: A Partial History," *Afterimage* 9(May 1982): 4-5; *Creative Camera*, no. 223-224 (July/August 1983), a double issue dedicated primarily to the Photo League, with an essay by Anne Tucker; Carl Chiarenza, *Aaron Siskind: Pleasures and Terrors* (Boston: New York Graphic Society, 1982), particularly chapters 2 and 3; and Louis Stettner, "Cézanne's Apples and the Photo League," *Aperture*, no. 112(Fall 1988): 14-35.

277 Stettner, "Cézanne's Apples and the Photo League," p. 14.

278 From McCausland's lecture "Documentary Photography," reprinted in Susan Dodge Peters, "Elizabeth McCausland on Photography," *Afterimage* 12(May 1985): 10-15.

279 See Stott, *Documentary Expression and Thirties America*, pp. 92-118. For a study of one aspect of the American Guide Series, see Christine Bold, "The View From the Road: Katharine Kellock's New Deal Guidebooks," *American Studies* 29(Fall 1988): 5-29.

280 Elizabeth McCausland, "The Photography of Berenice Abbott," *Trend* 3(March-April, 1935): 16; quoted in Michael G. Sundell, *Berenice Abbott: Documentary Photographs of the 1930s* (Cleveland: The New Gallery of Contemporary Art, 1980), p. 3.

281 The "Changing New York" stamps on the back of each print indicate the exact date of exposure—November 19, 1935, and April 14, 1937, respectively.

282 Abbott, *New York in the Thirties*, p. 52.

283 Aaron Siskind also photographed this wrapped statue. See Chiarenza, *Aaron Siskind: Pleasures and Terrors*, pp. 26-27.

284 For an outline of some of these varied agencies, see Pete Daniel et al., *Official Images: New Deal Photography* (Washington, D.C.: Smithsonian Institution Press, 1987).

285 On the film careers of Steiner and Strand, see, for example, Scott Hammen, "Ralph Steiner's 'H₂O': simple significance, abstract beauty," *Afterimage* 7(Summer 1979): 10-11; and William Alexander, "Paul Strand as Filmmaker, 1933-1942," in Stange, ed., *Paul Strand: Essays on His Life and Work*, pp. 148-60.

286 For a useful study of the early years of their professional relationship, see Maren Stange, "The Management of Vision: Rexford Tugwell and Roy Stryker in the 1920s," *Afterimage* 15(March 1988): 5-10.

287 Maren Stange, "Documentary Photography in American Social Reform Movements: The FSA Project and its Predecessors," *Multiple Views: Logan Grant Essays on Photography, 1983-89* (Albuquerque: University of New Mexico Press, 1991), pp. 207, 218.

288 Cited in Alan Trachtenberg, "From Image to Story: Reading the File," in Carl Fleischhauer and Beverly W. Brannan, eds., *Documenting America, 1935-1943* (Berkeley: University of California Press, 1988), p. 58.

289 For a good summary of Stryker's own conception of this process, see Rosa Reilly, "Photographing the America of Today," *Popular Photography* 3(November 1938): 10-11, 76-77.

290 Hank O'Neal's *A Vision Shared: A Classic Portrait of America and Its People, 1935-1943* (New York: St. Martin's Press, 1976) contains the clearest outline of these comings and goings, as well as brief biographies of each photographer.

291 Edwin Rosskam, "Not Intended for Framing: The FSA File," *Afterimage* 8(March 1981): 9-11.

292 This relationship is discussed in some depth in Laura Katzman, "The Politics of Media: Painting and Photography in the Art of Ben Shahn," *American Art* 7(Winter 1993): 61-87.

293 Ibid., p. 67.

294 Shahn frequently cropped his photographs in varying ways. See, for example, the significantly different croppings of this image included in Davis Pratt, *The Photographic Eye of Ben Shahn* (Cambridge: Harvard University Press, 1975), and Margaret R. Weiss, *Ben Shahn, Photographer: An Album from the Thirties* (New York: Da Capo Press, 1973).

295 Leslie Katz, "Interview with Walker Evans," *Art in America* 59(March/April 1971): 84.

296 The work of Steiner's that probably most influenced Evans was published in "Vanishing Backyards," *Fortune* 1(May 1930): 78-79.

297 The quality of Brewer's work, and the nature of his impact on Evans's career, make him a significant figure in the history of American photography. Brewer apparently took up photography in the 1910s, perhaps at the time of his service in World War I. With his wife, Jane Beach Evans Brewer, he lived in Spain in 1930-31 before returning to the U.S. to reside in Ossining, New York. At the personal request of Harry Hopkins, the New Deal's relief director, Brewer worked for the Resettlement Administration/Farm Security Administration from 1935 to 1942, ultimately serving as the top administrator in the agency's Qualification Section, Personnel. Brewer's role in the hiring of his brother-in-law can, at this point, only be guessed. Other aspects of this relationship merit attention. It is clear, for example, that some of Brewer's photographs were in Evans's possession at the time of the latter's death in 1975. It appears that at least some of them (those not signed or stamped by Brewer) subsequently entered the marketplace as the work of Evans. This seems particularly true of Brewer's Spanish pictures, which were misidentified as part of Evans's work in Cuba. My thanks to George Rinhart for bringing this important body of work to my attention, and for biographical data on Brewer.

298 For a good study of this theme, see Diana Emery Hulick, "Walker Evans and Folk Art," *History of Photography* 17(Summer 1993): 139-46.

299 Katz, "Interview with Walker Evans," p. 87.

300 Kirstein reproduced Evans's early work in *Hound and Horn*, commissioned him to photograph Victorian houses outside Boston in 1930-31, and arranged a one-man show of these architectural pictures at the Museum of Modern Art in 1933. Kirstein also played an important role in Evans's 1938 retrospective and the accompanying book *American Photographs*. Douglas R. Nickel's "American Photographs Revisited," *American Art* 6(Spring 1992): 79-97, provides a provocative, if less than convincing, analysis of the relationship between Evans and Kirstein.

301 Lionel Trilling, "Books: Greatness with One Fault in It," *Kenyon Review* 4(Winter 1942): 100.

302 Lincoln Kirstein, "Photographs of America: Walker Evans," in *American Photographs* (1938; repr. New York: East River Press, 1975), p. 191.

303 William Carlos Williams, "Sermon with a Camera," *New Republic* 96(October 12, 1938): 283.

304 Evans was "loaned" to the *Fortune* project by Stryker with the understanding that his negatives would become part of the RA files.

305 For a thoughtful review of the first edition, see Trilling, "Books: Greatness with One Flaw in It," pp. 99-102.

306 This exhibition received wide attention and critical praise, solidifying Evans's position as one of the nation's most respected artistic photographers. See, for example, *Time* 32(October 3, 1938): 43.

307 *American Photographs*, p. 192.

308 For critical contemporary views of this book see, for example, S.T. Williamson, "American Photographs by Walker Evans," *New York Times Book Review* (November 27, 1938): 6; and Mary Street Alinder and Andrea Gray Stillman, *Ansel Adams: Letters and Images 1916-1984* (Boston: New York Graphic Society, 1988), p. 109. For an eloquent interpretation of *American Photographs*, see Alan Trachtenberg, *Reading American Photographs: Images as History, Mathew Brady to Walker Evans* (New York: Hill and Wang, 1989), pp. 231-85.

309 Cited in Milton Meltzer, *Dorothea Lange: A Photographic Life* (New York: Farrar, Straus Giroux, 1978), p. 6.

310 See, for example, Carmen Ballen, "The Art of Dorothea Lange," *Overland Monthly* 74(December 1919): 405-08.

311 Willard Van Dyke, "The Photographs of Dorothea Lange—A Critical Analysis," *Camera Craft* 41(October 1934): 461-67.

312 Richard Steven Street, "Paul S. Taylor and the Origins of Documentary Photography in California, 1927-1934," *History of Photography*, 7(October-December 1983): 293-304.

313 For studies of this and other collaborative works of the 1930s, see Jefferson Hunter, *Image and Word: The Interaction of Twentieth-Century Photographs and Texts* (Cambridge, Mass.: Harvard University Press, 1981); and Carol Shloss, *Invisible Light: Photography and the American Writer, 1840-1940* (New York: Oxford University Press, 1987).

314 For the argument on whether this photograph was, in fact, completely posed, see James C. Curtis, *Mind's Eye, Mind's Truth: FSA Photography Reconsidered* (Philadelphia: Temple University Press, 1989), pp. 76-89, and his endnotes to this chapter, particularly numbers 16 and 25. As Curtis observes, Rothstein's vintage prints from this negative tend to be relatively light in tone, while later prints are considerably darker.

315 Curtis, *Mind's Eye, Mind's Truth*, p. 67. For Lange's own reminiscence of this photograph see "The Assignment I'll Never Forget," *Popular Photography* 46(February 1960): 42, 126; repr. in Newhall, ed., *Photography: Essays & Images*, pp. 263-64.

316 Curtis, *Mind's Eye, Mind's Truth*, pp. 34-44.

317 The following discussion is derived in part from Glenn A. Matthews, "Photography Goes Forward—A Review of A Decade of Progress," *American Annual of Photography 1940*, pp. 7-26.

318 For a good early article on the Leica see "The Small Movie-Film Cameras," *Photo-Era* 60(June 1928): 326-33. The author of this essay, C.T. Chapman, mentions a less-known precursor of the Leica that produced images in the half-frame size: "About two years ago the Agfa Ansco Corporation brought out the Memo Camera, which used standard film and made fifty pictures of single-frame movie size to the roll."

319 Nelson was an associate of Edward Steichen's at Condé Nast Publications. For data on his career, see Steichen's essay, "The Lusha Nelson Photographs of Alfred Stieglitz," *U.S. Camera* 3(February/March 1940): 16-19; and Mrs. Lusha Nelson, "Lusha Nelson: The Life of an American Photographer," *U.S. Camera 1941*, vol. I, pp. 117-128, 253.

320 The latter, first issued in 1931, was published as a special autumn issue of *The Studio* (London).

321 Jack Price, "Let's Take a Look at Life," *Popular Photography* 1(September 1937): 10-14, 78.

322 Ibid., p. 13. Of the 12,800 pictures sent to *Life* in a typical week in 1937, only 800 were made by its own staff photographers. In addition, 5,000 were derived from the four leading picture syndicates, 1,200 from smaller agencies and free-lancers, and 5,000 from amateurs. Undoubtedly, however, a disproportionately high percentage of the photographs produced by *Life's* staffers were actually used in the magazine. For a brief overview of the operation of the Acme News Service, see Gray Strider, "The Inside Workings of a National News Service," *Popular Photography* 1(July 1937): 16-17, 80-81.

323 For a brief history of this technology, see Marianne Fulton, "Bearing Witness: The 1930s to the 1950s," in Fulton, ed., *Eyes of Time: Photojournalism in America* (Boston: New York Graphic Society, 1988), pp. 108-14.

324 For background on Maloney, see Harvey V. Fondiller, "Tom Maloney and U.S. Camera," *Camera Arts* 1(July/August 1981): 16-23, 106.

325 The difference in viewpoint between Maloney's and Fraprie's publications is suggested by the latter's review of the 1940 U.S. Camera Annual (in *American Photography* 34[1940]: 148-49), which reads in part:

As usual, the pictures are for the most part startlingly objective, with the squalid and the wretched much in evidence ... It's outlook is typically that of New York, and must give the rest of the country, the world, and coming generations the impression that we are a wretched but hectic race. The dreamers, the home bodies, the quietly contented, the people who see a preponderance of good and beauty around them, of whom there must still be a few left in the United States, are but sparingly represented.

326 The most interesting of these articles were profiles of leading photographers, and analyses of individual pictures. Ház had a one-man exhibition at the Brooklyn Institute as early as 1925 (see *The Camera* 30[June 1925]: 329-30). For an amusing early profile of Ház, see *Camera Craft* 35(January 1928): 3-9. For a succinct expression of Ház's attitude toward the medium, see his "Modern Photography," *Camera Craft* 44(May 1937): 212-20.

327 Compare, for example, Taft's "M.B. Brady and the Daguerreotype Era," *American Photography* 29(August 1935): 486-98, and (September 1935): 548-60, or his "John Plumbe: America's First Nationally Known Photographer," *American Photography* 30(January 1936): 1-12, with earlier essays such as C.J. Greenleaf, "Brady—The Civil War Photographer," *Photo-Era* 64(1930): 13-16, or Harriet E. Alverson, "A News Photographer of the Civil War," *Camera Craft* 39(November 1932): 456-60.

328 For a brief discussion of Newhall's history, see Mary Warner Marien, "What Shall We Tell The Children? Photography And Its Text (Books)," *Afterimage* (April 1986): 4-7.

329 The following data is derived in part from Maria Morris Hambourg, "From 291 to the Museum of Modern Art: Photography in New York, 1910-1937," in Hambourg and Phillips, *The New Vision*, and the essay and appendix of David Travis's *Photographs from the Julien Levy Collection Starting With Atget* (Chicago: The Art Institute of Chicago, 1976).

330 This show subsequently traveled to the Wadsworth Atheneum in Hartford and the John Becker Gallery in New York.

331 The Museum acquired ten Stieglitz prints from this exhibition. My thanks to Tom Hinson, Curator of Contemporary Art at the Cleveland Art Museum, for data on this show.

332 In addition to the Travis catalogue cited above, see Levy's reminiscence *Memoirs of an Art Gallery* (New York: G.P. Putnam's Sons, 1977).

333 For a discussion of this shift, and of Newhall's overall tenure at the Museum of Modern Art, see Christopher Phillips, "The Judgment Seat of Photography," *October*, no. 22(Fall 1982): 27-63. For Newhall's own recollection of this exhibition, see his *Focus: Memoirs of a Life in Photography* (Boston: Bulfinch Press, 1993), pp. 39-53.

334 On the latter, see, for example, F. Anthony Saunders, "50,000 People Saw the Show," *Popular Photography* 2(February 1938): 17-19, 88-89.

335 The adoption of modernist traits by commercial photographers was, at least in part, a result of their awareness of the international nature of their market. For a valuable essay on this subject (with illustrations of his own work), see Fred G. Korth, "Free-Lancing for European Magazines," *American Photography* 28(May 1934): 305-09. See also William Stosahl, "Surrealism in Photography," *Popular Photography* 4(June 1939): 16-17, 82-83. Stosahl was the Art Director of the J. Walter Thompson Company.

336 *Fortune* 2(July 1930): 81.

337 This summary is indebted to Robert Sobieszek's essay "Edward Quigley and the Modernist Context," in *Edward Quigley: American Modernist* (New York: Houk Friedman Gallery, 1991), and to his book *The Art of Persuasion*.

CHAPTER III **From Public to Private Concerns 1940-1965**

1 Useful cultural and historical overviews of this period include William Graebner, *The Age of Doubt: American Thought and Culture in the 1940s* (Boston: Twayne Publishers, 1991); John Patrick Diggins, *The Proud Decades: America in War and Peace, 1941-1960* (New York: W. W. Norton & Company, 1988); Lary May, ed., *Recasting America: Culture and Politics in the Age of Cold War* (Chicago: University of Chicago Press, 1989); David Halberstam, *The Fifties* (New York: Fawcett Columbine, 1993); J. Ronald Oakley, *God's Country: America in the Fifties* (New York: Dembner Books, 1986); and David Farber, *The Age of Great Dreams: America in the 1960s* (New York: Farrar, Straus and Giroux, 1994).

2 See, for example, Norman Cousins, "Modern Man is Obsolete," *Saturday Review* 28(August 18, 1945): 5-9; and Sidney B. Fay, "The Idea of Progress," *American Historical Review* 52(January 1947): 231-46.

3 Christopher Phillips, "The Judgment Seat of Photography," *October* no. 22(Fall 1982): 35-36.

4 "From the Birdie's Nest," *Time* 37(January 6, 1941): 32. See also, H. I. Brock, "Is Photography an Art?," *New York Times Magazine* (February 16, 1941): 14-15, 26, which used news of the new department to reopen the "old controversy" over photography's artistic status.

5 Other members included Walter Clark, Laurence S. Rockefeller, James T. Soby, John E. Abbott, and Alfred H. Barr. For Newhall's own reminiscence, see his *Focus: Memoirs of a Life in Photography* (Boston: Bulfinch Press, 1993), pp. 64-66.

6 In a process of discovery that seems destined to endless repetition, it was reported that "surprised visitors found that some of photography's finest workmanship was very old stuff." *Time* 37(January 6, 1941): 32.

7 Robert W. Brown, "Photos Join Paintings in Museum of Modern Art," *Popular Photography* 8(February 1941): 38, 110.

8 The following discussion is indebted to Christopher Phillips's observations in "The Judgment Seat of Photography."

9 See Beaumont Newhall, "Photography as a Branch of Art History," *College Art Journal* 1(May 1942): 86-90.

10 For his own account of these years, see Newhall, *Focus*, pp. 71-97.

11 This fascinating collection was given to the George Eastman House in 1977. For articles on its origins, see Robert A. Sobieszek, "An American Century of Photography: 1840-1940: Selections from the Sipley/3M collection," and David Vestal, "Louis Walton Sipley," both in *Camera* 57(June 1978): 4, 9-10, 19-20, 29, 30, 39-40.

12 *New York Times* (October 12, 1941): sec. 10, p. 5. This article reveals that these prints were acquired by the American Museum after being discovered in storage "at Memorial Hall in the Philadelphia Museum of Art."

13 For a profile of Boyer, see Rachel Stuhlman, "'It Isn't Sanity, But It Sure Is Fun,'" *Image* 34(Spring/Summer 1991): 22-28.

14 Five of these received two fellowships, while Morris (1942, 1946, 1954) and Adams (1946, 1948, 1959) each received three. For contemporary articles on these awards, see, for example, Arthur J. Busch, "Fellowships for Photographers," *Popular Photography* 12(February 1943): 22-23, 82-83; and "U. S. Camera Contributors win Guggenheim Awards," *U.S. Camera* 9(June 1946): 15-17.

15 *U.S. Camera Annual 1944*, p. 6.

16 See, for example, Sally J. Davis, "WAAC Photographers," *Popular Photography* 12(May 1943): 32-33, 92, for a description of one of the smaller photographic units.

17 Ben Schnall, "Fort Monmouth—Signal Corps' Number 1 Photo School," *U.S. Camera* 4(September 1941): 29-31.

18 On the latter, see Victor Keppler, "The Yank is Coming," *U.S. Camera* 5(September 1942): 26-27.

19 For a brief summary of aerial photography, see Jack Hamilton, "The Rise of American Aerial Photography," *American Photography* 38 December 1944): 20-23.

20 For a study of this unit, see Christopher Phillips, *Steichen at War* (New York: Harry N. Abrams, 1981).

21 Quoted in Susan D. Moeller, *Shooting War: Photography and the American Experience in Combat* (New York: Basic Books), p. 216.

22 See Bruce Downes, "Camera Over the Pacific," *Popular Photography* 13(November 1943): 19-23, 81-83.

23 See "Vandivert's England," *U.S. Camera* 5(June 1942): 17-24, 64-65.

24 This is described in some detail in her book *Shooting the Russian War* (New York: Simon and Schuster, 1942), particularly p. 123.

25 Bourke-White's war experience is detailed in her books *Shooting the Russian War* (1942), *Purple Heart Valley* (1944), *Dear Fatherland, Rest Quietly* (1946), and *Portrait of Myself* (1963).

26 Moeller, *Shooting War*, pp. 182-83.

27 For a contemporary perspective on this process, see Rowland Carter, "Censored!" *Popular Photography* 10(April 1942): 24-25, 99-101.

28 The propagandistic function of photography was widely understood. See, for example, Vernon Pope, "Manufacturing War Propaganda with Photographs," *Popular Photography* 5(December 1939): 20-21, 173-74; and "Photo Cartoonist Flays Nazi Regime," *U.S. Camera* 4(July 1941): 36-37, on the work of John Heartfield.

29 Moeller, *Shooting War*, p. 183.

30 See, for example, Peter Martin, "The Kid Who Lives Photography," *Popular Photography* 13(July 1943): 19-22, 90-91.

31 Eliot Elisofen, "War Photography," *U.S. Camera Annual 1944*, p. 266.

32 For varying summaries of the story and impact of this image, see Moeller, *Shooting War*, pp. 244-46; Marianne Fulton, ed., *Eyes of Time: Photojournalism in America* (Boston: New York Graphic Society, 1988), pp. 160-61; and Vicki Goldberg, *The Power of Photography: How Photographs Changed Our Lives* (New York: Abbeville, 1991), pp. 142-43.

33 *Life* 18(March 26, 1945):17-18; quoted in Goldberg, *The Power of*

Photography, p. 142. Goldberg notes that "this may be the most widely reproduced and re-created photograph in history: 3,500,000 posters of the image were printed for the Seventh War Loan drive, 15,000 outdoor panels and 175,000 car cards were published, and the photograph was reproduced on an issue of three-cent stamps" (p. 143).

34 Frank R. Fraprie, "The Editor's Point of View," *American Photography* 39(July 1945): 7.

35 For a suggestion of Kerlee's technical sophistication, see Wick Evans, "Charles Kerlee, Photo-Perfectionist," *Popular Photography* 4(March 1939): 10-11, 98-100; and Kerlee's article "Pictures with a Purpose," *U.S. Camera* 4(July 1941): 49-63.

36 "Patterns for Victory," *Popular Photography* 10(April 1942): 22-23.

37 Born in Berlin, Gehr began photographing as a teenager. He worked in the German film industry in the early 1930s, and then as a photojournalist in Cairo for the *New York Times*. Gehr came to the United States in 1937, and was employed by *Life* for twelve years, from 1939 to 1950. He then returned to work in film and, for professional reasons, changed his name to Edmund Bert Gerard. My thanks to Mrs. Hermine Gerard and George Rinhart for information on Gehr's life and work.

38 Ellen G. Landau, "'A Certain Rightness': Artists for Victory's 'America in the War' Exhibition of 1943," *Arts Magazine* 60(February 1986): 43-54.

39 "Road to Victory," *U.S. Camera* 5(July 1942): 17-18. For a good study of this exhibition, see Christopher Phillips, "Steichen's *Road to Victory*," *Exposure* 18:2(1981): 38-48.

40 *Life* 18(May 7, 1945): 34.

41 While more eloquently stated, Susan Sontag's memory of these images may be indicative of the reaction of many of the time:

One's first encounter with the photographic inventory of ultimate horror is a kind of revelation, the prototypically modern revelation: a negative epiphany. For me, it was photographs of Bergen-Belsen and Dachau which I came across by chance in a bookstore in Santa Monica in July 1945. Nothing I have seen—in photographs or real life—ever cut me as sharply, deeply, instantaneously. Indeed, it seems plausible to me to divide my life into two parts, before I saw those photographs (I was twelve) and after.... When I looked at those photographs, something broke. Some limit had been reached, and not only that of horror; I felt irrevocably grieved, wounded, but a part of my feelings started to tighten; something went dead; something is still crying.

Sontag, *On Photography* (New York: Farrar, Straus and Giroux, 1977), pp. 19-20.

42 This difference reflected, in part, a much looser system of censorship than had been in effect in World War II. It was observed early in the conflict that "censorship was left largely to the discretion of the publications and the men who filed the pictures and stories themselves—an unusual circumstance dictated by the unusual nature of the 'war' in which we had become involved." "Life's Photo Coverage in Korea," *U.S. Camera* 13(October 1950): 31.

43 Bruce Downes, "Assignment: Korea," *Popular Photography* 28 (March 1951): 45.

44 Carol DiGrappa, ed., *Landscape: Theory* (New York: Lustrum Press, 1980): 97.

45 See, for example, "Pictures and the Art Center," *Popular Photography* 18(June 1946): 58-59, 144. After teaching at the Art Center in the spring of 1940, Adams organized the first U. S. Camera Yosemite Photographic Forum in the summer of that year, with such faculty members as Weston, Kerlee, and Lange. For a notice of this summer workshop, see *Camera Craft* 47(June 1940): 310.

46 See "Photography is a Major," *U.S. Camera* 11(August 1948): 16-17.

47 See Van Deren Coke, "The Art of Photography in College Teaching," *College Art Journal* 19(Summer 1960): 332-42. By this time, some 400 institutions in all offered photographic courses of some type. See *A Survey of Photographic Instruction* (Rochester, N.Y.: Eastman Kodak Company, 1960): 2.

48 Much of the following discussion is drawn from John Grimes, "The New Vision in the New World," and Charles Traub, "Photographic Education Comes of Age," in Traub, ed., *The New Vision: Forty Years of Photography at the Institute of Design* (Millerton, N.Y.:

Aperture, 1981). See also Stephen Prokopoff, *The New Spirit in American Photography* (Champaign-Urbana, Ill.: Krannert Art Museum, 1985).

49 Quoted in Al Bernsohn and DeVera Bernsohn, "Moholy-Nagy: Iconoclast," *Camera Craft* 46(August 1939): 358.

50 The school's reopening was financed by Moholy-Nagy, with backing from Walter Paepcke, chairman of the Container Corporation of America, and his wife. In 1944 the name of the school changed yet again, to the Institute of Design. In 1949 it became part of the Illinois Institute of Technology.

51 See, for example, Bernsohn and Bernsohn, "Moholy-Nagy Iconoclast," and Moholy-Nagy's own article "Making Photographs Without a Camera," *Popular Photography* 5(December 1939): 30-31, 167-69.

52 Moholy-Nagy, "Making Photographs Without a Camera," p. 169.

53 See Kepes's article, "Modern Design! with Light and Camera," *Popular Photography* 10(February 1942): 24-25, 100-01.

54 Traub, ed., *The New Vision*, p. 73.

55 A list of master's degree recipients from 1952 to 1981 is given in ibid., pp. 74-75.

56 For example, see Bernard Rosenberg and David Manning White, *Mass Culture: The Popular Arts in America* (New York: The Free Press, 1957).

57 For a useful discussion of this concept, see Philip Gleason, "Identifying Identity: A Semantic History," *Journal of American History* 69(March 1983): 910-31.

58 "A Life Round Table on the Pursuit of Happiness," *Life* 25(July 12, 1948): 97.

59 See Eric and Mary Josephson, eds., *Man Alone: Alienation in Modern Society* (New York: Dell Publishing Company, 1962).

60 Lionel Trilling, *Sincerity and Authenticity* (Cambridge, Mass.: Harvard University Press, 1971). For a more detailed study of these issues, see also Richard Sennett, *The Fall of Public Man: On the Social Psychology of Capitalism* (New York: Vintage Books, 1974).

61 From a survey by the Eastman Kodak Company, cited in the *New York Times*, September 24, 1950.

62 In "Amazing Pictures of the Beginning of Human Life," *U.S. Camera* 9(August 1946): 13, it was reported that Chester F. Reather had been making photomicrographs of human embryos for twenty-four years. *U.S. Camera* annuals for both 1950 and 1951 reported on the 200-inch Hale telescope on Mt. Palomar.

63 "World's Most Photographed Event," *U.S. Camera* 9(September 1946): 21-23

64 Duane Featherstonhaugh, "Photography—Propaganda or Art," *American Photography* 41(June 1947): 13.

65 Stanley Kalish and Arthur A. Goldsmith, Jr., "Photography Fights Communism," *Popular Photography* 29(October 1951): 40-45, 126.

66 The best biographical outline of Telberg's life is included in Van Deren Coke, *Val Telberg* (San Francisco: San Francisco Museum of Modern Art, 1983). For early surveys of his life and work, see "Art and the Subconscious: The Multi-Negative Photography of Vladimir Telberg-von-Teleheim," *American Artist* (January 1949): 42-43, 60-61; "The Work of Kathleen and Vladimir Telberg-von-Teleheim," *American Photography* 44(October 1950): 12-17; "Val Telberg: A Portfolio," *American Photography* 47(May 1953): 41-47; and Val Telberg, "Composite Photography," *American Artist* (February 1954): 46-47

67 "Art and the Subconscious," p. 60.

68 In the 1951 *U.S. Camera Annual* (p. 280), Jacobi wrote of these images,

After long photographic experience, I was convinced that the range of photographic media was more vast than commonly assumed. Therefore, a few years ago I asked my old painter friend, Leo Katz, who Stieglitz called "the greatest theorist in photography," to give me a summer course in my field. These pictures are the result of many years of experimentation stimulated by some of Mr. Katz's theories.

Jacobi's light abstractions were shown at least as early as the 1948 "In and Out of Focus" exhibition at the Museum of Modern Art.

69 For useful studies of Sommer's life and work, see the works listed in the bibliography, as well as Lanier Graham, "The Art of Frederick Sommer," *Image* 33(Winter 1990-91): 31-33, 43-52; and David L. Jacobs, "Frederick Sommer: A Portrait of Prisms," *Afterimage* 16 October 1988): 14-16.

70 It is significant that the overall structure of these photographs predated the first similarly composed works by Abstract Expressionist painters by several years. Max Ernst selected several of Sommer's pictures for publication in 1944 in the noted Surrealist journal *VVV*. It is unclear, however, what specific impact this work may have had on painters like Arshile Gorky or Jackson Pollock.

71 In addition to the monographs listed in the bibliography, see also John Pultz, "Harry Callahan: The Creation and Representation of an Integrated Life," *History of Photography* 15(Autumn 1991): 222-27, for a perspective on Callahan's early influences and themes.

72 See, for example, Callahan's first published article, "An Adventure in Photography," *Minicam Photography* 9(February 1946): 28-29. For an early profile of the photographer, see Tom Maloney, "The Callahan Story," *U.S. Camera* 11(November 1948): 48-50.

73 See Diana Edkins's "Chronology," in John Szarkowski, *Callahan* (New York: Museum of Modern Art/Aperture, 1976).

74 "One in a Thousand," *Newsweek* 46(May 7, 1951): 48.

75 Carl Chiarenza, *Aaron Siskind: Pleasures and Terrors* (Boston: New York Graphic Society, 1982), p. 48.

76 Aaron Siskind, "The Drama of Objects," *Minicam Photography* 8(June 1945): 20-23, 93-94. This essay is reprinted in Chiarenza, *Aaron Siskind: Pleasures and Terrors*, pp. 65-66, and (in slightly abbreviated form) in Nathan Lyons, ed., *Photographers on Photography* (Englewood Cliffs, N.J.: Prentice-Hall, 1966), pp. 96-98. For a later recollection of this turning point in his career, see Siskind's essay "In 1943 and 1944 a Great Change Took Place," in Newhall, ed., *Photography: Essays & Images* (New York: Museum of Modern Art, 1980), pp. 305-06.

77 These photographs, in particular, suggest the general connection of Siskind's work to the ideas of Existentialism. One of the most important Existentialist texts, Albert Camus's *The Myth of Sisyphus* (1942), suggested that the fate of modern man was similar to that of Sisyphus, who, in legend, was doomed for eternity by the gods to pushing a large rock to the top of a mountain. Camus felt that Sisyphus's task was absurd and tragic, but also monumental and heroic, observing that "Each atom of that stone, each mineral flake of that night-filled mountain, in itself forms a world." Cited in Richard Ellman and Charles Feidelson, Jr., *The Modern Tradition: Backgrounds of Modern Literature* (New York: Oxford University Press, 1965), p. 852.

78 Most of these images were made in 1953-54, but the date of the work included in this volume indicates that Siskind worked intermittently on this theme through at least 1961. The earliest reproduction of these pictures appears to have been in "'The essential photographic act..,'" *Art News* 54(December 1955): 36-37, which presented nine of them arrayed dramatically across a double spread.

79 Siskind had shows at the Egan Gallery in 1947, 1948, 1949, 1951, and 1954.

80 Compare Siskind's writings with those of the leading Abstract Expressionists, as collected, for example, in Herschel B. Chipp, ed., *Theories of Modern Art* (Berkeley: University of California Press, 1968), pp. 536-77

81 A few of these complex relationships are suggested in Thomas B. Hess's introduction to *Places: Aaron Siskind Photographs* (New York: Light Gallery/Farrar, Straus and Giroux, 1976). It is also interesting to note that elements of Siskind's 1945 essay, "The Drama of Objects," are echoed in numerous later statements by painters. In 1947, for example, Mark Rothko wrote, "I think of my pictures as dramas; the shapes in the pictures are the performers." Rothko, "The Romantics Were Prompted" (1947) in Chipp, ed., *Theories of Modern Art*, p. 549.

82 Valuable insights into White's teaching methodology and ideas in this period are provided by his articles published in *American Photography* in 1951. These begin with "Your Concepts Are Showing," *American Photography* 45(May 1951): 290-97.

83 James Baker Hall, *Minor White: Rites & Passages* (Millerton, N.Y.: Aperture, 1978), p. 39.

84 See "Selected Books from Minor White's Library," in ibid., pp. 139-41. For a short study of one of these topics, see Arnold Gassan, *Hypnosis & Minor White* (Athens, Oh.: Arnold Gassan, 1982).

85 Jonathan Green, *American Photography: A Critical History 1945 to the Present* (New York: Harry N. Abrams, 1984), p. 58.

86 Cited in Peter C. Bunnell, *Minor White: The Eye That Shapes* (Princeton, N.J.: Princeton University Art Museum, 1989), p. 19.

87 White, "Your Concepts Are Showing," p. 297.

88 Minor White, *Mirrors Messages Manifestations* (New York: Aperture, 1969), p. 63. This is a slightly modified version of a statement from 1950 (as cited in Bunnell, *The Eye That Shapes*, p. 231).

89 Ibid., pp. 42-47, 227, and 237. The version of this sequence in the Hallmark Photographic Collection was made ca. 1963, includes thirteen images, and varies significantly in structure from the sequence (dated 1960) reproduced in *Mirrors Messages Manifestations*. To a slightly lesser degree, White also exercised considerable freedom in the interpretation of single images. For example, *Warehouse Area, San Francisco*, 1949, was also presented by White as both a reversed image (Bunnell, *The Eye That Shapes*, plate 33), and in tightly cropped form (White, *Mirrors Messages Manifestations*, p. 6).

90 Cited in Green, *American Photography*, p. 71.

91 For example, Nathan Lyons, Syl Labrot, and Walter Chappell, *Under the Sun: The Abstract Art of Camera Vision* (New York: George Braziller, 1960; repr. Aperture, 1972).

92 A good summary of this activity is included in Green, *American Photography*, pp. 75-79.

93 For a reminiscence on *Aperture's* history by current editor Michael E. Hoffman, see his "Forty Years After," *Aperture*, no. 129(Fall 1992): 80-96.

94 For an early profile of Weegee, see Rosa Reilly, "Free-Lance Cameraman," *Popular Photography* 1(December 1937): 22.

95 *Weegee by Weegee: An Autobiography* (New York: Ziff-Davis Publishing Company, 1961), p. 37.

96 Ibid., pp. 21-23, 76-78.

97 Miles Orvell, "Weegee's Voyeurism and the Mastery of Urban Disorder," *American Art* 6(Winter 1992): 27.

98 There has been some confusion over the date of this image. Weegee photographed this subject sometime prior to 1945 (the publication date of *Naked City*) and then again in 1952. The photograph reproduced here was included (in a tighter cropping) in *Naked City*. A date of ca. 1943 has been given to reflect the popularity of this circus act by that time. For a similar rendition of this subject by the photographer Clyde Hodges, see "Speedlite Stops a Human Projectile," *Popular Photography* 13(July 1943): 51.

99 Aaron Sussman, "The Little Man Who's Always There," *Saturday Review* 28(July 28, 1945): 17. For a more recent analysis of *Naked City*, see Orvell, "Weegee's Voyeurism," pp. 19-41. *Naked City* contains many of Weegee's best-known images, including the two cited above; they were, however, more tightly cropped than the prints in the Hallmark Photographic Collection.

100 "Speaking of Pictures...Weegee Shows How to Photograph a Corpse," *Life* 21(August 12, 1946): 8-9.

101 For the flavor of Weegee's initial years in Hollywood, see "Weegee Goes Hollywood," *Popular Photography* 24(March 1949): 51-55, 160.

102 Wilson Hicks, "Feininger As I Know Him," *Popular Photography* 25(November 1949): 57.

103 For a comparison of this photograph, and the print derived from it, see figures 120 and 121 (page 113) in Barbara Haskell, *Ralston Crawford* (New York: Whitney Museum of American Art, 1985).

104 Charles Baudelaire, *The Painter of Modern Life and Other Essays*, trans. and ed. by Jonathan Mayne (New York: Da Capo Press, 1986), p. 9.

105 Charles Baudelaire, *Oeuvres complètes* (Paris: Editions Gallimard, 1961), pp. 243-44; cited in Burton Pike, *The Image of the Modern City* (Princeton: Princeton University Press, 1981), p. 25. For an

eloquent expression of a similar sensibility, see Alfred Kazin, *A Walker in the City* (New York: Harcourt, Brace Jovanovich, 1951).

106 Levitt worked as a film editor beginning in the early 1940s, and made two highly acclaimed films later in the decade: *In the Street* (1945-46) and *The Quiet One* (1946-47).

107 Within the frame of the photograph itself we have, progressively, the frame of the window, the vertical "frame" of the arms of the woman in the striped shirt, and, within that, the curiously rectangular form of the arms of the other young woman. These suggest a relentlessly inward spiral that seems both physical and psychological.

108 Each of these signs also emphasized the role of the doorway as the juncture between the public world of the street and the intimate realm of the family. They remind one of Gaston Bachelard's observation on how concrete everything becomes in the world of the spirit when an object, a mere door, can give images of hesitation, temptation, desire, security, welcome and respect. If one were to give an account of all the doors one has closed and opened, of all the doors one would like to re-open, one would have to tell the story of one's entire life.
Bachelard, *The Poetics of Space*, trans. Maria Jolas (Boston: Beacon Press, 1969), p. 224.

109 For contemporary reviews of this work, see for example, Beaumont Newhall, "City Lens: Todd Webb's New York on Exhibition," *Art News* 45(October 1946): 46-47, 73-74; and "Todd Webb's New York," *U.S. Camera 1948*, pp. 282-87.

110 Artist's statement for "Diogenes With a Camera" exhibition at the Museum of Modern Art, 1954. From manuscript in Webb archive, Center for Creative Photography, Tucson.

111 This work was shown at the Museum of Modern Art in 1953, described at considerable length in the April 1954 issue of *Modern Photography*, and (as a 4 x 24-foot enlargement) featured in the American display at the 1958 Brussels World's Fair.

112 James Agee, untitled essay in Helen Levitt, *A Way of Seeing* (New York: Horizon Press, 1981), p. xi.

113 Lincoln Kirstein, "Photographs of America: Walker Evans," in *American Photographs* (New York: East River Press, 1975), p. 188.

114 "Metropolis," *U.S. Camera 1941*, 1, p. 141.

115 This photograph was reproduced in *U.S. Camera 1949*, p. 176. For other selections of Weiner's work, see *U.S. Camera 1950*, pp. 180-81; "Dan Weiner: A Portfolio," *Photography* 32(June 1953): 40-47, 108; *U.S. Camera 1958*, pp. 26-33; and "Dan Weiner," *Camera 35* 3:4(1959): 234-37.

116 Yavno received his greatest recognition for photographs of San Francisco and Los Angeles in the late 1940s. These were commissioned by Houghton Mifflin and published in Max Yavno and Herb Caen, *The San Francisco Book* (Boston: Houghton Mifflin, 1948); and Max Yavno and Lee Shippey, *The Los Angeles Book* (Boston: Houghton Mifflin, 1950).

117 For an essay on his mentor, see Liebling's "Walter Rosenblum," *American Photography* 45(May 1951): 273-81.

118 For an early publication of DeCarava's work, see *U.S. Camera 1953*, pp. 282-83.

119 James Alinder, ed., *Roy DeCarava Photographs* (Carmel, Calif.: Friends of Photography, 1981), p. 14.

120 Four of Parks's images, including a variant of this photograph, were reproduced in "A Man Becomes Invisible," *Life* 33(August 25, 1952): 9-11. The text for this article reads in part, "...with Ellison's help [Parks] re-created from the novel the scenes on these pages to show the loneliness, the horror and the disillusionment of a man who has lost faith in himself and the world."

121 Hawthorne's phrase, from his "The Gray Champion," forms a central metaphor in Burton Pike's *The Image of the City in Modern Literature* (Princeton: Princeton University Press, 1981).

122 "What is Modern Photography?" *American Photography* 45(March 1951): 151. For an early article on Page's own work, see Christiana Page, "The Reluctant Reformer," *Minicam Photography* 9(February 1946): 50-57, 144.

123 The verso of this print is inscribed: "'Homage to Muybridge,' Chestnut St. between 10th and 11th Streets, Philadelphia, Pa." It is unclear, however, if this is the image's original title, since it was reproduced in *Photography 1947* (p. 65) as *Street Scene*.

124 Grossman's picture, from a series documenting one or more American Legion parades in 1947-48, stems from the period in which he and the Photo League were coming under increasing pressure from the FBI for Communist associations. Soon after this series, Grossman felt compelled to end the people-oriented work for which he was known. Stettner's photograph, while one of his best known, is not altogether typical of his work. See Louis Stettner, *Early Joys* (New York: Janet Iffland, 1987), p. 127.

125 Leo Braudy, "Realists, Naturalists, and Novelists of Manners," in Daniel Hoffman, ed., *Harvard Guide to Contemporary American Writing* (Cambridge, Mass.: Belknap Press, 1979), p. 133.

126 Ibid., p. 103.

127 Thomas Wolfe, *Of Time and the River* (New York: Charles Scribner's Sons, 1935), p. 155.

128 Information on these pictures is drawn largely from Sarah Greenough, *Walker Evans: Subways and Streets* (Washington, D.C.: National Gallery of Art, 1991).

129 Subway images were later made by photographers such as Arthur Leipzig (in both 1949 and ca. 1954) and Alfred Gescheidt (ca. 1952). See, respectively, Arthur Leipzig, "I See the Subway in Color," *U.S. Camera* 18(January 1955): 66-67; and *U.S. Camera 1953*, pp. 253.

130 These images were made in Bridgeport, Connecticut, in 1941, and in Detroit and Chicago in 1946. See Greenough, *Walker Evans*, pp. 20-21.

131 As he related in a telephone conversation in June 1994, Newman first studied photography with Walter Rosenblum at Brooklyn College. He also used the darkrooms at the Photo League before going to Chicago. Since the mid-1950s, Newman has been engaged in a successful commercial practice.

132 *Photography* (December 1953): 94.

133 "Leon Levinstein," *U.S. Camera 1956*, p. 255. In her study *The New York School: Photographs 1936-1963* (New York: Stewart, Tabori & Chang, 1992), Jane Livingston notes that this statement "makes utterly transparent [Levinstein's] adherence to the ideas Sid Grossman was espousing in 1949 and 1950" (p. 325). For other contemporary publications of Levinstein's work, see, for example, *U.S. Camera 1951*, p. 337, and *U.S. Camera 1952*, pp. 47, 60.

134 Helen Gee has been one of the most consistent supporters of Levinstein's work. She gave him a one-man show at her Limelight Gallery in 1956; wrote the text for a portfolio of his images published in the March/April 1982 issue of *Camera Arts*; and contributed the introduction to the 1990 Photofind Gallery exhibition catalogue, *Leon Levinstein*.

135 Much of the following is based on Livingston, *The New York School*, pp. 312-16; and John Heilpern's essay in *William Klein: Photographs* (Millerton, N.Y.: Aperture, 1981).

136 Heilpern, *William Klein: Photographs*, p. 7.

137 Livingston, *The New York School*, p. 314.

138 Jacquelyn Judge, "The Inhabitants," *Popular Photography* 19(December 1946): 218.

139 Morris's next combination of photographs and text was *God's Country and My People* (1968).

140 Robert Frank was one of the numerous younger photographers who admired these volumes. See Colin L. Westerbeck, Jr., "The Photography and Fiction of Wright Morris," in Daniel P. Younger, ed., *Multiple Views: Logan Grant Essays on Photography, 1983-1989* (Albuquerque: University of New Mexico Press, 1991), p. 280.

141 For valuable perspectives on this project, see, for example, John Rohrbach, "*Time in New England:* Creating a Usable Past," in Maren Stange, ed., *Paul Strand: Essays on His Life and Work*, pp. 161-77; Eric Himmel, "Pilgrim's Progress," *Camera Arts* 1(November/December 1981): 10, 12, 16, 19-21; and "*Time in New England* in the Making: Excerpts from Correspondence between Paul Strand and Nancy Newhall," in Newhall, ed., *Photography: Essays & Images*, pp. 297-303.

142 Strand's political views are discussed by Mike Weaver in "Dynamic Realist," in Stange, ed., *Paul Strand*, pp. 197-207, and "Paul Strand: Native Land," in Mike Weaver and Anne Hammond, *Paul Strand and*

Ansel Adams: Native Land and Natural Scene (Tucson: Center for Creative Photography, 1990); and by Ben Maddow in "A View from Below: Paul Strand's Monumental Presence," *American Art* 5(Summer 1991): 49-67.

[143] These resulted in the following books: *La France de Profil* (1952), *Un Paese* (1955), *Tir a'Mhurain* (1962), *Living Egypt* (1969), and *Ghana, An African Portrait* (1976).

[144] Harold Clurman used this phrase to describe Strand's vision as early as 1934. Quoted in Himmel, "Pilgrim's Progress," p. 16.

[145] James L. Collings, "Photography: Smith Carries Torch With His Camera," *Editor & Publisher* 81(October 2, 1948): 46; quoted in William Johnson, *W. Eugene Smith: Early Work* (Tucson: Center for Creative Photography, 1980), p. 16.

[146] For an interesting defense of Smith, see Emily A. Mack, "The Myth Named Smith," *Camera* 35 (December/January 1960): 45-47, 74-79.

[147] Quoted in Glenn G. Willumson, *W. Eugene Smith and the Photographic Essay* (Cambridge: Cambridge University Press, 1992), p. 234. This book provides an excellent analysis of Smith's most notable essays and his working method.

[148] Mack, "The Myth Named Smith," p. 76.

[149] Willumson, *W. Eugene Smith and the Photographic Essay*, p. 238.

[150] Ibid., p. 113.

[151] On the remarkable subtlety of the layout of "Spanish Village," see ibid., pp. 112-15.

[152] *Life's* publication of this essay included 25 photographs, while Smith's ideal version encompassed nearly 250. See William S. Johnson, *W. Eugene Smith: Master of the Photographic Essay* (Millerton, N.Y.: Aperture, 1981), p. 147.

[153] Ibid., p. 149.

[154] Smith's own eighty-seven print version of this essay was published in *Photography Annual 1959*, pp. 96-133.

[155] Details on Link's life and work are drawn from Carolyn Carr, "Rite of Passage: O. Winston Link's Railroad Photographs of the 1950s," in *Ghost Trains: Railroad Photographs of the 1950s by O. Winston Link* (Norfolk, Va.: Chrysler Museum, 1983): 6-7.

[156] The use of complex flash setups was common in this period. See, for example, "World's Biggest Flash Shot," *U.S. Camera* 14(November 1951): 35-39; and "The World's Greatest Flash Picture," *U.S. Camera* 18(January 1955): 56-57, 96. The latter describes a railroad photograph made with 6,000 flashbulbs.

[157] Transcribed comments from symposium "What Is Modern Photography?" *American Photography* 45(March 1951): 148.

[158] For a contemporary perspective on these classes, see David Jon Ebin, "A Master Teaches the Experts," *Photography* 36(January 1955): 48-51, 122-23.

[159] Owen Edwards, "Zen and the Art of Alexey Brodovitch," *American Photographer* 2(June 1979): 55.

[160] For a survey of Liberman's career, see Dodie Kazanjian and Calvin Tomkins, *Alex: The Life of Alexander Liberman* (New York: Alfred A. Knopf, 1993).

[161] "Walker Evans: The Unposed Portrait," *Harper's Bazaar* no. 3005(March 1962): 120-25. For a brief profile of Israel, see Owen Edwards, "Marvin Israel, the Mentor, Doesn't Want to Be Famous," *Village Voice* 20(October 27, 1975): 103-04.

[162] Martin Harrison, *Appearances: Fashion Photography Since 1945* (New York: Rizzoli, 1991), pp. 25, 27, 30. My discussion owes a considerable debt to this fine study.

[163] "Richard Avedon: A Portfolio," *U.S. Camera 1955*, p. 54.

[164] "Leslie Gill: His Work and Influence," *Modern Photography* 23(January 1959): 80-89.

[165] Interestingly, by late 1948, Avedon was already being described as "the most controversial figure in photography." See Jonathan Tichenor, "Richard Avedon, Photographic Prodigy," *U.S. Camera* 12(January 1949): 35.

[166] "Richard Avedon," *U.S. Camera 1950*, p. 169.

[167] For a contemporary account of the making of this photograph, see "High Fashion in a Menagerie," *U.S. Camera* 19(June 1956): 64-65, 104-05.

[168] *U.S. Camera 1956*, p. 254.

[169] In 1955, Penn stated, "As far as I am concerned, Brodovitch is the most important influence on the printed page in our time." "Irving Penn: '...cut an incision into their lives...,'" *Photography Annual 1966*, p. 18.

[170] Nonetheless, Penn's work, like Avedon's, was controversial in its day. For example, *U.S. Camera 1949* (p. 23) notes that "Irving Penn, a photographer on the staff of the Condé Nast publications, is one of the newer names in photography, and one whose work has aroused violent differences of opinion..."

[171] John Szarkowski, *Irving Penn* (New York: Museum of Modern Art, 1984), p. 25.

[172] These were published in *Vogue* and elsewhere. For example, sixty of Penn's small trades images (including such subjects as *House Painter, Shoemaker, Deep-Sea Diver*, and *Pneumatic Driller*) were published in the July 1951 issue of *Vogue*, and in *U.S. Camera 1952*. Penn's images of international clothing and body adornment are collected in his book *Worlds in a Small Room* (New York: Grossman, 1974).

[173] For a contemporary profile of Bassman, see Walter Ian Fishman, "A Woman's Camera in a Woman's World," *Popular Photography* 28(April 1951): 36-41, 98-99.

[174] Quoted in Heilpern, *William Klein: Photographs*, p. 15.

[175] Harrison, *Appearances*, p. 98.

[176] In 1957, Newman observed,

> Inevitably there is a great deal of the photographer in his finished product, and if it's a portrait, then you're viewing your sitter in the light of your own creative and personal life. If there isn't much of you, then there isn't much of a portrait. In other words, you must be part of the picture yourself. It is a matter of joining forces with the sitter, in a sense.

Arthur Goldsmith, "Arnold Newman on Portraiture," *Popular Photography* 40(May 1957): 126. This issue also includes the article, "On Assignment with Arnold Newman," pp. 80-85, 113. For an earlier essay on Newman's work, see "Portraits That Break the Rules," *U.S. Camera* 14(April 1951): 36-37, 93.

[177] John Szarkowski, *Photography Until Now* (New York: Museum of Modern Art, 1989), p. 251.

[178] Comments ca. 1964, quoted in Szarkowski, *Irving Penn*, p. 28.

[179] John Szarkowski, "Photography and the Mass Media," *Aperture* 13:3(1967): n.p.

[180] Most of these photographs were made by Robert Capa, George Rodger, and Chim (David Seymour). The picture editor of *Ladies' Home Journal* at this time was John G. Morris. See William Manchester, Jean Lacouture, and Fred Ritchin, *In Our Time: The World as Seen by Magnum Photographers* (New York: American Federation of Arts/W. W. Norton, 1989), pp. 430-31.

[181] *U.S. Camera 1944*, p. 5.

[182] This issue begins with a picture story on the birth of a baby, and then touches on such themes as the end of the war, the construction of new houses for returning servicemen and their families, followed by a varied catalogue of political turmoil, natural disasters, and perspectives on the human condition. Steichen's direct involvement in these publications ended with his employment at the Museum of Modern Art; the 1947 annual (issued in late 1946) is thus the last to so clearly embody his ideas.

[183] Gilbert Bailey, "Photographer's America," *New York Times Magazine* (August 31, 1947): 39. The same sentiments are recorded in "Steichen Heads Museum Department of Photography," *U.S. Camera* 10(October 1947): 17, 50-51.

[184] Bruce Downes, "Steichen at Mid-Century," *Popular Photography* 27(September 1950): 115.

[185] Lew Parella, "The Family of Man," *U.S. Camera* 18(March 1955): 56.

[186] Jacob Deschin, "Family of Man," *New York Times* (January 30, 1955): X17.

[187] Parella, "The Family of Man," p. 69.

[188] "Preview Address: 'The Family of Man,'" *U.S. Camera 1956*, p. 18.

[189] Green, *American Photography*, p. 48.

[190] Ibid., p. 70.

191 Ibid.

192 Deschin, "Family of Man."

193 For a remarkably detailed list of these publications, see Stuart Alexander, *Robert Frank: A Bibliography, Filmography, and Exhibition Chronology 1946-1985* (Tucson: Center for Creative Photography/Houston Museum of Fine Arts, 1986).

194 Anne Wilkes Tucker, *Robert Frank: New York to Nova Scotia*, (Houston: Museum of Fine Arts, 1986), p. 20. Frank's application was accompanied by the strongest possible list of references: Evans, Brodovitch, Liberman, Steichen, and art historian Meyer Shapiro.

195 The chronology and routes of these trips are reconstructed by Tucker in *Robert Frank: New York to Nova Scotia*, pp. 9-10, 94-95.

196 Ibid., p. 95.

197 For useful overviews of this theme in photography, see, for example, Ulrich Keller, *The Highway as Habitat: A Roy Stryker Documentation, 1943-1955* (Santa Barbara, Calif.: University Art Museum, 1986), and Marilyn Laufer, *In Search of America: Photography From the Road 1936-1976* (Ph.D. diss., Washington University, St. Louis, 1992).

198 See John Malcolm Brinnin, "Henri Cartier-Bresson, Portrait of the Artist, ca. 1947," *Camera Arts* 2(January/February 1982): 14-17, 20-24, 28-29, 110-13; and Henri Cartier-Bresson, *America in Passing* (Boston: Bulfinch Press, 1991).

199 Kerouac's *On the Road* was written from 1948 to 1951, and partially rewritten between 1951 and 1956, before its publication in 1957. Frederick R. Karl, *American Fictions 1940-1980* (New York: Harper & Row, 1983), p. 200.

200 Fourteen of these images were published in Erwitt's article, "35mm Images From a Moving Car," *U.S. Camera* 17(September 1954): 52-55.

201 "Robert Frank: Ben James, Story of a Welsh Miner," *U.S. Camera* 1955, p. 92.

202 On the relationship between the work of Evans and Frank, see Leslie K. Baier, "Visions of Fascination and Despair: The Relationship between Walker Evans and Robert Frank," *Art Journal* 41(Spring 1981): 55-63; and Tod Papageorge, *Walker Evans and Robert Frank: An Essay on Influence* (New Haven: Yale University Art Gallery, 1981).

203 See, for example, "The Congressional," *Fortune* 52(November 1955): 118-22.

204 For a summary of these influences, see William S. Johnson, "History—His Story," in Johnson, ed., *The Pictures Are a Necessity: Robert Frank in Rochester, NY, November 1988* (Rochester: Rochester Film & Photography Consortium, 1989), pp. 29-36.

205 Studies of the structure and meaning of this book include John Brumfield, "'The Americans' and the Americans," *Afterimage* 8(Summer 1980): 8-15; Jno Cook, "Robert Frank's America," *Afterimage* 9(March 1982): 9-14; Green, *American Photography*, pp. 81-93; and George Cotkin, "the photographer in the beat-hipster idiom: robert frank's the americans," *American Studies* 26(Spring 1985): 19-33.

206 Karl, *American Fictions*, p. 201.

207 Robert Frank, "A Statement," *U.S. Camera 1958*, p. 115.

208 Edna Bennett, "Black and White Are the Colors of Robert Frank," *Aperture* 9:1(1961): 22.

209 Translations of some of these texts (which were chosen by Alain Bosquet) are reprinted in Cook, "Robert Frank's America," pp. 10-11.

210 "An Off-Beat View of the U.S.A.," *Popular Photography* 46(May 1960): 104-6.

211 "New Photo Books," *Modern Photography* 24(June 1960): 32. The only critic in the photographic press to avoid this line of reasoning was H. M. Kinzer, who wrote,

> In *The Americans*, one of our finest photographers has produced a slashing and bitter attack on some U.S. institutions, while completely ignoring others. However much one may quarrel with this one-sidedness (which is most assuredly intentional, and not the result of any ignorance of the "better" aspects of our culture), it is impossible to deny the sharp perception and the sheer power of most of the images in the book. It is useless to argue that Robert Frank should have devoted a part of his book to the vast and smiling American middle class, another

to the champagne-and-Jaguar stratum, and so on. The fact is simply that he feels strongly about some of the things he sees in his adopted country, and wants to call them to our attention. He does it superbly.

"An Off-Beat View of the U.S.A.," pp. 104-05. In contrast to the critical hostility with which *The Americans* was received, it is interesting to note the warm response given to Klein's work in *Modern Photography* 23(September 1959): 52-59, 96.

212 "An Off-Beat View of the U.S.A.," p. 104.

213 Walker Evans, "Robert Frank," *U.S. Camera 1958*, p. 90.

214 Frank, "A Statement," p. 115.

215 Tucker, *New York to Nova Scotia*, p. 96.

216 John Szarkowski, *Winogrand: Figments From The Real World* (New York: Museum of Modern Art, 1988), p. 18.

217 Arthur A. Goldsmith, Jr., "Garry Winogrand," *Photography* 35(October 1954): 60, 95. For other reproductions of his work of this period, see *Photography Annual 1954*, p. 66, and *Photography Annual 1955*, pp. 92-93, 108-09.

218 Winogrand's mood of this period is summarized in his 1963 Guggenheim application:

> I look at the pictures I have done up to now, and they make me feel that who we are and what we feel and what is to become of us just doesn't matter. Our aspirations and successes have been cheap and petty. I read the newspapers, the columnists, some books, I look at the magazines (our press). They all deal in illusions and fantasies. I can only conclude that we have lost ourselves, and that the bomb may finish the job permanently, and it just doesn't matter, we have not loved life.
>
> I cannot accept my conclusions, and so I must continue this photographic investigation further and deeper. This is my project.

Quoted in Szarkowski, *Winogrand: Figments from the Real World*, p. 34.

219 For good analyses of Winogrand's work, see Alex J. Sweetman, "The Death of the Author: Garry Winogrand, 1928-1984," *The Archive* 26 (Tucson: Center for Creative Photography, 1990), pp. 5-12; and Carl Chiarenza, "Standing On The Corner...Reflections Upon Winogrand's Photographic Gaze: Mirror Of Self Or World," Part I, *Image* 34(Fall/Winter 1991): 17-51, and Part II, *Image* 35(Spring/Summer 1992): 25-45.

220 Biographical details of Friedlander's life and career are drawn largely from Rod Slemmons's "A Precise Search for the Elusive," in *Like a One-Eyed Cat: Photographs by Lee Friedlander 1956-1987* (New York: Harry N. Abrams/Seattle Art Museum, 1989), pp. 111-17; and Richard B. Woodward, "Lee Friedlander: American Monument," *Art News* 88(November 1989): 140-45.

221 Many of the Atlantic covers were designed by Marvin Israel.

222 See James Thrall Soby, "Lee Friedlander," *Art in America* 48(Summer 1960): 66-69.

223 Artist's statement of 1963 quoted in Slemmons, "A Precise Search for the Elusive," p. 111.

224 For a very early, and purely technical, approach to this subject, see Robert Eichberg, "Photographing Television Images," in the April, May, and June 1942 issues of *American Photography*.

225 "The Little Screens," *Harper's Bazaar*, no. 3015(February 1963): 126-29. Several of these were also included in "Is TV Viewing An Addiction?" *Current* (April 1963): 32-36.

226 Green, *American Photography*, p. 106.

227 "The Vertical Journey," *Esquire* 55(July 1960): 102-07; and "The Full Circle," *Harper's Bazaar*, no. 3000(November 1961): 133-37. For a full discussion of this, and Arbus's subsequent magazine work, see Thomas W. Southall, "The Magazine Years, 1960-1971," in Doon Arbus and Marvin Israel, eds., *Diane Arbus Magazine Work* (New York: Aperture/Spencer Museum of Art, 1984), pp. 152-71.

228 "Telling It As It Is," *Newsweek* 69(March 10, 1967): 110.

229 Anne W. Tucker, "Arbus Through the Looking Glass," *Afterimage* 12(March 1985): 9.

230 "Diane Arbus," *Creative Camera* (May 1974): 164.

231 Andy Grundberg, "Photography: Chicago, Moholy, and After," *Art in America* 64(September-October 1976): 35.

232 These photographers received master's degrees from the Institute of

Design in the following years: Newman (1952), Metzker (1959), Josephson (1960), Swedlund (1961), Jachna (1961), and Sterling (1962). Sinsabaugh, the oldest of this group, returned to receive his degree in 1967.

233 On Sinsabaugh's life and work, see Sherman Paul, "Images of a City: Art Sinsabaugh's Chicago Landscapes," *New Letters* 39(Summer 1973): 38-59; and Ralph Gibson's interview with the artist in DiGrappa, ed., *Landscape: Theory*, pp. 130-41.

234 *Aperture* 9:2(1961).

235 See also, "Ken Josephson's Experiments Make Classic Pictures," *Modern Photography* 25(May 1961): 70-73.

236 Anne Wilkes Tucker, *Unknown Territory: Photographs by Ray K. Metzker* (Houston: Museum of Fine Arts/Aperture, 1984), p. 8.

237 Information on this group is contained in Coke's short essay, "The Lexington Camera Club," *Exposure* 18:2(1981): 4-5.

238 Barbara Tannenbaum, "Fiction as a Higher Truth: The Photography of Ralph Eugene Meatyard," in Tannenbaum, ed., *Ralph Eugene Meatyard: An American Visionary* (Akron, Oh.: Akron Art Museum/Rizzoli, 1991), p. 40.

239 Ralph Eugene Meatyard, *The Family Album of Lucybelle Crater* (Millerton, N.Y.: Jargon Society, 1974).

240 "Post-Visualization," cited in William E. Parker, "Uelsmann's Unitary Reality," *Aperture* 13:3(1967): n.p.

241 Parker, "Uelsmann's Unitary Reality," and John L. Ward, *The Criticism of Photography as Art: The Photographs of Jerry Uelsmann* (Gainesville: University of Florida Press, 1970).

242 Quoted in Shelley Rice, "Duane Michals's 'Real Dreams,'" *Afterimage* 4(December 1976): 6.

243 See Barbara Lobron, "Limelight Lives!" *Photograph* 1:3(1977): 1-3, 30; and Helen Gee, "Limelight: Remembering Gene Smith," *American Art* 5(Fall 1991): 11-19.

244 It is nonetheless true, however, that Steichen's predilection for group exhibitions over one-person shows (except in the case of his own 1961 retrospective) represented a continual reinforcement of his own presence (as editor) in the final result. Much of the following is drawn from the biographical outline included in Steichen, *A Life in Photography*, n.p.

245 The definitive study of this subject is Miles Barth, ed., *Master Photographs from "Photography in the Fine Arts" Exhibitions, 1959-1967* (New York: International Center of Photography, 1988).

246 Miles Barth, "Ivan Dmitri and the History of PFA," in ibid., p. 16.

247 Cited in Nathan Lyons, "PFA and its Controversy," in ibid., p. 27.

CHAPTER IV **The Image Transformed 1965-Present**

1 "They Fight a Fire That Won't Go Out," *Life* (May 17, 1963): 26-36. See Michael S. Durham, *Powerful Days: The Civil Rights Photography of Charles Moore* (New York: Stewart, Tabori & Chang, 1991). For Jesse Jackson's comments on this image, see Marvin Heiferman and Carole Kismaric, *Talking Pictures: People Speak About the Photographs that Speak to Them* (San Francisco: Chronicle Books, 1994), pp. 174-77.

2 This image has been published with various titles or descriptions, including: *Reaching Out (After Taking Hill 484, South Viet Nam)*, and *Jeremiah Purdie, Wounded, Is Led to Helicopter After Fighting South of DMZ*.

3 Mark Johnstone, "The Photographs of Larry Burrows: Human Qualities in a Document," in David Featherstone, ed., *Observations: Essays on Documentary Photography* (Carmel, Calif.: Friends of Photography, 1984), p. 95. A good summary of photography of the war is contained in Susan D. Moeller, *Shooting War: Photography and the American Experience of Combat* (New York: Basic Books, 1989), pp. 325-413.

4 Larry Burrows, "Vietnam: A Degree of Disillusion," *Life* (September 19, 1969): 66-75.

5 Adam D. Weinberg, *On The Line: The New Color Photojournalism* (Minneapolis: Walker Art Center, 1986), p. 38.

6 The following information is drawn largely from John Durniak, "The Double Exhibition Explosion," *Photography Annual 1970*, pp. 7-8.

7 Cited in Candida Finkel, "Photography as Modern Art: The Influence of Nathan Lyons and John Szarkowski on the Public's Acceptance of Photography as Fine Art," *Exposure* 18:2(1981): 22.

8 Kleber's gallery opened in April 1963 at 51 East 10th Street. In 1972 it was moved to 134 5th Avenue, where it was paired with a photographer's supply shop. The gallery was closed in 1975. My thanks to Mr. Kleber for kindly providing this information.

9 With the artistic direction of Harold Jones, and the financial backing of Tennyson Shad, Light Gallery provided a particularly high-profile showcase for contemporary photographers. Light also functioned as a training ground for some of the leading gallery owners of the next decade, including Peter MacGill and Laurence Miller. The gallery's exhibition schedule between November 1971 and December 1979 is given in *Light* (New York: Light Gallery, 1981), pp. 7-9.

10 Douglas Davis, "Photography," *Newsweek* (October 21, 1974): 65.

11 These prints were, respectively, Charles Sheeler's *Wheels*, 1939 ($67,100), Edward Weston's *Nautilus Shell*, 1927 ($115,000), and Tina Modotti's *Roses, Mexico*, 1925 ($165,000). In the private gallery market, an important benchmark came in 1985, when a rare print of Paul Strand's *Wall Street*, 1915, was sold for $170,000.

12 *A Book of Photographs from the Collection of Sam Wagstaff* (New York: Gray Press, 1978).

13 The Exchange National Bank Collection is documented in *Aperture* 14(Fall 1969). For data on the Gilman Collection, see Maria Morris Hambourg et al., *The Waking Dream: Photography's First Century, Selections from the Gilman Paper Company Collection* (New York: Metropolitan Museum of Art, 1993).

14 In the 1950s, Polaroid collected prints by the leading photographers of the 1920s-50s (Weston, Cunningham, etc.), under the direction of Dr. Edwin H. Land and Ansel Adams, who served as a consultant to the firm.

15 The first NEA award to a photographer was a "special grant" to Bruce Davidson, in 1968, for the work later published under the title *East 100th Street*. For a good survey of early NEA activity, see Merry Amanda Foresta, *Exposed and Developed: Photography Sponsored by the National Endowment for the Arts* (Washington, D.C.: Smithsonian Institution Press, 1984).

16 Michael Starenko reports that "of the approximately 140 visual arts M.F.A. programs now in existence, over 70 percent were founded in the '60s and early '70s." See his article "Glass Houses—The Academicization of Activism," *New Art Examiner* 18(February 1991): 32.

17 Coke taught at the University of Florida (1958-61), and Arizona State University (1961-62), before arriving at the University of New Mexico in 1962. He held a number of positions at the university from 1962 to 1979, with a two-year hiatus in 1970-72 to serve as deputy director and director of the George Eastman House. From 1979 to 1987 he was the director of the department of photography at the San Francisco Museum of Modern Art.

18 Jonathan Green, *American Photography: A Critical History 1945 to the Present* (New York: Harry N. Abrams, 1984), p. 145.

19 This book was widely reviewed, with the photographic field itself expressing considerable skepticism. For a sampling of these responses, see Michael Lesy, "An Unacknowledged Autobiography," *Afterimage* 5(January 1978): 5; Suzanne Boorsch, "On Photography. By Susan Sontag," *Print Collector's Newsletter* 9(March-April 1978): 23-25; Estelle Jussim, "On Photography," *History of Photography* 2(April 1978): 182-84; David L. Jacobs, "Sontag reviewed," *Afterimage* 6(Summer 1978): 37; John McCole, "Walter Benjamin, Susan Sontag, and the Radical Critique of Photography," *Afterimage* 7(Summer 1979): 12-14; and Michael Starenko, "Benjamin, Sontag," *Exposure* 17:4(1980): 20-31.

20 Nathan Lyons, "PFA and Its Controversy," in Miles Barth, ed., *Master Photographs from "Photography in the Fine Arts" Exhibitions, 1959-1967* (New York: International Center of Photography, 1988), p. 28.

21 For various summaries of Szarkowski's career and his tenure at the Museum of Modern Art, see Maren Stange, "Photography and the Institution: Szarkowski at the Modern," in Jerome Liebling, ed., *Photography: Current Perspectives* (Boston: Massachusetts Review, 1978), pp. 65-81; Christopher Phillips, "The Judgment Seat of Photography," *October*, no. 22(Fall 1982): 27-63; Finkel, "Photography as Modern Art"; Michael Kimmelman, "John Szarkowski," *Art News*

83(May 1984): 68-71; and Erla Zwingle, "John Szarkowski" *American Photographer* 19(November 1987): 80-82, 84, 86.

22 John Szarkowski, "Photographing Architecture," *Art in America* no. 2(1959): 84-89.

23 John Szarkowski, *The Photographer's Eye* (New York: Museum of Modern Art, 1966), n.p.

24 Green, *American Photography*, p. 99.

25 John Szarkowski, "New Documents" exhibition wall text, Museum of Modern Art, 1967; cited in Martha Rosler, "In, Around, and After-thoughts (on Documentary Photography)," in Richard Bolton, ed., *The Contest of Meaning: Critical Histories of Photography* (Cambridge, Mass.: MIT Press, 1989), p. 321.

26 In this light, see other volumes of this period such as Lee Friedlander and John Szarkowski, *E. J. Bellocq: Storyville Portraits* (New York: Museum of Modern Art, 1970); and Mike Mandel and Larry Sultan, *Evidence* (Greenbrae, Calif.: Clatworthy Colorvues, 1977).

27 John Szarkowski, "A Different Kind of Art," *New York Times Magazine* (April 13, 1975): 16. As Szarkowski noted in the beginning of this essay, "Suddenly—within the past decade"—a sizeable portion of the sophisticated public has come to regard photographs as repositories not only of dumb facts but of personal visions."

28 Letter from the artist, undated [1994].

29 This work is collected in Richard Avedon, *In the American West 1979-1984* (New York: Harry N. Abrams, 1985).

30 At the time of this sitting, shortly before his death, Levant "was in the final stages of debilitating mental illness and drug addiction." Jamie James, "Transcending Fashion," *Art News* 93(March 1994): 107.

31 Robert Heinecken, "Manipulative Photography," *Contemporary Photography* 5:4(1967): n.p.

32 For a good overview of this subject, see Charles Desmarais, *Proof: Los Angeles Art and The Photograph 1960-1980* (Laguna Beach, Calif.: Laguna Art Museum, 1992).

33 See Robert Heinecken, "I Am Involved in Learning to Perceive and Use Light," *Untitled*, no. 7-8(1974): 44-46; and Charles Hagen, "Robert Heinecken: An Interview," *Afterimage* 3(April 1976): 8-12.

34 In general, see volumes such as *The Photography of Space Exploration* (New York: Grey Art Gallery, 1981); and Ron Schick and Julia Van Haaften, *The View From Space: American Astronaut Photography 1962-1972* (New York: Clarkson N. Potter, 1988).

35 On these prints, see Richard B. Woodward, "The Final Frontier?" *Aperture*, no. 130(Winter 1993): 70-72.

36 For an introduction to the "Generative Systems" movement of the period, see Sonia Landy Sheridan, "Generative Systems: Six Years Later," *Afterimage* 2(March 1975): 6-10. The artistic use of xerography and other photocopying processes is documented in Marilyn McCray, *Electroworks* (Rochester: George Eastman House, 1979).

37 Paula Marincola, *William Larson: Photographs 1969-1985* (Philadelphia: Institute of Contemporary Art, 1986), p. 2. See also Skip Atwater, "William Larson: Time and Structure," *Afterimage* 4(December 1976): 4-5, 18.

38 The following discussion is indebted to the fine summary of Barrow's career provided in Kathleen McCarthy Gauss, *Inventories and Transformations: The Photographs of Thomas F. Barrow* (Albuquerque: University of New Mexico Press/Los Angeles County Museum of Art, 1986).

39 Gerald Graff, *Literature Against Itself* (Chicago: University of Chicago Press, 1979), p. 175. In addition, the importance of the "X" motif in the earth art of the early 1970s is suggested in Lucy R. Lippard, *Overlay: Contemporary Art and the Art of Prehistory* (New York: Pantheon, 1983), pp. 52-53.

40 John Grimes, "Arthur Siegel," in *Arthur Siegel: Retrospective* (Chicago: Edwynn Houk Gallery, 1982), n.p.

41 Stephen R. Milanowski, "The Biases Against Color in Photography," *Exposure* 23(Summer 1985): 17. This essay provides a good introduction to the subject.

42 This work was intended for use in Kodak advertisements. See *Edward Weston: Color Photography* (Tucson: Center for Creative Photography, 1986); and Harry M. Callahan, ed., *Ansel Adams in Color* (Boston:

Little, Brown, 1993). Adams also used color materials in his capacity as technical consultant for the Polaroid Corporation, from 1945 until his death in 1984.

43 Quoted in Alexander Liberman, *The Art and Technique of Color Photography* (New York: Simon and Schuster, 1951), p. 44.

44 Quoted in Louis Kronenberger, *Quality: Its Image in the Arts* (New York: Atheneum, 1969), p. 208.

45 Porter's relative wealth made his use of the dye-transfer process more practical than it was for most other noncommercial photographers of the 1940s and 1950s.

46 In addition to exhibitions of color work by Siegel (1954) and others at the Art Institute of Chicago, color exhibitions by Porter (1943), Haas (1962), and Cosindas (1966) were presented at the Museum of Modern Art. It is notable that not one of the 503 photographs included in "The Family of Man" was in color.

47 Milanowski, "The Biases Against Color in Photography," p. 5. This change occurred in the amateur market in 1964, and in the commercial field in 1965.

48 *Cape Light: Color Photographs by Joel Meyerowitz* (Boston: New York Graphic Society, 1978), n.p.

49 Green, *American Photography*, p. 188.

50 Richard B. Woodward, "Memphis Beau," *Vanity Fair* (October 1991): 240.

51 Despite the date of this exhibition, most of the pictures included seem to have been made between 1969 and 1971.

52 John Szarkowski, *William Eggleston's Guide* (New York: Museum of Modern Art, 1976), pp. 9, 14.

53 Hilton Kramer, "Art: Focus on Photo Shows," *New York Times* (May 28, 1976): C18.

54 Quoted in Woodward, "Memphis Beau," p. 218.

55 The phrase "aesthetic of heterogeneity," coined by art critic Lawrence Alloway, is cited in Andy Grundberg, "Popular Culture, Pop Art," in Andy Grundberg and Kathleen McCarthy Gauss, *Photography and Art: Interactions Since 1946* (New York: Abbeville Press, 1987), p. 83.

56 See Henri Man Barendse, "Ed Ruscha: An Interview," *Afterimage* 8(February 1981): 8-10.

57 Lisa Lyons and Martin Friedman, *Close Portraits* (Minneapolis: Walker Art Center, 1980), p. 34.

58 Ibid., p. 63. The painting resulting from this sitting, *Joe*, 1969, is in the Saatchi Collection, London.

59 Peter Schjeldahl, "The Wizard in the Tower," in *Lucas Samaras* (New York: Pace/MacGill Gallery, 1991), n.p.

60 Lucas Samaras, *Samaras Album* (New York: Whitney Museum/Pace Editions, 1971), p. 9.

61 A large selection of these AutoPolaroids were published in *Art in America* 58(November/December 1970): 66-83.

62 Judith Russi Kirschner, "Non-Uments," Artforum 23(October 1985): 108.

63 Joan Simon, "Gordon Matta-Clark: Reconstructions," *Arts Magazine* 62(Summer 1988): 85.

64 Cited in Charles Stainback, *Special Collections: The Photographic Order From Pop to Now* (New York: International Center of Photography, 1992), p. 12.

65 James Alinder, *Cumming Photographs* (Carmel, Calif.: Friends of Photography, 1979), pp. 5-6.

66 Many of the ideas of postmodernism were derived from the writings of literary and cultural critics such as Roland Barthes, Jacques Derrida, Jean Baudrillard, Jean-Francois Lyotard, and Frederic Jameson. In the U.S., this movement was codified and promoted in journals such as *October*, and by art critics such as Rosalind Krauss, Craig Owens, Douglas Crimp, Hal Foster, and Abigail Solomon-Godeau. On the history of this term, see, for example, Douglas Davis, "Post-Every-thing," *Art in America* 68(February 1980): 11, 13-14.

67 Andy Grundberg, "Self-Portraits Minus Self," *New York Times Book Review* (July 22, 1984): 12.

68 Gerald Marzorati, "Imitations of Life," *Art News* 82(September 1983): 82.

69 Peter Schjeldahl, "Shermanettes," *Art in America* 70(March 1982): 110.

70 Kate Linker, *Love for Sale: The Words and Pictures of Barbara Kruger* (New York: Harry N. Abrams, 1990), p. 14.

71 Allan Sekula, "On The Invention of Photographic Meaning," *Artforum* 13(January 1975): 37.

72 Anne H. Hoy, *Fabrications: Staged, Altered, and Appropriated Photographs* (New York: Abbeville Press, 1987), p. 101.

73 Hal Foster, "Postmodernism: A Preface," in Foster, ed., *The Anti-Aesthetic: Essays on Postmodern Culture* (Port Townsend, Wash.: Bay Press, 1983), p. xii.

74 Abigail Solomon-Godeau, "Photography After Art Photography," in Brian Wallis, ed., *Art After Modernism: Rethinking Representation* (New York: New Museum of Contemporary Art, 1984), p. 77.

75 As Michael Starenko has written,

> A career as an academic theorist appeals to many artists and writers because it holds out the promise of worldly innocence and ideological purity. In this monastic ideal, innocence is the freedom to avoid contact with "the public" while presuming to speak on its behalf; and purity is the satisfaction of knowing that all other "subject positions" are hopelessly compromised by vested interest, ignorance, and false consciousness. In other words, innocence and purity are forms of power: in order to be innocent someone else must be guilty; in order to be pure someone else must be impure.

Starenko, "Glass Houses—The Academicization of Activism," p. 33.

76 For useful early critiques of Postmodern photography see, for example, Linda Andre, "The Politics of Postmodern Photography," *Afterimage* 13(October 1985): 14-17; and Lynn Stern, "The Bankruptcy of the Avant-Garde: Deconstructive Photography," *Photographic Insight* 1:4(1989): 10-15. General criticisms of Postmodernism range from Charles Newman's *The Post-Modern Aura: The Act of Fiction in an Age of Inflation* (Evanston, Ill.: Northwestern University Press, 1985) to Robert Hughes's *Culture of Complaint: The Fraying of America* (New York: Oxford University Press, 1993).

77 Lyotard, *The Postmodern Condition: A Report on Knowledge*, trans. by Geoff Bennington and Brian Mussumi (Minneapolis: University of Minnesota, 1984), p. 79.

78 A brief biographical outline is contained in Eric Levin, "Gossage Country," *American Photographer* 21(July 1988): 55-62.

79 This series is described in Denise Miller-Clark, *Within This Garden: Photographs by Ruth Thorne-Thomsen* (Chicago: Museum of Contemporary Photography/Aperture, 1993), pp. 35-37.

80 Michael Sand, "Adam Fuss," *Aperture*, no. 133(Fall 1993): 51.

81 Owen Edwards, "Joel-Peter Witkin," *American Photographer* 15(November 1985): 42.

82 On the popularity of these images in the marketplace, see ibid., p. 52.

83 Quoted in Debra Heimerdinger, *Optiks: Photographs by Zeke Berman* (San Francisco: Friends of Photography, 1992), n.p.

84 The difference between these two camps forms the basis of such articles as Richard B. Woodward's "It's Art, But Is It Photography?" *New York Times Magazine* (October 9, 1988): 29-31, 42, 44, 46, 54-55, 57.

85 Ansel Adams and Mary Street Alinder, *Ansel Adams: An Autobiography* (Boston: New York Graphic Society, 1985), p. 149.

86 For a brief discussion of these books, see Charles Hagen, "Land and Landscape," *Aperture* no. 120(Late Summer 1990): 16-20.

87 Ibid., p. 16.

88 See, for example, D. W. Meinig, ed., *The Interpretation of Ordinary Landscapes* (New York: Oxford University Press, 1979).

89 Ibid., p. 2.

90 William Jenkins, *New Topographics* (Rochester: George Eastman House, 1975), pp. 5,7.

91 Ibid., p. 5.

92 For example, Nicholas Nixon wrote, in part,

> The world is infinitely more interesting than any of my opinions concerning it. This is not a description of a style or an artistic posture, but my profound conviction. The fictional properties of even the most utilitarian photograph suggest the difficulty of coming to a genuine understanding of the medium's paradoxes, let alone its power. As it is somewhere on a cloudy continuum between the literary and the painterly, so likewise does it hover between fact and point of view...

Ibid., p. 6.

93 See Baltz's commentary in "Notes on Recent Industrial Developments in Southern California," *Image* 17(June 1974): 2; and his text in Carol DiGrappa, ed., *Landscape: Theory* (New York: Lustrum Press, 1980): 24-29.

94 It is interesting to note that Adams received a copy of *This Is the American Earth* from his parents in 1960, traveled through Glen Canyon in 1962, and purchased a print of Ansel Adams's *Moonrise, Hernandez, New Mexico*, in 1966. Cited in "Chronology," Robert Adams, *To Make It Home: Photographs of the American West* (New York: Aperture, 1989), pp. 166-67.

95 Robert Adams, *Why People Photograph: Selected Essays and Reviews* (New York: Aperture, 1994), p. 180.

96 Robert Adams, *Los Angeles Spring* (New York: Aperture, 1986).

97 John Pfahl, "Power and Smoke: Two Statements," *Aperture*, no. 120, (Late Summer 1990): 24.

98 See, for example, Richard Misrach with Myrian Weisang Misrach, *Bravo 20: The Bombing of the American West* (Baltimore: Johns Hopkins Press, 1990); Richard Misrach and Susan Sontag, *Violent Legacies: Three Cantos* (New York: Aperture, 1992); and Peter Goin, *Nuclear Landscapes* (Baltimore: Johns Hopkins Press, 1991).

99 On this theme, see Michael Barkun, "Divided Apocalypse: Thinking About The End in Contemporary America," *Soundings* 66(Fall 1983): 257-80; Eleanor Heartney, "The End of the World," *Arts Magazine* 58(February 1984): 99-101; and Suzi Gablik, "Art Alarms: Visions of the End," *Art in America* 72(April 1984): 11-14.

100 The Dunmore & Critcherson photographs were commissioned by the painter William Bradford and were included in Bradford's publication *The Arctic Regions* (London: Sampson Lowe, Marston, Low & Searle, 1873).

101 Alexandra Anderson-Spivey, *Lynn Davis* (Overland Park, Kan.: Johnson County Gallery of Art, 1994), unpaginated exhibition brochure.

102 Linda Connor, "Gestures of Faith," in Connor et al., *Marks in Place: Contemporary Responses to Rock Art* (Albuquerque: University of New Mexico Press, 1988), p. 12.

103 This work was published in Mark Klett et al., *Second View: The Rephotographic Survey Project* (Albuquerque: University of New Mexico Press, 1984).

104 Friedlander's interest in monuments is documented in his superb book, *The American Monument* (New York: Eakins Press Foundation, 1976).

105 Advocates of multiculturalism in art, like Whitney curator Elisabeth Sussman, answer this question in the following terms:

> Although sexual, ethnic, and gendered subjects motivate the content of recent art, these identities fragment but do not destroy the social fabric. Paradoxically, identities declare communities and produce a decentered whole that may have to be described as a community of communities.

Sussman, "Coming Together in Parts: Positive Power in the Art of the Nineties," *1993 Biennial Exhibition* (New York: Whitney Museum/Harry N. Abrams, 1993), p. 13. For a less sanguine view of this exhibition, see Robert Hughes, "A Fiesta of Whining," *Time* (March 22, 1993): 68-69.

106 Fay Hirsch, "Odd Geometry: The Photographs of Francesca Woodman," *Print Collector's Newsletter* 25(May-June 1994): 45. See also Lorraine Kenny, "Problem Sets: The Canonization of Francesca Woodman," *Afterimage* 14(November 1986): 4-5.

107 In addition to the Blinderman catalogue listed in the bibliography, see Richard Martin, "The Expeditionary Photographs of Tseng Kwong Chi," *Arts Magazine* 60(September 1986): 94-97.

108 This work is discussed in Kathleen McCarthy Gauss, *New American Photography* (Los Angeles: Los Angeles County Museum of Art, 1985), pp. 58-62.

109 Among his other achievements, Coplans was the founding editor (1962) and editor-in-chief of *Artforum* magazine, senior curator of the Pasadena Art Museum (1967-70), director of the Akron Art Museum (1978-80), and the author of books on Cézanne, Warhol, Roy Lichtenstein, Ellsworth Kelly, and Weegee.

110 The Day photograph reproduced in this volume as plate 20 was formerly in Mapplethorpe's collection.

111 See Matthew Rose, "David Wojnarowicz: An Interview," *Arts*

Magazine 62(May 1988): 60-65; and Lucy R. Lippard, "Out of the Safety Zone," *Art in America* 78(December 1990): 130-39, 182, 186.

[112] Quoted in Lucy Lippard's overview of Serrano's work, "Andres Serrano: The Spirit and The Letter," *Art in America* 78(April 1990): 242.

[113] For an early statement on this work, see Milton Rogovin, "Six Blocks Square," *Image* 17(June 1974): 10.

[114] Larry Sultan, *Pictures From Home* (New York: Harry N. Abrams, 1992), p. 114. Elsewhere in this volume, Sultan notes, "I realize that beyond the rolls of film and the few good pictures, the demands of my project and the confusion about its meaning, is the wish to take photography literally. To stop time. I want my parents to live forever" (p. 18).

[115] Peter Galassi, *Pleasures and Terrors of Domestic Comfort* (New York: Museum of Modern Art, 1991), p. 22.

[116] Richard B. Woodward, "The Disturbing Photography of Sally Mann," *New York Times Magazine* (September 27, 1992): 36.

[117] Sally Mann, *Immediate Family* (New York: Aperture, 1992), n.p.

[118] Peter Nulty, "The New Look of Photography," *Fortune* (July 1, 1991): 36.

[119] This work was created with the technical assistance of Richard Carling and David Kramlich.

[120] Kathleen Ruiz, quoted in Charles Hagen, "Photography: The Dawn of a New Age?" *Art News* 92(March 1993): 75.

[121] Charles Hagen, "Reinventing the Photograph," *New York Times* (January 31, 1993): 1, 29. On this subject, see William J. Mitchell, *The Reconfigured Eye: Visual Truth in the Post-Photographic Era* (Cambridge, Mass.: MIT Press, 1992).

[122] Hagen, "Photography: The Dawn of a New Age?" p. 75.

[123] Hagen, "Reinventing the Photograph," p. 29.

[124] Nulty, "The New Look of Photography," p. 39.

[125] Wright Morris, "Photography in My Life," in James Alinder, ed., *Wright Morris: Photographs & Words* (Carmel, Calif.: Friends of Photography, 1982), p. 54.

Bibliography

The following list provides an introductory bibliography of American photography from 1890 to the present, including significant monographs on the artists whose works are reproduced in this volume. The emphasis is on publications that are currently in print or readily available. Basic biographical data is given for all the photographers reproduced in this volume, including those without monographic references. Additional sources for many of these artists, including journal articles, are cited in the endnotes.

General Works

Gordon Baldwin, *Looking at Photographs: A Guide to Technical Terms* (Malibu, Calif.: J. Paul Getty Museum, 1991).

James Enyeart, ed., *Decade by Decade: Twentieth-Century American Photography From the Collection of the Center for Creative Photography* (Boston: Bulfinch Press/Center for Creative Photography, 1989).

Andrew H. Eskind and Greg Drake, eds., *Index to American Photographic Collections* (Boston: G.K. Hall & Co., 1990).

Thomas Weston Fels, *O Say Can You See: American Photographs, 1839-1939; One Hundred Years of American Photographs from the George R. Rinhart Collection* (Cambridge, Mass.: MIT Press, 1989).

Vicki Goldberg, ed., *Photography in Print: Writings from 1816 to the Present* (New York: Simon and Schuster, 1981).

Sarah Greenough, Joel Snyder, David Travis, and Colin Westerbeck, *On the Art of Fixing a Shadow: One Hundred and Fifty Years of Photography* (Washington, D.C.: National Gallery of Art, 1989).

Maria Morris Hambourg et al., *The Waking Dream: Photography's First Century* (New York: Metropolitan Museum of Art/Harry N. Abrams, 1993).

Nathan Lyons, ed., *Photographers on Photography* (Englewood Cliffs, N.J.: Prentice-Hall, 1966).

Beaumont Newhall, *Photography: A Short Critical History* (New York: Museum of Modern Art, 1938); and *The History of Photography* (New York: Museum of Modern Art, editions of 1949, 1964, and 1982).

Beaumont Newhall, ed., *Photography: Essays & Images* (New York: Museum of Modern Art, 1980).

Peninah R. Petruck, ed., *The Camera Viewed: Writings on Twentieth-Century Photography* (New York: E. P. Dutton, 1979).

Naomi Rosenblum, *A World History of Photography* (New York: Abbeville Press, 1984).

Robert A. Sobieszek, *Masterpieces of Photography from the George Eastman House Collections* (New York: Abbeville Press, 1985).

John Szarkowski, *Looking at Photographs* (New York: Museum of Modern Art, 1973).

John Szarkowski, *Photography Until Now* (New York: Museum of Modern Art, 1989).

Alan Trachtenberg, *Reading American Photographs: Images as History, Mathew Brady to Walker Evans* (New York: Hill and Wang, 1989).

David Travis, *Photography Rediscovered: American Photographs, 1900-1930* (New York: Whitney Museum of American Art, 1979).

CHAPTER I A Reluctant Modernism 1890-1915

General Works

Peter C. Bunnell, ed., *The Art of Pictorial Photography, 1890-1925* (Princeton: Princeton University Art Museum, 1992).

Jonathan Green, ed., *Camera Work: A Critical Anthology* (Millerton, N.Y.: Aperture, 1973).

Peter Bacon Hales, *Silver Cities: The Photography of American Urbanization, 1839-1915* (Philadelphia: Temple University Press, 1984).

William Innes Homer, ed., *Pictorial Photography in Philadelphia: The Pennsylvania Academy's Salons, 1898-1901* (Philadelphia: Pennsylvania Academy of the Fine Arts, 1984).

Harry W. Lawton and George Knox, eds., *The Valiant Knights of Daguerre: Selected Critical Essays on Photography and Profiles of Photographic Pioneers by Sadakichi Hartmann* (Berkeley: University of California Press, 1978).

Weston Naef, ed., *The Collection of Alfred Stieglitz: Fifty Pioneers of Modern Photography* (New York: Metropolitan Museum of Art, 1978).

Mary Panzer, *Philadelphia Naturalistic Photography, 1865-1906* (New Haven: Yale University Art Gallery, 1982).

Martha A. Sandweiss, ed., *Photography in Nineteenth-Century America* (New York: Harry N. Abrams/Amon Carter Museum, 1991).

Robert Taft, *Photography and the American Scene* (1938; repr. New York: Dover Publications, 1964).

William Welling, *Photography in America: The Formative Years, 1839-1900, A Documentary History* (New York: Thomas Y. Crowell, 1978).

Individual Artists

Horace D. Ashton (U.S., active 1900s)

Wilson A. Bentley (U.S., 1865-1931)

Wilson A. Bentley and W.J. Humphreys, *Snow Crystals* (New York: Dover Publications, 1962).

Duncan C. Blanchard, "Wilson Bentley, Pioneer in Snowflake Photomicrography," *Photographic Applications in Science, Technology and Medicine* 8(May 1973): 26-28, 39-41.

Francis Blake (U.S., 1850-1913)

Anne Brigman (U.S., 1868-1950)

Therese Thau Heyman, *Anne Brigman: Pictorial Photographer/ Member of the Photo-Secession* (Oakland: Oakland Museum, 1974).

John G. Bullock (U.S., 1854-1939)

Tom Beck, *An American Vision: John G. Bullock and the Photo-Secession* (Baltimore: Albin O. Kuhn Library and Gallery/Aperture, 1988).

John Chislett (U.S., 1856-1938)

Alvin Langdon Coburn (Britain, b. U.S., 1882-1966)

Helmut Gernsheim and Alison Gernsheim, eds., *Alvin Langdon Coburn: Photographer, An Autobiography* (London: Faber & Faber, 1966).

Mike Weaver, *Alvin Langdon Coburn: Symbolist Photographer, 1882-1966* (New York: Aperture, 1986).

Edward S. Curtis (U.S., 1868-1952)

Christopher M. Lyman, *The Vanishing Race and Other Illusions: Photographs of Indians by Edward S. Curtis* (New York: Pantheon Books, 1982).

Barbara A. Davis, *Edward S. Curtis: The Life and Times of a Shadow Catcher* (San Francisco: Chronicle Books, 1985).

Dwight A. Davis (U.S., 1852-1944)

F. Holland Day (U.S., 1864-1933)

Ellen Fritz Clattenburg, *The Photographic Work of F. Holland Day* (Wellesley, Mass.: Wellesley College Museum, 1975).

Estelle Jussim, *Slave to Beauty: The Eccentric Life and Controversial Career of F. Holland Day, Photographer, Publisher, Aesthete* (Boston: David R. Godine, 1981).

Baron Adolph de Meyer (U.S., b. Germany, 1868-1949)

Robert Brandau, ed., *De Meyer* (New York: Alfred A. Knopf, 1976).

Rudolf Eickemeyer, Jr. (U.S., 1862-1932)

Mary Panzer, *In My Studio: Rudolf Eickemeyer, Jr. and the Art of the Camera, 1885-1930* (Yonkers, N.Y.: Hudson River Museum, 1986).

Benjamin Falk (U.S., 1853-1925)

William A. Fraser (U.S., ca. 1840-1925)

Arnold Genthe (U.S., b. Germany, 1869-1942)

Arnold Genthe, *As I Remember* (New York: Reynal & Hitchcock, 1936).

John Kuo Wei Tchen, *Genthe's Photographs of San Francisco's Chinatown* (New York: Dover, 1984).

James H. Hare (U.S., b. England, 1856-1946)

Cecil Carnes, *Jimmy Hare News Photographer: Half a Century with a Camera* (New York: Macmillan Company, 1940).

Lewis L. Gould and Richard Greffe, *Photojournalist: The Career of Jimmy Hare* (Austin: University of Texas Press, 1977).

Lewis W. Hine (U.S., 1874-1940)

Walter Rosenblum, Naomi Rosenblum, and Alan Trachtenberg, *America and Lewis Hine: Photographs 1904-1940* (Millerton, N.Y.: Aperture, 1977).

Verna Posever Curtis and Stanley Mallach, *Photography and Reform: Lewis Hine & the National Child Labor Committee* (Milwaukee: Milwaukee Art Museum, 1984).

Daile Kaplan, *Lewis Hine in Europe: The "Lost" Photographs* (New York: Abbeville Press, 1988).

Daile Kaplan, ed., *Photo Story: Selected Letters and Photographs of Lewis W. Hine* (Washington, D.C.: Smithsonian Institution Press, 1992).

Bertha E. Jaques (U.S., 1863-1941)

Clifton Johnson (U.S., 1865-1940)

Frances Benjamin Johnston (U.S., 1864-1952)

Lincoln Kirstein and Frances Benjamin Johnston, *The Hampton Album* (New York: Museum of Modern Art, 1966).

Pete Daniel and Raymond Smock, *A Talent for Detail: The Photographs of Frances Benjamin Johnston, 1889-1910* (New York: Harmony Books, 1974).

Constance W. Glenn and Leland Rice, *Frances Benjamin Johnston,*

Women of Class and Station (Long Beach: Art Museum and Galleries, California State University, 1979).

Gertrude Käsebier (U.S., 1852-1934)

William Innes Homer et. al., *A Pictorial Heritage: The Photographs of Gertrude Käsebier* (Wilmington: University of Delaware/Delaware Art Museum, 1979).

Barbara L. Michaels, *Gertrude Käsebier: The Photographer and Her Photographs* (New York: Harry N. Abrams, 1992).

Edwin Hale Lincoln (U.S., 1848-1938)

George Dimock, *A Persistence of Vision: Photographs by Edwin Hale Lincoln* (Lenox, Mass.: Lenox Library Association/Berkshire Museum, 1981).

Eadweard Muybridge (U.S., b. England, 1830-1904)

Gordon Hendricks, *Eadweard Muybridge: The Father of the Motion Picture* (New York: Grossman Publishers, 1975).

Muybridge's Complete Human and Animal Locomotion (New York: Dover Publications, 1979).

David Harris and Eric Sandweiss, *Eadweard Muybridge and the Photographic Panorama of San Francisco, 1850-1880* (Montreal: Canadian Centre for Architecture, 1993).

James L. Sheldon and Jock Reynolds, *Motion and Document, Sequence and Time: Eadweard Muybridge and Contemporary American Photography* (Seattle: University of Washington Press, 1993).

William B. Post (U.S., 1857-1925)

William H. Rau (U.S., 1855-1920)

Stephen Perloff and Gerald Bastoni, *William Herman Rau: Lehigh Valley Railroad Photographs, 1899* (Bethlehem, Penn.: Lehigh University Art Galleries, 1989).

Robert S. Redfield (U.S., 1849-1923)

Jacob A. Riis (U.S., b. Denmark, 1849-1914)

Alexander Alland, Sr., *Jacob A. Riis, Photographer and Citizen* (Millerton, N.Y.: Aperture, 1974).

Frank A. Rinehart (U.S., 1861-1928)

Harry C. Rubincam (U.S., 1871-1940)

George H. Seeley (U.S., 1880-1955)

George Dimock and Joanne Hardy, *Intimations & Imaginings: The Photographs of George H. Seeley* (Pittsfield, Mass.: Berkshire Museum, 1986).

Thomas O'Conor Sloane, Jr. (U.S., 1879-1963)

Ema Spencer (U.S., 1857-1941)

Edward Steichen (U.S., b. Luxembourg, 1879-1973)

Edward Steichen, *A Life in Photography* (New York: Doubleday & Company, 1963).

Dennis Longwell, *Steichen: The Master Prints 1895-1914, The Symbolist Period* (New York: Museum of Modern Art, 1978).

Alfred Stieglitz (U.S., 1864-1946)

Waldo Frank, Lewis Mumford, Dorothy Norman, Paul Rosenfeld, Harold Rugg, eds., *America and Alfred Stieglitz: A Collective Portrait* (1934; repr. Millerton, N.Y.: Aperture, 1979).

Doris Bry, *Alfred Stieglitz: Photographer* (Boston: Museum of Fine Arts, 1965).

Dorothy Norman, *Alfred Stieglitz: An American Seer* (Millerton, N.Y.: Aperture, 1973).

Marianne Fulton Margolis, ed., *Camera Work: A Pictorial Guide* (New York: Dover Publications, 1978).

Georgia O'Keeffe, *Georgia O'Keeffe: A Portrait by Alfred Stieglitz* (New York: Metropolitan Museum of Art, 1978).

Sarah Greenough and Juan Hamilton, *Alfred Stieglitz: Photographs & Writings* (Washington, D.C.: National Gallery of Art, 1983).

Karl Struss (U.S., 1886-1981)

Susan Harvith and John Harvith, *Karl Struss: Man with a Camera* (Bloomfield Hills, Mich.: Cranbrook Academy of Art/Museum, 1976).

Barbara McCandless, Bonnie Yochelson, and Richard Koszarski, *New York to Hollywood: Photographs by Karl Struss* (Albuquerque: University of New Mexico Press/Amon Carter Museum of Art, 1994).

Adam Clark Vroman (U.S., 1856-1916)

Ruth I. Mahood, ed., *Photographer of the Southwest: Adam Clark Vroman, 1856-1916* (Los Angeles: The Ward Ritchie Press, 1961).

William Webb and Robert A. Weinstein, *Dwellers at the Source: Southwestern Indian Photographs of A.C. Vroman, 1895-1904* (New York: Grossman, 1973).

Clarence H. White (U.S., 1871-1925)

William Innes Homer, ed., *Symbolism of Light: The Photographs of Clarence H. White* (Wilmington: University of Delaware/Delaware Art Museum, 1977).

Peter C. Bunnell, *Clarence H. White: The Reverence for Beauty* (Athens: Ohio University Gallery of Fine Art, 1986).

CHAPTER II Abstraction and Realism 1915-1940

General Works

Lucinda Barnes, Constance W. Glenn, and Jane K. Bledsoe, eds., *A Collective Vision: Clarence H. White and His Students* (Long Beach: California State University Art Museum, 1985).

Van Deren Coke, *Avant-Garde Photography in Germany, 1919-1939* (San Francisco: San Francisco Museum of Modern Art, 1980).

Pete Daniel, Merry A. Foresta, Maren Stange, and Sally Stein, *Official Images: New Deal Photography* (Washington, D.C.: Smithsonian Institution Press, 1987).

Jeannine Fiedler, ed., *Photography at the Bauhaus* (Cambridge, Mass.: MIT Press, 1990).

Carl Fleischhauer and Beverly W. Brannan, eds., *Documenting America, 1935-1943* (Berkeley: University of California Press, 1988).

Maria Morris Hambourg and Christopher Phillips, *The New Vision: Photography Between the World Wars* (New York: Metropolitan Museum of Art/Harry N. Abrams, 1989).

Rosalind Krauss and Jane Livingston, eds., *L'Amour fou: Photography and Surrealism* (Washington, D.C.: Corcoran Gallery of Art, 1985).

Beaumont Newhall and Steven Yates, *Proto-Modern Photography* (Santa Fe: Museum of Fine Arts, Museum of New Mexico, 1992).

Hank O'Neal, *A Vision Shared: A Classic Portrait of America and Its People, 1935-1943* (New York: St. Martin's Press, 1976).

Terence Pitts, *Photography in the American Grain: Discovering a Native American Aesthetic, 1923-1941* (Tucson: Center for Creative Photography, 1988).

John Pultz and Catherine B. Scallen, *Cubism and American Photography, 1910-1930* (Williamstown, Mass.: Sterling and Francine Clark Art Institute, 1981).

Dennis Read, *Japanese Photography in America, 1920-1940* (Los Angeles: George J. Doizaki Gallery/Japanese American Cultural & Community Center, 1985).

William Stott, *Documentary Expression and Thirties America* (New York: Oxford University Press, 1973).

David Travis, *Photographs from the Julien Levy Collection Starting with Atget* (Chicago: Art Institute of Chicago, 1976).

Individual Artists

Berenice Abbott (U.S., 1898-1991)

Elizabeth McCausland and Berenice Abbott, *Changing New York* (1939; repr. as *New York in the Thirties as Photographed by Berenice Abbott* [New York: Dover, 1973]).

Berenice Abbott, *Photographs* (New York: Horizon Press, 1970).

Michael G. Sundell, *Berenice Abbott: Documentary Photographs of the 1930s* (Cleveland: New Gallery of Contemporary Art, 1980).

Ansel Adams (U.S., 1902-1984)

Nancy Newhall, *Ansel Adams: The Eloquent Light* (San Francisco: Sierra Club, 1963).

Ansel Adams, *Examples: The Making of 40 Photographs* (Boston: New York Graphic Society, 1983).

Ansel Adams with Mary Street Alinder, *Ansel Adams: An Autobiography* (Boston: New York Graphic Society, 1985).

Mary Street Alinder and Andrea Gray Stillman, *Ansel Adams: Letters and Images, 1916-1984* (Boston: New York Graphic Society, 1988).

Ilse Bing (U.S., b. Germany 1899)

Nancy C. Barrett, *Ilse Bing: Three Decades of Photography* (New Orleans: New Orleans Museum of Art, 1985).

Frances M. Bode (U.S., active 1920s)

Margaret Bourke-White (U.S., 1904-1971)

Margaret Bourke-White, *Portrait of Myself* (New York: Simon and Schuster, 1963).

Jonathan Silverman, *For the World to See: The Life of Margaret Bourke-White* (New York: Viking Press, 1983).

Vicki Goldberg, *Margaret Bourke-White, A Biography* (Reading, Mass.: Addison-Wesley Publishing Co., 1987).

Maurice Bratter (U.S., 1905-1986)

Talbot M. Brewer (U.S., 1893-1981)

Francis Bruguière (U.S., 1879-1945)

James Enyeart, *Bruguière: His Photographs and His Life* (New York: Alfred A. Knopf, 1977).

Arthur D. Chapman (U.S., 1890-?)

Alfred Cohn (U.S., 1897-1977)

Will Connell (U.S., 1898-1961)

Van Deren Coke, *Photographs by Will Connell: California Photographer and Teacher (1898-1961)* (San Francisco: San Francisco Museum of Modern Art, 1981).

Stephen White, *Will Connell—Interpreter of Intangibles* (Birmingham, Mich.: Halsted Gallery/Stephen White Gallery, 1991).

Marjorie Content (U.S., 1895-1984)

Jill Quasha, *Marjorie Content Photographs* (New York: W. W. Norton, 1994).

Harold Haliday Costain (U.S., 1897-1994)

Imogen Cunningham (U.S., 1883-1976)

Margery Mann, *Imogen!...Photographs 1910-1973* (Seattle: University of Washington Press, 1974).

Richard Lorenz, *Ideas Without End: Imogen Cunningham, A Life in Photographs* (San Francisco: Chronicle Books, 1993).

Harold Edgerton (U.S., 1903-1990)

Harold E. Edgerton and James R. Killian, Jr., *Moments of Vision: The Stroboscopic Revolution in Photography* (Cambridge, Mass.: MIT Press, 1979).

Estelle Jussim and Gus Kayafas, *Stopping Time: The Photographs of Harold Edgerton* (New York: Harry N. Abrams, 1987).

Walker Evans (U.S., 1903-1975)

Walker Evans, *American Photographs* (1938; repr. New York: East River Press, 1975).

James Agee and Walker Evans, *Let Us Now Praise Famous Men* (Boston: Houghton Mifflin Company, 1960).

John Szarkowski, *Walker Evans* (New York: Museum of Modern Art, 1971).

Jerald C. Maddox, *Walker Evans: Photographs for the Farm Security Administration, 1935-1938* (New York: Da Capo Press, 1973).

Walker Evans First and Last (New York: Harper & Row, 1978).

Jerry L. Thompson, *Walker Evans at Work* (New York: Harper & Row, 1982).

Adolf Fassbender (U.S., b. Germany, 1884-1980)

Adolf Fassbender, *Pictorial Artistry: The Dramatization of the Beautiful in Photography* (New York: B. Westermann Company, 1937).

W. Grancel Fitz (U.S., 1894-1963)

Laura Gilpin (U.S., 1891-1979)

Martha A. Sandweiss, *Laura Gilpin: An Enduring Grace* (Fort Worth: Amon Carter Museum, 1986).

Ben Glaha (U.S., 1899-1971)

John Gutmann (U.S., b. Germany 1905)

Max Kozloff and Lew Thomas, *The Restless Decade: John Gutmann's Photographs of the Thirties* (New York: Harry N. Abrams, 1984).

Maia-Mari Sutnik, *Gutmann* (Toronto: Art Gallery of Ontario, 1985).

Johan Hagemeyer (U.S., b. Holland, 1884-1962)

Richard Lorenz, John P. Schaefer, and Terence R. Pitts, *Johan Hagemeyer* (Tucson: Center for Creative Photography, 1982).

Harold L. Harvey (U.S., 1899-1971)

Paul Heismann (U.S., b. 1912)

Florence Henri (Switzerland, b. U.S., 1893-1982)

Diana C. Du Pont, *Florence Henri: Artist-Photographer of the Avant-Garde* (San Francisco: San Francisco Museum of Modern Art, 1990).

E. O. Hoppé (England, 1878-1972)

E. O. Hoppé, *Romantic America: Picturesque United States* (New York: B. Westermann, 1927).

E. O. Hoppé, *Hundred Thousand Exposures* (London: Focal Press, 1945).

Bernard Shea Horne (U.S., 1867-1933)

A Catalog of Design Photographs by Bernard Shea Horne (New York: Keith Douglas de Lellis, 1986).

Tom Howard (U.S., 1893-1961)

Consuelo Kanaga (U.S., 1894-1978)

Sarah M. Lowe and Barbara Head Millstein, *Consuelo Kanaga: An American Photographer* (Brooklyn: Brooklyn Museum, 1992).

Gyorgy Kepes (U.S., b. Hungary 1906)

Gyorgy Kepes: Light Graphics (New York: International Center of Photography, 1984).

André Kertész (U.S., b. Hungary, 1894-1985)

Nicholas Ducrot, ed., *André Kertész: Sixty Years of Photography* (New York: Grossman, 1972).

Nicholas Ducrot, ed., *Distortions: André Kertész* (New York: Alfred A. Knopf, 1976).

André Kertész, *From My Window* (Boston: New York Graphic Society, 1981).

Edwynn Houk and Keith F. Davis, *André Kertész: Vintage Photographs* (Chicago: Edwynn Houk Gallery, 1985).

Sandra S. Phillips, David Travis, and Weston J. Naef, *André Kertész: Of Paris and New York* (Chicago: The Art Institute of Chicago/Metropolitan Museum of Art, 1985).

Robert Enright, *Stranger to Paris: Photographs by André Kertész* (Toronto: Jane Corkin Gallery, 1992).

Dorothea Lange (U.S., 1895-1965)

Suzanne Reiss, *The Making of a Documentary Photographer* (Berkeley: University of California Press, 1968).

Milton Meltzer, *Dorothea Lange: A Photographer's Life* (New York: Farrar, Straus and Giroux, 1978).

Therese Thau Heyman, *Celebrating a Collection: The Work of Dorothea Lange* (Oakland: Oakland Museum, 1978).

Karin Becker Ohrn, *Dorothea Lange and the Documentary Tradition* (Baton Rouge: Louisiana State University Press, 1980).

Therese Thau Heyman, Sandra S. Phillips, and John Szarkowski, *Dorothea Lange: American Photographs* (San Francisco: Chronicle Books, 1994).

Clarence John Laughlin (U.S., 1905-1985)

Clarence John Laughlin, *The Personal Eye* (Millerton, N.Y.: Aperture, 1973).

Keith F. Davis, ed., *Clarence John Laughlin: Visionary Photographer* (Kansas City: Hallmark Cards, 1990).

Alma Lavenson (U.S., 1897-1989)

Susan Ehrens, *Alma Lavenson Photographs* (Berkeley, Calif.: Wildwood Arts, 1990).

Milton Lefkowitz (U.S., active 1920s-30s)

Leonard B. Loeb (U.S., 1891-1978)

Eleanor L. Ludeman (U.S., active 1920s)

George Platt Lynes (U.S., 1907-1955)

Jack Woody, ed., *George Platt Lynes Photographs, 1931-1955* (Pasadena, Calif.: Twelvetrees Press, 1981).

James Crump et al., *George Platt Lynes: Photographs from the Kinsey Institute* (Boston: Bulfinch Press, 1993).

Ira W. Martin (U.S., 1886-1960)

Margrethe Mather (U.S., 1885-1952)

William Justema and Lawrence Jasud, *Margrethe Mather* (Tucson: Center for Creative Photography, 1979).

Toyo Miyatake (U.S., b. Japan, 1895-1979)

Lisette Model (U.S., b. Austria, 1906-1983)

Ann Thomas, *Lisette Model* (Ottawa: National Gallery of Canada, 1990).

Tina Modotti (Italy, 1896-1942)

Mildred Constantine, *Tina Modotti: A Fragile Life* (New York: Rizzoli, 1983).

Amy Stark, ed., *The Letters from Tina Modotti to Edward Weston* (Tucson: Center for Creative Photography, 1986).

Margaret Hooks, *Tina Modotti: Photographer and Revolutionary* (London: Pandora, 1993).

László Moholy-Nagy (U.S., b. Hungary, 1895-1946)

Sibyl Moholy-Nagy, *Moholy-Nagy: Experiment in Totality* (Cambridge, Mass.: MIT Press, 1969).

Leland D. Rice and David W. Steadman, eds., *Photographs of Moholy-Nagy from the Collection of William Larson* (Claremont, Calif.: Pomona College, 1975).

Andreas Haus, *Moholy-Nagy: Photographs and Photograms* (New York: Pantheon, 1980).

Eleanor M. Hight, *Moholy-Nagy: Photography and Film in Weimar Germany* (Wellesley, Mass.: Wellesley College Museum, 1985).

Richard Kostelanetz, *Moholy-Nagy: An Anthology* (New York: DaCapo Press, 1991).

Arthur Mole and John Thomas (U.S., active 1910s)

Barbara Morgan (U.S., 1900-1992)

Peter C. Bunnell, *Barbara Morgan* (Hastings-on-Hudson, N.Y.: Morgan & Morgan, 1972).

Barbara Morgan, *Martha Graham: Sixteen Dances in Photographs* (Dobbs Ferry, N.Y.: Morgan & Morgan, 1980).

Curtis L. Carter and William C. Agee, *Barbara Morgan: Prints, Drawings, Watercolors & Photographs* (Dobbs Ferry, N. Y.: Morgan & Morgan, 1988).

William Mortensen (U.S., 1897-1965)

William Mortensen, *Monsters and Madonnas* (1936; repr. New York: Arno Press, 1973).

Martin Munkacsi (U.S., b. Hungary, 1896-1963)

Nancy White and John Esten, *Style in Motion: Munkacsi Photographs '20s, '30s, '40s* (New York: Clarkson N. Potter, 1979).

Susan Morgan, *Martin Munkacsi* (Millerton, N.Y.: Aperture, 1992).

Kentaro Nakamura (active 1920s)

Lusha Nelson (U.S., b. Latvia, 1900-1938)

Carl Nesensohn (U.S., active 1920s-30s)

Sonya Noskowiak (U.S., b. Germany, 1900-1975)

Sonya Noskowiak (Tucson: Center for Creative Photography, 1979).

Donna Bender, Jan Stevenson, and Terence R. Pitts, *Sonya Noskowiak Archive* (Tucson: Center for Creative Photography, 1982).

Paul Outerbridge, Jr. (U.S., 1896-1958)

Graham Howe and G. Ray Hawkins, eds., *Paul Outerbridge, Jr.: Photographs* (New York: Rizzoli, 1980).

Elaine Dines, ed., *Paul Outerbridge: A Singular Aesthetic, Photographs and Drawings 1921-1941, A Catalogue Raisonné* (Laguna Beach, Calif.: Laguna Beach Museum of Art, 1981).

Edward Quigley (U.S., 1898-1977)

Edward Quigley: American Modernist (New York: Houk Friedman Gallery, 1991).

Man Ray (U.S., 1890-1976)

Man Ray, *Self Portrait* (Boston: Little, Brown and Company, 1963).

Merry Foresta et al., *Perpetual Motif: The Art of Man Ray* (New York: Abbeville Press, 1988).

Neil Baldwin, *Man Ray, American Artist* (1988; repr. New York: Da Capo Press, 1991).

Wynn Richards (U.S., 1888-1960)

Walter Rosenblum (U.S., b. 1919)

Milton W. Brown, *Walter Rosenblum: Photographer* (Cambridge, Mass.: Fogg Art Museum, 1974).

Shelley Rice and Naomi Rosenblum, *Walter Rosenblum* (Dresden: Verlag der Kunst, 1990).

Arthur Rothstein (U.S., 1915-1985)

Arthur Rothstein, *The Depression Years as Photographed by Arthur Rothstein* (New York: Dover Publications, 1978).

Morton Schamberg (U.S., 1881-1918)

Ben Wolf, *Morton Livingston Schamberg* (Philadelphia: University of Pennsylvania Press, 1963).

Robert Seelig (U.S., active 1930s) and **Charles Hoff** (U.S., 1905-1975)

Ben Shahn (U.S., b. Lithuania, 1898-1969)

Margaret R. Weiss, *Ben Shahn Photographer: An Album from the Thirties* (New York: Da Capo Press, 1973).

Davis Pratt, *The Photographic Eye of Ben Shahn* (Cambridge, Mass.: Harvard University Press, 1975).

Charles Sheeler (U.S., 1883-1965)

Constance Rourke, *Charles Sheeler: Artist in the American Tradition* (1938; repr. New York: Kennedy Galleries/Da Capo Press, 1969).

Theodore E. Stebbins, Jr., and Norman Keyes, Jr., *Charles Sheeler: The Photographs* (Boston: Museum of Fine Arts, 1987).

Carol Troyen and Erica E. Hirschler, *Charles Sheeler: Paintings and Drawings* (Boston: Museum of Fine Arts, 1987).

Karen Lucic, *Charles Sheeler and the Cult of the Machine* (Cambridge, Mass.: Harvard University Press, 1991).

Peter Stackpole (U.S., b. 1913)

Peter Stackpole, *The Bridge Builders: Photographs and Documents of the Raising of the San Francisco Bay Bridge 1934-1936* (Corte Madera, Calif.: Pomegranate Artbooks, 1984).

Peter Stackpole, *Peter Stackpole: Life in Hollywood, 1936-1952* (Livingston, Mont.: Clark City Press, 1992).

Ralph Steiner (U.S., 1899-1986)

Ralph Steiner, *A Point of View* (Middletown, Conn.: Wesleyan University Press, 1978).

Paul Strand (U.S., 1890-1976)

Paul Strand and Nancy Newhall, *Time in New England* (1950; repr. New York: Aperture, 1980).

Maren Stange, ed., *Paul Strand: Essays on His Life and Work* (New York: Aperture, 1990).

Sarah Greenough, *Paul Strand: An American Vision* (New York: Aperture, 1990).

Max Thorek (U.S., b. Hungary, 1880-1960)

Doris Ulmann (U.S., 1884-1934)

William Clift and Robert Coles, *The Darkness and the Light: Photographs by Doris Ulmann* (Millerton, N.Y.: Aperture, 1974).

David Featherstone, *Doris Ulmann, American Portraits* (Albuquerque: University of New Mexico Press, 1985).

James Van Der Zee (U.S., 1886-1983)

Deborah Willis-Braithwaite and Rodger C. Birt, *VanDerZee, Photographer: 1886-1983* (New York: Harry N. Abrams/National Portrait Gallery, 1993).

Carl Van Vechten (U.S., 1880-1964)

Keith F. Davis, *The Passionate Observer: Photographs by Carl Van Vechten* (Kansas City: Hallmark Cards, 1993).

Rudolph P. Byrd, *Generations in Black-and-White: Photographs by Carl Van Vechten from the James Weldon Johnson Memorial Collection* (Athens: University of Georgia Press, 1993).

William Vandivert (U.S., b. 1912)

Margaret Watkins (Canada, 1884-1969)

Brett Weston (U.S., 1911-1993)

Beaumont Newhall, *Brett Weston: Voyage of the Eye* (Millerton, N.Y.: Aperture, 1975).

Brett Weston, *Master Photographer* (Carmel, Calif.: Photography West Graphics, 1989).

Edward Weston (U.S., 1886-1958)

Charis Wilson and Edward Weston, *California and the West* (1940; repr. Millerton, N.Y.: Aperture, 1978).

Nancy Newhall, ed., *The Daybooks of Edward Weston: Volume I: Mexico* and *Volume II: California* (Millerton, N.Y.: Aperture, 1973).

Ben Maddow, *Edward Weston: Fifty Years* (Millerton, N.Y.: Aperture, 1973).

Amy Conger, *Edward Weston in Mexico, 1923-1926* (Albuquerque: University of New Mexico Press, 1983).

Beaumont Newhall and Amy Conger, eds., *Edward Weston Omnibus* (Salt Lake City: Gibbs M. Smith, 1984).

Peter C. Bunnell and David Featherstone, eds., *EW:100*, Centennial Essays in Honor of Edward Weston (Carmel, Calif.: Friends of Photography, 1986).

Beaumont Newhall, *Supreme Instants: The Photographs of Edward Weston* (Boston: New York Graphic Society, 1986).

Amy Conger, *Edward Weston: Photographs from the Collection of the Center for Creative Photography* (Tucson: Center for Creative Photography, 1992).

CHAPTER III **From Public to Private Concerns 1940-1965**

General Works

Jonathan Green, *American Photography: A Critical History 1945 to the Present* (New York: Harry N. Abrams, 1984).

Andy Grundberg and Kathleen McCarthy Gauss, *Photography and Art: Interactions since 1946* (Los Angeles: Los Angeles County Museum of Art/Museum of Art, Fort Lauderdale/Abbeville Press, 1987).

Martin Harrison, *Appearances: Fashion Photography Since 1945* (New York: Rizzoli, 1991).

Jane Livingston, *The New York School: Photographs 1936-1963* (New York: Stewart, Tabori & Chang, 1992).

Charles Traub and John Grimes, *The New Vision: Forty Years of Photography at the Institute of Design* (Millerton, N.Y.: Aperture, 1981).

Peter Turner, *American Images: Photography 1945-1980* (Harmondsworth, Eng.: Penguin Books/Barbican Art Gallery, 1985).

Individual Artists

Richard Avedon (U.S., b. 1923)

Richard Avedon, *Portraits* (New York: Farrar, Straus and Giroux, 1976).

Richard Avedon, *An Autobiography* (New York: Random House, 1993).

Richard Avedon, *Evidence, 1944-1994* (New York: Random House, 1994).

Lillian Bassman (U.S., b. 1918)

Ruth Bernhard (U.S., b. Germany 1905)

James Alinder, *Collecting Light: The Photographs of Ruth Bernhard* (Carmel, Calif.: Friends of Photography, 1979).

Margaretta K. Mitchell, *Ruth Bernhard: The Eternal Body* (Carmel, Calif.: Photography West Graphics, 1986).

Ruth Bernhard: The Collection of Ginny Williams (Santa Fe: Tallgrass Press, 1993).

Harry Callahan (U.S., b. 1912)

John Szarkowski, *Callahan* (New York: Museum of Modern Art/ Aperture, 1976).

Peter C. Bunnell, *Harry Callahan* (New York: American Federation of Arts, 1978).

Harry Callahan, *Water's Edge* (Lyme, Conn.: Callaway Editions/ Viking Press, 1980).

Keith F. Davis, *Harry Callahan: Photographs* (Kansas City: Hallmark Cards, 1981).

Louise Shaw, Virginia Beahan, and John McWilliams, *Harry Callahan and His Students: A Study in Influence* (Atlanta: Georgia State University Art Gallery, 1983).

Keith F. Davis, *Harry Callahan: New Color, Photographs 1978-1987* (Kansas City: Hallmark Cards, 1988).

Carlotta Corpron (U.S., 1901-1988)

Martha A. Sandweiss, *Carlotta Corpron: Designer With Light* (Austin: University of Texas Press/Amon Carter Museum, 1980).

Ralston Crawford (U.S., b. Canada, 1906-1978)

Barbara Haskell, *Ralston Crawford* (New York: Whitney Museum of American Art, 1985).

Roy DeCarava (U.S., b. 1919)

Langston Hughes and Roy DeCarava, *The Sweet Flypaper of Life* (1955; repr. Washington, D.C.: Howard University Press, 1984).

James Alinder, ed., *Roy DeCarava, Photographs* (Carmel, Calif.: Friends of Photography, 1981).

Morris Engel (U.S., b. 1918)

Elliott Erwitt (U.S., b. France 1928)

Elliott Erwitt, *Personal Exposures* (New York: W. W. Norton, 1988).

Elliott Erwitt, *Elliott Erwitt: photographies, 1946-1988* (Paris: Nathan Image, 1988).

Louis Faurer (U.S., b. 1916)

Edith A. Tonelli, *Louis Faurer: Photographs from Philadelphia and New York, 1937-1973* (College Park: University of Maryland Art Gallery, 1981).

Andreas Feininger (U.S., b. France 1906)

Stuart Alexander, *The Archive: Andreas Feininger, Early Work* (Tucson: Center for Creative Photography, 1983).

Robert Frank (U.S., b. Switzerland 1924)

Robert Frank, *The Americans* (1959; repr. New York: Aperture, 1969).

Anne Wilkes Tucker, ed., *Robert Frank: New York to Novia Scotia* (Houston: Museum of Fine Arts, 1986).

Stuart Alexander, *Robert Frank: A Bibliography, Filmography, and Exhibition Chronology 1946-1985* (Tucson: Center for Creative Photography, 1986).

Sarah Greenough and Philip Brookman, *Robert Frank: Moving Out* (Washington, D.C.: National Gallery of Art & Scalo, 1994).

Lee Friedlander (U.S., b. 1934)

Lee Friedlander, *Self Portrait* (New City, N.Y.: Haywire Press, 1970).

Lee Friedlander, *Lee Friedlander: Photographs* (New City, N.Y.: Haywire Press, 1978).

Rod Slemmons, *Like a One-Eyed Cat: Photographs by Lee Friedlander 1956-1987* (N.Y.: Harry N. Abrams/Seattle Art Museum, 1989).

Lee Friedlander, *Nudes* (New York: Pantheon Books, 1991).

William Garnett (U.S., b. 1916)

William Garnett, *The Extraordinary Landscape: Aerial Photographs of America* (Boston: Little, Brown and Company, 1982).

Martha A. Sandweiss, *William Garnett: Aerial Photographs* (Berkeley: University of California Press, 1994).

Herbert Gehr (U.S., b. Germany, 1910-1983)

Leslie Gill (U.S., 1908-1958)

Tina Freeman and Frances McLaughlin-Gill, eds., *Leslie Gill: A Classical Approach to Photography 1935-1958* (New Orleans: New Orleans Museum of Art, 1983).

Sid Grossman (U.S., 1913-1955)

Sid Grossman and Millard Campbell, *Journey to the Cape* (New York: Grove Press, 1959).

Joseph Jachna (U.S., b. 1935)

Steven Klindt, *Light Touching Silver: Photographs by Joseph D. Jachna* (Chicago: Chicago Center for Contemporary Photography, 1980).

Lotte Jacobi (U.S., b. Germany, 1896-1990)

Kelly Wise, ed., *Lotte Jacobi* (Danbury, N.H.: Addison House, 1978).

N. Jay Jaffee (U.S., b. 1921)

Kenneth Josephson (U.S., b. 1932)

Lynne Warren and Carl Chiarenza, *Kenneth Josephson* (Chicago: Museum of Contemporary Art, 1983).

Charles Kerlee (U.S., 1907-1981)

William Klein (U.S., b. 1928)

John Heilpern, *William Klein: Photographs* (Millerton, N.Y.: Aperture, 1981).

William Klein, *Close Up* (London: Thames and Hudson, 1989).

Saul Leiter (U.S., b. 1923)

Leon Levinstein (U.S., 1913-1988)

Helen Gee, *Leon Levinstein* (New York: Photofind Gallery, 1990).

Helen Levitt (U.S., b. 1913)

Helen Levitt and James Agee, *A Way of Seeing* (1965; repr. New York: Horizon Press, 1981).

Sandra S. Phillips and Maria Morris Hambourg, *Helen Levitt* (San Francisco: San Francisco Museum of Modern Art, 1991).

Jerome Liebling (U.S., b. 1924)

Estelle Jussim, *Jerome Liebling: Photographs 1947-1977* (Carmel, Calif.: Friends of Photography, 1978).

Anne Halley and Alan Trachtenberg, *Jerome Liebling Photographs* (New York: Aperture, 1982).

O. Winston Link (U.S., b. 1914)

Ghost Trains: Railroad Photographs of the 1950s by O. Winston Link (Norfolk, Va.: Chrysler Museum, 1983).

Tim Hensley, *Steam, Steel, & Stars: America's Last Steam Railroad, Photographs by O. Winston Link* (New York: Harry N. Abrams, 1987).

Ralph Eugene Meatyard (U.S., 1925-1972)

James Baker Hall, ed., *Ralph Eugene Meatyard* (Millerton, N.Y.: Aperture, 1974).

Barbara Tannenbaum, ed., *Ralph Eugene Meatyard: An American Visionary* (New York: Rizzoli/Akron Art Museum, 1991).

Ray K. Metzker (U.S., b. 1931)

Anne Wilkes Tucker, *Unknown Territory: Photographs by Ray K. Metzker* (Houston: Museum of Fine Arts/Aperture, 1984).

Richard B. Woodward, *Ray K. Metzker: Composites* (New York: Laurence Miller Gallery, 1990).

Duane Michals (U.S., b. 1932)

Duane Michals, *A Visit With Magritte* (Providence, R.I.: Matrix Publications, 1981).

Wright Morris (U.S., b. 1910)

Wright Morris: Structures and Artifacts, Photographs 1933-1954 (Lincoln, Neb.: Sheldon Memorial Art Gallery, 1975).

James Alinder, ed., *Wright Morris: Photographs and Words* (Carmel, Calif.: Friends of Photography, 1982).

Sandra S. Phillips and John Szarkowski, *Wright Morris: Origin of a Species* (San Francisco: San Francisco Museum of Modern Art, 1992).

Arnold Newman (U.S., b. 1918)

One Mind's Eye: The Portraits and Other Photographs of Arnold Newman (Boston: David R. Godine, 1974).

Arnold Newman, *Artists: Portraits from Five Decades* (Boston: New York Graphic Society, 1980).

Arnold Newman, *Five Decades* (San Diego: Harcourt Brace Jovanovich, 1986).

Marvin E. Newman (U.S., b. 1927)

Gordon Parks (U.S., b. 1912)

Gordon Parks, *Voices in the Mirror: An Autobiography* (New York: Doubleday, 1990).

Irving Penn (U.S., b. 1917)

John Szarkowski, *Irving Penn* (New York: Museum of Modern Art, 1984).

Irving Penn, *Passage: A Work Record* (New York: Alfred A. Knopf, 1991).

Joe Rosenthal (U.S., b. 1911)

Arthur Siegel (U.S., 1913-1978)

John Grimes, "Arthur Siegel: A Short Critical Biography," *Exposure* 17(Summer 1979): 22-35.

John Grimes, *Arthur Siegel: Retrospective* (Chicago: Edwynn Houk Gallery, 1982).

Art Sinsabaugh (U.S., 1924-1983)

Henry Holmes Smith and Sherman Paul, *The Chicago Landscapes of Art Sinsabaugh* (Chicago: Art Sinsabaugh, 1976).

Aaron Siskind (U.S., 1903-1991)

Nathan Lyons, ed., *Aaron Siskind Photographer* (Rochester, N.Y.: George Eastman House, 1965).

Thomas B. Hess, *Places: Aaron Siskind Photographs* (New York: Light Gallery/Farrar, Straus and Giroux, 1976).

Carl Chiarenza, *Aaron Siskind: Pleasures and Terrors* (Boston: New York Graphic Society, 1982).

Henry Holmes Smith (U.S., 1909-1986)

Howard Bossen, *Henry Holmes Smith, Man of Light* (Ann Arbor, Mich.: UMI Research Press, 1983).

James Enyeart and Nancy Solomon, eds., *Henry Holmes Smith: Collected Writings 1935-1985* (Tucson: Center for Creative Photography, 1986).

Leland Rice, *Henry Holmes Smith, Photographs 1931-1986: A Retrospective* (New York: Howard Greenberg Gallery, 1992).

W. Eugene Smith (U.S., 1918-1978)

W. Eugene Smith: His Photographs and Notes (New York: Aperture, 1969).

William S. Johnson, *W. Eugene Smith: Master of the Photographic Essay* (Millerton, N.Y.: Aperture, 1981).

Jim Hughes, *W. Eugene Smith: Shadow & Substance* (New York: McGraw-Hill, 1989).

Glenn G. Willumson, *W. Eugene Smith and the Photographic Essay* (Cambridge: Cambridge University Press, 1992).

Frederick Sommer (U.S., b. Italy 1905)

John Weiss, ed., *Venus, Jupiter and Mars: The Photographs of Frederick Sommer* (Wilmington: Delaware Art Museum, 1980).

Constance W. Glenn and Jane K. Bledsoe, *Frederick Sommer at Seventy-Five* (Long Beach: Art Museum and Galleries, California State University, 1980).

Sommer: Words and Pictures (Tucson: Center for Creative Photography, 1984).

Joseph Sterling (U.S., b. 1936)

Louis Stettner (U.S., b. 1922)

Louis Stettner, *Early Joys: Photographs from 1947-1972* (New York: J. Iffland, 1987).

Charles Swedlund (U.S., b. 1935)

Charles A. Swedlund Photographs: Multiple Exposures with the Figure (Cobden, Ill.: Anna Press, 1973).

Val Telberg (U.S., b. Russia 1910)

Van Deren Coke, *Val Telberg* (San Francisco: San Francisco Museum of Modern Art, 1983).

Edmund Teske (U.S., b. 1911)

Edmund Teske, *Images From Within* (Carmel, Calif.: Friends of Photography, 1980).

Jerry N. Uelsmann (U.S., b. 1934)

Jerry N. Uelsmann, *Silver Meditations* (Dobbs Ferry, N.Y.: Morgan & Morgan, 1975).

James L. Enyeart, *Jerry N. Uelsmann, Twenty-Five Years: A Retrospective* (Boston: Little, Brown and Company, 1982).

William Vandivert (U.S., b. 1912)

Todd Webb (U.S., b. 1905)

Keith F. Davis, *Todd Webb: Photographs of New York and Paris, 1945-1960* (Kansas City: Hallmark Cards, 1986).

Todd Webb, *Looking Back: Memoirs and Photographs* (Albuquerque: University of New Mexico Press, 1991).

Weegee [Arthur Fellig] (U.S., b. Poland, 1899-1968)

Weegee, *Naked City* (1945; repr. New York: Dover, 1985).

Louis Stettner, ed., *Weegee* (New York: Alfred A. Knopf, 1977).

John Coplans, *Weegee's New York* (New York: Grove Press/Schirmer/Mosel, 1982).

Dan Weiner (U.S., 1919-1959)

Cornell Capa and Sandra Weiner, eds., *Dan Weiner* (New York: Grossman, 1974).

William A. Ewing, *America Worked: The 1950s Photographs of Dan Weiner* (New York: Harry N. Abrams, 1989).

Minor White (U.S., 1908-1976)

James Baker Hall, *Minor White: Rites and Passages* (Millerton, N.Y.: Aperture, 1978).

Peter C. Bunnell, *Minor White: The Eye That Shapes* (Princeton: Princeton University Art Museum/Bulfinch Press, 1989).

Garry Winogrand (U.S., 1928-1984)

John Szarkowski, *Winogrand: Figments From The Real World* (New York: Museum of Modern Art, 1988).

Max Yavno (U.S., 1911-1985)

Ben Maddow, *The Photography of Max Yavno* (Berkeley: University of California Press, 1981).

CHAPTER IV The Image Transformed 1965-Present

General Works

Richard Bolton, ed., *The Contest of Meaning: Critical Histories of Photography* (Cambridge, Mass.: MIT Press, 1989).

Victor Burgin, ed., *Thinking Photography* (London: Macmillan, 1982).

Hal Foster, ed., *The Anti-Aesthetic: Essays on Postmodern Culture* (Port Townsend, Wash.: Bay Press, 1983).

Kathleen McCarthy Gauss, *New American Photography* (Los Angeles: Los Angeles County Museum of Art, 1985).

Andy Grundberg, *Crisis of the Real: Writings on Photography 1974-1989* (New York: Aperture, 1990).

Anne H. Hoy, *Fabrications: Staged, Altered and Appropriated Photographs* (New York: Abbeville Press, 1987).

William Jenkins, *New Topographics: Photographs of a Man-Altered Landscape* (Rochester, N.Y.: George Eastman House, 1975).

William J. Mitchell, *The Reconfigured Eye: Visual Truth in the Post-Photographic Era* (Cambridge, Mass.: MIT Press, 1992).

Joshua P. Smith and Merry A. Foresta, *The Photography of Invention: American Pictures of the 1980s* (Washington, D.C.: Smithsonian Institution Press, 1989).

Susan Sontag, *On Photography* (New York: Farrar, Straus and Giroux, 1977).

John Szarkowski, *Mirrors and Windows: American Photography Since 1960* (New York: Museum of Modern Art, 1978).

Brian Wallis, ed., *Art After Modernism: Rethinking Representation* (Boston: David R. Godine, 1984).

Lee D. Witkin and Barbara London, *The Photograph Collector's Guide* (Boston: New York Graphic Society, 1979).

Individual Artists

Robert Adams (U.S., b. 1937)

Robert Adams, *The New West: Landscapes Along the Colorado Front Range* (Boulder: Colorado Associated University Press, 1974).

Robert Adams, *The New West: Landscapes Along the Colorado Front Range* (Boulder: Colorado Associated University Press, 1974).

Robert Adams, *From the Missouri West* (Millerton, N.Y.: Aperture, 1980).

Robert Adams, *Beauty in Photography: Essays in Defense of Traditional Values* (Millerton, N.Y.: Aperture, 1981).

Robert Adams, *Summer Nights* (New York: Aperture, 1985).

Robert Adams, *Los Angeles Spring* (New York: Aperture, 1986).

Robert Adams, *To Make It Home: Photographs of the American West* (New York: Aperture, 1989).

John Baldessari (U.S., b. 1931)

Coosje Van Bruggen, *John Baldessari* (New York: Rizzoli, 1990).

Lewis Baltz (U.S., b. 1945)

Lewis Baltz, *The New Industrial Parks near Irvine, California* (New York: Castelli Graphics, 1974).

Lewis Baltz and Gus Blaisdell, *Park City* (Albuquerque: Artspace Press/Castelli Graphics/Aperture, 1980).

Lewis Baltz, *Rule Without Exception* (Albuquerque: University of New Mexico Press/Des Moines Art Center, 1990).

Tina Barney (U.S., b. 1945)

Tina Barney, *Friends and Relations* (Washington, D.C.: Smithsonian Institution Press, 1991).

Thomas F. Barrow (U.S., b. 1938)

Kathleen McCarthy Gauss, *Inventories and Transformations: The Photographs of Thomas Barrow* (Albuquerque: University of New Mexico Press, 1986).

Richard Benson (U.S., b. 1943)

Richard Benson and Lincoln Kirstein, *Lay This Laurel* (New York: Eakins Press, 1973).

Zeke Berman (U.S., b. 1951)

Marvin Trachtenberg, *Zeke Berman Photographs* (New York: Lieberman & Saul Gallery, 1989).

Keith F. Davis, *Zeke Berman Photographs* (Kansas City, Mo.: University of Missouri-Kansas City Gallery of Art, 1992).

Debra Hermerdinger, *Optiks: Photographs by Zeke Berman* (San Francisco: Friends of Photography, 1992).

Larry Burrows (England, 1926-1971)

Editors of Time-Life, *Larry Burrows: Compassionate Photographer* (New York: Time, Inc., 1972).

Nancy Burson (U.S., b. 1948)

Nancy Burson, Richard Carling, and David Kramlich, *Composites: Computer-Generated Portraits* (New York: Beech Tree Books, 1986).

Nancy Burson, *Faces* (Houston: Contemporary Arts Museum, 1992).

Peter Campus (U.S., b. 1937)

Peter Campus, Wulf Herzogenrath, and Roberta Smith, *Peter Campus* (Cologne: Kölnischer Kunstverein, 1979).

David S. Rubin and Judith Tannenbaum, *Peter Campus: Selected Works 1973-1987* (Reading, Penn.: Freedman Gallery, Albright College, 1987).

Keith Carter (U.S., b. 1948)

Keith Carter, *From Uncertain to Blue* (Austin: Texas Monthly Press, 1988).

Keith Carter, *The Blue Man* (Houston: Rice University Press, 1990).

James Casebere (U.S., b. 1953)

James Casebere (Tampa: Museum of the University of South Florida, 1990).

James Casebere (Nevers, France: APAC, 1991).

Carl Chiarenza (U.S., b. 1935)

Carl Chiarenza, Estelle Jussim, and Charles W. Millard, *Chiarenza: Landscapes of the Mind* (Boston: David R. Godine, 1988).

William Christenberry (U.S., b. 1936)

William Christenberry, *Southern Photographs* (Millerton, N.Y.: Aperture, 1983).

Thomas W. Southall, *Of Time and Place: Walker Evans and William Christenberry* (San Francisco: Friends of Photography/Amon Carter Museum of Art/University of New Mexico Press, 1990).

Mark J. Spencer and J. Richard Gruber, *William Christenberry* (St. Joseph, Mo.: Albrecht-Kemper Museum of Art, 1994).

Chuck Close (U.S., b. 1940)

Lisa Lyons and Martin Friedman, *Close Portraits* (Minneapolis, Minn.: Walker Art Center, 1980).

Lisa Lyons and Robert Storr, *Chuck Close* (New York: Rizzoli, 1987).

Joechen Poitter, Helmut Friedel, and Robert Storr, *Chuck Close: Retrospective* (Baden-Baden: Staatliche Kunsthalle, 1994).

Lois Conner (U.S., b. 1951)

Photographs of China by Lois Conner: In the Shadow of the Wall (Taichung: Taiwan Museum of Art, 1992).

Lois Conner, *Panoramas of the Far East* (Washington, D.C.: Smithsonian Institution Press, 1993).

Linda Connor (U.S., b. 1944)

Linda Connor, *Solos* (Millerton, N.Y.: Apeiron Workshops, 1979).

Jane Livingston, *Linda Connor* (Washington, D.C.: Corcoran Gallery of Art, 1982).

Rebecca Solnit and Denise Miller-Clark, *Linda Connor: Spiral Journey, Photographs 1967-1990* (Chicago: Chicago Museum of Contemporary Photography, 1990).

John Coplans (U.S., b. England 1920)

John Coplans, *A Body of Work* (New York: Printed Matter, 1987).

John Coplans, *Hand* (New York: Galerie Lelong, 1988).

John Coplans, *Foot* (New York: Galerie Lelong, 1989).

Robert Cumming (U.S., b. 1943)

James Alinder, *Cumming Photographs* (Carmel, Calif.: Friends of Photography, 1979).

Lynn Davis (U.S., b. 1944)

Joe Deal (U.S., b. 1947)

Mark Johnstone and Edward Leffingwell, *Joe Deal: Southern California Photographs, 1976-86* (Albuquerque: University of New Mexico Press, 1992).

Jed Devine (U.S., b. 1944)

Jed Devine and Jim Dinsmore, *Friendship* (Gardiner, Maine: Tilbury House, 1994).

Rick Dingus (U.S., b. 1951)

William Eggleston (U.S., b. 1939)

John Szarkowski, *William Eggleston's Guide* (New York: Museum of Modern Art, 1976).

William Eggleston, *The Democratic Forest* (New York: Doubleday, 1989).

William Eggleston, *Ancient and Modern* (New York: Random House, 1992).

Wendy Ewald (U.S., b. 1951)

Wendy Ewald, *Portraits and Dreams: Photographs and Stories by Children of the Appalachians* (London: Writers and Readers, 1985).

Wendy Ewald, *Magic Eyes: Scenes from an Andean Girlhood* (Seattle: Bay Press, 1992).

Adam Fuss (England, b. 1961)

Barbara Tannenbaum, *Adam Fuss: Photograms* (Akron, Oh.: Akron Art Museum, 1992).

Ralph Gibson (U.S., b. 1939)

Ralph Gibson, *The Somnambulist* (New York: Lustrum Press, 1970).

Ralph Gibson, *Deja-Vu* (New York: Lustrum Press, 1973).

Ralph Gibson, *Days At Sea* (New York: Lustrum Press, 1974).

John Gossage (U.S., b. 1946)

John Gossage, *The Pond* (New York: Aperture, 1985).

John Gossage, *Stadt des Schwarz* (Washington, D.C.: Loosestrife Editions, 1987).

Emmet Gowin (U.S., b. 1941)

Emmet Gowin, *Emmet Gowin Photographs* (New York: Alfred A. Knopf, 1976).

Martha Chahroudi, *Emmet Gowin Photographs* (Philadelphia: Philadelphia Museum of Art, 1990).

Jan Groover (U.S., b. 1943)

Laurence Shopmaker and Alan Trachtenberg, *Jan Groover* (Purchase: State University of New York, 1983).

Susan Kismaric, *Jan Groover* (New York: Museum of Modern Art, 1987).

Jan Groover, *Pure Invention: The Table Top Still Life* (Washington, D.C.: Smithsonian Institution Press, 1990).

John Szarkowski, *Jan Groover Photographs* (Boston: Bulfinch Press, 1993).

Robert Heinecken (U.S., b. 1931)

James Enyeart, ed., *Heinecken* (New York: Light Gallery/Friends of Photography, 1980).

Mark Klett (U.S., b. 1952)

Peter Bacon Hales, *One City/Two Visions: Eadweard Muybridge & Mark Klett, San Francisco Panoramas, 1878 and 1990* (San Francisco: Bedford Arts, 1990).

Patricia Nelson Limerick and Thomas W. Southall, *Revealing Territory: Photographs of the Southwest by Mark Klett* (Albuquerque: University of New Mexico, 1992).

Barbara Kruger (U.S., b. 1945)

Craig Owens et al., *We Won't Play Nature to Your Culture: Works by Barbara Kruger* (London: Institute of Contemporary Art, 1983).

Kate Linker, *Love For Sale: The Words and Pictures of Barbara Kruger* (New York: Harry N. Abrams, 1990).

Barbara Kruger, *Remote Control: Power, Cultures, and the World of Appearances* (Cambridge, Mass.: MIT Press, 1993).

William Larson (U.S., b. 1942)

William Larson, *Fireflies* (Philadelphia: Gravity Press, 1976).

Paula Marincola, *William Larson: Photographs 1969-1985* (Philadelphia: Institute of Contemporary Art, 1986).

Annie Leibovitz (U.S., b. 1949)

Annie Leibovitz Photographs 1970-1990 (New York: HarperCollins, 1991).

David Levinthal (U.S., b. 1949)

David Levinthal and Garry Trudeau, *Hitler Moves East, A Graphic Chronicle, 1941-43* (Kansas City: Sheed Andrews and McMeel, 1977).

David Levinthal, *The Wild West* (Washington, D.C.: Smithsonian Institution Press, 1993).

W. Snyder MacNeil (U.S., b. 1943)

Eugenia Parry Janis, *W. Snyder MacNeil: Daughter/Father* (Boston: Photographic Resource Center, 1988).

Sally Mann (U.S., b. 1951)

Sally Mann, *At Twelve* (New York: Aperture, 1988).

Sally Mann, *Immediate Family* (New York: Aperture, 1992).

Robert Mapplethorpe (U.S., 1946-1989)

Janet Kardon, *Robert Mapplethorpe: The Perfect Moment* (Philadelphia: Institute of Contemporary Art, 1988).

Richard Marshall, Ingrid Sischy, and Richard Howard, *Robert Mapplethorpe* (Boston: New York Graphic Society, 1988).

Arthur C. Danto, *Mapplethorpe* (New York: Random House, 1992).

Patricia Morrisroe, *Mapplethorpe: A Biography* (New York: Random House, 1993).

Gordon Matta-Clark (U.S., 1943-1978)

Mary Jane Jacobs, Robert Pincus-Witten, and Joan Simon, *Gordon Matta-Clark: A Retrospective* (Chicago: Museum of Contemporary Art, 1985).

Corinne Diserens, Mariane Brouwer, Judith Russi Kirshner et al., *Gordon Matta-Clark* (Valencia: IVAM Centre Julio Gonzalez, 1993).

David McDermott (U.S., b. 1952) and **Peter McGough** (U.S., b. 1958)

Messrs. McDermott & McGough (Kyoto: Kyoto Shoin/Art Random, 1990).

Wolfgang Fetz and Gerald Matt, *Messrs. McDermott & McGough: Some Modern Photographers and Their Work* (Bregenz: Vorarlberger Kunstverein, 1993).

Joel Meyerowitz (U.S., b. 1938)

Joel Meyerowitz, *Cape Light* (Boston: Museum of Fine Arts/New York Graphic Society, 1978).

Joel Meyerowitz, *St. Louis & The Arch* (Boston: New York Graphic Society/St. Louis Art Museum, 1980).

Joel Meyerowitz, *Creating a Sense of Place* (Washington, D.C.: Smithsonian Institution Press, 1990).

Richard Misrach (U.S., b. 1949)

Richard Misrach, *A Book of Photographs* (San Francisco: Grapestake Gallery, 1979).

Richard Misrach, *Desert Cantos* (Albuquerque: University of New Mexico Press, 1987).

Richard Misrach Photographs 1975-1987 (Tokyo: Gallery Min, 1988).

Richard Misrach and Myriam Weisang Misrach, *Bravo 20: The Bombing of the American West* (Baltimore: Johns Hopkins University Press, 1990).

Richard Misrach and Susan Sontag, *Violent Legacies: Three Cantos* (New York: Aperture, 1992).

Andrea Modica (U.S., b. 1960)

Andrea Modica, *Minor League* (Washington, D.C.: Smithsonian Institution Press, 1993).

Charles Moore (U.S., b. 1931)

Michael S. Durham, *Powerful Days: The Civil Rights Photography of Charles Moore* (New York: Stewart, Tabori & Chang, 1991).

Abelardo Morell (U.S., b. Cuba 1948)

Nicholas Nixon (U.S., b. 1947)

Peter Galassi, *Nicholas Nixon, Pictures of People* (New York: Museum of Modern Art, 1988).

Nicholas Nixon, *Family Pictures* (Washington, D.C.: Smithsonian Institution Press, 1991).

Nicholas Nixon and Bebe Nixon, *People With AIDS* (Boston: David R. Godine, 1991).

John Pfahl (U.S., b. 1939)

Edward Bryant, *Picture Windows: Photographs by John Pfahl* (Boston: New York Graphic Society, 1987).

Estelle Jussim, *A Distanced Land: The Photographs of John Pfahl* (Albuquerque: University of New Mexico Press/Albright-Knox Art Gallery, 1990).

Leland Rice (U.S., b. 1940)

Leland Rice and Charles E. McClelland, *Up Against It: Photographs of the Berlin Wall* (Albuquerque: University of New Mexico Press, 1991).

Milton Rogovin (U.S., b. 1909)

Robert J. Doherty and Fred Licht, *Milton Rogovin: The Forgotten Ones* (Seattle: University of Washington Press/Albright-Knox Art Gallery, 1985).

Milton Rogovin and Michael Frisch, *Portraits in Steel* (Ithaca, N.Y.: Cornell University Press, 1993).

Milton Rogovin, *Triptychs: Buffalo's Lower West Side Revisited* (New York: W. W. Norton, 1994).

Lucas Samaras (U.S., b. Greece 1936)

Ben Lifson, *Samaras: The Photographs of Lucas Samaras* (New York: Aperture, 1987).

Andres Serrano (U.S., b. 1950)

Cindy Sherman (U.S., b. 1954)

Peter Schjeldahl and Lisa Phillips, *Cindy Sherman* (New York: Whitney Museum of American Art, 1987).

Rosalind Krauss and Norman Bryson, *Cindy Sherman 1975-1993* (New York: Rizzoli, 1993).

Sandy Skoglund (U.S., b. 1946)

Patrick Roegiers and Gloria Picazo, *Sandy Skoglund* (Barcelona: Fundacio La Caixa, 1992).

Michael Spano (U.S., b. 1949)

Doug Starn (U.S., b. 1961) and **Mike Starn** (U.S., b. 1961)

Andy Grundberg, *Mike and Doug Starn* (New York: Harry N. Abrams, 1990).

David Stephenson (U.S., b. 1955)

Joel Sternfeld (U.S., b. 1944)

Andy Grundberg and Anne W. Tucker, *American Prospects: Photographs by Joel Sternfeld* (1987; repr. San Francisco: Friends of Photography/Chronicle Books, 1994).

Joel Sternfeld, Richard Brilliant, and Theodore E. Stebbins, *Campagna Romana: The Countryside of Ancient Rome* (New York: Alfred A. Knopf, 1992).

Hiroshi Sugimoto (Japan, b. 1948)

Kerry Brougher, *Sugimoto* (Los Angeles: Museum of Contemporary Art, 1993).

Larry Sultan (U.S., b. 1946)

Larry Sultan, *Pictures from Home* (New York: Harry N. Abrams, 1992).

Ruth Thorne-Thomsen (U.S., b. 1943)

Denise Miller-Clark, *Within this Garden: Photographs by Ruth Thorne-Thomsen* (Chicago: Chicago Museum of Contemporary Photography/Aperture, 1993).

Arthur Tress (U.S., b. 1940)

John Minahan, *Arthur Tress: The Dream Collector* (Richmond, Va.: Westover Publishing Co., 1972).

Arthur Tress, *Theater of the Mind* (Dobbs Ferry, N.Y.: Morgan & Morgan, 1976).

Marco Livingstone, ed., *Arthur Tress: Talisman* (New York: Thames and Hudson, 1986).

Tseng Kwong Chi (U.S., b. Hong Kong, 1950-1990)

Tseng Kwong Chi (Tokyo: Kyoto Shoin, 1989).

Barry Blinderman, *Tseng Kwong Chi: The Expeditionary Works* (Houston: Houston Center for Photography, 1992).

Andy Warhol (U.S., 1928-1987)

Robert Rosenblum, Benjamin H. D. Buchloh, and Marco Livingstone, *Andy Warhol: A Retrospective* (New York: Museum of Modern Art, 1989).

Carrie Mae Weems (U.S., b. 1953)

Carrie Mae Weems, *Then What? Photographs and Folklore* (Buffalo: CEPA Gallery, 1990).

Andrea Kirsh and Susan Fisher Sterling, *Carrie Mae Weems* (Washington, D.C.: National Museum of Women in the Arts, 1993).

Joel-Peter Witkin (U.S., b. 1939)

Van Deren Coke, *Joel-Peter Witkin: Forty Photographs* (San Francisco: San Francisco Museum of Modern Art, 1985).

Joel-Peter Witkin, *Gods of Earth and Heaven* (Pasadena, Calif.: Twelvetrees Press, 1991).

David Wojnarowicz (U.S., 1954-1992)

Barry Blinderman, ed., *David Wojnarowicz: Tongues of Flame* (Normal: Illinois State University Galleries, 1990).

David Wojnarowicz, *Close to the Knives: A Memoir of Disintegration* (London: Serpent's Tail, 1992).

Jeffrey Wolin (U.S., b. 1951)

Scott R. Sanders and Jeffrey A. Wolin, *Stone Country* (Bloomington: Indiana University Press, 1985).

Francesca Woodman (U.S., 1958-1981)

Ann Gabhart, Rosalind Krauss, and Abigail Solomon-Godeau, *Francesca Woodman: Photographic Work* (Wellesley, Mass.: Wellesley College Museum, 1986).

Harm Lux and Kathryn Hixson, *Francesca Woodman: Photographic Works* (Zürich: Shedhalle Zürich, 1992).

Index